太刀
橫
量

NINJA

Also by John Man

Gobi
Atlas of the Year 1000
Alpha Beta
The Gutenberg Revolution
Genghis Khan
Attila
Kublai Khan
The Terracotta Army
The Great Wall
The Leadership Secrets of Genghis Khan
Xanadu
Samurai

NINJA

1,000 YEARS OF THE
SHADOW WARRIOR

JOHN MAN

WILLIAM MORROW
An Imprint of HarperCollins*Publishers*

3280999

HarperCollins books may be purchased for educational, business, or sales promotional use. For information please write: Special Markets Department, HarperCollins Publishers, 10 East 53rd Street, New York, NY 10022.

Originally published in slightly different form in the United Kingdom in 2012 by Transworld Publishers.

FIRST U.S. EDITION

Library of Congress Cataloging-in-Publication Data

Man, John, 1941–
Ninja: 1,000 years of the shadow warrior / John Man.
p. cm.
Includes bibliographical references and index.
ISBN 978-0-06-222202-2
1. Ninja—History. 2. Ninjutsu—History. I. Title.
II. Title: Ninja, one thousand years of the shadow warrior.
UB271.J3M36 2013
355.5'48—dc23 2012031912

13 14 15 16 17 DIX/RRD 10 9 8 7 6 5 4 3 2 1

CONTENTS

CONTENTS

A NOTE ABOUT TRANSLITERATION

Except for Japanese names and words common in English (e.g., Tokyo, Kyoto, shogun), Japanese has been romanized according to the "revised Hepburn" system, with a macron on ō and ū to indicate long vowels.

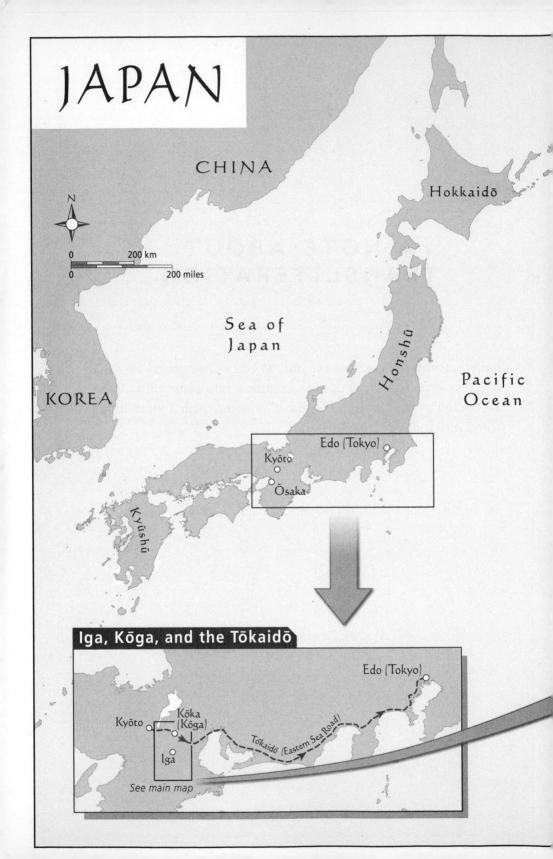

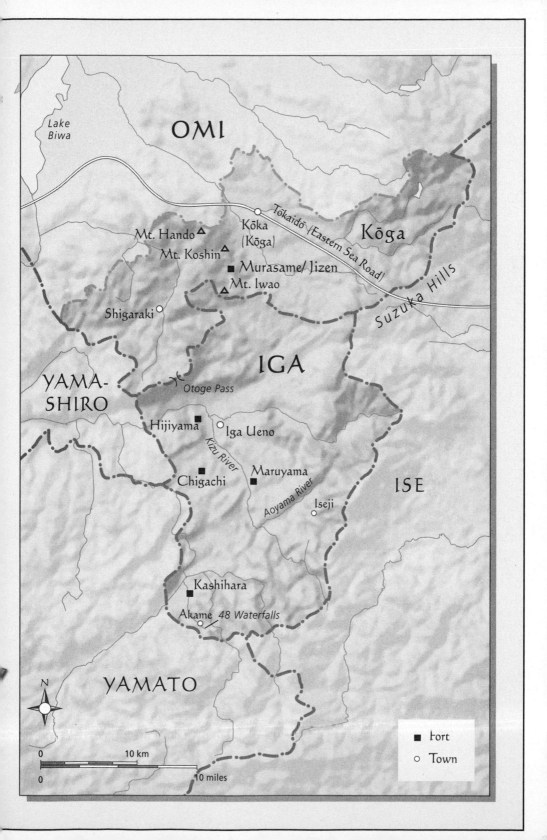

NINJA

INTRODUCTION: GHOSTS OF THE SHADOW WARRIORS

Once you get the details and layout of the castle or the camp, all you need to do is get back with the information as soon as possible.

<div align="right">Ninja instructional poem</div>

THE RESTAURANT OWNER, IN HIS MID-SEVENTIES BUT AS FIT AS someone half his age, was talking about his ninja ancestors. A firm gaze behind huge glasses, a ready laugh, a torrent of words: Mr. Ueda's ninja blood had kept him youthful and exuberant.

"But how do you know all this?" I asked, because ninjas were famous for leaving few written records.

"It's in the family. My grandmother was a Momochi." A famous name, an eminent family, one of several hundred who shared these forested hills and steep-sided valleys. "She used to talk to me about the past, when I was helping her on the farm and when we went away on holiday."

It was from her, with her childhood memories of her grandparents—his great-great-grandparents—that he had

learned about Iga's ninja families, about the way they had worked together to build an early form of democracy, keeping themselves independent of power-hungry lords. Did people where I came from know about this? No, I said, it would be news to them, because most people thought ninjas were comic-book creatures.

Mr. Ueda had much more to tell, but I was short of time, and interrupted with a glance at my watch and an abrupt question. Was there anything else? I was hoping for another swift bullet point that I could follow up on at leisure, and was utterly unprepared for what came next.

"I would like to show you what I inherited from my grandmother."

How could I refuse, without seeming impolite? He led the way past tables, pushed aside boxes, and revealed a narrow door into the roof space, for like most countryside buildings in this earthquake-prone country, the restaurant was a single-floor structure, with a loft for storage.

"Be careful," he said, stepping over a mat on the floor. "That's to catch rats. Very sticky. If you step on that, you will not get off."

The stairs rose steep and shoulder-width into shadows. I followed, with a twinge of anxiety at the delay, wondering how on earth I could beat a gracious retreat.

Above and ahead, he stooped clear of the sloping roof along a little space too small to be called a corridor, and led the way into a gloomy attic packed with, of all things, what looked like tailor's dummies. It took my eyes a few seconds to get used to the half-light before I realized what was before me: suits of ninja armor.

There were ten of them, slung over simple wooden cross-pieces, lined up among piles of empty cardboard boxes. They were nothing like the theatrical creations favored by samurai, with segmented breastplates and garish face masks and

exotic helmets. These were austere, dark, hooded, cloak-like doublets, the ghosts of shadow warriors. When I got up close, they turned out to be chain-mail doublets made of minute metal rings. From a meter away they looked more like cloth than metal, armored versions of the black peasant costumes that are nowadays considered traditional ninja garb.

Downstairs, Mr. Ueda had regaled me with family memories that may have been no more than folklore. These were the real things, direct links back centuries to a time when ninjas were ordinary farmers until called upon to defend not some lord but themselves—fighting for their families and villages against armies that had to be opposed with covert, nighttime operations because to engage with them in open, daylight conflict would be suicidal.

Nothing could have more powerfully brought home a fact I had hardly glimpsed until that moment: I was involved with a tradition that was very Japanese, yet completely different from the more obvious, better-documented traditions of the samurai. To learn about ninjas, I would be peering into shadows, and it would take a good deal of help and luck to discern underlying truths.

Before starting on this book, I thought I would be engaging mainly with myth: cartoon turtles, invisibility, flying, and other such nonsense. I was wrong. The ninjas, for centuries secret agents acting for their communities and their employers, had remarkable qualities—among them an extraordinary ability to inspire legends—but there was nothing magical about them. If ninjas ever mastered the art of invisibility (the subtitle of at least one book about them), they did so by being masters of disguise and camouflage.

I found instead a complex subject, rooted in true events, real people, and a charming region, little known to outsiders, of steep, forested hills, hidden valleys, mountain streams,

and patchworks of paddy fields. Here, in the two areas that used to be the provinces of Iga and Kōga (and are now parts of Shiga and Mie Prefectures in central Japan), the ninjas were part of life for centuries, and still are, because they are a growing tourist attraction. I got to know a little about a way of life—*ninjutsu*—that had less in common with martial arts than with the arts of survival. And I learned something of the mystical traditions the ninjas shared with those who sought to gain their power, by undertaking rigorous mind-and-body training regimes in sacred mountains. The true ninjas were, it turns out, not only masters of exotic fighting skills who worked as spies, mercenaries, police, and soldiers; they were men who sought "right-mindedness" for all aspects of life.

What was going on here? What was it about Iga and Kōga and the late Middle Ages that suited the development of the ninja way of life? In the 1970s, the evolutionary biologist Richard Dawkins suggested that ideas take root and spread in the same way as genes. He called the intellectual equivalent of a gene a "meme." Perhaps *ninjutsu* started as a recessive meme in ancient China and Japan, evolved into a dominant one because it proved useful to its hosts, and was then spread to outlying areas by carriers, who in this case were mercenaries. It seemed there was much to explain: Why then? Why there? Why did *ninjutsu* in the end cease to be so effective?

Perhaps most surprising to me was the realization that the ninjas had been around in Japan for seven hundred years before the word *ninja* appeared, and remained a thread in Japanese history long after the "real" ninjas had been deprived of almost all relevance by unification in 1600. The ninja ethos resurfaced, remarkably, in World War II as the very opposite of mainstream Japanese militarism: These ninjas (though not named as such) were no less loyal to the emperor but imbued with a spirit of generosity, creativity, and internationalism, ut-

terly at odds with the arrogance and xenophobia that typified the armed forces until they went down in defeat in 1945.

There have been several "last of the ninjas." In fact, *ninjutsu* seems to have found its final and most extraordinary expression in the career of the World War II soldier who held out for thirty years in the Philippines, Onoda Hiroo.[1] In his commitment to survive, in the techniques he used to do so, and in his humanity, Onoda—who, as I write, is still going strong at ninety—is in many ways the *real* last of the ninjas.

[1] As he is known in Japan, with his given name following his family name. In the West, the names are reversed.

1

ORIGINS

*Make yourself resolute with the idea that you will win when-
ever you go on a mission, and you can win even if it is not so
realistic.*

Ninja instructional poem

JAPAN'S "SHADOW WARRIORS" ROSE TO FAME AT A PARTICU-
lar time, roughly 1400–1600, in a particular region, and in
particular circumstances. But they did not spring into exis-
tence fully formed. To find their roots, look far away and long
ago, to China, almost eight hundred years earlier.

In the early seventh century, Tang dynasty emperors emerged
as rulers of a powerful empire and a great culture. The Japa-
nese, precariously united under their own ambitious emperors,
wanted to know its secrets. Court officials, students, teach-
ers, monks, and artists visited, were vastly impressed, and re-
turned with the "new learning," which was in effect all the
main elements of Chinese civilization—Confucianism, medi-
cines, textiles, weaving, dyeing, the five-stringed lute, masks,
board games, and whole libraries of books on scripture, his-
tory, philosophy, and literature, all in Chinese.

One thing China knew a lot about was war. For centuries, it was armed conflict that divided the nation, yet it was war—and ultimately conquest—that, in 221 BC, brought peace and unity. China's military wisdom had been summarized some hundred years earlier (or more, no one knows for sure) by the great military theoretician Sun Zi (Sun Tzu in the old Wade-Giles orthography). His *Art of War* was already one of the great classics. Sun Zi was a professional through and through. He spelled out the "five fundamentals"—politics, weather, terrain, command, and management—and went on to analyze details such as the cost of entertaining envoys and the price of glue. He was not concerned with glory; he was interested in fast and total victory, for as he said, "There has never been a protracted war which benefited a country." Only by quick victory can more war be avoided. Today's generals study him. Politicians ignore him at their peril. George Bush might have had second thoughts about invading Iraq, let alone boasting of "mission accomplished," had he pondered one of Sun Zi's aphorisms: "To win victory is easy; to preserve its fruits, difficult." The lessons were clear: Don't engage unless sure of victory; Avoid risks; Better to overawe your opponent than to fight. But if you have to fight, do it my way! Learn the rules of military leadership, logistics, maneuvering, terrain, and, in particular—he saves this for last—deception.

It is the final chapter that interests us in our pursuit of the ninja's origins:

All warfare is based on deception. Therefore when capable of attacking, feign incapacity; when active in moving troops, feign inactivity. When near the enemy, make it seem that you are far away; when far away, make it seem that you are near. Hold out baits to lure the enemy. Strike the enemy when he is in disorder. Prepare against the enemy when he is secure at all points. Avoid the enemy for the time being when he is stronger.

Only in this way can you gain the essential—speedy victory.

Of all the weapons vital for a speedy victory, the most vital is information. "The reason a brilliant sovereign and a wise general conquer the enemy . . . is their foreknowledge of the enemy situation. This 'foreknowledge' cannot be elicited from spirits, nor from gods, nor by analogy with past events, nor by astrologic calculation. It must be obtained from men," namely, spies.

There are five types of spies, he says: native, internal, double, doomed, and surviving. In brief, your own people, the enemy's people, double agents, expendables, and ninja-like spies who can penetrate enemy lines, do their job, and return. All these men are vital for victory. None should be closer to the commander, and none more highly rewarded, and "of all matters none is more confidential than . . . spy operations." He who is not sage, wise, humane, and just cannot handle them, "and he who is not delicate and subtle cannot get the truth out of them. Delicate, indeed! Truly delicate," for if plans are divulged prematurely, the agent and all those to whom he spoke must be put to death.

An example of what Sun Zi was talking about occurred when Zheng of Qin, the future first emperor, was halfway through unifying what would in 221 BC become the heart of modern China. The first emperor, brilliant, ambitious, and utterly ruthless, was the target of several assassination attempts. Like many heads of state today, he took care to protect himself at all times. When traveling he was particularly vulnerable, as we know from an archaeological find made near his grave site close to Xian, and also near the tomb's greatest treasure, the several thousand life-size soldiers that make up the Terra-cotta Army.

In 1980 archaeologists working at the western end of the tomb mound found a pit divided into five sections, in one of which were the remains of a wood-lined container, crushed be-

neath the fallen earth. Inside lay what have become the crown jewels of the Terra-cotta Army Museum: two four-horse, two-wheeled carriages, in bronze, half life-size, complete with their horses and drivers. The carriages had been smashed into fragments, but after eight years' work they were restored to full working order, perfect down to every rein and harness and free-spinning axle flag.

One chariot is an outrider, with a driver standing on a canopied platform. The other is the emperor's. It has a front section for a charioteer and a second, enclosed section for the emperor, with a roof of silk or leather waterproofed with grease. In the windows there is mosquito netting—all this rendered in bronze, of course—and, on the side windows, a little sliding panel so the emperor could see out, get air in, and issue orders without his august person being seen.

But Zheng's chariot is not exactly a tank. It had to be relatively lightweight for easy movement and was therefore vulnerable to heavy-duty arrows or swords, such as might be carried by would-be assassins. The solution, as Sun Zi knew, was deception, which meant exactly the same solution as adopted by many a head of state today: decoy vehicles. The emperor traveled in any one of several identical carriages. At least one assassination attempt failed because the assailant attacked the wrong carriage. Possibly, another four decoy carriages remain to be found, so that a would-be assassin had only a one-in-five chance of attacking the right carriage.

So to get at Emperor Zheng, a conventional approach would be useless. What was needed, in effect, was a ninja.

In what became one of the best-known incidents in Chinese history, Emperor Zheng conspirators against Zheng employed a proto-ninja for the job. The episode has become a popular subject for film and TV dramatization (most effectively in the 1998 epic *The Emperor and the Assassin*, directed by Chen Kaige). The source is the grand historian Sima Qian, whose

account, written a century after the event but based (he says) on eyewitness accounts, is as vivid as a film synopsis.

One of Emperor Zheng's generals, Fan Yuqi, defected, and is now under the protection of the prince of Yan, a rival province. Zheng has offered a reward of a city plus 250 kilos of gold for his head. The emperor's troops are massing on Yan's border, and the only way to stop Zheng's meteoric rise is to find an assassin to kill him. A young adventurer named Jing Ke is chosen for the task. He is a man with nerves of steel and high intelligence, who likes "to read books and practice swordsmanship"—in brief, the essence of the true ninja. He refuses to quarrel; if offended, he simply walks away. Jing Ke is too smart to agree at once, but his reluctance is overcome when he is made a minister and given a mansion.

Knowing he has no chance of getting close to Zheng without a good excuse, he approaches the renegade Qin general, Fan, with an extraordinary suggestion: If he could have the general's own head, he will go to Zheng offering Yan's surrender, with Fan's head as a sign of good faith. He will also have a map of Yan territory. These two items will gain him access. Inside the rolled-up map he plans to conceal a poisoned dagger, with which he will stab Zheng. The general finds this an excellent idea—"Day and night I gnash my teeth and eat out my heart trying to think of some plan. Now you have shown me the way!" So saying, he obligingly cuts his own throat.

Head and map gain Jing Ke and an accomplice entry into the court and an audience with the king. At this moment the accomplice has an attack of nerves, leaving Jing Ke to go on alone. Watched by a crowd of courtiers, Jing Ke unrolls his map, seizes the dagger, grabs the king by the sleeve, and strikes. The king leaps back, tearing off his sleeve, and Jing Ke's lunge misses its mark. Zheng flees with the assassin in pursuit, while the unarmed courtiers stand back, appalled, watching their lord and master dodging around a pillar, try-

Ninja: The Word Explained

English-speakers are often puzzled that the word *ninja* is sometimes rendered *shinobi*. How can two such different words in English be the same in Japanese? Here's how:

From the seventh century, Japanese took on Chinese culture as the foundation of their own. This included writing with Chinese signs, despite the fact that there is no connection between the two languages. This script, kanji, is used in combination with two other scripts, both of which are syllabic. The two syllabic scripts are relatively easy to learn, but in practice they are not much use without knowing several hundred kanji signs as well. It's a struggle and, frankly, for non-Japanese, a nightmare.

The kanji signs have two pronunciations: mock Chinese, which, being more scholarly, has high status, and real Japanese. For example, a "mountain" in Chinese is written 山 and pronounced *shān*, the line over the *a* [*ā*] representing a level tone of voice, as opposed to a rising [á], falling [à] or falling-rising [ǎ] tone. In the Japanese version of the Chinese, that becomes *san*. But in proper Japanese, "mountain" is *yama*. The Japanese use both, with *san* as the higher status—hence Fuji-san for their most famous mountain, rather than Fuji-yama, which is favored by foreigners. One sign, two utterly different pronunciations.

The same system applies to the signs and words usually transcribed in English and many other languages as *ninja*. In Chinese, the signs 忍者/ *rěn zhě* mean "one who endures or hides." Japanese uses the same signs. But in the Japanese pronunciation, the term is distorted into *nin sha*, usually transliterated as *ninja*. In spoken Japanese, the word for "one who endures or hides" is *shinobi mono* ("enduring or hiding per-

son"), usually shortened to *shinobi*. The "nin" part of *ninja* consists of two elements, "blade" (刀) placed above "heart" (心) in the wide sense of intelligence, soul, life. By tradition, the two suggest a hidden meaning. Perhaps a ninja is someone who has a sword blade hanging over him, ready to end his life if anything goes wrong; perhaps he is someone who knows how to make his intelligence as sharp as a blade.

Until quite recently, Japanese were happy to use both terms indiscriminately, because they have the same signs and mean the same thing, except that the mock-Chinese version is higher status. Since early contacts between foreigners and Japanese were at a high social level, *ninja* became the preferred version in both foreign languages and Japan.

ing in vain to untangle his long ceremonial sword from his robes. A doctor has the presence of mind to hit Jing Ke with his medicine bag, which gives the king a moment's grace.

Even as Jing Ke comes at him again, the king manages to untangle his sword, draw it, and wound Jing Ke in the leg. Jing Ke hurls the poisoned dagger, misses, and falls back as the king strikes at him, wounding him again. Jing Ke, seeing he has failed, leans against the pillar, then squats down, alternately laughing hysterically and cursing the king. The crowd moves in and finishes him off.

Would it be fair to call Jing Ke a forerunner of the ninjas? Hardly. True, he gained entry to the emperor by means of a trick. But the plot demanded that he operate in public and be prepared to die. Ninjas moved in secret and planned for survival. If there are lessons in this story, they are that rulers should be more careful and that secret agents should up their game. There's no point in half a ninja.

The incident, along with much of China's recorded history,

became familiar to the Japanese from their embassies. Scholars knew about the first emperor and were familiar with the "Five Classics," among them Sun Zi's *Art of War*, known in Japan as *Shonshi*, a Japanese version of "Sun Zi." In theory, therefore, they knew about Sun Zi's admiration for the dark, covert arts of deception and spying. In addition, a number of wealthy Chinese fled the war-torn mainland in the early Middle Ages (tenth through twelfth centuries), many traveling through the Japanese heartland to the court and some settling along the way, emphasizing to their Japanese hosts the importance of Chinese culture, including the techniques of covert warfare. The famous Takeda family, which rose to prominence in the sixteenth century, owned at least six of the Chinese classics, including those by Sun Zi, Confucius, and Sima Qian (the grand historian who told the story of Jing Ke), suggesting that key ingredients of *ninjutsu*, the "art of invisibility," are Chinese in origin.

In fact, the idea of deception also has well-established Japanese roots, as two stories reveal. They appear in Japan's most ancient surviving book, the *Kojiki* (*Record of Ancient Things*). The *Kojiki* was one of two works produced for Emperor Temmu, who in AD 682 commanded his princes and nobles to "commit to writing a chronicle of the emperors and also of matters of high antiquity." Produced for the court thirty years later, the *Kojiki*'s amalgam of written and oral tales purports to explain the origin of the nation, from the beginning of heaven and earth, "when the land was young, resembling floating oil and drifting like a jellyfish." From three gods sprang the islands of Japan and eight million—"eight hundred myriad"—other gods, among them Amaterasu, the sun goddess, ancestor of the royal family. In a slurry of myth, song, legend, pseudo-history, and history, the 149 brief chapters reveal how, over twelve hundred years, thirty-four em-

perors imposed their wills on rival clans as Japan's divinely ordained ruling family.

Two stories tell of a young hero called Wo-usu, later renamed Prince Yamato the Brave, who still wore his hair up on his forehead in the style of a teenager. He was (supposedly) the younger son of the twelfth emperor, Keikō of Yamato, which in the second century AD was one of the five provinces of central Honshu, the heartland of the almost unified nation. The words in quotes are from the original as translated by Donald Philippi.

The Wiles of Prince Yamato

Emperor Keikō tells the elder of his two sons, whose name is Opo-usu, to bring him two beautiful sisters to marry. Instead Opo-usu marries the sisters himself. Then, in embarrassment, he avoids coming to eat morning and evening meals with his father.

The emperor tells the younger son, Wo-usu, to summon his brother.

Five days later, Opo-usu has not appeared.

"Why has your elder brother not come for such a long time?" says the emperor. "Is it perhaps that you have not yet admonished him?"

"I have already entreated him," replies Wo-usu.

"In what manner did you entreat him?"

"Early in the morning when he went into the privy, I waited and captured him, grasped him and crushed him, then pulled off his limbs and, wrapping them in a straw mat, threw them away."

Wo-usu's ruthlessness strikes the emperor as a pretty rough punishment for skipping a few meals. He instantly finds a mission that will suit his son's "fearless, wild disposition."

"Toward the west," he says, meaning the southern part

of Japan's southern island, Kyūshū, "there are two Kumaso-takeru"—*kumaso* being a word for the aboriginals of that part of untamed Kyūshū and *takeru* meaning "brave." If this were an English fairy tale, these aboriginal chieftains would be ogres, and Wo-usu a Japanese Jack of the beanstalk. Anyway, says the emperor, "they are unsubmissive, disrespectful people. Therefore, go and kill them."

Before departure, Wo-usu's aunt, who in other versions of the story is a high priestess of the sun goddess, gives him two items of clothing suitable for a woman, an "upper garment" and a skirt. Why? Because very soon they will become vital to the story, and he has to get them from somewhere. Armed with a small sword, which he tucks into his shirt, he sets off.

When Wo-usu arrives at his destination, he finds the ogre brothers inside a newly built pit house, for in olden days aboriginals often lived in houses hollowed out of the ground. There is much noise, for the ogres are preparing a feast to celebrate the completion of the house. Wo-usu waits, walking around until the feast day. Then he dons a ninja-like disguise. He combs his hair down in the style of a young girl, puts on the robe and skirt given him by his aunt, hides his sword under his costume, mingles with the women, and enters.

The two ogres take one look at this vision of loveliness and command the "maiden" to sit between them.

When the feast is at its height, Wo-usu draws his sword, seizes the elder ogre by the collar, and plunges the sword into his chest.

The younger ogre, seeing this, takes fright and flees, with Wo-usu in pursuit. At the foot of the stairs leading out of the pit house, Wo-usu catches up with his victim, seizes him by the shoulder, and stabs him in the rectum.

"Do not move the sword," says the ogre. "I have something to say." At this the action, as if in a dream, comes to a dead

halt, giving the ogre, to whom it has now occurred that the "maiden" is no maiden, time to ask, "Who are you, my lord?"

Wo-usu launches into a long explanation of his origins, naming his father the emperor. Hearing that "you [ogres] were unsubmissive and disrespectful," he says, "he dispatched me to kill you."

Then the ogre, still ignoring the sword up his backside, says politely, "Indeed, this must be true. For in the west there are no brave mighty men besides us. But in the land of Yamato there is a man exceeding the two of us in bravery. Because of this I will present you with a name. May you be known from now on as Yamato the Brave."

Then, at last, Wo-usu, now Yamato-takeru, Yamato the Brave, killed his long-suffering victim, "slicing him up like a ripe melon."

In the next chapter, Yamato the Brave comes to an old province in southwestern Honshu, intending to kill the ruler, Idumo the Brave, otherwise known as Many-Clouds-Rising. To do this, he uses two deceptions. First, he pretends to be Idumo's friend, then he makes an imitation wooden sword.

The two "friends" go to a river to bathe.

Yamato comes out first, and says, as a friend might, "Let us exchange swords!" Idumo agrees, and straps on Yamato's wooden sword.

At this Yamato issues a challenge, but of course Idumo can do nothing with the imitation sword and falls an easy victim to Yamato, who exults in his unsporting victory with a song:

> The Many-Clouds-Rising
> Idumo the Brave
> Wears a sword
> With many vines wrapped round it
> But no blade inside, alas!

*

After my visit to the restaurant owner and his collection of ninja armor, we—my local guide, Noriko, and I—had gone south in a small, swaying train to Akame, to explore a beauty spot known as the Forty-Eight Waterfalls. We were on a paved path, walking up a gorge beside a river that fell over rocks and trees brought down by a typhoon a few days earlier. Japanese of a certain age strolled ahead and behind. Walking shoes, backpacks, and jackets with many pockets—these were people prepared for a serious day out, the ladies shielding themselves with parasols from the late-summer sun filtering through the near-vertical forest. I wanted to see the falls because the mountain from which they flow was a place once favored by ascetics who practiced Shugendō, Japan's ancient folk religion. The practitioners, uncounted generations of them coming here for more than a thousand years, included warrior farmers who would eventually be known as ninjas, for they wanted to share in the knowledge and skills that gave the "mountain ascetics"—the *yamabushi*—their power. That was why I was interested in this extraordinary tradition.[1]

They came for two reasons. The first is that mountains have a particular significance in Japanese religious thinking. In old Japan, existence depended on rice, which grew in patchworks of fields that had to be created and managed with expertise and hard work. Men and women needed to be in control. The landscape was flat. Water must flow gently in and out, at the right time. Mountains were the opposite of all this. They were steep and, in Japan, forest-covered (not rocky eminences, like the Alps), and home to wild and dangerous things—bears and snakes and the supernatural beings called *tengu*, with their

[1] *Yamabushi* is sometimes translated as "mountain warrior," because *bushi* means "warrior." In this case, not so. This *bushi* has a different sign, and derives from a word meaning "to prostrate oneself." A *yamabushi* is "one who prostrates himself on a mountain."

red faces and long noses and scaly forearms. Mountains were uncivilized, untamed places, where the souls went after death, and where countless deities lived. They were the sources of life-giving water, of the spirits that cause disease, and of the medicinal plants that can control the spirits and cure the diseases. In short, they were places of power. The ways ordinary people could respond to the world of spirits was with subservience, expressing gratitude, or awe, or contrition to the spirits that came and went from the mountains.

Alternatively you could be more proactive and choose a more autonomous path. That was what it took to develop what ninja sources call "correct mind." For "shadow warriors" were—in principle, at least—more than the traditional idea of warriors, as one of my advisers was keen to make clear. Toshinobu Watanabe, a remarkably fit, seventy-something, from the ninja base of Kōka (or Kōga, as it used to be), will appear several times in this book, guiding us here and there, but here he is a guide to the state of mind sought by the ideal ninja. "You Westerners often think of ninjas as men of darkness who only knew how to assassinate. Completely wrong! The records, every single one of them, insist in their first lines that you need the correct mind."

"What does that mean?"

"Do no evil! The ninjas believed in peace. They gathered information in order to avoid as much war as possible. They were dedicated to the idea of killing only if necessary—and to their own survival. They practiced martial arts only for self-defense. Of course, not all ninjas were like this. That is why the sources emphasize the need for correct mind. But most of the time they did their best."

If you wanted correct mind, if you sought power over your own life, over others, over events, and over the world of spirits, you would go to the mountains, find yourself a master, and subject yourself to rigorous physical, mental, and spiri-

tual rituals. This is the practice known as Shugendō, the way of mountain asceticism. You walked the sacred spots, among groves, exposed rocks, ancient trees, waterfalls, streams. You fasted, purified yourself by sitting under waterfalls, hardened your body with feats of endurance, got to know the spirits of the mountain, and because the spirits might object to your presence on their territory, you learned how to propitiate them. Having done this, you became a *yamabushi*. Moreover, you got a certificate from your master to prove you were not a fake.

"And there were plenty of fakes," said one of my advisers, Tullio Lobetti, an Italian expert in Shugendō at the University of London's School of Oriental and African Studies. He is a graduate of one of Japan's most famous training centers, on Mount Haguro in Yamagata Prefecture, and thus one of the few Western *yamabushi* ("though I have only the lowest form of certificate"). "How else do I show I am not a fake? By being able to perform supernatural feats. Like being able to stay in a cauldron of boiling water." He saw my raised eyebrows. "Being boiled—really!"

"You have actually seen this?"

"Yes. It was not much water, but still—it was hot."

"Do you know how it was done?"

"I know the rituals but not the mechanism. I didn't ask. It's not the kind of thing they want to talk about. Also walking on swords."

"You've seen that, too?"

"I have done it. Anyone can. It's not hard. You just have to know the right technique. It's all part of proving you have the right credentials and are part of an established group."

Perhaps, if you were an advanced adept, you would become a priest. That was the equivalent of an MA or PhD. But at the very least you would emerge with a technical and professional qualification—knowledge and skills and power to cure

diseases, exorcise evil spirits, and perform rituals essential for ordinary people, such as funeral rites and the breaking of new ground for building a house. You would be respected, and people would pay for your services.

For a ninja, the advantages of Shugendō training was obvious. Miyake Hitoshi, a pioneer in Shugendō studies, explains why:

> Especially remarkable among the activities of the *shugenja*, or *yamabushi*, in the Kamakura and Muromachi periods (1185–1573) were those in time of war—performing magico-religious rites, acting as messengers or spies, and practising the martial arts. The *shugenja*, who knew the mountain trails and through their travels were familiar with conditions all over the land, were well qualified to undertake these activities. Before battle, they blessed horses, arms and armour and prayed for the defeat of the enemy. Their intercessory rites were called for when camp was set up or broken. . . . Then too there were significant links between *shugenja* and the ninja masters of Koga (Omi province), Iga and Negoro. So skilled were the *shugenja* at stealthy appearances and disappearances that they were compared to the legendary mountain creatures called *tengu*, who were said to inhabit the very mountains where the *shugenja* had their centres.[2]

I asked Tullio about the training. In summary, this is what he said: In Japan, mind and body are not separate. In the West, we often say it doesn't matter how you are outside, it is the inside that matters, the mind. But in Japan, that is not true. How you are outside matches how you are inside. If you are tall, strong, beautiful and rich, that is how you are inside. If you are weak, bent, diseased, that is how you are inside. You

[2] Hitoshi, *Mandala of the Mountain*, pp. 67–68.

want to achieve some inner benefits? Well, you can do it by improving your body.

The idea is that whatever you do, it should take physical effort. When you walk from sacred spot to sacred spot, it's sort of like a pilgrimage, but harder. You can walk twenty or twenty-five kilometers a day over mountains, over rocks. There are often no paths. You may have a rope to climb down to worship a sacred spring or rock. It's a matter not of imposing pain for its own sake, but of doing something hard, and the harder it is, the greater the reward. So if it is done in winter, all the better. You know, Tullio told me, there is energy within us that we do not use. If you sit under a waterfall and it is minus ten degrees, what you feel is a surge of heat. That's the way your body reacts, if you don't die.

There is a whole universe of lore—religious, philosophical, literary—that you can do in advanced Shugendō, and an encyclopedia of magical gestures to be mastered and then performed hidden by clothing. Take the reading of the texts, he explained, which is mainly in kanji. But there is also a secret reading, with special Shugendō pronunciation, which is meant to be more powerful. Then you have Sanskrit mantras. In the Heart Sutra, for instance—he started a rhythmic, low-voiced chant, *Ya-te-ya-te-para-ya-te-parasan*—the sutra says, in effect, "Now I will teach you the greatest spell of all, the spell that conquers all passion, the spell that says, 'Form is emptiness, emptiness is form, there is no ear, no nose, no eye . . .'" Ultimately, this high-level esoteric practice is all about being reborn at ever higher levels until you become a Buddha and achieve enlightenment and enter nirvana.

How would this help a ninja with spying and fighting and survival? One thing is certain: If you, as a warrior, undertook even part of the training, you would emerge tougher in mind and body. Tullio knows because he has been through it. "You become completely estranged from everyday life. You are so

exhausted you do not think anymore. You do not remember where you are from. This is the point at which you can rebuild yourself in a different way." Tullio chose a computer analogy: "The experience *resets* you. I was told by a friend who had joined the Special Air Service, the British equivalent of the SEALs, that an SAS training course has the same effect. You emerge rebooted, refocused, ready for battle."

Why would you, as a would-be *yamabushi* or shadow warrior, come to one mountain as opposed to another? Because it had a tradition of being sacred that was guaranteed by an oral history (or in rare cases a text) that led from master to master, right back to the time the mountain was "opened" by the very first religious adept to come there, the one who marked out the sacred spots. The more ancient the opening and the more eminent the opener, the better. The most eminent of all was and remains Shugendō's semi-mythical eighth-century founder, En no Ozunu, better known to historians of religion as En no Gyōja, En the Ascetic.

En is a vital figure in Shugendō, because he was everywhere, or so countless traditions claim. "He's a sort of a wild card," as Tullio put it. "If you issue certificates to qualified *yamabushi*, you have to legitimize your practice. You do this with an impressive foundation narrative, and there is no one more impressive as a founder than En no Gyōja. That's why he is 'everywhere.' Well, obviously he cannot possibly have been to all these places, although he is imagined as running and jumping from one to another. That doesn't matter. What matters is the impressiveness of the claim."

So who opened the Forty-Eight Waterfalls? Why, En no Gyōja, of course.

So the future ninjas joined the *shugenja* (as those who practice Shugendō are called) and other would-be curers and warriors and priests. They came here to train on the mountain ways—in effect, marking out commando routes and running

and climbing them at speed and subjecting themselves to endurance tests, but also aiming to acquire purity of mind, with the hope of achieving magical skills, medical powers, and longevity.

Shugendō is alive and well, practiced by many groups all over Japan, as my guide, Noriko, was happy to tell me, because as mentor and fixer for films and TV channels she had explored many training areas, entered more temples and shrines than I knew existed, and met uncounted priests, martial artists, and ninja experts.

"My grandfather did Shugendō. He died from sitting under a waterfall."

"*What?*"

"It happens all the time." She sounded really casual.

"But *what* happened?"

"I don't know. It was long before I was born. He was forty-five. My father was five."

"B-but . . . ," I stuttered, "did he drown? Or catch a cold?"

"Well, it was December." She was speaking to me as if surprised at my surprise. "It's religious training! If you don't believe in the religion, don't do it. It has to be tough, so obviously it was winter. If you go under a waterfall in summer, it's not training, it's called 'nice.'"

That was half a century ago, but the traditions are still strong. My hosts in Kōka took us to a Shugendō fire festival, where, in an open space on a mountainside, a high priest in a green mantle led twenty elderly acolytes in honoring the spirit of the mountain. It deserved respect because this mountain, Iwao, had an eminent pedigree: It was one of three where the ninth-century founder of Buddhism's Tendai sect, Saichō, built temples and trained. A respectful audience of two dozen included five ladies in white, who would later offer light refreshments. There was much single-note, rhythmic chanting, punctuated by the sound of two conch shells being blown

like bugles. Once upon a distant time I played the trumpet, so I tried one after the ceremony. It had a simple mouthpiece, and its sound was something between a hunting horn and a very resonant one-note fart, which could be briefly pushed up an octave if you felt ambitious. Everyone was in traditional costume—white shirt, baggy white plus fours, white bootees molded to divide the big toe from the other toes, a white cape, and a sort of harness with two red bobbles on the back. In the middle of the open area was a pyre of green cedar branches. After more chanting and conch blowing, a devotee picked up a bow and arrow and prepared to fire. For a moment I imagined the creak and twang of a longbow and an arrow zipping away over treetops, but it was a ritual bow and a toy arrow, which flopped to the ground after a couple of meters. Never mind; it did its symbolic job, which was to break the power of evil spirits. A ritual axe and a few ritual chops cleared the holy space of invisible trees.

Then, despite my skepticism, the ceremony began to get to me. The high priest threw some bits of wood and paper with writing on them onto the pyre. They were messages to the god, I discovered later, to be burned like a child's Christmas list. "It's very, very strange," the priest told me, "but if you make a wish, it often comes true." Candles lit long broomlike tapers, which were applied to the pyre. Smoke poured out along the ground, like liquid oxygen in a stage show, before the heat built, and the crackling branches slowly caught and the smell of fir spread like incense, and smoke billowed around us, turning the participants to ghosts and the cathedral of trees to a faded backdrop, all this happening to the hypnotic, regular beat of a chant. *Ma ka han ya ha la mi ta . . .* It was, I discovered later, a Japanese version of the Sanskrit Heart Sutra.

Afterward, I asked the high priest to explain. "We do this twice a year, in autumn and spring, wishing everybody good

health and success in business. We are praying to a dragon god. A long time ago, a white snake was found here and someone heard the god saying that one should pay respects to it, because when snakes become old and die, they often become a dragon god. There is also *Fudō-myōō*"—a guardian god—"which you can see carved into the stone up there, where the shrine is. Have some sake." He gestured to a tray held by one of the white-clad women. "It is the best sake, and now purified because it has been touched by the god, which makes it taste even better."

The shrine, up a flight of steps, was a wooden side chapel of this natural cathedral, set on stilts. It shielded a rock face into which was carved a rough bas-relief of a man with a club over his right shoulder, as if he were a bodyguard ready to spring to the defense of the dragon god.

It was, of course, as much theater as many a Christian religious service. But I was touched by an element absent from Christianity: the sense of being present at something primeval, stemming from a time when we were awed by nature and were part of it and eager to please its good spirits and defend ourselves from the bad ones. The spirits were once part of life. For these worshippers, they still are. I'm no believer, but I could imagine myself believing that the good wishes and the smoke and the chanting and the shell blasts summon, or create, the very spirits that must be honored or banished. A Stone Age shaman would have understood. A shadow warrior would surely have been inspired.

All of which is to explain the background to the Forty-Eight Waterfalls, which in their foundation narrative reach back to the roots of Shugendō. You can't actually become a modern *yamabushi* or ninja by walking or running over these towering cliffs and through these looming forests nowadays, because the Forty-Eight Waterfalls is a protected area, but it doesn't

take much to see the challenges they present from the safety of the paved path.

White waters foamed under little bridges and past massive boulders shaken loose by earthquakes. Falls tumbled into the sudden silence of pools that would have been crystal clear, except for the gray-green cloudiness left by the recent floods. Not far upstream, a sheer cliff and a series of falls, flickering in the dappled sunlight, once blocked the way, which today is carried on upward by a footbridge. It was entrancing. If I ever seek enlightenment, this is my sort of a place, especially on a still September day, with the heat of the sun reduced by leaves above and cool waters below, and absolutely no chance of defying death on some vertiginous rock face or overarching forest. I glanced down and saw, where rock gave way to rising undergrowth, the stone statue of a cow with red eyes.

"Yes," said the guide, Kazuya Yamaguchi, raising his voice above the roar of rushing water. "When En was training here, he saw a red-eyed cow, which is how this place got its name— Akame, Red-Eye."

This, apparently, was as far as ordinary people could go in the old days. But off to the right, clear of trees, was a petrified cascade of boulders. In heavy rain, like the storm that had hit earlier, it turned into a torrent that stripped it of vegetation. Now, after a few days of warmth and sunlight, it was a steep and rocky way leading up into the overhanging forest. That, said Kazuya, was where Shugendō practitioners and their ninja students could climb to get to the upper falls. Remember this place; we shall be returning here to follow the last of the ninjas as they escape the army sent in to eliminate them, some nine hundred years after En opened it up.

Another tale of ninja-like intrigue takes place during a famous rebellion in the tenth century by the warlord Masakado against his own family, the Taira. This was a time when local

lords had all but broken free of the central government and set up what were in effect independent kingdoms with their own armies. Masakado was the most ambitious of these great landowners. He claimed that the sun goddess Amaterasu had actually intended him to be emperor, and set about making this a reality by seizing eight eastern provinces as a prelude to taking the capital, Kyoto, and ruling the whole country. He had one main obstacle, the opposition of his uncle Yoshikane. In early 940, Yoshikane attacked, devastating his nephew's lands, forcing him into hiding, but inspiring in him a fierce determination for revenge. The main source, the *Shōmonki*, describes the two armies skirmishing, without either gaining an advantage, until Yoshikane found himself a spy, in the form of one of Masakado's young servants. The teenager, a boy named Koharumaru, had been traveling back and forth to a nearby farm to visit relatives. Thinking that the boy might be a useful source of information, Yoshikane summoned him and put the idea to him, bribing him with a bolt of silk and talk of high office and all the food and clothing he could ever want. The young man happily accepted, his only condition being that he have an accomplice in the form of one of Yoshikane's farmhands.

So the two spies, ninjas in all but name, went to Masakado's residence as night watchmen, each carrying a load of charcoal. Over two nights, Koharumaru took his accomplice around, showing him the armory, Masakado's sleeping quarters, and the four gates. Yoshikane's man then returned to report to his boss.

All to no purpose. Masakado infiltrated Yoshikane's army, discovered the plot, executed the young servant, and was ready when Yoshikane's attack came. Yoshikane's soldiers dropped their shields and ran away, dispersing "like mice unable to find their holes, while those who gave chase showed the strength of a hawk leaving the hunter's gauntlet."

In the end, Masakado's victory was in vain. A few months later he himself was defeated, killed by a stray arrow, and beheaded, his head being exposed in Kyoto as a warning to other rebels.

The stories of Yamato and Masakado do more than show the importance of deception. They also highlight opposing themes in Japanese history: the capital, the emperor, and unity set against the provinces, warlords, and diversity. It would take seven hundred years for that conflict to be resolved in favor of capital, emperor, and national unity. Along the way, shadow warriors would play vital roles, though largely obscured by the glitter and drama and public displays of their counterparts, the samurai.

2

HOW TO BE A SHADOW WARRIOR, PART 1: MIND AND SPIRIT

If a ninja steals for his own interests, which is against common morals, how can the gods or Buddha protect him?

Ninja instructional poem

It seems almost magical, this art of night stealth that enables you to make yourself invisible.

Foreword, the *Shoninki*

THE FIRST TO REVEAL THE SECRETS OF THE NINJAS WERE THE ninjas themselves, long ago.

Throughout their history, the ninjas were by definition secretive. It would have been against all their training and teaching—indeed, self-destructive—to make public their way of life. But the secrets *were* revealed, not long after Japanese unification made the ninjas an irrelevance. Why? Perhaps it was to help train recruits into the contingent of two hundred

ninjas taken on by the shogun as secret police, perhaps it was simply to record a way of life that seemed about to vanish. Whatever the motive, it was done at least three times. The best of these records is the *Shoninki* (*Sho Nin Ki*, "true ninja tradition" or "Account"), probably written by Natori Masatake, a samurai in the service of the shogun, a century after the ninjas' Iga homeland was destroyed in 1581.

Probably written by Natori Masatake. He does not name himself, but a friend who provides the foreword mentions a name that has enabled scholars to agree on an identification, even though this Natori used several names, as was common in Japanese history. There are three versions of his book in English (see bibliography). I rely on the one translated and edited by the British *ninjutsu* scholar Antony Cummins and his Japanese colleague Yoshie Minami, because it best takes into account the difficulties of dealing with seventeenth-century Japanese. What follows is a combination of indirect and direct quotes, presenting the essence of Natori's teaching.

To modern eyes, the most surprising thing about the *Shoninki* is what it leaves out. Being used to seeing ninjas on film—more on that later in the book—you might expect (a) many weapons, and (b) a list of martial arts moves. But weapons get short shrift, and there is absolutely nothing about martial arts, raising the possibility that, for all its long life, *ninjutsu*, the art of the ninja, did not focus on martial arts at all until well after the *Shoninki* was written. Its focus is primarily on attitude, or right-mindedness; deception; and charms, which is surely where the idea of ninjas as masters of magic originated, an idea rejected by Natori right at the beginning.

First, to explain the essence of *ninjutsu*, Natori writes a little dialogue between apprentice and master. The apprentice is in awe of the rumored skills of the ninja. I have vaguely heard, he says, that even if a father and a son or brothers see each

other while engaged in ninja covert acts, they would not be able to recognize each other. They say a ninja can move instantly from in front of you to behind, that he appears and disappears from moment to moment. "Surely," he concludes, "this art cannot be attained by mere human beings?"

The master is scathing. True, ninjas are masters of deception, able to talk about a province they have never been to, tell a strange story about a place they don't know, buy things with gold or silver they don't have, eat food nobody gives, get drunk without drinking alcohol. They go out acting covertly all night and sleep in the wilderness without shelter. There is nowhere they cannot go. Even so, "what have you seen or heard in order to so misunderstand this path? Nothing is mystical about the true tradition and correct way of ninjutsu."

You must understand (says Natori) that when we speak of *ninjutsu* we are speaking of life skills. Nakashima Atsumi, who modernized the *Shoninki*'s seventeenth-century Japanese for translation into English, writes in a preface that the *Shoninki* "offers instruction for every aspect of your life and provides help in any circumstance."

But it will only provide help if you have the right attitude, namely, one that derives from the teachings of Confucius, which were back in fashion at the time Natori was writing: "A ninja can do anything as long as it is in accordance with his own sense of value and the justice of the group he belongs to." In other words, he must serve an impersonal cause. Sometimes he will be told to undertake assassination, theft, or robbery, but even dirty jobs like this are justified if the ninja is "right-minded," that is, if he acts for the benefit of his employer. "If ninjas used ninjutsu for their own interest, it would be mere theft and robbery," and no one would hire them. "Right-minded," however, is not necessarily "high-minded." Obeying orders does not equate to morality.

So serving your master's interests rather than your own is

only the most basic requirement. A ninja should aim higher than that, in accordance with the oath sworn by the warriors of the ninja heartland, the old provinces of Iga and Kōga, the great oath known as *Ichi Gun Ichi Mi*, (one district, one band). By doing this, it is said, they "show that their family tradition was extraordinarily exquisite and outstanding, and also show the marvel of their tradition of ninjutsu at its best."

What does this mean? First, it means behaving in the right way. "You must always appear graceful and calm, just as waterfowl do on a calm lake." Those who uphold the true way of the ninja "should stay on the path of perseverance, which makes them righteous, even though others around them disrespect the ways of the ninja; thus can they not be described as saints or even enlightened?"

Above all, your purpose is to survive and return home, for otherwise you cannot do your job, which is to bring back information, as Natori emphasizes. "What a *shinobi* [ninja] is meant to do is fulfill his mission without losing his life. . . . Those who can succeed on a mission are, in the end, described as good *shinobi*, even if they sometimes get behind schedule or hesitate."

For success, it is important not to fear death, for fear disturbs the mind. In modern terms, you must live a paradox: To fear death is to court death; to accept death is (perhaps) to gain life. Serenity is all. "If you enter into a dangerous situation and if the occasion arises, you should not value your life over death. Tradition says that life exists within death and death exists within life. Therefore if your actions risk the losing of your life and you have no fear, you may find a way out of a desperate situation. However, if you try to survive, you may lose your life because you are too stressed to see the way out.

"If you hold on to your ego, you will be unsettled or upset. If you come with a serene mind, you have nothing to fear."

Natori returns to the same theme several times, sometimes sounding like a modern self-help guru. "Do not get involved in things. If you get stuck on a problem and entangled within it, it is because you cannot let go of yourself but are preoccupied with pursuing your self-interest." And again: Don't indulge your emotions. Develop mental strength. If you neglect to nourish your true mind properly, you will run out of energy, get tired, and end up failing. Generally, when you have inner peace, you can fathom things that other people cannot and outmaneuver their thought processes. "Nothing is as amazing as the human mind!"

In practice, subtlety is the key quality. Perhaps the wisest advice in the *Shoninki* is summarized by a chapter title: "How to Avoid Defeating Other People." Do not defeat your enemy? But isn't that the ninja's whole purpose? No. The goal is that of the true secret agent: to learn and return. For that you must nurture your sources, not dominate. "If you psychologically defeat others, you will not be able to attain a desired result or get your needed information. If you offend them too much, they will lose their temper and get upset and become competitive, thus your aim will not be achieved."

So in conversation, be flexible. Those who are too inflexible will be hard when they should be soft, strong when they should be yielding.

Such skills demand great sensitivity, empathy as we would call it today. You should "identify with your enemy, which means you should guess with your own mind what he is thinking." As all things in the universe are common to us all, you can use what is in your mind to second-guess your enemy. "If you can achieve this desired result, it could be said you have attained the skill of 'the taking of the enemy's mind.' How clever it is and what a godlike skill to have!"

3

ANTI-NINJA:
THE SAMURAI

*The way a good ninja works is: to know about people without
letting them know about him.*

<div align="right">Ninja instructional poem</div>

ALMOST FROM THE BEGINNING OF JAPAN'S MILITARY TRADI-
tion, all things covert were deeply unfashionable, the agenda
in military matters being set by the proud, prickly, and ex-
tremely overt samurai. Yet, of course, spies and commando-
style fighters were necessary. Indeed, sometimes samurai also
acted as ninjas; *most* ninjas were samurai, *some* samurai were
ninjas. To understand why ninjas were necessary, and why
they remained hidden, you have to understand the very out-
ward and visible ways of the samurai, which hardened over
time as real events and warriors were transformed by tales
into an ideology.

The samurai, of course, considered themselves the only
true warriors, inheritors of a tradition that stretched back to
the ninth century. It started with bows and arrows shot from

horseback, from which evolved a complex set of highly public rituals. Opposing sides would line up and fire whistling arrows to call upon the gods as witnesses. Then top warriors, boxed into their leather-and-iron armor, would call out challenges to single combat, each boasting of his achievements, virtues, and pedigree. They would then discharge arrows at one another, either galloping past or at a distance—not a great distance, though, because Japanese bows were much weaker than those used by mainland warriors, such as the Huns, Mongols, and Turks, and their horses, too, far less sturdy than central Asian breeds. If there was no winner, a rather unseemly grapple occurred, with each trying to unseat the other, followed by a final bout with daggers. Since both warriors were totally enclosed in armor, the rounds of horseback archery were usually more show than substance, designed to give the individual warrior a chance to display his skills and cover himself in glory, whether he lived or died. Display was the essential element, for the warriors were, in the words of historian Karl Friday, "like modern professional basketball players, more apt to think of themselves as highly talented individuals playing for a team, than as the component parts *of* a team."[1] The best way to showcase their skills was in battle.

In the late twelfth century, two clans, the Taira, who had ruled Japan for two hundred years, and the upstart Minamoto, vied for dominance, each seeking to sideline the cloistered emperor. After a five-year war, the Taira were swept to oblivion by the Minamoto, under their great general, Minamoto no Yoshitsune, the greatest of Japan's popular heroes, indeed (in the words of one scholar) "probably the single most famous man in all of pre-modern Japanese history." Much is legend, but much is accepted as truth, both historical and per-

[1] *Samurai, Warfare and the State in Early Medieval Japan,* p. 10.

sonal. Cocksure, blunt, and impetuous, he had all the traits that came to define the medieval samurai.

Moreover, Yoshitsune lived at a turning point in Japanese history, when the ancient regime—whose super-refined ways are detailed in Japan's first novel, *The Tale of Genji*—had proved hopeless at imposing the sort of tough rule that Japan needed to hold it together, whether as a nation or as a collection of independent provinces sharing the same culture. The only way life worked, it seemed, was by using force to impose what would come to be called feudalism: a peasantry kept in line by a warrior caste that was absolutely loyal to its masters and to its emperor. It was as a general in the forefront of change that Yoshitsune made an enduring name.

There is also a deeply human story here. Yoshitsune was fighting on behalf of his elder half-brother, Yoritomo. After Yoshitsune's victorious campaign in the so-called Gempei War (1180–85), the jealous Yoritomo condemned him, drove him into exile, and then hunted him down, until in despair Yoshitsune committed suicide by slicing open his belly. Yoshitsune quickly became the subject of admiring legends, carried around Japan by blind storytellers. Collected (and translated), they form vivid sources, full of passion, incident, and character. He is still with us, in novels, manga, and kabuki and noh plays, as "the perfect example of heroic failure," in the words of Ivan Morris. "If he had not actually existed, the Japanese might have been obliged to invent him." In 2005, there was a forty-nine-part TV series devoted to him.

Seven years after his victory in the Gempei War, Yoritomo took a step that would define Japanese administration for the next seven hundred years. With the approval of the emperor (who was in no position to disapprove), he appointed his own officials in every province and estate so that he could hold power throughout the land. Yoritomo also had himself

awarded the highest military rank, *sei i tai shōgun* (barbarian-quelling great general). This title once referred to the general empowered to wage war against the wild indigenous tribes of the north. Its holder, known simply as the shogun, ruled the whole country as top samurai—in effect, military dictator—in the name of the revered but impotent emperor.

In *theory*, at least—though for centuries, the system broke down in practice, the principle remained as an ideal toward which all would-be rulers aimed. Basing his military government, the *bakufu* (shogunate), at his headquarters in Kamakura, the shogun did his best to rule a patchwork of sixty provinces and six hundred estates, all scrapping with their neighbors. To cram four centuries into a sentence, rule from Kamakura lasted just over a century, collapsing in 1333, ushering in a new line of shoguns, the Ashikaga, who, after a sixty-year interval of civil war with two rival emperors, re-established rule from Kyoto, where they ruled and misruled for another two hundred increasingly anarchic years.

From about 1200 onward, therefore, the main focus for any local leader was war, war, and more war, with all its trappings. No lord or commander could survive without an investment in armor, horses, bows, swords, daggers, and fighting men. There arose an elite of landowning warriors—*bushi*—fighting for their masters, the two being bound by mutual need: the lord providing land, war booty, and protection in exchange for the skills of the specialist warriors, the samurai (originally *saburai*, meaning "one who serves," in particular, one who provides military service for the nobility).

But there was an inherent instability in this relationship. If a vassal prospered, the status, power, and wealth he won was enough for him to claim his freedom. Why, as a boastful, independent, thuggish warrior, would he continue to devote himself to a lord? How could a master ensure his loyalty? How, in brief, could the feudal system be made stable?

The answer was to raise loyalty—to one's lord, not to the far-off emperor—ever higher, turning it into an ideal more loved than life itself, guaranteeing status and glory in both life and death, with a father's position and emotional commitment being inherited by his sons. Loyalty to a lord, or daimyō (great name), was like a gene, written into a samurai's DNA. Against provincial armies welded together by such bonds, no emperor or shogun had much chance of wielding local influence.

As an elite separate from the aristocrats, intellectuals, peasants, and brigands, the samurai were fiercely proud of their skills, status, and valor. For survival in this tough world, image and self-image were vital. Every man had to strut and preen like a cockerel or seem a loser. In battle, a warrior equated his very being with extreme acts of bravery and self-sacrifice, especially in the face of overwhelming odds, for this was the way to gain reputation and rewards. Crucially, his action had to be public—witnessed, remembered, talked about. One early-thirteenth-century warrior determined to be noticed dyed some of his horses purple, crimson, chartreuse, and sky blue, and covered others with stripes and spots. Another wrote, "If I were to advance alone, in midst of the enemy, and die in a place where none could witness my deeds, then my death would be as pointless as a dog's death."[2] Reputation was all, as another thirteenth-century commentary concludes: "To go forth to the field of battle and miss death by an inch; to leave behind one's name for a myriad generations; all in all, this is the way." Honor, or shame, would be passed down the generations, to be upheld or redeemed by descendants. So honor was above life itself. The samurai's whole being was dominated by their extreme sensitivity to any threat or insult to their honor, and their near-instantaneous readiness to take

[2] Both these examples are quoted by Conlan in *State of War*, p. 18.

violent action in its defense. Only in this way could honor be asserted, protected, or restored.

For rich samurai, the supreme item of self-advertisement was his armor, which underwent its own evolution in response to the growing sophistication of weapons and tactics—from bows and arrows to swords, from infantry to cavalry, from warrior gangs to field armies. In Europe, knightly armor made to be worn by horsemen eventually turned them into the military equivalent of crabs, so unwieldy that a fallen knight could hardly stand up without help. In Japan, the style of combat with bow and sword meant that armor had to be kept flexible, which was done by using scores of little plates or scales sewn together to make so-called lamellar armor (in Latin, a *lamina* is a layer, from which comes *laminate*, and its diminutive *lamella* is a "little layer" or small piece of something, usually metal). Designs evolved. Lamellar armor could be a misery in extreme heat or cold, and the bindings became heavy in rain and tended to rot, all of which forced experimental variations in scales and single-piece elements. By the sixteenth century, armor had become so rich and varied that a battle array looked like a confrontation between many species of exotic beetle.

A rich samurai's *ō-yoroi*, or "great armor," had plates and scales bound into skirts and aprons and shoulder pads and shin pads and earflaps, all designed to stop arrows and deflect swords but also to proclaim wealth and status and, at the same time, allow the wearer to shoot, swing, ride, and walk. His helmet alone was a work of art. Some were made of dozens of semicircular plates, others of a single piece of metal in a conical shape, like a witch's hat, with a visor and up to six sideflaps to protect both ears and neck. Some helmets sported vast horns, wave shapes, mountains, crabs (to suggest crab-like powers of self-protection), or rabbit's ears (to suggest longevity). The samurai might also have a mask

covering the whole lower face, with a detachable nosepiece, a bristling moustache, a little hole in the chin for the sweat to run through, and a built-in grimace to terrify the opposition. Since the outfit covered the whole body, it was impossible to recognize who was inside, so—since the whole purpose was to advertise himself—our hero would be a walking, riding flag, gaudy with colored scales and flapping banners.

The ultimate weapon was, of course, the sword, or rather the two swords, the long *katana* blade and the shorter blade, the *tantō*, used in hand-to-hand fighting. Vast collections and worlds of expertise are devoted to the accoutrements of both: mountings, belts, suspension braids, scabbards, scabbard knobs, hilts, handles, handle covers (ray skin gives a particularly good grip), sword collars, guards—all are subspecialties with their own arcane vocabularies and schools and histories.

The samurai's sword was his greatest treasure, one that occupied—occupies still—a multidimensional world of magic, spirituality, chemistry, artistry, and skill, each aspect with its own arcane vocabulary and traditions, and all focused by the mind and body of the swordsman into a lightning blow. Armor, however exotic and all-encompassing, was no guarantee of protection—and anyway, it slowed you down. The ultimate samurai swordsman wore nothing but his kimono. There was no shield but the sword itself, which was strong enough to deflect a blade that was its equal in resilience and suppleness. Japanese smiths, many of a renown reserved in the West for the greatest artists, created several major schools or traditions, each with several subgroups, all of which developed their own variations of the basic sword styles. The result, refined over four hundred years, was a glorious combination of practicality and beauty. The best blades—sharp as razors, heavy as hand axes, fast as whips in the right hands—could sever iron helmets and cut through skin and bone like a kitchen knife through asparagus.

I once had the good fortune to wield a *katana*, under the eye of masterswordsman Colin Young, one of the few English senseis. It was at the end of a lecture, under the gaze of an audience. My task was to cut through a roll of tatami matting soaked in water, which has the consistency of human flesh and the thickness of an arm. We played to the crowd, instructor and pupil. The sword, swung from overhead, went through as easily as an axe through sponge cake—no discernible resistance. I had half expected that result, having seen Colin do it. What I had not expected was the surge of emotion—the elation inspired by an act of power. For a few seconds, I was Rambo, a dealer in death, power incarnate. The feeling came partly from the sword and the blow, but also because I was on display, in public. What would have been the point of performing in private?

Death-defying bravery and an overriding ideal did not guarantee victory. What should the loser do, if he happened to survive? The answer lay in the concept of loyalty unto death. This was first taken to its logical conclusion by Minamoto no Yorimasa, whose revolt against the ruling Taira clan was crushed in 1180 (revenge and final victory came five years later). When he saw that all was lost, he determined to die while his sons held off the enemy. He ordered an aide to strike off his head, but the aide refused, weeping, saying he could not do it while his master lived. "I understand," said Yorimasa, and retired into a temple. In one version of the story, he joined his palms, performed a Buddhist chant, and wrote a poem on his war fan:

> Like a fossil tree
> Which has borne not one blossom,
> Sad has been my life.
> Leaving no fruit behind me.

Finally, he released his spirit, which traditionally resided in the abdomen, by thrusting his short sword into his belly. This was the first recorded instance of the painful and messy act known to outsiders as hara-kiri, which Japanese more commonly call *seppuku* (because that is the higher-status word deriving from the Chinese).

"Cutting the belly" became an established way to avoid the disgrace of defeat. One of the best-known and most dramatic examples occurred in 1333, after rebellion brought the Kamakura shogunate to an end. The rebels—bandits and armed peasants—forced the shogun's troops to flee from Kyoto for fifty kilometers along the shoreline of Lake Biwa to a temple in the little post town of Banba (now part of Maibara). The story is told in the collection of war stories known as the *Taiheiki*, which we shall be returning to later. In this tale, five hundred warriors gathered in the courtyard before the single-room temple. The general, Hōjō Nakatoki, saw that the end was near and addressed his men in a moving speech[3]:

> "I have no words to speak of your loyal hearts. . . . Profound indeed is my gratitude! How may I reward you, now that adversity overwhelms my house? I shall kill myself for your sakes, requiting in death the favours received in life . . ." He stripped off his armour, laid bare his body to the waist, slashed his belly and fell down dead.

There was no expectation that anyone else would copy him. But at once, one of his vassals responded: "How bitter it is that you have gone before me! I thought to take my life first, to prepare the way for you in the nether regions. . . . Wait a bit! I shall go with you." Seizing the dead man's dagger from his stomach, "he stabbed his own belly and fell on his face,

[3] McCullough, *Taiheiki*, p. 269.

embracing Nakatoki's knees. And thereafter four hundred and thirty-two men ripped their bellies all at once. As the flowing of the Yellow River was the blood soaking their bodies; as meats in a slaughterhouse were the corpses filling the compound."

The description is, of course, highly poetic, capturing the elements—commitment, failure, intense emotion, formality, public display—thought essential by those who listened to it. But there was no exaggeration in the numbers: A priest recorded the names of 189 of those who killed themselves that day; the same priest had gravestones made for all 432, which still stand, running in five lines up a gentle slope.

Since relationships between lord and vassal varied in strength, vassals were free to make their own decisions. A member of a household might feel his lord's death as his own, and choose death; a mercenary who would be able to offer his services to another lord could well choose life, as would a landowner with a workforce to look after. Either way, living or dying, the samurai was asserting his control over his destiny and pride in his elitism.

All this—the equipment, the actions, the theatricality—were the outward, visible, and very public means by which a samurai proclaimed his status. No samurai would for a moment accept the idea of doing anything secretive or underhand. It would be a denial of everything he stood for.

Yet—here's the paradox—everyone knew his Sun Zi, every commander knew that it would have been courting disaster not to have spies acting in secret, gathering intelligence and undertaking other covert operations. Hence the ninja, with an ethos that was the mirror image of the samurai's, and hence also a difficulty for historians, for if operations were secret, well, no one would record them.

So the formal bravado of the samurai is only a part of the story. Surprise attacks, artifice, betrayal, and deception played

equally significant roles in warfare. Witness several incidents in medieval sources: A Taira warrior named Sadamichi, ordered to kill another warrior, befriends the man, then rides out of sight, puts on his armor and returns to shoot his unarmored victim; a samurai avenging his father's murder disguises himself as a servant, sneaks into the man's room while he is sleeping, and slits his throat; Minamoto Yoritomo, wishing to execute one of his men, orders him to be entertained at a feast, during which he is beheaded. These incidents hardly rank as honorable, yet there is no suggestion that they are actually *dis*honorable or in any way improper. Indeed, a warrior was supposed to be on guard at all times, so who is to blame if he is taken off-guard by an assassin or successfully spied upon? *He* is, of course, all being fair in war. Ends justified means. Warriors and bards alike may have tacitly agreed not to mention it, but deception was as much part of Japanese culture as public glory.

4

HOW TO BE A SHADOW WARRIOR, PART 2: DECEPTION—AND CHARM

Ninjas should not be ashamed of falsifying, for it is their duty to outwit the enemy.

<div align="right">Ninja instructional poem</div>

FOR NATORI, DECEPTION IS THE KEY SKILL, TO BE PRACTICED on several levels, not least by charming the information you seek out of the opposition. This is how you "analyze people's minds without letting them know that they have been analyzed"—by employing flattery to gain knowledge. "By using this technique, you can steal into the opponent's mind with great ease without drawing his attention in a way to make him wary; meanwhile he bleeds all the information that you need. Truly amazing."

At the most basic level, however, you had better master the art of disguise. There are seven types of disguise a ninja should master.

1. Zen monk: useful because the big straw hat allows good visibility while hiding the face.
2. Buddhist monk: useful for getting close to people.
3. *Yamabushi* mountain priest: allows you to carry a sword without being questioned.
4. Merchant: for mixing freely with people.
5. Street entertainer: always traveling, and therefore arouses no suspicion.
6. Actor: Ditto.
7. Dress like those around you to blend in.

As a monk of any kind, you may also become a pilgrim, because that gives you a good reason to move around between temples and shrines. In this case, you may choose to join a small group.

You should also master the technique of *dakko*, which is to understand all the local customs and dialects. Originally, this skill involved imitating the dialects of more than sixty provinces with great fluency. Those with this skill "knew and were aware of all the points of interest, historic spots and places of natural beauty within each area." However, warned Natori, "this technique used to be achieved only by ancient masters and seems to be too difficult for people of the present time to master completely. Your efforts could easily be interpreted as tricks that are the tricks of con men and thus could be self-damaging."

In addition to a disguise, it is useful to change your appearance. To do this, wear a long jacket or rain cape. You could also reshape your eyebrows, blacken your teeth with iron (filings), change the shape of your hairline, wear black ink on your face, tousle your hair, and/or "put some tresses" (grass or straw?) in your mouth.

You may sometimes need to fake an illness on short notice.

Here are some ways to help your performance: Don't sleep at night; burn your skin with moxa;[1] fast to the utmost limits to make yourself emaciated; don't shave or cut your hair; don't clip your toenails or fingernails; and don't wash.

Be careful with whom you consort. Of course, whatever you do, luck plays a large part in whether you give yourself away or not. But remember that you put yourself at risk if you talk to low-minded scum and take them into your company.

You can ply someone with booze, sex, or gambling for the purpose of taking him in and getting your way. As you will be included in these pleasures, you must be sure not to lose your self-control.

If you think you are about to be revealed, create a diversion of some kind. Leave a tool or some other object that will confuse an investigation. Planting a fake letter, tricking someone into creating something strange or making up false traces of you, anything that gives misleading information—these are methods commonly used by a ninja to throw people off his scent.

Or you can head off in one direction and then double back unseen. People will give false information about you, and will do so willingly, because it makes them seem important.

[1] I had never heard of moxa, but it's common in Oriental medicine, which explains this long footnote. The word comes from the Japanese for "mugwort." *Artemisia moxa* or *vulgaris*, an herb with a soft, downy skin, is ground up and compressed into little cones or cigar-shaped cylinders, which are burned on the skin, usually as a companion to acupuncture. The treatment is known as moxibustion. The moxa may be removed before it hurts or left on until it scars the skin. The purpose is to strengthen the blood and stimulate the flow of qi. It acts as an emmenagogue—an agent that increases blood circulation to the pelvic area and uterus. For this reason, it has been associated, amazingly, with the correction of breech births. A paper in the *Journal of the American Medical Association* (November 1998) found that up to 75 percent of women suffering from breech presentations before childbirth had fetuses that rotated to the normal position after receiving moxibustion thirty minutes a day, with an intensity "just below the individual tolerability threshold." The really astonishing thing is that the moxa was placed on traditional Chinese acupuncture point BL 67 (known as *zhiyin*), which is *beside the outer corner of the fifth toenail.*

It is vital for you to master this deception above all things. The main point is that you should devise the simplest method possible, without any complications. A difficult or complex scheme could arouse suspicion and result in a more intensive investigation.

Intuition plays a major role in *ninjutsu*. For example, supposing you are on an unfamiliar mountain path in a dark forest. You come to a fork. Which way do you choose? Maybe there are clues: Cast around for abandoned sandals, horseshoes, dung, trampled grass, easily startled birds. Such things may tell you which road is better used, which to avoid, which to choose. But if not, simply let fate decide. "Buckle up and recite an old verse. Then count how many syllables there are in the verse and choose to go right if the number is odd, and left if even, and do not have any doubts about the decision. This is because if you simply use the first thing that flashes through your head without any intention or contemplation, you are consigning yourself to divine intervention and fate. Wonders can happen when you abandon your ego!"

One common task for a ninja was to infiltrate a castle. It is an iconic image—the ninja with hook and rope creeping over a wall in the dead of night. But there is a much easier, safer, and more effective way—deception. Talk your way in. For this you need confidence and charm. Stroll past the gate a few times to gain confidence. Then fake an illness in front of the gate, a sudden illness such as food poisoning. On no account pretend to be drunk. Take a rest, and have your servant or accomplice ask for medicine or just some hot or cold water. Thank those inside, and go on your way. Later, to show your gratitude, return with a present—no, two presents, one for the owner, one for his wife . . . no, three or more presents. Speak to the owner. "Don't forget to give his wife her present first." Praise his children. Give little presents to one or more of the favorite servants. "The master will be pleased about that, as

he sees that his people are happy and this will influence him. In this way you could glean information about what you want while talking to the people of the mansion. . . . If you creep into someone's favour with smooth words, you can deduce valuable information even from the smallest of small talk."

Remember this:

A WELL TRAINED *SHINOBI* (NINJA)
LOOKS LIKE A VERY STUPID MAN.

"It is a core principle to praise others as much as possible to keep them carrying on about a subject at their own leisure."

Here's a way of recording information about the size of a place or numbers of people. Prepare bags of pebbles or beans, counting them so you know the number in each bag. Then as you count whatever it is you want to record—the length of a wall, the number of houses or people—drop a pebble or bean for each unit. No need to count as you go. At the end, count what you have left in the bag. Subtract that from the original total. That's your number. You've counted without counting.

When infiltrating an army column or a retinue, deal only with the lower ranks or servants. If you ingratiate yourself with those of higher status, you will be hated by the lower-ranking people for the favor you are being shown by those above you.

When spying on a province, by far the best way is to visit shrines and temples. Give priests or other men of the cloth gold and silver coins, sparing no expense. Don't give to ordinary people, because this is not normal and will draw suspicion. But Buddhist and Shinto priests will be delighted to accept an offer to treat you with meals and hospitality. "Taking advantage of this opportunity, you should probe them for information while getting them drunk."

Natori has a pretty low opinion of priests, regarding them as naïve, garrulous, and easily manipulated. You can start them

talking by asking if there are any plans to construct a new building to pray for the fulfillment of wishes. If so, you will naturally ask: Whose wishes? What wishes? Thus, by hinting at your willingness to help financially, you may get wind of a possible rebellion or a family dispute or unrest in the army. "They will not be able to stop themselves bragging about their wonderful religious power or divine wonders, and then they will give away everything you need to know at great length. Thus by exploiting their nature, you can gain your goal."

Or you could go to a "licensed house of assignation"— that's a high-class brothel—"where the highest rank of courtesans are appointed to their clients," or to the public baths, or a gambling den. "There are no secrets that cannot be revealed at places such as these."

Deception and charm come way above any technical advice, on which Natori has surprisingly little to offer. He makes just one mention of a sword: "Whenever you steal up on someone you had better carry a short sword." Except for a brief reference to using a sword to give you a step up when climbing a wall, that's it for swords. Given the Japanese obsession with swords, this is odd. There are two possible implications. One is that for routine work as a spy or secret agent, a sword was not required. The other is that carrying a sword was so completely part of everyday life that he didn't think to mention it. Perhaps (he might have said, if asked) both were true: Take your sword if you want to, but you probably won't need it.

This is the sum total of what he has to say about equipment:

He recommends only six fundamental items, none of which can really count as a weapon: a straw hat, which allows you to see others but hides your face; a grappling iron and thin rope, for climbing, tying people up, locking sliding doors, and other uses too numerous to mention; a pencil for taking notes and making marks on buildings; basic medicine in case you

fall ill on the job; a meter-long piece of cloth, used as a head-band or an extension to your waistband, to improvise a rope; and a fire starter to make a body warmer or a cooking fire or for arson.

Ninjas are often called the original men in black, but Natori says that brown, dark red, and dark blue are all fine colors, because they are so common that they don't stand out.

In a perfect world, he says, you should not carry any tools at all. Even a tiny object such as a needle might give you away if it falls at the wrong moment. But most covert actions demand tools of some kind. He doesn't give a list, remarking only that they should not be strange, or they will attract attention. By implication, therefore, the choice is up to you—but make sure you carry tools that can also be used in everyday life on the land. You probably have your grappling iron. A simple long stick propped against a wall will allow you to climb or descend. Or you can use a sword leaned against it as a footrest (be sure to tie the cord to your foot so that you can pull the sword up after you).

To break through rammed-earth walls, you can use a tool with a round or oblong blade, which has saw teeth around the edge. For opening inside doors, you can use a smaller saw.

To get through a hedge, cut off the end of a barrel and push it into the hedge to make a hole—and remember to remove it afterward.

If you think someone might try to break in to your bed-room, it's no good staying awake to catch him. What if your enemy decides to delay his break-in until the next night, or the night after? You will be worn out and fall asleep anyway, so deeply that nothing will wake you. Instead, leave the window slightly ajar to tempt the intruder, tie a string from the window to your topknot, and sleep tight without worry (presumably with your sword at hand), knowing that any movement by the window will wake you.

5

A WORLD OF VIOLENCE
AND UNDERCOVER OPS

It is a fundamental lesson for ninjas to think more of the way out than the way in.

Ninja instructional poem

FROM TODAY'S MANGA AND FILMS AND GAMES, YOU MIGHT think that the ninja was the only nonaristocratic, non-samurai force in the land. In fact, they were one of many wild elements that kept medieval Japan in a state of ferment, swirling undercurrents of opposition to the lords and their samurai sidekicks. Near anarchy started in the early fourteenth century and would last for almost three hundred years. This was the chaotic context within which the ninja evolved.

Central Japan, though hardly crammed by modern standards, seethed with variety, especially along the single-lane main roads, which were no more than tracks on which two horses could hardly pass. Convoys carrying rents in the form of rice, messengers, pilgrims, slave traders, horse dealers, and merchants went by, and all needed rooms at the inns, where

they crowded around puppeteers, jugglers, musicians, and storytellers. In the words of Yoshihiko Amino, one of the greatest of modern historians (though little known in the West), these people formed "the wandering world," a counterpoint to the fixed world of rulers, nobles, temples, and landowners. Beyond this lay the other worlds of mountain and forest, occupied in folklore by demons and monsters and in reality by a scattering of esoterics devoted to pilgrimages and the Shugendō training regimes described in chapter 1. Such was the rich mix that interwove with the violence in what is now central Japan, Honshū and northern Kyūshū (while the northerly island of Hokkaidō was so remote from all this that it might have been in a different universe).

It was not all bad. In the right circumstances, violence can stimulate as well as destroy. It happened in China's Warring States period almost two thousand years earlier, in medieval Japan, and in fifteenth-century Italy, where bitter rivalries and brutal little wars coincided with the height of the Renaissance. It seems that under the pressure of constant though less-than-total warfare, leaders also yearn for peace, creative minds struggle to make sense of life, and an obsession with war can produce equal and opposite obsessions: diplomacy, art, philosophy, poetry, trade. And it is one of the paradoxes of social evolution that peace usually has to be imposed by violence. This was certainly true of medieval Japan, where everyone expected violence and fought for peace, though each wanted it on his own terms. From such diversity no unity could come. Every special-interest group—warlords, warrior priests, Buddhist temples, Shinto shrines, bandits, ninja villages—would have to be crushed or won over by any would-be leader aiming to unify Japan.

Anarchy, suspicion, and fear do strange things to minds and behavior. People took to concealing themselves with disguises and masks. Travelers wore wide-brimmed sun hats that hid

their faces. Women veiled themselves. When warrior monks paraded through Kyoto in protest against some act or law of which they disapproved, they disguised their voices, wore masks, or wrapped their faces in shawls, cutting slits to see through (like other men of violence of recent times, in Palestine, or the Basque Country, or Northern Ireland). Things came to such a pass that when the Ashikaga seized the shogunate in 1336, they banned outlandish clothing. It didn't make much difference. People responded by adopting the fashions associated with *hinin*—the "unhuman" pariahs who performed "unclean" tasks, such as dealing with corpses on the riverbanks, tasks that were unclean but also vital, which gave the *hinin* a cachet despite their occupations. Riverbanks were outside the reach of any lord. They were places where gangs staged stone-throwing battles, troops practiced maneuvers, artisans set up informal markets, and performers and artists gathered. From a world of lepers and corpses and sand and pebbles sprang great talent, such as the landscape gardener Zen'ami, who created the sand-and-stone Zen gardens that we now see as typically Japanese. The "people of the riverbanks" made a vibrant demimonde, a sort of medieval Left Bank, a hip, arty, decadent, freewheeling world, which produced weird mixtures of male and female fashions that were adopted by those who liked to proclaim themselves yet hide their faces.

All this was against a background of anarchic violence, involving every subgroup: classes, families, temples, landowners, city dwellers, peasants, and many more. Another was formed by bandits known as *akutō*, the "evil groups," gangs of ruffians of all sorts—disaffected warriors, pirates, vagabonds, farmworkers eager for pillage, mercenaries, poachers—who sometimes resorted to a sort of uniform, carrying bamboo spears and rusty swords, wearing sleeveless war kimonos and six-sided caps, and covering their faces with yellow scarves

to make themselves look "strange." They were, perhaps, the equivalent of roving gang members terrorizing a neighborhood, taking anything unattached and undefended, and moving on. A monk writing in Harima Province (in the southwest of Honshū, part of today's Hyōgo Prefecture) about the years around 1300 portrayed an area "awash in blood and fire and abounding in violence, assaults, piracy, robberies and manhunts."[1]

Yet another force were the warrior monks, who had their tenth-century origins in the rivalry between two Buddhist factions with temples on Mount Hiei, near Kyoto. The two fought over land and the appointment of abbots, their violent conflicts often spilling over into Kyoto itself and mixing with other wars between warlords. In 1117 an ex-emperor commented, "There are three things that are beyond my control: the rapids of the Kamo river, the dice at gambling and the monks of the Mountain" (that is, Enryaku-ji, the temple on Mount Hiei).[2] They settled into a more peaceful existence in the thirteenth century but would surface again in the fourteenth, when anarchy returned and violence rose to new levels.

So far, the sources make no mention of ninjas, not because there weren't any but because their equivalents had many different names, depending on where they lived. There were several famous ninja-like operations, stories told in the great

[1] Souyri, World Turned Upside Down, p. 106. Souyri's excellent and well-translated book is the source of much of this chapter.
[2] Sansom, A History of Japan to 1334, p. 223. The emperor was Shirakawa (1053–1129), who entered a monastery in 1096 but remained in control for the rest of his life as a "cloistered emperor." These words, though widely quoted, appeared only two centuries after Shirakawa's death. They may well be apocryphal, but most scholars agree they summarize a widely held view about the warrior monks, who in the words of the British historian George Sansom "failed miserably to provide the moral force the times demanded . . . spreading disorder, corruption and bloodshed."

late-fourteenth-century chronicle, the *Taiheiki* (*Chronicle of the Great Peace*, an odd title given that it's all about war). Like other medieval epics, it was rooted in the tales told and sung by blind bards, Japanese Homers who went from castle to castle, entertaining the courts with tales of derring-do. Unlike the two great Homerian epics, it lacked a good editor; two-thirds of it, as Helen Craig McCullough says in the introduction to her translation, is "dull reading for any but the specialist." But the narrative was based on real events and real people, and here and there it soars. The problem for historians is that they can seldom separate out truth from exaggeration and invention.

These actions happen in the 1330s, during a would-be revolution started by the emperor Go-Daigo (in Kyoto) in a supposedly secret attempt to destroy the shogunate (in Kamakura) and restore direct imperial rule, something that had not existed for centuries. A man named Hino Suketomo went off to recruit allies, disguised as a wandering monk. The plot was revealed and the shogun sent an army to stop Go-Daigo. He protested his innocence, and Suketomo, left to carry the can, was exiled to Sado, an island off the north coast where dissidents were sent. The military leaders debated. Order had to be restored, dissidents killed. Suketomo was sentenced to death. It happened that Suketomo had a thirteen-year-old son, Master Kumawaka, who heard of the sentence and decided to do something about it. And so the story with its ninja-like hero, sometimes called the "first ninja," begins:

The boy says to his mother, "Why should I prize life? Let me perish together with my father, that I may share his journey to the nether regions." [3]

His mother cannot bear the thought. Sado is a dreadful island, she says, unfrequented by human beings. If he goes, she will die. In that case, he says, he might as well throw him-

[3] McCullough, *Taiheiki*, chapter 2.

self into a river and drown. So, unwillingly, she relents, and he goes, walking, in straw sandals and tilted sedge hat. He reaches the coast, takes a ferry, and arrives at the castle of Sado's governor, a monk named Homma. He begs to see his father. Homma is moved, bathes the boy's feet, and treats him with all consideration, but he refuses to allow father and son to meet. It would only increase Kumawaka's anguish, he says. But father and son are so close that the father, imprisoned in a place overgrown with bamboo, hears of his son's presence. How cold was Homma's heart, laments the poet. Since the father was a prisoner and the son but a child, why was it dangerous to place them together?

Men come to Suketomo, inviting him to bathe as a prelude to execution. He takes the news calmly, as a samurai should. They lead him to a river beach, where he writes a farewell poem seated upright on an animal skin, and even as he finishes, "his noble head fell on to the animal skin while yet his body sat up straight." He is cremated, and his bones taken to his son.

Kumawaka is grief-stricken and swears revenge. "If there is a chance," he says, "I will stab Homma or his son and rip out my belly."

So to avoid returning home with his father's remains, he feigns illness for four or five days. Then one night a storm comes. The boy takes his chance but fails to find either of his intended victims. Instead, in a well-lit room, he comes across the executioner. "Very well," thinks Kumawaka. "He too may be called my father's enemy." Moreover, he has his sword and dagger beside him. But the candle is too bright. Kumawaka notices moths on the outside of the door. He opens the door. The moths swarm in and put out the candle. He carefully draws the sword, kicks the executioner awake, and stabs him twice, ignoring his cries, through the navel and the throat. Then he hides in a bamboo thicket.

Guards come, see the little footprints, and at once guess who

has committed the crime. The boy must still be on the prem-
ises, they say, because the moat is deep. They start searching.
Kumawaka wonders whether to kill himself; but no—and this
is what marks him as more ninja, less traditional samurai—
better to live a useful life than die a useless death. "If I can
preserve my life in some way, may I not assist the emperor as
well, and accomplish my father's desire of many years?"

So he climbs a bamboo, which bends until it reaches across
the moat, depositing him on the other side. Day dawns. He
hides again, this time in a growth of hemp and mugwort, while
guards gallop this way and that, hunting him. In the evening he
comes out and looks for the harbor, where he intends to take
a ferry. Perhaps the spirits were protecting him in reward for
his filial resolution (despite the fact that he has not killed his
intended victim), for he meets a monk, who carries him on his
back to the harbor, summons a boat, and climbs aboard, just in
time to evade their pursuers. Thus it was with divine protection
that Kumawaka "came forth alive from the crocodile's mouth."

The story is told with no great narrative technique, for we
never learn what happens to Homma or whether Kumawaka
ever gets to aid the emperor. But it does reveal something
about ninja-style acts, though of somewhat dubious morality:
Vengeance is a valid motive; any victim will do; opportuni-
ties must be seized; escape must be improvised with what-
ever means are available; better to survive ninja-like to fight
again than die a samurai's death; and if the motive is pure—
apparently the intention is more vital than the deed—then
luck will be with you.

Meanwhile, Go-Daigo had fled south from Kyoto with the im-
perial regalia to the mountains and forests of Yamato Province,
where scattered castles—so-called "hilltop" castles, though
few were actually on the very top—guarded remote valleys. He
holed up in one of them, on Mount Kasagi, while his greatest

general, Kusunoki Masashige, and his son, Prince Morinaga, based themselves in other castles. The shogun's army went in pursuit. The consequences were horribly complicated—castles were taken and Go-Daigo exiled to "Oki Island," as most sources claim. In fact, Oki is a group of four islands, none of which is called Oki, fifty kilometers off the north coast, but never mind the details, because he escaped, hiding under sea-weed in a fishing boat; he returned to Kyoto, made a total mess of governing for four years, and fled again to Yamato. The Kamakura *bakufu* (shogunate) fell, leaving power in the hands of the incoming Ashikaga; Go-Daigo set up a rival Southern Court in Yoshino, a division that would last, with almost continuous warfare between Northern and Southern Courts, rebel versus loyalist, shogun versus emperor, for another sixty years.

Fortunately, we do not need to know much about the war as a whole. We are interested in the opening actions against the hilltop castles, because these assaults, sieges, and defenses demanded new and unconventional tactics from both attackers and defenders. The way Kusunoki, in particular, established his bases and fought held lessons for anyone fighting superior forces in similar landscapes, which is precisely what the ninjas were doing as they developed their communities and their techniques in neighboring regions.

In this world of steep forests, rocky outcrops, and precipitous ravines, set-piece battles were impossible, and cavalry useless. Both sides had to use other means. Kusunoki, later to acquire a reputation as the epitome of loyalty, was a noted guerrilla fighter, so skilled in covert warfare that some wishful thinkers, of which there are many in the world of martial arts, credit him with setting up his own martial arts "school" (*ryu*). His opponents, the shogun's generals, were faced with the need to take four great mountain castles, the first shielding the emperor, the others his partisan defenders, including the great Kusunoki himself.

It is autumn 1331. The emperor is holed up in a mountain-top castle on Mount Kasagi, a holy place of wooden palisades and towers set about with massive boulders that have images of Buddha carved into them (the *Taiheiki* mentions the boulders but not the Buddha images, which remain to this day). The shogun's forces, seventy-five thousand of them, are preparing an assault. The numbers are arbitrary; they grow with each new chapter, adding a steady crescendo to the drama, for the *Taiheiki* at its best tells a tale in the style of epics from Homer to Hollywood, in which every feature and action is larger than life, with a wealth of detail, some realistic, some poetic, all designed to make the events appeal to the imaginations of an openmouthed audience.

The peak is covered in cloud, and mossy crags drop away below for a myriad fathoms. The winding approach path is walled with immense boulders. It is no easy climb, even without a single defender. The attackers yell their battle cries, as loud as a hundred thousand thunderclaps, and fire humming arrows announce the assault. Yet from the castle, not a sound, not an arrow. Perhaps it has been abandoned. The shogun's forces climb, and see the emperor's banner flapping over the walls. His men are ready, three thousand archers moistening their bowstrings and lining the wooden walls like clouds. The battle that follows is fierce enough to knock the earth off its axis. A giant monk tosses boulders from the walls to smash shields below. Valleys fill with dead and the river below runs red with blood, but the castle holds out. Then news comes of other bases falling to the rebels. It seems the imperial army must withdraw to face them.

No! Two samurai, Suyama and Komiyama, urge a covert operation. Too many have fallen uselessly, they say, their names forgotten because they died without doing great deeds. "How much the more glorious if by our strength alone we bring down this castle. . . . Our fame will be unequalled for

all time; our loyalty will stand above that of a myriad men. Come! Under cover of this night's rain and wind, let us secretly enter the castle precincts."[4]

So in pitch darkness and foul weather they and fifty volunteers make knots in a rope tied to a grapnel, which they use to clamber over branches and boulders and then to scale the cliff that leads to the castle's northern rampart, where even a bird could not fly easily. Halfway up, they are stopped by a mossy overhang. Suyama blazes a trail upward, carrying the rope, which he loops over a branch, allowing the squad to climb safely to the top. After that, the castle wall is no obstacle at all, for the defenders thought the cliffs unclimbable and "no warriors watched there, but only two or three soldiers of low degree," who had fallen asleep on their straw mats beside their campfire.

"Then in stealth they spied upon the castle's interior by following a sentry making his rounds," noting the numbers and positions of the defenders. Suyama and Komiyama decide to pinpoint the emperor. A guard accosts them from the shadows, but Suyama has a quick answer: "We are warriors of Yamato, guarding against attackers slipping in by night, for the wind and rain are violent, and there is much noise."

"To be sure," comes the voice from the darkness, and they hear no more. So they proceed, boldly pretending to be guards, shouting, "All positions be on the alert!" They find the main hall, where candles burn and a bell rings faintly. Three or four retainers, capped and robed, ask where the intruders are from. They come out with convincing answers, "giving the names of such and such persons and thus and so provinces."

And finally they and their fifty comrades fulfill their mission, lighting a fire that tells their waiting forces to attack, while they themselves run from place to place yelling war

[4] McCullough, *Taiheiki*, p. 77.

cries and starting fires in offices and towers. It's still dark, and the defenders think a whole army has broken in. They cast off their armor, throw down their weapons and flee, "falling and tumbling over cliffs and into ditches." Only one warrior has the courage to fight back, leading his son and thirteen servants, but having shot off all his arrows and broken his sword, he sees death looming, and all fifteen commit *seppuku*.

The emperor, too, flees, barefoot and aimless, along with his princes and nobles, all but two losing their master in the wind, rain, and darkness. Thus did the Son of Heaven "transform his august person into the figure of a rustic and wander forth without an object. How shocking it was!" Hiding behind hillocks by day and by night stumbling through dewdrops on desolate moors, he is eventually captured, along with his entourage and hundreds of courtiers and retainers. Kasagi Castle is left burned out and abandoned, while the emperor is sent into exile, from which he will shortly escape.

On goes the shogun's vast army to the next hilltop castle, Akasaka, forty kilometers to the southwest. (The *Taiheiki* says the army numbered 300,000 riders, and scholars agree it was large, though not *that* large, consisting of three divisions attacking the loyalists from three directions. No one knows the true numbers of the shogun's army, but a likely figure is 100,000.) Akasaka is Kusunoki's base. But it doesn't seem all that formidable. "The moat was not a proper moat and there was but a single wooden wall, plastered over with mud. Likewise in size the castle was not more than 100 or 200 yards around, with but 20 or 30 towers within, made ready in haste. Of those who saw it, not one but thought: 'Ah, what a pitiable spectacle the enemy presents!'" They try a frontal assault. But it isn't so easy. Archers (scholars estimate their numbers at 200) fire devastating volleys, and contingents of horsemen mount raids that throw the attackers into confu-

sion. They try again. This time they scale a wall—which turns out to be a false wall, built to fall when the supporting ropes are released. "More than a thousand of the attackers became as though crushed by a weight, so that only their eyes moved as the defenders threw down logs and boulders on them." A third assault is met by cascades of boiling water. So the attackers decide to starve the castle into surrender.

Kusunoki opts for deception in a rousing speech announcing that he will, in effect, become a shadow warrior:

During the past weeks we have overcome the enemy in one engagement after another and killed countless quantities of his soldiers. Yet so great are his numbers that these setbacks mean nothing to him. Meanwhile we have used up all our food, and no one is coming to our rescue. Being the first warrior in the land to enlist himself in His Majesty's great cause, I am not likely to begrudge my life when virtue and honour are at stake. Nevertheless in the face of danger the courageous man chooses to exercise caution and devise stratagems. I therefore intend to abandon this castle for a while and to make the enemy believe I have taken my life. If they are convinced that I have killed myself, those eastern soldiers will no doubt return to their provinces rejoicing. If they leave, I shall return; and if they come back here, I shall withdraw deep into the mountains. After I have harassed them a few times in this way, they are sure to grow weary. Such is my plan for fulfilling my [mission] and destroying the enemy.[5]

Luckily, a storm, with "rain violent enough to pierce bamboo," allows the defenders to dig their pit, gather bodies, set them ablaze, and then slip away by twos and threes. "When

[5] This is Ivan Morris's down-to-earth translation, which in this case I prefer to Helen Craig McCullough's more poetic style.

the flames died away, [the attackers] saw a mighty hole inside the castle, piled with charcoal, wherein lay the burned bodies of many men. And then not a man of them but spoke words of praise, saying: 'How pitiful! [Kusunoki] Masashige has ended his life! Though he was an enemy, his was a glorious death.'"

Not so, of course. He is more ninja than samurai. Over the next two years, he learned his lesson, regrouped, created a new castle close by—at Chihaya—and also rebuilt Akasaka on higher ground as an outlying defense, his "front gate," in his own term. It was therefore the rebuilt Akasaka that the shogun's army had to take first when they returned to the attack in 1332. "Tall cliffs like folding screens fell away below this castle on three sides, while on the south side, which alone was near to flat land, there was a wide and deep ditch with a wall on its bank bearing a line of towers." A head-on assault fails. The commander guesses that Kusunoki has prepared for a long siege but is puzzled that there is no obvious source of water, "yet they extinguish our fire-arrows with water-jets." So there must be an underground water supply. He orders his men to dig on the only piece of flat land, and "they uncovered a trough twenty feet below the ground, with stone walls and cypress tiles on top, bringing water from a place more than a thousand yards distant."[6]

With the water cut, that's the end in sight for Akasaka. For four or five days the defenders lick morning dew from leaves and grass. Fire arrows set the place ablaze. A monk negotiates surrender, with the assurance that the defenders will be spared because to kill them would be to harden Kusunoki's opposition. So 282 warriors—epic poems are often exact to give the impression of realism—are sent off as prisoners with their arms bent at the elbows and tied, to Kyoto, where the shogun promptly has them beheaded. When they heard of this

[6] McCullough, *Taiheiki*, p. 172.

deception, Kusunoki's men "ground their teeth like lions, nor did any man think of coming out to surrender."

This leaves two remaining fortresses, Yoshino under Go-Daigo's son, Prince Morinaga, and Kusunoki's extremely formidable Chihaya.

Yoshino, a fortified monastery named after its 455-meter mountain, is today a town of many hilltops and ridges and one of Japan's favorite spots for viewing cherry blossoms, because the trees range up the hillsides and come into bloom at successive altitudes, flowing uphill like an incoming tide.[7] In the words of a famous haiku:

> "Ah!" I said, "Ah!"
> It was all that I could say—
> The cherry flowers of Mount Yoshino![8]

The mountain no doubt had its springtime charms back in 1333, but this was high summer, and the blossoms were long gone. This cross between monastery and town is "a place of steep heights and slippery moss." For a week the two sides fight, until "green things were dyed with blood and bodies lay across the paths." A warrior monk tells the attackers they will lose more men uselessly if they keep on with frontal assaults. What's needed is guile, says the monk. "I shall choose a hundred and fifty foot-soldiers, men acquainted with the mountain, to steal inside the castle in the darkness, and raise a battle shout when the light of dawn appears." In the chaos, the main army will attack. The plan works well. The 150 special-ops men—lightly armed *ashigaru* (light feet)—make their entry, raise their shout, and set the place alight. "Powerless to stand

[7] It is also a place of many shrines and pilgrimage routes, now protected as a UNESCO World Heritage site.
[8] By Teishitsu (1610–73), Kyoto paper merchant and musician.

against their enemies in front and behind, the monks of Yo-shino perished each after his own fashion, cutting open their bellies and running into the blazing fire to die."[9]

But Prince Morinaga launches a counterattack, and . . .

A brief interruption about this prince, because he was al-ready a noted loyalist hero, and still is today. His father had made him abbot of the Enryaku-ji monastery, known as the Great Pagoda, when he was only eighteen—it helps, of course, if your father is the emperor—but he trained as a warrior, at which he proved a champion, becoming a masterfencer with an ability to leap over "seven-foot screens," as the *Taiheiki* says, and a determination to read "even the shortest of the secret military treatises. Never had there been so strange an abbot." At twenty-three, when his father started the civil war, he gave up life as a monk to join him. On the prince's way through the old capital of Nara, Kasagi fell and his father was captured, which meant that the shogun's forces would be after him. "The prince's peril was even as that of one treading on a tiger's tail." He hid in a monastery, where in due course his enemies came looking for him.

At this the *Taiheiki* tells one of its detailed stories:

There is no way out, and the prince is considering whether to commit *seppuku* when, in the main hall, he sees a monk read-ing near three Chinese chests that contain Buddhist scriptures. (Why the monk? I have no idea. In terms of the narrative, he's not necessary, and creates a problem, for modern readers any-way, because he does nothing except read.) Two of the chests are full, but the monk has removed some manuscripts from the third, which stands open. The prince climbs in—apparently without disturbing the scholarly monk—covers himself with books, and begins muttering prayers, holding a dagger against his stomach in case discovery should force him to commit *sep-*

[9] McCullough, *Taiheiki*, p. 177.

puku. Just in time—the searchers enter, hunt high and low, then become suspicious of the boxes and turn the two full ones over, scattering the books. Wonderful to relate, they do not look in the open box, and leave, for no reason (narrative technique today would demand one—a shout from outside, perhaps). Again, no reaction from the scholarly monk. The prince thinks: Perhaps they will be back. So he gets out and hides again, in one of the other two chests.

Yes, the warriors return, having decided to check the remaining chest. Nothing, of course, except books. They all leave. Prince Morinaga thanks his lucky stars. It's all due to the protection of the scriptures, he says, and of Marishiten, the multi-faced Indian goddess, also known as Marici ("light" or "mirage"), the deification of mirages who could make warriors difficult to see or even invisible. This is a story recalling the myth that ninja—for this is a very ninja-like act—could make themselves invisible. So he was able to escape and continue his journey in the guise of a wandering monk, ending up after many adventures in Yoshino.

Now here he is, driving the enemy back briefly, allowing him time—despite seven arrows sticking out of his armor and blood pouring from his wounded arm—to organize a drinking party to celebrate their coming death. With the battle still in progress outside, a warrior named Murakami Yoshiteru appears "with sixteen arrows drooping in his armor like lingering winter grasses." He offers to don the prince's armor and stand in his place while the prince escapes. After demurring briefly, the prince agrees. While the prince flees, weeping— accompanied by Yoshiteru's son—Yoshiteru takes his place on a tower and addresses the enemy, announcing that he is the prince, and will now commit *seppuku*. "Mark me well," he yells, "that you may know how to rip open your bellies when fortune fails." Stripping off his armor, and "clad only in brocade trousers, he pierced his fair white skin with a dag-

ger. He cut in a straight line from left to right, flung out his bowels onto the board of the tower, thrust his sword into his mouth, and fell forward on to his face." [10] The prince, though, is not yet safe. An enemy force surrounds him. Yoshiteru's son stages a rearguard action on a narrow path, holding off five hundred men until wounds and imminent death force him to rip open his belly. The prince once again escapes.

Now the story reaches its climax, with a "million riders"— a million!—approaching Chihaya. "Thicker than plumes of pampas grass on an autumnal moor were their plumes; as morning dew on withered herbs were their weapons, glittering and shining in the sunlight." Chihaya is small—probably defended by some two thousand men—but in a fine position, with deep chasms to the east and west and a high mountain protecting it to north and south. (I can't quite imagine this, but today's ruins lie three kilometers below the peak of Mount Kongō, 1,125 meters, a great shoulder of rock that is Osaka Prefecture's highest mountain, and a popular destination for mountain walkers; there is also a cable car that takes you almost to the top.) Frontal assaults fail—Kusunoki had prepared boulders and tree trunks, which flattened "thousands," so many that "twelve scribes recorded their names day and night for three days." The attackers wonder about the water supply and stake out a possible source, but Kusunoki has water enough inside, stored in two or three hundred troughs made from tree trunks. More frontal attacks, repelled by more falling tree trunks, "by which four or five hundred attackers were smitten, who fell over dead like chessmen." So the attackers start a siege. Time passes. They turn to poetry writing, checkers, and backgammon. Inside, Kusunoki's defenders are bored out of their minds.

[10] McCullough, *Taiheiki*, p. 179.

So Kusunoki makes a plan to raise their spirits with a ninja-like trick. He orders them to gather rubbish and make twenty or thirty life-size figures, which are placed at the foot of the castle by night. In the morning the besiegers draw close, not quite daring to attack the figures, at which the defenders drop boulders on them, mocking them for their cowardice. The attackers pull back again, demoralized, and entertain themselves with prostitutes and games. Some quarrel. Orders come from headquarters, demanding they do something positive. The commanders decide to build a bridge, an immense structure sixty-five yards long, which they haul into place and rush across over the chasm. But the defenders throw down torches and spray oil, setting the bridge and its crowds of warriors alight and consigning thousand to a fiery death in the chasm.

What can break the deadlock?

The answer is Prince Morinaga, whom we left escaping into the backwoods from Yoshino. He and his warriors attack the shogun's troops from the rear, cut off all paths of retreat, seize their armor, and leave them to run wild in tattered straw coats and plant leaves. So thanks to Kusunoki's brilliant defense, he and the Southern Court survive to continue their resistance to Kyoto and the Northern Court, helping to restore Go-Daigo as emperor.

Can the unconventional, nighttime attacks in these campaigns really count as ninja operations? Not quite. There were too many warriors. But the right elements are there for the emergence of the fully fledged ninja: lightly armed soldiers, opportunities taken to fight in stormy weather, night operations, wild landscapes, secrecy, deception, hilltop fortresses and fortified villages, the impossibility of using cavalry and traditional samurai methods. It was the early campaigns in the war between the Northern and Southern Courts—focusing on Go-Daigo's courtly mountaintop redoubt of Yoshino—that showed the way forward for those who would create a ninja homeland.

*

Go-Daigo did not remain emperor for long. In late 1334, a year after the successful defense of Chihaya, the shogun, Takauji, made false charges that Morinaga was planning to overthrow his father, and forced Go-Daigo to hand him over. Morinaga was then sent to Takauji's brother Tadayoshi in Kamakura and imprisoned in a cave for eight months. In July 1335, when a rebellion forced Tadayoshi to retreat from Kamakura, Tadayoshi had Morinaga beheaded.

The following year, a rebellion against Go-Daigo threatened Kyoto. Go-Daigo wanted to confront them in battle. Kusunoki, certain of defeat, advised evacuation to prepare for battle later in the summer, when the rebel soldiers would have been keen to get home for the harvest. Go-Daigo would not hear of it. Kusunoki accepted the decision, a perfect example of a samurai embracing death on behalf of his lord, who was in this case also his emperor. He did this willingly, he told his ten-year-old son, because he knew that one day the boy would take up the cause.

The two sides met on the site of present-day Kōbe, beside a small, dried-up river, the Minato, after which the battle is named. It was high summer, July 5. Kusunoki was vastly outnumbered on land, and threatened also by a naval force. Attacked on all sides, he fought for six hours until he could fight no longer. Finally, severely wounded, with seven hundred of his men dead and the day lost, he committed *seppuku*, in the proper samurai fashion, winning himself an almost unparalleled reputation as the ideal of gallantry and loyalty.

So ended the attempt by the emperor to restore ancient powers to imperial rule. Go-Daigo fled again, back to his Southern Court capital of Yoshino, now restored, and the war between the courts continued for half a century after Go-Daigo's death in 1339, his heir (another son) and grandson still vainly trying to reassert imperial power as of old, with the real power

being exercised by the new shogunal family, the Ashikaga, from Kyoto. In the end, in 1392, the not-so-old pattern was restored: the shogun claiming executive authority in the name of the semidivine, pampered, but impotent emperor.

But this merely papered over the cracks in a society that was divided against itself in many ways, including those at the top: The shogun's supporters themselves quarreled and were divided three ways, while everyone else was further fractured if you take into account the bandits, the "light-feet" soldiery, the increasingly independent warlords, and the warrior monks in their fortified monasteries, among others. In the words of Pierre Souyri, "the most dangerous enemy was the neighbour who had his eye on one's land or the cousin who rejected the superiority of the leader." As one war-loving Ashikaga vassal put it, "If you want to build yourself a fief, take the neigh-bouring estate!" He might have added, "If you want to feed your army, loot the countryside!" That's what happened, frequently. In 1336 the peasants of Mino Province in central Honshū complained to their landlord, the local monastery: "During the war the armies of both Kyoto and Kamakura invaded the estate and took everything from the houses. We do not know how to express our misfortune. The war started last winter, but this year the violence was such that nothing remains on the estate. Everything has been taken. . . . Our dis-tress is so great that no complaint can do it justice."

What could a poor man, or village, or collection of villages do? The only thing possible was self-help, which was exactly what the provincials of Iga and next-door Kōga set about doing.

6

HOW TO BE A SHADOW WARRIOR, PART 3: MAGIC

If there is an unlucky aspect to the direction or date of your mission, you should back out and choose another day or time for departure.

Ninja instructional poem

NOW WE TURN TO AN ASPECT OF LIFE THAT SURVIVES ONLY IN vestigial form in the West: the world of superstition and magic. If I see a ladder, I walk under it, just to prove I am not so superstitious as to believe that it will bring me bad luck. So far, so good, touch wood. Millions take their horoscopes seriously. I don't, because I'm a Taurus, which means I'm a skeptic. But this is nothing compared with times when astrology and astronomy were flip sides of the same subject, and when so-called medical treatments were based on unproven beliefs about "humors." Mumbo jumbo ruled supreme because there was nothing else to go on. So it was in seventeenth-century Japan, and a ninja was supposed to have an intimate knowledge of those physical signs that provided insight into char-

73

acter and destiny, most of which now seem as ludicrous as phrenology. For example:

- If you are a leader with a large head, you will not be poor, but also you will not live long.
- These traits give lifelong bad luck: small and elongated head, knees shake when sitting, small waist like a bee, and downturned corners of the mouth.
- A short torso means an early death or an evil nature.
- If the torso is shorter than the legs, you are poor and mean, or sickly, or will move to another province.
- If a woman laughs at others while covering her mouth with her hand, and scratching her eyebrows, and looking at them sideways, she is a prostitute.
- Women with tiny bodies are servants.
- People with flared nostrils are mean and shabby.
- The signs of a long, prosperous life include a fully fleshed top of the head, a mouth like a halo, looking like a mountain when sitting, and smelling like orchids.
- If a woman has shaking knees and rubs her face while bowing, she is adulterous.

Natori proceeds with a detailed list of the signs indicating good and bad luck, wealth and poverty, long and short lives, wisdom and stupidity, and many other qualities as revealed in the main parts of the body: head, eyebrows (thin and flat are good, long, linear ones a sign of wisdom), eyes (a bad downward slant indicates a quick divorce), nose (a mole on the top means you will have many sons; horizontal wrinkles indicate an accident with a horse and carriage), ears, mouth, teeth, tongue (if you can touch your nose with your tongue, you will ascend the throne or become a lord), and hands. He ends by listing twenty-three signs of negativity on the palms and analyzing the meanings of moles according to color and position.

This is all considered vital knowledge for ninjas, but Natori has the sense to warn against being too rigorous. Reading character in this way is difficult, he says, and not always accurate. (Indeed! If you apply his information on teeth, royalty [which rates thirty-eight teeth], nobility [thirty-six], and wisdom [thirty-four] must be nonexistent, given that humans have thirty-two teeth at most.) Besides, if you try too hard to read an opponent's character and guess his intention, you may end up staring to the point of discourtesy. Only with great care will you be able to use the information for your ninja activities.

It's fine to help yourself with esoteric knowledge, if you can. But you can do so actively, with—and this is his chapter title—"Charms and Secret Rituals That Protect You from Being Targeted by the Enemy's Agents." It's easy to sneer. But remember that at this time in the West (the late seventeenth century), women were still being burned for witchcraft, and few dared assert that belief in witches was one vast, murderous delusion. Almost everyone, everywhere, believed in the spirit world, and thought that with the right acts and incantations you could persuade spirits to act on your behalf, freeing you of disease or casting spells on others. The belief is still alive today—that's why religious people say their prayers and adherents of Shugendō send requests to heaven in the smoke of their fires.

Natori reveals five powerful spells, the number five having special significance deriving from Chinese beliefs and practices. There are five elements (wood, fire, earth, metal, water), five emotions, five senses, five stages of life, five seasons, and many other sets of five, which passed into Buddhism, and thus to Japan and ninja teaching.

Of the first, which provides protection, he says: Cut some heavy paper into a twenty-one-centimeter square, write the spell on it, and paste it in the corner where you sleep. You

The five spells: The *Shoninki* advises: (1) For protection, hang this in the corner of your bedroom. (2) Write your name and that of an acquaintance alongside this charm. If you fold the names together, you will get along; if apart, you will fall out. (3), (4), and (5) These charms freeze people's blood and cause them to make mistakes. If used correctly, they will enable you to walk on blades and all arrows aimed at you will miss their mark.

should also carry a copy with you and perform cold-water ablutions. The second makes people stick together or split up, depending on how you write the spell. You can use it to cement friendships or cause a falling-out. The third, fourth, and fifth protect you from wounds. Write them in vermilion ink mixed with your blood on a silk cloth embroidered with gold, and wear it on your chest. "Then even if you fight against a mountain of swords, you will not be hurt. Fear not!"

Well, perhaps. Natori adds a note of skepticism. "Some people say that those who rely on charms and spells and use this kind of sorcery are no different from women and children." So don't rely on spells alone. They are like good armor: useful but not infallible.

7

BUILDING THE NINJA HEARTLAND

Even if a ninja does not have impressive physical abilities, remember the most vital thing is to have acute observation.

Ninja instructional poem

THE CAMPAIGNS OF THE SOUTHERN AND NORTHERN COURTS happened close to what would become the ninja homeland, and they introduced many of the elements that would make up the ninja ethos. One of these was the growth of lower-class, peasant violence. When this started in the late thirteenth century, it was a novelty. Traditionally, while warriors fought, peasants were supposed to remain humble tillers of the soil. Since time immemorial peasants had been as compliant as sheep, concerned only with avoiding disease, bad weather, and the tax man, leaving samurai armies to march across farmland and extort taxes without fear of reprisal. But peasants are not infinitely patient. Those who lived near main roads, for example, objected to the way campaigning armies flattened crops, stole food, and destroyed houses. Villagers took

to confronting generals, negotiating to supply food and horses in exchange for considerate treatment.

It worked. Villages turned themselves into communes, known as *sō*. The oldest known *sō* dates from 1262, when the people of a village called Okitsushima on Lake Biwa got into a dispute with their lord over fishing rights. Under the aegis of the village council, which controlled the worship of the Shinto spirits, they drew up a secret document by which they agreed to oppose their lord, and "those who break this agreement will be expelled from their land." In 1298, villagers threatened to direct the anger of the gods on to the lord, in forms both known (such as illnesses and accidents) and unknown (monsters and ghosts). Apparently resistance worked. At the same village in 1342, a similar protest forced the lord to apologize and make amends.

Landowners also looked after their own interests. Sometime in the 1330s, sixty-seven small landholders who doubled as warriors formed themselves into a self-help group, or league, known as an *ikki*. Under the terms of their constitution, a majority had to agree that service was necessary before they joined up as a group, and all swore to look after the families of those killed. This was nothing more than a straw or rice husk in the wind, but the *ikki* and similar organization planted the seed of an idea that low-ranking warriors-cum-landowners need not always remain sheep but could take control of their own lives if they acted collectively.[1]

As the country descended into near anarchy—trade guilds turning to violence, tenants ousting landlords, provincial

[1] Japanese peasants were far readier to stand up for themselves than their Chinese counterparts. Pierre Souyri suggests this was in part because they were healthier, with better cultivation producing higher yields, and partly because their holdings were not on plains watered by huge, erratic rivers but in valleys with streams, which did not require large-scale irrigation projects, based on forced labor and oppression.

warriors seizing power from the shogun's officials, families destroying themselves in disputes over succession, not to mention the pirates terrorizing the coasts—peasants fought for their own interests. One way was to run away from a lord and become an *ashigaru* (light feet), so called because they habitually joined up, fought, deserted, looted, and rejoined when it suited them. These low-class characters, usually armed with just a single sword or spear or halberd, were the equivalent of cannon fodder, but they also had a use as ninjas in all but name and expertise, sneaking into enemy camps, taking prisoners, or setting fire to watchtowers under cover of darkness. During wartime they performed all the subservient but vital roles needed in the ranks—making up squads specializing in bows, guns, spears, and swords, or working as grooms, cooks, signalers, and standard-bearers. Between wars, if they had not returned to a farming life, they formed armed gangs. By the mid-fifteenth century, they were a well-established military essential and an equally well-established menace. "Proper" soldiers and upper-class types looked upon the rise of the *ashigaru* as the end of civilization as they knew it. "These men, who have recently been used by the armies, are excessively dangerous rascals." So wrote the aristocratic scholar and statesman Ichijō Kanera in the late fifteenth century. "They tear down or set fire to any place in or out of the city where they know they will not be caught by their enemies. They do not spare either private dwelling or monastic buildings. They search only for loot, and they are nothing but daylight robbers. They are a new evil and should be done away with. They are a disgrace to our country."

Another way for ordinary men to look after themselves was to join an *ikki*, a term that came to apply to both landowners and peasants. This was an attractive alternative because as a fighting unit the members all knew one another and trained together. They were very effective, controlling the abuses of

lords, mounting protests, and demanding rent rebates. In 1428, peasants objecting to tax increases ran riot in Kyoto. In 1441, when the shogun was assassinated and there was no central government to speak of, tens of thousands converged on Kyoto, and several thousand made camps within its walls, burning buildings and setting up roadblocks that isolated the capital. The rulers bought peace by promising "virtuous government," returning land sold over the previous twenty years, and canceling debts. Peasant uprisings followed every one or two years for the next fifteen years, including one ending in an all-out battle in which the *ikki* forces thrashed a samurai army of eight hundred.

The peasants had a point. At the other end of the social scale, lords and samurai could, it seemed, do nothing but fight battle after battle, with results well displayed by a decade of extremely bloody unrest (1467–77) known as the Ōnin War, after the year it started.[2] Amid a welter of causes, a major factor was the rivalry of two families fighting to succeed the ineffective shogun, Yoshimasa, who had been childless, adopted an heir, then promptly produced a son. The adopted son and new baby acquired their own factions, who started to tear the country apart. One was led by a priest so famous for his paroxysms of red-faced fury that he was known as "the Red Monk"; on the other side was his son-in-law, equally famous for his restraint. In just a single year, their conflict turned Kyoto's palaces, temples, and great houses into burned-out ruins. After one action, eight carts were filled with heads, the rest—uncounted—being tossed into ditches. The streets were barricaded, the gardens trenched. "The flowery capital which we thought would last forever," lamented one official, "is to become the lair of foxes and wolves." Kyoto became a miniature

[2] The Japanese divide their history into "reign eras." The year 1467 was the first of the short Ōnin Era (1467–9).

Western Front, with the two sides glaring at each other across a no-man's-land of weeds and blackened timbers, divided by a trench seven meters wide. It was a war of negatives—no aims, no heroes, no leadership, a total waste of lives and resources. Finally, the carnage ushered in war-weariness. At the end of 1477, one side burned their positions and fled into the darkness. Looters moved in to complete the city's ruin, and all to no purpose. The historian George Sansom calls the unheroic leaders "unfortunate creatures demented by their own ambitions."

An uneasy peace came to ruined Kyoto, but the surrounding countryside remained at war, with armies and bandits prowling for loot. To the south, in Yamato and Yamashiro, villagers intent on self-defense and self-government built their houses behind earth levees and surrounded themselves with ditches, ponds, and moats. They had good reason, because Yamashiro was still at war with its neighbor, Kawachi, over control of the main road between Kyoto and Nara (a mere fifteen kilometers from Kasagi, where Emperor Go-Daigo had based himself at the beginning of the civil war a century and a half before; even in a chaotic world, some things never change). On the front line, armies from both sides pillaged, plundered, looted, stole, raped, and burned, until the locals had had enough. In 1485 lower-order warriors and *ashigaru*, appalled by the loss of crops and farmland, deserted from both sides and marched to a local shrine. Peasants joined them. The decision was made to turn the whole southern part of Yamashiro into an *ikki*. They sent an ultimatum to both armies, demanding withdrawal or else, forcing mass desertions. The following year, warrior chiefs proclaimed virtual independence as a "provincial commune." This was not a peasant or a village commune but rather a new government, which quickly alienated its peasant constituents, with the result that after eight years and the appointment of a new governor by Kyoto, it collapsed.

One hundred and twenty kilometers north, in what was then Kaga and is now Ishikawa, there was another sort of rebellion from below, this one driven by warrior monks belonging to the Buddhist True Pure Land (Jōdo Shinshū) sect. This group, which appealed to ordinary people because it was rooted in village life without the usual trappings of monasticism, had been in existence for two hundred years, without making much impression on those beyond its communities, referred to as Ikkō (meaning "single-minded, devoted," or as we might put it today, "fundamentalist." Not to be confused with *ikki*). The True Pure Landers believed that to escape the tribulations of this life you only had to have faith in a form of Buddha known as Amida, a symbol for the transcendent reality and mystery, which is unborn, uncreated, and formless. No, I don't know what that means either, but anyone desiring rebirth into this mystical realm could achieve it by calling Amida's name ten times or more. Its founder was said to have repeated Amida's name sixty thousand times a day, which must have qualified him for many instant rebirths.

The history of religions suggests two universal laws: (1) that all religions spawn sects; and (2) that extremist sects, drunk with self-righteous certainty, often turn to violence. Such was the case here. After a century and a half of ineffective nonviolence, True Pure Land changed. In 1457 a charismatic monk named Rennyō set up shop in Kaga, preaching salvation by faith in Amida, rejecting the established Buddhist church, and appealing directly to ordinary people. Like Martin Luther, he taught that anyone could arrange his own salvation without recourse to priests, and as Luther promoted German over Latin, so Rennyō taught in direct, simple language, avoiding Chinese, so that "even women and the most miserable peasants" could understand, political correctness not being much in evidence at the time. One of his articles of faith was that death in battle was rewarded by eternal bliss. "Advance and

be reborn in paradise," read his banner. "Retreat and go instantly to hell." Official Buddhism insisted on celibacy, hard work, such as copying religious tracts, and paying for religious services. Rennyō dispensed with all the rules, proclaiming that only his followers went to paradise and everyone else didn't, a simplistic creed that appealed particularly to those who had been barred from salvation by their occupation as killers, whether of people or vermin. He had many wives and fathered twenty-eight children, the last when he was eighty-four, just before his death. When he retired, he built himself a hermitage, Ishiyama Hongan-ji, which became the heart of a city. It lay on a well-forested plateau on the coast downstream from Kyoto at a place called "the Long Slope"—Ōsaka, the core of today's city. He was hugely successful. His church was thronged with believers of peasant stock, eager for women, war, death, and paradise. Ishiyama Hongan-ji grew from a hermitage into an immense temple-fortress with ten thousand monks and a score of major and minor outlying temples.

Soon other Ikkō leagues sprang up. In Kaga itself a local lord recruited battalions of warrior monks under the command of his samurai. In 1488 they revolted, threw out the samurai, and seized a dominant role, so that Kaga became "a province held by commoners," in a much-quoted phrase—the first time a province was ruled by a nonaristocratic, non-samurai group. This was people power, Japanese-style, and it was just the beginning. Ikkō bands would seize temples and land, and rule and fight for a century, escaping from their peasant roots to build commercial and military strongpoints defended by walls and ditches.

Everyone had an idea of Japan as a unified nation, for all shared common literature, religions, and culture. Unfortunately, they didn't accept the same idea of political unity beneath the umbrella authority of the emperor and shogun, for war had reduced both to impotence, even penury. When

one emperor died in 1501, there was no money to bury him. Another sold autographs to passersby. Without a universal victory, there could be no political unity, and thus no lasting peace.

Everywhere war continued, family against family, warriors against Ikkōs, province against province, shogun against emperor, and the *ashigaru* against everyone else. It was a world turned upside down, and thus it became known as *gekokujō*, translated as "the low oppress the high," or "the lower commanding the upper." To compound this chaos, around 1500 there were some two dozen major warlords and three hundred minor ones, all acting as gods in their own domains, each eager to expand his little empire. To track them would be like following particles in a cloud chamber. In Shinano—today's Nagano, a landlocked province in the middle of Honshū—two rival lords fought in the same place every year for five years, as if determined to do no more than provide their samurai with chances to display themselves. Every leader struggled to find some advantage, and for more than a century—the long century (1480–1600) known as the Age of the Warring States—none achieved lasting success.

These chaotic times inspired the evolution of the ninja proper. Several sources refer to ninja and its Japanese-language counterpart, *shinobi*, while others mention soldiers who acted in a ninja-like fashion as spies, scouts, surprise attackers, and agitators. But the ninja training and activities were mainly focused in the areas still most closely associated with them, the regions then known as Iga and Kōga (now parts of Mie and Shiga Prefectures, Iga being a province and Kōga—today's Kōka—a town and its surrounding area).

Together, the two offered unique advantages to their villagers. Both straddled the eighty-kilometer wide neck of land between Lake Biwa and the coast, neatly bisecting the main

island and placing them in a potentially dominant position. To the north was the ancient capital Kyoto, and the road that would one day become the great east-west coastal highway linking Kyoto and Edo, the Tōkaidō (Eastern Sea Road), which ran through a pass on the borders of Kōga. Yet both were isolated by their mountainous landscapes. Iga is a basin about forty kilometers across surrounded by hills ranging from five hundred to one thousand meters, through which the Nabari River cuts a dramatic gorge. Kōga lies over the hills to the north, where high ground falls away to the shores of Lake Biwa.

These areas were only two or three days' walk from Kyoto but were never natural centers that would have made cities from which lords could build miniature empires. Instead, they had networks of villages and fortified manors, several hundred of them, which were proud of their independence and self-reliance. Iga, in particular, had no military governor for many centuries, being under the loose control of a temple in the ancient capital of Nara, and so never paid a land tax either to the shogun or to the emperor. Both relied on a main river and had managed to control floods and distribute water cooperatively. And both were sturdily independent, with families known as "warriors of the soil," who would not tolerate the empire-building landowners and towering castles that dominated the rest of the country.

These days Iga and Kōga are easy to cross by road. But in the Middle Ages the going was tough—still is, actually, when you get off the paved roads. The pine-covered slopes are divided by streams that turn to torrents in rain, carving deep gorges. The one-horse paths linking the villages were narrow and steep—"tiger's mouths," as they were called by the locals, who knew all the passes intimately and could block them with just a few men. This was a happy balance between accessibility and remoteness, between density and diffuseness. They had

something worth defending, and moved from near anarchy to communality in order to do so.

Several other elements made these remote-yet-accessible areas just right for the development of ninja self-defense forces.

First, both areas were a natural base for bandits—the *akutō*—attracted to the rich pickings available on the highway from Kyoto, the future Tōkaidō road, which in the early Middle Ages was mainly used to get to the great Shinto shrine at Ise, dedicated to the sun goddess from whom all emperors descend. You can understand the attraction for bandits even now, if you follow what is still the Tōkaidō from Minakuchi, the fiftieth of the fifty-three post stations that marked the way from Edo (now Tokyo) to Kyoto. Go eastward, toward Kyoto, for ten kilometers or so, a day and a half's journey on foot.

I did, with my host Yoshihisa Yoshinori, who was keen to show it to me because he lived right on the Tōkaidō. Along the way, now neatly paved and suburbanized by single-story gray-tiled houses, the old track is the same width it always was, still hardly wide enough for two palanquins, or cars, to pass. "That's where I was born," said Yoshihisa, pointing out a house as plain and simple as most others, its front right on the road. I wondered if this was a choice made by his parents, a way of buying into a privileged community, perhaps? No, nothing like that. "My great-grandparents wanted the rice field behind it, that's all. Better a rice field than a house." But he was proud of living on such a historic way, like his neighbors, as the houses themselves showed. There are no formal planning regulations, but—this being Japan, with a strong sense of community—residents conform with tradition when they build.

The low gray houses marshaled us out into flat, open lands, which gave way to one of the two ranges on the whole route, the Suzuka hills. The track rose steeply. It was up here that

travelers faced danger from lurking highwaymen. We were far beyond houses. Back then, it was hard to find your way at night, especially in winter when the slope was slick with mud, and you had to dismount to climb, if you were rich enough to have a horse, and if not, then your straw sandals, bought from some wayside stall only a few hours before, were already falling apart. So the locals had made a huge stone lantern, still in place after five hundred years (well, almost in place; a motorway runs in a tunnel underneath, and the builders had to move the lantern fifty meters). It's a monstrous thing, thirty-eight tons and more than five meters high, consisting of a bulbous base, a pillar supporting the hollowed-out lantern, and a roughly carved, monolithic roof to keep the rain away from the flickering oil lamp. The "road" may have been nothing but a muddy, three-meter-wide track, but this lantern proclaimed its importance.

Besides the bandits, several other elements contributed to the radical nature of Iga and Kōga:

- Since they were only two or three days' walk from the old capitals of Kyoto and Nara, if there was a sudden need for additional troops, they could quickly be summoned. We are talking individuals, not armies. The result was that in both areas, fighting was in the blood.
- Though largely peasant communities, they contained a strand of sophisticates (relatively speaking), which derived from the Chinese and Korean immigrants to Yamato, centuries before: monks, military families, potters, merchants, craftsmen. Their intellectual and artistic abilities had worked their way into the villages and temples.
- The forested ranges, with their fast-flowing streams and steep valleys, were favorite haunts of the *yamabushi*, who needed to know about living in the wilderness and surviv-

ing on nuts, berries, fish, and game, and treating themselves with medicines made from plants.

- The same landscapes were ideal for anyone wishing to escape being swept up by civil war—high-ranking families who had lost their positions and property, ordinary folk who had seen their land ruined by rampaging soldiers, others wishing to escape being drafted into the ramshackle army of some upstart lord, or the survivors of yet another inconclusive skirmish.
- Lacking a centralized authority, both Iga and Kōga were open to those who loved the open road—monks, entertainers, and craftsmen. And the inhabitants were, of course, farmers, with easy access to dozens of tools that were easily adapted to become weapons.

It was (at a guess, because there are no sources from the earliest days) all the challenges and threats from outside combined with their own advantages that inspired the people of Iga and Kōga to build on their centuries of independence, to continue to look after their own interests, and to defend themselves by turning themselves into ninjas.

While much of the country was at war with itself, Kōga and Iga had kept themselves relatively isolated behind their mountain bulwarks. Traditionally, both were dominated by families that were forever feuding. Kōga had a mere fifty-three, and Iga, being a much larger place, some three hundred to five hundred, at a rough estimate ("I heard there were five hundred and thirty," a monk in one of Iga's temples told me). Neither had any powerful, ambitious lords, so the fighting was small-scale, low-level, more like the jousting between rival stags than the all-out destruction suffered elsewhere at the hands of predatory armies. The skills they developed were

as much life skills as military ones, evolving to preserve, not destroy, to conserve secrets rather than proclaim status.

The first mention of the ninjas by that name came in 1488, in the official government annals.[3] A local governor, Rokkaku Takayori, appointed by the shogun, had started taking over the estates of local landowners, clearly aiming to make himself a lord, a daimyō. The landowners protested to the shogun, Yoshihisa. It was Yoshihisa's unexpected birth in 1465 that had snatched the shogunate from his father's adopted heir, thus starting the Ōnin War. In 1488, after eleven years of peace, he was still only twenty-three, and keen to prove himself by slapping down his upstart governor. He laid siege to Rokkaku's castle, with an Iga family, the Kawai, "earning considerable merit as *shinobi* (ninja). . . . Since then successive generations of Iga men have been admired. This is the origin of the fame of the men of Iga." Unluckily for Yoshihisa, he fell ill and died. It was his successor who managed to take the castle, using ninja in some unspecified way. Recording the campaign, the annals say: "Concerning ninja, they were said to be from Iga and Kōga and went freely into enemy castles in secret. They observed hidden things, and were taken as being friends."

By then the villages of Iga and Kōga had decided that cooperation offered a better way of life than constant low-level feuding. No one knows exactly when this was first formalized, but it seems there was a precedent nearby, from an estate named Oyamato, marked today by a small temple thirteen kilometers south of Nara. In the summer of 1494, right at the beginning of the Warring States period, the men of Oyamato recorded two contracts—sworn, legally binding declarations—witnessed by a monk named Shinsei. The first,

[3] This incident is from the Muromachi *bakufu*'s *Nochi Kagami*, retold by both Zoughari (*The Ninja*, p. 40) and Turnbull (*Ninja*, p. 30–32).

signed by 350 land workers, was a sort of local constitution or code of conduct, made up of five articles, designed to preserve the peace. According to one of the articles: "The common people shall not fight over paddy fields, mountains or forests. They shall not seize cultivation rights or steal." In the second contract, dated a month later, 46 wealthy locals—*jizamurai*, "samurai of the soil," as they were known—promised not to fight over taxes on peasants, and to control both troublesome subordinates and themselves: "If anyone acts badly, inside or outside Oyamato, he will be judged and sentenced." Since both contracts were witnessed by the same monk, it seems clear that the two groups, landowners and farmworkers, were cooperating to impose peace. On whom, we may ask? There was no war, no center of warrior monks. Nor were the signatories being told what to do by a local princeling, baron, or warlord. This was a community, a network of otherwise unremarkable people, united in their determination to sort out their problems—mostly administering land and water rights—peacefully, eradicate bandits, use taxes locally, and build a strong community on their own terms.

There is a subtext to this little piece of evidence. It suggests a sort of idyll: cheerful and friendly villagers trooping off from their fields to link up for mutual support. But almost certainly the pre-contract life of these farmworkers, and of those who lay outside the contract, was very unidyllic: a life made nasty, brutish, and short by intervillage feuding and by immigrants fleeing the effects of the Ōnin War.

Not that communes were all that charming. They worked because they were tough, even barbaric in the way they imposed justice, with zero tolerance of any deviation from their own laws and no appeal to any other court. An imperial dignitary, Kujō Masamoto, described an incident that occurred when he visited his estate around 1500.

He invited peasants from one of the local villages for a New

Year's Day banquet in honor of the village chiefs. During the banquet, a villager announced that his dagger had been stolen. To catch the thief, Masamoto told the chiefs to meet at the local shrine, where they would hold a trial by the ordeal of boiling water. Trials by ordeal were for much of history a common, indeed virtually universal, way of finding criminals, the idea being that if a person was innocent, they would show no ill effects, or simply survive—the grounds for judgment varied—but in any event the trial would reveal the guilty because God or the spirits would look after the innocent. (In Europe, language itself preserves a memory of this process: The German for "judgment" is *Urteil*, which has the same root as the English *ordeal*.) In this form of ordeal, everyone was required to retrieve a stone from a kettle of boiling water. The scalded hands would be bound and examined after a few days to see whether they were healing (innocent) or festering (guilty). In this case, the mere threat of an ordeal worked, and the guilty man stepped forward. Masamoto deprived the man of his rights, but that was not good enough for the villagers. The theft had, after all, occurred on a special occasion when they were their lord's guests. They felt humiliated, and applied their own form of justice. A few days later they went to the thief's house, killed him, his wife, and his three sons, and burned his house down.

Oyamato's peasant commune worked, and the neighbors took note. Next door, in Iga, the villagers adopted a similar if somewhat more ambitious scheme, the "Iga Commune," as scholars call it. The written evidence for when it started has not survived, but it seems to have begun around 1500. Iga called itself an *ikki*, a "league," though it was a good deal bigger than other *ikkis*, perhaps following the example of the Yamashiro "provincial commune" as it might have been if it had had more peasants and fewer warriors. Iga's *ikki* was a province-size confederation of villages under the control of

sixty-six warrior families, who had their own fortresses and came together as a council in the Buddhist temple that once stood on the site of today's castle in the local capital, Iga Ueno. So the council was prepared to fight against more than just a few bandits.

Despite the lack of a foundation document, a constitution— probably a refined version of something that had been in effect for decades—was written around 1560, which included the following (see box on pp. 95–6 for the full text):

- All foreign troops to be repelled.
- Upon receiving alerts from watchmen at the fortified passes, villagers to spread the alarm and provide food, arms, and reinforcements along all defended routes.
- All men between 17 and 50 to be mobilized; captains to be designated; monks to pray.
- Peasants giving exceptional service in action to be raised to samurai status.
- Traitors to be beheaded and their heads to be displayed.

But this is a document with rather vague provenance. It has no year date. It lacks signatures, which suggests it is a draft. And it was preserved by a family living in Kōga, not Iga. Ishida Yoshihito, a specialist in medieval Japan at Okayama University until his death in 1996, suggested that it was written in Iga because it refers to a "self-governing league" (*Sokoku ikki*), which was what Iga called itself. He also concluded that it was written in the sixteen-year period between 1552 and 1568, because (a) the document mentions a clan, the Miyoshi, who seized power in central Japan in 1549, but only after 1552 were they powerful enough to rate a mention; and (b) only before 1568 was Oda Nobunaga, the great unifier of Japan, *not* powerful enough to rate a mention.

Kōga, too, followed the examples of Oyamato and Iga,

forming a commune of villages. Iga and Kōga warrior families had agreed to recognize one another as allies. Indeed Iga's constitution contained a clause stating that "we now see fit to unite our forces with Kōga" and hold common assemblies at the border, so-called "field meetings."

So by the second half of the sixteenth century, this whole area was a collection of communes, each overseeing irrigation, land clearance, and the collection of cash to fund self-defense against warlords and their forces from outside. At the entrance to one village stood a notice: "It is forbidden for local warlords to enter this place, which is under autonomous judicial administration." Other places demanded that warlords could only enter if they signed a contract restricting their authority to named vassals.

(It is no coincidence that at the same time similar conditions in Europe—lack of central authority and a drive to assert it in the teeth of local resentment—produced similar results. As towns started to grow after the year 1000, townspeople sought protection from nobles, bandits, and churchmen hungry for loot and taxes. To establish and preserve their liberties, they formed self-governing communes, promising mutual defense and vengeance for assaults on their members, and winning charters guaranteed by a local lord, or king, or emperor. The commune movement grew in the eleventh century in northern Italy, then spread across most of western Europe in the early twelfth century. In northern and central Italy, dozens of communes—Milan, Genoa, Padua, Ferrara, and many more—were able to create stable city-states. Some German communes—Frankfurt, Nuremberg, Hamburg—survived for centuries. Rural communes formed, notably in France and England, and other groups fulfilled similar and more specialized roles: parishes, craftsmen's and merchants' guilds, monasteries. The Swiss were particularly successful: In 1291, three cantons signed up to an "Everlasting League" in order to break

free of their local rulers, the Habsburgs; one of them was Schwyz, which would go on to give its name to the whole nation [Switzerland]; and together, like Iga, they produced warriors whose skills were valued far beyond their own borders. All well and good for the communes themselves; not so good from the point of view of a central administration ambitious to enforce peace nationwide.)

The Ninjas' Foundation Document: The Constitution of Iga's "Self-Governing League" [4]

1. When any other domain's army intrudes on our province, the collective of the *Sokoku* [self-governing village] should fight to defend against them together, with each other, as one.

2. Upon the alert sent from the gateway when the enemy are spotted, all the bells in every village should be struck and everyone should take up a position immediately. Everyone should prepare himself with food, weapons and shields and set up an encampment so as not to allow the enemy to enter the gateways of our realm.

3. All people of the ages 17 to 50 should be stationed for war. If a battle is a prolonged one, and they have to be stationed for a long period, they should rotate on a system. In every village and every area commanders should be appointed so all the men in the *Sokoku* can follow the orders of those said commanders. As for the temples in the *Sokoku*, the elders should carry out a devotional service for the prosperity of our province, while the young should take part in the camp.

4. All the *hikan* [lower-order people] of the *Sokoku* should

[4] Thanks to Antony Cummins and Yoshie Minami for this translation.

write a solemn oath, stating that they will follow their lord whatever be the situation of our land.

5. The *ashigaru* ["light feet" or common soldiers] of our land may even capture a castle of another domain. Therefore, those who serve as *ashigaru* during a siege and go beyond the borders and attack a castle in another land and succeed in capturing it should be rewarded liberally for their loyalty and promoted to samurai.

6. If anyone intentionally lets an army of another domain in, the combined *Sokoku* will subjugate him and his clan and annihilate them without leaving any trace, and the land will be given over to a temple or shrine. Similarly, anyone who communicates with the enemy secretly and gives them any inside information about our land will be treated just the same as those who let the enemy army in. If someone brings information of anyone's treason in the above manner, he will be highly valued.

7. No samurai or *ashigaru* foot soldiers of our land should serve the Miyoshi clan.

8. If someone refuses to pay the *Yumiya Hanjo* tax [a "bow-and-arrow signed document" tax, presumably a war fund], he, his father, sons or brothers will not be eligible to benefit from the fund for 10 years. Neither should they be allowed to use the *Yado Okuri* or *Mukae* transportation system [a system of relay stations].

9. When positioned in a village or camp, any disorderly behavior or violence should be prohibited within the borders of our alliance.

10. As the Yamato province has unjustly attacked our province over a prolonged period of time, we should not employ any *ronin* [samurai unattached to a lord] who once served in the Yamato military.

11. As we have controlled our province without any problems, it is of utmost importance for us to obtain cooperation from Kōga. Thus, we should have a meeting with Kōga at the border between Iga and Kōga at an early date.

The above commandment should be in effect with the signatures [of all who are concerned].
16th day of November [year unknown, probably *c.* 1560]

As in Europe, so in Japan, and in particular in Iga, where the commune showed much greater resilience than the one next door in Yamashiro, probably because it was both more remote from major trade routes and better rooted in the peasant community.

In any event, the strength of the bond remained fixed in the memory of the people of Iga and Kōga. Over a century later, well after the destruction of the ninja homelands, the *Shoninki* records how Kōga and Iga swore the friendship oath of *Ichi Gun Ichi Mi* (one district and one band), joining the people together. They went out expansively to various provinces to utilize their skills. Thus, being universally recognized as the premier *shinobi*, they exchanged a firm written form of oath, which says, "If I come to where you are, you should show me everything of your province, and if you come to where I am, I will show you everything about my province."

Kōga, too, was an incipient democracy, a "parliament without a prime minister," as Toshinobu, one of the local historians, put it. Iga's "parliament" seems to have met in several different places, but Kōga's fifty-three top families had one shrine as its focal point. Toshinobu explained: "Everyone had to make promises with their lives in a god's hands. That was why the meetings were held in one of three shrines, in succes-

sion. Often the contract was written on a special paper which had the god's name on the back. Everybody signed."

One of the shrines or rather its reconstructed successor, is still there today. On the outskirts of Kōka, a strange semicircular structure, like an impractical bridge, straddled a stream. A grand Shinto gate of thatch and many-jointed beams gave on to the gravel courtyard of a shrine, Yagawa. On this hot September afternoon, Yagawa was a place of peace and silence. Springwater flowed through the mouth of a metal dragon into a stone tank, with ladles lying alongside it for dusty pilgrims. Halfway across the yard was what Noriko called a dance hall. This was not for social occasions but for priests and sumo wrestlers to perform for the god. Beyond that again was the shrine itself, guarded by four Chinese-style stone lions. It was locked.

"There's a balcony," I said. "Maybe I can get a look inside."

"No!" Noriko was shocked at the idea. "This is the house of the god! No ordinary humans! Only the priest can allow you in, perhaps when you wish to introduce a new baby to the god."

To one side was a house, which in the old days would have been a storehouse or stable and was now a place for the priest to live. A woman spotted us and vanished. I was ready to leave, eager to catch a train back to Kyoto, when the priest, Somanosho by name, appeared, looking bleary, in his vest. We had woken him from his afternoon nap, but he was happy to talk, because the shrine, and he himself, had interesting histories.

In Edo times, the place had been a Buddhist temple run by the Tendai sect, though as usual with a Shinto element. Then when Shinto was banned after the Meiji Restoration in 1868, it had become totally Tendai. Tendai priests were not allowed to marry—yet the last Tendai priest had been Somanosho's father. How could that be? Because after the war, Shintoism

was allowed again, "and my father stopped being a Tendai priest and became a Shinto priest, so he was allowed to marry, and he had a child, and the child inherited his father's role, and that's me!"

I had almost forgotten my reason for being there. What about before all that, before unification in 1600?

"Well, this is an ancient place of worship. There is one sentence in the sources that confirms that this was the place where the Kōga families met, when it was both Tendai and Shinto."

That was what I had hoped to hear. I was standing on the spot where Japan had experimented with a form of democracy that sounded like something the Athenians developed in the fifth century BC: each village represented by a top family, so that only property owners participated; each family represented by its most important male, whose position would have been inherited by his son. Of course, there was no voting system, and no way that every qualifying adult male could have a direct say. But still, since this was being made up from scratch, it was not a bad start.

Unfortunately it came to a bad end before anyone could refine it.

8

THE RISE OF THE CONQUEROR

Though there are so many principles a ninja should learn, the first thing of all is to get close to the enemy.

Ninja instructional poem

BEYOND THE HILLS OF IGA AND KŌGA, EVENTS WERE AFOOT that would aid the rise of the man who would, over three decades, lay the foundations for the unification of Japan: Oda Nobunaga. His rise would bring the world of the ninjas to its peak, and then to a violent end.

In his background, as in his rise, Nobunaga almost matched Genghis Khan, starting from nothing much and, over twenty years, fighting his way up toward nationwide rule, though not quite achieving it before his death (unity took another eighteen years of warfare). He did it, in the words of his biographer Jeroen Lamers, by using "rational cruelty in the service of government." The story interweaves two themes—Nobunaga's brilliant, ruthless leadership, and new technology in the form

of handguns. We must follow them both to understand why and how the ninjas fell.

The story of how firearms came to Japan is usually told in simple terms: The Portuguese arrive with guns, the Japanese see how effective they are, and presto, the world changes. In fact, it's not that simple. Guns had been made in China from the late thirteenth century. They were primitive, but leaders recognized their potential. Firearms took longer to load than bows, and they were not as accurate, but they had one supreme advantage: To use a bow, you had to train for years and then keep in practice to build and preserve shoulder, arm, and finger muscles; but any weakling could use a gun. A century later Korea was making handguns. Yet the technology did not instantly spread to Japan. In 1510 a priest in Odawara (halfway along Honshū's southern coast) acquired a Chinese matchlock and showed it to his lord, who apparently was not impressed, because he did absolutely nothing with it. Others were more ambitious. Chinese guns were used in a battle in 1548, but only as a stopgap alternative to bows and swords. Why? No one knows, because no examples or designs have survived. Possibly, the barrels were not cast in one piece but as two bits welded together, which made them liable to explode.

It took a slightly more advanced design to convince the Japanese. In the early 1540s Portuguese merchant adventurers approached northward from Okinawa, hopping along the Ryūkyū Islands as if they were stepping-stones across a river. Among their weapons were some handheld, muzzle-loading matchlock guns known as arquebuses. Two Portuguese adventurers, both armed with arquebuses, joined the one hundred-strong crew of a Chinese junk, which was bringing merchandise to Japan, aiming to dock on Tanega-shima, the island off the south coast where all trading vessels had to register (and which is now famous for Japan's space center).

Damaged by a storm, the junk limped to shelter in a bay on the southern coast of the island.[1]

It was September 23, 1543, as we know from a local monk, who sixty-three years later wrote a meticulous account, because no one had seen a ship of this size or such strange-looking, long-nosed, bearded foreigners; and by then it had become clear that the incident had changed the course of Japanese history. The chief of the nearby village, Nishimura, could read kanji—Chinese script used to write Japanese. Since he knew only the Japanese pronunciation of the signs, he could not talk to the crew. But he "spoke" with them by drawing characters in the sand with a stick, asking where the foreigners came from. "They are traders from among the southwest barbarians," came the sandy reply.

Nishimura then galloped the fifty kilometers to the capital with the astounding news. The island's lord, Tokitaka, a curious fifteen-year-old, demanded to see the ship and the foreigners. Back went Nishimura to organize a dozen rowing boats, which towed the damaged junk around the coast to the main harbor. An astonished crowd gathered, among them young Tokitaka, who invited the two foreigners to his house. There he asked about the long stick that each carried, "an object which could not be compared with anything known. Its use was both strange and wondrous." They gave him a demonstration, hitting a target one hundred meters away, and he, of course, bought the two muskets on the spot, eager to get them copied. He had reason to think this would not be hard. His island was iron rich, with a tradition of sword making.

In four months his blacksmith, Yaita, made Japan's first effective musket, receiving instruction from a Portuguese, in exchange—according to tradition—for his sixteen-year-old daughter, Wakasa. Folklore claims that she had a miserable

[1] The main source for this account is Lidin, *Tanegashima*.

time in this, the first Japanese-European marriage. Yaita, however, prospered. His creation was instantly used to help retake the neighboring island. After a few lessons in how to make gunpowder (local sulfur, saltpeter from China), word spread. That same year, 1544, homemade muskets were taken to the main island of Honshū, and leaders soon saw the potential; five years later, Portuguese-style arquebuses were first used in battle, though not with the discipline that would make them truly revolutionary.

Soon Oda Nobunaga, warlord and future shogun, heard of the new weapon and ordered five hundred of them. When he finally realized how to make the best use of them, he would change the course of Japanese history, tackling other warlords, communes, warrior monks, ninjas—all of Japan's divisive, vested interests. But right then the guns were of less importance than the most powerful weapon of all—Nobunaga himself, the cause of much destruction and much novelty, and the survivor of several ninja-style assassination attempts.

Nobunaga, one of the greatest—as well as the most ruthless—leaders in Japanese history, was not marked out for leadership. The Oda family, rising from obscure origins, had become the shogun's deputies in their home province, Owari, which was Iga's near neighbor to the northeast, a small province centered on today's Nagoya and edging Ise Bay. Nobunaga inherited his father's rank as an assistant deputy to the shogun's representative, not a great start for the future unifier of the nation. But he was ambitious and merciless. At twenty, he had enough loyal followers to crush opposition from his own family, which included killing one of his brothers (as Genghis did). At twenty-five, he chased out the shogun's representative and ruled the province, with the shogun's support.

The following year (1560), a neighboring provincial ruler, Imagawa Yoshimoto, led 25,000 men into Owari on his way to Kyoto. One of Imagawa's generals seized a fort and sent seven

heads to his boss. Nobunaga ordered a counterattack, despite being outnumbered four to one. Luckily, the invaders were camped on the coast, near a little village called Okehazama, in a wooded defile (a *hazama*) that Nobunaga knew well. Leaving a few men with many banners to give the impression of a large force, he took most of his little army, some three thousand strong, through forest behind Imagawa's position. Suddenly, around midday, stifling summer heat gave way to a violent thunderstorm. Nobunaga attacked and Imagawa's army fled, mired in mud, their guns soaked and useless. Imagawa's tent was left unprotected, and he lost his head, literally, to one of Nobunaga's men. It was all over in minutes. By chance, one of Imagawa's allies, a man who would later name himself Tokugawa Ieyasu, was away from headquarters at the time, and survived. Soon he would switch his allegiance to Nobunaga and complete his new master's revolution. The battle of Okehazama made history: If Imagawa had been less arrogant and more circumspect; if Nobunaga had been less bold; if there had been no rainstorm; if Ieyasu had been near Imagawa—why, then Nobunaga would be a mere footnote and Ieyasu even less, rather than the founders of postmedieval Japan.

Meanwhile, Ieyasu had a problem. His family was held as hostages in the castle of the son of Imagawa, who had just lost his head to Nobunaga. How to remain true to his former master's family, thus ensuring his family's survival, while coming to some accommodation with Nobunaga, thus ensuring his own survival? As it happened, the gods were with him. His plan was to declare himself for Nobunaga, then, to prove his loyalty, seize one of Imagawa's castles and take hostages of his own, which he would then exchange for his family. This was a high-risk strategy, which would work only if he could take the castle fast enough to forestall the execution of his family. Failure would undoubtedly result in the death of his wife and children, an end to his ambitions, and probably his own death.

The castle he had in mind that spring of 1562 was Kamino, southeast of Nagoya in Mikawa (today's Aichi Prefecture), near his birthplace of Okazaki. Kamino was a tough nut, "built upon a formidable precipice," according to the main source,[2] so "we will be condemning many of our allies to suffer great losses." There was only one way to guarantee a quick victory—by using ninjas. "By chance, there are [among our allies] men having relations with Kōga"—i.e. that is, ninjas— so "let us convene Kōga's leaders through their compatriots and then they can sneak into the castle." Clearly, then, Kōga's ninjas had a reputation that reached far beyond its border, and were available for hire as mercenaries. Some eighty (or more—another source says two hundred) responded to the call. In mid-March this group, having dressed up so that they would be mistaken for defenders, "were ordered to lie down and hide in several places, and . . . sneaked inside the castle." Once inside, they made their way around in silence, killing as they went, communicating with one another by using a password. The defenders were totally bemused by what was happening, thinking that the shadowy figures were traitors from within their own ranks. "Before long they were setting fire to towers inside . . . the garrison was utterly defeated, and fled." The commander hid beside the Hall of Prayers, where the ninjas' leader found him, speared him, and took his head. Some two hundred defenders perished in the flames, and many others were taken hostage, among them the two sons of the slain commander, exactly as Ieyasu had planned.

He followed his stunning victory with an offer to exchange his hostages for his family. The deal was done, his family restored, his loyalty to Nobunaga established, his new career well launched.

[2] The story is told by both Turnbull (*Ninja*) and Zoughari, *The Ninja* quoting the original Japanese sources.

With one glitch. As part of the deal, Kamino's burned-out wreck was returned to the Imagawa clan. It was soon repaired and handed over to the two sons whose father had been killed in its defense. Rather foolishly, they sought revenge, reopening the feud with Ieyasu, who once again sent a force of Kōga ninjas to repeat their previous success. This they did "taking advantage of an unguarded point," and this time making sure of their victory by killing the two brothers, "who thus," as Turnbull says, "earned their place in history by being probably the only samurai to have been defeated by the same ninja twice!"

Ieyasu was grateful, though it took him a while to express his thanks for the victory. In a letter to the leader of the Kōga ninjas, a certain Tomo Sukesada, he wrote, "Since that time, I have been occupied with one thing and another and have neglected to write for some years. [I wish you] good health, and have the honour to congratulate you."

In 1568, Nobunaga set out for the capital, Kyoto, marching via southern Omi—right past Kōga—and defeating its local lord as he went (with interesting consequences, which we'll get to shortly). In Kyoto, Nobunaga appointed his own compliant shogun, with the obvious intention of unifying the country.

No one was better qualified for the task. The following year a leading Jesuit missionary, Luís Fróis, from Portugal, became the first European to meet Nobunaga, and left a pen portrait of this ambitious, ruthless, brilliant, and extremely scary leader:

This King of Owari, who would be about 37 years old, is tall of stature, lean, sparsely bearded, with an extremely sonorous voice, given to military exercises, indefatigable, inclined to works of justice and compassion, arrogant, a great lover of honour, very secretive in his decisions, a master of stratagems, hardly or not at all mindful of the reprimands or advice of his subordinates, and is feared and venerated by all to the

highest degree. He does not drink wine, is brusque in his manner, looks down on all the other kings and princes of Japan and speaks to them with disdain as if to his inferiors, is totally obeyed by all as the absolute lord, has good understanding and sharp judgment, despises the gods, the Buddhas and all other kinds of idolatry and pagan superstition.

In his actions, Nobunaga followed Chinese emperors who had established or reestablished unity: the first emperor, who crushed rival states and intellectuals; the Tang emperor Wuzong (reigned 840–46), who destroyed thousands of Buddhist monasteries and had some 250,000 priests defrocked. Utter ruthlessness in politics and war, moderated only by pragmatism, was his guiding principle. "Rule the empire by force" was his motto; but first he had to conquer it. Among the challenges Nobunaga faced were not only the many independent warlords but also those from the three main groups of nonsamurai: the warrior monks of Mount Hiei, the Ikkō *ikki*, and the ninjas of Kōga and Iga, all of whom he dealt with in a series of overlapping actions that lasted twelve years, from 1570 to his death in 1582.

He was lucky to live to start his campaigns, because he at once became a target for ninja assassins. One incident took place shortly after Nobunaga had marched through Omi. His arrival and victory were much resented by one of Omi's principal clan leaders, Rokkaku Yoshisuke, whose family had been dominant there for three hundred years but was now rather less so, thanks in part to Nobunaga. Yoshisuke also had considerable experience with ninjas, who outside their own territories were happy to work for whoever paid them. So it was natural for Yoshisuke to seek revenge on Nobunaga by sending a ninja to kill him. Nobunaga, being by now the most powerful commander around, was too well protected for a ninja with a knife to get near him. So Yoshisuke (so one

version of this story goes) hired a sharpshooter called Sugitani Zenjūbō, who lay in wait for Nobunaga and got off two shots, both of which were absorbed by Nobunaga's armor and padded costume. Two shots—how? Even if Sugitani had two guns, it is hard to imagine Nobunaga waiting around long enough to receive the second bullet. I asked the owner of a hotel where I was staying in Kōka. By chance, he was a member of a historical study group and had written on this very incident. It happened on May 19, 1570, near the Yokkaichi area, more than thirty kilometers east, the other side of the Suzuka hills. No, no, he said, not two shots. It was a single shot, and it just missed, passing through Nobunaga's right sleeve.

First on Nobunaga's list were the warrior monks, principally those of the temple-fortresses of Ishiyama Hongan-ji in Ōsaka, Enryaku-ji on Mount Hiei, and Nagashima. Not only were they fiercely independent; they were also potential allies for any rival warlord, and all extremely tough nuts. An attempt to crush Ishiyama Hongan-ji in 1570 was thrown back by volleys of arquebus fire, which taught Nobunaga two important lessons. The first was that the way to use muskets was for the matchlock men to form ranks and fire in controlled volleys, one rank after another, giving time for each rank to reload. The second was that to follow convention by giving pride of place to samurai with swords and spears would not do; ordinary foot soldiers with muskets could add a new dimension to battle, if they fired in volleys.

In the autumn of 1571, Nobunaga turned on Mount Hiei. He deployed his thirty thousand men in a ring around the mountain, then had them move uphill, burning and killing as they went. By nightfall the main temple was ablaze. In the words of a chronicle, many of the monks and their retainers "threw themselves into the raging flames, and not a few were thus consumed by the fire. The roar of the burning monastery, magnified by the cries and countless numbers of the old

and the young, sounded and resounded to the ends of heaven and earth." Luís Fróis rejoiced in the slaughter: "[Nobunaga] put his men into every hole or cave, as if he had been in chase of some wild beasts, and there butchered these miserable wretches." Possibly twenty thousand or more perished (though all such big, round numbers are guesstimates).

Nobunaga was then free to turn on the Ikkō *ikki* of Nagashima, whose monks had five strongholds on a long, thin spit of land in the swampy lower reaches of three rivers running in parallel into Ise Bay, near today's Nagoya. For Nobunaga, this was personal, twice over: Nagashima was part of his home province, Owari, and the *ikki*, holed up in their castle and a fortified monastery, had killed his brother (or rather "forced" him to commit suicide by defeating him) in a previous skirmish. The first attack on this "water world" in May 1571 had been a disaster, with Nobunaga's samurai trapped in muddy reed beds, falling easy victims of the *ikki*'s muskets and arrows, then being swamped when the *ikki* opened a dike.

In 1573, he tried again, and succeeded in taking only some outlying villages. A rainstorm soaked his muskets, while the defenders of the castle and fortified monastery were able to keep their powder dry and return withering fire. That might have been the end of all campaigning, because that same year he also crushed a family named Hatano, who decided to seek revenge by commissioning the steward of one of their vassals to undertake a ninja-style assassination. The killer, Manabe Rokurō, intended to enter Azuchi Castle and stab Nobunaga while he slept. He was caught, and committed suicide, his body displayed in the marketplace—a failure hardly worth a mention except that, three hundred years later, the incident was portrayed in a print, with Manabe in the role of the archetypal ninja.

The following year, having recruited a former pirate, Nobunaga mounted a third assault on Nagashima, using ships

to isolate the two strongholds, then battering them with cannonballs and burning them with fire arrows. Inside, the twenty thousand inhabitants—more big, round, and doubtful numbers—were beginning to starve. They offered to surrender. But Nobunaga wanted revenge for his brother's death and for previous humiliations. "As I want to exterminate them root and branch this time," he said, "I shall not forgive their crimes." Dismissing the monks and their dependents as "worthless beings" who did not deserve to live, he planned an annihilation as thorough as the one unleashed on Mount Hiei. He built a palisade around both positions, piled brushwood behind it, then, with the approach of a typhoon, set the brushwood ablaze so that the gale carried fire across the flat land into the castle and monastery. All twenty thousand inhabitants died, with another twenty thousand dying in battle: forty thousand dead, and still no end was in sight.

The Ikkō *ikki* had several other complexes owing allegiance to the formidable Ishiyama Hongan-ji, whose inmates were, in effect, kamikaze fighters, quite ready to die for their faith, because they were utterly convinced of the truth of their banner: "Advance, and be reborn in paradise." The struggle dragged on for six more years, with Nobunaga using every means possible to gain power: inspiring rivalry between religious factions, disarming rural populations, blockade, outright assault on temples.

Meanwhile, in June 1575, one of the most momentous battles in Japanese history occurred. It was a showdown with Nobunaga's notorious rivals, the Takeda clan of Kai Province. The background was this: One of Ieyasu's top ministers was a man called Oga. A genius at finance, he turned traitor and plotted a campaign with the Takeda clan's current head, Katsuyori, to take the great castle of Nagashino. Unhappily for the traitor Oga, he was himself betrayed. Ieyasu seized Oga's wife and four children and had them crucified. When Oga heard

the news he is supposed to have remarked, "You have gone on first. You are lucky. I must follow after you." Which he did, in gruesome fashion. He was buried up to the neck, and a saw placed beside him so that passersby could take turns cutting his head off, very slowly. It took him seven days to die.

Katsuyori, meanwhile, was on his way, leading fifteen thousand men. Despite the loss of Oga, he set about attacking Nagashino. Not an easy target, because it lay in the fork of two high-banked rivers and its five hundred defenders were led by a spirited twenty-four-year-old, Okudaira Sadamasa. Several assaults with mines, river rafts, and assault towers failed, with the death of eight hundred attackers. But Katsuyori was clearly not going to give up, so Sadamasa sent messages asking both Ieyasu and Nobunaga for help. Katsuyori settled down to starve the castle into surrender, building palisades and throwing a network of ropes across the rivers "so that not even an ant could get out." Remember how new the alliance was between Nobunaga and Ieyasu. Both foresaw disaster; both prevaricated. Perhaps, if young Katsuyori was going to prevail, Ieyasu would serve his own interest best by breaking with Nobunaga and allying with Katsuyori. Nobunaga gambled: Better keep the alliance intact than let Nagashino fall without a struggle. He and his thirty thousand men joined with Ieyasu and his eight thousand, and the two approached Nagashino together.

Nagashino had two days' supply of food left. Who knew if and when relief might come? Someone had to get a message out to Ieyasu, the closest of the approaching allies. One of Sadamasa's retainers, Torii Sune'emon, volunteered. His bravery and his fate made him part of history, and also part of folklore, so the tale of what he did and how he died is now a tangle of fact and fiction.

Already famous for his ninja-like skills, he says that if all goes well he will light beacon fires to signal that he is clear

of the besieging forces and that help is on its way. The first problem is to escape the castle unseen. A powerful swimmer, he leaves by night, perhaps simply through a gate or perhaps (in another version) through the castle sewer, falling into the nearest river. He swims downstream, cutting through the netting as he goes, and the following morning lights a beacon, as planned, to show that he is safe. What he does not know is that the cut cables and the beacon have been spotted by Katsuyori's men, who are on the lookout from this moment on, spreading sand on riverbanks to disclose telltale footprints and restringing the network of ropes, with bells attached this time.

Meanwhile, Torii makes contact with Ieyasu and Nobunaga, tells them of the castle's dire situation, receives a promise of relief the following day, signals the good news to the castle with beacon fires, and heads back—right into Katsuyori's arms. Katsuyori is full of praise for Torii's bravery and skill and offers him a job. Torii accepts—but with duplicity in mind, because at heart he remains loyal to his lord—at which Katsuyori gives him new orders: Go to the walls and shout that there is no hope of succor, and that surrender is the only option. He agrees. He is strapped to a cross, perhaps to attract attention, perhaps also to warn him of what dreadful fate lies in store for him if he does not do as he is told. In another version of the story, soldiers surround him, their spears pointed at him. Yet instead of calling for surrender, he yells for the besieged force to hang on, because relief is on its way. He is, of course, crucified or speared, either way achieving legendary status.

That left Katsuyori, with his 15,000 men, between a stubborn citadel and the approaching army of 38,000. Outnumbered, he might have decided to surrender or flee, but of course neither was acceptable to a samurai. Moreover, his

troops were experienced, his cavalry formidable, while Nobunaga's were not. He would fight.

Nobunaga, too, knew the odds, and decided to increase them in his own favor with a brilliant tactic using arquebuses, the antique muskets copied from those introduced by the Portuguese in Tanega-shima thirty years before. By now every warlord and armed temple had guns; Nobunaga, though, had a vast number. Almost a quarter of his army, 10,000 of the 38,000, had arquebuses. They were as rudimentary as ever— it took a good twenty seconds, perhaps a minute in battle, to reload them through the muzzle, and they were effective up to only about seventy meters, so guns alone did not offer an overwhelming advantage, especially in the face of charging cavalry. Nobunaga knew the answer. In many accounts, the idea seems to spring out of the blue; in fact, he had learned the hard way fighting the warrior monks of Hongan-ji five years before. He ordered 3,000 of his best shots to form a unit, divided them into three ranks, 1,000 each, and told them to fire in sequence, in volleys as one rank succeeded another, producing a volley every twenty seconds.

First, Nobunaga saw that the musketeers needed protection against the cavalry. So, on the afternoon before the battle, he had them build a palisade of stakes some four hundred meters long, in sections too high for horses to jump. Hills at one end and a river at the other would prevent cavalry from outflanking the guns. He gave orders that the troops should fire only when they could be sure of a hit, which meant at less than fifty meters. By now it was dark, and the musketeers settled for the evening behind their stockade.

During the night, it rained. Katsuyori, camped in woods in front of the castle and a few hundred meters from the stockade, assumed that the enemy's muskets would be too wet to use. Also his cavalry would cover the ground from woods to

stockade in a minute or two, which meant—in theory—that the horses would be upon the matchlock men before most had a chance to reload. So, soon after a midsummer dawn, while troops to left and right engaged in hand-to-hand combat, he did exactly as expected, sending his cavalry into the attack, a magnificent display of bravery and impetuosity. Out of the trees they came, across a shallow stream, up the bank, and on, laboriously, over rough, wet ground.

Seconds later, within fifty meters of Nobunaga's line, the first rank of his muskets spoke, and the first of Katsuyori's horses and riders fell. At that speed, the survivors would cover those fifty meters in just five seconds. But now the second rank fired, then the third, reducing the charge to a mêlée of fallen men and horses. Those who survived were impaled by the vast, five-meters spears of the foot soldiers defending the ends of the stockades. Other charges followed, and more slaughter. Seeing what was happening, many in the castle came out to join in the fighting. The musketeers advanced from their stockade, the battleground became a chaos of men fighting hand to hand, and by midafternoon Katsuyori's troops saw they were beaten. They broke and fled, many—some three thousand, according to the most widely accepted estimates— to their deaths. Not, however, Katsuyori himself, who lived to fight another day.

This is the strange tale of how Uesugi Kenshin died. All ninja-philes know it, so let's retell it, and then see if there could be any truth in it.

First, a little background. Uesugi was one of the greatest of sixteenth-century daimyōs. He owed his name to a former lord who, in defeat, came to him begging for refuge. He agreed, on the understanding that the lord would adopt him, give him his own name, Uesugi, and make him heir as provincial ruler with

immediate effect. The following year, in 1552, he also took the Buddhist name Kenshin. With his new name, he fought many battles in a series of confusing campaigns, attacking some rivals, allying with others, then turning on his allies and allying himself with former enemies. His main enemy, Takeda Shingen, felled by a sniper's bullet in 1573, was succeeded by his less brilliant son, Katsuyori, the one defeated by the fast-rising Oda Nobunaga at Nagashino in 1575. It was Nobunaga, therefore, who emerged as Uesugi's greatest threat, and Nobunaga who in 1578 engineered Uesugi's nasty death—so it is said, because it was he who benefited from it.

The story appears in its most developed form in *Asian Fighting Arts* by Donn Draeger[3] and Robert Smith. It opens with an attack on Kenshin by four of Oda's ninjas, headed by a certain Ukifune Kenpachi. They are spotted by Kenshin's ninja guards but hide in a ceiling, kill the guards with darts from blowguns, then head for Kenshin's quarters. But the guards' commander has faked death; he intercepts the assassins and kills them.

Then comes the sequel, which involves the brother of Ukifune Kenpachi, a ninja dwarf named Ukifune Jinnai, a sort of Japanese version of Gimli in *Lord of the Rings*. Here is the Draeger and Smith version of the story:

> The clever Oda, taking no chances, had dispatched a dwarf ninja, Ukifune Jinnai, weeks in advance to study and make special preparations to assassinate his rival Kenshin. Ukifune, who stood no more than three feet tall, concealed himself in the lower recesses of the Kenshin private lavatory on the day of the entry of the other Oda ninja. He clung perilously and at great personal discomfort for hours to the unsanitary

[3] Donn F. Draeger was martial arts coordinator in the James Bond film *You Only Live Twice*.

understructure by a technique perfected by him known as *tsuchigumo*.[4] Ukifune was accustomed to cramped living: it is said that in training camp he resided in a huge earthenware jar to prepare himself for such a situation. As Kenshin squatted in observance of his daily habit, Ukifune stabbed him with a spear that entered Kenshin's anus and continued through his body until it protruded from his mouth. The screams of agony brought Kenshin's ninja to the scene. But when Danjō [Kenshin's ninja chief] and the others arrived, Kenshin was dead, and his assassin was nowhere to be seen. Ukifune had dived under the reservoir of fecal matter where he remained motionless, breathing through a tube, until Danjō and his ninja left with the lifeless body of their master. Then he quietly slipped out of the lavatory and the castle to report the deed to Oda.[5]

This tale has been repeated in many books and is all over ninja sites on the Internet, as if it were established historical truth. It's no such thing. The source on which Draeger and Smith relied was published four years previously, in 1965; that source's source was an undated manuscript.

Other sources (well reviewed by Turnbull) suggest that Kenshin had not been well for some time. A sickness several years earlier had left him with one leg shorter than the other, after which he walked with a stick. He also drank heavily: "This chaste and vegetarian Galahad of Japan liked wine as he disliked women," in the words of Tokugawa Ieyasu's biographer, A. L. Sadler.[6] In the months before his death, an aide noted that he seemed to be getting worse by the day. A diarist recorded that he was very thin, with a pain in his chest "like an iron ball"; and that he often threw up after eating and had to

[4] "Ground spider," with other senses, including (in folktales) a spider-limbed monster and a race of underground dwarves.
[5] *Asian Fighting Arts*, p. 130.
[6] *Ieyasu*, 107.

drink cold water. The symptoms suggest cancer of the stomach. In the days before his death, according to Kenshin's heir, "an unforeseen bowel complaint took hold, and he could not recover." The account continues: "On the ninth day of the third month, he had a stomachache in his toilet. This unfortunately persisted until the thirteenth day when he died." Another source says his death at the age of forty-nine was due to "a great worm." The most likely cause of death was a stroke brought on by straining to defecate, or in the words of Sadler, who had an eye for a colorful story, "he was struck down in his lavatory with an attack of apoplexy," with absolutely nothing to back talk of a ninja assassin. In a poem found after his death, Kenshin seemed to think his life was nearing its end:

> Forty-nine years;
> One night's dream.
> A lifetime of glory;
> A cup of sake.

(Or in less condensed terms: "My forty-nine years have passed like a single night's dream. The glories of my life are no more than a cup of sake.") No mention of an assassin in any of this.

What seems likely is that folklore filled the gap left by the death of a great man, myth replacing fact—an old Japanese equivalent of the conspiracy theories that became attached to the murder of John F. Kennedy and the death of Princess Diana. On the question of how the elements of the myth came together, there is no definitive answer, but there are a couple of pointers. First, ninjas did indeed hide in toilets, simply because toilets were among the outhouses that provided cover at night, though not *down* them. Second, Kenshin did suffer an "attack" in his toilet. The linking of these two facts to make a fiction seems to have occurred at least by the eighteenth cen-

tury, because the story, minus the dwarf, is mentioned in an undated book (*Kashiwazaki Monogatari*), which was probably written in the eighteenth century because it is referred to in an early-nineteenth-century record of the Tokugawa shogunate (*Tokugawa Jikki*).[7] Some time after that, folklore added the dwarf, presumably to "explain" how a ninja managed to hide *down*, rather than in, a toilet. But it leaves some practical problems: How does a dwarf cling to the underside of planks "for a long time"? How could he be certain that Uesugi would come to the toilet within an hour, or however long he could remain suspended? If he dived under the shit, breathing through his scabbard, he did so to hide from curious eyes—but surely, inevitably, his scabbard would be exposed? How do Uesugi's retainers not realize where the assassin is, given that (a) he was not to be seen; and (b) there are no shitty footprints? Finally, how does a shit-covered dwarf sneak through a castle unnoticed?

Anyway, this was the version that Draeger (now dead) and Smith repeated, with embellishments, in their 1969 book, from where it escaped into the electronic ether.

Other campaigns followed Nagashino, driven by Nobunaga's need to crush rival warlords and cut the great temple of Ishiyama Hongan-ji from its network of provincial monasteries. That done, he could close in on the temple itself. It took ten years, on and off. In 1580, Hongan-ji surrendered, being burned by its defenders to stop it from falling into Nobunaga's hands undamaged. In today's Ōsaka, hardly a trace remains of the temple that once ruled here. This success ensured that the state triumphed over religious institutions, becoming an expression of Nobunaga's own conviction; as Luís Fróis had said, he "despises the gods, the Buddhas and all other

[7] Thanks to Yoshie Minami for this information.

kinds of idolatry and pagan superstition." From now on, religion would operate only with the consent of the state, rather as Russian Orthodoxy survived under communism in the Soviet Union, or Buddhism survived in Mongolia over the same period.

There remained one enemy who had to be crushed before all Japan became one: the Takeda leader who had survived Nagashino, Takeda Katsuyori. And that campaign also involved ending the independence of Iga and Kōga and their ninja villages.

9

THE CALM BEFORE
THE STORM

*Always draw what you have learned while scouting, and then
report it to the strategist directly in person.*

<div align="right">Ninja instructional poem</div>

BY THE TIME THE SURVIVING WRITTEN EVIDENCE WAS RE-
corded, the ninjas of Iga and Kōga had been in operation for
decades, perhaps a century or more. Doing what exactly, we
may ask, in the absence of contemporary documents? The an-
swer is, a great deal, because although many were no doubt
landowning samurai administering their estates, others were
ordinary, hardworking farmers. Besides doing their military
training and field work, they built up medical expertise, pre-
pared their houses for possible attack, fought far afield as
ninja mercenaries, and went off on the equivalent of com-
mando courses.

Training demanded a combination of physical and mental
preparation, aims that the ninjas shared with the adepts of
Shugendō, working out in the forested mountains. So, to re-

search ninja commando training, it was to a mountain and a Shugendō adept that I turned.

I had seen Kōzō Yamada the day before, when he was taking part in the dragon-god fire ceremony. Then he looked the image of the traditional adept, in white cloak, shoulder harness, and little monk's hat. Now he was the image of a modern one, though prepared more for hiking than commando training: conical sun hat, dark glasses, white sweat scarf, multi-pocketed waistcoat, backpack, heavy-duty gloves, a long machete-like knife on his belt, thick trousers, extremely serious walking boots. At seventy-six, he looked twenty years younger, while his light voice was that of a teenager. *Shugenja*, as the Shugendō students were called, *yamabushi*, and ninjas—the groups all overlap—claim that Shugendō practices have magical effects. In Kōzō's case, it seemed to be true.

The knife was for what exactly?

"This is a *nata*. I use it to cut branches, and sometimes to fight bears." He saw that I believed him, and set me straight. "We have deer, and boars, which can be dangerous. Lots of snakes, particularly at this time of year. No bears."

With host Yoshihisa driving me and Noriko, Kōzō guided us up a winding track deep into autumnal forest, where he was going to lead the way along a "training path," a re-creation of the sort of course used by ninjas. As if on cue, a small snake writhed away through the fallen leaves. He picked it up and held it out to me. "It's harmless. The only one you have to look out for is the *mamushi*. If you get bitten, you have to get an injection, or you may die." Snakes, in the words of Indiana Jones; why did it have to be snakes? I looked at my running shoes, compared them with his calf-length boots, and wondered how long it would take to get me injected. Luckily, until doing later research, I didn't know that every year some two thousand to three thousand people get bitten by *mamushi*, a sort of pit viper, of whom ten die. Nor did I know that

the *mamushi* is the same species I had taken care to avoid a couple of years before on the little island of Amami Ōshima, where they call it a *habu*. So, in happy ignorance, I fell in behind Kōzō, and—Jesus! There was another one, a meter long, and this one had a frog in its mouth. "Harmless," Kōzō said again, but it did leave me wondering about the significance of snakes in Shugendō-ninja training regimes.

This, he said, was where Kōga's ninja training started, here on Hando Mountain. There were two others nearby, Iwao (where they had held the fire ceremony) and Koshin, but this was his choice, because this was where the founder of Shugendō, En no Gyōja, came to train in the early eighth century (though the same claim is made for the Forty-Eight Waterfalls; adepts say he jumped from that one to this, among others).

Though all around was greenery and silence, this had once been open and crowded. The undergrowth blanketed the shapes of ancient walls, the remains of a Buddhist temple, Hando-ji, a place of dozens, perhaps as many as fifty buildings, with several hundred priests. Kōzō told its story, leading the way to a platform with a view over the valley below. With the mountain opened up by En and his trainees, the temple was built in 740, just before the emperor decided to create a new capital down there, in Shigaraki. He pointed out a small town, now famous for its ceramics. I had come that way into Kōka, driving past ranks of the Japanese equivalents of garden gnomes—owls, frogs, and supercute opossum-like *tanukis*.

"So when work started on the new palace, the officials were pleased to discover that this temple was already here, stopping evil spirits from coming into the new capital from the northwest." Shigaraki was a capital for only two or three years, when a fire (as some say) or disease convinced the court that the gods disapproved of the move, and they went back to Nara. The temple, which like most also included a Shinto shrine, stood for more than a thousand years, until the Meiji

Restoration (1868), when the new government decreed that Buddhism and Shintoism should be separated. "So the Buddhist buildings were knocked down, leaving only the Shinto shrine. You will see. Would you like to wear these gloves?"

"Why? Is this a Shinto tradition?"

"No." He laughed. "It's a difficult climb. You may need them to protect your hands."

He led the way down a leaf-coated path, which got steeper and steeper until we had to rappel a few meters, using a chain hanging from a tree. We came to a crag, slung about with two chains. "There's a cliff on the other side," said Kōzō. "Very dangerous." Well, perhaps it would have been in the old days, because the crag marked the edge of a precipice. Here ninjas and *shugenja*, their feet held by fellow trainees, lowered themselves backward over the abyss and "stayed there until the fear went," as Kōzō said. Once they had built up their courage, they were supposed to climb free-style across the face of the cliff ("I did it myself when I was a boy"). Today there is a metal bar set into the rock, and the traverse is only three or four meters, but back then barefoot trainees risked death, especially as they would surely do this in winter, just to make sure they suffered. And at speed, as Noriko reminded me. And chanting as they went.

Ahead was another crag, this one with a hole in it, through which the fitter, faster, and nimbler would have dashed. Kōzō led the way up a near-vertical climb, clinging on to roots, leaving Noriko and me floundering in leaf mold in his wake. I hadn't bothered with the gloves, so my hands were sticky with pine sap and coated with soil. We emerged on the summit— more rocks sticking out of the soft ground, and another terrific view over rolling forest to distant mountains. "That's Hiei-san," said Kōzō. I was unfamiliar then with the use of the honorific *san* attached to a mountain, as in Fuji-san "Mount Hiei," he said as he saw my blank gaze. "You know—the

mountain with the monastery Enryaku-ji, near Kyoto. The one destroyed by Nobunaga."

I remembered: the one where twenty thousand perished in the flames.

"All children are told about it in school. We call it the Enryaku-ji Incident," said Noriko. "This temple belonged to the same sect, the Tendai."

"So did he come on here and destroy this as well?"

Kōzō replied, "No, because he only destroyed those temples that opposed him."

We stood for a while admiring the view, content in the soft autumn sun, then moved down to a nearby building, which turned out to be a Shinto shrine, the predecessor of which had been part of the old Hando temple complex. It displayed various unlikely creatures—a yellow-eyed tiger and a *kirin*, a sort of winged lion, after which the beer is named.

Kōzō, meanwhile, explained his interest in the mountain. Actually, he had been doing this on and off during our climb. This is a collated version:

> Until the time of my grandfather, my ancestors were *yamabushi*—mountain ascetics—and rice farmers, living close to this mountain, which belonged to three small communities. When my grandfather was a boy, the temple was destroyed and the mountain became overgrown. Then about sixty years ago, the mayor decided to restore the mountain and suggested that the descendants of the *yamabushi* families look after it. I started as a banker, then I worked for medical companies, before turning to farming rice, but when I retired I thought I should do some sort of community work. The founder of the Tendai sect, Saichō, said, "Kill yourself for others," which he did not mean literally, but as "Do your utmost to serve others before yourself." So I decided to help with the mountain. That was when I started taking part in Shugendō ceremonies, like

the one you saw yesterday, and training my body and mind on the mountain. My greatest ambition"—he ended with a smile—"is to achieve world peace, and my smallest is to be a good person.

It was impossible to know from his words how to separate out the slurry of religious affiliations—different Buddhist sects, Shugendō, *yamabushi*, ninja. One thing seemed clear to me. The ninjas' reputation as sinister men in black who were happy doing the dirty work for their bosses should go. They were as committed to self-improvement and doing good as their priestly fellow trainees, with the proviso that this was part of their preparation for their main military purpose, which was spying.

I went to a tree-covered hill in Iga Ueno. On a flat space near the top is the ninja museum. The place is the architectural equivalent of a ninja, because it is much more than it seems at first glance. Its thatched roof and timbered rooms hide many tricks and devices and hidey-holes and hidden stairways that householders included to ensure they could vanish or fight back in case of attack: a door that pivots on a central hinge, a window that can be opened with a sliver of paper, a trapdoor and hinged floorboard that (if you know how) open to reveal swords. A model ninja, dressed rather incongruously in pink, stands on a dangling ladder, forever about to climb into the loft. But what the house really has to offer is underground, down twilit steps made mysterious by the sounds of a howling wolf and the call of an owl. Dug into the basement is a museum devoted to ninja life.

Here are all the tools and weapons used by the shadow warriors, far more than are mentioned in the *Shoninki*: grapples and ropes and folding ladders for climbing walls, knives, picks, borers, and saws for forcing ways through doors and

fences, a fearsome iron claw for climbing trees and warding off swords, a knuckle-duster, a sickle and chain for snaring and slicing an opponent, four-pointed caltrops that could be scattered to pierce the feet of pursuers. Swords have broad hand guards that could be used to make a first step when climbing, plus a cord to pull the sword up behind you. There is even a little tube, which was supposedly used as a blowpipe to fire a poisoned dart as a means of assassination.

Most of the equipment is safely locked away in cabinets, but one item was hands-on, or rather feet-on: the *mizugumo*, a pair of wooden discs that (so they say) acted as the agricultural equivalent of snowshoes, used to cross bogs, or castle moats if they happened to be drying out. These "mud shoes" or "water spiders" looked suspiciously new. With me was Hiromitsu Kuroi, the closest you can come to a ninja these days. Having been practicing and teaching *ninjutsu* for thirty years, he is the inspiration behind the museum and adviser to publishers on ninja themes. One illustrated book in English, *Secrets of the Ninja*, has him on the cover and in scores of pictures inside, slaying opponents in freeze-frame.

"I have seen pictures of ninja using these to walk on water," I said, nodding at the *mizugumo*.

"That's nonsense. You would fall over, or sink."

"Has anyone tried them?"

"I have. They work on mud, not water."

I can believe it, sort of. But, like much information about ninjas, it is more than possible that this "fact" became a fact only later. There is an illustration of the water spider in one of the prime sources on ninja matters, a multivolume manuscript known as the *Bansenshūkai*, about which I would be learning much more. The drawing shows a single "shoe," which when doubled makes a water spider like the one displayed in the museum. But take a closer look. There is no strap to hold it on the foot. How on earth are you supposed to lift it in order to

walk on mud? You could of course add your own strap. But if the "spider" was meant for walking, the artist would surely have recorded a strap. If not for walking, how might it have been used? Here's a clue: Historically, life preservers were called "water shoes." Another clue is that the *Bansenshūkai* shows a single water spider. The conclusion should be that a water spider was a simple float to get across water, not mud. You either sat on the central section and used a paddle or sat astride the central section and paddled with your feet. Now, that makes sense. Water is a more common hazard than mud, and it would be much easier to carry one of the spiders rather than two.

Almost all of the tools were originally no more weapons than a kitchen knife is. Like the water spiders, they were bits of farm equipment that were adapted for fighting. Perhaps this is why the *Shoninki* makes no mention of them—there's really nothing very special about them. Even the ninja "uniform," which in popular imagination turns them into "men in black"—loose jacket, loose trousers bound just below the knee, a slipper-and-sock combination with soft cotton soles, leg wraps, mask, and hood—was modified peasant clothing, such as would be worn in summer, when a fieldworker wished to keep mosquitoes from exposed flesh. Black seems to be a post-ninja imposition. As Hiromitsu puts it in his introduction to *Secrets of the Ninja*: "In fact dark blue was the colour of choice. In the bright moonlight, black stands out like a sore thumb."

One type of weapon, the *shuriken* or throwing star, is both well known and problematical. Made in all sorts of shapes, from simple crosses to many-pointed stars, *shuriken* are undoubtedly fun to use, because almost any throw at a wooden target gets them to stick in with a satisfying smack. And they would undoubtedly cause a nasty cut in exposed flesh. But they are puzzling things. You cannot sheath them, except by

putting them in a bag. But imagine reaching into the bag, especially in the dark, while fighting—wouldn't you risk cutting your fingers? Was it worth the trouble, for a weapon that, as Hiromitsu admitted, "did not have the power to kill, or even do much harm"? Some claim that they were smeared with poison; but wouldn't that make them even more dangerous to the user?

Frankly, when delving into the historical realities of the ninja, there is a problem with authenticity. Purists may be surprised to discover that there is not a single authentic tool or weapon in the museum. All were made recently. Should this bother us? The arguments for and against have many buts. Some of the designs were recorded, but only after the heyday of the ninjas—but not *that* long after.

One other example: The ninja museum (and countless books) insist that one of the ninjas' secrets was to tell the time of day by checking the eyes of a cat, because the pupils dilate and contract with the changing light: narrow at midday, wide at dusk. For a moment, the "cat's-eye clock" sounds resourceful. But give the matter a moment's thought. First, of *course* a cat's eyes dilate and contract with the changing light. *All* eyes do. You might as well tell the time by staring into a mirror. Second, do you really need a cat to tell you the time of day? Third, the amount of light and thus the size of the cat's pupil depends not only on the time of day but also on the season and the weather. And once you spot your cat, how on earth do you get close enough to get a good look at its eyes? The more you think about it, the sillier it gets.

Noriko also planted doubts about the significance of the so-called anti-ninja "nightingale" floors, made of teak boards that squeak when you walk on them. Just south of Kyoto's Nijō Castle are the remains of the older Imperial Palace, a house known as Nijo-jinya, which (in the words of my guide book) offers "a thrilling glimpse into a treacherous world—

the seemingly ordinary house riddled with trap doors, false walls and ceilings, 'nightingale' floors, escape hatches, disguised staircases and confusing dead ends to trap intruders." Elsewhere, too, nightingale floors are part of the standard tour-guide spiel.

Not so fast. The *Shoninki* makes no mention of them. When I was in the Tofuku-ji temple in Kyoto with Noriko, we walked over nightingale floors by the acre. "They say the squeaking wood is to deter assassins, but it's not true," said Noriko. "All corridors made of this certain wood over thirty years old squeak like this. My house corridor makes the same noise." That set me wondering: Why "nightingale"? The sound is nothing like nightingales, more like armies of mice being squashed beneath one's feet. In fact, the Japanese bird (*uguisu*) usually translated as "nightingale" is a bush warbler, traditionally the herald of spring. The translation was coined by the English in the nineteenth century, simply because both birds sing. So let us consider spoiling a good story by inverting it: The floors squeak naturally, but when the rich started to build ninja-proof houses, ordinary folk, impressed by their ingenuity, granted them even more of it, by giving them credit for an entirely natural effect. Teak floors sang before ninjas walked.

In the sixteenth century, while the rest of Japan fought itself to exhaustion, the two neighbors, Iga and Kōga, shared similar social systems, family connections, and ways of cooperation. With their councils and contracts, they were remarkable little semi-democracies (sort of: As in ancient Athens, only the top men counted; women and servants didn't). They were also capable of operating outside their own borders, designating ten men from Iga and twelve from Kōga to meet up on the frontier to sort out the problems between them.

That's the positive view of the two provinces: peace-loving

communities inching toward democracy. But there is reason to think that this was an uncertain process, because both communities were also riven by petty feuds. Iga's three hundred to five hundred little estates and the fifty-three families of Kōga squabbled endlessly, and it was in these internal struggles that both sides developed the skills that would make them famous.

Everyone, for instance, built for defense. You can see the results today in the ninja houses that are tourist attractions in both Iga and Kōga. We have seen Iga's with its museum, but of the two, Kōga's claims to be the more authentic.

Kōga's ninja house, which according to its PR material claims to be the "only genuine historical building of its kind," is a fine old place of dark wood, thatch, and undulating gray tiles, full of shadowy corners and steep stairways and secretive nooks and cabinets of curiosities, all evoking the vanished world of the ninjas.

For visitors, first comes a sort of a stage show, in which Hukui Minogu, a gnome-like old man with flyaway hair and astonishing energy, explains the devices used by house owners to trick their way out of danger, some similar to Iga's, some unique. "Here is a steel door, sealing off a *kura*, a storage area, which has an iron ceiling so no one can cut their way in from above, with clay walls to keep it cool and make sure it cannot burn. Lots of houses had *kura*. When Tokyo was firebombed in the war, it was the *kura* that survived. Try this door. It's really heavy. You would think it was locked, wouldn't you? So would an attacker. He would just give up. But the family know that they can move it, if they really try. Go on, *push*. You see? This window—it's got a secret catch, which you can open by sliding a piece of paper or a leaf into the frame. You slam the window, like this, and the catch falls into place. Look at this doorway. You can escape through it, and inside there's a ladder leading up, but also a false floor, so the owner can vanish. If someone follows, they see nothing but the ladder,

so he will climb. See this pit? It's got water in it now, because people stopped using the wells and the water table has risen, but down there is a tunnel that leads to next door. The wire net? Oh, that's not to catch visitors. It's there because a cat fell in there once."

But there's something odd about this house, with its array of tricks and devices. I would never have known without the guidance of Toshinobu Watanabe, the lean, fit professorial type who was chairman of the Kōga Ninjutsu Study Group. There is something about ninja blood and ninja studies that keeps their ageing followers in terrific health and full of youthful enthusiasm. Toshinobu pointed out that the house dates from the Edo period, the late seventeenth century, after the heyday of the ninja. The owner of the house, Mochizuki Izumonkami, had another reason for building these defenses. His family had been in the area for centuries, and had become experts as medical practitioners. The eldest son of an eldest son, and the leader of Kōga's fifty-three top families, Mochizuki had inherited the business, and built the house as a place to make medicines, founding what would become the Omi Medical Company. In fact, until fifty years ago, the house was not called a ninja house at all; it was "the medical company's house." Hence some of its major features: the *kura*, the roofless kitchen, which allowed the smoke to rise into the loft, where plants were hung for curing. All his information was top secret. In modern terms, he was nervous about industrial espionage and for that reason adapted old ninja devices for his own purposes. And, though surely no single ninja house had so many tricks, each of them was indeed authentic.

The ninja house in Iga is similar, if you remember—a revolving door and pits here, retractable ladders and hidden weapons there. But this house was an amalgam, built in the early nineteenth century and then rebuilt on its present site, on a wooded hill near the center of town, in the 1990s, with

several of the secret devices being added even later. So, to the quiet satisfaction of today's Kōga Ninjutsu Study Group, the Iga designers came to Kōka to get ideas for their ninja house.

Both in their different ways lack authenticity. It doesn't really matter. The display cases and the houses themselves distill the reality of pre-1581 ninja life, which was mostly that of farmers anywhere. The peasants who learned to fight back against bandits in Akira Kurosawa's *Seven Samurai* were ninjas in the making.

But the ninjas were more than farmers who fought. Each was linked into his local community, and each community to its neighbor, making a network of self-defense forces determined to preserve themselves against one another, and then against a world of ambitious lords and marauding armies. What use were ninja skills and secret home defenses if your house was burned and your family captured, scattered, or killed? You needed somewhere to gather as a group for protection, where food and weapons could be assembled in safety. What you needed was a fort, or two, or three.

We're not talking castles, like the restored ones that stand today all over Japan, with bases of dressed stone and intricate wooden towers and tiled roofs. The local forts of Iga and Kōga were mostly banks of earth around yards, with an entrance, but nothing in the way of towers or stockades. Toshinobu Watanabe was my guide to this little-known subject, which reveals some intriguing details about the nature of ninja society. There are some five hundred valleys in Kōka, he said as we arrived at a reservoir flanked by a clump of trees. "In those days each valley had a village or two. We think there were two to three hundred samurai families, no one knows for sure, but we do know that there were fifty-three strong families. All these top families had at least one fort, and so did many of the other families. This is a typical one, under the trees over there."

He led the way into the forest, and up a slope kept clear of undergrowth to allow access to archaeologists and local schoolchildren. There, like the body of a giant under a blanket, were the contoured limbs of something the shape of which was impossible to make out. Mounds, ridges, dips, and flat areas made a complex of storage places and passageways and walls, all sprouting trees and disguised by a blanket of fallen leaves. Toshinobu tried to make sense of it for me.

Murasame, as the fort was called, had been a natural mound, rising above a valley, where a stream had run, now all drowned by the reservoir. Then, up the slope, the mound had been reshaped, with courtyards a few meters across being excavated and the soil being thrown up to make walls—"only earth walls, no roof, not even any wooden defenses on top of the walls. This was a place for the *bushi*—the warriors—to gather in case of attack. The women and children would have run away to hide." Here was an entrance, with a steep, curving approach; here a narrow passageway, like a large ditch— "we think this was where warriors could hide"—and here what might have been a storage area for weapons and food.

Then, as we walked northward along the outer wall, the one that rose out of the reservoir, the ground dropped to what could have been a moat, except that we were well above the valley floor. "No, this was a division between this fort and the next." Two forts, right next door to each other? Yes, "and they were both used at the same time." The second, Jizen, had probably been a secondary defense, so defenders could retreat from one to the other. This one was smaller, sixty meters across, with its own maze of entrance, courtyards, and enigmatic dips and bumps.

Later, from a high point over a motorway, the whole valley lay open. Toshinobu pointed to a clump of trees a kilometer away, then another. In fact, within this one small area there were no fewer than seven "castle mounds," none of

them more than a few hundred meters from its neighbor. The same pattern holds true for the whole of Kōga. Archaeologists have recorded 180 forts; and many more must have vanished, washed away, or been reclaimed by farmers.

"These places were not for long-term occupation," said Toshinobu. "One or two had wells, some had a little pond for water, but on the whole, they seem to have been built to be used for only a few days."

I wondered what this told us about Kōga's society. How many people were involved? How many ninjas per village? It matters, because on this basis it should be possible to calculate the numbers the province could muster to repel the great invasions that were to come in 1579–81. "It's very difficult to know. Before the unification of Japan in 1600, there was no clear ranking system separating samurai, farmers, craftsmen, and businessmen. A farmer was a part-time soldier, and in the evening he would become a craftsman, and sometimes he would travel to sell his produce."

But wait. Surely you could do a time-and-motion study, based on the size of the forts, and the weight of the soil? What would it have taken to make forts like this? Not all that much. An archaeological plan records some 750 meters of walls. Say the average height was 3 meters, the average width 2 meters. That makes about 6,750 tons of earth. A man can shift 4.5 tons a day,[1] working flat out. So these two forts could have been made in a month by 50 men, in two weeks with 100. I imagined farming communities of 500 or so cooperating to make and maintain two or three forts each, where the men, and perhaps their families, could take refuge in the event of an attack; which would come from no formidable army, but from small-scale forces of some warlord looking for easy

[1] Quantity surveyors assume that the average man can move 1 cubic meter of earth (1.5 tons) in 2.7 hours, or about 4.5 tons in 8 hours.

pickings. I started to do sums: 300 villages, 500 people each, total population 150,000, of which, say, 100 *bushi* per village: 30,000 warriors . . .

Well, perhaps. Toshinobu was skeptical. "What we do not know, and there is no way of knowing, is the proportion of *bushi* per village. All the men could have been part-time fighters, or they could have had a lot of servants. We are just now starting this sort of research."

Farmers with growing skills as ninjas needed more than fighting talents. As important was the acquisition of information by traveling widely without being noticed. To do this the ninjas would join "the wandering world," those who could travel without automatically raising the suspicion of officials. But to do so, the ninja had to fit in seamlessly as puppeteer, juggler, musician, storyteller, peddler—or, most commonly, as a pilgrim *yamabushi*. Nobody had a better reason to travel or was more sure of a good reception, because as a pilgrim, he was always on the move from temple to temple.

Just outside the Forty-Eight Waterfalls is a temple, the only one to be rebuilt of the eight that were burned when the ninjas were destroyed. It was in remarkably good shape: tilted eaves, intricately carved roof joists, and beamed walls standing on a wooden platform, with several small buildings and a little shrine from which En no Gyōja the founder of Shugendō and thus the temple's founding father, glared out of the shadows, the whites of his eyes and teeth startling against remarkably black skin. A square arch with its upturned crosspiece married this Buddhist temple to its predecessor, Shintoism. The priest appeared, clothed not in an elegant loose robe but in a Mickey Mouse T-shirt and shorts. He was in a hurry, couldn't speak for more than a minute or two, but then spoke for twenty, the gist of which was that all the eight temples were part of a Pilgrims' Way of eighty-eight temples, centers not only for

pilgrims but for travelers, monks, entertainers, vagabonds, all the chaotic elements that made up medieval life, everyone bringing news and rumors from foreign parts, all therefore part of the wild elements that Oda Nobunaga was keen to control. That was why he hated the Tendai sect. That was why he burned all the temples. Which, as I was to ˙discover later, was a somewhat simplified version of the truth. What better way for a ninja to discover what was happening in the wide world than by pretending to be or actually becoming a traveling *yamabushi*?

Or perhaps even a painter or a poet? Such men were free to travel where they wanted. They even say that one of Iga's most famous sons, the poet Bashō, was a ninja. Matsuo Bashō, as every Japanese child knows, was a master of the haiku, with its three-line, approximately 5-7-5-syllable structure, its subtle references to a season, and its enigmatic nature. (As Bashō put it: "Is there any good in saying everything?") He was born in what is now Iga Ueno, where there is a museum devoted to him, but he was always wandering, making his way mysteriously without any obvious means of support. "Who was paying him to travel around on his on his own in the guise of a simple peasant?" Noriko wondered. "How come he had so many connections? How come he could stay in nice places? He would stare and stare, then always wrote about something really obscure. People were suspicious. They said he must be hiding something. Perhaps he was paid by some lord to report everything he saw. That was why he was so well off without ever earning any money. That's why they say he must have been a ninja."

But he lived and died in the seventeenth century, when no one needed ninjas anymore, so I think it's fair to ask—

> Bashō the master
> of enigmatic haikus
> —a ninja or not?

By the mid-sixteenth century, the ninjas of Iga and Kōga found their services in demand across Japan. Thirty-seven areas are known to have employed ninjas from Iga and Kōga (as well as training their own). The following are typical examples of many incidents and raids employing mercenary ninjas from the heartland, untypical only in that they were well recorded, providing proof that the ninjas were working for hire, with no inherited loyalty to the lords involved.

In two raids[2] that took place in 1559 and 1561, roughly when Iga's leaders were updating their contract, ninjas operated both for and then against the same commander, scion of that famous family the Rokkaku, whose castle had been seized by the shogun, with ninja help, a century before (see p. 90).

In the first episode, the Rokkaku clan have been betrayed by a retainer with the name of Dodo, who had seized a castle about forty kilometers north of Kōga on the shore of Lake Biwa. Rokkaku Yoshikata, the head of the family, determined to seize it back, but after several days without success he sent for an Iga ninja, Tateoka Dōshun. Tateoka, much impressed by a diviner who predicted imminent success, arrived with a team of forty-four other ninjas from Iga and four from Kōga. Tateoka tricked an entry by stealing a lantern with Dodo's crest on it, copied it several times, and simply led his team through the gate pretending to be Dodo's men. Inside, his men set the castle on fire, Rokkaku attacked, and they won the day.

It happened that the Rokkaku clan were great rivals with their neighbor, Asai Nagamasa. The two families had feuded for three generations. Rokkaku Yoshikata had seized a castle, Futō, also on Lake Biwa, just ten kilometers north of the one retaken from Dodo. In 1561, Asai resolved to take it back. He hired two generals, who in their turn contracted three Iga

[2] Both summarized in Zoughari, *The Ninja* (p. 45–6), and Turnbull, *Ninja* (p. 38), based on Japanese sources.

ninjas to plan a night attack. According to the plan, when the castle was ablaze, the two conventional assaults would follow. It all went horribly wrong, as the senior general, Imai Kenroku, saw with dismay from his hilltop headquarters. There was no night attack from the ninjas, no blazing castle. But Imai ordered—or allowed—his troops to advance anyway. When he complained about the delay to the ninja commander, Wakasa no Kami, Wakasa sent a scathing reply: Why hadn't Imai waited for the signal, which was the castle on fire? Okay it wasn't on fire yet. The ninjas couldn't be expected to explain their every move. They were a law unto themselves, and "a samurai from north of Lake Biwa could not understand ninja tactics."

All was not lost. The thing to do now was for Imai to tell his troops to withdraw for an hour, allow time for the ninjas to attack and set the castle ablaze, and then Imai could order the conventional assault. If he didn't like it, the ninjas would pack up and go home. Imai agreed—but failed to brief his fellow general, Isono Tamba no Kami. As Imai's men withdrew, they came up against Isono's men, who assumed they were under attack. The result was a classic "friendly fire" incident. One of Isono's samurai, eager to be first into battle, charged Imai, who was facing his own men, presumably trying to restore order, and speared him in the back. Imai's force retaliated. Twenty men died before order was restored. Meanwhile, the ninjas had done their job (though no one recorded how). The castle was at last on fire. Isono, having regained control, refocused his men, followed through on the assault, and retook the castle, snatching victory from the jaws of what might have been a total disaster.

So it was that the Rokkakus regained a castle, thanks to the Iga and Kōga ninjas, then lost another, also thanks to ninjas from the same areas.

10

THE END OF THE OLD NINJAS

If the camp is the subject of a night attack or an infiltration by an enemy ninja, you should judge that it is the fault of your own men.

<div align="right">Ninja instructional poem</div>

IN THE MID-SIXTEENTH CENTURY, WHILE MUCH OF THE REST of Japan fought, the ninjas of Iga and Kōga were doing very well for themselves. But the longer they proved successful, the greater the challenge for any leader aiming to build a nation. What of the authority of the emperor and of his deputy the shogun if local ninja communes kept on asserting their independence? Nobunaga, fighting his way to national unity, could never tolerate them. One day, the storm would break.

The first hint of trouble came from Iga's neighbor to the east, from the province of Ise, the site of Japan's holiest shrines. So far, this part of Japan—Kōga, Iga, Ise—had escaped the violence unleashed by Oda Nobunaga's rise. In the words of Ueda Masaru, the old man who kept a dozen ninja suits of

armor in his attic: Iga, with its three hundred or so strong communities, "was like the eye of a typhoon, with winds raging all around the outside, and a still point in the center." That was about to change, because Ise was controlled by a certain Kitabatake Tomonori, a former governor who had built himself up as a warlord.

Ambitious to extend his mini-empire by taking Iga, he had commissioned a castle in the middle of Iga, on a hill called Maruyama. Such ambitions brought him to the attention of Oda Nobunaga. As part of his campaign to unify Japan, Oda seized two castles in Ise and sent his second son, Nobuo, to become the adopted son of Kitabatake. This was not an offer Kitabatake could refuse, but it was also in effect a takeover. When in 1576 Kitabatake died—murdered, so it was said—Oda Nobuo inherited Ise. Understandably, other Kitabatake family members objected, and revolted. Nobuo crushed the uprising, but the rebels fled into Iga, and appealed for help to one of Oda's greatest opponents, Mōri Motonari. To forestall him, Nobuo had to take Iga, so in early 1579 he ordered his troops into the castle at Maruyama, the one left empty and unfinished by his adoptive father. The local Iga commanders saw the danger and took preemptive action. They knew exactly what to do, because their ninja spies were acting as laborers in the castle. They "forced their way into Maruyama, and the keep, the towers, the palace and so on all went up in smoke. They demolished the gates and the walls until nothing remained in any direction" (today a memorial stands on the spot).[1]

When the survivors reported what had happened, Oda Nobuo was so appalled he wanted to attack immediately.

[1] This, like all the quotes in this chapter, is from Momochi Orinosuke, *Kōsei Iran-ki* (Ueno, 1897), translated by Turnbull, in his *Ninja* (mainly chapters 5–6), with thanks.

Some of his officials advised restraint, reminding him that "from ancient times the honor of the Iga warriors has delighted in a strong army. Because they are not imbued with ordinary motives, they take no notice of death, and are daredevils when they confront enemies. They neither experience failure, nor allow for it, which would be an eternal disgrace." But the survivors included Nobuo's humiliated commander, Takigawa Saburōhei, much to the dismay of the Iga men: "a mortifying situation," they said, "and a very sad affair." Takigawa insisted on instant action, and Nobuo backed him, with disastrous consequences.

Nobuo's three-pronged invasion, with some twelve thousand troops, came in mid-September through the three main passes of Iga's eastern mountains. Oda Nobuo led one column along the main east-west road between Iga Ueno and the coast. "Ten thousand banners fluttered in the autumn breeze, and the sun's rays were reflected off the colours of armour and *sashimono* [the banners attached to the soldiers' backs]." Having camped overnight, Nobuo's troops woke in fog, and pushed on through "the steep and gloomy valley" toward the village of Iseji, right into the arms of the waiting Iga warriors.

> They had established strong-points, and fired bows and guns, and taking swords and spears fought shoulder to shoulder. They cornered the enemy and cut them down at the entrance to the rocky valleys. The army of Nobuo were so preoccupied with the attack that they lost direction, and the Iga men, hidden in the western shadows on the mountain, overwhelmed them easily. Then it began to rain, and they could not see the road. The Iga warriors took the opportunity, and aware of the others lurking in the mountain, raised their war-cry. The band of provincial samurai, hearing the signal, quickly gathered from all sides and attacked. The Ise samurai were confused in the gloom and dispersed in all directions. They ran

and were cut down in the secluded valley or on the steep rocks. They chased them into the muddy rice fields and surrounded them. . . . The enemy army collapsed. Some killed each other by mistake. Others committed suicide. It is not known how many thousands were killed.

Nobuo's second column, coming through a pass to the south, met the same fate, with one special prize. Riding with the column was the general who had supposedly murdered Kitabatake Tomonori. In the late afternoon he was surrounded by several hundred soldiers and stabbed to death, the victorious Iga men withdrawing into a misty, moonlit night. The third column, too, was ambushed, cut off, and destroyed— in Turnbull's words, "the end of one of the most dramatic triumphs of unconventional warfare over traditional samurai tactics in the whole of Japanese history."

An end, but also the beginning of something far more destructive for Iga, Kōga, and their ninja fighters.

Twice bitten, twice humiliated. Two years later, Oda Nobuo was embarrassed a third time, by his own father. "It was a mistake to go to the boundaries of Iga, and an extreme one," he said, as terrible as it would be if the sun and moon were to fall to earth. It was unpardonable that Nobuo should have allowed a general to be killed. Obviously, wrote Nobunaga, as if trying to find some mitigating circumstance, Nobuo's "youthful vigour" had led him astray. His error had been not to use ninjas, he went on, urging his son to go back to basics. Remember Sun Zi! "To break into an enemy's province which is skilfully defended inside and out a strategy should be devised in a secret meeting place. It is essential to get to know the weak points in the enemy's rear. When war is established, get *shinobi* [ninjas] or treacherous samurai prepared. This one action alone will gain you a victory."

He knew what he was talking about. Two "treacherous samurai" from northeast Iga had just presented themselves to him, offering to act as guides should Nobunaga decide on a revenge attack. They suggested a main assault through Kōga, because the mountains there were less formidable than elsewhere. Nobunaga's headquarters would be his own castle, Azuchi, on the eastern side of Lake Biwa—a glorious seven-story structure with the top two floors inside a unique octagonal tower (nothing remains of it now except a stone base; it was burned in 1582). It lay just thirty kilometers from Iga's border. He did not intend to repeat his son's mistakes; he would lead the assault from the north, but there would be five other columns driving into Iga from the north, east, and west, avoiding only the impenetrable southern mountains—impenetrable to him, but not so to the ninjas of Iga. And his invasion would muster not 12,000 men but 44,300, almost four times the force led so disastrously by his son. As it happened, when the campaign opened in August 1581, he was struck by some sickness. Sweaty and dizzy, he pulled back to Azuchi to recover.

A month later he was fit enough to rail against Iga's democratic ways, in words that sum up precisely why Iga's culture had been so successful, and (it seems now, with the advantage of hindsight) so charming:

> The Iga rebels grow daily more extravagant and presumptuous, exhausting our patience. They make no distinction between high and low, rich and poor, all of whom are part of carrying out this outrageous business. Such behaviour is a mystery to me, for they go so far as to make light of rank, and have no respect for high ranking officials. They practise disobedience, and dishonour both my name and ancient Court and military practices. Because they have rebelled against the government, we find them guilty, and will punish the various families. So

let us hurriedly depart for Iga, and bring the punishment to bear.

Iga. This is all to do with Iga. It was Iga that was the focus of Nobuo's ire, Iga that he attacked, Iga that became Oda Nobunaga's target. Why not Kōga, which was equally egalitarian, equally without respect for high-ranking officials? Lacking any documentary answer to the question, I put it to the half dozen local historians who formed the Kōga Ninjutsu Study Group.

It was clear from Oda's words that there was more to his ruthlessness than a mere desire to avenge the humiliation dealt to his son and the death of a general. Iga's whole way of life was an affront and a challenge. As a future unifier of his nation, he would never tolerate people who refused to allow for large-scale landowners and insisted on the right to govern themselves. That's what they believe in Iga, as I understood it: It was because they were a democracy that he didn't like them. On top of that, they were followers of Tendai Buddhism, and Oda was pro-Christian, so he hated them.

"It's a big lie!" That was the gently spoken Toshinobu, in surprisingly forceful English. He had a rich but long-dormant academic knowledge of the language, which ventured out of hibernation when he wanted to make a point. He hesitated, opted for speed, and went on in Japanese: "There are more Tendai shrines in Kōga than in Iga, so it was nothing to do with being Tendai. And actually, Oda didn't hate democracy. The reason he attacked Iga and did not attack Kōga was that Kōga decided to work with him."

What happened was this. The head of the Saji family, one of Kōga's fifty-three top families, contacted Oda and said he didn't know about the others, but he for one was willing to work with him. That planted the idea of cooperation. So when the others came to discuss it, there was a precedent.

"But why did he do that in the first place?" I asked.

"Because when Nobuo attacked Iga in 1579, Iga unfortunately won, so they thought they would win again. They did not see the real power of Oda's troops. Nobuo also attacked Kōga, and Kōga lost. Saji could see the future; he could see how powerful the enemy was. So when Oda asked if we would cooperate, we said yes. We also had the idea of not wasting our lives in the face of overwhelming odds."

Which was, of course, an idea fundamental to ninjas: survival, rather than samurai-style self-sacrifice.

"So you were better ninjas than Iga!" I said, to guffaws of laughter. Iga and Kōga may have shared similar systems, and collaborated to solve common problems, and intermarried, but here was a hint of friendly rivalry.

It wasn't quite as clear-cut as that, because the two groups had been so close in the past. There were some who refused to collaborate with Nobunaga and joined Iga instead.

An inhabitant of Kōga, Mochizuki Chotarō, was a soldier big and strong, and a hot-blooded warrior. He had a large *tachi* [a long, curved sword], which he brandished crosswise as he fought. One person . . . advanced to meet Chotarō to cross swords with him. Chotarō accepted the challenge, and advanced to kill him. He [Chotarō] parried the swordstroke, and then suddenly struck at him and broke both his legs. He [Chotarō] killed him without hesitation. He was a splendid master of the Way of the Sword, the model and example of all the samurai in the province.

But one or two Kōga men fighting for Iga does not undermine the main point, on which Toshinobu and his fellow historians agreed. Oda Nobunaga's attitude toward Iga "was completely different than toward Kōga"—with consequences that almost stopped Oda's revolution in its tracks, as we shall see.

*

Meanwhile, Iga bore the brunt of Nobunaga's anger. This time, there would be no mistakes, and no mercy. Nobuo, given a chance to avenge the disaster of two years before, commanded a ten-thousand-strong column that entered Iga along the same route as before, down the Aoyama (Blue or Green[2] Mountain) River, except now his force was three times the size. He reached the village of Iseji unmolested, and "burned people's houses to the ground." A few kilometers to the north, where Nobuo's army had been slaughtered two years before, they burned a monastery, a "sad and sacred place . . . when the smoke died down, inside and outside were dyed with blood. The corpses of priests and laymen were piled high in the courtyard or lay scattered like strange autumn leaves lying deep of a morning." Farther on down the valley, three warriors "put to the sword their ten children and their wives, and set off with light hearts to be killed in action, knowing that their wives and children would have been captured alive and carried off."

The Iga defenders, meanwhile, saw they had no chance of repeating their success of two years before. They had gathered their forces in the middle of Ueno village (what is now Iga Ueno) and eight kilometers to the south, near Maruyama. Unable to oppose such overwhelming odds, they scattered into the earthen forts that served as defenses in every village.

The campaign was all over very fast, in either two weeks or a month—sources vary. The end came in two places. The first was a castle on Hijayama, a hill that was part of a long tree-covered ridge a few kilometers west of today's Iga Ueno, beyond the rice fields that once formed the floodplain of the

[2] Oddly for English-speakers, both Chinese and Japanese *kanji* use the same sign 青 for "blue" and "green" (Chinese: *qīng*, Japanese: *sei* in Sino-Japanese, *ao* in Japanese). In the Inner Mongolian capital, Hohhot (from Kōkh-Khot, Mongolian for "Blue City"), Chinese sometimes insist that the name means "Green City."

Nabari River. Noriko and I took a cab there one morning to check if there was anything worth seeing. The place is not well known nowadays. The cabdriver had never heard of it. But a priest in long-sleeved white shirt and gray trousers pointed us toward a temple named Sai-ren (West Lotus), the lotus being of great significance in Buddhism. Nearby, two grim Buddhist statues guarded a flight of steps against demons. At the top was an imposing, well-kept building, with an astonishingly large cemetery—a dozen platforms, making several hectares, with thousands of graves. But why here? Another priest, almost catatonic with age and deafness, responded at last to Noriko's shouted questions: Yes, the hill behind the cemetery was Hijayama, and this was where the fort had been. A pillar confirmed it, commemorating the four hundredth anniversary of the campaign known as Iga no Ran (the Iga Revolt).

The Iga defenders put up a terrific fight, some defending the fort, others setting up an ambush below it, allowing Nobunaga's forces to advance uphill, then attacking from behind earthworks with swords and guns, and throwing rocks and branches. For a while, it worked. As the garrison recorded, "today the reputation of our army binds us all together in joy when we consider the bravery of our soldiers." The bravest of the brave were nominated as the Seven Spears of Hijayama, and a decision was made for a night attack that would end in the taking of the general's head, "which will be amazing to the eyes of the enemy and will add to the glory of the province."

Early on October 1, as the attack opened, Nobunaga's forces "raised an uproar like a kettle coming to the boil, and, as might be expected, in the army many otherwise experienced and brave soldiers had no time to put their armour on and tied it round their waists. They grabbed swords and spears, went down in haste and stood there to fight desperately." Then all became chaos, because "an intense mountain wind quickly

extinguished many of the pine torches, and friend and foe alike went astray in the dark paths. They could not distinguish between friend and foe in the direction of their arrows, so the samurai of the province [i.e., the Iga warriors] made their way by using passwords, while the enemy furiously killed each other by mistake."

It was no use. With thirty thousand ranged against them, the Iga men retreated into Hijayama. "On top of the mountain there was silence. They did not give a war-cry. More and more their colour faded. The tide of war was moving to the enemy samurai. They took great rocks and large trees carefully, and waited for an attack. . . . Each man who remained had the appearance of a wooden Buddha." In the end, the weather was against them. It was dry, with a strong wind, which favored fire. Nobunaga's men set fire to local temples, which spread to the whole complex. "The flames blazed and were seen in the sky like an omen. The inferno eventually died out, but it was many months before the black ashes disappeared."

The last stand came in the south, where the ninjas had their backs to the wall of mountains from which flowed the old Shugendō training ground of the Forty-Eight Waterfalls. A few kilometers north of here stood Kashihara[3] Castle, which today is, like so many old forts, a tree-covered mound. Once, it was the center of a little community: castle, lord's house, Shinto shrine. There's still an active shrine, built and rebuilt over centuries to honor the souls of those who lived and died here. Today's version, with its simple gray-tiled roof and a porch, looks more like a house than a temple.

"A *shrine*," Noriko corrected me. "A Shinto *shrine*. Buddhism has *temples*."

"Okay. What's Shinto about it?"

[3] Also spelled Kashiwara, even Kashiwahara. Confusingly, there is another Kashihara 15 kilometers to the west.

A traditional image of the lithe, black-coated ninja
published by the great Hokusai in 1817. This featured in
a series of martial arts drawings, part of the thousands
of naturalistic, three-color prints that form the fifteen-
volume Hokusai Manga (Hokusai's Sketches).

SHUGENDŌ: TRAINING FOR PURITY

The ninjas often undertook training to hone minds as well as bodies. They shared the training with the adepts of Shugendō (*yamabushi*, mountain ascetics), who isolated themselves in mountains to follow tough regimens of purification. Today's Shugendō rituals, combining elements of Shintoism, shamanism, and Buddhism, recall the ancient beliefs to which ninjas were exposed.

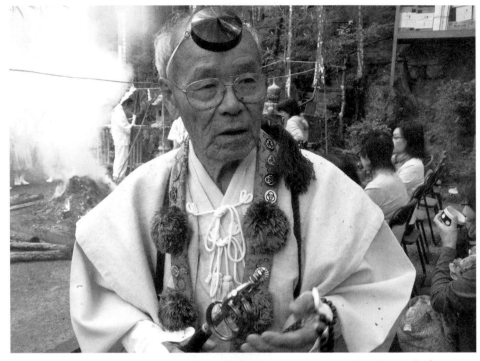

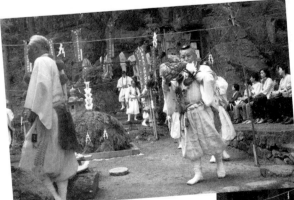

Above: *In this Shugendō fire-ceremony on Mount Iwao, the leading priest wears ancient regalia—little black hat, riband, and staff.*

Left: *The conch, used to summon good deities and banish bad ones, is the shell of a giant sea snail. When the end is cut off, it can be blown like a bugle, either with or without a mouthpiece.*

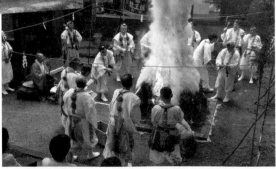

Right: *The bonfire of cedar branches is to honor the local dragon god and burn prayers for health and good luck.*

Iga and Kōga: Land of Hills and Forests

The ninja heartland of Iga and Kōga (centered on today's Iga Ueno in Mie Prefecture and Kōka in Shiga Prefecture) are set apart by forested mountains, yet well positioned close to Japan's old capital, Kyoto, and right on the Tōkaidō, the main coastal road to Tokyo. Ninja skills derived from a sturdy independence, which kept both regions free of warlords.

Left: *This ancient lantern marked a pass on the Tōkaidō, where it breasted the Suzuka Hills between old Kōga and Iga.*

Right: *Looking north over what used to be Kōga, from the hills dividing Iga and Kōka.*

Left: *Created by famed Japanese artist Utagawa Hiroshige in 1861, this work, entitled Iga kaitosan, depicts Mount Kaito in Iga Province, and is taken from the series Shokoku meisho hyakkei: 100 famous views of Japan.*

IN SEARCH OF NINJA FORTS

One little-known feature of the ninja heartland is the simple earthwork forts built by samurai and farmer landholders into which they would flee for a few days until danger passed. There were dozens, perhaps hundreds of them—no one knows, because so many of them have eroded back into the earth. A few sites are now known to archaeologists, but most are tree-covered.

Above: *From afar, this double fort (Murasame-Jizen), five kilometers south of Kōka, seems to be no more than a copse on a hillock.*

Above: *Toshinobu Watanabe enacts a defense, standing on a worn and overgrown wall.*

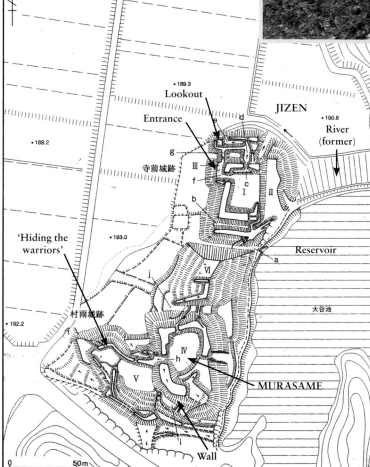

Left: *A detailed plan shows how the two forts were built—but no one yet knows how the different areas were used.*

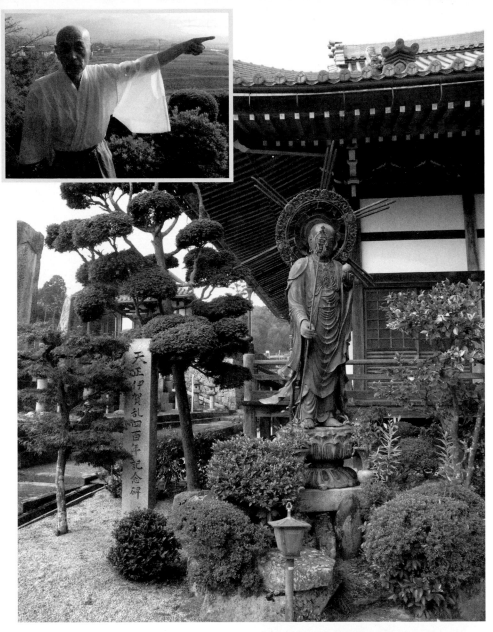

One fort, Hijayama, was the site of one of the final battles in which the ninjas were defeated by Oda Nobunaga. It's hard to find. A monk pointed the way (above left), *but the site itself is covered by a temple* (above), *which is approached by steps* (right).

OF ARMS AND ARMOR

Besides swords, the ninja armory consisted mainly of farming tools. But ninjas were not merely farmers. Many were samurai, and adapted samurai fighting traditions. Since ninjas operated in secrecy, they could not wear exotic samurai armor. If they had armor at all, it was chain mail, which could be worn beneath clothing. Many suits of ninja armor exist in museums, and some are still held privately.

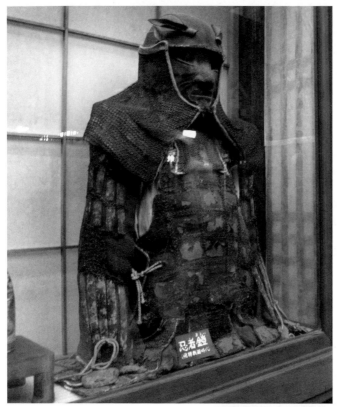

A piece of privately held ninja armor, displayed in the ninja museum in Takayama.

Dark chain-mail armor, ideal for nighttime operations. These pieces are owned by Ueda Masaru, who inherited them from his grandmother. In addition to collecting, Ueda runs a restaurant by the Forty-Eight Water-falls, an ancient training ground for both Shugendō students and ninjas.

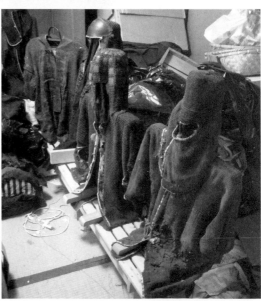

Above left: *The fearsome* tekko-kagi *(hand-armor hook) was supposedly attached to the hand as an extreme form of knuckle-duster.*

Above right: *The sickle-and-chain* (kusarigama) *derived from a farming tool. You disable or ensnare your opponent with the weighted chain, then kill him with the blade (or in the case of this one in the Iga Ueno ninja museum, with the double blade).*

Below: *In Kōka's ninja museum, Hukui Minogu displays two throwing stars* (shuriken).

Caltrops, scattered to wound the feet of pursuers, were usually made of iron—but they might also be natural: those at the back are water chestnut seeds, which are iron-hard when dried.

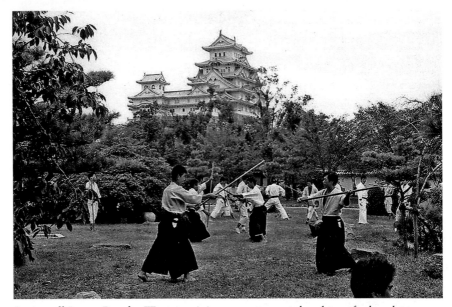

Some call James Bond a Western ninja: a secret agent, loyal to a fault, adept with specialist weaponry, master of unarmed combat, the ultimate survivor. So it's fitting that Bond (or rather his on-screen persona, Sean Connery) gave ninjas their first big—if inaccurate—PR boost in Europe and the US, in You Only Live Twice *(1967).*

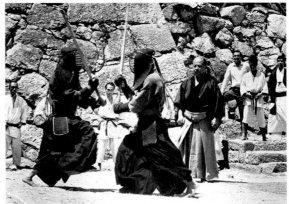

As these on-set shots show, the film's "ninjas" were martial art extras. They were armed with swords and staffs (above), wore protective clothing (right), and in the climax—the invasion of the villain's mountain lair—operated as a team of commandos (below) ready to die rather than individuals dedicated to survival.

"The stone columns."

On the porch were two little towers of flat stones, half a dozen stone memorials, two stone lanterns, and two vases of fresh flowers, this was a well-kept working shrine. Working in more ways than one. Inside was a room of historical memorabilia, where I knelt shoeless and with painful kneejoints while the mayor, Tomimori Kazuya, explained Kashihara's significance as the place where the Iga Revolt was finally crushed.

The local hero is the lord at the time of the revolt, Takino Jurobei. Tomimori led the way out of the shrine, uphill toward the castle mound, along a path edged by an electric fence between two rice fields. In one, a man wearing remarkably thick clothing—boots, jacket, hat with earflaps—was cutting rice flattened by the recent typhoon. "Be careful of the fence," said Tomimori. "It's live, to keep the animals out."

We reached the edge of the castle mound and its thick covering of trees. Behind the site was a proper hill, the Dragon God Mountain. Why not build up there? I wondered. No, that was too far and too high. The mound in front of us was perfect: raised above the valley floor, with a good view, and protected on the other side by the mountain. But of the castle there was nothing visible beneath the covering of trees. Could we explore further? Well, as long as we remembered it was the time for the *mamushi*, the pit viper, to lay its eggs. Tomimori led the way over a ditch along a path at the base of a steep bank, while to our left the ground fell away. A wall, no doubt, and perhaps the remains of a moat. It was all earth now, rich with spiders and, for all I knew, *mamushi*. Was it earth back then? Yes, all earth, said Tomimori. No stones, no solid foundations, no roofs.

That made sense of the story Tomimori told about Lord Takino and the castle beside which we were now wandering, brushing away spiders' webs, scuffing through fallen leaves, wary of *mamushi*. Surrounded by Nobunaga's forces, Takino

was besieged, along with his three top officers, Momochi Sandayu, Hattori Hanzō, and Nagato no Kami. (Of Nagato, little is known, but the other two are famous. Momochi had a house nearby, which still exists, along with his descendants; and Hattori, whose house and castle were a few kilometers west of Iga, was soon to become the staunchest ally of Nobunaga's heir.)

After a few days, Takino used a tactic first tried by the great fourteenth-century general Kusunoki Masashige. One dark night, when clouds hid the moon and stars, he ordered women and children to join the men in lighting two or three torches each. "It gave the impression there were more than a thousand in here, but the clouds disappeared, and the moon came out, and Nobunaga's troops could clearly see just how many were holding the torches. Then, as conditions got worse and food low, he had his people use grinding stones to give the impression they had more than enough food."

Meanwhile, Takino found other ways to fight back, as a contemporary source describes.

From the skilled men of Iga, twenty men who had mastered *shinobi no jutsu* [the art of being a *shinobi*, or ninja] set fire to various places outside the castle and reconnoitred among the smouldering camp fires. Night after night they made frequent excursions in secret, and made night raids on the camps of all the generals and set fire to them using various tactics. . . . Over a hundred men were killed, and because of this the enemy were placed in fear and trembling. Their alertness decreased because they could not rest at all.

It was no use. There was no way to win. Takino surrendered the fort and fled with his officers and half those in the castle. Then came the destruction, though there was nothing much to destroy in the fort. Its earthen ramparts were aban-

doned and soon overgrown. Many were killed. How many? Some sources say between three hundred and five hundred, which would indeed be half of the original one thousand. "We cannot tell," said Tomimori. "But there's a story that in this area of the village, people here used to make a particular sort of sweet using bamboo leaves, which are very sharp and often cut your fingers when you work with them. After Takino fled, the people stopped making the sweet, because they had seen so much blood. That's what they say. So from this story, I guess there was some sort of a massacre, even though the castle was surrendered peacefully." One thing is certain. There used to be eight temples around here, and all were burned, because the temples—with their tide of monks, and travelers, and entertainers—were centers for the flow of information from all over the country and so were at the heart of the opposition to Nobunaga's rule.

Now, of course, archaeologists were interested. But—Tomimori explained—the hill was owned by several families, and no one could agree on cutting the trees and opening it up for research. But surely it would be worth it for the tourists? There were no tourists, he said. That was a surprise, for did not everyone agree that this was where the ninjas made their last stand? Wasn't that why the local authority had placed a monument here, commemorating the four hundredth anniversary of the Iga Revolt? One day, perhaps. And then, surely, there would be a big change: Takino's fort stripped of its trees, its walls and gateway revealed, the escape path made clear, a signposted walk in place directing curious crowds to the route taken by Takino, Hattori Hanzō, and their surviving ninjas.

Their escape route led south, following today's narrow road above the fast-flowing Taki Gawa (Waterfall River), the steep valley of the Forty-Eight Waterfalls where for centuries Shugendō students and ninjas had put themselves through their

arduous physical and mental courses. So they knew exactly what to do. Pursued by Nobunaga's troops, they followed the river up to the fourth waterfall. Here, where the water from above falls into a cliff-lined pool, the old trail ended. In fine weather, it is a gorgeous spot, with the thirty-meter cliffs topped by trees and the white water roaring into a pool, which, when I was there, was not translucent but a soft emerald green, the color of minerals and algae stripped from the mountain by the recent typhoon. No way up the river, then. But up the other side of the ravine, cutting through the trees, rose a near-vertical wall of boulders, which in downpours turned into a torrent of water and loosened rocks. It still does today. This was the unstable route *shugenja* and ninjas took to reach the upper falls, where they could find themselves yet greater challenges. So this was the way by which the fugitives vanished.

And also the route that the pursuers either did not know or would not take. Anyway, it was getting dark. The light, almost blocked by the overarching canopy, faded into a sunset glow. Perhaps they had also heard of the local species of salamander, which haunts the pools and backwaters, and can grow up to two meters long. So they invented, or were given, a good reason to retreat. Perhaps it was the red sky and the name of the falls—Akame (Red Eye), after the red-eyed cow seen by En when he first came—that suggested a nightmare vision. Suddenly—you can almost hear them heightening the fear in their voices as they report back to their senior officer—everything got really red and a huge snake appeared, and that was why they could not continue the chase. And that is why today the recently built path upward, with steps and a wooden bridge climbing over the cliffs and tumbling water, is called Holy Snake Pass.

The fugitives got away safely and ended up in Ieyasu's territory the other side of Nagoya, 130 kilometers to the east.

There, perhaps because they were no longer a threat, they were well received and allowed to return home—a generous gesture by Ieyasu that would have interesting consequences.

Defeat brought a sudden end to the old ways of Iga and also an end to the commune system. Iga city was given to a lord named Tōdō Takatora, who had rendered good service during the invasion. He built a fine castle on top of the hill, which still dominates the town today. On a tidal wave of well-shaped stone, a place of overlapping gray roofs and glorious beams overlooks a large open space where, during festivals, schoolchildren practice their archery. It is, as Ieyasu himself said, a treasure. It is a focal point, a symbol of power, where there had been neither before, and a clear statement that the old days were over for good.

But the memories live on, and so do many of the families. By chance, I came across descendants of two of the families, Takino and Momochi.

Takino survived, not to fight another day but to negotiate a truce, settle back into farming, marry, and produce many children. So, said Tomimori as we left the woods that covered Takino's earthworks, that's why many people living in the village today are called Takino. "You see the man who is cutting the rice over there? He's a Takino." He looked up and called, "Takino! This man has come from England to see your ancestor's fort!"

It was in the little village of Akame, where tourists enter the path leading up the Forty-Eight Waterfalls, that the cheerful old restaurant owner, Ueda Masaru, led me into his attic and showed me the suits of ninja armor inherited from his grandmother. And his grandmother, remember, had been a Momochi, a descendant of the Momochi Sandayu who had escaped from Takino's fort when it was surrendered to Oda Nobunaga.

Names, shrines, temples, memorials—all recalled what happened here in the autumn of 1581. There is at least one enclave where life seems remarkably unchanged. A winding road led uphill through woodland and down into a secluded valley, where, among a patchwork of terraced rice fields and up a driveway, stood the house of my dreams, should I ever dream of living in Japan. A curly-tiled porch with heavy wooden doors led to a Zen-style courtyard: a little pond, fringed with sun-dappled, autumnal bushes, gravel, and rocks, on one of which lay a contemplative black cat. The house with its two wings held the garden as a setting holds a jewel. It was a jewel itself—all dark wood and blue-gray tiles, perfect in its plainness.

As with other works of art, its simple beauty was maintained by hard work, at the hands of the man who now appeared from a garage beside the driveway, dressed in dusty T-shirt, jeans, and muddy boots. He had one of the most strikingly beautiful—there's no other word—faces I had seen in any man, let alone one in his fifties. This was Momochi Mikyo, another descendant of Momochi Sandayu.[4] The Momochi family had owned this house then and still own it now. One of the larger stones in the garden recorded the link, and added: THIS WAS PUT UP IN MEMORY OF THE 350TH ANNIVERSARY OF THE IGA REVOLT, in 1931. Momochi had the self-contained dignity that you often find in long-established families. They know who they are, they know where they belong, and they work to preserve their house, their family, their inheritance. Momochi was a gardener by profession. His garage was crammed with bits of machinery, the driveway littered with tires, boxes, bins,

[4] Zoughari says that the name Sandayu does not appear in the Momochi genealogies, "which leads one to suppose he is a fictitious character." Momochi Mikyo's account leads one to suppose the opposite. Zoughari suggests that, if he was not fictitious, Sandayu was so good at the art of invisibility that he managed to hide evidence of his existence. See Zoughari, *The Ninja* (pp. 84–5).

a wheelbarrow, an old bathtub. It was lucky he happened to be in, and lucky that Noriko had called ahead to explain my interest. He stopped work and talked.

"Yes, the house was built before the Iga Revolt. Well, the tiles and the outer walls have been replaced, but the inside is as it was." Its survival was remarkable, considering this was an earthquake-prone area, but the structure clearly helped. "It was built in the old-fashioned way, without nails," he said, which allowed it to flex. Tiles may fall, but the heart remains firm.

I asked: "Did your family tell you many stories of the Iga Revolt?"

"Oh, many."

"So what happened when the castle surrendered?"

"We don't know exactly. There is no documentary evidence. But Momochi Sandayu was definitely in there with Lord Takino when they negotiated an end to the siege with Oda Nobunaga. They say he killed three hundred people a day." (Or was it perhaps just one day, which would fit the numbers better?) "Sandayu must have got away, because I'm here, the nineteenth generation from him. They both survived, even though the two of them had been part of the force that had defeated his son seven years earlier."

The two families remained close. Indeed, as Momochi said, all the old families married together. "My mother," he said, nodding at an ancient, stooped figure walking with some difficulty across the courtyard, "she is a Takino."

The ninja past is not just present in the tree-covered mounds of the old forts, the shrines and temples, and the names. It's in the genes.

11

NOBUNAGA'S END,
IEYASU'S RISE

If lightning is behind you, it is auspicious; if it is ahead of you, be careful.

Ninja instructional poem

NOBUNAGA WAS GOING FROM STRENGTH TO STRENGTH. IN April 1582, with imperial backing, he mounted a great victory cavalcade in Kyoto: 130,000 men in full dress marching and riding past an imperial grandstand for hours, with Nobunaga taking care to "show off and enhance his status" in mid-parade—as the Jesuit priest Luís Fróis wrote—by getting off his horse and climbing into a crimson velvet sedan ornamented with gold, a gift from the Jesuits. "Never had there been an event where all were such excellent horsemen and were dressed so splendidly," wrote a Japanese eyewitness. "The crowd of onlookers, whether high or low, would remember in what glorious times they had been born for the rest of their lives." The emperor was delighted. A month later he decided to offer Nobunaga the position of shogun. But

Nobunaga was focusing on yet another campaign in western Honshū. The shogunate could wait.

At this moment, one of his generals, Akechi Mitsuhide, made the decision to turn on his master. No one knows why for certain, though there is a story about Nobunaga abusing Akechi over some meat and fish that, he said, had gone bad. Or perhaps Akechi was simply ambitious for power. Whether he was acting out of revenge or ambition, now was the moment, because Nobunaga had dealt with most of the opposition. On June 19, Nobunaga lodged in the Honnō-ji, a temple in Kyoto, on his way westward. Akechi, staying in a nearby castle, led his thirteen thousand troops to the Honnō-ji, ostensibly, he said, to be inspected by Nobunaga before joining him on campaign. Only his close accomplices knew the real purpose.

In the Honnō-ji, troops armed with arquebuses surrounded Nobunaga's quarters. The opening rounds told him all was lost. "Treason!" he shouted. "Who is the traitor?" His aide told him. Nobunaga grabbed a bow, then a spear, and fought his attackers, until, with the building burning around him and wounded in an arm by an arquebus ball, he retreated into a back room and committed suicide, making sure his body would be consumed by fire.

There followed eleven days of chaos—Nobunaga's heir, Nobutada, also dead by *seppuku*, his third son deserted by his troops, a cousin killed as a suspected traitor—until Nobunaga's senior ally, Hideyoshi, defeated Akechi, took his head, and presented it in the burned-out ruins of the Honnō-ji. He confirmed his status by staging a grand funeral for his lord, and then crushed opposition from within Nobunaga's family. By mid-1584, Toyotomi Hideyoshi, Japan's future unifier, was master of central Japan, and in an uneasy truce with his main rival, Ieyasu, who would seize the nation for his own dynasty and secure its enduring unity.

*

But how come Ieyasu, Nobunaga's other staunch ally, had escaped? He had been in Sakai, just south of Ōsaka and only some 45 kilometers from Kyoto, at the time of Nobunaga's murder. A messenger arrived with the dire news. Appalled, Ieyasu said his duty was to avenge his lord, but with such a small force that was impossible. The only other course was an honorable suicide in Kyoto. He was under way with several advisers when one of them suggested that Ieyasu would serve his dead master better by returning to his base in Mikawa (today's Aichi Prefecture), 150 kilometers to the east, and there raise a force with which to avenge the shogun's murder. But how to get home across Iga without being intercepted by Akechi's men or set upon by bandits or murdered by ninjas eager to avenge their defeat? A retainer named Hasegawa said he would get him through, because he had been a guide to Oda Nobunaga in the Iga Revolt. They set out (in the vivid if unsourced words of A. L. Sadler, Ieyasu's biographer), with one guard "brandishing his halberd 'Dragon-fly Cutter' in the faces of the rustics with a view to eliciting reliable information about the route," and another "distributing money with the same purpose." After 40 kilometers, at the Kizu River, there was no ferry, but they commandeered two brushwood boats, which one of the guards sank after crossing the river by punching holes in them with his halberd. On then for 25 kilometers of "mountain roads and precipices . . . infested by mountain bandits" to Shigaraki, the small town famed for being briefly the capital back in the eighth century, and later for its pottery. This brought them to the borders of Kōga and Iga, where one of Iga's top men, Hattori Hanzō, heard of their predicament and came to help.

Hattori, second in a line of famous samurai, had made his name as a warrior in his mid-teens and helped Oda Nobunaga to victory in the hard-fought battle of Anegawa in 1570, ac-

quiring the nickname "Devil Hanzō." Then, as a resident of Iga, he had found himself fighting against his onetime lord in the Iga Revolt. He was one of those who, after Iga's defeat, had fled over the Forty-Eight Waterfalls, taken refuge in Ieyasu's territory, and been well treated, an act of generosity that turned out well for everyone. Possibly by this time Devil Hanzō was back at his home just west of Iga, which, given his fame, I thought would be a prime tourist site. So I took a taxi with Noriko and went in search of it.

There was nothing prime about it. A few kilometers outside Iga, a winding lane and a narrow alleyway led past a huddle of houses to a flight of cement stairs. At the top, steps roughly cut into the slippery earth gave onto a glade about fifty meters across. A sign said that here were the remains of Hattori's castle, Chigachi. But there were no remains. Other castle mounds are contoured with walls and ditches and entrances. This was entirely flat. Perhaps it had been a house, not a castle. A scattering of bushes made it a pretty spot for a picnic, except that no one had been there for months and spiders had taken possession. Noriko did not like the webs, but she was no arachnophobe. "This spider," she said, peering at a yellow-legged beauty, "is *jorigama*, a prostitute spider, so-called because she eats the male as well as the flies." Several engraved stelae, standing about like tombstones, commemorated the significance of the place: THIS IS THE BIRTHPLACE OF HATTORI HANZŌ, claimed one, BUT HE LEFT HERE WHEN HE WAS 18 TO WORK FOR TOKUGAWA IEYASU. Another prayed for peace for the souls of those who died in the Iga Revolt.

It was strange. Trees had been cleared, the memorials set up, yet who ever came here to disturb the spiders? The taxi was waiting, but the question was worth a few minutes more. Back down below, we braved a barking dog and exchanged bows with its owner, and of course cards. Tsukii Katsuya, a lean, sharp-featured fifty-something with laughing eyes, was a

potter, and a master of his craft, specializing in the local ware. Inside, beside his kiln, he showed me a rectangular vase to explain the subtleties of Iga-style pottery: the deliberately coarse texture, the way the black merged into charcoal and then a soft yellow, a technique that he called "rained on." I remembered something I had been told a few days before: The great English potter Bernard Leach came to Iga once. He loved the ware for its colors, its roughness, its simplicity. Apparently there were examples in his studio in St. Ives. I had never been. I promised myself I would go, if and when I was better prepared. There was a chance here to be inducted into the mysteries of great art—perhaps, who knew, to acquire a . . .

No. This was foolishness. I didn't have the time to go off on such tangents. I explained my interest in Hattori Hanzō. Were there many visitors here, Japanese, locals perhaps, keen to reconnect with their history? "Maybe one or two a week. Of whom," he added, "twenty percent are foreign." How did he know? Did he talk to them all? And what did this statistic mean? But the taxi was waiting, and we were out of time.

If Hattori was at Chigachi as Ieyasu approached Iga, he would have been only some fourteen kilometers from Ieyasu's party, a day's ride north over the hilltop where Iga and Kōga families used to meet to sort out their problems. Now, under Hattori's direction, two hundred to three hundred men from Tsuge, a village on Iga's northern border, and another hundred from Kōga came to Ieyasu's aid.

Which route to take? This was going to be tricky. There was, of course, a well-established road, of sorts, leading eastward—the Tōkaidō. But it was crowded with people from far and wide, some of whom would surely be on the lookout for Nobunaga's successor, while others would be quick to oppose Hattori and take revenge on an ally of Nobunaga who had been with him during the conquest of Iga.

The answer, probably, was to head for the hills, back the way Hattori had (perhaps) just come. The route is still there today. Shigaraki, with its arrays of ceramic figures crowding the front of shops, drops away behind you. The road winds up through forested hills. Back then, of course, it would have been nothing but a one-horse track, leveling out at the top with a view through the trees down to the flatlands of Iga. Today, it is no more than a pretty little road leading past an upmarket country club, but it has a claim to historical significance because it was on this crest, Otoge, that the leading families of both sides, twelve from Iga and ten from Kōga, used to meet. Besides, of the half dozen roads between the two, this is the smallest and most tortuous. Local officials are in no doubt, as a newish wooden post proclaims: "TOKUGAWA IEYASU CAME THIS WAY TO IGA."

I can believe it, because there was one other piece of circumstantial evidence. At the bottom of that wooden post was another sign, broken off, with a grim statement. When Ieyasu became shogun in 1603, it read, he appointed police chiefs everywhere, and IN THIS REGION, THE POLICE FORCE'S EXE-CUTION AREA WAS HERE. It is still there today. A grassy side-track led downhill through cedars, whose tall, smooth trunks and high canopies created (in my Eurocentric mind) a Gothic gloom, like that of a medieval abbey. Branches brought down by the recent typhoon littered the forest floor, and the still air was damp from moldering foliage. The cedars opened onto a small clearing, where, in a glow of light from above, two small stone memorials turned the place into an open-air chapel. They were flanked by vases of fresh flowers. Each stone bore an engraving.

"Buddhist chants," said Noriko. "To make sure the souls of those executed here rest in peace."

"What do they say?"

"*Nam yo horen* . . . ," she said, peering at the first. "It's Sanskrit. I don't know. Don't ask a priest. His answer will last for hours."

How many died here? Were they criminals, or perhaps local ninjas who continued the fight against Ieyasu, twenty years after the defeat of Iga? Anyway, this mournful place suggested a narrative: Ieyasu's placeman imposes his master's will by condemning locals to death, and then faces a problem: where to hold the executions. Ieyasu himself sends a message—go up the road to the top of the rise, and you will find a suitable spot. Kill them there, privately, far from any unruly warrior farmers.

He could suggest the spot because he came this way himself, if the sign is to be believed. Perhaps. No one can ever be certain, as Ieyasu himself intended. He would not have risked anyone but his closest and most trusted advisers knowing his whereabouts. How could he have done this? By copying the measures adopted by countless rulers from the first emperor of China to Saddam Hussein. Not that there is a mention of this in the sources, but local historians have no doubt. Yoshihisa Yoshinori, as driver for the Kōka Tourist Board, knew what was said. "There is no document telling us his route, but there could have been two or three different ones, because his look-alikes would have had a choice."

"He had a *double*?"

"Yes. All lords had look-alikes, to avoid assassins. Perhaps his look-alikes had more guards than he did himself, so that villagers here and there would all claim to have seen his procession."

"How would they know, or think they knew?"

"They would not show their faces. They would all be wearing his armor and helmet and colors. They would all look the same, with no way to tell which was the real one. So he could come along this road in safety."

It worked. Hattori Hanzō and his three hundred or so warriors guided Ieyasu along Iga's northern borders into Ise. How dangerous the journey was emerged when Ieyasu's ninja escorts caught and beheaded a notorious bandit, Ikkihara Genda, and his gang, while one of Ieyasu's retainers, taking a different route, was murdered by a different gang.

So, after a further week's travel, they came to the coast at a little place called Shiroko, a port on Ise Bay now little more than a railway station on the line running north to Nagoya. Here they hired a merchant willing to take their charge across the bay and home (though Sadler adds an unsourced and unlikely tale about Akechi's men searching the boat and Ieyasu being hastily hidden under cargo and the searchers poking about with spears, one of them wounding Ieyasu, who had the presence of mind to wipe the blood off the spear as it was withdrawn to avoid giving himself away).

The success of this mission made a terrific impression on Ieyasu. He showed his gratitude by rewarding top ninja aides with gifts of swords and commendations. And the ninjas, never previously known for their loyalty to an outsider, stuck by him. Ieyasu's initial generosity, the ninjas' guidance, Ieyasu's rewards, the ninjas' declaration of loyalty—all worked together to create a powerful bond, with many ramifications. Ieyasu would, 20 years later, emerge as the leader of the nation and impose a peace that would define its destiny for the next 250 years. But the peace would also mean that the ninjas, the products of centuries of war, would be barred from their traditional roles as spies and specialists in covert warfare. It was Ieyasu who would provide them with a new if diminished role in the emerging, peaceful Japan.

12

THE FINAL BATTLES

*Fighting among yourselves can always happen, [so] always de-
cide on a sign for your warriors beforehand.*

<div align="right">Ninja instructional poem</div>

IEYASU, JAPAN'S THIRD UNIFIER, WOULD HAVE TO WAIT
twenty years before assuming dictatorial rule of all Japan.
Under him, the ninjas would enter a long decline, debilitated
by peace, killed by kindness.

Meanwhile, under Japan's second unifier, Hideyoshi,
the ninjas could pretend for a while that the world had not
changed, and play a traditional role, not in Japan, but over-
seas. Hideyoshi, "the Napoleon of Japan," completed unifica-
tion and dreamed of regaining Japan's old empire in Korea, a
first step in a much grander vision: to conquer all China. The
invasion in 1592 included a one-hundred-strong unit of Iga
ninjas, who saw action in the assault on the castle guarding
Seoul. But it all came to nothing. The Japanese army was cut
from its roots by the Korean navy, and at home Hideyoshi
bogged himself down with lavish entertainments. In the sum-
mer of 1598, Hideyoshi, sixty-three, became ill and, in the

words of common metaphors, took the dark road to the Yellow Spring and became a guest in the White Jade Pavilion. His heir was a five-year-old, watched over by a council of regents. Factions formed, tensions grew, war threatened.

Ieyasu, the most powerful of the regents, had been awarded the Kantō region (the central eastern provinces of Japan's main island, Honshū). Having never been part of the Korean campaign, he had been busy building his base in the little fishing village of Edo (which eventually grew into today's Tokyo). It was he and his implacable foe Ishida Mitsunari who now held the fate of Japan in their hands.

There followed a campaign, which, like a game of chess on a massive scale, involved the taking of many castles vital for the control of the great roads, the coastal Tōkaidō and the inland Nakasendō. The campaign ended in the biggest battle ever fought on Japanese soil: Sekigahara, on the Nakasendō road about one hundred kilometers northeast of Kyoto.

By the time it occurred, on October 21, the time and place were so obvious that people gathered to watch, setting up with teapots and luncheon boxes on a nearby hilltop. They would have a good view, because the battleground was hemmed by hills, except that the morning started foggy. Some 160,000 men fought that day, in an action too complex to describe here.

For ninjaphiles, there are two points of interest.

First, Ieyasu won, largely because he managed to persuade several commanders to switch sides.

Second, one of the losing commanders introduced a novel ninja-like tactic. The commander was one of the Shimazu clan from Satsuma, on the southern tip of the southerly island of Kyūshū. Satsuma was famous for the fertility of its volcanic soils, or hence the oranges named after it. It was also notoriously independent, first because it was isolated by ranges of mountains and second because it possessed the superb harbor

of Kagoshima, a natural window to the world beyond Japan, to the Pacific, China, and all points south. The Shimazus were among the first to appreciate the advantages of the firearms introduced by the Portuguese. Recently, they had developed the use of guns by snipers, whose job was to lie low—playing dead, perhaps, or hiding—if their army retreated, and pick off enemy combatants. This they did at Sekigahara when their main contingent came up against the "Red Devils" of one of Ieyasu's top commanders, Ii Naomasa. Like all samurai, Ii's men were easy to spot, because they wore brilliantly colored armor and carried silk banners and flags and ribbons identifying them by rank, affiliation, and name. "All armour, harness, saddles and stirrups to be red" ran one of their regulations. Ii himself was on horseback, turned into a bull's-eye by his standard, 5 *shaku* (about 1.5 meters) long, four widths of silk wide, bearing the first character of his name in gold. A Satsuma sniper shot at him, close up, not very accurately, because the bullet passed through his horse's belly and shattered Ii's right elbow. The horse collapsed, Ii was carried from the field, and a ninja officer in his service gave some medicine— evidence that ninjas did indeed acquire medical skills when they did their Shugendō training. After victory was declared, Ieyasu personally bound Ii's wound, but some say he never fully recovered. He died two years later.

That left Ieyasu as Japan's virtual dictator, confirmed when he had the emperor proclaim him shogun in 1603, the start of the Tokugawa government that would last for the next 265 years. He moved fast to consolidate his power, executing some of his main opponents,[1] forgiving others, confiscating

[1] Sadler reports a story about the death of Ishida Mitsunari, loser at Sekigahara. On his way to execution with his colleague, Konishi Yukinaga, he asked for a cup of tea from his captors. He was offered a persimmon, but refused it, saying that it would not be good for his digestion. "It seems hardly necessary to consider one's digestion just before decapitation," said Konishi dryly. "How

fiefs here, dispensing them there, controlling enemies, securing allies, and starting the immense task of making Edo into the capital.

One of his acts was to reward the ninjas who had come to his aid with such spectacular success twenty years before. Iga was at peace under its new lord, Tōdō Takatora, with the local ninjas returning to their lives as farmers. Kōga, his ally during the Iga Revolt, was allowed to continue its self-governing traditions, on the understanding that there would be no challenge to his authority. But he knew better than to allow any resentment to fester, and to this end gave two hundred ninjas positions, and a significant income, as security guards in Edo.

To secure peace in this way demanded a rare combination of ruthlessness, vision, and generosity. If Oda Nobunaga was like Genghis Khan in rising from nowhere to become a national leader, Ieyasu was like him in that both did what autocrats are notoriously bad at: looking after the succession in good time. In 1605, Ieyasu made his third son, Hidetada, shogun, ensuring continuity and stability, while retaining power behind the scenes for the next eleven years.

There remained Hideyoshi's heir, Hideyori, now a grown man of twenty-one, living in his great fortress of Ōsaka, and eager to make a comeback. Tens—possibly hundreds—of thousands of samurai, resentful of Ieyasu's seizure of power, were willing to join him. The potential revolt was centered on Ōsaka Castle, Japan's most impressive castle after Edo itself. Built by Hideyoshi in 1586, it stood on the site of the Ishiyama Hongan-ji temple destroyed by Oda Nobunaga. Its base was a platform of immense stones, the provision of which had been a matter of intense competition between rival lords. They

little you understand," was the retort. "You can never tell how things will turn out . . . while you have breath in your body you have got to take care of yourself." That's the samurai spirit: Always look on the bright side of death. See Sadler, *Maker of Modern Japan* (p. 214).

are still there today, some of them weighing up to seventy-five tons. This, combined with some fifteen acres of walls and palisades and three moats and arrays of guns, should have made it very hard to take. For that reason, the ninja officer who had attended to Ii during the battle of Sekigahara, Miura Yoemon, went to Iga—to the Nabari area, not far from the Forty-Eight Waterfalls—to hire ninjas, who were still keen to make use of their skills after a decade of peace.

In the winter of 1614, Ieyasu arrived with his army to begin the siege. On one occasion, the ninjas used unorthodox tactics that saved lives. A force led by Ii's son, Ii Natada, attacked across a dry outer moat, using a fog bank to hide their approach, when a hail of bullets from the walls ahead drove them back. Such was the confusion of fog and fighting that Ii could not make himself heard to order a retreat. On the bank, Miura, busy removing arrowheads from wounded soldiers, ordered his ninjas to lob arrows *at their own men.* That got their attention. They turned to face this apparent new threat, and "advanced" away from danger, to safety.

The winter siege proved too much for both sides. Ieyasu's guns—seventeen European cannons and three hundred homemade ones—undermined morale: A cannonball smashed a tea cabinet while Lady Yodo, Hideyoshi's ageing consort, was entertaining, and another felled a pillar on top of two of her ladies. Sleep was impossible. For the besiegers, so was the cold. Neither side, though, was ready to give up. The result was a peace treaty that neither intended to take seriously. Hideyori promised never to rebel again. Ieyasu promised to back off but got the better deal, because the treaty allowed him to fill in the two outer moats. He then departed, proclaiming eternal peace, leaving the ladies in Ōsaka to return to their beds and tea ceremonies.

Peace after war is either imposed by the victor or based on trust. In this case, there was no victor and no trust. Both

sides prepared for another round. Osaka repaired its defenses; Ieyasu regathered his forces. Miura returned to Iga to persuade the ninjas to rejoin. It could not have been easy. They had only just gotten home, and now it was spring—time to start preparing the rice fields. But they were, after all, mercenaries, and they responded when the price was right. In the two months of fighting that followed, the only ninja action recorded was when they were ordered to fire on an unruly crowd of camp followers and locals who were impeding operations. The crowd quickly dispersed, leaving two or three dead who were under the command of Tōdō Takatora, Iga's new lord and owner of the newly built castle that still crowns Iga Ueno's central hill. He would not have been a popular figure among the sturdily independent inhabitants of Iga. It sounds as much like a by-mistake-on-purpose act as a piece of crowd control, but it was soon forgiven and forgotten amid the many other actions that involved uncounted deaths, suicides, heads taken and displayed on poles, and eventually, in early June, the surrender of the castle.

It must have seemed to the ninjas that they would never fight again, until twenty years later, when trouble broke out on the southern island of Kyūshū. It stemmed from the persecution of Christians, which came about because over the previous century, Catholic missionaries had won a core of some 300,000 converts, who seemed to challenge the shogun's authority. In 1612 a campaign of persecution started, which reached a peak of ferocity in the 1630s. Tens of thousands of converts recanted, while those who didn't were subjected to tortures that would have delighted a grand inquisitor: a forced recantation might involve being drowned, tossed into a snake pit, sliced with sharpened bamboo, roasted alive, branded, boiled in hot springs, or immersed in icy water. Tens of thousands died and hundreds fled the country (despite a law forbidding flight

abroad), leaving a hard core of Christians in Kyūshū, most of them in the Amakusa Islands off the west coast. The final straw, literally, was the behavior of a tyrannical local lord, who liked to punish recalcitrant peasants by dressing them in straw capes, such as the locals wore against rain, dowsing them with oil, and setting them on fire. In December 1637, driven beyond endurance by oppression and a harvest failure, peasants and Christians on the mainland rebelled, killing a dozen officials, and attacking several castles before taking ship across the Ariake Bay to the Shimabara Peninsula and rebuilding an abandoned stronghold called Hara. There was nothing sophisticated about their work—no great stone platform, simply earthworks and trenches topped by a scaffold of tree trunks, with planks from their ships as firing platforms and piles of rocks to drop on attackers. But the location was good, with cliffs on one side and a marsh on the other. No one knows how many there were inside—some say twenty thousand, others fifty thousand—but anyway, they included women and children.

Morale was high, because as Christians, they believed they were bound for heaven, not that it would come to that because their leader, appointed as a figurehead by a general, was a charismatic Catholic teenager named Amakusa Shirō. The arrival of a redeemer had been much prophesied by Kyūshū's put-upon Christians. In the words of a poem written some years before:

A God will come into this world, a boy aged twice times eight.
The youth, endowed by birth with every gift,
Will effortlessly show forth his wondrous power.

Lo, he appeared when needed, a boy of sixteen, able (it was said) to attract birds, like Saint Francis, and to walk on water. To end the rebellion, the local governor sent a three-

thousand-strong force, which endured the humiliation of failing to break in to Hara. The Tokugawa government in Edo sent an army of some fifty thousand, which tried again at the beginning of January 1638, this time using cannon bought from the Dutch, who joined in the bombardment from the sea. Among the government forces was a contingent of Kōga ninjas.[2] They surveyed the earth walls, moat, and approach roads, and drew plans that were forwarded to the shogun in Edo, further proof that ninjas were skillful in much more than secret operations. Later that month they launched a raid to seize bags of provisions that were crucial for the defenders.

A week later, the Tokugawa commander, wanting to know the conditions inside the fortress, called for ninja volunteers to break in, warning them that only two or three could expect to survive. Five answered the call, at least two of whom were from families listed as ninjas prior to Ieyasu's invasion in the 1560s and 1570s, further proof that ninja skills were passed down the generations even after the defeat of 1579–81. A contemporary account runs: "We dispersed spies who were prepared to die [or "were a suicide squad," in an alternative translation] inside Hara castle."

An assault followed, a special operation intended to spread fear and confusion and gain information. The ninjas, dressed in plain clothes like the defenders, planned to attack at night before the moon rose, which would mean climbing walls that were well lit by flaming torches. With the infiltrators in place, a contingent of gunners fired their arquebuses, at which the defenders, fearing a conventional attack, doused all the torches, leaving the place in starlit darkness. "Then," the record continues, "we raided at midnight." Entry was not as tricky as climbing a stone platform, like those typical of many castles, with a broad base sloping up to a vertical top. Earthworks can

[2] These details are mainly based on Turnbull in *Ninja* (pp. 85–8).

be climbed in relative silence, with spiked shoes and knives to act as pitons.[3] Still, it was dark enough for one of the ninjas to fall into a pit of some sort. Perhaps it was this that alerted the defenders. Torches were relit, the moon rose, and the ninjas just had time to haul their comrade clear and make their escape, taking a Christian banner with them as a souvenir. As they climbed back down the wall, the moon made them targets for volleys from above, which wounded two of them. They suffered "for forty days," says the record of the raid, after which (presumably) they recovered.

The siege continued for another three months, by which time the defenders were down to a few bushels of rice and soybeans, with some reduced to eating seaweed, scraped from rocks beneath the cliffs. In mid-April the government forces, now increased to 125,000, at last managed to breach the walls, and the rebellion ended three days later. Many of the defenders committed suicide, hurling their families and themselves into burning buildings, and most of the others—men, women, and children—were slaughtered in one of the greatest massacres in Japanese history. In the words of Ivan Morris in his magisterial analysis, *The Nobility of Failure*: "Vast ditches were filled to overflowing with severed heads, and heads were strewn thickly over the fields, with 10,000 stuck on wooden spikes and 3,000 loaded on to ships for mass burials in Nagasaki." Among the dead was "the Japanese messiah," Amakusa, who has since become one of Japan's "heroic failures," those beloved for their sincerity and bravery who die in a hopeless cause.

That was the end of resistance against Tokugawa rule, the end of all fighting for both the samurai and ninjas, the end of any hopes for Christianity, and the beginning of the two and a

[3] The assault is portrayed in the Akizuki Folk Museum (cf. Turnbull's *Strongholds of the Samurai*, pp. 131–132 and 180–81, and his *Ninja*, p. 88).

half centuries during which Japan became a "closed country."
For the ninjas, it also marked the beginning of a new phase:
emergence from the shadows; self-promotion; and the reinter-
preting of the past—or, to put it bluntly, of spin, gloss, fantasy,
and myth-making.

13

SHADOWS IN RETREAT

Every single thing is decided by your own mind and by the way you think. Never let your guard down nor fail to observe your state of mind.

Ninja instructional poem

SHIMABARA MARKED THE END OF THE NINJAS' FIGHTING ROLE, but they had already been playing a part in keeping the peace for more than thirty years. Ieyasu owed a debt of thanks to the ninjas of Kōga and Iga, who had, under the direction of Hattori Hanzō, seen him safely across hostile territory in 1582. As soon as his great castle in Edo was ready for occupation, he took on about a hundred ninjas each from Iga and Kōga as bodyguards and guards. Hattori himself was given a residence there, with a salary of eight thousand *koku* (a measure of rice, one *koku* being enough to feed a peasant for a year). A low-level samurai cost about twenty *koku*. Hanzō's Gate remains as a reminder of his presence. The ninjas' job was to patrol the buildings and keep the peace by ensuring that no one wore a sword inside the castle. They were expected to be masters of

unarmed combat, able to disarm anyone with their bare hands or with a rope.

That wasn't all Ieyasu did for them. He employed other ninjas as spies to keep an eye on lords whose loyalty could be in doubt. In short, they became his secret police. And later in his reign he asked some of his lords to do what they could for the ninjas by employing them.

Now, two hundred ninjas employed as guards, a few dozen others as shogunal spies, and another few dozen employed by other (*daimyos*) was hardly equal to the numbers who had acted as ninjas previously. Most of them returned to their main occupation as farmers and family men, as craftsmen and doctors. But there was no denying that for those still hoping for employment, opportunities all but vanished. With no more battles to fight, no one wanted mercenaries. Peace meant a loss of status and self-image.

One answer was to keep on practicing those skills that had been so useful in the past, and teach them, and make it as clear as possible how important they were for personal development, self-control, and strength of body and character. That was why the ninjas broke with tradition and recorded their secrets.

When I was eleven, I was in a small, private boarding school for boys. That summer, the class was seized by a mania for physical strength. We avidly discussed our merits. We flexed biceps, and wrestled, and wondered how to get strong. Was it an inbred talent? Could it be cultivated? If so, how? One day, in a magazine, I saw a tiny advertisement showing a man stripped to the waist with giant biceps and pecs like beached whales. He made a promise that I too could have a body like his, if I bought his bodybuilding program. It was called Dynamic-Tension. I had no idea what that meant, but suddenly I realized that, if I had the money, I had access to

something that would turn me from a weed into an oak. To my classmates, I let slip that I knew the secret of strength. This was an explosive claim. Instantly, I was surrounded. They demanded that I share my knowledge. I was astonished to discover I was in possession of a secret that was, in its way, as strong as my body would become after I had studied, swallowed, injected, or otherwise absorbed Dynamic-Tension. Obviously, the whole point was to keep the secret, or I would end up simply making all the others as strong as me. I refused. They threatened. They said there were ways of making me talk. I said there weren't, which was foolish. They tortured me. They sat on my head, they boxed my ears, they gave me Chinese burns—which for the uninitiated means counter-twisting the flesh on the forearm. I cried but kept silent. In the end they gave up, pretending they didn't care. But they did, and I was able to capitalize on my knowledge by telling two allies, swearing them to secrecy. For a brief, sweet while, I had a cocoon of friendship and security. It didn't last, because soon afterward, we forgot about strength and became obsessed with the little colored glass balls known as marbles. It was a lesson, though. Strength would have been good; but almost as good was the secret of how to acquire it. A secret that others want confers power.

The ninjas had status partly because they were good at what they did, but also because they kept it secret, until the late sixteenth century. This makes it hard to say anything definitive about pre-1600 ninja fighting skills, the body of knowledge and activities wrapped up in the term *ninjutsu*. To publicize their skills would have undermined the very purpose of their existence. Masters took care to pass on their skills to one chosen heir. If you were not on an inside track, you had to make up your own set of techniques. So there arose a general body of skills, and many subgroups, schools or *ryu*, perhaps as many as eighty, developed all over Japan, though focused on

the prime areas of Kōga and Iga, and all of them secret. Occasionally, a master or scholar recorded the details of a *ryu*, to be kept safely under lock and key. But the country was at war, and writings were hard to preserve. So, little documentation survives from the fifteenth and sixteenth centuries.

That takes us up to 1638, at which point conflict came to an end permanently, and the ninjas, like the samurai, lost the fundamental point of their existence, which was war. They might then have vanished. But there were traditions, and some had a job of a sort to do. What they could not do was go out and infiltrate castles, spy, and assassinate. How in this changed world could they preserve themselves? One answer was that they could retain a sense of identity by clinging to their teachings and making them available to a wider public, while maintaining the myth that war was still a fact of everyday life.

There are several summaries of ninja knowledge and techniques, all of them dating back no farther than the late seventeenth century, when the ninjas' great days were over. One is the *Shoninki*, which forms the three "How to" chapters in the early part of this book. It is the most literary and succinct of the manuscripts. Another is the *Ninpiden* (*The Secret Ninja Tradition*), perhaps written by a Hattori, but at least in the possession of the Hattoris, the famous ninja family from Iga. A third is the *Gunpo Jiyoshu* (*The Collected Way of the Samurai Military Arts*), so called because Ieyasu thought all samurai should read it; it's fifty-nine paragraphs of severely practical advice on tactics and equipment. Finally, there is the encyclopedic *Bansenshūkai*, which intrigued me because it was the only one of the four not translated into English,[1] and because of its size.

[1] It is now. The 180,000-word translation by Antony Cummins and Yoshie Minami is due for publication in autumn 2013.

*

The hotel in Kōka was of the traditional sort, built around little Zen-style courtyards of gnarled trees and stones, with corridors of sliding doors and paper screens leading to steamy mineral baths. One moved to the tinkling twitter of caged grasshoppers, which call with the sound porcelain would make if it could sing. My room had fitted, off-white *tatami* matting, and that was all, the futon being still stored away.

"There's nowhere to sit or lie down," I complained.

"You can sit or lie *anywhere*," said Noriko.

But I couldn't. It seemed odd to lie on the floor, and it hurt to kneel or sit cross-legged. Compared with the kimono-clad lady of the house, who could drop to her knees and rise again with ease and elegance, I was a graceless lump, unworthy of the hotel's charm.

Besides that, though, the hotel had one overwhelming advantage. The owner, Tsuji Kunio, was a member of the local historical society, and among his many books he had a multivolume copy of the most famous of ninja books, often called its bible, the *Bansenshūkai*. The Japanese like four-part titles and phrases, such as the nineteenth-century political slogan *Son nō jō i* (Revere the emperor, expel the barbarians). *Ban Sen Shū Kai*—though usually transcribed as one word—is one of them. It means "Ten thousand rivers merge (into) the sea," which I take to be a metaphor meaning that "countless elements make a single philosophy" (i.e., *ninjutsu*). So it was here, with the *Bansenshūkai* spread out on the table, that half a dozen local amateur historians met to tell me about the ninja response to redundancy. I was in awe; here, apparently, was a copy of the most impressive of ninja records. I was about to touch the very roots of my subject.

Why, though, would some ninja authors choose to reveal their secrets at all?

It was the elderly Toshinobu Watanabe, he who had taken

me around to various ninja sites in Kōka, who explained. For the first twenty or thirty years after the Iga Revolt, the ninjas found gainful employment with the shogun as guards, and twice as spies and soldiers in the last great actions, in the siege of Ōsaka and the Shimabara Rebellion. Then all was quiet. They were in the uncomfortable position of not being needed anymore—worse, actually, because they had fallen in status, and were ordinary farmers, much put upon by the tax man. Like the samurai, they were at best gradually turning from active to passive, from soldiers to bureaucrats, dependent (if they could claim samurai status) on stipends of rice to feed their families. Soon, perhaps, they would be out of a job altogether. They would age, and die, and because they had been so secretive, no one would remember them or their great deeds. They had to show what they were made of, the skills they had, and the importance of passing them on from generation to generation. Nor was it just the practitioners of *ninjutsu*: all specialists—in archery, sword fighting, firearms in all their different schools—felt the need to record details of their ways.

"In fact the *ninjutsu* experts came to this view quite late," said Toshinobu. "Around 1670, specialists from Iga and Kōga got together and said, 'My goodness, we had better do something about this, or we will disappear.' So that's how the *Bansenshūkai* came to be written, along with several other works on *ninjutsu*."

To focus on the *Bansenshūkai*: This is a ten-book record of ninja ways, in some twenty to twenty-six chapters or "volumes," depending on the edition. It was compiled by an ex-samurai called Fujibayashi Yasutake and completed in 1676. "He wrote it as a combination of the Kōga and Iga *ninjutsu*," said Toshinobu, "because his house was on the border between the two." It is, in effect, an encyclopedia of *ninjutsu*, a manual of covert operations that includes fighting techniques, weaponry, strategy, spying, astronomy (because the

stars pointed the way at night), psychology, explosives, basic chemistry, and guidance for survival in warfare (see box for details).

The *Bansenshūkai*: The Contents[2]

1. Introduction
Preface and Prologue; Guiding philosophy of successful warfare; Historical examples; Index; Questions and Answers

2. Correct Mind/1
Sincerity, motivation, and moral strength of intention; Correct approaches to life and death

3. Correct Mind/2
How to manage a ninja organization; Successful use of ninjas; Considerations for stopping enemy agents; Methods of entering the enemy's base

4. A Guideline for Commanders/1
Methods for discovering the enemy's intentions; Continuous observation by agents placed during peaceful times; Location of agents after war breaks out; Observing the geographical layout of the enemy's territory; Observing the enemy's numbers, capabilities, and other strengths; Observing the enemy's strategy and positioning; Agents specializing in watching and listening

5. A Guideline for Commanders/2 and 3
An agreement between lord and ninja; The three prohibited matters in *ninjutsu*; Two points on secret letters; Two points on letters sent tied to arrows; Four points on signals; Secret

[2] Adapted from Antony Cummins (personal communication), with thanks.

letters with occult power; Six points on making an agreement; Three qualifications for a commander; Two ways to guarantee a ninja's safety; Reasons for hiring a ninja (Part 3: missing)

6. A Guideline for Commanders/4
How to protect against the enemy's tactics/1: Five reasons for not hiring the enemy's ninja; Disciplining your force

7. A Guideline for Commanders/5
How to protect against the enemy's tactics/2: Watch-fires; Passwords and secret signs to identify allies; Watch guards; Patrolling night guards; Listening scouts; Tools for defending against enemy ninja

8. Infiltration/1
Preparation; Planting an undercover agent; The same in a tense situation; Female ninja; Using locals; Turning a local into a spy; Serving the enemy to betray him; False letters to make an enemy retainer look like a traitor; Winning over an enemy ninja; Defecting falsely; Ninja-commander relations

9. Infiltration/2
Passwords; Secret signs; Infiltration at a distance; Disguise; Infiltration during a night attack; Sporadic infiltration; "Turning" a prisoner; Making an enemy commander seem a traitor by forging letters to his family

10. Reconnaissance
Reconnaissance: Investigating mountains and valleys; Further points on the same; Seashores and rivers; The depth of rice fields; The depth and width of a moat; Discovering how well a castle is fortified; Estimating topography, distance, and elevation; Estimating the strength of the enemy; Estimating enemy numbers; The numbers of an enemy formation; Estimating

numbers of an enemy on the march; Scouting a castle or camp from without; Likely mistakes when scouting at night; Judging if the enemy is advancing or retreating from camp or castle; Judging if the enemy is taking up a position or retreating; Assessing if there are ambushes; Judging if the enemy is about to cross a river; Judging the enemy by observing flags and dust

11. Secret Infiltration/1
Ten points to consider before the mission; The art of taking advantage of gaps; Taking advantage of the enemy's negligence

12. Secret Infiltration/2
Where you should infiltrate from; The art of choosing tools; Infiltrating when allies arrive; Infiltrating by consecutive raiding; The art of the "invisible cloak"; Arson

13. Secret Infiltration/3
Distinguishing seasonal sleep patterns; Detecting if people are asleep or not by age, disposition, and behavior; Dealing with dogs; Ways of walking; Hiding your shadow and making no noise; Appropriate nights for action; The appropriate place for action; Listening to snoring; Observing the enemy; Hiding; How to arrange your men when infiltrating a house; How to be cautious; Using the sword cord; Traps to injure the enemy

14. Secret Infiltration/4
Preparing to open doors; Feeling for locking sticks; How to undo locking sticks; Feeling for hooked latches; How to undo hooked latches; Finding bolts; Undoing bolts; Discovering wooden latch pegs; Releasing wooden latch pegs; Identifying padlocks; Opening padlocks

15. Secret Infiltration/5
Scouting; Outfits for night raids; Instructions during night

raids; Tactics before night raids; The right time for night attacks; Ninja night attacks; Burglary raids; Taking captives

16. The Time of Heaven/1
The divination of time; How to know the right times and directions; The *Five Precepts* and times of day; Knowing a lucky day by consulting the *Five Elements*

17. The Time of Heaven/2
Astronomy; Predicting wind and rain; Knowing the time of moonrise and moonset; Tides; Knowing the direction on moonless nights; How to tell the time

18. Tools/1
Climbing tools: illustrations of eight kinds of ladders, hooks, grappling irons, the "dragon-climbing aid," flying tools, and ninja sticks

19. Tools/2
Illustrations of bridges, reed rafts, pot rafts, basket rafts, "water-spider" floats, flippers, marsh shoes, the "cormorant," war boats

20. Tools/3
Tools for bypassing locks

Since working as a ninja involved having a "correct mind," there is also much esoteric lore, some of it in Chinese (or rather *kanbun*—Chinese adapted for Japanese), with many quotes from Chinese sources, because so much of the theory—strategy, tactics, divination, the calendar—came from China, and because using Chinese conferred authority on the text. For example, the sections "Determining Direction and Location from the Stars" and "Divination" include much in Chi-

nese about Chinese divination that was standard knowledge among Japanese generals—"They are not to be trusted," says the *Bansenshūkai*, "but the knowledge of them is useful when conducting warfare against a general who believes in them." Practical matters—burglary, infiltration, espionage, tools, explosives—are mostly in Japanese.

It's a puzzle. It looks like the proud product of the ninjas' heyday, when they were living secure, happy, and active lives. But if that were so, the secrets would never have been written down. The very existence of the *Bansenshūkai* suggests insecurity, unhappiness, and inactivity—an attempt to make sure that later generations would know their birthright, and be able to apply it if necessary.

In its original form, it was no literary masterpiece, as the edition in front of me proved. It was a photocopy of a hand copy of an original, which has been lost. Noriko had been wondering about the calligraphy. It seemed to her to be pretty substandard. She guessed this because her father is an eminent historian, Katsuhisa Moriya,[3] and as a child she was used to seeing good-quality calligraphy and printing of all ages around the house. Later, Professor Katsuhisa expressed his own opinion, in no uncertain terms. On the basis of this copy, the original must have been the work of an educated commoner, which was not saying much. "A samurai with an education in *kanbun* would never write rubbish like this!"

True, but a little harsh, because Fujibayashi was indeed a low-level samurai, who would not be expected to be a master of Kanbun. As Antony Cummins pointed out to me, "The fact that he could write *kanbun* at all is totally amazing."

At some point, a century after it was written, when the for-

[3] Former dean of the Human Environmental Science Department and now emeritus professor of Japanese history, Mukogawa Women's University. Author of several books on Japanese history and contributor to *Traditions Unbound: Groundbreaking Painters of Eighteenth-Century Kyoto* (in English).

mer ninjas needed even more help, the *Bansenshūkai* was re-copied in finer calligraphy to become a plea to the shogun for recognition, in effect an extended job application. The subtext of this later, improved edition was: Appreciate our skills! Employ us! Make sure our masters are able to pass on our secrets from generation to generation!

"That's the one that is in the National Archives today,"[4] said Toshinobu.

"Did it have an effect?"

"Not at all! Nothing changed!"

So much for the ninjas' hopes for employment. And what of my hopes of touching the roots of ninja culture? How accurate are the copies? How well did the long-gone original represent the realities of ninja life, given that it was written a century after the true ninja lifestyle came to an end? Extremely well, according to the Kōka historians and to the *Bansenshūkai*'s translator, Antony Cummins. "An outstanding manual," he told me. "One hundred percent correct. No doubts here." And the proof? The *Bansenshūkai* and the *Shoninki* both record "the same set of skills and reflect each other." That's what shows this to be "one of the all-time survival and guerrilla warfare manuals." Which in turn implies that those who dismiss the *Bansenshūkai* as shoddy and unreliable are expressing deep-seated prejudices against ninjas, deriving from samurai traditions about the supreme value of calligraphy and scholarship and display and death-defying bravado.

By the time the *Bansenshūkai* was written, the ninjas were on their way into the realms of make-believe. Even the *Bansenshūkai*, with all its supposed authenticity, has its share

[4] It is known as the Ohara Kazuma version, after the Kōga man who presented it.

of doubtful information. It prints a "ninja code" made up of mock-Chinese signs that makes no sense; it suggests that ninjas could transmit information by training a horse to walk in certain ways; it insists that a good ninja can live "off snow and hail," it gives a recipe for pills to counteract thirst (pickled plums, crystallized sugar, and wheat).

Over the next century, the ninja began to acquire his modern traits as a superman in black, able to perform magical feats. An illustration of an 1802 romance shows a black-clad figure crossing a moat by climbing along a rope held to a castle wall by a grapple.[5] A similar rope-climbing figure appears in a sketch done around 1814 by the great artist Hokusai. Several other black-robed ninjas appear regularly in nineteenth-century prints, though the range of subjects was limited by the censorship of the Tokugawa shogunate, which was sensitive about anything that suggested secret opposition. In one of a grisly series entitled "28 Scenes of Murder," Tsukioka Yoshitoshi portrays a hero on the point of committing suicide, with the shadow of doom looming over him—a shadow that is a ninja in silhouette. It was done in 1866, and the ominous shadow might well symbolize the fate of the Tokugawa shogunate. The strongest image of a latter-day ninja appeared only after the end of the shogunate in 1868. It is a woodblock print created in 1883 by Toyonobu Utagawa, of an attempt on the life of Oda Nobunaga in 1573 by an assassin named Manabe Rokurō. The print shows him as the archetypical ninja, dressed in black, thrashing about with his sword with a servant woman on his back, while the shogun looks on coolly.

Of the many bizarre ninja transformations, the strangest is the one that changed the twelfth century's great hero Yoshitsune from a tragic failure into a glorious success. After

[5] *Ehon Taikō-ki* by Takenouchi Kakusai. Details are in Turnbull's *Ninja* (p. 125).

an (apocryphal) incident in which he is smuggled through the Ataka Gate by his loyal servant, Benkei, Yoshitsune was defeated in battle and committed suicide. Or did he? Folklore does not like its great men to vanish. So it suggests an alternative fate in which the hero finds a destiny suitable to his greatness. In this legend he does not die but escapes northward, to the island of Hokkaidō, where the local aborigines, the Ainu, welcome him as a leader. Then what? Obviously he cannot die. So he travels on, ever northward, across the island of Sakhalin, to the mainland, then westward to Mongolia, where he reemerges as the world conqueror Genghis Khan.

This is utter rubbish, of course. Yoshitsune killed himself (or vanished) in the battle of the Koromo River in 1189, at the age of thirty. Genghis became the founder of his nation in 1206, which presumably acted as the legend's foundation stone, because the intervening seventeen years offer enough time for Yoshitsune's transformation. As it happens, the two were about the same age. But the storytellers were ignorant of the fact that at the time of Yoshitsune's death or disappearance, young Genghis—Temujin, as he was still called—was already busy uniting Mongolia's feuding tribes. Not that this could have been widely known in Japan, but it is clear enough in both Chinese and Mongol sources. Actually, the whole thing is batty. It ignores distances, problems of travel, language, and cultural differences. But legends grow by avoiding inconvenient facts. The real question is how and why the story arose.

It started at least in the early nineteenth century, because it was first recorded by the all-around German scholar and scientist Philipp von Siebold, who visited Hokkaidō in the 1820s. The legend gained a new lease on life soon after the revolution of 1868, which ended the shogunate and brought the Meiji government to power. During the revolution, rebels had set up a short-lived republic on the northern island of Hokkaidō.

Crushing the rebels focused the attention of the new regime on the island. They remained there, mainly because they were afraid the Russians would seize it. In the ferment of nationalism, some Japanese needed to see a future building an empire on the mainland. All the better for the future if there was a precedent. Here it was—an empire had been built by Genghis that included all of China. Obviously, ran the argument, no Mongol could have done this, because the Mongolians, as everyone knew, were mere barbarians. Therefore Genghis, genius that he was, could not have been Mongolian. And since he conquered China, he could not have been Chinese. So, by iron logic, he must have been Japanese. This was the lunatic rationale of a Japanese author named Oyabe Zenichiro, whose book on the subject was published in 1924. It became a bestseller, and the idea acquired a certain respectability, with the result that it is constantly recycled as part of Yoshitsune's story, itself part of the process that was fast taking the ninjas away from reality into the realm of myth.

Yet a seed of reality remained, and was about to rebloom in the most unlikely circumstances.

14

THE NAKANO SPY SCHOOL

When you are on night patrol or have to stand guard in an emergency, you should keep quiet so that you can hear any sounds.

<div align="right">Ninja instructional poem</div>

THE NINJAS LIVE ON IN MANY DISTORTIONS OF A DISTANT RE-
ality, but they also live on in one man, Onoda Hiroo, who
survived in the Philippines for thirty years after the end of
the Second World War. It is a famous story. Onoda, ninety as
I write and still going strong, was as loyal to his country as
any samurai to his lord, but kept himself alive with techniques
and an attitude that owed more to the ninjas than the samu-
rai. His attitude in particular: Where the samurai accepted,
or sought, or ensured a "glorious" death, Onoda was a dedi-
cated survivor.

We'll get to Onoda himself in chapter 16. First, we should
look at the roots of his ethos, which he shared with a small
band trained in covert operations. They were a remarkable

group. All alumni of or instructors in a "spy school" devoted to intelligence gathering and guerrilla warfare, these few, twenty-five hundred in all, might have been examples of expansionist, imperialist, militaristic Japan at its most extreme. In fact, they were just the opposite; though unshakably patriotic, they possessed extraordinary streaks of creativity, liberalism, idealism, and flexibility. One man in particular possessed all these qualities. It is rare for anyone to retain moral integrity in opposition to the beliefs and actions of his nation. Fujiwara Iwaichi was such a man. He would not have put it in these terms, but he was a "shadow warrior," in the tradition of those few ninjas who tried to balance loyalty, action, and morality.

He and Onoda owed their careers to the Nakano Spy School,[1] the roots of which go back to Japan's emergence on to the world stage in the late nineteenth century. The emperor had been restored to full power in 1868. The samurai vanished. Japan's new modern armed forces went from strength to strength, defeating China (1895) and Russia (1905), joining the Allies in World War I, then in the 1930s building an empire in Manchuria, with ambitions for a greater one in Siberia, Mongolia, and China. But brute military strength was not enough. Inner Asia was a complicated place, with China torn by warlords, nationalists, and Communists, Soviet armies strengthening their grip on Siberia, and Mongolians eager both for independence and for Soviet support. The Japanese army saw it needed to help conquest along with subversion and covert operations. Spies posing as Buddhist missionaries or businessmen built intelligence networks that produced maps and information on opposing armies.

As Japan's military machine grew in strength in the 1930s, the army saw that something rather more professional was

[1] Officially, the Rikigun Nakano Gakko (Army Nakano School).

needed in terms of covert warfare. In 1937, focusing princi-
pally on the threat from the Soviet Union, the army began to
develop the tools and techniques of "shadow warfare": secret
inks, cameras hidden in cigarette lighters, explosives disguised
as canned food and coal, couriers reporting on what they saw
while traveling on the Trans-Siberian Railway, an intelligence
unit of anti-Soviet Russians, a counterintelligence agency. Fi-
nally, in summer 1938, it was decided to formalize training in
a spy school, which the following year acquired a headquar-
ters in Tokyo's Nakano district.

The Nakano Spy School, a compound of nondescript build-
ings with a forest of telegraph poles, had once been a mili-
tary telegraph unit, and—according to a deliberately deceptive
sign—was no more than an "Army Communications Research
Institute." It was run at first by the brilliant and unconven-
tional Akigusa Shun. Fluent in Russian, with round glasses
and a gentle manner, Akigusa drank no alcohol, preferred
coffee to tea, and took his students to the Imperial Hotel,
designed by Frank Lloyd Wright, to improve their Western
manners. He selected his students with care, preferring reserv-
ists and disdaining army officers drilled in absolute obedience
and rote learning. From six hundred candidates, he chose just
eighteen, all notable for their intellectuality, internationalism,
and fitness. They were an elite, and acted the part, sporting
fashionable haircuts and wearing smart suits.

From the first, they were taught a new type of covert war-
fare that would help establish the Japanese empire, or as they
termed it, the Greater East Asia Co-prosperity Sphere. The
twentieth century, as World War I had shown, was an age of
total war. But, they learned, full-frontal assaults were of less
importance than intelligence, with which one could under-
mine the enemy by fomenting religious strife or class conflict.
A single spy, said one teacher, could be more valuable than
a division of soldiers. Shadow warfare, ninja-style, was the

thing—but adapted to the modern world. They studied psychology, aviation, marine navigation, pharmacology. They were taught how to handle explosives and time bombs. They read up on German strategy, American politics, and the campaigns of Lawrence of Arabia. They learned how to photograph documents surreptitiously, to disguise themselves, even (with known criminals as teachers) to crack safes. In an introduction to biological warfare, they were shown how to use special pens designed to release bacteria into water supplies. Everything, of course, was top secret. No one was to expect public honor. All should accept that they might die for their country without recognition. Nothing could have been more different from the samurai ethos, nothing more in line with that of modernized ninja-ism: dedication, patriotism, flexibility, thoroughgoing professionalism in shadow warfare.

And spirituality, Japanese-style. A shrine at the front gate was dedicated to Kusunoki Masashige, the great fourteenth-century general who fought for the emperor Go-Daigo in the early years of the sixty-year civil war between the Northern and Southern Courts, the one who oversaw the defense of several "hilltop" castles in Yoshino, who escaped from one castle by pretending to have committed suicide, who defended another with an army of mock figures, and who obeyed his imperial master by going into battle (Minatogawa, 1336), even though he knew it meant his death, and who, dying by committing *seppuku*, became the paragon of loyalty.

On this basis, the first students were supposed to take on board two root concepts: integrity and spirit, *makoto* and *seishin*. "Success in clandestine activity comes from integrity" was a key motto, while "spirit" meant a fervent patriotism. These attitudes might have evolved into modern versions of the gung-ho, arrogant, nineteenth-century samurai cry of *Son nō jō i!* (Revere the emperor, expel the barbarians!). One of Akigusa's subordinates, Major Ito Samata, almost put this

idea into action by planning to raid the British consulate in Kobe, to search for evidence of bribes offered to Japanese politicians and financiers. In the event, this plan, made in classic ninja tradition, was discovered, Ito court-martialed, and his boss, Akigusa, reassigned to Berlin. After that, Nakano avoided such "cowboy" schemes, preferring well-thought-out projects. Covert ninja-style operations were all very well, but they would need a clear military and political purpose.

That same year, 1939, world events and a setback on the mainland rewrote Japan's plans for imperial conquest and gave the Nakano School its true agenda. In inner Asia, Japan's advance came to a sudden halt when its army was crushed by a joint Russian-Mongol force. In Europe, Hitler signed a nonaggression pact with Russia and invaded Poland, inspiring Britain and France to declare war. War in Europe offered a chance for Japan to end European imperialism in Asia by driving out the British, French, and Dutch—and then, in June 1941, with Hitler's invasion of the Soviet Union, a new opportunity to seize the Soviet Far East, even all Siberia. What a vision for an ambitious young power, to become the force to free Asian peoples from Western rule, to reverse centuries of humiliation! By "Western," Japanese meant both European and American, since it had been the United States, more than any other nation, that had forced Japan to open itself to the world in the mid-nineteenth century and turned the Pacific into its own backyard. Surely no Asians, from Siberian hunters to native Hawaiians, from British-ruled Indians to Filipinos, could possibly object to a war of "liberation" by fellow Asians?

In pursuit of these goals, the ethos of Japan's new ninjas was very different from that commonly associated with the Japanese military. As Stephen Mercado puts it in his history of the school: In an army that "inculcated unquestioning execution of orders and a fiery patriotism, the Nakano School

began encouraging its shadow warriors to think creatively. They were to know the enemy, not simply fight him. Such knowledge would be the strength underlying whatever technical skills in martial arts, safe-cracking, or the like in their covert quiver. From such knowledge, too, would flow empathy. A competent intelligence officer must, whatever his personal beliefs, be able to grasp the basis of his opponent's beliefs and actions." In brief, Nakano trainees were to develop a combination of private initiative and group "spirit."

Purists in today's "ninja community" argue that the Nakano graduates were not true ninjas. Quite right, in the sense that the historical circumstances in which ninjas and *ninjutsu* evolved had vanished. No one could be loyal to a lord anymore, because lords no longer existed. And in purist terms, a *ninjutsu* specialist could only learn his expertise from a master, which had to be passed on man to man, not learned in a group. But several aspects of ninjaism justify the use of the term here. The man who claims to be the inheritor of the ninja tradition, Masaaki Hatsumi, lists eighteen fundamental areas of expertise, eleven of which were echoed in Nakano's training: spiritual refinement, unarmed combat, swordsmanship, fire and explosives, disguise and impersonation, stealth and entering methods, strategy, espionage, escape and concealment, meteorology and geography. Seven others were not exactly mainstream in modern warfare: stick-and-staff fighting, throwing blades, spear fighting, halberd fighting, chain-and-sickle weapons, water training, and horsemanship. But there was enough in common between traditional ninja training and Nakano's to call these men modern ninjas. The two shared loyalty, secrecy, a sense of duty, a sense of integrity. As Onoda puts it:

In what then can those engaged in this kind of warfare put their hope? The Nakano Military School answered this ques-

tion with a simple sentence: "In secret warfare, there is integrity." And this is right, for integrity is the greatest necessity when a man must deceive not only his enemies but his friends. With integrity—and I include in this sincerity, loyalty, devotion to duty and a sense of morality—one can withstand all hardships and ultimately turn hardship itself into victory.[2]

Well, it may be a challenge to you and me to justify the deception of friends or a nationalist, militaristic agenda as moral, but secret services the world over have no problem in believing it. And many Nakano graduates and teachers were able to maintain their personal integrity by opposing or avoiding the worst aspects of Japanese wartime behavior.

How the entrance examiners found men with the right qualities was as much a matter of gut reaction as analysis. A corporal arriving for the interview was ushered into a room where half a dozen high-ranking officers started to fire questions at him. "You," said one, "d'you like women?" The corporal was totally nonplussed, unable to answer yes or no. Afterward, he asked the assistant commandant, Ueda Masao, if the questions were planned. No, came the reply, nor did it matter; whatever the question, it was the way the interviewee answered that mattered, not what he said. The interview was not an examination but a personality test to see how the candidate responded to pressure. In this case, apparently, confusion was seen as a perfectly appropriate response.

When the war broke out in Europe, Nakano graduates focused on British-ruled India and the rest of Southeast Asia. They scored some extraordinary successes, thanks to a team of agents under the remarkable Fujiwara Iwaichi, a onetime lecturer at the Nakano School and at the outbreak of war a

[2] Onoda's words in this and the next chapter are from his book, *No Surrender.*

captain in the army's Eighth Section, which handled intelligence. At first glance, he seemed a conventional type. Akashi Yoji, the translator of his memoirs, met him after the war: "The lanky general with his short haircut, tight lips and hawkish eyes gave me the impression that he was a man of strong will and principle . . . something like the old-fashioned samurai with all the virtues attributed to that class." [3] But there was much more to him than that; indeed, he impressed everyone with whom he came in contact during and after the war—Malayan, Indian, even British—everyone except his own benighted superiors.

In September 1941, Fujiwara was given the task of leading covert operations in Malaya. He was supposed to contact Indians in the British Indian Army and in the independence movement, and Malay and Chinese anti-British groups. He had five Nakano graduates, each "sound in thought and pure in heart"—in his own positive, *always* positive, words—but utterly naïve. Fujiwara was "dumbfounded by the unexpected order," first, because he (like his team) had no experience of espionage, and second, because he was very different from regular soldiers and officers. He was the opposite of everything Japan would soon come to stand for: arrogance, xenophobia, brutality. Fujiwara was loyal and patriotic, of course, but also generous, flexible, and idealistic. In addition, he was highly emotional, often weeping at crucial moments, contrary to the chilly stoicism usually associated with Japanese officers. All of this made him one of those rare romantic figures in Japanese history. He knew it, too, comparing himself to Lawrence of Arabia (not the only Nakano graduate who did so, as we will see).

In Fujiwara's view, operations so far had been "devoid of a principle that would inspire the cooperation of alien nation-

[3] Fujiwara, F. *Kikan*, introduction.

als." What was needed was "an ideology based on noble and universal political principles," which ought to involve "an understanding of the Asian peoples' aspirations for freedom and liberation." After a sleepless night agonizing over these ideological differences, he accepted his task, telling himself he would do what he could to revolutionize attitudes in the imperial army. In that, he failed; but he made a pretty good start.

He called his young officers to his home, had his wife prepare a supper of sea bream, and gave them a pep talk of shining idealism and—in hindsight—staggering naïveté:

Keeping in mind His Majesty's concern for benevolence that extends not only to our troops but also to enemy soldiers, we must impress his concern about indigenous peoples and the enemy, especially prisoners of war, and build, by inducing them to cooperate with us, the foundations for a new friendship and peace out of the ashes of war. . . . We must impress on them that this war is a war of righteousness aimed at freeing indigenous people and POWs and helping them to achieve their national aspirations and happiness. . . . We should be modest and moderate, refraining from being loud-mouths, political bullies or swaggerers. Men of such arrogance will not achieve anything.[4]

It's a message he repeats several times. "We were inexperienced, ill-prepared and ill-equipped to challenge the Western colonial powers. For us, the only way to break through this citadel of colonialism was to respect national aspirations with love and sincerity and win their hearts. Sincerity could move even heaven." Seldom has an officer been so out of tune with the spirit of his government and its top military brass, and seldom so prescient.

[4] Fujiwara's words here and later are from his book, F. Kikan.

The Fujiwara Kikan (Agency), as it was called—F. Kikan for short—set themselves up under cover in Thailand. At the heart of several nations and colonies all about to be at war with one another, Bangkok had suddenly become a center of international espionage. Fujiwara's account makes the city sound like the set of a farce, with German, French, Japanese, Chinese, American, and British agents all sneaking around trying to avoid being followed, constantly changing rickshaws and doubling back on their tracks.

Fujiwara made surreptitious contact with Pritam Singh, a young, fragile-looking Sikh, the leader of the Indian Independence League, banned as subversive by the British. He was ushered furtively up to Fujiwara's hotel room. "I have come to help you realize your high ideals," Fujiwara told him, as excited "as if meeting a sweetheart." Other meetings followed, one in a smelly warehouse that appeared to be a pickle factory, where Fujiwara promised to help the cause of Indian nationalism if Singh provided information and spread anti-British propaganda among Indian military units. Fujiwara and Singh agreed that Indian soldiers who surrendered to the Japanese would be returned to the frontline, where they would help undermine the morale of Britain's Indian troops.

When the invasion came, Fujiwara's operation rapidly moved from its covert, ninja-style roots to something overt, large-scale, and very political, with important consequences. Indian units in Malaya, outflanked, overrun, and cut off, surrendered by the hundred—some twenty-five hundred of them by mid-January 1942. Fujiwara was so impressed by one of the prisoners, Captain Mohan Singh (there are many Singhs in this story), that he organized a lunchtime banquet for him and his officers, with Singh acting as master chef. Singh was impressed by Fujiwara's readiness to embrace Indian ways, eating with his fingers, trying curry for the first time, so different from the racial superiority and aloofness of the British.

Singh was bowled over by Fujiwara's qualities, reeling them off in a foreword to Yamashita's memoirs—shrewd, tactful, well-informed, calm, cool, unruffled, sympathetic. It seemed a match made in heaven: "Mentally, emotionally and spiritually, we had become one." A few days later, Fujiwara agreed to back Singh as commander of an Indian national army.

When Singapore fell on February 15, Fujiwara and Singh had thousands of Indian prisoners from which to build the Indian National Army. Two days later, in a terrific propaganda coup, Fujiwara spoke to forty-five thousand of them in Singapore's Farrer Park, his words translated first into English, then into Hindi. Japan was waging a war of Asian liberation, and had no designs on India, he said, to much cheering. "When I told them of my conviction that the fall of Singapore would provide a historic opportunity for Asian peoples who had suffered under the yoke of British and Dutch colonialism to liberate themselves from bondage, they went into a frenzy. The Park reverberated with such echoes of applause and shouts of joy that I had to stop my speech until the tumultuous commotion had subsided." Japan was their friend, Fujiwara went on. She recognized their freedom struggle. She would help. The prisoners need not remain prisoners, if they chose to join the struggle to free India. With "continuous applause, flying caps and waving hands," tens of thousands surged forward to pledge themselves to the cause of national liberation.

That was Fujiwara's moment of triumph. But his success drew the appalled gaze of those in power. Almost immediately, higher echelons of the government and army took over from Fujiwara, with a very different agenda. Disagreements arose with Indian nationalists over the timing, size, and leadership of the INA. Japanese racism surfaced. Indian leaders, believing they would be treated as equals, made demands that the Japanese saw as unreasonable. Indian prisoners were used as mere laborers. Resentment grew. In March, having been in office

only four months, Fujiwara was replaced by Iwakuro Hideo, a founder of the Nakano School, who lacked Fujiwara's idealism. In December 1942, the Japanese, fearing revolt, disarmed the INA and arrested its commander, Mohan Singh.

But this new Indian army was too important an asset to be allowed to die. The key to what happened next lay in Berlin, where the leading nationalist militant, Subhas Chandra Bose—wealthy, brilliant, charismatic—was in exile. Bose had courted Hitler and Mussolini in the 1930s, had an Austrian wife, and in 1941 had fled house arrest in India through Afghanistan, where he was given a false passport by the Italian ambassador, completing his journey to Berlin through the Soviet Union three months before Germany invaded. In Japan's conquests, Bose saw his chance. The day after Singapore's surrender, Bose met Japanese diplomats in Berlin and begged to be allowed to command the Indian prisoners in Malaya, in effect to re-form the Indian National Army. Tokyo agreed, Hitler agreed, and Bose sailed by U-boat to Madagascar, there to be transferred to a Japanese submarine and taken via the Dutch East Indies to Tokyo and, finally, to Singapore. There he revived the INA as the army of his Provisional Government of Free India. It fought with the Japanese against the British and Commonwealth forces in Burma throughout the war, until March 1945, when the British advance into Burma totally undermined its morale. In the words of one account, as Lieutenant General William Slim's 161st Brigade drove south, "it rounded up parties of dispirited INA, whose only anxiety appeared to be to find out where to 'report in.'" Some twenty thousand of the INA troops were repatriated to India, where they were to be tried for treason, making them a focal point for those striving for freedom from British rule. Protests turned to demonstrations and riots. As it happened, it was Gandhi's pacifism, not Bose's militancy, that came to dominate Indian politics, but it remains true that, in

totally unpredictable ways, the decision to set up the Nakano School in 1937 played a significant role in Indian independence ten years later. Fujiwara played the most crucial part, for "without him it is doubtful whether the INA would have existed."[5]

Fujiwara chalked up another success in Malaya with a man whose story makes a remarkable footnote in the history of Japanese covert warfare. His name was Tani Yutaka, and he became famous as a bandit leader known in Malaya as Harimau, "the Tiger." Just before World War I, his father, a barber, had come to work in Malaya with his wife, bringing baby Tani with him. When he was twelve, his parents had another child, a girl. At the age of twenty, Tani returned to Japan to do his military service but failed the physical because he was too short. He stayed on in Japan to work. By then, Japan had started to build her mainland empire, carving Manchukuo from northern China and earning the hatred of Chinese everywhere, with catastrophic results for Tani and his family. Back in British-ruled Malaya, local Chinese took out their anger on the Japanese community. Among the victims were Tani's family: His father's barbershop was burned and his sister, now eight, killed.

Tani returned to Malaya, radicalized by the tragedy and consumed with hatred both of the Chinese and of the British, who had (in his view) failed to protect his family. In his anger, he turned to crime, for which he was well qualified as a Malay speaker with intimate local knowledge. He gathered a band of Malay and Thai bandits—actually, a small army of between one thousand or fewer, or three thousand or more (estimates vary)—who specialized in robbing trains as well as

[5] Louis Allen, author of *Burma: The Longest War*, in what he called the "postface" to Fujiwara's *F. Kikan*.

routine theft. As his notoriety grew, he acquired his nickname: Harimau, "the Tiger."

As the Japanese prepared for expansion, his skill in mounting what were in effect commando-style raids brought him to the attention of Japanese intelligence. An agent made contact, appealed to his sense of patriotism, and recruited him into the Fujiwara Agency. Come the invasion, Tiger Tani gathered intelligence and led raids on British units, which included derailing a British supply train outside Kuala Lumpur. Unfortunately for him, life in the Malayan jungle gave him severe malaria.

Fujiwara finally met the Tiger, between bouts of malaria, just before the fall of Singapore. "Harimau of Malaya, who had rampaged through Kelantan at the head of several hundred bandits, was, contrary to my expectations, a fair-skinned young man of small stature. His appearance was so gentle and timid that he hardly gave me the impression of being Japanese." A few days later, Fujiwara sent Harimau, now much weaker, to a military hospital in southern Malaya, then on to another in Singapore, where Fujiwara visited him, bringing flowers and some good news. "He was lying in bed amongst a row of other Japanese soldiers. Outside his bedroom were five Malays sitting on their haunches, as if they were servants attending a noble. Their eyes were bloodshot due to sleepless nights of looking after their master. . . . I told him: 'Tani, today I talked to General Manaki of the military government requesting him that you be appointed an officer of the military administration. General Manaki has agreed to it.' His joyful reaction was so overwhelming I was quite taken aback."

Harimau died a few days later. Fujiwara had him commemorated in Tokyo's Yasukuni Shrine, set up after the Meiji Restoration in memory of those who died for the emperor. Then—well aware of the ex-bandit's propaganda potential—he convinced the newly established Japanese movie company

Daiei that his story had commercial possibilities. *The Tiger of Malaya* appeared the following year.[6]

One of Japan's greatest strategic problems—indeed, a prime reason for war—was oil. Japan had a few small fields in Niigata Prefecture, but nowhere near enough. Without more, the carriers, battleships, planes, factories, the tanks and trucks in Manchukuo—all would be useless. There was an excellent source within reach—the oil wells of Palembang, in the swampy, jungly interior of Sumatra, in the Dutch East Indies (which became Indonesia in 1945). The Dutch had every reason to fear an assault, and were prepared. Not that their small defenses would be a match for the Japanese war machine, but, given the difficulty of a one-hundred-kilometer advance either up a small river or through the jungle, they would have ample time to blow the wells up before they could be taken.

What to do? The Nakano School was given the job of finding an answer.

Assistant commandant Colonel Ueda Masao devised a plan: Paratroopers would swoop down in advance of an upriver assault. But no one knew anything much about oil fields, and anyway, Japanese paratroopers had no experience of jumping into them. Nakano's commandant commissioned a small team who spent a month researching newspapers and journals, visiting the Niigata fields, and persuading Japanese companies that had been operating in the region to hand over information and pictures. After a few practice jumps, the paratroopers— six from Nakano, another half dozen army men, all "barely

[6] Not to be confused with General Yamashita Tomoyuki, who commanded the invasion of Malaya, was hanged in 1948 after a controversial trial, and is also known as "the Tiger of Malaya." A 2003 play of this name, by Hiro Kanagawa (Japanese-born Canadian actor, playwright, and screenwriter), is about the general, not the bandit. The two Tigers were linked through Fujiwara, one his boss, the other his employee.

old enough to shave"—set off in mid-January 1942, hopping from southern Japan via Taiwan, Vietnam, and Cambodia to their jump-off point on the Malay Peninsula.

One Nakano man, Lieutenant Hoshino Tetsuichi, with only a few parachute drops under his belt, left a dramatic account of what happened next, one of the most successful paratroop operations ever, wonderfully retold by Stephen Mercado.

Hoshino and his five companions had assumed they would jump in the first wave. Instead, they were told they were relegated to the second. They were incensed. That evening Hoshino accosted an officer to protest, arguing that his group knew the terrain and the facilities better than anyone, while he himself had studied Malay. Moreover, he lied, he had actually scouted Palembang. It worked, sort of: He was given a place on the first jump, though his five Nakano companions were not. That night he tossed and turned with nerves, wondering if he could possibly hope to win over the locals, round up the technical personnel, and disarm the demolition charges in time. The next day, February 14, he was on his way, complete with currency and propaganda leaflets proclaiming in Malay: "People of Indonesia are our friends. We have come down from the skies. Everyone, please put your minds at ease." Below was Singapore, smoking under the Japanese assault, one day from surrender. As they approached their drop zone, the leader called him to the door, pointed to the refinery three thousand meters below, and yelled: "You follow me!" So Hoshino, with no experience in action, found himself second in the invasion. He landed safely and ran through a refinery gate with some others. Seeing some Indonesians in an air-raid shelter, he passed out some of his leaflets and questioned them (so his Malay was up to the mark): 350 troops, no tanks or armored vehicles. He raced on to other shelters, found three captive Dutch technicians, and learned there were no demolition charges, which he confirmed by checking key points. By

evening, his group had secured most of Palembang. The next day, the second company of paratroopers—including Hoshino's five Nakano companions—arrived, as did the main force advancing up the Musi River. The Dutch retreated to Java, and Japan had the oil it needed to fuel its war.

Hoshino was left to spread more propaganda, prepare the way for occupation by troops and petroleum engineers, and to play a later part in the story of Nakano alumni, which will emerge in due course.

Japan's involvement with Burma might have worked out well, if only the high brass had listened to the leader of its covert operations, Major Suzuki Keiji. Suzuki, whose agency employed many Nakano School graduates, was another sort of Lawrence of Arabia figure—more hands-on than Fujiwara, though equally idealistic, equally romantic—as devoted to the Burmese and their independence from British rule as Lawrence had been to the Arabs. As the historian of his exploits puts it, "he devised unorthodox and audacious schemes which left people in astonishment."[7] And like Lawrence, Suzuki was seen as "wild" and sidelined by a conservative and fearful establishment, dedicated not to Burmese independence but to military rule, with dire consequences for Japanese interests in Burma. This is Suzuki's story.

By 1940, British-ruled Burma had become a problem for the Japanese military, because they wanted to control all China, and Chinese nationalists and Communists were fighting back, Chiang Kai-shek's nationalists in particular being supplied by the British from Burma along the 1,120-kilometer Burma Road, newly built by 160,000 Chinese across the eastern Himalayas, which included an infamous twenty-four-bend zigzag descent into China. The way to close the Burma Road was

[7] Izumiya, Tatsurō, *The Minami Organ*, University Press, Rangoon, 1985.

to support the Burmese struggle for independence, headed by Aung San, famous father of a now famous daughter, the pro-democracy activist and Nobel Peace Prize laureate Aung San Suu Kyi. His organization, the Thakin (Master) Party, had of course been banned by the British. In March 1940, Suzuki, a specialist in Anglo-American affairs, then an obscure backwater of intelligence operations, was told to come up with a plan to cut the Burma Road.

Suzuki, with a piercing gaze and "fierce" moustache, seized this chance to make his mark. He entered Burma posing as a journalist under the name Minami Masuyo.[8] Hearing that Aung San and a group of companions had escaped Burma to evade arrest, he used private funds to have Aung San sent to Tokyo, where the two men met. Suzuki, eager to show his fighting spirit, boasted to his guest of killing Russian civilians, including women and children, in Vladivostok when in 1918–22 Japanese troops joined Allied forces to oppose the communist revolution; the Burmese, he said, should fight with equal ferocity against the British, with Japanese help.

Suzuki's wildness spurred his superiors into action. In February 1941, they authorized Suzuki to head his own network, a joint army-navy operation known as the Minami Agency after his nom de guerre. His boss was a Nakano instructor, Oseki Masaji, and his team included five Nakano graduates. Working in Bangkok, they were to back Aung San by smuggling arms into Burma and training his group to become guerrillas—thirty of them, known later as the Thirty Comrades, one of whom was Ne Win, Burma's future military dictator.[9] The uprising was to be in June, after a few months of training in a secret camp on Hainan off China's south coast.

[8] Minami means "south," the direction in which the Imperial Japanese Army was heading.

[9] Ne Win (Brilliant Sun) was his alias. His real name was Shu Maung.

It didn't happen. The Burmese didn't like the authoritarian training regime, nor did they like being made to bow every morning in the direction of the imperial palace in Tokyo. And the Japanese army changed its mind on independence, because they were now planning the assault into Southeast Asia. June passed, with no action. The Thirty Comrades found themselves taken from Hainan to Taiwan. Only in December, after the attack on Pearl Harbor, did the high command turn to Burma. Aung San and the Thirty Comrades were brought to Bangkok, where Suzuki put together a volunteer force, the Burmese Independence Army (BIA), with some two dozen Nakano "advisers"—all to no avail. The imperial army did not want anything to do with the unpredictable Suzuki and his irregulars. Sidelined into a separate mini-invasion, they entered an area of minority groups hostile to the Burmese and pro-British. Suzuki did his dashing best, riding a white horse, leading assaults on local police, railways, and offices of colonial administration. In a separate BIA operation, Ne Win headed a small group, including two Nakano graduates, into Rangoon. But all hopes of immediate independence vanished when the Japanese army, unwilling to relinquish Burma with British India on the doorstep, set up a military administration, promising independence at some unspecified date in the future. Suzuki, his Minami Agency, Aung San, Ne Win—all, like Lawrence and the Arabs, learned the hard way that "imperial interests trump ideals of liberation" (as Mercado succinctly put it).

Suzuki pestered his army bosses to distraction, until they saw him as a rogue element who had "gone native." But he still had influence, directing the BIA, now a force of thirty thousand well stocked with captured arms, and with considerable combat experience, against the retreating British. In May 1942, Burma fell. In a chaotic retreat, British, Burmese, and Chinese fled over the northern borders, just before the mon-

soon struck. On June 11, Japan's army ordered the dissolution of Suzuki's agency and scattered his staff to new appointments (some to the Dutch East Indies, with results detailed in the next section). Aung San, with no political role, was graciously allowed command of the Burma Defense Army, a 10 percent rump of the BIA. He, Ne Win, and the other Thirty Comrades were part of an impotent puppet force, subject to Japanese "advisers" and under surveillance from the dreaded military police, the Kempeitai. Suzuki was transferred to Tokyo, where he spent the rest of the war organizing military transport.

So ended Burma's dreams of independence under the Japanese. Under Suzuki and his ninja-like operation, what had started with such high and liberal hopes foundered on the rocks of Japanese military and political conservatism. Independence of a sort came in 1943, but under a puppet regime. Japan's decision to treat Burma as an occupied nation rather than an ally virtually guaranteed that when events turned against Japan, Burma's nationalists would turn back to the British and lead a behind-the-lines revolt against those who had once seemed their liberators. In early 1945 the BNA's eight thousand men started to fight the Japanese, something that Aung San was keen to do before the British arrived in order to lay the foundations for independence from Britain.

The shadow warriors of Nakano staged one other mission of high drama, because it involved raiding Australia itself just at a time when Japan was on the way to losing the war—high drama, a few comic elements, and absolutely zero significance. So it goes with covert operations. There's no telling what they may lead to.[10]

[10] This section is based on Allen, "The Nakano School." Allen cites no source for this account but gives the impression it is based on a personal communication from Suzuki Hachiro.

In February 1943, the army decided to reconnoiter northern Australia from its base in the Dutch East Indies. Not that they lacked information, because they had very detailed reports from naval intelligence. The problem was that the reports were too good to be true. They suggested an on-the-spot source, and there was none. In the main base of Ambon, the Nakano School graduate Yamamoto Masayoshi decided to check for himself, using his own people and also eight from Suzuki's Minami Agency, who had been redeployed from Burma. Setting up his headquarters on Timor, some 640 kilometers off the Australian coast, he contracted two boats from some reluctant Japanese fishermen, who were nervous of being blown out of the water by the Australian navy. That might happen anyway, Yamamoto told them. Better to have a gun aboard and rely on us to rescue you. But there was another problem: Japanese Nakano alumni did not look much like Australians, whether white or native. So Yamamoto decided to use Timor locals to go ashore, providing a sort of life insurance for them by building huts for all the families.

By the time the operation started, Yamamoto had a little society of some three hundred men, women, and children, all on his payroll. It was proving an expensive business. To pay for it, Yamamoto approached a colleague who was running his own agency, none other than Hoshino Tetsuichi, the same Hoshino who had parachuted second in line to seize the Palembang oil wells. Yamamoto had been Hoshino's senior in Nakano, and he tried pulling rank. Surely Hoshino hadn't used up all his funds? Surely he could use some to help pay for Yamamoto's operation? Surely Hoshino, as the junior, was in the position of a son, and owed Yamamoto help out of some sort of filial duty? Surely imperial funds should be used in the most effective way, whoever controlled them? Hoshino saw the force of these arguments, or perhaps lacked the authority to counter them, and did his bit.

The time came for action. There was a rumor of an Allied naval base being built in King Sound, the fifty-kilometer-wide bay on the coast of western Australia. The Japanese navy wanted the rumor checked out. They couldn't risk it themselves, because Australian planes would sink them. One of Yamamoto's fishing boats would be much more suitable. But, Yamamoto complained, a fishing boat would also be much more vulnerable. Never mind, he was told. This was an order.

The boat, the *Shōei Maru*, was made ready, with an antitank gun fitted to the bow and three heavy machine guns aboard. A light bomber would keep watch above, and for much of the way the crew would be in contact with base by radio. But once they got near the coast, a radio signal would give the game away, so crew and landing party—four Japanese and twenty-five locals—would rely on forty pigeons for land-to-sea communication. At midnight on January 10, 1944, the No. 1 Australian Expeditionary Intelligence Unit set off over rough seas.

Come the dawn, the wind died. The boat approached a speck of an island just over halfway across the Timor Sea. High above, Captain Suzuki Hachiro (nothing to do with "wildman" Suzuki who ran the Minami Agency) in the light bomber spotted a shocking sight—an Australian submarine on the surface, with men preparing an attack. No one on the fishing boat had seen the danger. Suzuki ordered his pilot to open fire, saw the crew race for the conning tower, and as the sub began to dive, aimed a bomb that struck the bows. An oil slick spread across the surface. On the fishing boat, the crew and landing party, finally aware of the threat, waved in relief and delight as the bomber turned for home to refuel.

The next day Suzuki was back, and saw the fishing boat moored in the lee of Browse Island, some 160 kilometers offshore and 320 kilometers northeast of their destination, with the landing party relaxing on the sandy beach, for movement

during the day would have been fatal. Seeing that there was nothing more to be done, Suzuki headed home for the last time. That night the boat completed its journey and entered King Sound. By dawn, it was moored inshore, its superstructure well camouflaged, and the landing party was ashore, searching for the rumored base.

They found absolutely nothing. There was no base. They shot some film to prove it, then made for home. That was the extent of the Nakano School's covert operation in Australia, and the only time that Japanese troops actually landed there.

Back home, the Nakano School faced a stark new reality. Japan's advance had stalled, then been reversed. By late 1943, Guadalcanal, lynchpin of the South Pacific, was lost. New Guinea, the base from which Japan had planned to invade Australia, was held by a small group of irregulars, the Eighteenth Army's Special Volunteer Corps, led by Nakano-trained Lieutenant Saito Shunji. He and two other Nakano men commanded three squads each, 135 men in all, many of them aborigines from the mountains and jungles of Taiwan, famous for their stamina and hunting abilities. In September 1943, carrying explosives, hand grenades, and incendiaries, they made a night attack on an Australian camp, seizing several machine guns and five thousand rounds of ammunition, and killing some sixty and wounding eighty without a single loss. Later assaults on other villages and camps killed three hundred, again without loss.

When briefed on the results, military intelligence drew the obvious conclusion. Intelligence and subversion were no longer enough. The empire needed to focus on unconventional warfare. Since no one could contemplate defeat, it seemed clear that Japan would be at war for a long, long time, and to maintain a foothold in its fading empire it needed commandos not only to undertake guerrilla actions but also to survive

behind enemy lines, gathering intelligence, until the moment came when they could help in reconquest.

The result was the opening of Nakano's new commando training center at Futamata (today part of Tenryu, some two hundred kilometers southwest of Tokyo). Here, in an intense three months, students were taught reconnaissance, infiltration, demolition, propaganda, mapmaking, the military government of occupied territories, and guerrilla fighting techniques, keeping fit with kendo and karate. Much of the training was similar to ninja techniques, and some of it derived directly from them, such as the practice of walking close up against a wall to avoid casting a shadow. One of those who taught there was Fujita Seiko, a shadowy figure who claimed to be the last of the ninjas—of which there have been quite a few, as we will see—and specifically the last of the Kōga ninjas, no less.

One of the 220 at the opening ceremony on September 1, 1944, was Second Lieutenant Onoda Hiroo, later to become Nakano's most famous graduate. He had worked in China, spoke Chinese, and had then served in China as a soldier, perfect background for commando training. He was surprised by what followed:

> It was certainly very different from the officers' training school. Military forms and procedures were observed, but without excessive emphasis on regulations. On the contrary, the instructors kept stressing to us that in our new role as commando trainees, we should learn that so long as we kept the military spirit and remained determined to serve our country, the regulations were of little importance. . . . They urged us to express our opinions concerning the quality of the instruction and to make complaints if we felt like it. We had four hours of training in the morning and four in the afternoon. Classes lasted

two hours each, with fifteen-minute breaks in mid-morning and mid-afternoon. When the time for a break came, everyone piled out of the classroom windows into the yard to have a smoke. There were 230 of us, packed like sardines into one small barracks, and the break was not long enough for all of us to leave and return in orderly fashion through the door. At officers' training school, if anyone had dared leave by the window, the punishment would have been swift and severe. At Futamata it was routine.

In an unimposing collection of wooden buildings, half a dozen expert instructors, all with international experience in diplomatic missions, stressed not only the need for individual initiative and a willingness to develop critical views but also something totally opposed to the samurai tradition of courting or choosing an honorable death rather than face the humiliation of defeat. That tradition was still alive, not in the expectation that defeated soldiers would commit suicide by cutting their bellies, but in other ways. Officers returning from the defeat by Russian and Mongolian troops in eastern Mongolia in 1939 were presented with pistols. In Mercado's words, "Left alone with the weapon, the repatriated officers did what was expected by committing suicide to expiate their 'shame.'" Later, when the war turned against Japan, soldiers would choose a final suicidal charge rather than surrender. The tradition would, in October 1944, find renewed expression in the suicide bombings of the kamikaze pilots. But none of these was the Nakano way, which derived directly from the ninja tradition: first and foremost the mission, only to be fulfilled by staying alive.

At the end of his three-month training, Onoda and his fellow trainees were deployed to where Japan's next and perhaps final battles would be fought: on home ground in the south, in

Okinawa, Tokyo, and the far north, and overseas in Vietnam, Indonesia, Burma, Taiwan, Korea, and the Philippines, which was where Onoda and twenty others were to go.

By 1944, Japanese authority in the Philippines was facing widespread resistance. The Japanese, welcomed as liberators by many in 1942, had squandered all goodwill by their arrogance and brutality. This was not a liberation but an occupation. Often, soldiers slapped local men in the street for not bowing to them. They shot those suspected of being sympathetic to the United States, raped, and stole. Mercado quotes one Futamata/Nakano commando's rueful assessment: The Spanish had brought Christianity in their three-hundred-year-rule, the Americans had brought roads, cars, and movies in their fifty years, but all the Japanese had done in their two years was take. As a result, American guerrillas, preparing the ground for the U.S. return, proved very effective but inspired ever more brutal responses from the Japanese military police. Into this stew of regular, guerrilla, and covert operations came some Nakano graduates, twenty-four of them by September 1944, even as Japanese losses in the Pacific mounted. In October the navy lost four carriers and the super-battleship *Musashi*. Kamikaze pilots made the fight more brutal, fearful, and bitter but would not restore Japan's fortunes. Japan lost airfield after airfield and mounted daring, often suicidal raids to retake some of them, crash-landing transport planes wheels up, firing machine guns and dropping bombs from parachutes, bayoneting sleeping Americans, all to no avail. Next would come the American invasion of Mindoro, then Luzon, the Philippines' main island. Onoda and his fellow graduates were supposed to do whatever they could to disrupt the advance. In all, there were ninety-eight shadow warriors in the Philippines, of whom a third survived the war.

On December 17, Onoda and twenty-one others from Na-

kano flew into Clark Airfield on Luzon and were taken to Manila. Five then traveled on to divisional headquarters in Lipa, an overnight drive away, with Major Taniguchi Yoshimi, boss of covert operations, who had both trained and taught at Nakano. He briefed the five men. Four were to lead groups on the islands of Luzon and Mindoro, while Onoda was told he was to lead a garrison in guerrilla warfare on Lubang, fifty kilometers southwest of Luzon. This was the first he had heard of Lubang. Only twenty-five kilometers long, it was dominated by a jungly spine of mountains and had an airfield and pier, which Onoda was to destroy to slow the American invasion of Luzon.

In the presence of a visiting lieutenant general, Onoda was also briefed by his division commander, Lieutenant General Yokoyama, who reemphasized one of Nakano's main lessons:

> With his eyes directly on me, he said, "You are absolutely forbidden to die by your own hand. It may take three years, it may take five, but whatever happens, we'll come back for you. Until then, so long as you have one soldier, you are to continue to lead him. You may have to live on coconuts. If that is the case, live on coconuts! Under no circumstances are you to give up your life voluntarily." A small man with a pleasant face, the commander gave me this order in a quiet voice. He sounded like a father talking to a child. . . . [In another version of the same occasion, it is the lieutenant general, Chief of Staff Muto Akira, who delivers the pep talk, but with the same message: "Let me repeat, suicidal *banzai* charges are absolutely forbidden."] I vowed to myself that I would carry out my orders. Here I was, only an apprentice officer, receiving my orders directly from a division commander! That could not happen very often, and I was doubly impressed by the responsibility I bore. I said to myself, "I'll do it! Even if I don't have coconuts, even if I have to eat grass and weeds, I'll do it!"

One of his comrades, Yamamoto Shigeichi, born in the same prefecture and also a graduate of Futamata, was told he would be leading fifty men in an attack to retake the airfield at San Jose. He said he expected to die soon. He nearly did, because his group was torn apart during the assault. But he survived, vanished into the jungle, and reemerged eleven years later, in 1956, as a sort of curtain-raiser to Onoda's much more extended experience.

As Onoda prepared to disappear into the jungles of Lubang, his comrades back home were preparing for the ultimate victory-or-death battle, a sort of mass, ninja-style Armageddon. The army was building a massive underground shelter for the emperor in Matsushiro, in the mountains of Nagano (nothing to do with Nakano) Prefecture, a natural fortress in central Japan that would be the heart of the empire's last stand. Industries, too, were shifting into the area. Mitsubishi had two entire cities ready for the construction of its Zero fighters and other weapons. In total, some six hundred other factories had set up in Nagano by the summer of 1945.

All would be defended to the end by shadow warriors co-ordinated by the Nakano School. Now that the Philippines was lost, the next line of defense would be Okinawa and the other Ryūkyū islands that led, like stepping-stones, northward to Japan's heartland. In the Philippines the army had learned that to meet the invaders on the beaches or in open combat was not merely suicidal, it was futile. In Okinawa there was no hope for victory over a vastly superior force, the greatest armada in history. The only aim could be to make the price too high for the enemy to pay, with suicide boats, kamikaze planes, and troops dug into the mountains, exacting losses that would force the Allies to negotiate, and thus spare Japan the humiliation of unconditional surrender.

On every one of the myriad small islands, the military

posted lone shadow warriors who were supposed to organize locals to resist. Eleven were from the Nakano School, and in the guise of teachers. One of them, Sergeant Sakai Kiyoshi, arrived on Japan's most southerly point, a coral island named Hateruma, with a large orange crate containing his uniform, swords, pistols, hand grenades, explosives, and even one of those pens designed to release bacteria into the water supply if the Americans landed. After school, he taught martial arts, exhorted his students not to fear death, giving hand grenades to young girls with the order to use them on themselves if capture seemed imminent.

As it happened, lone individuals would play hardly any role and commando units only a small one in a battle that was the most deadly and costly of the war. In three months—twice as long as planned—Japan's so-called "typhoon of steel" led to the death of some 100,000 Japanese soldiers and 120,000 civilians. Some 1,500 kamikaze attacks sank more than 30 U.S. ships and damaged 400, to no avail. In mid-June, Okinawa was lost, and the Nakano men could begin their real missions—except that it was too late. On Hateruma, Sakai managed to evacuate his charges to a neighboring island, where many died of malaria. On Okinawa itself, Murakami Haruo, commanding the Third Raiding Unit, planned to use his local Okinawan auxiliaries as terrorists, posing as refugees until they received the order to attack. No order came: The United States dropped its two atomic bombs, Japan surrendered, and Murakami led his commandos into captivity. In the far north of the Ryūkyūs, where islanders were angry at their leaders for taking them into war in the first place, they denounced their "teacher" to U.S. soldiers.

The next line of retreat—the site for yet another "final battle"—was Kyūshū, the southernmost of the four islands that make up the Japanese heartland. This would be even tougher for the Americans to take, and might, if it was too

costly, force a negotiated settlement. The plan was to have coastal defense units sacrifice themselves by delaying the invaders on the beaches, and then stopping them in the forested hills of the interior, where fortifications lay far beyond the guns of the U.S. warships. Douglas MacArthur's assault would throw 350,000 men onto the beaches, but they would contend with 2,000 suicide planes, 1,100 conventional aircraft, and 700,000 troops. In this, potentially the greatest invasion in history, the Americans might lose 250,000.

Then, given victory of sorts, there would be the unconventional forces, the guerrillas, trained by some one hundred Nakano men, intelligence people from Manchukuo, China, Southeast Asia. The prime mission was to teach guerrilla warfare to civilians—attacking airborne troops, setting ambushes, conducting night raids, sabotaging—a task undertaken by a group of shadow warriors known as the Kirishima Unit, named after a local shrine and a mountain range. By the late summer, they had trained about five thousand soldiers and ten thousand veterans and civilians. These were the latter-day ninjas who would pick off Americans floating down on parachutes or threading their way in single file through paddy fields.

On the home front, students and staff traveled by train, truck, and even ox cart to a new headquarters in Tomioka, near the emperor's underground shelter in Matsushiro. They would lead the population in mass, nationwide resistance, demolishing facilities, infiltrating, and mounting assaults. Across the nation, Nakano School shadow warriors began drilling everyone—reservists, civilians, men, women, and children—for the coming invasion. For most, there were no weapons except bamboo spears with which to attack American foot patrols. Members of the so-called Izumi ("Spring") Unit, one of the Nakano School's most secret programs, had undergone intensive training beginning in June, focusing on the use of

explosives, hiding out in mountains and valleys, where they would be linked by runners rather than radio. When the time came they would throw off their civilian roles and bring assassination and terror to bear against Allied forces and collaborators. Resistance in the Tokyo area would be handled by the Yashima Unit, after an old name for Japan, whose commander, Arai Fujitsugu, had stocked hill caves with radios, weapons, clothing, and food, much of it taken from downed B-29 bombers. Ten Nakano graduates commanded one hundred men, who would organize civilians to mount attacks behind enemy lines. But in early August, Arai was told to shift his operation to the coast, which would mean certain death when the invasion came. Arai was appalled, and complained to his army headquarters.

Why throw away his men in vain? "What's the point of having them die a dog's death before fighting?" he asked.

"Is life so precious to you?" came the blinkered reply. "The kind of tactics you're talking about aren't written in the Military Academy textbooks."

Of course, Arai and his men did not have to fight and die after all. Ten days later, Japan surrendered.

In the far north, too, in Hokkaidō and beyond, Nakano men prepared for battles that never came. Here they had to consider another possible enemy. Russia and Japan were (and are) old rivals in both the island chains that almost link Japan to Russia—principally the long thin island of Karafuto (the Japanese name) or Sakhalin, and the Chishima (or Kuril) group. In December 1944, an old Nakano acquaintance of ours resurfaced—Suzuki Keiji, mastermind of the Minami Agency and minder of Burma's Thirty Comrades, of whom Aung Sang Suu Kyi's father had been the leading light. Suzuki had been sidelined after objecting too vociferously to Japan's refusal to back Burmese independence. Now here he was on one of the Chishima islands, Etorofu (Iturup in Russian). The

island, a two-hundred-kilometer spine of volcanoes looming above fir forests, had one good feature, a bay that provided fine anchorage. There was a brief operation to train twenty-five officers, fourteen of them from Nakano, to attack enemy ships and their shore-based headquarters, but it lasted only a couple of months, and the focus shifted to Hokkaidō, just in time for the surrender.

Not that their presence would have amounted to anything. When, three days after the atom bombs were dropped, the Soviet Union invaded Manchukuo, Japan's puppet nation on the mainland, Stalin already had Allied agreement that he could, as a reward, have the Chishima Islands. Today, as southern Sakhalin, they are still in Russian hands.

Nakano men were meant to be different, more creative, more flexible than their regular army counterparts. In building their new empire, all were supposedly "liberating" their Asian brothers and sisters. The training made some shadow warriors less arrogant, less xenophobic, willing and occasionally eager to put the interests of other peoples and cultures before their own. But there was nothing in their training that taught respect for the enemy. Of course, almost all governments and almost all high commands like to see their troops hating their opponents, lumping them together as the embodiment of evil. You can't have your men fraternizing with the enemy, because they might then not kill them with quite such abandon. But most wars have been against neighbors, and in most wars ordinary fighting men know that the enemy are also ordinary fighting men doing a job they dislike for some greater cause. In World War I, British and German troops referred to each other as Tommy and Jerry, with a certain affection. In World War II, some commanders won grudging admiration from the other side. But in the war with Japan, not even shadow warriors were touched by such humanity. They believed the

Americans would kill and rape and maim indiscriminately, and did their best to make civilians believe it, too.

(Their attitude had its mirror image. Ordinary American fighting men who watched kamikaze pilots diving to their deaths concluded they were up against some new and perverted form of the human species. It was remarkable, given the horror and inhumanity of the conflict, that in victory American troops often surprised Japanese civilians with their lack of vindictiveness.)

There were, of course, atrocities on both sides. Nakano graduates were on occasion as barbarous in their behavior as any. One particular incident stands out. This occurred outside Fukuoka, which guards Hakata Bay on the southern island of Kyūshū. Fukuoka, Sixteenth Area Army headquarters, had been pounded to rubble by American bombers. Four days after Hiroshima and Nagasaki vanished under mushroom clouds, the headquarters learned from foreign radio stations that surrender was imminent. Some shadow warriors decided to take out their rage and frustration on American prisoners. These men were airmen, and were considered criminals for their indiscriminate, indeed deliberate bombing of civilian areas (let alone the atom bombs of Hiroshima and Nagasaki, and the great fire-bombing raid on Tokyo of March 9, 1945, that killed or injured 120,000 and destroyed 250,000 homes).

On the evening of August 10, Captain Itezono Tatsuo summoned more than twenty shadow warriors, Nakano graduates who had not yet seen combat, and told them that they were to participate in the execution of eight American POW airmen. Permission had been given to practice guerrilla and martial arts training on them, this being a form of execution that had been widespread since 1937. They could use hands, bows and arrows, and swords. It would, Itezono said, boost the morale of his men.

If this was sadism, it was also sanctioned by the culture.

Until late in the nineteenth century, samurai swordsmen had honed their skills by beheading the corpses of prisoners. It was, after all, something they might be called upon to do if they had to participate in *seppuku*, when a man who commits suicide by cutting his belly would be finished off by a coup de grâce from an aide.

The next morning, the prisoners were taken to Aburayama, a forested hill just south of Fukuoka. The prisoners were stripped. One was made to kneel. Itezono asked for volunteers. While others warmed up, practicing karate strokes, a lieutenant took a sword and, when given the go-ahead by a colonel, Tomomori Kiyoharu, beheaded the prisoner with one stroke. Four others were also beheaded. Then came the martial arts exercises. One of the men struck the fifth prisoner several vicious karate blows, and another volunteer beheaded him. Two others died in the same way. The eighth prisoner was forced to sit, while a Futamata probationary officer shot at him with a bow and arrow. The third shot pierced the man's head above his left eye. He was then beheaded.

Colonel Tomomori said that for his men the experience would be valuable for the decisive battle to come.[11]

That battle never came, of course. Japan surrendered instead, nine days after the A-bombs fell. Already the Nakano School, in its new buildings in Tomioka, was dead, condemned by orders to close it from its new commandment, Major General Yamamoto Hayashi. Across the empire, its hundreds of operatives obeyed orders to cease fighting. Though some, meeting in Tokyo, were for rebelling against the decision to surrender,

[11] Later, forty were tried for war crimes. Nine death sentences were handed out but commuted on retrial. Twelve were condemned to life imprisonment, fifteen to prison sentences of twenty to forty years.

they backed down after a major, Hata Masanori, an expert on Germany, pointed out that Hitler's determination to fight to the bitter end was disastrous for his people. Better to obey the emperor, he said, and focus on reconstruction. Even those who planned to continue the war underground as members of the secret Izumi Unit never put their plans into effect. As one American liaison officer and an expert in Japan commented, "When the Japanese were told by the emperor to stop, boy, they stopped." [12] It was an attitude that, once conveyed to General MacArthur, helped ensure there would be no direct military rule by the United States, but indirect, relatively benign rule through a Japanese government.

On August 13, burning documents, weapons, and communications gear sent clouds of smoke billowing over the school's buildings. Two days later, at an assembly in the school's courtyard called by Yamamoto, the staff heard the emperor's voice on the radio calling upon his subjects to "bear the unbearable." Then, wracked with emotion, Yamamoto set fire to the Nanko Shrine, the one dedicated to Kusunoki Masashige, which had been brought from the school's original buildings to Tomioka. A few remained to bury weapons in case of a future uprising. That was the school's formal end. Futamata, its specialist commando branch, closed ten days later.

Other than the small memorials that mark the sites, the Nakano School shadow warriors shared a considerable legacy. As Louis Allen, historian of the war in Asia, puts it: "In the long perspective, difficult and even bitter as it may be for Europeans to recognize this, the liberation of millions of people in Asia from their colonial past is Japan's lasting achievement." [13]

[12] Mercado, *Nakano,* p. 199.
[13] Allen, *The Nakano School.*

*

Fujiwara would have been gratified by Allen's words. His story makes a telling postscript to that of the Nakano School and adds a personal footnote to Allen's conclusion. At the end of the war, he was in Fukuoka, recovering from malaria contracted during the Burma campaign. A few months later he was back in India, subpoenaed to help defend the first three of almost twenty thousand Indian National Army officers being tried for treason by the British. The upcoming trial inspired protests, then riots. The British backed down, the men were released, British prestige plummeted, independence became a certainty. But Fujiwara was kept in India, to face accusations that he, like countless other Japanese, was a war criminal. He spent three months in Changi Prison, in grim conditions. Handcuffed, half-starved, shoved about by guards, Fujiwara was appalled that his agency could be confused with the imperial army. He defended himself vociferously. Transferred to a prison in Kuala Lumpur and reinterrogated, he was cleared of all charges. At the end of his incarceration, he was given a final interview, in a totally different atmosphere. The tall, balding colonel was puzzled. How was it that Fujiwara and his colleagues, who were really no more than naïve amateurs, had proved so successful? His answer is worth quoting, because it captures the essence of the ideals of a tiny minority, which were the complete reverse of the ethos that dominated the Japanese military.

I was at my wits' end when I was given this difficult assignment shortly before the war, when we started out with nothing and with an extremely poorly trained staff. Then I became aware of one thing. The British and the Dutch had made remarkable achievements in the development of industry and in the construction of roads, schools, hospitals and houses, in their respective colonies. They were, however, developed and

built for their own benefit, not for the welfare of the indig-
enous people. . . . The [colonial powers] made no pretence to
understand native national aspirations for freedom and inde-
pendence, but suppressed and emasculated them, [and] had no
love for the local people. . . . I made a pledge with my men
that there was no other way but to put into practice our love
and sincerity. The indigenous people who were hungry for love
reached out for the mother's milk that we offered. I believe this
is the reason for our success.

This was the attitude that infused Japan's wartime shadow
warriors. Yes, it's naïve, even childlike in its simplicity. It never
had a chance to grow up, because the F. Kikan and the other
covert agencies were quickly opposed by the Japanese leader-
ship. On the other hand, Fujiwara would perhaps always have
remained a Peter Pan idealist, because he saw his role as mak-
ing independence possible, not engaging in the complex, dif-
ficult, compromising business of creating new governments.
Love and sincerity can remain pure and simple, if not tested
by reality.

15

TO JAPAN, WITH LOVE

*If you always assume you are facing the enemy, you will never
drop your guard in any way.*

<div align="right">Ninja instructional poem</div>

ON DECEMBER 6, 2011, THE *GUARDIAN* PUBLISHED A REPORT
on the violence that broke out in London and other cities in the
U.K. in August. The article, "Reading the Riots," was based
on 270 interviews with participants. It revealed that the rioters
were young and poor and felt so alienated from society that
they felt no shame at trashing stores and stealing the contents.
In many areas, as word spread of coming violence, few saw
any connection between their actions and the individuals on
the receiving end. Almost all shops were fair game, especially
big stores and those selling clothes and electronic goods. A
major factor in the spread of the riots was the slow response by
the police. The explosion of violence, the absence of immediate
police action, the rage, the heady sense of freedom, the feeling
of power and of entitlement—all combined into a toxic mix.

One nineteen-year-old from Battersea described how he
plundered shops at least twelve times, stashing the stolen

goods in a hiding place: "I felt like I was a ninja, on a mission
... like I was jumping in all the shops, using front rolls, yeah,
run in there, get a bag out there quick ... tie it up, put it back
on my back, roll out, run to my little road that I know no one
else knows."

"*I felt like I was a ninja.*" Here is a young man untroubled
by morality, whose sole purpose at that moment was theft,
which had to be done surreptitiously, and this, he imagines,
was what ninjas did.

That pretty much sums up today's popular image of the
ninja—the man in black whose task in life is to break, enter,
steal, and kill (luckily our young rioter did not come up against
opposition). He felt like he was "on a mission," but the only
mission was self-serving theft. No sense of family or a cause.
He was not part of a gang. He was not gathering information
that would help others. In brief, other than being a loner, his
use of the word *ninja* bears no relationship to the historical
ninja. Where did it all go wrong?

As for the international appeal of the ninjas, it's largely the
fault of Ian Fleming, creator of James Bond. Bond is, in any
case, a Western ninja—dependent on and utterly loyal to his
boss, M, a master of unarmed combat and of fighting with a
variety of exotic weaponry, an infiltrator, gatherer of infor-
mation, assassin, and above all a survivor. Fleming does not
make the comparison himself, until the last Bond book before
his death, when Bond actually becomes a ninja.

The idea seems to have come to Fleming as the result of a
trip to Japan in 1959, when he went for three days to research
an article for a *Sunday Times* series entitled "Thrilling Cities"
(subsequently republished in a book of the same name). That
was enough to introduce him to martial arts, then reemerg-
ing from the shadows at the hands of enthusiasts. His guide
was "Tiger" Saito, editor of an annual magazine on Japan

produced by the Japanese Embassy in London. "Tiger" was "chunky, reserved, tense . . . he looked like a fighter—one of those war-lords from Japanese films." Together, they shared a "cheerful and excellent luncheon" with the writer Somerset Maugham, who had by chance just arrived on a visit. Fleming claimed they were friends, their friendship being based on the fact that eighty-four-year-old Maugham "wishes to be married to my wife, and he is always pleased to see me if only to get news of her." The real link was that Maugham had been a spy in Russia, an experience reflected in the fictional adventures of Ashenden, the archetype of the secret agent and much admired by Fleming. Maugham referred to Ashenden's boss by his initial (C.), a device copied by Fleming, who named Bond's boss M. Anyway, the three went off to watch a display of jujitsu. No mention of ninjas.

But five years later Fleming set his twelfth Bond novel, *You Only Live Twice*, in Japan, and built on the subject of martial arts. The novel has some rather dark themes. Bond's wife has been murdered by the master criminal Ernst Stavro Blofeld, founder of SPECTRE, the Special Executive for Counter-intelligence, Terrorism, Revenge and Extortion. Bond is depressed, drinks too much, gambles too much. Later, his girlfriend, Kissy, gets pregnant. There are subtexts about the decline of empire, Britain's lack of moral fiber, and the rise of America to world domination. He is given one last chance. The real-life Tiger Saito becomes Tiger Tanaka, head of the Japanese Secret Service. Bond's job is to get from him vital information about Soviet plans to destabilize the world by testing nuclear weapons and then using them as a threat. In exchange, Tanaka sets a challenge for "Bondo-san" (as Fleming points out, Japanese prefer to end words with a vowel).

A certain Dr. Guntram Shatterhand, a Swiss multimillionaire and amateur botanist with impeccable credentials, has created a castle estate, which includes a pool of piranhas and several

death-dealing volcanic fumaroles, and in which he grows nu-
merous fatally poisonous plants. It's a wild premise, but made
credible because Fleming lists the plants, all twenty-two of
them, with their effects, and classes them in six categories of
poisons. This "Castle of Death" attracts would-be suicides,
for as is well known, Japanese seeking to restore honor do so
by committing suicide. Hundreds have entered Shatterhand's
estate and chosen to die horrible deaths. This is an embarrass-
ment to the government. Shatterhand, who protects himself
from poison by wearing armor, has committed no crime and
is immune to prosecution. Bond's task is to take on the role
of Saint George, to redeem Britain's tarnished image, to enter
this "Castle of Death and slay the Dragon within." Success
will qualify him to receive the information he seeks.

As part of his training, Tanaka plans to take Bond to his
Central Mountaineering School near Kyoto.

> It is here that my agents are trained in one of the arts most
> dreaded in Japan—*ninjutsu*, which is, literally, the art of stealth
> or invisibility. All the men you will see have already gradu-
> ated in at least ten of the eighteen martial arts of *bushido*, or
> "the ways of the warrior," and they are now learning to be
> *ninja*, or "stealers-in," which has for centuries been part of the
> basic training of spies and assassins and saboteurs. You will
> see men walk across the surface of water, walk up walls and
> across ceilings, and you will be shown equipment which makes
> it possible for them to remain submerged under water for a full
> day. And many other tricks besides. For of course, apart from
> physical dexterity, the *ninja* were never the super-humans they
> were built up to be in the popular imagination.

So it is. The school is a castle where ninjas—dressed in
black, of course, with their heads hooded—stage a mock in-
vasion of the Castle of Death. They skim across the moat on

wooden floats and scale the immense wall. One weakling falls to his death. Inside, attackers and defenders whack one another with staves, leaving many unconscious or groaning in pain, but none the worse, apparently, for blows to the groin. Bond sees ninja armament: throwing stars, caltrops, hollowed bamboo for breathing underwater—all the paraphernalia of ninja tourist museums.

Later, relaxing on a pleasure steamer, Tanaka tries to interest Bond in haikus, quoting some of Bashō's. "Do me a favour, Bondo-san. Write a haiku for me yourself. I'm sure you could get the hang of it. After all, you have had some education." Bond admits to some rusty Latin and Greek, and tries his hand at one.

> You only live twice:
> Once when you are born
> And once when you look death in the face.

Tanaka applauds the sincerity, but really it's a disaster—too many syllables, and an odd first line implying many lives. But it provides the novel with its title.

Bond asks how the ninjas can take stave blows to the groin. "That might be of some practical value to me instead of all this waffle about poetry." Tanaka explains:

> You know that, in men, the testicles, which until puberty have been held inside the body, are released by a particular muscle and descend between the legs? . . . Well, by assiduously massaging those parts, [the warrior or sumo wrestler] is able, after much practice, to cause the testicles to re-enter the body. . . . Then before a fight, he will bind up that part of the body most thoroughly to contain these vulnerable organs in their hiding-place. Afterwards in the bath, he will release them to hang normally. It is a great pity it is now too late for you to practise

this art. It might have given you more confidence on your mission. It is my experience that agents fear most for that part of the body when there is fighting to be done or when they risk capture. These organs, as you know, are most susceptible to torture for the extraction of information.

Only now does Tanaka brief Bond about his target. Wonder of wonders, Shatterhand is none other than his wife's murderer, Ernst Stavro Blofeld. Suddenly, this is no longer an official assignment. It's personal. Bond wants revenge. "And with what weapons? Nothing but his bare hands, a two-inch pocket knife and a thin chain of steel."

First, though, Bond has to get to the base of the castle wall. He will do this from an island that is home to the Ama people, who make their living diving for *awabi* (abalone) shells. For this he becomes a ninja, adopting the persona of an anthropologist coming to live with the Ama. He goes out to sea with the daughter of his hosts, accompanied by her pet cormorant, which is trained to catch fish. The girl is, of course, his next love, Kissy Suzuki, who was briefly in Hollywood, and therefore English-speaking, before returning to her island life. After a few idyllic days, she insists on swimming with him across the half mile of ocean to the castle. It's night. He climbs in, dressed in his ninja gear, which is "as full of concealed pockets as a conjurer's tail-coat," with numerous useful bits of equipment. He finds a base in a garden shed, makes a stealthy survey, identifies sulfurous fumaroles and the piranha pool, witnesses two suicides, hides, and sleeps through the day.

That night he breaks into the castle, is captured and placed above a geyser that erupts under tight control at regular intervals. Interrogated by Blofeld, Bond manages to strangle him, upset the timing mechanism of the geyser, and escape, using, of all things, a balloon (over the top, even for Fleming). The castle is blasted to bits by volcanic action. But, while escaping,

Bond is wounded in the head and loses his memory. Kissy rescues him, nurses him for weeks, reignites his dormant sexuality, and is soon pregnant.

Meanwhile, back home, it's assumed he has died. M writes his obituary in *The Times*, with a witty reference to "a series of popular books written around him by a personal friend and former colleague of James Bond. If the quality of these books, or their degree of veracity, had been any higher, the author would certainly have been prosecuted under the Official Secrets Act." The book ends with Bond, unaware of Kissy's pregnancy, wondering about his past, intrigued by the word *Vladivostok*, which he sees in a scrap of newspaper. It suggests another name: Russia. "I have a feeling that I have had much to do with this Russia," he says, and determines—with Kissy's brokenhearted consent—to go there in pursuit of his memories and his past life.

Fast-forward three years to the film version. The dark themes are ditched in favor of action, gimmicks, and a few "sex" scenes so unbelievably coy it hardly counts as sex these days. The plotline is irredeemably ludicrous, even more so than Fleming's. So is the script, as the writer, Fleming's friend and children's book author Roald Dahl, well knew. Blofeld is set on igniting a war between the United States and the Soviet Union. This he does by launching a spacecraft that gobbles up the satellites of both powers and miraculously vanishes with them, turning both sides toward war. Blofeld's castle is replaced by a volcano, inside which is a space center, source of the cannibalistic spacecraft. The crater floor slides back when the rockets take off and return. Today, it is about as convincing as the original *King Kong*. But it made its budget back four times over. One thing the film kept was the idea that Bond should work with ninjas, who overwhelm Blofeld and his evil empire in the climax.

The film needed a consultant. In the West, there were none. The most obvious choice was Donn Draeger, ex–U.S. marine, veteran of the Pacific and Korean wars, founder of the U.S. Judo Federation, expert in many martial arts, and prolific author, but as yet no expert on ninjas.

There were, however, ninja experts in Japan—not many, because all martial arts had been banned in 1945 by the Supreme Command Allied Powers (SCAP) as symbolic of Japanese militarism. Besides, many—perhaps most—Japanese themselves looked upon all martial traditions as part of the folly that had led them into war in the first place. The ban was repealed in 1948, with martial arts undergoing a steady renaissance in the following years and increasing popularity in books. A favorite theme was suggested by the Nakano Spy School. Japan found its equivalent of James Bond in Ichikawa Raizo, who appeared in six spy films, waging desperate battles against both foreign spies and regular officers of the Japanese army. In the martial arts, the revival was led by the few who had kept the old traditions intact through the war years. The most famous of these was Fujita Seika, the self-proclaimed "last of the ninjas"—but he died in 1966, as filming of *You Only Live Twice* got under way.

So while in Japan coaching Sean Connery in martial arts techniques, Draeger recruited Masaaki Hatsumi, who was seeking to establish himself as a *ninjutsu* master with his teacher, Toshitsugu Takamatsu,[1] who had his own claims to fame. He lived in Kashihara, near the Forty-Eight Waterfalls, the heartland of the Iga ninjas. As a young man in the early twentieth century, he traveled through Mongolia, taught martial arts in China, and was bodyguard to the last Chinese emperor, Puyi. One of several "last of the ninjas," he is said to

[1] Because both these two are known internationally, their family names are usually placed last, following the Western tradition.

have won twelve fights to the death and gouged out the eyes of one of his attackers, while somehow avoiding the attention of the police. Both were great self-publicists, and both involved in the Japanese film *Ninja Band of Assassins* and its many sequels. Soon Hatsumi was on set, waiting to offer advice. Apparently, he was not called upon much, though he did get a walk-on part as the photographic assistant to Tiger Tanaka.

Perhaps he expressed surprise when he saw the so-called ninjas in action. Bond arrives alongside a castle by helicopter. It is in fact Himeji Castle in Hyōgo, a fine example of a restored seventeenth-century keep, all gray-tiled roofs and upturned eaves, with a maze of interlocking walls and gates. Blofeld's rocket has just consumed a Russian satellite. Tiger Tanaka and Bond greet each other with information known to the other, which is normally banned in Hollywood scripts. But Dahl was not going to throw away the chance of a good line:

TANAKA

Bad news from outer space.

BOND

Yes, I heard. This time the Russians are accusing the Americans.

TANAKA

Next time it will be war.

BOND

We'll have to get down into that volcano.

TANAKA

I agree.

> BOND

We'll also need a company of first-rate men. Do you have any commandos here?

> TANAKA

I have much, much better. [A beat] *Ninjas!* Top secret, Bond-san.[2] This is my ninja training school.

Instant cutaway to several dozen iron-hard men in judo gear punching, wrestling, and hacking away at one another with staves. This top-secret operation is conducted in full public view, in brilliant sunshine, to a chorus of ferocious yells. Bond is a little slow, which gives Tanaka a chance to define ninjas, over a cacophony of grunts and screams.

> BOND

Ninjas?

> TANAKA

The art of concealment and surprise, Bond-san.

Perhaps Bond—or Dahl—is being ironic, for there is nothing ninja-like about these very unconcealed fighters. They are martial art experts and, as their assault on Blofeld's space center shows, commandos, expert in mass assaults, rappeling, and modern weaponry. Also, like samurai, they are quite prepared to die. They are the very opposite of shadow warriors. Real ninjas, operating in small numbers at night, don't make for huge, expensive, rip-roaring set pieces.

[2] Not "Bondo-san," as in the book. Fleming liked authenticity. Mass-market moviemakers don't much care.

No matter. It was the film more than the book that popularized the term *ninja* in the West.

The film also gave Hatsumi a terrific leg up into the role he has played ever since as the latest, greatest exponent of his branch of *ninjutsu*, Togakure. In his hands, *ninjutsu* became a martial art with an impressive pedigree. He established Togakure as a *ryu*, a school, of which he is the thirty-fourth head. He is the founder of an international martial arts organization, the Bujinkan, and the author of many books. He says he inherited his title of *soke*, or head of his *ryu*, from Takamatsu, behind whom—writes Hatsumi—"eight centuries of history and tradition stretch all the way back to the founder of our system, Daisuke Nishina of Togakure Village" in Nagano Prefecture. Hatsumi backs these impressive claims by listing the thirty-three preceding Togakure heads and by referring to "ancient ninjutsu documents that I inherited from my teacher," one of which supposedly lists the eighteen "levels of training" of ancient *ninjutsu*.

All this and more is repeated as fact on many websites and in many books. And for all of it the only source is Hatsumi himself. No one else has confirmed the existence, let alone the contents, of the "ancient scrolls." The result is that a few skeptics began to wonder about Hatsumi's authenticity. As one ninja expert told me, "Nobody ever said there was a ninja martial art until Takamatsu came along. He taught it to Hatsumi. I think he made it up." Skepticism even has spread to Wikipedia, which flashes up warnings: "factual accuracy is disputed," "needs additional citations," "has multiple issues," "needs attention from an expert."

This controversy is a minefield. The *ninjutsu* community seethes with claim and counterclaim on the subject of authenticity. The reason for these high passions lies in the way skills and authority are passed down the generations, from master

to pupil, in direct line of succession, rather as authority is passed in Islamic tradition, or the authenticity of a Shugendō mountain established by tracing its traditions back to the revered priest who "opened" it. Coming to Hatsumi as a pupil, an outsider like me would be impressed by his actual teaching: Does he teach the skills he claims to? But for martial artists, authenticity lies more in the lineage. Tracing it back a couple of generations is not good enough; eight hundred years carries conviction. But if it's a made-up tradition, there are those who will feel betrayed, as if, in the words of my rather-not-be-named expert, "they have been rolling around on the floor for the last twenty years for nothing."

Though Bond did his bit to popularize ninjas in the West, in Japan, ninja lovers had no need of him. There, a boom was already under way in film, TV, books, and the graphic novels known as manga, with effects that show little sign of fading. This was fertile ground, because there had been a mini boom in ninja fiction earlier in the century, in the form of the fictional Sarutobi Sasuke, boy hero of children's literature between 1911 and 1925, resurrected in 1950s manga.

Another boost came in 1958, when the novelist Yamada Fūtaro published a tale with pseudo-historical roots: *Kōga Ninpōchō (The Kouga Ninja Scrolls—Kōga* becomes *Kouga* because in some transliterations all macrons are represented with a *u*). The context is the unification of Japan in the early seventeenth century, the geographical setting Iga and Kōga. That's pretty much it as far as history is concerned. Kōga and Iga, far from being allies, have been at each other's throats for four hundred years. But at present they are held apart by a truce arranged by Hattori Hanzō. Yamada's ninjas, cut off for centuries in their mountain fastness, have interbred and evolved into magical beings, monsters or beauties who can fly, shape shift, and deploy outlandish fighting skills. One can

spurt blood from every pore, another is a slug-like creature without limbs, a third has a body like jelly that can absorb sword blows and squeeze through the narrowest spaces.

Here's a sense of the fairy-tale quality of the stories, taken from the beginning of the first and most successful book. Two ninjas, one from Kōga and one from Iga, are fighting five warriors each, before turning on each other. Shougen, the Kōga ninja, is a hideous creature with bumpy forehead, hollow cheeks, long gray limbs bloated at their ends, a humpback, and red dots for eyes. He climbs a wall, backward, with one hand and two feet, the other hand still wielding his sword. He spits a glob of thick, sticky mucus, which blinds his five opponents. Meanwhile, the Iga ninja, Yashamaru, is a beautiful youth, with cheeks the color of cherry blossoms and shining black eyes.

> He drew out a black ropelike object. This "rope" had immense power. It was incredibly thin, yet had the strength of steel wire. Even a direct chop from a sword could not cut it. During the day, it shone with dazzling brilliance. But once the sun went down, it became completely invisible. . . .
>
> The rope had been forged through a special technique: Black strands of women's hair had been tied together and sealed with animal oil. A mere touch of the rope upon human flesh had the same effect as a blow from an iron whip. As the rope coiled around the thighs and bodies of the defeated soldiers, their skin burst open as if sharp swords were slicing them. Several dozen feet long, the rope moved like a living creature—spinning, twisting, striking, encircling, and amputating the limbs of its enemies.

The book's plot centers on the question of who will succeed Japan's unifier, Ieyasu, now seventy-three. Which of two grandsons should he choose? A monk provides the an-

swer. Ieyasu should decree an end to the truce. Let ten ninja warriors from each side fight one another, until one side is exterminated. The clan of the survivors will decide on the succession, with the added advantage that the top ninjas will have exterminated one another. Two scrolls—the scrolls of the book's title—record the names of the warriors. Meanwhile, in Kōga and Iga, two young people have fallen in love. They are Gennosuke from Kōga—a graceful, intelligent boy with long eyelashes—and Oboro of Iga, whose beauty shines through her veil. This is the story of two houses, both alike in dignity, and of star-crossed lovers. Can romance heal a four-hundred-year rift? Or are they doomed? Doomed, as it happens: All twenty die, the lovers being the last to go.

The story, with its magical elements, burrowed into Japanese culture. Yamada wrote another twenty-three ninja novels over the next decade, many of them being turned into films. A five-volume manga adaptation of the first book is available in English. In 2005, almost fifty years after it was first published, the story became a feature film, *Shinobi: Heart Under Blade* (the subtitle recalling the hidden meaning of the kanji sign), all gorgeous landscapes, beautiful people—though with five warriors per side rather than ten to make things simpler—and much magical fighting.

Other ninja novels, manga, films, TV series, and video games are too numerous to mention, with two exceptions.

No account of modern ninja literature can omit *Naruto*, the multivolume manga series by Masashi Kishimoto. This is pure fantasy, with no pretense of any historical roots, and phenomenally successful, easily the best-selling manga of all time, with almost 60 volumes—113 million copies—sold in Japan. The anime versions (220 episodes in Japanese, 209 in English) and video games and novels and card games and on and on and on have all had equivalent success.

Second, with even less connection with reality, is the bril-

liant, bizarre phenomenon of the *Teenage Mutant Ninja Turtles*. The idea sprang as a parody of several different comics from two young artists, Kevin Eastman and Peter Laird. In the late 1980s, their rough, self-published seed grew overnight into a cultural and commercial beanstalk, with comics, TV series, films, toys, games, songs, and a parody of its own (*Adolescent Radioactive Black Belt Hamsters*).

And a backstory:

Once upon a time in Japan, a handsome young ninja master named Yoshi, who had a pet rat called Splinter that copied his every ninja move, loved a beautiful girl named Tang Shin. He had an evil rival called Saki. Rather than risk a fight between the two rivals, Shin persuaded Yoshi to flee with her to America, plus rat. They settle in New York. But one day Shin and Yoshi are murdered by Saki, leaving the rat, now a ninja master, to fend for himself in the sewers. There Splinter finds four baby turtles in a puddle of radioactive slime. They are mutants. They grow, and speak. He names them after Italian artists: Leonardo, Raphael, Donatello, and Michelangelo.

What is this all about? Teenagers certainly, especially New York teenagers, who are, as parents know, mutants, if not aliens, with a language of their own. But there are many other possibilities, principally assimilation versus non-assimilation.[3] The turtles are immigrants who modify their traditions to fit in with the American way. Rat and turtles bond, just as the poor and dispossessed on the Statue of Liberty are supposed to do. They love pizza, which they slice with ninja weapons. They have nicknames. They are streetwise, slang-talking, powerful individuals, yet bonded by their code into a Democratic Brotherhood. They like girls, in the form of their mother figure, April O'Neil (God forbid the turtles should fancy one

[3] The idea is well explored by Nora Cobb, in "Behind the Inscrutable Half-Shell."

another). They oppose the evil Shredder (Saki), who is a criminal non-assimilator in black kimono and preys on vulnerable child dropouts. In brief, they are archetypes, with echoes of the Four Musketeers, Robin Hood, and Peter Pan, but with something very reassuring to middle America and a little disturbing for the rest of us: They are separate, they cannot truly assimilate, they cannot reproduce, they cannot threaten the old white, dominant culture.

What it's not about is ninjas, except in terms of weapons and their dress, which keeps them together, yet apart from mainstream society.

Fantasy, it seems, is crucial for the survival of ninjas in today's world. It certainly was for the man who all this while had been surviving in the jungles of the Philippines, but for him it was fantasy of a totally different sort.

16

THE LAST OF
THE NINJAS

If guiding and planning the way whilst moving position, the essential information you must bring are the mountains, the rivers, and the distance from the enemy.

<div align="right">Ninja instructional poem</div>

ONODA'S STORY OF SURVIVAL IS EXTRAORDINARY ENOUGH. Anyone able to live alone for thirty years, close to civilization but apart from it, deserves admiration. But in what follows perhaps the most extraordinary thing, not so much admirable as simply astonishing, is his motivation, his mind-set, his determination to cling to his mission, a commitment based on his unshakable belief that World War II was not over.

That belief derived from his training not just as a shadow warrior but as the product of a society in which loyalty had been the very stuff of life for centuries—loyalty to one's lord and to the semidivine emperor, loyalty so powerful that it suggests evolutionary or IT metaphors: "inbred," "hardwired," "part of the DNA." "Programmed" is a better analogy.

Onoda's loyalty was to his division commander. Once he was programmed with his mission, only his commander could deactivate him with new orders. For thirty years, no new orders arrived. Therefore everything that happened had to be interpreted in the light of the old ones. For those thirty years, Onoda's mind ran a program that treated all evidence contrary to his worldview as a virus to be rejected. Those who suffer from such programming are often too far removed from reality to be considered sane. But Onoda was perfectly sane, and his programming was not *totally* rigid. He recognized reality when he was finally able to see it clearly. Given the right "input," his old worldview collapsed, freeing him to adopt a new one, pretty much in line with one that we call normality.

But where, we have to ask, did his loyalty come from? Whence this extraordinarily rigid belief that orders from a superior must be obeyed, absolutely? Of course, most armies train their fighting men to obey instantly, without question. But Onoda's training as a shadow warrior had specifically told him that orders could be questioned, that he had to remain flexible in his responses.

He was a living paradox. Programmed to be creative and show initiative, he deployed his creativity and initiative in proving to himself that the world was not as it seemed but as he wished it to be. For comparable examples of faith carried to extremes, you usually have to look to closed systems: churches, dictatorships, cults, lunatic asylums. But Onoda was and is unique: tough and dedicated, of course, but also as humane and moral as a fighting man can be. Today, at ninety, he works for his own children's charity.

Onoda arrived in Lubang with a cargo of explosives aboard a motorized sailing boat whose captain kept making the dangerous crossing because he made money importing cows from the island. He, a newly trained lieutenant, was supposed to

lead about two hundred men divided into army, radar, intelligence, and naval sections. But he had no authority to command. He could only lead if others followed, and they didn't. They had high hopes of leaving Lubang, and objected to an attack on the airfield because it would be needed when—not if—Japan started to win. Nor would they agree to guerrilla war. They were true Japanese! They would repulse the enemy or die fighting! With little help, Onoda shifted his explosives to a base at the foot of a mountain and fell into an exhausted sleep.

Two days later, on January 3, 1945, a yell from the mountaintop summoned him. There, through his binoculars, he saw an astounding sight: the U.S. fleet heading north—battleships, aircraft carriers, cruisers, light cruisers, destroyers, some 150 troop transporters, and more landing craft than he could count. The invasion of Luzon was about to begin. It was perhaps Onoda's coded shortwave radio message—no one is certain, even now—passed from base to base, that triggered the Japanese response: waves of kamikaze pilots, who sank 25 U.S. ships. It was the beginning of a long, hard campaign, for the Japanese had already withdrawn into Luzon's interior, where they would continue resisting until almost all were killed.

On Lubang, Onoda failed to fulfill the first part of his mission. He had set charges on the pier, but they didn't work. He could not get the other men to help destroy the airfield. Besides, he soon realized that blowing holes in the runway would delay landings by no more than a day or two. But he did what he could. He recalled the story of how the great Kusunoki Masashige, defending Chihaya Castle in 1333, set up straw men to draw the fire of the enemy (the incident detailed in chapter 5). Kusunoki's statue, remember, stood outside the Nakano headquarters.

I decided to take a leaf out of Masashige's book. With Lieutenant Suehiro's assistance, I gathered up pieces of airplanes that had been destroyed and laid them out to look like new airplanes, taking care to camouflage them with grass. As I think back on it, the scheme sounds rather childishly simple, but it worked. After that, when enemy planes came, they invariably strafed my decoys on the airfield. At that time, they were coming over every other day, and we utilized the other days to put together fake airplanes. I considered it good guerrilla tactics to make attacking planes waste as much ammunition as possible.

A suicide group turned up, seventy of them, boats laden with explosive, expecting to be fed. But food could come only from the locals, and they were unwilling to help. The Japanese did what so many had done: They stole, and further alienated the locals. "My heart was sinking," Onoda writes. "What can you do with a bunch of idiots?"

At the end of February, American troops arrived, with a sea and air bombardment, followed by a battalion-strong landing. All Onoda could do was retreat into the hills to avoid detection, while the others, "babbling about dying for the cause," succumbed to disease or got shot. At one point, he helped twenty-two sick men prepare charges to blow themselves up when the U.S. troops appeared. "Later, I came back to the place and found no trace of either the tent or the twenty-two corpses. Nothing was left but a gaping hole in the ground. I just stood and stared at that awful hole. Even the tears refused to come." After three months, only three dozen remained alive, with him the only officer. They decided to split into groups. Onoda was left with just two others, living on iron rations for the next six months, shooting a cow for meat now and then, keeping in occasional contact with the other groups.

In mid-October, they found a leaflet in Japanese: "The war

ended on August 15. Come down from the mountains!" None of them believed it, because only a few days earlier one of the groups had been fired on. How could that happen if the war was over? This was a delusion embraced by all, but already Onoda was in a class of his own. He decided he would go on with his self-selected task, to keep clear of the other "disorderly, irresponsible soldiers" and "to study the terrain so that I could be useful when the Japanese army launched its counter-attack."

At the end of 1945, they saw their second surrender leaflet, dropped by a B-17 bomber. It was an order to surrender signed by General Yamashita Tomoyuki, "the Tiger of Malaya," conqueror of Singapore and ex-commander of the Fourteenth Area Army. Nothing could have carried greater authority. But Onoda was in the grip of his faith. He pounced on an obscurity in a sentence, which said those who surrendered would be given "hygienic succour" and "hauled" to Japan, whatever that meant. Also it said that Yamashita was responding to a "Direct Imperial Order," which neither Onoda nor anyone else had heard of. "I could only conclude that the leaflet was phoncy. The others all agreed with me. There was no doubt in our minds that this was an enemy trick."

In 1946 many of the Japanese surrendered, while the others were all short of food and kept begging Onoda for his carefully limited supplies. He told them sternly, "You men made pigs of yourselves when you had rice, so now you don't have any. Don't come asking me to give you any of ours. I was sent here to destroy the airfield, and I still plan to do it. We're eating as little rice as possible. If we give you rice, we'll all be in trouble."

There were more leaflets urging surrender, and Onoda heard people calling in Japanese. Those who had surrendered also left pencil-written notes. But still he and his three companions refused to believe the war had ended. "We thought

the enemy was simply forcing prisoners to go along with their trickery."

They were now the only ones holding out on Lubang and formed a tight-knit group: Corporal Shimada, the oldest at thirty-one, tall, fit and cheerful; Private Kozuka, twenty-five, very reticent, rarely speaking unless spoken to; Private Akatsu, twenty-three, a shoemaker's son and the weakest both emotionally and physically, in a word a liability; and twenty-four-year-old Onoda, who kept them together not by giving orders but by persuasion, always taking care to match the workload with the strength of the men. Each had a knife, a rifle with several hundred rounds, a bayonet, two hand grenades, and two pistols.

They established a routine: moving around the mountains, steering clear of local groups coming up from the plains and coasts to work, entering campsites in search of rice, always examining signs—ashes, leaves, tree stumps, footprints—to assess how long the workers had been there and whether they would be returning, sometimes taking rice, and if so always moving to a new location, staying only a few days in any one place, working in a rough circle.

In all this, Onoda's training was of little use. Guerrilla warfare was almost impossible. It took all his time and energy just to survive. He needed to know how to make fire without much smoke, how to make a net, how to hunt for food, how to sneak bananas from plantations, how to kill and butcher cows (more on this important subject later).

So life continued for another three years. Eventually, Akatsu, the weakest link and the least trustworthy, could not take it anymore. "Unlike me, he had no assignment, no objective, and the struggle to keep alive here in the mountains may well have come to seem pointless to him." So he disappeared, presumably to surrender. As it happened, he was on his own for six months before giving himself up, not that Onoda knew

it at the time. But the following year Onoda found a note left by Akatsu saying that Filipino troops had greeted him as a friend.

Soon after Akatsu vanished, the three survivors heard a loudspeaker telling them in Japanese they had "seventy-two hours" to surrender, or a task force would come after them. Again Onoda found a reason to doubt. Japanese didn't refer to three days as seventy-two hours—"still more proof that the war had not ended." Anyway, he could not contemplate surrender, for a very good reason:

> I had come to this island on the direct orders of the division commander. If the war were really over, there ought to be another order from the division commander releasing me from my duties. I did not believe the division commander would forget orders that he had issued to his men. Supposing he had forgotten. The orders would still have been on record at division headquarters. Certainly somebody would have seen to it that the commander's outstanding orders were properly rescinded.

After that, Onoda speeded up the trips around their circuit, firing on locals whenever they saw any, for "we considered people dressed as islanders to be enemy troops in disguise or enemy spies." Their confidence grew, for they knew the whole area intimately. It would take a battalion or two to find them. Patrols of fifty or a hundred were no threat. Far from it—Onoda relished the challenge. They were only three men, but they were healthy, motivated, and fit. "We were making a force of fifty look silly. That is the kind of warfare I had been taught at Futamata."

They got used to their life and even had times of contentment, sitting in a shelter, listening to the familiar sounds of the forested hills, talking about the old days in Japan. Shimada would describe his daughter ("I guess she must be old

enough to like boys now"), wonder if the child his wife had been expecting was a boy or a girl, reminisce about dancing at a festival.

In February 1952 a small plane circled overhead, calling their names through a loudspeaker. It dropped leaflets, including letters and photographs from the families of all three men. One was from Onoda's oldest brother, Toshio. It mentioned the man who had brought the letter to the Philippines, said the war had ended, told Onoda that his parents were well—all proof enough, surely, that the war was over and that the men could surrender at last with their integrity intact.

Not a bit of it. "My reaction was that the Yankees had outdone themselves this time. I wondered how on earth they had obtained the photographs. That there was something fishy about the whole thing was beyond doubt, but I could not figure out exactly how the trick had been carried out."

In this way, Onoda shored up his illusory world, an illusion that could be sustained not simply by remaining committed to the ethos of wartime Japan as promulgated by the Nakano School but also by becoming an ever-more-expert shadow warrior, indeed far more expert than any other. He was the ultimate ninja, the man with a mission who would do anything to survive and fulfill it.

A month later they heard another loudspeaker. This time it was (supposedly) a journalist, from *Asahi Shimbun*, wanting an interview. He kept repeating that he was Japanese, and ended by singing a Japanese war song.

"They're at it again," commented Onoda, and the three remained hidden.

Later, they scouted out the area where the man with the loudspeaker had been and found a newspaper. Circled in red was a story about a lieutenant colonel coming to the Philippines to persuade the government to stop its "punitive mis-

sions" to capture Japanese soldiers on Lubang. The three men read the newspaper. Well, it looked genuine. Equally obviously, it was a trick. The enemy must have gone to a lot of trouble inserting a *false* article in a *genuine* newspaper. But it just wasn't good enough. "Punitive missions" indeed! If they were punitive, the war must still be going on. And there was something funny about the broadcasting schedules. Too many light-entertainment programs. Poisoned candy, said Onoda. "It looked good, but it was deadly."

June 1953: In an exchange of fire with some fishermen, Shimada was shot in the right leg. Onoda carried him into the forest and bound the wound with cow fat as a poultice. It took him four months to recover, but he walked with a limp and was not his old self. It was like a premonition, which almost a year later was fulfilled. They spotted a search party of thirty-five down on the shore and retreated, but then argued about whether to stay or move across the island. They stayed, and sliced up some fruit, which they put out to dry. A little later, Onoda saw something move nearby. An intruder. Onoda fired, and the man dived for cover. Shimada stood still, aiming. A shot rang out, and he fell forward, killed outright by a bullet between the eyebrows. Onoda and Kozuka fled.

Ten days later, near the spot where Shimada was killed, a plane dropped leaflets, and a loudspeaker called, "Onoda, Kozuka, the war has ended." This merely angered them, for they were now utterly gripped by their own version of reality. "We wanted to scream out to the obnoxious Americans to stop threatening and cajoling us. We wanted to tell them that if they did not stop treating us like scared rabbits, we would get back at them some day, one way or another."

Later, back in the same spot, Onoda recalled Shimada's friendship, which had lasted almost ten years. "I vowed that somehow we would avenge Shimada's death. . . . I wiped my cheek with the back of my hand. For the first time since I came

to Lubang, I was crying." With powerful emotions added to his peculiar brand of loyalty, what could ever convince him that the world was not as he believed it to be?

Not, for instance, a flag he found on which the names of family members had been written. But why were they *slightly misspelled*? He pondered until the explanation occurred to him. It ran as follows: His bosses would obviously be trying to contact him to help reoccupy the airfield; they wanted the Americans to know this so that they (the Americans) would shift troops away from other areas; so the flag was allowed to fall into enemy hands; and the enemy were now using the flag to entice Onoda out; knowing they would do this, the Japanese had deliberately made a mistake in the spelling of the names in order to warn him not to take the message seriously. "Today all this sounds ridiculous, but I had been taught in Futamata always to be on the lookout for fake messages." Moreover, Onoda had taught Kozuka to be equally skeptical. The two supported each other in their paranoia.

As leaflet followed leaflet, each was interpreted as a fake. Here was a picture of Onoda-san's family. But why the presence of a nonfamily member? Why the honorific *san*, if the picture was intended for him alone? And here was Kozuka's family *in front of a new house*. "How do they expect me to believe this?" he scoffed, unaware of the Allied bombing raids and the shattered cities. And the leaflets were on poor-quality paper; which meant they were being mass produced; which meant they were being dropped all over the Philippines; which meant there must be hundreds if not thousands of guerrillas out there; that explained the honorific *san*, quite suitable if the picture was being seen by nonfamily men; all of which meant the war was still on. And the nonfamily person in the family picture? Obviously a warning not to take any of the leaflets seriously.

"With both sides sending all sorts of messages like this,"

said Onoda to Kozuka, "the Japanese counter-attack must be coming soon."

In the absence of what they considered hard information, anything and everything fed their fantasy that the Japanese were fighting back, regaining what had been lost. Bombs that were dropped in target areas by the Philippine Air Force must have been to stop Japanese guerrilla units from landing. A loudspeaker announcement claimed to be from the former chief of staff of the naval air force. A *naval* man coming to look for *army* men? Transparently ridiculous! Believing that a landing was imminent on Lubang's south coast, the two determined to keep it safe by scaring away locals. All attempts at contact, of which there were many, were simply seen as enemy agents blocking them from contacting other Japanese agents. Each time they heard a loudspeaker, they moved away.

The fact was that after fifteen years the two of them were so fixed in their ideas that they were unable to understand anything that did not fit in with them. It's a common human condition, the idée fixe. Once programmed into the mind, it acts as a lens that either distorts all that passes through it to fit the image or else rejects what cannot be made to fit. Such obsessions have had horribly real consequences. Witness the witch hunts of the late Middle Ages, which caused the burning of hundreds of innocent women. Self-delusion is a staple of comedy and drama in theater, film, and fiction. Malvolio is made to believe that Olivia loves him, cross-gartering and all, and is judged mad as a result; Jed Parry in Ian McEwan's novel *Enduring Love* interprets every rejection by Joe, the object of his obsession, as a come-on. So it was with Onoda. "If there was anything that did not fit, we interpreted it to mean whatever we wanted it to mean."

In 1959, reality almost broke through. A loudspeaker called: "This is your brother Toshio. Kozuka's brother Fukuji has

come with me. This is our last day here. Please come out where we can see you." At first Onoda thought it was a recording. He crept closer, and was amazed to see what really seemed to be his brother. Yes, "he was built like my brother, and his voice was identical."

Then he had second thoughts. "That's really something. They've found a prisoner who looks at a distance like my brother, and he's learned to imitate my brother's voice perfectly."

The man began to sing a student song that both of them knew from school, which almost had Onoda convinced but then went off key. Onoda laughed. The impersonator couldn't keep it up. He had given himself away. Onoda and Kozuka remained hidden, watched as the search party sadly left, then slipped back into the jungle. (Soon after this, in December 1959, Onoda was officially declared dead, along with Kozuka. They had supposedly been killed five years before in a clash with Philippine troops.)

The search party left behind a stack of newspapers and magazines, with countless articles about life in postwar Japan. Fakes! When Onoda left Japan, the war had been going badly, but the nation had sworn to fight to the last man, woman, and child. "One hundred million souls dying for honor" had been the phrase on everyone's lips. If Japan had lost the war, there wouldn't be any life! Everyone would be dead! If they weren't, Japan could not have lost the war. Indeed, it seemed to be winning, since it was obviously prosperous. Naturally, fourteen years after the end of the war, there was no mention of the flattened cities, the atomic bomb, the surrender, the occupation, the reconstruction—all the developments that might have allowed a truer interpretation of the articles.

Slowly, a new and utterly false picture of the modern world formed in their minds. Sure, Japan was now democratic. But it must still have an empire—its Greater East Asia Co-prosperity

Sphere—because there were good relations with former enemies. If China was communist, it must be under Japanese auspices. That was how the Americans and English had been driven from China. Presumably the Dutch had been driven from Java and Sumatra. Perhaps Siberia was also in the empire. No doubt the war was still being fought in the outer fringes, for after all, Onoda had been taught that it might take one hundred years of war to build the empire.

One article was a particular challenge. It was about him and the school: "Secret Mission on Lubang: What Did the Nakano School Order Lt. Onoda to Do?" Reviewing the history of the school, it said no one was quite sure who had issued his orders. Like a theologian wrestling to reconcile scripture with some alleged piece of evidence, Onoda took a while to see that this, too, was fake. Of *course* the school knew who had issued his orders. It was all there in the records. This was merely a way for his bosses to send him a message: Hang on, Onoda! We haven't forgotten you.

Hanging on demanded ever higher degrees of ingenuity. The solutions they found to the problems of survival would make a fine field guide to self-sufficiency. They learned to deal with rats, swarms of bees, ants of many species (including five that stung like bees), centipedes with poisonous bites, and scorpions. They became superb ecologists, working out how to catch rats and snare jungle fowl. They discovered how best to deal with the steamy, one-hundred-degree heat of May, the July rains, when it poured so hard you couldn't see ten meters, the second rainy season in September, the balmy days of October to December, the relative coolness of January and February (though the temperature could still go up to eighty-five degrees F). A major concern was where to spend the rainy season, during which they couldn't move around. With their tents long gone, they built anew each year. The spot, with a suitable tree to act as an anchor for the hut, had to be on

sloping ground for good drainage, safe from intrusion, on the eastern side of the mountains for coolness, not too near a village to avoid their fire being spotted, but near banana fields and coconut groves, all of which had to be planned without knowing exactly when the rains would come. There weren't many such places, and once identified they used the same ones every three or four years. At the first downpour, they would strip the tree of branches, use one for a ridge pole, bind the others to it with vines, and make a roof of palm leaves. Flat rocks made a stove. At the end of the rainy season, they tore the hut down, scattered the site with mud and branches, and again began a nomadic life, sleeping in the open fully dressed. "During the whole thirty years, I never once took off my trousers at night." If it rained, they got wet.

Their clothes rotted and split. They needed a needle to patch them. Onoda made one by sharpening a piece of wire, using a hemp-like plant for thread. Occasionally, they requisitioned American goods—canteens, tents, shoes, blankets—from stores made by the islanders. They made sandals from old inner tubes or sneaker soles. They camouflaged themselves by using fishing line to sew twigs and leaves to their jackets. They ate bananas, ripe if possible, but often bitter green ones, skin and all, sliced and boiled in coconut milk with dried meat to take away the bitterness.

Three cows a year kept them in meat, supplemented by a water buffalo or horse now and then. Onoda gives a lesson in how to kill and prepare a cow. It takes about an hour for two men. Start just before dark when the villagers have gone home. Shoot the cow from no more than seventy meters to fell it, using only one shot, preferably in the rain to muffle the sound. Finish off the fallen cow by smashing its head with a stone and/or stabbing it in the heart with a bayonet. It is lying on its side. Cut off the two upper legs, slice it down the middle of the belly, strip back the skin, turn it over, and re-

peat. Remove the heart, liver, sweetbreads, and other innards, and put them in a sack. After the butchery, with the meat on your back, haul the carcass away as far as possible in darkness and hide it to prevent the villagers putting two and two together. Fresh meat lasted a few days, boiled meat for ten, dried meat—smoked over an open fire—for four months.

Salt they either gathered from brine on the shore or from the islanders' salt pans. There was never a shortage of water, though they feared contamination from cattle and always boiled it. Rice was kept clear of ants in bags placed in five-gallon cans. Coconuts provided copra, milk (for soup), and fibers that made reasonable toothbrushes. At every campsite they dug a toilet pit, leaving the soil available to fill it in when they left. They used palm leaves for toilet paper. Every day, they examined their shit and urine, modifying diet and activity if anything looked wrong. It worked well. Onoda developed a fever twice in thirty years; Kozuka impaled his heel on thorns twice, causing his leg to swell. Otherwise, no health problems.

Through all this, they remained soldiers, looking after their weapons, hoarding their ammunition, keeping it dry in ammunition pouches made of rubber sneakers. Onoda had several hundred rounds of machine-gun ammunition, which he modified to fire as single shots from his rifle. He carried sixty cartridges with him, just in case of trouble, but used them only infrequently, to scare off locals or shoot cows. Faulty and rusty cartridges were opened to release the gunpowder, which was used as tinder, ignited by focusing sunlight through a stolen lens. Spare ammunition was squirreled away in holes stopped with rocks.

Life improved over time. Their expertise grew, and they learned how to "requisition"—that is, steal—from locals with impunity. Besides, the islanders were increasingly well off, so Onoda's life improved with theirs. "Life in the jungle was never

easy, but so far as food, clothing and utensils were concerned, it was easier in the later years than in the first five or ten."

Long-term survival is not all about technique. Underlying the technical skills is emotional and psychological health, as I learned when involved in several media projects on the subject of survival—a TV series and three radio series. There has been a good deal of research into post-traumatic stress disorder, focusing mainly on the malign effects of life-threatening events. I was interested in the opposite: why some seem to come through such events better than others, without ill effects. The plain fact is that some people are better survivors than others, both during and after the event. Naturally, academic research has focused on those who suffer. Those who don't have been less studied. But my interviews suggested to me some guidelines:

- **Have a long-term aim,** an agenda that makes you look beyond your own immediate concerns. This may be no more than a determination to return to a wife, or friends, or beloved children. It may be a whole philosophy or belief system. In German concentration camps, for example, two groups tended to survive slightly better than others: Seventh-day Adventists and Communists. They did so because their experience reinforced their worldviews. Seventh-day Adventists were certain the Last Days were at hand and that they would be chosen for salvation. Communists, taught that capitalism would collapse, saw around them proof that Marx's prediction was coming true. In brief, these two groups saw themselves as part of a great historical process. The truth or falsity of the belief is not important, because that can only be established in different circumstances. In the extreme and usually brief conditions of an extermina tion or labor camp, a belief system may help. In Onoda's

case, it certainly did. His suffering was for a purpose. He knew why he had to survive.

- **Be wary of faith.** Belief is not always a prop. Those with a naïve faith that God is on their side and will be on hand to help are, on the whole, disappointed. In the concentration camps, God was notably absent, and many simply despaired. Despair can do strange things to minds. Take one of my interviewees, Bob Tininenko. He and his brother-in-law were sailing south from Seattle in a catamaran when a storm overturned them. The two were trapped in the hull. Improvising hammocks swinging just above the surface, Bob set about the task of survival by rationing the remaining stores. But the brother-in-law was a fundamentalist Christian who believed not only that God would save them but that any attempt to save themselves would be to preempt God's intervention. In order to allow God to act in his own time, he actually threw away some of the rations—an extreme example of faith undermining survival (he died; Bob survived). Onoda was not encumbered by a faith in a personal, interventionist god. He knew that no one was going to help him but himself.

- **Accept the possibility of your own death.** This removes a crucial threat—panic, which is one of the prime causes of death in the early days of catastrophe. There is a paradox here: To say to yourself "I accept that I may die tomorrow" frees you to add a corollary—"but not today, not yet, not here." That in turn opens the possibility of survival for an hour, a day, a week, a month, a life. Accept death, find life—that was what Onoda did.

- **Be familiar with your environment.** Two of my interviewees come to mind.[1] The first was a young German woman,

[1] Both these stories were the subject of many newspaper articles and several books.

Juliane Köpcke, who was on a plane flying from Lima to Pucallpa on the upper Amazon basin when a lightning storm broke the plane apart, killing ninety-two passengers, including her mother, all except Juliane herself. Still strapped in her seat, she fell several thousand meters, hit the forest canopy, and woke up, on the jungle floor, with a few bruises and a cracked collarbone. She then walked for some ten days through the jungle, until she came across people. Her big advantage was that she was on home territory. Her parents were zoologists, and she knew what she could eat (in fact, nothing but some cake she retrieved from the crash) and what to avoid, and also knew that following a stream downriver would not only give her fresh water but also lead her to civilization. When I met her, she was back in the same area, researching bats.

The second example was a Canadian pilot, Martin Hartwell, who crashed with three passengers in the vast forests of the Northwest Territories. He came through the crash with two broken legs. The others died, over a period of time. It was winter. It's a long story with many twists, but the main point is that he survived by making fire and by cooking and eating the frozen flesh of one of the dead passengers. By the time he was found a month later (after a hugely controversial search), he was in remarkably good shape physically. Another few weeks and he would have walked out. Psychologically, he was deeply affected, both by the means of his survival and by a storm of unwelcome publicity. His survival contrasted tragically with the fate of an Inuit boy, who was used to the treeless barrens but was so disoriented and scared by the surrounding forests that he simply gave up and died. Onoda did not know anything about jungles when he first arrived on Lubang, but his commitment to his mission drove him to learn fast. Pretty soon, he was as practiced a survivor as Juliane Köpcke and Martin Hartwell.

- **Establish routines.** Tininenko persuaded his brother-in-law to share formal meals, which in the end amounted to nothing more than a few peas. But the formality gave a shape to the days, a sense of purpose. In the concentration camps, survivors noted that those who withdrew entirely, refused to wash, brush their hair, look after themselves in any way, and became what the inmates referred to as *Musselmänner* (Muslims), did not have long to live. Onoda imposed many small rituals on the two of them, insisting that they brush their teeth every morning, give each other regular haircuts, celebrate birthdays, keep track of the phases of the moon, and mark New Year's Day with a meal of rice and string beans in place of the lentils they used to have at home.

- **Have a secure childhood.** This sounds a bit glib, like the recipe for a long life: Have long-lived parents. But it's important. A secure childhood—almost the same as happy, but not quite—builds trust. Mother love, or at least close human contact; continuity of care; a good supporting network— all of this creates an expectation that the universe is essentially friendly. When things go wrong, you—well-grounded child or adult—believe they can be fixed. When things go *really* wrong, you interpret the catastrophe as an aberration that may make the universe seem more random but no less friendly overall. Chances are, you can cope. Whereas the unhappy, damaged, insecure child grows into an adult who sees a disaster as proof of what he or she "always knew," that the universe is a malign and dangerous place. What follows? Depression, panic, negativity. These are not attitudes that will help you deal with disaster. Of course, there is no strict cause and effect in emotional and psychological development. Secure children may grow into panicky adults, insecure and unhappy ones into happy and creative ones.

And there is a danger in childhood security, as I know from experience. As a child, I had all due care and attention from my mother, combined with encouragement to live freely in a safe rural setting—orchards, streams, woods, empty roads. I loved it. It might all have turned out badly, because at eight I was sent to boarding school. There are those who would say this was a parental rejection enough to scar my soul. Not a bit of it. By eight, I was firmly enough grounded to consider school another big adventure. It worked out fine. But there has been a problem: a feeling that the universe is a supportive place induces me to take unnecessary risks, from swimming with piranhas to catching planes with minutes to spare. Sometimes things go wrong. I once spent two weeks in an Ecuadorian jail. (It's a long story to do with a rented car and an attempted extortion. A lawyer got me out. I took a taxi to the Colombian border and escaped into Cali, then the drug capital of the world and notorious for its murder rate. I have never been more delighted to see anywhere.) So far, so good, but perhaps real survivors don't get into tight spots in the first place.

Always, Onoda looked toward the day the Japanese army would return. To this end, at the start of the dry season they would go to the fields where islanders had been gathering rice onto straw matting. At twilight, when the fields were empty, they would set fire to the rice to make beacons, which would, they hoped, be visible to incoming Japanese and tell them that their agents were still active. To the islanders, this was mere criminality, as was their habit of occasionally stealing what they needed, or staging holdups. To the islanders, the pair of them were "mountain devils." But they were careful not to antagonize the locals more than necessary. Once, for instance, they took a farmer prisoner, forced the terrified man into the mountains at gunpoint, interrogated him, then told him to go home to bed.

In 1965 they stole a radio. When its batteries ran down, they improvised with flashlight batteries, firing at farmers who dropped the light, as they ran away. The radio, like the newspapers, should have been enough to show them that they were living in a fantasy world. But they mainly listened to crackly shortwave stations with the volume turned down, and only briefly to conserve power. Some things they could accept as true, like the Tokyo Olympics and the bullet train. As for the rest, the two concluded they were listening to tapes put out by Americans to present American propaganda to Japanese living abroad. "I take my hat off to them," said Onoda to Kozuka. "It must be very tricky work." Tricky work, indeed, as he realized later, but on his part, not the Americans'—"tricky for us to read into the news broadcasts the meanings we wanted them to have."

Their lives had settled into regular patterns. Year followed year, often with little to mark the passage of time, with only occasional dramas: Kozuka's swollen leg from a poisoned thorn, the time Kozuka's trousers were swept away when they were doing laundry in a river in preparation for New Year's Day. But October 19, 1972, marked a turning point. They had dismantled their rainy-season hut and were planning their usual dry-season "beacon raids." Looking out over a field, they saw farmers preparing to carry away all the rice. They decided to move quickly, scaring away the farmers with a shot, guessing that it would take a few minutes for the police to come, giving them time enough to set a few fires. It worked. They were on the point of leaving when Kozuka spotted a pile of sacks under a tree. A pot hung from a branch. Time for one last fire. They laid their guns down, and Kozuka stepped aside to pick up some straw matting to use as fuel while Onoda went to see what was in the pot. At that moment there was a shot, then a volley of shots. The two men dived for their weapons. Onoda saw that Kozuka could not move his arm.

"It's my shoulder," he said.

"If it's only your shoulder, don't worry! Get back down into the valley."

Onoda grabbed both guns and fled. Kozuka stood but did not move. He stood with his arms folded tight. "It's my chest." He sobbed. Then: "It's no use!" Blood and foam spewed from his mouth, and he fell forward. Onoda fired three shots, uselessly. He called Kozuka's name and shook him by the ankle. No response. There was nothing more to be done. With the two rifles, he ran downhill into a thicket, the gunfire continuing behind him. "I'll get them for this," he yelled. "I'll kill them all!" He had no idea, of course, that he had been declared dead, and that to the world outside this clash was the first proof in thirteen years that they had been alive all this time.

He made his way to a coconut grove, where he sorted through his equipment. Nearby he heard voices, saw a small group of people, then later a larger group, but he knew better than to attack. Take it easy, he told himself; now was not the time.

He was alone and when he came to consider it, other than being shocked and saddened by Kozuka's death, no worse off materially. For a time the death hardened him. He would shoot to kill, if only to keep islanders out of "his" territory. But the search parties and their loudspeakers were closing in. "Onoda-san, wherever you are, come out!" Then one day he heard a woman's voice in the distance, though all he could make out was, "Hiroo, you gave me two, didn't you?" It was his older sister, Chie, referring to a pair of pearls he had given her as a wedding present. Then he heard his brother Tadao's voice, singing a familiar song. This time Onoda seemed to accept reality, in a way. So it was Tadao. Might as well stay and listen to him. He always was a good talker, and now he talked and talked. Still, Onoda held back, as if suspended between

two worlds. Later he visited the spot where Kozuka was killed and found a tombstone engraved with his name and a wreath. His hands clasped in prayer, Onoda repeated his oath to his friend: "I will avenge your death."

He found newspapers with long reports of Kozuka's death, yet still found reasons to doubt. There was information that should have been included that wasn't. Why? His reasoning was becoming more and more convoluted, because he did not doubt that the search parties were indeed from Japan, somehow operating despite the presumed presence of American forces on the mainland. He concluded that they were here to survey Lubang and win over the islanders. Indeed, since the Americans were having a hard time in Vietnam, the Japanese government could be preparing to woo the whole of the Philippines over to its side. So the appeals to Onoda were simply a cover. If he came out, they would not have time to complete their real task. Only by remaining hidden could he help them. Why, if they really wanted him to come out, all they had to do was leave him a telephone, and he could call them up. They didn't, so the conclusion was clear: "The pleas urging me to come out really meant that I should *not* come out."

So it went on, in the face of the evidence, with Onoda almost playing hide-and-seek with search parties. In his absence, one that included his ageing father found his mountain hut, where his father left a touching haiku:

> Not even an echo
> Responds to my call in the
> Summer mountains.

But to Onoda, his family were just being used by the Japanese High Command for a deeper purpose, to show the Americans that there was a growing threat to Lubang, and thus compel them to keep forces in reserve for the attack that was

surely coming. "So long as I remained in the place, the larger the 'search' operations would be—and the more it would cost the Americans in the long run." Anything he didn't understand, he simply put down to his ignorance. There was much that puzzled him. He wondered if the Filipinos were now allies with Japan. If so, how come they shot Kozuka, and how could he, Onoda, find out what side they were on?

In February 1974, sixteen months after Kozuka's death, he checked a favorite banana plantation and saw a mosquito net. Police, he thought, and prepared for a fight. But no, there was only one unarmed man. Onoda approached, pointing his rifle, and called out. The man, dressed in a T-shirt, dark blue trousers, and rubber sandals, saluted and stood his ground, shaking. That was odd. Islanders usually ran off at the sight of him.

"I'm Japanese," said the man.

"Are you from the Japanese government?"

"No."

"Are you from the Youth Foreign Cooperation Society?"

"No."

"Well, who are you?"

"I'm only a tourist."

Tourist? What could that mean? Onoda was fairly sure he had been sent by the enemy, except he noticed that the man was wearing thick woollen socks. If he hadn't been wearing those socks, Onoda might have shot him. With the sandals, they made an incongruous sight. He really must be Japanese.

The man said: "Are you Onoda-san?" and went on to ask him to come back to Japan, because the war was over.

Not for Onoda, it wasn't. "Bring me my orders. There must be proper orders!"

The man offered a cigarette—Onoda's first for years—and said he would like to talk. "In that case," said Onoda, "let's go someplace else." The man picked up an expensive-looking

camera and followed Onoda across a rice field to a clump of trees. The man talked about Japan having lost the war. But Onoda couldn't believe him, and kept quiet. The man asked if he could take a picture, but it was getting dark, and he doubted the quality of his flashlight pictures. He suggested coming back the following afternoon. Onoda was at once suspicious, and continued the conversation, thinking to trap him. The man gave his name: Suzuki Norio. They talked for two hours. Suzuki finally asked what would persuade Onoda to come out.

"Major Taniguchi is my immediate superior," said Onoda. "I won't give in until I have direct orders from him." Actually, his real commander was Lieutenant General Yokoyama, but Onoda did not want to mention him without positive proof that Suzuki was not an enemy agent.

So, said Suzuki, if I bring him and "he tells you to come to such and such a place at such and such a time, you will come, right?"

"Right," said Onoda, and then suggested staying at Suzuki's camp for the night, as a pretext for keeping him under surveillance.

Back at the camp, Suzuki asked and answered questions, Onoda probing all the time. Suzuki, a university dropout, described his travels—fifty countries in the previous four years, during which time, as Onoda's translator, Charles Terry, says in his foreword, he had contributed "to the woes of numerous Japanese embassies." When he left Japan, he told his friends he was going to look for Lieutenant Onoda, a panda, and the Abominable Snowman, in that order. He had been on Lubang just four days. Onoda warmed to him, telling him how his two comrades died, thinking this would be the best way for the details to reach their families, even if Suzuki was working for the enemy.

The following morning there were more, and better, photo-

graphs and Suzuki left, promising to return. Despite a 1 per-
cent niggle of uncertainty, despite Suzuki's apparent charm
and honesty, Onoda was 99 percent sure that he should not
take him seriously. Taniguchi—who, according to the news-
papers, was now a book dealer—would not appear. There
would be no new orders. He still believed Japan and Amer-
ica were at war, because of the size of the "search" opera-
tions, which surely couldn't be just to find him, had to be
to survey the island for some future military purpose. So it
was his duty to hang on. With the ammunition he had left,
he could afford thirty bullets a year for another twenty years.
He was fifty-two, but "I considered my body to be no more
than thirty-seven or thirty-eight." Twenty more years? No
problem.

Two weeks later he heard voices, and found a bag taped to
a tree. It contained Suzuki's photos of him, a note saying he
had come back as promised, and two orders, one from Gen-
eral Yamashita and a second saying that "instructions would
be given to Lieutenant Onoda orally," presumably by Tanigu-
chi himself.

This was what he had been waiting for, direct, face-to-face,
no-nonsense secret orders, for the only way to deliver secret
orders was orally. He could hardly guess what he would be or-
dered to do—keep fighting on Lubang? Start a new operation
somewhere else? The only certainty was that he had to get to
the meeting point, the spot in the center of the island where
he had met Suzuki two weeks earlier—Wakayama Point, on a
river a good eight hours' walk across the mountains. It might
be a trap, of course. But he had to take that risk.

In hindsight, it was no risk. Suzuki had returned to Japan
and reported to the government, touching off what Terry calls
"some of the most extravagant coverage ever provided by Jap-
anese press and television." They found Taniguchi and flew
him to Lubang, with no fewer than one hundred Japanese

news reporters. Taniguchi was there as Onoda approached Wakayama Point on the afternoon of March 9, 1974.

He hid in the bushes, intending to wait until the light was right: dark enough to be safe, light enough to recognize Taniguchi. There was no one about. He camouflaged himself with sticks and leaves, crossed the river, and climbed a small hill where he could oversee the meeting place. He saw a yellow tent but no sign of people. He approached warily to about a hundred meters and settled down to wait for sunset. Then, holding his rifle, he thrust out his chest and walked forward. Suzuki stood there, facing away, between the tent and a campfire. He turned and came forward, arms outstretched. "It's Onoda!" he shouted. "Major Taniguchi, it's Onoda!"

As Suzuki grasped Onoda's hand, a voice came from the tent. "Is it really you, Onoda? I'll be with you in a minute." He was just changing his shirt. Yes, definitely Taniguchi's voice.

He emerged, fully dressed, wearing an army cap.

"Lieutenant Onoda, sir," said Onoda smartly. "Reporting for orders."

"Good for you!" said Taniguchi, patting Onoda on the shoulder. He gave Onoda a pack of cigarettes with the imperial crest on them, and then, as Onoda took a couple of paces back, said, "I shall read your orders." These told Onoda that all combat activity had ceased, that the special squadron had no more military duties, and that all members, Onoda being one, should cease military activities and place themselves under the nearest superior officer.

For a few seconds, Onoda wondered if Taniguchi would follow up with his real orders.

Silence.

Onoda realized at last that this was it.

"We really lost the war! How could they have been so sloppy? Suddenly everything went black. A storm raged inside

me. I felt like a fool for having been so tense and cautious on the way here. Worse than that, what had I been doing for all these years?"

The emotion subsided. He took off his pack, laid his rifle on top of it, and followed the major and Suzuki into the tent, where, through the night, he gave his report, often blinking back tears, with Suzuki, a little the worse for drink, snoring on his bed. With the coming of dawn, Taniguchi slept, but Onoda, on his first bed in thirty years, could not.

The next morning Suzuki's beacon fire summoned the rest of the party, a military escort and Onoda's oldest brother, Toshio. After a day retrieving weapons from the hills, there followed a meeting with President Ferdinand Marcos. In a very public ceremony, Onoda, performing his role of prisoner of war, formally surrendered his sword. But he was no ordinary prisoner. As a mark of respect and as a sign of reconciliation, Marcos handed the sword back.[2] "For a moment, something like the pride of a samurai swept over me."

That was just the start of intense, almost hysterical press coverage. Why did he create such a stir? Nothing like this had attended the reappearance of Onoda's comrade-in-arms, Yamamoto, when he emerged from the Philippine jungle in 1956, nor the emergence of an NCO, Yokoi Shoichi, from Guam in 1972. Terry's theory is that Onoda was exactly what Japan needed as an antidote to defeat: a genuine, uncompromising war hero. Also, in Mercado's words, "his spare frame, intense gaze and goatee gave him the air of a samurai who has seemingly reached Japan in a time machine." But there was a lot more to him than that. He was intelligent, articulate, strong-willed, and stoic.

[2] Another oddity in Onoda's book, perhaps a reflection of the strain he was under: In the text, he says the ceremony was with General Jose Rancudo, chief of the air force. But a photograph in the picture section clearly shows him either handing his sword to Marcos or receiving it back.

He was also, incidentally, exactly the opposite of another type of uncompromising Japanese hero—the sort that takes on impossible odds and dies. Such a one was Saigō Takamori, "the last samurai," who in 1877 led a pointless rebellion against the government of the Meiji Restoration and met an extremely sticky end, vastly outnumbered, wounded, unable to commit *seppuku*; he was beheaded, in true samurai fashion, by a close aide. But who, in a nation recovering from defeat, wants to identify with heroic failure? Onoda was an example of a man who had lived, not died, for his ideals.

Terry, a long-established and well-respected translator of Japanese, was skeptical of accepting Onoda as a hero, until, on TV, he saw Onoda arrive. "When I saw this small, dignified man emerge from the plane, bow, and then stand rigidly at attention for his ovation . . . I was hooked." For the next two weeks, the press and TV were full of Onoda's doings—greeting his father, his mother, his friends, having a checkup, eating, traveling to his hometown. He received tens of thousands of letters of praise (though the foreign press looked askance at such adulation heaped on a man who had killed some thirty Filipinos and lived by theft). Naturally, publishers fell over one another hoping to win the rights to his story. He turned all of them down, choosing a publisher he admired because of its youth magazines, which he had read as a young man. Here was a man of inflexible will but also a certain gentleness and nostalgia for the old days. That, perhaps, is what drew him to the openhearted Suzuki, which in its turn opened the way to his return.

He also had a phenomenal memory. Within three months, he had dictated two thousand pages of recollections, many of them amazingly detailed. He made sketches of his bases. Articles began to appear in serial form, and editors began work on book versions in both Japanese and English, with Terry as the translator and editor of the English edition.

Onoda was not happy with all the publicity, and the following year he decided to join his brother Tadao in Brazil, where he married a Japanese woman, Machie, joined a Japanese community, and started raising 250 head of cattle on a remote ranch on the borders of Bolivia and Paraguay. He was very good at it. In ten years he doubled the size of the ranch and had more than a thousand head of cattle. In 1980 he was shocked by an account of a Japanese teenager who had murdered his parents. Seeing this as a symbol of a decline in youthful standards, he moved back to Japan and set up a "nature school" at the foot of Mount Fuji to educate children in survival skills, living off the land.

In May 1996, Onoda returned to the Philippines on a trip proposed by the governor of Occidental Mindoro Province, Josephine Ramirez Sato, whose Japanese husband had been a member of one of the search parties hunting for Onoda. Onoda's purpose was to honor the memory of those who had died during his thirty years in the jungle. On Lubang, he laid flowers on the spot where Kozuka had been shot, which had been made into a peace monument in 1981, at the behest of the then Japanese prime minister, Fukuda Takeo, among others. Afterward, he gave the local mayor a check for ten thousand dollars to fund scholarships. There were courtesy calls on Governor Sato and the president, Fidel Ramos. Questioned by reporters and confronted by protesters demanding compensation for murder and theft, Onoda made his message clear. He had acted honorably, as a soldier, for his country. Compensation was for governments. All he could do was help reconciliation by showing goodwill.

The school and the visit seem to be Onoda's answer to his three questions: Why had he fought on Lubang for thirty years? Whom had he been fighting for? What was the cause?

He had fought to survive; he had survived to do what he could to reconcile old enemies and to bring the survival skills

he had acquired to a new generation. Now Japan and the Philippines are close business partners. And, in twenty years, some twenty thousand children have passed through the school started by the man the children call "Uncle Jungle," but whom others call the *real* last of the ninjas.

ACKNOWLEDGMENTS

With overall thanks to:
Noriko Ansell for her help and advice in Iga and Kōka, and her father, Katsuhisa Moriya; Antony Cummins, in particular for his help on the Iga Commune and for his translations (along with Yoshie Minami) of the ninja poems that begin each chapter; Tullio Lobetti, SOAS, Shugendō initiate; Dr. Gaynor Sekimori, SOAS, Shugendō expert.

In Iga:
Hiromitsu Kuroi, Iga-ryu Ninja Museum; Kazuya Kamaguchi, Akame (Forty-Eight Waterfalls); Momochi Mikio, owner of Momocho Sandayu's house, Iga Ueno; Morimoto Satoshi, Iga Ueno Tourist Office; Tomomori Kazuya, Kashihara Castle; Tsuki Katsuya, potter, Chigachi Castle; Ueda Masaru, restaurant owner, Akame (Forty-Eight Waterfalls).

In Kōka:
Hukui Minogu, Kōga ninja house; Koyama Haruhisa Kōga Ninjutsu Study Group; Kōzō Yamada, *shugenja* and mountain walker; Sikimoto Jei-ichi, Shugendō priest; Somanosho, priest; Taki Sugao, Kōga Ninjutsu Study Group; Toshinobu Wata-

nabe, Kōga Ninjutsu Study Group; Tsuji Kunio, hotel owner; Yoshihisa Yoshinori, Kōka Town Tourism.

My thanks as always to Felicity Bryan and her staff; Doug Young and Simon Thorogood at Transworld; and Mari Roberts for her excellent editing.

Picture Acknowledgments

Every effort has been made to contact the copyright holders. We apologize for any omissions in this respect and will be pleased to make the appropriate acknowledgments in any future edition. All images have been supplied courtesy of the author unless otherwise stated.

Photo Insert
Page 1: Ninja sketch by Katsushika Hokusai (1817). Page 6: Ninja armor at the ninja museum in Takayama © Miguel A. Muñoz Pellicer/Alamy. Page 8: *You Only Live Twice* film stills courtesy of www.007magazine.com © 1967 Danjaq LLC and United Artists Corporation. All rights reserved.

BIBLIOGRAPHY

There are scores, perhaps hundreds, of books that focus on what are supposed to be the ninjas' martial arts, magical skills, and esoteric supremacy. There's a great deal of dross out there. The following are the books I found most useful.

Adolphson, Mikael. *The Gates of Power: Monks, Courtiers and Warriors in Premodern Japan.* Honolulu: University of Hawaii Press, 2000.

Allen, Louis. "The Nakano School." In *Proceedings of the British Association for Japanese Studies* (edited by John Chapman and David Steeds). Vol. 10. Sheffield: University of Sheffield Press, 1985.

Black, Jeremy. *The Politics of James Bond: From Fleming's Novels to the Big Screen.* Lincoln and London: University of Nebraska Press, 2005.

Breen, John, and Mark Teeuwen. *Shinto in History: Ways of the Kami.* Richmond, U.K.: Curzon Press, 2000.

Cobb, Nora Okja. "Behind the Inscrutable Half-Shell: Images of Mutant Japanese and Ninja Turtles", *MELUS*, vol. 16, no. 4,

Conlan, Thomas Donald. *State of War: The Violent Order of Four-*

teenth Century Japan. Ann Arbor: University of Michigan Press, 2003.

Cummins, Antony, and Yoshie Minami. *The Book of the Ninja* [the *Bansenshūkai*]. London: Watkins, to be published 2013.

———. *True Path of the Ninja: The Definitive Translation of the Shoninki.* Tokyo, Rutland, VT, and Singapore: Tuttle, 2011.

———. *True Ninja Traditions: The Ninpiden and the Unknown Ninja Scroll.* Bloomington, IN: Wordclay, 2010.

Deal, William E. *Handbook to Life in Medieval and Early Modern Japan.* Oxford: Oxford University Press, 2007.

Draeger, Donn F., and Robert Smith. *Asian Fighting Arts.* New York: Berkley, 1974.

Ferejohn, John A., and Frances McCall Rosenbluth. *War and State Building in Medieval Japan.* Palo Alto, CA: Stanford University Press, 2010.

Fleming, Ian. *You Only Live Twice.* London: Hodder and Stoughton, 1964.

———. *Thrilling Cities (1).* London: Jonathan Cape, 1963.

Friday, Karl F. *Samurai, Warfare and the State in Early Medieval Japan.* New York and London: Routledge, 2004.

Fujiwara, Iwaichi, F. *Kikan: Japanese Army Intelligence Operations in Southeast Asia during World War II.* Translated by Akashi Yoji. London: Heinemann Educational, 1983.

Hatsumi, Masaaki. *Illustrated Book of Warring States Ninpo,* Santa Cruz, CA: American Bujinkan Dojo, 1992.

Hevener, Phillip T. *Fujita Seiko: The Last Koga Ninja.* Xlibris, 2008.

Hitoshi, Miyake. *The Mandala of the Mountain: Shugendō and Folk Religion.* Tokyo: Keio University Press, 2005.

Ishida Yoshihito. *Chūsei sonraku to Bukkyō* 中世村落と仏教. Kyōto-shi: Shibunkaku Shuppan, 1996.

Izumiya, Tatsurō. *The Minami Organ.* Rangoon: University Press, 1985.

Lamers, Jeroen P. *Japonius Tyrannus: The Japanese Warlord Oda Nobunaga Reconsidered.* Leiden: Hotei, 2000.

Lidin, Olof G. *Tanega-shima: The Arrival of Europe in Japan.* Copenhagan: Nordic Institute of Asian Studies Monograph Series, no. 90. 2002.

McCullough, Helen Craig, trans. and ed. *The Taiheiki: A Chronicle of Medieval Japan.* Rutland, VT, and Tokyo: Tuttle, 1979 (many later editions).

Mercado, Stephen. *The Shadow Warriors of Nakano: A History of the Imperial Japanese Army's Elite Intelligence School.* Washington, DC: Brassey's, 2002.

Momochi Orinosuke (百地織之助), *Kōsei Iran-ki* 校正伊亂記. 1897.

Morris, Ivan. *The Nobility of Failure: Tragic Heroes in the History of Japan.* London: Secker and Warburg, 1975.

Onoda Hiroo. *No Surrender: My Thirty-Year War.* London (translated by Charles S. Terry) Transworld, 1976.

Peterson, Kirtland C. *Mind of the Ninja: Exploring the Inner Power.* Chicago: Contemporary Books, 1986.

Philippi, Donald, trans. *Kojiki.* Princeton, NJ, and Tokyo: Princeton University Press and University of Tokyo Press, 1969.

Rabinovitch, Judith. *Shōmonki: The Story of Masakado's Rebellion.* Monumenta Nipponica monograph 58. Tokyo: Sophia University, 1986.

Sadler, A. L. *The Maker of Modern Japan: The Life of Shogun Tokugawa Ieyasu,* Rutland, VT, and Tokyo: Tuttle, 1937.

Segawa, Masaki. *Basilisk* (manga version of Yamada Fūtarotaro's *The Kouga Ninja Scrolls*). 5 vols. New York: Random House, 2006.

Souyri, Pierre François. *The World Turned Upside Down: Medieval Japanese Society* (translated by Käthe Roth), New York; Columbia University Press, 2001.

Sun Tzu. *The Art of War.* Ware, U.K.: Wordsworth, 1998.

Turnbull, Stephen. *Ninja 1460–1650.* Oxford: Osprey, 2003.

———. *Japanese Warrior Monks AD 949–1603.* Oxford, U.K.: Osprey, 2003.

————. *Nagashino 1575.* Oxford: Osprey, 2000.

————. *Osaka 1615,* Oxford: Osprey, 2006.

Yamada Fūtaro, *The Kouga Ninja Scrolls.* New York: Ballantine, 2006.

Zoughari, Kacem. *The Ninja: Ancient Shadow Warriors of Japan.* North Clarendon, VT, and Tokyo; Tuttle, 2010.

INDEX

INDEX

INDEX

ZEITOUN

ZEITOUN

BY DAVE EGGERS

McSWEENEY'S BOOKS
SAN FRANCISCO

McSWEENEY'S BOOKS
SAN FRANCISCO

For more information about McSweeney's:
www.mcsweeneys.net

Copyright © 2009 Dave Eggers
All rights reserved, including right of reproduction in whole or part in any form.

Cover art by Rachell Sumpter

McSweeney's and colophon are registered trademarks of McSweeney's, a privately held company with wildly fluctuating resources.

ISBN: 978-1-934781-63-0

First Printing

For Abdulrahman, Kathy, Zachary, Nademah,
Aisha, Safiya, and Ahmad in New Orleans

For Ahmad, Antonia, Lutfi, and Laila in Málaga

For Kousay, Nada, Mahmoud, Zakiya, Luay, Eman, Fahzia,
Fatimah, Aisha, Munah, Nasibah,
and all the Zeitouns of Jableh, Lattakia,
and Arwad Island

For the people of New Orleans

...in the history of the world it might even be that there was more punishment than crime...

Cormac McCarthy, *The Road*

To a man with a hammer, everything looks like a nail.

Mark Twain

NOTES ABOUT THIS BOOK

This is a work of nonfiction, based primarily on the accounts of Abdulrahman and Kathy Zeitoun (pronounced "zay-toon"). Dates, times, locations, and other facts have been confirmed by independent sources and the historical record. Conversations have been recounted as best as can be remembered by the participants. Some names have been changed.

This book does not attempt to be an all-encompassing book about New Orleans or Hurricane Katrina. It is only an account of one family's experiences before and after the storm. It was written with the full participation of the Zeitoun family, and reflects their view of the events.

I

FRIDAY AUGUST 26, 2005

On moonless nights the men and boys of Jableh, a dusty fishing town on the coast of Syria, would gather their lanterns and set out in their quietest boats. Five or six small craft, two or three fishermen in each. A mile out, they would arrange the boats in a circle on the black sea, drop their nets, and, holding their lanterns over the water, they would approximate the moon.

The fish, sardines, would begin gathering soon after, a slow mass of silver rising from below. The fish were attracted to plankton, and the plankton were attracted to the light. They would begin to circle, a chain linked loosely, and over the next hour their numbers would grow. The black gaps between silver links would close until the fishermen could see, below, a solid mass of silver spinning.

Abdulrahman Zeitoun was only thirteen when he began fishing for sardines this way, a method called *lampara*, borrowed from the Italians. He had waited years to join the men and teenagers on the night boats,

and he'd spent those years asking questions. Why only on moonless nights? Because, his brother Ahmad said, on moon-filled nights the plankton would be visible everywhere, spread out all over the sea, and the sardines could see and eat the glowing organisms with ease. But without a moon the men could make their own, and could bring the sardines to the surface in stunning concentrations. You have to see it, Ahmad told his little brother. You've never seen anything like this.

And when Abdulrahman first witnessed the sardines circling in the black he could not believe the sight, the beauty of the undulating silver orb below the white and gold lantern light. He said nothing, and the other fishermen were careful to be quiet, too, paddling without motors, lest they scare away the catch. They would whisper over the sea, telling jokes and talking about women and girls as they watched the fish rise and spin beneath them. A few hours later, once the sardines were ready, tens of thousands of them glistening in the refracted light, the fishermen would cinch the net and haul them in.

They would motor back to the shore and bring the sardines to the fish broker in the market before dawn. He would pay the men and boys, and would then sell the fish all over western Syria — Lattakia, Baniyas, Damascus. The fishermen would split the money, with Abdulrahman and Ahmad bringing their share home. Their father had passed away the year before and their mother was of fragile health and mind, so all funds they earned fishing went toward the welfare of the house they shared with ten siblings.

Abdulrahman and Ahmad didn't care much about the money, though. They would have done it for free.

Thirty-four years later and thousands of miles west, Abdulrahman Zeitoun was in bed on a Friday morning, slowly leaving the moonless

Jableh night, a tattered memory of it caught in a morning dream. He was in his home in New Orleans and beside him he could hear his wife Kathy breathing, her exhalations not unlike the shushing of water against the hull of a wooden boat. Otherwise the house was silent. He knew it was near six o'clock, and the peace would not last. The morning light usually woke the kids once it reached their second-story windows. One of the four would open his or her eyes, and from there the movements were brisk, the house quickly growing loud. With one child awake, it was impossible to keep the other three in bed.

Kathy woke to a thump upstairs, coming from one of the kids' rooms. She listened closely, praying silently for rest. Each morning there was a delicate period, between six and six-thirty, when there was a chance, however remote, that they could steal another ten or fifteen minutes of sleep. But now there was another thump, and the dog barked, and another thump followed. What was happening in this house? Kathy looked to her husband. He was staring at the ceiling. The day had roared to life.

The phone began ringing, today as always, before their feet hit the floor. Kathy and Zeitoun — most people called him by his last name because they couldn't pronounce his first — ran a company, Zeitoun A. Painting Contractor LLC, and every day their crews, their clients, everyone with a phone and their number, seemed to think that once the clock struck six-thirty, it was appropriate to call. And they called. Usually there were so many calls at the stroke of six-thirty that the overlap would send half of them straight to voicemail.

Kathy took the first one, from a client across town, while Zeitoun shuffled into the shower. Fridays were always busy, but this one promised madness, given the rough weather on the way. There had been

rumblings all week about a tropical storm crossing the Florida Keys, a chance it might head north. Though this kind of possibility presented itself every August and didn't raise eyebrows for most, Kathy and Zeitoun's more cautious clients and friends often made preparations. Throughout the morning the callers would want to know if Zeitoun could board up their windows and doors, if he would be clearing his equipment off their property before the winds came. Workers would want to know if they'd be expected to come in that day or the next.

"Zeitoun Painting Contractors," Kathy said, trying to sound alert. It was an elderly client, a woman living alone in a Garden District mansion, asking if Zeitoun's crew could come over and board up her windows.

"Sure, of course," Kathy said, letting her feet drop heavily to the floor. She was up. Kathy was the business's secretary, bookkeeper, credit department, public-relations manager — she did everything in the office, while her husband handled the building and painting. The two of them balanced each other well: Zeitoun's English had its limits, so when bills had to be negotiated, hearing Kathy's Louisiana drawl put clients at ease.

This was part of the job, helping clients prepare their homes for coming winds. Kathy hadn't given much thought to the storm this client was talking about. It took a lot more than a few downed trees in south Florida to get her attention.

"We'll have a crew over this afternoon," Kathy told the woman.

Kathy and Zeitoun had been married for eleven years. Zeitoun had come to New Orleans in 1994, by way of Houston and Baton Rouge and a half-dozen other American cities he'd explored as a young man. Kathy had grown up in Baton Rouge and was used to the hurricane routine: the litany of preparations, the waiting and watching, the power outages,

the candles and flashlights and buckets catching rain. There seemed to be a half-dozen named storms every August, and they were rarely worth the trouble. This one, named Katrina, would be no different.

Downstairs, Nademah, at ten their second-oldest, was helping get breakfast together for the two younger girls, Aisha and Safiya, five and seven. Zachary, Kathy's fifteen-year-old son from her first marriage, was already gone, off to meet friends before school. Kathy made lunches while the three girls sat at the kitchen table, eating and reciting, in English accents, scenes from *Pride and Prejudice*. They had gotten lost in, were hopelessly in love with, that movie. Dark-eyed Nademah had heard about it from friends, convinced Kathy to buy the DVD, and since then the three girls had seen it a dozen times — every night for two weeks. They knew every character and every line and had learned how to swoon like aristocratic maidens. It was the worst they'd had it since *Phantom of the Opera*, when they'd been stricken with the need to sing every song, at home or at school or on the escalator at the mall, at full volume.

Zeitoun wasn't sure which was worse. As he entered the kitchen, seeing his daughters bow and curtsy and wave imaginary fans, he thought, *At least they're not singing.* Pouring himself a glass of orange juice, he watched these girls of his, perplexed. Growing up in Syria, he'd had seven sisters, but none had been this prone to drama. His girls were playful, wistful, always dancing across the house, jumping from bed to bed, singing with feigned vibrato, swooning. It was Kathy's influence, no doubt. She was one of them, really, blithe and girlish in her manner and her tastes — video games, Harry Potter, the baffling pop music they listened to. He knew she was determined to give them the kind of carefree childhood she hadn't had.

17

*　*　*

"That's all you're eating?" Kathy said, looking over at her husband, who was putting on his shoes, ready to leave. He was of average height, a sturdily built man of forty-seven, but how he maintained his weight was a puzzle. He could go without breakfast, graze at lunch, and barely touch dinner, all while working twelve-hour days of constant activity, and still his weight never fluctuated. Kathy had known for a decade that her husband was one of those inexplicably solid, self-sufficient, and never-needy men who got by on air and water, impervious to injury or disease — but still she wondered how he sustained himself. He was passing through the kitchen now, kissing the girls' heads.

"Don't forget your phone," Kathy said, eyeing it on the microwave.

"Why would I?" he asked, pocketing it.

"So you don't forget things?"

"I don't."

"You're really saying you don't forget things."

"Yes. This is what I'm saying."

But as soon as he'd said the words he recognized his error.

"You forgot our firstborn child!" Kathy said. He'd walked right into it. The kids smiled at their father. They knew the story well.

It was unfair, Zeitoun thought, how one lapse in eleven years could give his wife enough ammunition to needle him for the rest of his life. Zeitoun was not a forgetful man, but whenever he did forget something, or when Kathy was trying to prove he had forgotten something, all she had to do was remind him of the time he'd forgotten Nademah. Because he had. Not for such a long time, but he had.

She was born on August 4, on the one-year anniversary of their

wedding. It had been a trying labor. The next day, at home, Zeitoun helped Kathy from the car, closed the passenger door, and then retrieved Nademah, still in her carseat. He carried the baby in one hand, holding Kathy's arm with the other. The stairs to their second-floor apartment were just inside the building, and Kathy needed help getting up. So Zeitoun helped her up the steep steps, Kathy groaning and sighing as they went. They reached the bedroom, where Kathy collapsed on the bed and got under the covers. She was relieved beyond words or reason to be home where she could relax with her infant.

"Give her to me," Kathy said, raising her arms.

Zeitoun looked down to his wife, astonished at how ethereally beautiful she looked, her skin radiant, her eyes so tired. Then he heard what she'd said. The baby. Of course she wanted the baby. He turned to give her the baby, but there was no baby. The baby was not at his feet. The baby was not in the room.

"Where is she?" Kathy asked.

Zeitoun took in a quick breath. "I don't know."

"Abdul, where's the baby?" Kathy said, now louder.

Zeitoun made a sound, something between a gasp and a squeak, and flew out of the room. He ran down the steps and out the front door. He saw the carseat sitting on the lawn. He'd left the baby in the yard. *He'd left the baby in the yard.* The carseat was turned toward the street. He couldn't see Nademah's face. He grabbed the handle, fearing the worst, that someone had taken her and left the seat, but when he turned it toward him, there was the tiny pink face of Nademah, scrunched and sleeping. He put his fingers to her, to feel her heat, to know she was okay. She was.

He brought the carseat upstairs, handed Nademah to Kathy, and before she could scold him, kid him, or divorce him, he ran down the

stairs and went for a walk. He needed a walk that day, and needed walks for many days following, to work out what he'd done and why, how he had forgotten his child while aiding his wife. How hard it was to do both, to be partner to one and protector to the other. What was the balance? He would spend years pondering this conundrum.

This day, in the kitchen, Zeitoun wasn't about to give Kathy the opportunity to tell the whole story, again, to their children. He waved goodbye.

Aisha hung on his leg. "Don't leave, Baba," she said. She was given to theatrics — Kathy called her Dramarama — and all that Austen had made the tendency worse.

He was already thinking about the day's work ahead, and even at seven-thirty he felt behind.

Zeitoun looked down at Aisha, held her face in his hands, smiled at the tiny perfection of her dark wet eyes, and then extracted her from his shin as if he were stepping out of soggy pants. Seconds later he was in the driveway, loading the van.

Aisha went out to help him, and Kathy watched the two of them, thinking about his way with the girls. It was difficult to describe. He was not an overly doting father, and yet he never objected to them jumping on him, grabbing him. He was firm, sure, but also just distracted enough to give them the room they needed, and just pliant enough to let himself be taken advantage of when the need arose. And even when he was upset about something, it was disguised behind those eyes, grey-green and long-lashed. When they met, he was thirteen years older than Kathy, so she wasn't immediately sold on the prospect of marriage, but those eyes, holding the light the way they did, had seized

her. They were dream-filled, but discerning, too, assessing — the eyes of an entrepreneur. He could see a run-down building and have not only the vision to see what it might become, but also the practical knowledge of what it would cost and how long it would take.

Kathy adjusted her hijab in the front window, tucking in stray hairs — it was a nervous habit — while watching Zeitoun leave the driveway in a swirling grey cloud. It was time for a new van. The one they had was a crumbling white beast, long-suffering but dependable, filled with ladders and wood and rattling with loose screws and brushes. On the side was their ubiquitous logo, the words ZEITOUN A. PAINTING CONTRACTOR next to a paint roller resting at the end of a rainbow. The logo was corny, Kathy admitted, but it wasn't easy to forget. Everyone in the city knew it, from bus stops and benches and lawn signs; it was as common in New Orleans as live oak or royal fern. But at first it was not so benign to all.

When Zeitoun first designed it, he'd had no idea that a sign with a rainbow on it would signify anything to anyone — anything other than the array of colors and tints from which clients might choose. But soon enough he and Kathy were made aware of the signals they were sending.

Immediately they began getting calls from gay couples, and this was good news, good business. But at the same time, some potential clients, once they saw the van arrive, were no longer interested in Zeitoun A. Painting Contractor LLC. Some workers left, thinking that by working under the Zeitoun Painting rainbow they would be presumed to be gay, that somehow the company managed to employ only gay painters.

When Zeitoun and Kathy finally caught on to the rainbow's signifying power, they had a serious talk about it. Kathy wondered if her

husband, who did not at that point have any gay friends or family members, might want to change the logo, to keep their message from being misconstrued.

But Zeitoun barely gave it a thought. It would cost a lot of money, he said — about twenty signs had been made, not to mention all the business cards and stationery — and besides, all the new clients were paying their bills. It wasn't much more complicated than that.

"Think about it," Zeitoun laughed. "We're a Muslim couple running a painting company in Louisiana. Not such a good idea to turn away clients." Anyone who had a problem with rainbows, he said, would surely have trouble with Islam.

So the rainbow remained.

Zeitoun pulled onto Earhart Boulevard, though a part of him was still in Jableh. Whenever he had these morning thoughts of his childhood, he wondered how they all were, his family in Syria, all his brothers and sisters and nieces and nephews scattered up and down the coast, and those who had long ago left this world. His mother died a few years after his father passed on, and he'd lost a treasured brother, Mohammed, when he was very young. But the rest of his siblings, those still in Syria and Spain and Saudi Arabia, were all doing well, extraordinarily so. The Zeitouns were a high-achieving clan, full of doctors and school principals and generals and business owners, all of them with a passion for the sea. They had grown up in a big stone house on the Mediterranean, and none had strayed far from the shore. Zeitoun made a note to call Jableh sometime that day. There were always new babies, always news. He only had to reach one of his brothers or sisters — there were seven still in Syria — and he could get the full report.

Zeitoun turned on the radio. The storm that people were talking

about was still far down in Florida, moving slowly west. It wasn't expected to make it up the Gulf for another few days, if at all. As he drove to his first job of the day, the restoration of a wonderful old mansion in the Garden District, he turned the dial on the radio, looking for something, anything, else.

Standing in her kitchen, Kathy looked at the clock and gasped. It was all too rare that she got the kids to school on time. But she was working on it. Or planned to work on it as soon as the season calmed down. Summer was the busiest time for the business, with so many people leaving, fleeing the swamp heat, wanting these rooms or that porch painted while they were away.

With a flurry of warnings and arm movements, Kathy herded the girls and their gear into the minivan and headed across the Mississippi to the West Bank.

There were advantages to Zeitoun and Kathy running a business together — so many blessings, too many to name — but then again, the drawbacks were distinct and growing. They greatly valued being able to set their own hours, choose their clients and jobs, and be at home whenever they needed to be — their ability to be there, always and for anything relating to their children, was a profound comfort. But when friends would ask Kathy whether they, too, should start their own business, she talked them out of it. You don't run the business, she would say. The business runs you.

Kathy and Zeitoun worked harder than anyone they knew, and the work and worry never ended. Nights, weekends, holidays — respite never came. They usually had eight to ten jobs going at any one time, which they oversaw out of a home office and a warehouse space on Dublin Street, off Carrollton. And that was to say nothing of the

property-management aspect of the business. Somewhere along the line they started buying buildings, apartments, and houses, and now they had six properties with eighteen tenants. Each renter was, in some ways, another dependent, another soul to worry about, to provide with shelter, a solid roof, air-conditioning, clean water. There was a dizzying array of people to pay and collect from, houses to improve and maintain, bills to deal with, invoices to issue, supplies to buy and store.

But she cherished what her life had become, and the family she and Zeitoun had created. She was driving her three girls to school now, and the fact that they could go to a private school, that their college would be taken care of, that they had all they needed and more — she was thankful every hour of every day.

Kathy was one of nine children, and had grown up with very little, and Zeitoun, the eighth of thirteen children, had been raised with almost nothing. To see the two of them now, to stand back and assess what they'd built — a sprawling family, a business of distinct success, and to be woven so thoroughly into the fabric of their adopted city that they had friends in every neighborhood, clients on almost any block they passed — these were all blessings from God.

How could she take Nademah, for instance, for granted? How had they produced such a child — so smart and self-possessed, so dutiful, helpful, and precocious? She was practically an adult now, it seemed — she certainly spoke like one, often more measured and circumspect than her parents. Kathy glanced at her now, sitting in the passenger seat playing with the radio. She'd always been quick. When she was five, no more than five, Zeitoun came home from work for lunch one day and found Nademah playing on the floor. She looked up at him and declared, "Daddy, I want to be a dancer." Zeitoun took off his shoes and sat on the couch. "We have too many dancers in the city," he said,

rubbing his feet. "We need doctors, we need lawyers, we need teachers. I want you to be a doctor so you can take care of me." Nademah thought about this for a moment and said, "Okay, then I'll be a doctor." She went back to her coloring. A minute later, Kathy came downstairs, having just seen the wreck of Nademah's bedroom. "Clean up your room, Demah," she said. Nademah didn't miss a beat, nor did she look up from her coloring book. "Not me, Mama. I'm going to be a doctor, and doctors don't clean."

In the car, approaching their school, Nademah turned up the volume on the radio. She'd caught something on the news about the coming storm. Kathy wasn't paying close attention, because three or four times a season, it seemed, there was some early alarmist talk about hurricanes heading straight for the city, and always their direction changed, or the winds fizzled in Florida or over the Gulf. If a storm hit New Orleans at all, it would be greatly diminished, no more than a day of grey gusts and rain.

This reporter was talking about the storm heading into the Gulf of Mexico as a Category 1. It was about 45 miles north-northwest of Key West and heading west. Kathy turned the radio off; she didn't want the kids to worry.

"You think it'll hit us?" Nademah asked.

Kathy didn't think much of it. Who ever worried about a Category 1 or 2? She told Nademah it was nothing, nothing at all, and she kissed the girls goodbye.

With the thrump of three car doors, Kathy was suddenly and definitively alone. Driving away from the school, she turned the radio on again. City officials were giving the usual recommendations about having three

days' worth of supplies on hand — Zeitoun had always been vigilant about this — and then there was some talk about 110-mile-per-hour winds and storm surges in the Gulf.

She turned it off again and called Zeitoun on his cell phone.

"You hear about this storm?" she asked.

"I hear different things," he said.

"You think it's serious?" she asked.

"Really? I don't know," he said.

Zeitoun had reinvented the word "really," prefacing a good deal of his sentences with "Really?" as a kind of throat-clearer. Kathy would ask him any question, and he would say, "Really? It's a funny story." He was known for anecdotes, and parables from Syria, quotations from the Qur'an, stories from his travels around the world. All of it she'd gotten used to, but the use of "Really?" — she'd given up fighting it. For him it was equivalent to starting a sentence with "You know," or "Let me tell you." It was Zeitoun, and she had no choice but to find it endearing.

"Don't worry," he said. "Are the kids at school?"

"No, they're in the lake. My God."

The man was school-obsessed, and Kathy liked to tease him about it and any number of other things. She and Zeitoun spoke on the phone throughout every day, about everything — painting, the rental properties, things to fix and do and pick up, often just to say hello. The banter they'd developed, full of his exasperation and her one-liners, was entertaining to anyone who overheard it. It was unavoidable, too, given how often they talked. Neither of them could operate their home, their company, their lives or days without the other.

That they had come to such symbiosis continually surprised Kathy. She had been brought up a Southern Baptist in suburban Baton Rouge

with dreams of leaving home — she did so just after high school — and running a daycare center. Now she was a Muslim married to a Syrian American, managing a sprawling painting and contracting business. When Kathy met her husband, she was twenty-one and he was thirty-four and a native of a country she knew almost nothing about. She was recovering from an unsuccessful marriage and had recently converted to Islam. She wasn't even vaguely interested in getting married again, but Zeitoun had turned out to be everything she had not believed possible: an honest man, honest to the core, hardworking, reliable, faithful, devoted to family. And best of all, he very much wanted Kathy to be who and how she wanted to be, nothing more or less.

But it didn't mean there wasn't some fussing. Kathy called it that, their spirited back-and-forth about everything from what the kids ate for dinner to whether they should enlist a collection agency to help with a particular client.

"We're just fussin'," she would tell her kids when they heard the two of them. Kathy couldn't help it. She was a talker. She couldn't hold anything in. I'm going to speak my mind, she told Abdul early in their relationship. He shrugged; that was fine with him. He knew that sometimes she just needed to blow off steam, and he let her. He would nod patiently, sometimes thankful that his English wasn't as quick as hers. While he searched for the right words to respond with, she would go on, and often enough, by the time she was finished, she had tired herself out, and there was nothing left to say.

In any case, once Kathy knew that she would be heard, and heard to the end, it softened the tone of her arguments. Their discussions became less heated, and often more comical. But the kids, when they were young, sometimes couldn't tell the difference.

Years before, while Kathy was driving and fussing about something

with Zeitoun, Nademah spoke up. Strapped into a car seat in the back, she had had enough. "Dad, be nice to Mom," she said. And then she turned to Kathy. "Mom, be nice to Dad." Kathy and Zeitoun stopped cold. They looked at each other, and then, in unison, back to little Nademah. They already knew she was smart, but this was something different. She was only two years old.

After she hung up with Zeitoun, Kathy did what she knew she shouldn't do, because clients no doubt needed and expected to reach her in the morning. She switched off her phone. She did this every so often, after the kids had left the car and she'd turned toward home. Just to have that thirty minutes of solitude during the drive — it was decadent but essential. She stared at the road, in total silence, thinking of nothing at all. The day would be long, it would be nonstop until the kids went to bed, so she allowed herself this one extravagance, an uninterrupted, thirty-minute expanse of clarity and quiet.

Across town, Zeitoun was at his first job of the day. He loved this place, a magisterial old house in the Garden District. He had two men on the job and was stopping by to make sure they were there, that they were busy, that they had what they needed. He jumped up the steps and strode into the house. It was easily 120 years old.

He saw Emil, a painter and carpenter from Nicaragua, kneeling in a doorway, taping off a baseboard. Zeitoun snuck up behind him and grabbed his shoulders suddenly.

Emil jumped.

Zeitoun laughed.

He wasn't even sure why he did things like this. It was hard to explain — sometimes he just found himself in a playful mood. The

workers who knew him well were unsurprised, while the newer ones would often be startled, thinking his behavior a bizarre sort of motivational method.

Emil managed a smile.

In the dining room, applying a second coat to the wall, was Marco, originally from El Salvador. The two of them, Marco and Emil, had met at church and had gone looking for work as a team of housepainters. They'd shown up at one of Zeitoun's job sites, and because Zeitoun nearly always had more work than he could handle, he'd taken them on. That had been three years ago, and Marco and Emil had worked for Zeitoun consistently since then.

Outside of employing a number of New Orleans natives, Zeitoun had hired men from everywhere: Peru, Mexico, Bulgaria, Poland, Brazil, Honduras, Algeria. He'd had good experiences with almost all of them, though in his business there was an above-average rate of attrition and turnover. Many workers were transient, intending only to spend a few months in the country before returning to their families. These men he was happy to hire, and he'd learned a fair bit of Spanish along the way, but he had to be prepared for their short-notice disappearances. Other workers were just young men: irresponsible and living for today. He couldn't blame them — he'd been young and untethered once, too — but he tried, whenever he could, to instill in them the knowledge that if they kept their heads down and saved a few dollars a week, they could live well, could raise a family doing this kind of work. But he rarely saw a young man in this business who had an eye to the future. Just keeping them in food and clothing, chasing them down when they were late or absent — all of it was exhausting and occasionally disheartening. He felt, sometimes, as if he had not four children but dozens, most of them with paint-covered hands and mustaches.

His phone rang. He looked at the caller ID and picked up.

"Ahmad, how are you?" Zeitoun said in Arabic.

Ahmad was Zeitoun's older brother and closest friend. He was calling from Spain, where he lived with his wife and two children, both in high school. It was late where Ahmad was, so Zeitoun worried that the call might bring grave news.

"What is it?" Zeitoun asked.

"I'm watching this storm," he said.

"You scared me."

"You should be scared," Ahmad said. "This one could be for real."

Zeitoun was skeptical but paid attention. Ahmad was a ship captain, had been for thirty years, piloting tankers and ocean liners in every conceivable body of water, and he knew as much as anyone about storms, their trajectories and power. As a young man, Zeitoun had been with him for a number of those journeys. Ahmad, nine years older, had brought Zeitoun on as a crewman, taking him to Greece, Lebanon, South Africa. Zeitoun had gone on to work on ships without Ahmad, too, seeing most of the world in a ten-year period of wanderlust that eventually brought him to New Orleans and to his life with Kathy.

Ahmad clicked his tongue. "It really does seem unusual. Big and slow-moving. I'm watching it on the satellite," he said.

Ahmad was a technophile. At work and in his spare time he paid close attention to the weather, to developing storms. At the moment he was at his home in Málaga, a beach town on the Spanish Mediterranean, in his cluttered office, tracking this storm making its way across Florida.

"Have they begun evacuating?" Ahmad asked.

"Not officially," Zeitoun said. "Some people are leaving."

"And Kathy, the kids?"

Zeitoun told him they hadn't thought about it yet.

Ahmad sighed. "Why not go, just to be safe?"

Zeitoun made a noncommittal sound into the phone.

"I'll call you later," Ahmad said.

Zeitoun left the house and walked to the next job, one block over. It was often like this, multiple jobs in close proximity. Clients seemed so surprised to work with a painter or contractor they could trust and recommend that through referrals and in rapid succession Zeitoun would get a half-dozen jobs in any given neighborhood.

This next house, which he'd worked on for years, was across the street from the home of Anne Rice, the writer — he had not read her work, but Kathy had; Kathy read everything — and was as stately and gorgeous a home as existed in New Orleans. High ceilings, a grand winding staircase descending into the foyer, hand-carved everything, each room themed and with a distinct character. Zeitoun had painted and repainted probably every room in the house, and the owners showed no signs of stopping. He loved to be in that house, admiring the craftsmanship, the great care put into the most eccentric details and flourishes — a mural over the mantel, one-of-a-kind ironwork on every balcony. It was this kind of willful, wildly romantic attention to beauty — crumbling and fading beauty needing constant attention — that made this city so unlike any other and such an unparalleled sort of environment for a builder.

He walked in, straightened the drop cloth in the front hall, and made his way to the back of the house. He peeked in on Georgi, his Bulgarian carpenter, who was installing new molding near the kitchen.

Georgi was a good worker, about sixty, barrel-chested and tireless, but Zeitoun knew not to get him talking. Once Georgi started you were in for a twenty-minute discourse on the former Soviet Union, waterfront property in Bulgaria, and his various cross-country motorhome trips with his wife Albena, who had passed away years ago and was greatly missed.

Zeitoun got in his van and the radio assaulted him with more warnings about this storm called Katrina. It had formed near the Bahamas two days earlier and had scattered boats like toys. Zeitoun took note, but thought little of it. The winds were still many days from being relevant to his life.

He made his way to the Presbytere Museum on Jackson Square, where he had another crew working on a delicate restoration of the two-hundred-year-old building. The museum had been a courthouse long ago and was now home to a vast and extraordinary collection of Mardi Gras artifacts and memorabilia. It was a high-profile job and Zeitoun wanted to get it right.

Kathy called from home. She had just heard from a client in the Broadmoor neighborhood. Zeitoun's men had painted a window shut and someone needed to come unstick it.

"I'll go," he said. Easier that way, he figured. He would go, he would do it, it would be done. Fewer phone calls, no waiting.

"You hear about the winds?" Kathy said. "Killed three in Florida so far."

Zeitoun dismissed it. "This is not the storm for us," he said.

Kathy often poked fun at Zeitoun's stubbornness, at his unwillingness to bow before any force, natural or otherwise. But Zeitoun couldn't

help it. He had been raised in the shadow of his father, a legendary sailor who had faced a series of epic trials, and had always, miraculously, survived.

Zeitoun's father, Mahmoud, had been born not far from Jableh, on Arwad Island, the only island off Syria, a landmass so small it didn't appear on some maps. There, most boys grew up to be shipbuilders or fishermen. As a teenager Mahmoud began crewing on shipping routes between Lebanon and Syria, on large sail-powered cargo boats, bringing timber to Damascus and other cities along the coast. He had been on such a ship during World War II, sailing from Cyprus to Egypt. He and his shipmates were vaguely aware of the danger of Axis forces targeting them as potential suppliers to the Allies, but they were astounded when a squadron of German planes appeared on the horizon and bore down on them. Mahmoud and the rest of the crew dove into the sea just before the planes began strafing. They managed to detach an inflatable lifeboat before their ship sank, and were crawling into it when the Germans returned. They were intent, it seemed, on killing all the crew members who had survived. Mahmoud and his fellow sailors were forced to dive from the dinghy and wait underwater until the Germans were satisfied that the crew had all been shot or drowned. When the surface seemed safe again, the sailors returned to their lifeboat and found it full of holes. They stuffed their shirts into the gaps and paddled by hand, for miles, until they reached the Egyptian shore.

But the story Mahmoud told most often when Zeitoun was growing up, the story he told when forbidding his children to live on the sea, was this one:

Mahmoud was returning from Greece on a thirty-six-foot schooner when they ran into a black and tortuous storm. They sailed through it for hours until the main mast cracked and dropped the sail into the

water, threatening to drag the whole ship into the sea. Without thinking, Mahmoud climbed up the mast, intending to free the sail and right the hull. But when he reached the crack in the mast, it gave way completely, and he fell into the ocean. The ship was traveling at eight knots and there was no chance of turning it around, so the crew threw what they could to Mahmoud — a few planks and a barrel — and in minutes the boat was gone into the darkness. He was alone at sea for two days, with sharks below and storms above, clinging to the remnants of the barrel, when he finally washed ashore near Lattakia, fifty miles north of Arwad Island.

No one, including Mahmoud, could believe he had survived, and thereafter he vowed never to take the chance again. He quit sailing, moved his family from Arwad onto the mainland, and forbade his children to work on the sea. He wanted good schooling for them all, opportunities apart from fishing and shipbuilding.

Mahmoud and his wife went looking all over Syria for a new home, a place far from the water. They spent months traveling with their small children, inspecting this town and that house. But nothing seemed right. Nothing, that is, until they found themselves inside a two-story home, with enough room for all their current and future children. When Mahmoud declared that this was the place for them, his wife laughed. They were facing the sea, not fifty feet from shore.

There, in Jableh, Mahmoud opened a hardware store, sent his sons and daughters to the best schools, and taught his boys every trade he could. Everyone knew the Zeitouns, all of them hardworking and quick, and they all knew Abdulrahman, the eighth-born, a young man who wanted to know everything and who feared no kind of labor. As a teenager, he watched the tradesman in town whenever he could, studying their

craft. And once they realized he was serious and a quick learner, they'd teach him whatever they knew. Over the years he'd learned every trade he could get close to — fishing, ship rigging, painting, framing, masonry, plumbing, roofing, tile work, even auto repair.

Zeitoun's father would likely be both proud and bemused by the trajectory of his son's life. He hadn't wanted his kids to work on the sea, but many of them, including Zeitoun, had. Mahmoud wanted his children to be doctors, teachers. Zeitoun, though, was too much like his father: first a sailor, then, to provide for a family and to ensure that he lived to watch them grow up, a builder.

Zeitoun called Kathy at eleven. He'd freed the window in Broadmoor and now was at Home Depot.

"You hear anything new?" he asked.

"Looks bad," she said.

She was online. The National Hurricane Center had upgraded Katrina to a Category 2. They had shifted the possible track of the storm from the Florida panhandle to the Mississippi–Louisiana coast. The storm was crossing southern Florida with winds around ninety miles an hour. At least three people had been killed. Power was out for 1.3 million households.

"People here are worried," Zeitoun said, looking around the store. "A lot of people buying plywood." The lines were long. The store was running low on plastic sheeting, duct tape, rope — anything that would protect windows from the winds.

"I'll keep watching," Kathy said.

In the parking lot, Zeitoun looked to the sky for signs of the coming weather. He saw nothing unusual. As he pushed his cart to his van, a

young man, pushing his own cart full of supplies, approached Zeitoun.

"How's business?" the man asked.

Probably an electrician, Zeitoun figured.

"Not bad," Zeitoun said. "You?"

"Could be better," he said, and introduced himself and his trade: he was indeed an electrician. He was parked next to Zeitoun, and began helping Zeitoun unload his cart. "You ever need one," he said, "I show up when I say I'll show up, and I finish what I start." He handed Zeitoun his card. They shook hands, and the electrician got into his own van, which Zeitoun noticed was in better shape than his own.

"Why do you need me?" Zeitoun asked. "Your van's newer than mine."

They both laughed, and Zeitoun put the card on his dashboard and pulled out. He would call the young man, he figured, sooner or later. He always needed electricians, and he liked the man's hustle.

When he began working in New Orleans, eleven years earlier, Zeitoun labored for just about every contractor in the city, painting, hanging Sheetrock, tiling — anything they needed — until he was hired by a man named Charlie Saucier. Charlie owned his own company, had built it from scratch. He'd become wealthy, and was hoping to retire before his knees gave out on him.

Charlie had a son in his late teens, and he wanted nothing more than to leave the company to this son. He loved his son, but his son was not a worker; he was shifty and ungrateful. He failed to show up for work, and when he did, he worked listlessly, and condescended to his father's employees.

At the time, Zeitoun didn't have a car, so he rode to Charlie's work sites on a bike — a ten-speed he bought for fory dollars. One day, when

Zeitoun was already in danger of being late, the bike blew a tire. After riding on the rim for half a mile, he gave up. He needed to get four miles across the city in twenty minutes, and it was looking like he would be late for work for the first time in his life. He couldn't leave the bike and run — he needed that bike — and he couldn't ride on the flat tire, so he threw the bike over his shoulders started jogging. He was panicking. If he was late for this job, what would happen to his reputation? Charlie would be disappointed, and he might not hire him again. And what if Charlie talked to other contractors, and found he couldn't recommend Zeitoun? The consequences could be far-reaching. Work was a pyramid, he knew, built on day after solid day.

He ran faster. He would be tardy, but if he sprinted, he had a shot at being no more than fifteen minutes late. It was August and the humidity was profound. A mile or so into his run, already soaked in sweat, a truck pulled up next to him.

"What are you doing?" a voice asked. Without breaking stride, Zeitoun turned to see who it was. He figured it was some smart aleck poking fun at the man running along the road with a bike over his shoulders. But instead it was his boss, Charlie Saucier.

"I'm going to the job," Zeitoun said. He was still running; in hindsight he should have stopped at this point, but he was in a rhythm and he continued, with the truck puttering beside him.

Charlie laughed. "Throw your bike in the back."

As they drove, Charlie looked over to Zeitoun. "You know, I've been at this for thirty years, and I think you're the best worker I've ever had."

They were driving to the job site and Zeitoun had finally managed to relax, knowing he wouldn't be fired that day.

"I have one guy," Charlie continued, "he says he can't come to work

because his car won't start. I have another guy, he doesn't come because he slept late. He slept late! Another guy, his wife kicked him out of the house or something. So he doesn't show. I have twenty or thirty employees, and ten of them show up to work any given day."

They were at a stop sign, and Charlie took a long look at Zeitoun. "Then there's you. You have the perfect excuse. All you have is a bike, and the bike has a flat. But you're carrying your bike on your back. You're the only guy I've ever known who would have done something like that."

After that day, things moved quickly forward and upward for Zeitoun. Within a year, he had saved enough to buy his own truck. Two years later, he was working for himself and employing a dozen men.

At noon Zeitoun made his way to the Islamic Center on St. Claude — a humble-looking mosque and community gathering place downtown. Though his siblings worshiped in a variety of ways, Zeitoun was perhaps the most devout, missing none of his daily prayers. The Qur'an asked Muslims to worship five times daily: once between first light and dawn; again after midday; at mid-afternoon; at sunset; and lastly an hour and a half after sunset. If he found himself near home during the afternoon prayers, he would stop, but otherwise he prayed wherever he was, on any job. He had worshiped all over the city by now, at job sites, in parks, and in the homes of friends, but on Fridays he always stopped here, to meet friends for the *jumu'ah*, a ritual gathering of all the Muslim men in the community.

Inside, he first washed in a ritual cleansing called *wuduu*, required of worshipers. Then he began his prayers:

In the name of God, the Most Beneficent, the Most Merciful:
Praise be to God, the Lord of the Heavens and the Earth.
The Most Beneficent, the Most Merciful.
Master of the Day of Judgment.
You alone we worship, and You alone we ask for help.
Guide us to the straight way;
the way of those whom you have blessed,
not of those who have deserved anger,
nor of those who are astray...

Afterward he called Kathy.

"It'll be a Category 3 soon," she said.

Kathy was at home, checking the weather online.

"Coming at us?" he asked.

"They say it is."

"When?"

"Not sure. Maybe Monday."

Zeitoun dismissed it. Monday, to him, meant never. This had happened before, Zeitoun noted, so many times. The storms always raged across Florida, wreaking havoc, and then died somewhere overland or in the Gulf.

Kathy's call waiting went off; she said goodbye to Zeitoun and switched over. It was Rob Stanislaw, a longtime client and friend.

"You leaving or are you crazy?" he asked.

Kathy cackled. "'I want to leave. Of course. But I can't speak for my husband."

Rob had a similar predicament. His husband, Walt Thompson, was like Zeitoun — bullheaded, always feeling like his information was better than what anyone else had access to. Rob and Walt had been together

for fifteen years, and had been close with the Zeitouns since 1997. They had hired the Zeitouns to help with the renovation of a house they'd bought, and immediately the two couples had clicked. Over the years they'd grown to depend on each other.

Walt's family was in Baton Rouge, and it was likely that Rob and Walt would go there for the weekend, he said. Rob and Kathy agreed to update each other throughout the day.

She was about to take a break from the internet when something caught her attention. A news item, just posted: a family of five was missing at sea. The details were few — two parents, three kids aged four, fourteen, and seventeen. They had been sailing in the Gulf, and had been expected Thursday in Cape Coral. But when the storm came, they'd lost contact. Family and friends had notified the Coast Guard, and boats and planes were searching as best they could. That was all anyone knew for now, and it looked bad.

Kathy was a mess. Stories like this just wrecked her.

Kathy called her husband. "Rob and Walt are leaving."

"Really? Walt wants to leave?"

Zeitoun trusted Walt's judgment on just about everything.

Kathy thought she might have her husband tilting her way. "Fifteen inches of rain, I hear."

Silence from Zeitoun.

"Twenty-five-foot waves," Kathy added.

Zeitoun changed the subject. "Did you get the DeClercs to approve that paint sample?"

"I did," Kathy said. "Did you hear about this family of five?"

He had not, so in a breathless rush Kathy told him what she knew

about the family lost at sea in their tiny boat, swept away in the hurricane, just as the Zeitouns might be swept away if they didn't flee its path.

"We're not at sea, Kathy," Zeitoun said.

Zeitoun had spent the better part of ten years on ships, carrying everything from fruit to oil. He worked as a crewman, an engineer, a fisherman — he'd been everywhere from Japan to Cape Town. All along, his brother Ahmad had told him that "If a sailor finds the right port or the right woman, he'll drop anchor." In 1988 Zeitoun came to the United States on a tanker carrying oil from Saudi Arabia to Houston. He began working for a contractor in Baton Rouge, and it was there that he met Ahmaad, a Lebanese American who became one of his closest friends and the conduit through which he met his bride.

Ahmaad was working at a gas station at the time, and Zeitoun was hanging drywall. They bonded over common ancestry, and one day Zeitoun asked Ahmaad if he knew any single women who might be appropriate for him. Ahmaad was married to a woman named Yuko, an American of Japanese ancestry who had converted to Islam. And Yuko, it turned out, had a friend. Ahmaad was conflicted, though, because while he liked and trusted Zeitoun and wanted to help, he was hoping this friend of Yuko's might be a match for another friend of his. If it didn't work out between his friend and Yuko's, he said, he would surely introduce her to Zeitoun. Zeitoun was willing to respect that boundary, but at the same time his interest was piqued. Who was this woman who was so prized that Ahmaad would not even mention her name?

That year Zeitoun became increasingly determined to find the right woman. He told friends and cousins he was looking for a down-to-earth Muslim woman who wanted a family. Knowing he was a serious and

hardworking man, they provided many introductions. He was sent to New York to meet the daughter of an acquaintance. He went to Oklahoma to meet the cousin of a friend. He went to Alabama to meet the sister of a coworker's roommate.

Meanwhile, Yuko's friend had been set up with Ahmaad's friend, and though they courted for a few months, that relationship came to an end. Ahmaad, as promised, let Zeitoun know that Yuko's friend was now single. It was only then that Zeitoun was told her name: Kathy.

"Kathy?" Zeitoun asked. He hadn't known too many Muslims named Kathy. "Kathy what?"

"Kathy Delphine," Ahmaad said.

"She's American?"

"She's from Baton Rouge. She converted."

Zeitoun was more intrigued than ever. It took a courageous and self-possessed woman to take such a step.

"But listen," Ahmaad said. "She's been married. She has a two-year-old son."

This did nothing to dissuade Zeitoun.

"When can I see her?" he asked.

Ahmaad told him she worked at a furniture store, and gave Zeitoun the address. Zeitoun formulated a plan. He would park out front and observe her unnoticed. This was, he told Ahmaad, Jableh style. He didn't want to make a move, or allow anyone representing him to mention his intentions, before he could see her. This was the way of doing things where he'd come from: observe from afar, make inquiries, gather information, then meet. He wanted no confusion, no hurt feelings.

He pulled into the furniture store's parking lot at about five o'clock one day, planning to wait and watch as she left at the end of her shift.

He was just settling in for his stakeout when a young woman burst through the door, wearing jeans and a hijab. She was striking, and very young. She tucked a few strands of hair into her scarf and looked around the parking lot. And then she was walking again, striding with a powerful confidence, her hands flying about as if she were drying just-painted fingernails. Then she broke into a private smile, as if recounting something that had made her laugh. *What was it?* Zeitoun wondered. She was beautiful, fresh-faced, and the smile was everything — wide, shy, electric. *I want to make her smile like that*, he thought. *I want to be the one. I want to be the reason.* He liked her more with every step she took toward him. He was sold.

But she was getting too close. She was heading straight for him. Did she know he had come to see her? How was this possible? Someone had told her. Ahmaad? Yuko? She was almost at his car. He would look foolish. Why was she coming right at him? He wasn't ready to meet her.

Not knowing what else to do, he ducked. Crouching below his dashboard, he held his breath and waited. *Please God*, he thought. *Please.* Would she pass by, or would she appear at his window, wondering about the man trying to disappear below her? He felt ridiculous.

Kathy, though, had no idea she was passing a man hiding under his steering wheel. Her car just happened to be parked next to his. She unlocked her door, got in, and drove off.

When she was gone, Zeitoun righted himself, breathed a sigh of relief, and tried to settle his stampeding heart.

"I need to meet her," he told Ahmaad.

It was agreed that they would meet at Ahmaad and Yuko's house. There would be a casual dinner, with Ahmaad and Yuko's kids and

Kathy's son Zachary. It would be low-pressure, just an opportunity for the two of them to talk a bit and for Kathy, who had yet to even see Zeitoun, to meet this man who had inquired about her.

When she saw him, she liked his eyes, his handsome, gold-skinned face. But he seemed too conservative, and he was thirty-four to her twenty-one — well beyond the age she had imagined for a husband. Besides, it had been just two years since she'd left her first marriage, and she felt unready to begin again. She could think of nothing she needed from a man. She could certainly raise Zachary herself; the two of them had become a very good and streamlined team, and there seemed no reason to upset the balance of her life. She couldn't risk the chaos that her first marriage had wrought.

After he left that night, Kathy told Yuko that he was a nice enough man, but she didn't think it was a good match.

But over the next two years, she and Zeitoun saw each other occasionally. He would be at a barbecue at Ahmaad and Yuko's, but out of deference to her — he didn't want her to feel uncomfortable — when Kathy arrived, he would leave. He continued to ask about her, and once a year he sent an offhand inquiry through Yuko, just to be sure she hadn't changed her mind.

Meanwhile, Kathy's outlook was evolving. As Zachary grew, she began to feel guilty. She would take him to the park and watch the other boys playing with their fathers, and she began to wonder if she was being selfish. *A boy needs a dad*, she thought. Was it unfair to dismiss the possibility of a father figure in Zachary's life? Not that she was ready to act on these notions, but there was a slow thaw occurring within her. As the years went by, as Zachary turned three and then four, she grew more open to the idea of someone new.

Kathy called Zeitoun in the early afternoon.

"Let's wait and see," he said.

"That isn't why I'm calling," she said.

A client on the West Bank wanted a bathroom repainted.

"Really? We just finished that one," he said.

"She doesn't like how it looks."

"I told her that color was wrong. Tangerine."

"Well, now she agrees with you."

"I'll go now," he said.

"Don't rush," she said.

"Well, make up your mind."

"I just don't want you driving fast," she said. Kathy worried about his driving, especially when there were people worried about a coming storm. She knew Zeitoun considered himself a good driver, but when they rode together she was a jumble of nerves.

"Kathy, please—" he started.

"I just get scared when you drive!"

"I ask you," he said, beginning what Kathy knew was one of his frequent thought experiments. "Let's say the average person drives maybe two hours a day, every day, and that person gets, on average, two tickets a year. I drive maybe *six* hours *each day*. How many tickets should I have? This is what I ask."

"I'm just saying, I personally get scared."

"I get only two, three tickets a *year,* Kathy! I knew this man, a cab driver in New York for thirty years. No license, and this man—"

Kathy didn't want to hear about the man in New York. "I'm just saying…"

"Kathy. Kathy. In Syria we have a saying, 'The crazy person talks, the wise person listens.'"

"But you're the one talking."

Zeitoun had to laugh. She always got the best of him.

"I'll call you later," she said.

Zeitoun headed to the West Bank to get a look at the tangerine bathroom. He tried to be amused by the fickle nature of clients' tastes; it was part of the job, and if he got exasperated every time someone changed their mind, he'd never survive. The upshot was that it ensured no day was dull. The intensely personal nature of his business, the subjectivity of taste, the variables of light and curtains and carpets, guaranteed that minds would reevaluate and work would have to be redone.

Still, the most unusual requests often came from the most normal-seeming people. One customer, a Southern belle in her sixties, had called Zeitoun Painting and had been happy to talk with Kathy, with her chatty demeanor and familiar accent. But when the painters showed up to begin work on the exterior of her home, the woman immediately called Kathy.

"I don't like these men," she said.

"What's wrong with 'em?" Kathy asked.

"They're swarthy," she said. "I only want white people working on my house." She said it like she was choosing a kind of dressing for her salad.

"White people?" Kathy laughed. "Sorry, we're fresh out of those."

She convinced the woman that the men who had been sent — all of them Latino, in this case — were skilled professionals who would do an excellent job. The woman assented, but continued to call. "He's too short to be a painter," she said about one worker, Hector, who was over

six feet tall. Realizing that no matter how much she complained, she would not be able to replace these painters with taller, Caucasian ones, the Southern belle resigned herself to watching the men, checking on them frequently.

Of course, every so often, would-be clients could not get past Zeitoun's last name. They would call for an estimate and ask Kathy, "Zeitoun, where's that name come from? Where is he from?" And Kathy would say, "Oh, he's Syrian." Then, after a long pause or a shorter one, they would say, "Oh, okay, never mind." It was rare, but not rare enough.

Kathy sometimes told Zeitoun about such incidents, sometimes not, and never at dinner. Usually he just laughed it off, but occasionally it got under his skin. His frustration with some Americans was like that of a disappointed parent. He was so content in this country, so impressed with and loving of its opportunities, but then why, sometimes, did Americans fall short of their best selves? If you got him started on the subject, it was the end of any pleasant meal. He would begin with a defense of Muslims in America and expand his thesis from there. Since the attacks in New York, he would say, every time a crime was committed by a Muslim, that person's faith was mentioned, regardless of its relevance. When a crime is committed by a Christian, do they mention his religion? If a Christian is stopped at the airport for trying to bring a gun on a plane, is the Western world notified that a Christian was arrested today and is being questioned? And what about African Americans? When a crime is committed by a black man, it's mentioned in the first breath: "An African American man was arrested today..." But what about German Americans? Anglo Americans? A white man robs a convenience store and do we hear he's of Scottish descent? In no other instance is the ancestry mentioned.

Then Zeitoun would quote the Qur'an.

Be one who is staunch in equity,
witnesses for God
even against yourselves
or ones who are your parents or nearest of kin;
whether rich or poor,
for God is closer to both than you are;
so follow not your desires
that you become unbalanced;
and if you distort or turn aside,
then truly God is aware of what you do.

Kathy was astonished at how well he knew the book, and how quickly he could quote a passage appropriate for any occasion. Still, though, these monologues at dinner? It was good for the kids to have some awareness of such prejudices, but to see Zeitoun disappointed, to get him so worked up after a long day — it wasn't worth it. In the end, though, Zeitoun could laugh this kind of thing off, but the one thing he could not abide was a client raising their voice to Kathy.

There had been one client, a young woman married to a doctor. She was thin, pretty, immaculately put together. She had not set off any alarm bells when Zeitoun had provided an estimate and begun work on painting her stairway and guest bedroom. She told him that she and her husband were expecting houseguests, and she wanted the stairway and guest room painted in five days' time. Zeitoun said the timetable would be tight, but would present no problems on his end. She was thrilled. No other painter had been able to commit to such a deadline.

Zeitoun sent a crew of three over the next day. The client, seeing the quick and efficient work Zeitoun's team was doing, asked him if they could paint her husband's office and her daughter's bedroom, too. He said

they could. He sent more painters to the house, and she continued to add rooms and jobs — including re-tiling and painting a bathroom — and Zeitoun's men continued to execute the work quickly.

But not quickly enough. On the third day, Kathy phoned Zeitoun, near tears. The woman had called Kathy four times in rapid succession, cursing and carrying on. The house wasn't ready, the client had screamed, and her guests were coming in less than two days. Kathy had told her that Zeitoun's crew had finished the original work on the guest room in plenty of time. But this wasn't what the client wanted. She wanted everything — all seven rooms and their myriad tasks — done in five days. She wanted three times the work done in the same amount of time.

Kathy had tried to reason with her. She and Zeitoun had never promised that he could finish all of the additional work in five days. That schedule was irrational; no one, not even Zeitoun A. Painting Contractor LLC, could complete the work on that timetable. But the client was beyond reason. She barked at Kathy, hanging up, calling again, hanging up. She was loud, condescending, and cruel.

Kathy, in tears, reached Zeitoun on his cell phone while he was driving to a job on the other side of the city. Even before they hung up, he had turned his truck around and was barreling to the client's house as fast as was legal. When he got there, he walked calmly into the house and told his crew they were leaving. In the space of ten minutes, they packed their paint, ladders, brushes, and tarps, and loaded them into the bed of Zeitoun's truck.

As Zeitoun was backing out, the client's husband ran out to the truck. What's wrong? he asked. What happened? Zeitoun was so angry he could barely think of the words in English. It was better, in fact, that he did not speak. He waited a few seconds to say only that no one talked

that way to his wife, that he was leaving the job, that this was over and good luck.

When he arrived at the tangerine-bathroom house, he called Kathy to run through the prices for the materials they'd need. Looking around the orange room — it really was difficult to look at — he noted the clients' new tub, a huge claw-footed antique.

"It's big, but isn't it beautiful?" Kathy asked.

"Yes, like you!" he joked.

"Watch it," she said. "I can lose this weight, but you're never growing that hair back."

When they'd met, Kathy had been weight-obsessed, and was far too thin. She had been chubby as a child, at least to some eyes, and in her teens her weight fluctuated wildly. She binged and dieted and then cycled through it all again. When she and Zeitoun were married, he insisted that she get beyond the weight issues and eat like a normal person. She did, and now joked that she'd gone too far. "Thank God for the abaya," she told friends. When she didn't want to bother worrying about clothes or how they looked on her, the shoulder-to-floor Islamic dress solved the problem, and tidily.

There was a knock on the door. Kathy went to answer it and found Melvin, a Guatemalan painter. He was looking to get paid before the weekend.

Zeitoun was relentless in his efforts to pay the workers well and promptly. He always quoted the Prophet Muhammad: "Pay the laborer his wages before his sweat dries." Zeitoun used that as a bedrock and constant guide in the way he and Kathy did business, and the workers took note.

Still, Zeitoun preferred to pay on Sundays or Mondays — because when he paid on Fridays, too many of the workers would disappear all weekend. But Kathy's heart was soft, her resolve to withhold payment even an hour weakened in the presence of these workers soaked with sweat, knuckles bleeding, forearms yellow with sawdust.

"Don't tell Zeitoun," she said, and wrote him a check.

Kathy turned on the TV and flipped through the channels. Every station was covering the storm.

Nothing had changed: Katrina was still headed their way, and it was losing no power. And because the hurricane as a whole was traveling so slowly, about eight miles per hour, the sustained winds were causing, and would continue to cause, catastrophic damage.

The coverage was just background noise, though, until Kathy caught the words "family of five." They were talking about the family lost at sea. *Oh no*, she thought. *Please.* She turned up the sound. They were still missing. The father's name was Ed Larsen. He was a construction supervisor. *You're kidding me*, she thought. He had taken the week off to take his family sailing on his yacht, the *Sea Note*. They had been at Marathon and were sailing back to Cape Coral when they'd lost radio contact. His wife and three kids were with him. They were on their way back to shore for a family reunion. The extended family had gathered only to realize that the Larsens were missing; the celebration turned into a vigil of worry and prayer.

Kathy couldn't stand it.

She called her husband. "We have to go."

"Wait, wait," he said. "Let's wait and see."

"Please," she said.

"Really?" he said. "You can go."

<p style="text-align:center">*　*　*</p>

Kathy had taken the kids north a handful of times when storms had gotten close. But she was hoping she wouldn't have to make the trip this time. She had work to do over the weekend, and the kids had plans, and she always came back from those trips more exhausted than when she'd left.

Almost without exception, whether it was fleeing a storm or for a weekend vacation, Kathy and the kids had to go without Zeitoun. Her husband had trouble leaving the business, had trouble relaxing for days on end, and after years of this vacationless life Kathy had threatened to pack the kids and just leave for Florida some Friday after school. At first Zeitoun hadn't believed her. Would she really pack up and leave with or without him?

She would, and she did. One Friday afternoon, Zeitoun was checking on a nearby job and decided to stop at home. He wanted to see the kids, change his shirt, pick up some paperwork. But when he pulled into the driveway, there was Kathy, loading up the minivan, the two youngest already buckled inside.

"Where you going?" he asked.

"I told you I'd go with or without you. And we're going."

They were going to Destin, Florida, a beach town on the Gulf about four hours away, with long white beaches and clear water.

"Come with us, Daddy!" Nademah pleaded. She had just come out of the house with their snorkeling gear.

Zeitoun was too stunned to react. He had a hundred things on his mind, and a pipe at one of the rental properties had just burst. How could he go?

Nademah got in the front seat and put on her seatbelt.

"Bye bye," Kathy said, backing out. "See you Sunday."

And they were gone, the girls waving as they left.

He didn't go that Friday, but after that, he no longer doubted Kathy's resolve. He knew she was serious — that in the future he'd be consulted on vacation plans, but that trips to Florida or beyond could and would happen with or without him. So over the years there were other trips to Destin, and he even made it on a few of them.

But always his decision was made at the last minute. One time Kathy was late in getting started, and he was so late in deciding that he couldn't even pack. She was in the driveway, backing out, when he pulled in.

"Now or never," she said, barely stopping the car.

And so he jumped in the car. The girls giggled to see their dad in the back seat, still in his work clothes, dirty and sweating — as much from the stress of the decision as from the day's work. Zeitoun had to buy beach clothes when they got to Florida.

Kathy was proud that she'd gotten him to Destin once a year. Zeitoun didn't mind going too much because, given how close it was, he knew he could come back at any time — and more than once, he had cut a vacation short because of some problem at one of the work sites.

By 2002, though, Kathy wanted something that really felt like a vacation. And she knew she had to do something drastic. In all their time together — eight years at that point — he had never taken more than two days off in a row. She knew that she had no choice but to kidnap him.

She started by planning a weekend in Destin. She chose a weekend when she knew things would be calm at work; it was just after Christmas, and there was rarely much work till well after New Year's. As usual,

Zeitoun wouldn't commit till the last minute, so she took the precaution of actually packing a bag for him and hiding it in the back of the minivan. Because she had made sure the weekend was quiet, he came along — as always, at the last minute. Kathy told him she'd drive, and because he was exhausted, he agreed. She made sure the kids were quiet — they were in on the plan — and he soon fell asleep, drooling on his seatbelt. While he slept, Kathy drove right on through Destin and onward down the paunch of Florida. Each time he woke up she would say, "Almost there, go back to sleep," and thankfully he would — he was so tired — and it wasn't until an hour north of Miami that he realized they weren't going to Destin. Kathy had driven straight down to Miami. Seventeen hours. She'd checked on the computer for the warmest place in the country that week, and Miami was it. Being that far away was the only way to ensure he would take a real vacation, a full week's worth of rest. Every time she thought back on the gambit, and how well it had worked, Kathy smiled to herself. A marriage was a system like any other, and she knew how to work it.

At about two-thirty, Ahmad called Zeitoun again. He was still tracking the storm from his computer in Spain.

"Doesn't look good for you," he said.

Zeitoun promised he would keep watch on it.

"Imagine the storm surge," Ahmad said.

Zeitoun told him he was paying close attention.

"Why not leave, just to be safe?" Ahmad said.

Kathy decided to go to the grocery store before picking up the girls from school. You could never tell when people would make a run on the basics before a storm arrived, and she wanted to avoid the crush.

She went to the mirror to adjust her hijab, brushed her teeth, and left the house. Not that she thought about it much, but any trip to the grocery store or the mall presented the possibility that she would encounter some kind of ugliness. The frequency of incidents seemed tied, to some extent, to current events, to the general media profile of Muslims that week or month. Certainly after 9/11 it was more fraught than before, and then it had calmed for a few years. But in 2004 a local incident had stoked the fire again. At West Jefferson High School, a tenth grader of Iraqi descent had been repeatedly harassed by her history teacher. He had called Iraq a "third-world country," had worried that the student would "bomb us" if she ever returned to Iraq. In February of that year, while passing out tests, the teacher had pulled back the girl's hijab and said, "I hope God punishes you. No, I'm sorry, I hope Allah punishes you." The incident was widely reported. The student filed a lawsuit against him, and his termination was recommended by the Jefferson Parish School District superintendent. The school board overruled; he was given a few weeks' suspension and returned to the classroom.

After the decision, there had been an uptick in minor harassment of Muslims in the area, and Kathy was aware of the invitation she was providing in going out in her hijab. There was a new practice in vogue at the time, favored by adolescent boys or those who thought like them: sneak up behind a woman wearing a headscarf, grab it, and run.

One day it happened to Kathy. She was shopping with Asma, a friend who happened to be Muslim but who wore no hijab. Asma was originally from Algeria, and had been living in the U.S. for twenty years; she was usually taken for Spanish. Kathy and Asma were leaving the mall, and outside, Kathy was trying to remember where she'd parked

her car. She and Asma were on the sidewalk, Kathy squinting at the rows of gleaming cars, when Asma gave her a funny look.

"Kathy, there's a girl behind you—"

A girl of about fifteen was crouched behind Kathy, her arm raised, about to yank the hijab off Kathy's head.

Kathy cocked her head. "You got a problem?" she barked.

The girl cowered and slunk away, joining a group of boys and girls her age, all of whom had been watching. Once back with her friends, the girl directed some choice words Kathy's way. Her friends laughed and echoed her, cursing at Kathy in half a dozen different ways.

They could not have expected Kathy to return the favor. They assumed, no doubt, that a Muslim woman, presumably submissive and shy with her English, would allow her hijab to be ripped from her head without retaliation. But Kathy let loose a fusillade of pungent suggestions, leaving them dumbfounded and momentarily speechless.

On the drive home, even Kathy was shocked by what she'd said. She had been brought up around plenty of cursing, and knew every word and provocative construction, but since she'd become a mother, since she'd converted, she hadn't sworn more than once or twice. But those kids needed to learn something, and so she'd obliged.

In the weeks after the attacks on the Twin Towers, Kathy saw very few Muslim women in public. She was certain they were hiding, leaving home only when necessary. In late September, she was in Walgreens when she finally saw a woman in a hijab. She ran to her. *"Salaam alaikum!"* she said, taking the woman's hands. The woman, a doctor studying at Tulane, had been feeling the same way, like an exile in her own country, and they laughed at how delirious they were to see each other.

On this day in August, the grocery-store trip went off without confrontation, and she picked up her girls.

"You hear about the storm?" Nademah asked.

"It's coming toward us," Safiya added from the back seat.

"Are we going to leave?" Nademah asked.

Kathy knew that her kids wanted to. They could go to one of their cousins' homes, in Mississippi or Baton Rouge, and it would be a vacation, a two-day sleepover. Maybe school would be canceled on Monday as the city cleaned up? This was surely what they were thinking and hoping. Kathy knew the workings of her children's minds.

When they got home, it was five o'clock and Katrina was all over the news. The family watched footage of enormous waves, uprooted trees, whole towns washed grey with torrential rain. The National Hurricane Center was suggesting that Katrina would soon become a Category 3. Governor Blanco held a press conference to declare a state of emergency for Louisiana. Governor Barbour did the same for Mississippi.

Kathy was rattled. Sitting on the arm of the couch, she was so distracted that soon it was six o'clock and she hadn't started dinner. She called Zeitoun.

"Can you get Popeyes on your way home?" she asked.

At home, Nademah arranged the tablecloth and placemats. Safiya and Aisha set out the silverware and glasses. Kathy threw together a salad and poured milk for the kids and juice for herself and Zeitoun.

Zeitoun arrived with the chicken, showered, and joined the family for dinner.

"Finish, finish," he said to his daughters, who were picking at their food, leaving huge swaths of it uneaten.

He had gotten used to it after all these years, but still, there were times when the waste got to him. The disposability of just about everything. Growing up in Syria he had often heard the expression "If your hand doesn't work for it, your heart doesn't feel sorry for it." But in the U.S., it wasn't just the prosperity — because New Orleans was not uniformly prosperous, to be sure — there was a sense that everything could be replaced, and on a whim. In his children he was trying to instill a sense of the value of work, the value of whatever came into their house, but he knew that much would be lost in the context, the waste and excess of the culture at large. He had been brought up to know that what God hates as much as anything is waste. It was, he had been told, one of the three things God *most* hated: murder, divorce, and waste. It destroyed a society.

After dinner the girls asked if they could watch *Pride and Prejudice* again. It was Friday night, so Zeitoun had no school-related reasons to block the movie. Still, it didn't mean he had to sit and watch it again. He'd liked the movie fine the first time, but the need to watch it a dozen times in as many days was beyond him. In the past week, he and Zachary had retired to other rooms to do something, anything, else. Kathy, though, was right there with the girls each time, and this time all of them draped over each other on the couch, misting up at the same parts they always did. Zeitoun shook his head and went into the kitchen to fix a cabinet door that had gotten loose.

All evening they paused the movie to watch the news reports about the storm's intensity and direction. Still moving slowly, the hurricane

was heading up the coast with winds over one hundred miles per hour. The longer it lingered over any region, the more destruction it would bring. All the news was terrible, and when Kathy saw the picture of the family of five she was ready to turn it off. She was sure they were gone, and she would obsess over this family for weeks, thinking about all their relatives gathered for the reunion, now forced to mourn the loss of so many at once — but then Kathy realized that the family was not lost. She turned up the volume. They had been rescued. They had docked their boat on a mangrove island near Ten Thousand Islands, and had ridden out the storm in the cabin of the yacht, praying and taking turns climbing up to look for help in the skies. Just hours earlier, the Coast Guard had spotted their boat and lifted them all to safety. The family of five had been saved.

Later, after kissing Zachary goodnight, Kathy lay down in Nademah's bed and the girls arranged themselves around her, a mess of overlapping limbs and pillows.

"Who wants to start?" Kathy asked.

Safiya began a story about Pokémon. The stories, which the girls told collaboratively, were often about Pokémon. After Aisha introduced the protagonist, Safiya provided the setting and central conflict, and Nademah took it from there. They continued, taking turns advancing the plot, until Aisha was asleep and Nademah and Safiya were drifting off. Kathy looked up to find Zeitoun in the doorway, leaning against the frame, watching them all. He did this often, just watching, taking it all in. The scene was almost too much, too beautiful. It was enough to burst a man's heart wide open.

Zeitoun and Kathy woke late, after eight. When they turned on the TV they saw Michael Brown, director of the Federal Emergency Management Agency, telling all residents of New Orleans to leave as soon as they could, to head inland with all possible haste. The National Hurricane Center had issued a watch for central Louisiana and warned that the hurricane could become a Category 5 by the time it made landfall. Category 5 hurricanes had only struck the United States mainland three times before, and never New Orleans.

"Honey," Kathy said, "I think we should go."

"You go," Zeitoun said. "I'll stay."

"How can you stay?" she asked.

But she knew the answer. Their business wasn't a simple one, where you could lock an office door and leave. Leaving the city meant leaving all their properties, leaving their tenants' homes, and this they couldn't do unless absolutely necessary. They had job sites all over the city, and any number of things could happen in their absence. They would be liable for damage if their equipment caused harm to clients' property. It was yet another hazard of the company they'd built.

Kathy was leaning strongly toward fleeing, and watching the news throughout the day it seemed that there were so many new indicators that this storm was unique that she didn't feel she could even contemplate staying in the city. They'd already closed down most operations at Louis Armstrong International Airport. The Louisiana National Guard had called four thousand troops into service.

Mid-morning, it was at least ninety-five degrees, the air leaden with humidity. Zeitoun was in the backyard, running around with the kids

and Mekay, the dog. Kathy opened the back door.

"You're really staying?" Kathy asked him. Somehow she thought that he might be wavering. She was wrong.

"What're you worried about?" he said.

She wasn't worried, in fact. She didn't fear for her husband's safety, really, but she did have the feeling that life in the city would be very trying during and after the storm. The electricity would go. The roads would be covered with debris, impassable for days. Why would he want to struggle through all that?

"I have to watch the house," he said. "The other houses. One small hole in the roof — if I fix it, no damage. If not, the whole house is wrecked."

By the early afternoon Mayor Nagin and Governor Blanco had called for a voluntary evacuation of the city. Nagin told residents that the Superdome would be open as a "shelter of last resort." Kathy shuddered at the thought; the year before, with Hurricane Ivan, that plan had been a miserable failure. The Superdome had been ill-supplied and overcrowded then and in '98, with Hurricane Georges. She couldn't believe the place was being used again. Maybe they'd learned from the last time and better provisioned the stadium? Anything was possible, but she was doubtful.

Kathy planned to leave as soon as the contraflow took effect, supposedly around four o'clock. The contraflow would allow all lanes of every highway to flow outward from the city. By then Kathy would have the Odyssey packed and ready in the driveway.

But where would she be going? She knew well that every hotel within two hundred miles would be booked already. So it was a matter

of deciding which family member she'd impose on. She had thought first of her sister Ann, who lived in Poplarville, Mississippi. But when she called, Ann was considering leaving, too. Her home was technically within the area that would be affected by the high winds, and it was surrounded by old trees. Given the likelihood that one of them might fall through her roof, Ann wasn't sure she should stay there herself, let alone with Kathy and her kids.

The next option was the family headquarters in Baton Rouge. Owned by her brother Andy, it was a three-bedroom ranch in a subdivision outside the city. Andy traveled frequently and was currently in Hong Kong, working on a construction project. While he'd been gone, two of Kathy's sisters, Patty and Mary Ann, had moved in.

Kathy knew they would allow her family to stay, but it would be cramped. The house wasn't so big to begin with, and Patty had four kids of her own. With Kathy's family there, all told there would be eight kids and three sisters living together in a house that would likely lose electricity in the high winds.

Still, it had been some time since the families had gotten together. This might bring them closer. They could all eat out, maybe go shopping in Baton Rouge. Kathy knew her kids would endorse the plan. Patty's kids were older, but they got along well with the Zeitouns, and anyway, eight kids always found something to do together. It would be cramped and loud, but Kathy found herself looking forward to it.

Throughout the afternoon, Kathy tried to convince her husband to come with them. When had officials suggested an all-city evacuation before? she asked. Wasn't that reason enough to go?

Zeitoun agreed that it was unusual, but he had never evacuated

before and he saw no need to do so now. Their home was elevated three feet above the ground, and rose two stories on top of that, so there would be no danger of getting stuck in an attic or on a roof, even if the worst happened. Zeitoun could always retreat to the second floor. And they lived nowhere near any levees, so they wouldn't get any of the flash flooding that might hit some of the other neighborhoods. It was East New Orleans, or the Lower Ninth, with its one-story houses so close to the levees, that were in the gravest danger.

And he certainly couldn't leave before he secured all his job sites. No one else would do it, and he wouldn't ask anyone else to do it. He'd already told his workers and his foremen to leave, to be with their families, to get a head start on the traffic. He planned to go to every one of the nine job sites to gather or tie down his equipment. He had seen what happened when a contractor failed to do this: ladders careening through windows and walls, tools damaging furniture, paint all over the lawn and driveway.

"I better go," he said.

He set out, visiting the work sites, tying down ladders, packing up tools, brushes, loose tiles, Sheetrock. He was through about half the sites when he headed home to say goodbye to Kathy and the kids.

Kathy was loading up a few small bags in the back of the Odyssey. She had packed enough clothes, toiletries, and food for two days. They would return on Monday night, she figured, after the storm had come and gone.

Kathy had the minivan's radio on and heard Mayor Nagin repeat his instructions for residents to leave the city, but she noted that he had stopped short of a mandatory evacuation. This would embolden her husband, she was certain. She switched to another station, where they were issuing a warning that anyone who planned to ride out the storm in

New Orleans should be prepared for a flood. Levee breaches could happen, they said. Storm surges might cause flooding. Ten or fifteen feet of water would be a possibility. Any diehards staying home should have an axe, in case they needed to chop through their attic to reach the roof.

Zeitoun pulled up and parked the van on the street in front of the house. Kathy watched him approach. She never doubted his ability to care for himself in any situation, but now her heart was jumping. She was leaving him to fend for himself, leaving him to chop holes in the attic with an axe? It was insane.

He and Kathy stood in the driveway, as they had many other times when she and the family were leaving and he was staying.

"Better hurry," Zeitoun said. "Lot of people leaving at once."

Kathy looked at him. Her eyes, much to her own frustration, teared up. Zeitoun held her hands.

"C'mon, c'mon," he said. "Nothing's going to happen. People are making a big deal for no reason."

"Bye, Daddy!" Aisha sang from the back seat.

The kids waved. They always waved, all of his children, as he stood on the driveway. None of this was new. A dozen times they had lived this moment, as Kathy and his children drove off in search of sanctuary or rest, leaving Zeitoun to watch over his house and the houses of his neighbors and clients all over the city. He had keys to dozens of other houses; everyone trusted him with their homes and everything in them.

"See you Monday," he said.

Kathy drove away, knowing they were all mad. Living in a city like this was madness, fleeing it was madness, leaving her husband alone in a home in the path of a hurricane was madness.

She waved, her children waved, and Zeitoun stood in the driveway

waving until his family was gone.

Zeitoun set out to finish securing the rest of his job sites. The air was breezy, the low sky smudged brown and grey. The city was chaotic, thousands of cars on the road. Traffic was worse than he expected. Brake lights and honking, cars running red lights. He took streets that no one fleeing would use.

Downtown, hundreds of people were walking to the Superdome carrying coolers, blankets, suitcases. Zeitoun was surprised. Previous experiments using the stadium as shelter had failed. As a builder, he worried about the integrity of the stadium's roof. Could it really withstand high winds, torrential rain? You couldn't pay him enough to hide there from the storm.

And anyway, in the past it had been little more than a few hours of squealing winds, some downed trees, a foot or two of water, some minor damage to fix once the winds had passed.

He already felt good. New Orleans would soon be largely vacated, and being in the empty city always felt good, at least for a day or two. He continued to make his rounds, secured the last few sites, and arrived home just before six.

Kathy called at six-thirty.

She was stuck in traffic a few miles outside the city. Worse, between her own confusion and the unprecedented volume of cars, she had gone the wrong way. Instead of taking the I-10 west directly to Baton Rouge, she was on I-10 heading east, with no way to correct her error. She would have to cross Lake Pontchartrain and swing all the way back through Slidell and across the state. It was going to add hours. She was harried and exhausted and the trip had barely begun.

Zeitoun was sitting at home, his feet up on the table, watching TV. He made a point of telling her so.

"Told you so," he said.

Kathy and the kids were expected at her brother's house for dinner, but at seven o'clock she'd traveled less than twenty miles. Just short of Slidell, she pulled into a Burger King drive-through. She and the kids ordered cheeseburgers and fries and got back onto the road. A little while later, a foul odor overtook the Odyssey.

"What is that?" Kathy asked her kids. They giggled. The smell was fecal, putrid. "What *is* that?" she asked again. This time the girls couldn't breathe they were laughing so hard. Zachary shook his head.

"It's Mekay," one of the girls managed, before collapsing again into hysterics.

The girls had been sneaking the dog pieces of their cheeseburgers, and the cheese was clogging her pipes. She'd been farting for miles.

"That is awful!" Kathy wailed. The kids giggled more. Mekay continued to suffer. She was hiding under the seat.

They passed Slidell and soon met up with I-190, a smaller road Kathy figured would have less traffic. But it was just as bad, an endless stream of brake lights. Ten thousand cars, twenty thousand lights, she guessed, extending all the way to Baton Rouge or beyond. She had become part of the exodus without entirely registering the enormity and strangeness of it. A hundred thousand people on the road, all going north and east, fleeing winds and water. Kathy could only think of beds. Where would all these people sleep? A hundred thousand beds. Every time she passed a driveway she looked at the home longingly. She was so tired, and not even halfway there.

She thought again of her husband. The images she'd seen on the news were absurd, really — the storm looked like a white circular saw heading directly for New Orleans. On those satellite images the city looked so small compared to the hurricane, such a tiny thing about to be cut to pieces by that gigantic spinning blade. And her husband was just a man alone in a wooden house.

Zeitoun called again at eight o'clock. Kathy and the kids had been on the road for three hours and had only gotten as far as Covington — about fifty miles. Meanwhile, he was watching television, puttering around the house, enjoying the cool night.

"You should have stayed," he said. "It's so nice here."

"We'll see, smart guy," she said.

Though she was exhausted, and was being driven near-crazy by her flatulent dog, Kathy was looking forward to a few days in Baton Rouge. At certain moments, at least, she was looking forward to it. Her family was not easy to deal with, this was certain, and any visit could take a wrong turn quickly and irreparably. *It's complicated*, she would tell people. With eight siblings, it had been turbulent growing up, and when she converted to Islam, the battles and misunderstandings multiplied.

It often started with her hijab. She'd come in, drop her bags, and the suggestion would come: "Now you can take that thing off." She'd been a Muslim for fifteen years and they still said this to her. As if the scarf was something worn under duress, only in the company of Zeitoun, a disguise she could shed when he was not around. As if only in the Delphine household could she finally be herself, let loose. This was actually the command her mother had given the last time Kathy had visited: "Take that thing off your head," she'd said. "Go out and have a good time."

There were times, however, when her mother's loyalty to Kathy trumped her issues with Islam. Years earlier, Kathy and her mother had gone to the DMV together to have Kathy's license renewed. Kathy was wearing her hijab, and had already received a healthy number of suspicious looks from DMV customers and staff by the time she sat down to have her picture taken. The employee behind the camera did not disguise her contempt.

"Take that thing off," the woman said.

Kathy knew that it was her right to wear the scarf for the photo, but she didn't want to make an issue of it.

"Do you have a brush?" Kathy asked. She tried to make a joke of it: "I don't want to have my hair all matted for the photo." Kathy was smiling, but the woman only stared, unblinking. "Really," Kathy continued, "I'm okay with taking it off, but only if you have a brush…"

That's when her mother jumped to the rescue — in her way.

"She can wear it!" her mother yelled. "She can if she wants to!"

Now it was a scene. Everyone in the DMV was watching. Kathy tried to diffuse the situation. "Mama, it's okay," she said. "Really, it's okay. Mama, do you have a brush?"

Her mother barely registered Kathy's question. She was focused on the woman behind the camera. "You can't make her take it off! It's her constitutional right!"

Finally the DMV woman disappeared into the back of the office. She returned with permission from a superior to take the photo with Kathy wearing her scarf. As the flash went off, Kathy tried to smile.

Growing up in Baton Rouge, it was a crowded house, full of clamor

and extremes. Nine kids shared a one-story, 1,400-square-foot home, sleeping three to a room and squabbling over one bathroom. They were content, though, or as content as could be expected, and the neighborhood was tidy, working-class, full of families. Kathy's house backed up against Sherwood Middle School, a big multiethnic campus where Kathy felt overwhelmed. She was one of a handful of white students, and she was picked on, pushed around, gawked at. She grew to be quick to fight, quick to argue.

She must have run away from home a dozen times, maybe more. And almost every time she did, from age six or so on, she ran to her friend Yuko's house. It was just a few blocks away, on the other side of the high school, and given that she and Yuko were among the few non–African American kids in the neighborhood, they had bonded as outsiders. Yuko and her mother Kameko were alone in their house; Kameko's husband had been killed by a drunk driver when Yuko was small. Even though Yuko was three years older, she and Kathy grew inseparable, and Kameko was so welcoming and dedicated to Kathy's well-being that Kathy came to call her Mom.

Kathy was never sure why Kameko took her in, but she was careful not to question it. Yuko joked that her mom just wanted to get close enough to Kathy to bathe her. As a kid Kathy didn't like baths much, and they weren't a great priority in her house, so every time she was at Yuko's, Kameko filled the tub. "She looks greasy," Kameko would joke to Yuko, but she loved to make Kathy clean, and Kathy looked forward to it — Kameko's hands washing her hair, her long fingernails tickling her neck, the warmth of a fresh, heavy towel around her shoulders.

After high school Kathy and Yuko grew closer. Kathy moved into an apartment off Airline Highway in Baton Rouge, and they began

working together at Dunkin' Donuts. The independence meant everything to Kathy. Even in her small apartment off a six-lane interstate, there was a sense of order and quiet to her life that she had never known.

A pair of Malaysian sisters used to come into the shop, and Yuko began talking to them, questioning them. "What does that scarf mean?" "What do you see in Islam?" "Are you allowed to drive?" The sisters were open, low-key, never proselytizing. Kathy had no real inkling that they had made a great impression on Yuko, but Yuko was captivated. She began reading about Islam, investigating the Qur'an. Soon the Malaysian sisters brought Yuko pamphlets and books, and Yuko delved deeper.

When she caught on to how serious Yuko was about it, it drove Kathy to distraction. They'd both been brought up Christian, had gone to a rigorous Christian elementary school. It was baffling to see her friend dabbling in this exotic faith. Yuko had been as devout a Christian as walked the Earth — and Kameko was even more so.

"What would your mom think?" she asked.

"Just keep an open mind," Yuko said. "Please."

A few years passed, and Kathy, through a series of missteps and heartbreaks, was divorced and living alone with Zachary, who was less than a year old. She was renting the same apartment off Airline Highway and working two jobs. In the mornings she was a checkout clerk at K&B, a chain drugstore on the highway. One day the manager of Webster Clothes, a menswear store across the road, had come into the drugstore and, admiring Kathy's ebullient personality, asked her if she'd be willing to quit K&B or, if not, take a second job at Webster. Kathy needed the money, so she said yes to the second job. After finishing in the early afternoon at K&B, she would walk across the highway to Webster and

work there until closing. Soon she was working fifty hours a week and making enough to cover health insurance for herself and Zachary.

But her life was a struggle, and she was looking for some order and answers. Yuko, by contrast, seemed peaceful and confident; she'd always been centered, so much so that Kathy had been envious, but now Yuko really seemed to have things figured out.

Kathy began borrowing books about Islam. She was just curious, having no particular intention to leave the Christian faith. At first she was simply intrigued by the basic things she didn't know, and the many things she'd wrongly presumed. She had no idea, for instance, that the Qur'an was filled with the same people as the Bible — Moses, Mary, Abraham, Pharaoh, even Jesus. She hadn't known that Muslims consider the Qur'an the fourth book of God to His messengers, after the Old Testament (referred to as the *Tawrat*, or the Law), the Psalms (the *Zabur*), and the New Testament (*Injeil*). The fact that Islam acknowledged these books was revelatory for her. The fact that the Qur'an repeatedly reaches out to the other, related faiths, knocked her flat:

> *We have believed in God*
> *and what has been sent forth to us,*
> *and what was sent forth to Abraham,*
> *Ishmael, Isaac, Jacob,*
> *and the Tribes*
> *and what was given the Prophets*
> *from their Lord;*
> *we separate and divide not*
> *between any one of them;*
> *and we are the ones who submit to Him.*

She was frustrated that she hadn't known any of this, that she'd been blind to the faith of a billion or so people. How could she not know these things?

And Muhammad. She'd been so misinformed about Him. She'd thought He was the actual god of Islam, the one whom Muslims worshiped. But he was simply the messenger who related the word of God. An illiterate man, Muhammad was visited by the angel Gabriel (*Jibril* in Arabic), who related to him the words of God. Muhammad became the conduit for these messages, and The Qur'an, then, was simply the word of God in written form. *Qur'an* meant "Recitation."

There were so many basic things that defied her presumptions. She'd assumed that Muslims were a monolithic group, and that all Muslims were made of the same devout and unbending stock. But she learned that there were Shiite and Sunni interpretations of the Qur'an, and within any mosque there were the same variations in faith and commitment as there were in any church. There were Muslims who treated their faith lightly, and those who knew every word of the Qur'an and its companion guide to behavior, the Hadith. There were Muslims who knew almost nothing about their religion, who worshiped a few times a year, and those who obeyed the strictest interpretation of their faith. There were Muslim women who wore T-shirts and jeans and Muslim women who covered themselves head to toe. There were Muslim men who modeled their lives on the life of the Prophet, and those who strayed and fell short. There were passive Muslims, uncertain Muslims, borderline agnostic Muslims, devout Muslims, and Muslims who twisted the words of the Qur'an to suit their temporary desires and agendas. It was all very familiar, intrinsic to any faith.

At the time, Kathy was attending a large evangelical church not far

from her jobs. Though not always full, it could seat about a thousand parishioners. She felt a need to connect with her faith; she needed all the strength she could find.

But there were things about this church that bothered her. She was accustomed to the kind of fiery preaching that the church offered, the extremes of showmanship and drama, but one day, she thought, they crossed a line. They had just passed the collection plates, and after they had gathered and counted the funds donated, the preacher — a short man with a rosy face and a mustache — seemed disappointed. His expression was pained. He couldn't hold it in. He chastised the congregation calmly at first, and then with increasing annoyance. Did they not love this church? Did they not appreciate the connection this church created with their lord Jesus Christ? He went on and on, shaming the congregants for their miserly ways. The lecture lasted twenty minutes.

Kathy was aghast. She'd never seen the collection counted during a Sunday service. And to ask for more! The congregants were not wealthy people, she knew. This was a working-class church, a middle-class church. They gave what they could.

She left that day shaken and confused by what she'd seen. At home, after putting Zachary to bed, she turned again to the materials Yuko had given her. She flipped through the Qur'an. Kathy wasn't sure that Islam was the way, but she knew that Yuko had never misled her before, that Yuko was the most grounded and sensible person she knew, and if Islam was working for her, why wouldn't it work for Kathy? Yuko was her sister, her mentor.

Kathy struggled with the question of faith all week. She lived with the questions in the morning, at night, all day through work. She had just started her shift at Webster one day when a familiar man walked in.

Kathy recognized him immediately as one of the preachers at the church. She came over to help him with a new sport coat.

"You know," he said, "you should come to our church! It's not far from here."

She laughed. "I know your church! I'm there all the time. Every Sunday."

The man was surprised. He hadn't seen her before.

"Oh, I sit in the back," she said.

He smiled and told her that next time he'd look for her. He made it his business to make sure everyone felt welcome.

"You know," Kathy said to him, "this must be a sign from God, seeing you here."

"How so?" he asked.

She told him about her crisis, how she had been disappointed with aspects of the Christianity she knew, in some of the things she'd seen, in fact, at his own church. She told him that she had actually been considering converting to Islam.

He was listening closely, but he didn't seem worried about losing a member of the congregation.

"Oh, that's just the devil toying with you," he said. "He'll do that, try to tempt you away from Christ. But this'll only make your faith stronger. You'll see come Sunday."

When he left, Kathy already felt more certain about her faith. How could his visit not be a sign from God? Just at the moment she was having doubts about her church, a messenger from Jesus walked straight into her life.

She went to church that Sunday with a renewed sense of purpose. Yuko may have found comfort and direction in Islam, but Kathy was

sure that she herself had been personally called by Christ. She walked in and sat near the front, determined that her new friend should see her and know that he had made a difference.

It didn't take long. When he looked down at the congregation and upon her, his eyes opened wide. He gave her an expression that made clear that she was the one he'd been looking for all day. She'd seen the same expression on kids spotting a birthday cake with their name on it.

And then suddenly, in the middle of the service, her name was being called. The preacher, in front of a full room of almost a thousand people, was saying her name, Kathy Delphine.

"Come up here, Kathy," the preacher commanded.

She rose from her seat and stepped toward the blinding lights of the pulpit. Onstage, she didn't know where to look, how to avoid the glare. She shielded her eyes. She squinted and looked down — at her shoes, at the people in the front row. She had never stood in front of so many people. The closest thing had been her wedding, and that had been only fifty or so friends and family. What was this? Why had she been called forth?

"Kathy," the preacher said, "tell them what you told me. Tell us all."

Kathy froze. She didn't know if she could do this. She was a talkative person, rarely nervous, but to recount something she'd said privately to the reverend in front of a thousand strangers — it didn't seem right.

Still, Kathy had faith that he knew what he was doing. She believed she'd been chosen to remain in this church. And she wanted to serve. To help. Perhaps, like Reverend Timothy entering the store that day, this was another event that was meant to be, meant to bring her closer to Christ.

She was given a microphone and she spoke into it, telling the congregation what she'd told the reverend, that she had been investigating Islam, and that—

The preacher cut her off. "She was looking to Islam!" he said with a sneer. "She was considering" — and here he paused — "the worship of Allah!" And with that, he made a snorting, derisive sound, the sort of sound an eight-year-old boy would make on a playground. This preacher, this leader of this church and congregation, was using this tone to refer to Allah. Did he not know that his God and Islam's were one and the same? That was one of the first and simplest things she'd learned from the pamphlets Yuko had given her: Allah is just the Arabic word for God. Even Christians speaking Arabic refer to God as Allah.

He went on to praise Kathy and Jesus and reaffirm the primacy of his and their faith, but by then she was hardly listening. Something had ruptured within her. When he was done, she sat down in a daze, bewildered but becoming sure about something right there and then. She smiled politely through the rest of the service, already knowing she would never come back.

She thought about the episode while driving home, and that night, and all the next day. She talked to Yuko about it and they realized that this man, preaching to a thousand impressionable and trusting parishioners, didn't know, or didn't care, that Islam, Judaism, and Christianity were not-so-distantly related branches of the same monotheistic, Abrahamic faith. And to dismiss all of Islam with a playground sound? Kathy could not be part of what that man was preaching.

So by fits and starts, she followed Yuko into Islam. She read the Qur'an and was struck by its power and lyricism. The Christian preachers she'd heard had spent a good amount of time talking about who would and wouldn't go to hell, how hot it burned and for how long, but the imams she began to meet made no such pronouncements. Will I go to heaven? she asked. "Only God knows this," the imam would tell her. The various doubts of the imams were comforting, and drew her closer.

She would ask them a question, just as she had asked questions of her pastors, and the imams would try to answer, but often they wouldn't know. "Let's look at the Qur'an," they would say. She liked Islam's sense of personal responsibility, its bent toward social justice. Most of all, though, she liked the sense of dignity and purity embodied by the Muslim women she knew. To Kathy they seemed so wholesome, so honorable. They were chaste, they were disciplined. She wanted that sense of control. She wanted the peace that came with that sense of control.

The actual conversion was beautifully simple. With Yuko and a handful of other women from the mosque present, she pronounced the *shahadah*, the Islamic pledge of conviction of faith. "AshHadu An La Ilaha Il-lallah, Wa Ash Hadu Anna Muhammadar Rasul-allah." That was all she needed to say. *I bear Witness that there is no deity but Allah and I bear witness that Muhammad is His Messenger*. With that, Kathy Delphine had become a Muslim.

When she tried to explain it to friends and family, Kathy fumbled. But she knew that in Islam she had found calm. The doubt sewn into the faith gave her room to think, to question. The answers the Qur'an provided gave her a way forward. Even her view of her family softened through the lens of Islam. She was less aggressive. She had always fought with her mother, but Islam taught her that "heaven is at the feet of your mother," and this reined her in. She stopped talking back and learned to be more patient and forgiving. *It brought back a purity in me*, she would say.

Her conversion might have been a step forward in her eyes, but in the eyes of her mother and siblings it was as if she'd renounced her family and all they stood for. Kathy tried to get along with them nevertheless, and her family tried too. There were times when all was good, visits were enjoyable, uneventful. But for every one of those, there was one that spiraled

into sniping and accusations, slammed doors and quick departures. There were a few of her eight siblings she wasn't in touch with at all.

But she wanted extended family. She wanted her own kids to know their aunts and uncles and cousins, and so the relief was profound when the Odyssey arrived at her brother's house in Baton Rouge at eleven-thirty. She unpacked the kids and they fell asleep, on couches and floors, in minutes.

Settled, she called Zeitoun.

"Winds come?"

"Nothing yet," he said.

"I'm gonna pass out," Kathy said. "Never been so tired."

"Get some rest," he said. "Sleep in."

"You too."

They said good night and turned out the lights.

SUNDAY AUGUST 28

Kathy woke before dawn and turned on the TV. Katrina was now a Category 5 storm with winds over 150 miles an hour. It was heading almost directly toward New Orleans, with the brunt of it expected to strike about sixteen miles west of the city. Meteorologists were predicting furious winds, ten-foot storm surges, possibilities of levee breaches, flooding everywhere along the coast. It was estimated that the storm would reach the New Orleans area that night.

Throughout the day, as news of the hurricane grew more dire, clients called Kathy or Zeitoun, asking them to secure their windows and doors. Kathy collected requests and relayed them to Zeitoun. Zeitoun discovered that one of his carpenters, James Crosso, was still in the city, so the

two of them spent the day driving around, rigging the houses on the list. James's wife worked for one of the hotels downtown, and the couple was planning to ride the storm out there. Zeitoun and James drove from job to job, a quarter ton of plywood in the back of the truck, doing what they could before the winds came. The roads were still crowded, a new surge of cars leaving, but Zeitoun didn't consider it. He would be safe in their house on Dart Street, he figured, far from any levees, with two stories, plenty of tools, and food.

Mid-morning, Mayor Nagin ordered the city's first-ever mandatory evacuation. Anyone who could leave must leave.

All day Zeitoun and James saw people lined up at bus stops — those who planned to stay in the Superdome. Families, couples, elderly men and women carrying their belongings in backpacks, suitcases, garbage bags. Seeing them exposed like that, as the winds picked up and the sky darkened, worried Zeitoun. He and James passed the same groups, waiting patiently, on the way to their job sites and on their way back.

In Baton Rouge, the weather was dark and unruly. High winds, black skies at noon. The kids played outside for a while, but then came inside to watch DVDs while Kathy caught up with Patty and Mary Ann. The trees in the neighborhood swung wildly.

The power went out at five o'clock. The kids played board games by candlelight.

Kathy periodically went out to the car to listen to the news on the radio. The winds were smashing windows in New Orleans, knocking down trees and power lines.

Kathy tried to call Zeitoun, but the call went straight to his voice-mail. She tried the home phone. Nothing. The lines were down, she assumed. The hurricane had not hit the city yet, and already she had no way to reach her husband.

By six o'clock, Zeitoun had dropped James off and was home and ready. He watched the news on TV; the reports had not changed much. The outermost edge of the hurricane was expected about midnight. He assumed that would be the end of the electrical grid for a few days.

Walking through the darkening rooms, Zeitoun assessed all the possible dangers he would face during the storm. The house had four bedrooms — the master bedroom on the first floor and the kids' rooms upstairs. He expected leaks up there. Portions of the roof might be compromised. A few windows might break — the front sitting room, with its bay window, was at risk. There was an outside chance the tree in the backyard would fall on the house. If that happened, there could be significant damage, because nothing, then, could keep the water out.

But he was optimistic. And in any case he wanted to be in the house, on which he had spent untold thousands for improvements, to protect it in whatever way possible. His grandmother had stayed put during countless storms in her home on Arwad Island, and he planned to do the same. A home was worth fighting for.

The only thing that concerned him was the levees. Again and again the news reports warned of the storm surge. The levees were meant to hold back fourteen feet of water, and the storm surges in the Gulf were already nineteen, twenty feet high. If the levees were breached, he knew the battle would be lost.

He called Kathy at eight o'clock.

"There you are," she said. "You disappeared."

He looked at his phone and saw that he'd missed three calls from her.

"Coverage must be spotty already," he said. His phone had not rung. He told her that nothing significant had happened yet. Just strong winds. Nothing new.

"Stay away from the windows," she said.

He said he would try.

Kathy wondered aloud if there was something foolish in what they were doing. Her husband was in the path of a Category 5 hurricane and they were talking about staying away from the windows.

"Say goodnight to the kids," he said.

She said she would.

"Better go. To save the battery," he said.

They said goodnight.

The kids asleep, Kathy sat on the couch in her brother Andy's house and stared at the candle in front of her. It was the only light left on in the house.

Just after eleven o'clock, the front end of the storm arrived at Zeitoun's house. The sky was a brutal grey, the winds swirling and cool. Rain came in sheets. Every half hour brought an escalation in the mayhem outside. At midnight the power went out. The leaks began at about two or three. The first was in the corner of Nademah's bedroom. Zeitoun went down to the garage and retrieved a forty-gallon garbage can to catch the water. Another leak opened a few minutes later, this one in the upstairs hallway. Zeitoun found another garbage can. A window in the master bedroom broke just after three o'clock, as if a brick had been

thrown through the glass. Zeitoun gathered the shards and stuffed the opening with a pillow. Another leak opened in Safiya and Aisha's room. He found another, bigger garbage can.

He dragged the first two garbage cans outside and dumped them on the lawn. The sky was a child's fingerpainting, blue and black hastily mixed. The wind was cooler. The neighborhood was utterly dark. As he stood on the lawn, he heard a tree fall somewhere on the block — a crack and then a shush as the branches pushed down through other trees and rested against the side of a house.

He went inside.

Another window had broken. He stuffed another pillow into it. Branches clawed at the walls, the roof. There were unknown thumps everywhere. The bones of the house seemed to be moaning under the strain of it all. The house was under assault.

When he next checked, it was four o'clock in the morning. He hadn't stopped moving in five hours. If the damage continued at this pace, it would be worse than he had predicted. And the real storm hadn't come yet.

In the small hours, Zeitoun had a thought. He didn't expect the city to flood, but he knew a flood was not impossible. So he walked outside, tasting the cool wind, and dragged his secondhand canoe from the garage and righted it. He wanted to have it ready.

If Kathy could only see him now. She had rolled her eyes when she saw him come home with that canoe. He'd bought it a few years before, from a client in Bayou St. John. When the client was moving, Zeitoun had seen it on his lawn, a standard aluminum model, and asked him if he was selling it. The client laughed. "You want *that*?" he asked. Zeitoun bought it on the spot for seventy-five dollars.

Something about the canoe had intrigued him. It was well-made, undamaged, with a pair of wooden benches inside. It was about sixteen feet long, built for two people. It seemed to speak of exploration, of escape. He tied it to the top of his van and brought it home.

Through the living room window, Kathy saw him pull up. She met him at the door.

"No way," she said.

"What?" Zeitoun said, smiling.

"You're crazy," she said.

Kathy liked to act exasperated, but Zeitoun's romantic side was central to why she loved him. She knew that any kind of boat reminded him of his childhood. How could she deny him a used canoe? She was fairly certain he would never use it, but having it in the garage, she knew, would mean something to him — a connection to the past, the possibility of adventure. Whatever it was, she wouldn't stand in the way.

He did try, two or three times, to get his daughters interested in the canoe. He brought them to Bayou St. John, put the canoe in the water, and sat down inside. When he reached for Nademah, standing on the grass, she refused. The younger girls weren't having it, either. So for half an hour, as the girls watched from the grass, he paddled around by himself, trying to make it all look fun, irresistible. When he returned, they still wanted no part of it, so he put the canoe back on the roof of the van and they all went home.

The wind picked up after five o'clock. He couldn't tell when the hurricane actually made landfall, but the day barely brightened that morning. It went from black to a charcoal grey, the rain like pebbles thrown against glass. He could hear tree limbs succumbing to the wind,

great exhalations as their trunks fell on streets and roofs.

Eventually he could not stay awake. Though his house was under attack, he lay down, knowing something would awaken him soon enough, and so, surrendering for now, he fell into a shallow sleep.

MONDAY AUGUST 29

Zeitoun woke late. He couldn't believe his watch. It was after ten a.m. He hadn't slept that late in years. All the clocks had stopped. He got up, tried the light switches in three rooms. The power was still out.

The wind was strong outside, the sky still dark. The rain was coming down — not heavily, but enough to keep Zeitoun inside much of the day. He ate breakfast and checked for any other damage to the house. He put buckets under two new leaks. Overall the damage had remained at about the level it had been at before he fell asleep. He had slumbered through the worst of the hurricane. Through the windows he could see the streets were covered with downed power lines and fallen trees and about a foot of water. It was bad, but not much worse than a handful of storms he could remember.

In Baton Rouge, Kathy brought her kids to Wal-Mart to stock up on supplies and buy flashlights. Inside, there seemed to be more people than products. She'd never seen anything like it. The place had been bought out, the shelves nearly bare. It looked like the end of the world. The kids were scared, holding on to her. Kathy looked for ice and was told that the ice was long gone. Improbably, she found a package of two flashlights, the last one, and reached for it a split second before another woman did. She gave the woman an apologetic smile and went to the check-out counter.

In the afternoon the wind and rain calmed. Zeitoun went outside to explore. It was warm, over eighty degrees. He estimated there were eighteen inches of water on the ground. It was rainwater, murky and grey-brown, but soon, he knew, it would drain away. He looked in the backyard. There was the canoe. It called to him, floating and ready. It was a rare opportunity, he thought, to be able to glide over the roads. He had only this day. He bailed the water resting in the hull, and in his T-shirt and shorts and sneakers, he stepped in.

Leaving the yard was difficult. A tree across the street had been ripped from its roots and lay across the road, branches spread over his driveway. He paddled around them and looked back to the house. No great damage to the exterior. Some shingles missing from the roof. The windows broken. A gutter that would need remounting. Nothing too bad, three days' work.

In the neighborhood, other homes had been hit by all manner of debris. Windows had been blown out. Wet, black branches covered cars, the street. Everywhere trees had been pulled out of the earth and lay flat.

The quiet was profound. The wind rippled the water but otherwise all was silent. No cars moved, no planes flew. A few neighbors stood on their porches or waded through their yards, assessing damage. No one knew where to start or when. He knew he would be giving many estimates in the coming weeks.

He paddled only a few blocks before he began to have second thoughts. There were power lines down everywhere. What would exposed lines do if they made contact with his aluminum canoe? Besides, there wasn't enough water to paddle much. In some parts of

the neighborhood, there was scarcely any water at all — only a few inches. He ran aground, got out, turned the canoe around, and paddled back home.

Throughout the afternoon, the water fled from the streets, a few inches an hour. The drainage system was working. By that evening, the water had receded completely. The streets were dry. The damage was extensive, but really no worse than a handful of other storms he could remember. And it was over.

He called Kathy.

"Come back," he said.

Kathy was tempted, but it was already seven o'clock, they were about to eat dinner, and she knew she wasn't about to drive through the night again with four kids and a flatulent dog. Besides, there was no power in New Orleans, so they would be returning to the same situation they were suffering through in Baton Rouge. The kids were still enjoying the time spent with their cousins — the laughter rattling the house was testament to it.

She and Zeitoun agreed to talk about it again in the morning, though they both expected Kathy to be packing up the kids sometime the next day.

She went inside and the combined families, three adults and eight kids, ate hot dogs by candlelight. That her sisters had put pork on the table did not go unnoticed, but Kathy vowed not to make an issue of it. *Better to let it go*, she said to herself. *Let it go, let it go.* She had so many battles to fight. There would be so many more in the coming days, she was sure, that she couldn't expend her energy on her sisters, on hot dogs. If they wanted to serve her children pork, they could try.

Later, when Kathy went to the car to steal a few moments with the radio, she heard Mayor Nagin echoing her reluctance to return. Don't come back yet, he said. Wait to see what the damage is, until everything is settled and cleaned up. Give it a day or two.

In the afternoon, Zeitoun got a call from Adnan, a second cousin on Zeitoun's mother's side. Adnan had done well since emigrating over a decade earlier; he owned and managed four Subway franchises in New Orleans. His wife Abeer was six months pregnant with their first child.

"You still in the city?" he asked, assuming Zeitoun was.

"Of course I am. You in Baton Rouge?" Zeitoun asked.

"I am." Adnan had driven up the night before with Abeer and his elderly parents. "How is it there?"

"Windy," Zeitoun said. "Really? It's a little scary." He would never have admitted this to Kathy, but he could confide in Adnan.

"You think you'll stay?" Adnan asked.

Zeitoun said he planned to, and offered to look after Adnan's shops. Before Adnan had left the city, he'd emptied the cash register at the City Park Avenue location and made sure bread was baked; he'd assumed he'd be back on Tuesday.

"You know any mosques in Baton Rouge?" Adnan asked. All the motels were booked, and he and Abeer knew no one in Baton Rouge. They'd been able to place Adnan's parents in a mosque the previous night, but there were already hundreds of people there, sleeping on the floors, and they couldn't accommodate more. Adnan and Abeer had spent the night in their car.

"I don't," Zeitoun said. "But call Kathy. She's with family. They'll take you in, I'm sure." He gave Adnan her cell phone number.

Zeitoun emptied all of the buckets in the house, put them under the holes in the roof again, and got ready for bed. It was warm outside, stifling inside. He lay in the dark. He thought about the strength of the storm, its duration, how oddly minimal the damage had been to this house. He went to the front window. Already, at eight o'clock, the streets were dry as bone. All that effort to flee, and for what? Hundreds of thousands of people rushing north for this. A few inches of water, all of it now gone.

It was quiet that night. He heard no wind, no voices, no sirens. There was only the sound of a city breathing as he breathed, weary from the fight, grateful it was over.

TUESDAY AUGUST 30

Zeitoun woke up late again. He squinted at the window above, saw the same grey sky, heard the same strange quiet. He had never known a time like this. He couldn't drive anywhere, couldn't work. For the first time in decades, there was nothing to do. It would be a day of calm, of rest. He felt strangely lethargic, ethereally content. He fell back into a shallow sleep.

Arwad Island, his family's ancestral home, was soaked in light. The sun was constant there, a warm white light that bleached the stone buildings and cobblestone alleys, that brought incredible clarity to the surrounding cobalt sea.

When Zeitoun dreamt of Arwad, it was the Arwad he visited during

the summers of his boyhood, and in these dreams he was doing boyish things: sprinting around the island's tiny perimeter, scaring seagulls to flight, searching in the tide pools for crabs and shells or whatever oddities had been thrown onto the island's rocky shore.

By the outer wall, facing the western expanse of the sea, he and Ahmad chased a lone chicken through the ruins around the outermost homes. The scrawny bird raced up a pile of garbage and rubble and into a cave of coral and masonry. They turned at the sound of a frigate dropping anchor, waiting to land at Tartus, the port city a mile east. There were always a half-dozen ships, tankers, and freighters waiting for a berth at the busy port, and often they would anchor close enough to cast a shadow over the tiny island. Abdulrahman and Ahmad would stare up at them, the hulls rising twenty, thirty feet over the sea. The boys would wave to the crew and dream of being aboard. It seemed a life of impossible romance and freedom.

Even then, when Ahmad was a skinny, tanned boy of fifteen, he knew he would be a sailor. He was careful not to tell his father, but he was certain he wanted to steer one of those ships. He wanted to guide great vessels around the world, to speak a dozen languages, to know the people of every nation.

Abdulrahman never doubted that Ahmad would do this. Ahmad was, in Abdulrahman's eyes, capable of anything. He was his best friend, his hero and teacher. Ahmad taught him how to spear a fish, how to row a boat alone, how to dive from the great Phoenician stones on the island's southern wall. He would have followed Ahmad anywhere, and often did.

The boys stripped to their underwear and set out for a narrow archipelago of rocks. Abdulrahman and Ahmad found the spear they kept hidden in the stones and took turns diving for fish. Swimming came naturally to the boys of the Zeitoun family, and to all the children

of Arwad. They could swim as soon as they could walk and would stay in the water, swimming and treading, for hours. When Ahmad and Abdulrahman emerged they would lay on a low stone wall, the sea on one side and the town's outer promenade on the other.

The promenade wasn't much to look at, a wide, crumbling paved area, dotted with litter, evidence of the island's half-hearted attempts to attract tourists. Most of the residents of Arwad didn't much care if visitors came or not. It was home, and a place where real industry happened: fish were caught, cleaned, and brought to the mainland, and ships, strong wooden sailboats of one or two or three masts, were built using methods perfected on the island centuries before.

Arwad had been a strategic military possession for an endless succession of sea powers: the Phoenicians, the Assyrians, the Achaemenid Persians, the Greeks under Alexander, the Romans, the Crusaders, the Mongols, the Turks, the French, and the British. Various walls and battlements, in pieces and all but gone, spoke of past fortresses. Two small castles, scarcely altered since the Middle Ages, stood in the center of the island and could be explored by curious children. Abdulrahman and Ahmad often ran up the smooth stone stairs of the lookout tower by their home, pretending they were spotting invaders, sounding bells of warning, planning their defenses.

But usually their games took place in the water. They were never more than a few steps from the cool Mediterranean, and Abdulrahman would follow Ahmad to the shore and up the great Phoenician stones of the wall. From the top they could see into the windows of the higher-sitting dwellings of the town. Then they would turn to the sea and dive. After swimming, they would lay on the stone wall, the surface polished by the crashing waves and the feet of uncountable children. They warmed themselves with the heat of the rocks and the sun above. They

would talk of heroes who had defended the island, of armies and saints who had stopped there. And they would talk of their plans, their own great deeds and explorations.

Soon the two of them would grow quiet, near sleep, hearing the waves push against the island's outer walls, the ceaseless shushing of the sea. But in Zeitoun's half-dream, the sound of the ocean seemed wrong. It was both quieter and less rhythmic — not an ebb and flow, but instead the constant whisper of a river.

The dissonance woke him.

II

TUESDAY AUGUST 30

Zeitoun opened his eyes again. He was home, in his daughter Nademah's room, under her covers, looking through the window at a dirty white sky. The sound continued, something like running water. But there was no rain, no leaks. He thought a pipe might have broken, but that couldn't be it; the sound wasn't right. This was more like a river, the movement of great volumes of water.

He sat up and looked down through the window that faced the back-yard. He saw water, a wide sea of it. It was coming from the north. It flowed into the yard, under the house, rising quickly.

He couldn't make sense of it. The day before, the water had receded, as he had expected it to, but now it had returned, far stronger. And this water was different from the murky rainwater of the day before. This water was green and clear. This was lake water.

At that moment, Zeitoun knew that the levees had been overtopped or compromised. There could be no doubt. The city would soon be

underwater. If the water was here, he knew, it was already covering most of New Orleans. He knew it would keep coming, would likely rise eight feet or more in his neighborhood, and more elsewhere. He knew the recovery would take months or years. He knew the flood had come.

He called Kathy.

"The water's coming," he said.

"What? No, no," she said. "Levees broke?"

"I think so."

"I can't believe it."

He heard her stifle a sob.

"I better go," he said.

He hung up and went to work.

Elevate, he thought. *Elevate, elevate.* Everything had to be brought to the second floor. He recalled the worst of the predictions before the storm: if the levees broke, there would be ten, fifteen feet of water in some places. Methodically, he began to prepare. Everything of value had to be brought higher. The work was simply work, and he went about it calmly and quickly.

He took the TV, the DVD player, the stereo, all the electronics upstairs. He gathered all the kids' games and books and encyclopedias and carried those up next.

Things were tense at the house in Baton Rouge. With the weather windy and grey, and so many people sharing a small house, tempers were flaring. Kathy thought it best to make her family scarce. She and her kids put away their sleeping bags and pillows and left in the Odyssey, intending to drive around most of the day, going to malls or restaurants — anything to kill time. They would return late, after

dinner, only to sleep. She prayed that they could return to New Orleans the next day.

Kathy called Zeitoun from the road.

"My jewelry box!" she said.

He found that, and the good china, and he brought it all upstairs. He emptied the refrigerator; he left the freezer full. He put all the chairs on top of the dining room table. Unable to carry a heavy chest, he put it on a mattress and dragged it up the stairs. He placed one couch on top of another, sacrificing one to save the other. Then he got more books. He saved all the books.

Kathy called again. "I told you not to cancel the property insurance," she said.

She was right. Just three weeks before, he had chosen not to renew the part of their flood insurance that covered their furniture, everything in the house. He hadn't wanted to spend the money. He admitted she was right, and knew she would remind him of it for years to come.

"Can we talk about it later?" he asked.

Zeitoun went outside, the air humid and gusty. He tied the canoe to the back porch. The water was whispering through the cracks in the back fence, rising up. It was flowing into his yard at an astonishing rate. As he stood, it swallowed his ankles and crawled up his shins.

Back inside, he continued to move everything of value upward. As he did, he watched the water erase the floor and climb the walls. In another hour there was three feet of water indoors. And his house was three feet above street level.

But the water was clean. It was translucent, almost green in tint. He watched it fill his dining room, momentarily struck by the beauty of

the sight. It brought forth a vague memory of a storm on Arwad Island, when he was just a boy, when the Mediterranean rose up and swallowed the lower-sitting homes, the blue-green sea sitting inside living rooms and bedrooms and kitchens. The water breached and dodged the Phoenician stones surrounding the island without any difficulty at all.

At that moment, Zeitoun had an idea. He knew the fish in his tank wouldn't survive without filtration or food, so he reached inside and liberated them. He dropped them in the water that filled the house. It was the best chance they had. They swam down and away.

Using his cell phone, he talked to Kathy throughout the day. They reviewed what couldn't be saved, the furniture too large to carry upstairs. There were dressers, armoires. He removed all the drawers he could, carried upstairs everything that could be removed and lifted.

The water devoured the cabinets and windows. Zeitoun watched, dismayed, as it rose four, five, six feet in the house — above the electrical box, the phone box. He would have no access to electricity or a landline for weeks.

By nightfall the neighborhood was under nine feet of water and Zeitoun could no longer go downstairs. He was spent; he had done all he could. He lay on Nademah's bed on the second floor and called Kathy. She was driving around with the kids, dreading a return to the house in Baton Rouge.

"I saved all I could," he said.

"I'm glad you were there," she said, and meant it. If he hadn't been at home they would have lost everything.

They talked about what would become of the house, of the city. They knew the house would have to be gutted, all the insulation and

wiring replaced, the plaster and Sheetrock and paint and wallpaper. Everything, down to the studs, was gone. And if there was this much water Uptown, there was more in other neighborhoods. He thought of them — the houses near the lake and the houses near the levees. They didn't stand a chance.

As they talked, Zeitoun realized his phone was dying. Without electricity, they both knew, when his battery was gone there would be no reliable way to call out.

"Better go," he said.

"Please leave," she said. "Tomorrow."

"No, no," he said, but even as he spoke, he was reconsidering. He had not anticipated being confined to this house for long. He knew there was enough food for a week or more, but now the situation would present a greater strain than he had planned.

"Tell the kids I said goodnight," he said.

She said she would.

He turned off his phone to conserve what power it had left.

Kathy was still driving. She'd exhausted all means of diversion and was about to go back to her brother's house when her phone rang again. It was Adnan. He was in Baton Rouge with his wife Abeer, he said, and they had no place to stay.

"Where'd you stay last night?" Kathy asked.

"In the car," he said, sounding apologetic and ashamed.

"Oh my God," she said. "Let me see what I can do."

She planned to ask Mary Ann and Patty once she got back to the house. It would be crowded, but there was no way a pregnant woman should be sleeping in a car when there was enough room at her family's house.

* * *

When Kathy returned to Andy's, it was ten o'clock and the rooms were dark. All the kids, save Nademah, were asleep in the car. She roused them and walked quietly into the house. After the kids were settled in their sleeping bags, Mary Ann appeared and confronted her.

"Where were you all day?"

"Out," Kathy said. "Trying to stay out of the way."

"Do you know how expensive gas is?" Mary Ann said.

"Excuse me?" Kathy said. "I didn't know you were paying for my gas."

Kathy was exasperated, defeated. In the house, they were made to feel burdensome; now she was being scolded for leaving. She vowed to herself to get through the night and think of a new plan the next day. Maybe she could drive to Phoenix to stay with Yuko. It was a ludicrous idea, to travel fifteen hundred miles when her blood relatives lived fifty miles from New Orleans, but she'd run to Yuko's house before and could do so again.

The tension was bad enough already, but for Adnan and Abeer's sake, Kathy had to ask. After all, Mary Ann knew them; she'd met Adnan and Abeer many times. Couldn't they stay for one night?

"Absolutely not," Mary Ann said.

On the dark second floor, Zeitoun held a flashlight between his teeth, sifting through the pile of belongings he'd salvaged. He shelved the books he could. He boxed the certificates and pictures. He found pictures of his children when they were smaller, pictures from a vacation they'd all taken to Spain, pictures from their trip to Syria. He organized them, found a plastic bag, put them safely inside and then re-boxed them.

In another, older box he came upon another photo, sepia-toned and in a rickety frame, and paused. He hadn't seen it in years. He and his

Zeitoun home, Jableh, Syria

brother Luay and sister Zakiya were playing with their brother Mohammed, eighteen years older. They were all wrestling with him in the bedroom Zeitoun and Ahmad and all the younger boys had shared in Jableh. There little Abdulrahman was, on the far right, maybe five years old, his tiny fingers swallowed by Mohammed's huge hand.

Zeitoun stared at his brother's electric smile. Mohammed had everything then. He *was* everything, the most famous and accomplished athlete in Syrian history. He was a long-distance ocean swimmer, one of the best the world had ever known. That he was from a country not well known for its coast made his achievements all the more remarkable. He had won races in Syria, Lebanon, and Italy. He could swim thirty miles at a stretch, and faster than anyone else. Faster than any Italian, any Englishman or Frenchman or Greek.

Zeitoun examined the picture more closely. Poor Mohammed, he thought, all his brothers and sisters swamping him. They did that to him whenever he was home. The races — in Greece, Italy, the United States — kept him away too long. He was feted by heads of state and featured in newspapers and magazines all over the world. They called him the Human Torpedo, the Nile Alligator, the Miracle. When he was home his siblings went wild, buzzing around him like flies.

And then, at age twenty-four, he was gone. Killed in a car accident in Egypt, just before a race in the Suez Canal. Zeitoun still missed him terribly, though he was only six when it happened. After that, he knew Mohammed only through stories, photos, and tributes, and the monument to him that stood on the waterfront in Jableh, just down the street from their home. Growing up they had to pass it every day, and its presence made forgetting Mohammed, even momentarily, impossible.

Zeitoun sat and stared at the photo for a minute or so before putting it back in the box.

He couldn't sleep inside the house. It was hotter this night, and in New Orleans he had never withstood this kind of heat without air-conditioning. Laying on sweat-soaked sheets, he had a thought. He looked in one of the upstairs closets for the tent he'd bought a few years back. The previous summer, he'd set it up in the backyard, and the kids had slept outside when the heat relented and allowed it.

He found the tent and crawled through the window of Nademah's room and onto the roof. Outside it was cooler, a breeze cutting through the stagnant air. The roof over the garage was flat, and he set up the tent there, securing it with books and a few cinder blocks. He dragged one of the kids' mattresses out and squeezed it through the tent's door. The difference was vast.

Laying on the mattress, he listened for the movement of water. Was it still rising? He wouldn't be surprised. He would not be shocked if, come morning, there was twelve, thirteen feet of water covering the neighborhood.

The darkness around him was complete, the night silent but for the dogs. First a few, then dozens. From all corners of the neighborhood he heard them howling. The neighborhood was full of dogs, so he was accustomed to their barking. On any given night, one would become excited by something and set off the rest, an arrhythmic call-and-response that could last hours until they calmed, one by one, into silence. But this night was different. These dogs had been left behind, and now they knew it. There was a bewilderment, an anger in their cries that cut the night into shards.

Zeitoun woke with the sun and crawled out of his tent. The day was bright, and as far as he could see in any direction the city was underwater. Though every resident of New Orleans imagines great floods, knows that such a thing is possible in a city surrounded by water and ill-conceived levees, the sight, in the light of day, was beyond anything he had imagined. He could only think of Judgment Day, of Noah and forty days of rain. And yet it was so quiet, so still. Nothing moved. He sat on the roof and scanned the horizon, looking for any person, any animal or machine moving. Nothing.

As he did his morning prayers, a helicopter broke the silence, shooting across the treetops and heading downtown.

Zeitoun looked down from the roof to find the water at the same level as the night before. He felt some relief in knowing that it would likely remain there, or even drop a foot once it reached an equilibrium with Lake Pontchartrain.

Zeitoun sat beside his tent, eating cereal he had salvaged from the kitchen. Even with the water no longer rising, he knew he could do nothing at home. He had saved what he could save, and there was nothing else to do here until the water receded.

When he had eaten, he felt restless, trapped. The water was too deep to wade into, its contents too suspect to swim through. But there was the canoe. He saw it, floating above the yard, tethered to the house. Amid the devastation of the city, standing on the roof of his drowned home, Zeitoun felt something like inspiration. He imagined floating,

alone, through the streets of his city. In a way, this was a new world, uncharted. He could be an explorer. He could see things first.

He climbed down the side of the house and lowered himself into the canoe. He untied the rope and set out.

He paddled down Dart Street, the water flat and clear. And strangely, almost immediately, Zeitoun felt at peace. The damage to the neighborhood was extraordinary, but there was an odd calm in his heart. So much had been lost, but there was a stillness to the city that was almost hypnotic.

He coasted away from his home, passing over bicycles and cars, their antennae scraping the bottom of his canoe. Every vehicle, old and new, was gone, unsalvageable. The numbers filled his head: there were a hundred thousand cars lost in the flood. Maybe more. What would happen to them? Who would take them once the waters receded? In what hole could they all be buried?

Almost everyone he knew had left for a day or two, expecting little damage. He passed by their homes, so many of which he'd painted and even helped build, calculating how much was lost inside. It made him sick, the anguish this would cause. No one, he knew, had prepared for this, adequately or at all.

He thought of the animals. The squirrels, the mice, rats, frogs, possums, lizards. All gone. Millions of animals drowned. Only birds would survive this sort of apocalypse. Birds, some snakes, any beast that could find higher ground ahead of the rising tide. He looked for fish. If he was floating atop water shared with the lake, surely fish had been swept into the city. And, on cue, he saw a murky form darting between submerged tree branches.

* * *

He remembered the dogs. He rested his paddle on his lap, coasting, trying to place the pets he'd heard crying in the dark.

He heard nothing.

He was conflicted about what he was seeing, a refracted version of his city, one where homes and trees were bisected and mirrored in this oddly calm body of water. The novelty of the new world brought forth the adventurer in him — he wanted to see it all, the whole city, what had become of it. But the builder in him thought of the damage, how long it would take to rebuild. Years, maybe a decade. He wondered if the world at large could already see what he was seeing, a disaster mythical in scale and severity.

In his neighborhood, miles from the closest levee, the water had risen slowly enough that he knew it was unlikely that anyone had died in the flood. But with a shudder he thought of those closer to the breaches. He didn't know where the levees had failed, but he knew anyone living nearby would have been quickly overwhelmed.

He turned on Vincennes Place and headed south. Someone called his name. He looked up to see a client of his, Frank Noland, a fit and robust man of about sixty, leaning out from a second-story window. Zeitoun had done work on his house a few years ago. The Zeitouns would see Frank and his wife occasionally in the neighborhood, and they always exchanged warm greetings.

Zeitoun waved and paddled over.

"You got a cigarette?" Frank asked, looking down.

Zeitoun shook his head no, and coasted closer to the window where Frank had appeared. It was a strange sensation, paddling over the man's yard; the usual barrier that would prevent one from guiding a vehicle up to the house was gone. He could glide directly from the street, diagonally across the lawn, and appear just a few feet below a second-story window. Zeitoun was just getting accustomed to the new physics of this world.

Frank was shirtless, wearing only a pair of tennis shorts. His wife was behind him, and they had a guest in the house, another woman of similar age. Both women were dressed in T-shirts and shorts, suffering in the heat. It was early in the day, but the humidity was already oppressive.

"You think you could take me to where I can buy some smokes?" Frank asked.

Zeitoun told him that he didn't think any store would be open and selling cigarettes this day.

Frank sighed. "See what happened to my motorcycle?" He pointed to the porch next door.

Zeitoun remembered Frank talking about this motorcycle — an antique bike that he had bought, restored, and lavished attention on. Now it was under six feet of water. As the water had risen the day before, Frank had moved it from the driveway up to the porch and then to his next-door neighbor's porch, which was higher. But now it was gone. They could still see the faint, blurred likeness of the machine, like a relic from a previous civilization.

He and Frank talked for a few minutes about the storm, the flood, how Frank had expected it but then hadn't expected it at all.

"Any chance you can take me to check on my truck?" Frank asked. Zeitoun agreed, but told Frank that he'd have to continue on a while longer. Zeitoun was planning to check on one of his rental properties, about two miles away.

Frank agreed to come along for the ride, and climbed down from the window and into the canoe. Zeitoun gave him the extra paddle and they were off.

"Brand new truck," Frank said. He had parked it on Fontainebleau, thinking that because the road was a foot or so higher than Vincennes, the truck would be spared. They made their way up six blocks to where Frank had parked the truck, and then Zeitoun heard Frank's quick intake of breath. The truck was under five feet of water and had migrated half a block. Like his motorcycle, it was gone, a thing of the past.

"You want to get anything out of it?" Zeitoun asked.

Frank shook his head. "I don't want to look at it. Let's go."

They continued on. Soon they saw an older man, a doctor Zeitoun knew, on the second-floor porch of a white house. They paddled into the yard and asked the doctor if he needed help. "No, I've got somebody coming," he said. He had his housekeeper with him, he said, and they were well set up for the time being.

A few doors down, Zeitoun and Frank came upon a house with a large white cloth billowing from the second-floor window. When they got closer, they saw a couple, a husband and wife in their seventies, leaning out of the window.

"You surrender?" Frank asked.

The man smiled.

"You want to get out?" Zeitoun asked.

"Yes, we do," the man said.

They couldn't safely fit anyone else in the canoe, so Zeitoun and Frank promised to send someone back to the house as soon as they got to Claiborne. They assumed there would be activity there, that if anywhere would have a police or military presence, it would be Claiborne, the main thoroughfare nearby.

"We'll be right back," Zeitoun said.

As they were paddling away from the couple's house, they heard a faint female voice. It was a kind of moan, weak and tremulous.

"You hear that?" Zeitoun asked.

Frank nodded. "It's coming from that direction."

They paddled toward the sound and heard the voice again.

"Help."

It was coming from a one-story house on Nashville.

They coasted toward the front door and heard the voice again: "Help me."

Zeitoun dropped his paddle and jumped into the water. He held his breath and swam to the porch. The steps came quicker than he thought. He jammed his knee against the masonry and let out a gasp. When he stood, the water was up to his neck.

"You okay?" Frank asked.

Zeitoun nodded and made his way up the steps.

"Hello?" the voice said, now hopeful.

He tried the front door. It was stuck. Zeitoun kicked the door. It wouldn't move. He kicked again. No movement. With the water now to his chest, he ran his body against the door. He did it again. And again. Finally it gave.

＊　＊　＊

Inside he found a woman hovering above him. She was in her seventies, a large woman, over two hundred pounds. Her patterned dress was spread out on the surface of the water like a great floating flower. Her legs dangled below. She was holding on to a bookshelf.

"Help me," she said.

Zeitoun talked gently to the woman, assuring her that she would be taken care of. He knew that in all likelihood she had been there, clinging to her furniture, for twenty-four hours or more. An elderly woman like this would have no chance of swimming to safety, much less have the strength to cut a hole through her roof. At least the water was warm. She might not have survived.

Zeitoun pulled her out the front door and caught a glimpse of Frank in the canoe. His jaw had gone slack, his eyes disbelieving.

No one knew what to do next. It would be very difficult to fit a woman of her size into the canoe under normal circumstances. And lifting her into it would require more than two men. Even if they could lift her and fit her inside, they couldn't possibly fit all three of them. The canoe would certainly capsize.

He and Frank had a quick whispered conversation. They had no choice but to leave her and find help. They would paddle quickly to Claiborne and flag down a boat. They told the woman the plan. She was unhappy to be left alone again, but there was no choice.

They reached Claiborne in a few minutes and immediately saw what they were looking for: a fan boat. Zeitoun had never seen one in person, but they were familiar from movies. This was a military model, loud,

with a great fan anchored perpendicularly to the rear. It was headed directly toward them.

Zeitoun thought it was very lucky to have found another craft so quickly, and he was filled with something like pride, knowing that he had promised help and could now deliver it.

He and Frank positioned their canoe in the path of the boat and waved their arms. The fan boat came straight for them, and when it was close, Zeitoun could see that there were four or five uniformed officers aboard; he wasn't sure if they were police or military, but he was very happy to see them. He waved, and Frank waved, both of them yelling "Stop!" and "Help!"

But the fan boat did not stop. It swung around the canoe holding Zeitoun and Frank, not even slowing down, and continued down Claiborne. The men aboard the fan boat barely glanced at them.

The fan boat's wake nearly tipped their canoe. Zeitoun and Frank sat still, gripping either side until the waves subsided. They hardly had time to exchange incredulous looks when another boat came their way. Again it was a fan boat, also with four military personnel aboard, and again Zeitoun and Frank waved and called for help. Again the fan boat swung around them and continued without a word.

This happened repeatedly over the next twenty minutes. Ten of these vessels, all staffed by soldiers or police officers, ignored their canoe and their calls for assistance. Where were these boats going, what were they looking for, if not for residents of the city asking for help? It defied belief.

Finally a different sort of boat approached. It was a small fishing boat manned by two young men. Though Zeitoun and Frank were

disheartened and unsure if anyone would stop, they gave it a try. They stood in the canoe, they waved, they yelled. This boat stopped.

"We need help," Frank said.

"Okay, let's go," the men on the boat said.

The young men threw a line to Zeitoun, who tied it to the canoe. The motorboat towed Zeitoun and Frank to the woman's house, and once they were close, the young men cut the engine and coasted toward the porch.

Zeitoun jumped into the water again and swam to her door. The woman was exactly as they'd left her, in her foyer, floating near the ceiling.

Now they only had to figure out how to get her into the fishing boat. She couldn't lift herself into the boat; that wasn't an option. She couldn't drop down into the water for leverage. It was too deep and she could not swim.

"You have a ladder, ma'am?" one of the young men asked.

She did. She directed them to the detached garage at the end of the driveway. Zeitoun dropped into the water, swam to the garage, and retrieved it.

When he brought it back, he set it on the ground and against the boat. The plan was that the woman would let go of the bookshelf, grab the ladder, put her feet onto it, and climb up until she was above the boat and able to step into the hull.

Zeitoun held the ladder while the two young men steadied it against the boat, ready to receive her. It seemed an ingenious plan.

But she couldn't climb the ladder. She had a bad leg, she said, and couldn't put pressure on it. It took a certain degree of agility, and she was eighty years old, weakened by staying awake for twenty-four hours while

floating near her ceiling, thinking only that she might drown in her own home.

"I'm sorry," she said.

There was only one option now, they decided. They would use the ladder as a sort of gurney. They would prop one end on the side of the fishing boat, and one of the young men would stand on the porch, holding the other side. They would then have to lift it high enough to get her over the lip of the boat, and far enough in that she could roll into the hull.

Zeitoun realized that two men, one on either end of the ladder, would not be enough to lift a woman of over two hundred pounds. He knew he would have to push from below. So when the two young men were in position, and the woman was ready, Zeitoun took a deep breath and went under. From below the surface, he could see the woman let go of the bookshelf and grab the ladder. It was awkward, but she managed to place herself atop it, as if it were a kind of raft.

As she put weight on the ladder, Zeitoun positioned his shoulders under it and pushed up. The motion was akin to a shoulder-press machine he'd once used at a gym. He straightened his legs, and as he did, the ladder rose from the water until he saw light breaking the surface, until he felt the air on his face and was finally able to exhale.

The woman rolled into the bed of the boat. It was not a graceful landing, but she managed to sit up. Though she was wet and breathing heavily, she was unhurt.

Zeitoun shuddered as he watched her recover. It was not right to watch a woman of her age suffer like this. The situation had stolen her dignity, and it pained him to bear witness.

Zeitoun climbed back into the canoe. Frank, smiling and shaking his head, stretched out his hand from the fishing boat.

"That was something," Frank said.

Zeitoun shook his hand and smiled.

The men sat in silence, letting the woman determine when it was time to go. They knew it was an impossible thing for her to see her house like this, untold damage and loss within. At her age, and with the years it would take to restore the home, she would likely never return. They gave her a moment. Finally she nodded and they arranged their convoy. Zeitoun was alone in the canoe, being towed behind. He was soaked and exhausted.

With Frank directing the fishing boat, they made their way toward the couple who had been waving the white cloth. On the way there, they heard another cry for help.

It was another older couple in their seventies, waving from their second-story window.

"You ready to leave?" Frank asked.

"We are," the man in the window said.

The young fishermen brought the caravan to the window, and the couple, fit and agile, lowered themselves into it.

With six people now aboard the fishing boat, they arrived at the white-flag house. The couple living there lowered themselves down, making the number in the fishing boat eight. The young men had seen a temporary medical staging ground set up at the intersection of Napoleon and St. Charles, and they agreed that they would deliver the passengers there. It was time for Zeitoun and Frank to part ways with their companions. Frank stepped back into the canoe and said goodbye.

"Good luck with everything," one of the young men said.

"You too," Zeitoun said.

They had never exchanged names.

*　*　*

In Baton Rouge, Kathy was again driving to kill time, her car full of children. Needing distraction from the news on the radio — it was getting worse every hour — she stopped periodically at whatever stores or restaurants were open. Zeitoun had sounded so calm on the phone the previous night, before his phone had given out. But since then conditions in the city had devolved. She was hearing reports of unchecked violence, widespread chaos, thousands presumed dead. What was her lunatic husband doing there? She tried his phone again and again, hoping he had somehow found a way to charge it. She tried the home phone, in case the water had miraculously dropped below the phone box and the wiring was undamaged. She got nothing. The lines were dead.

On the radio, they were reporting that another ten thousand National Guardsmen were being sent to the region, about one-third of them directed to maintain order. There would soon be twenty-one thousand National Guard troops in the area, coming from all over the country — West Virginia, Utah, New Mexico, Missouri. How could her husband be so calm when every branch of the armed forces was scrambling?

She turned off the radio and tried Zeitoun again. Nothing. She knew she shouldn't worry yet, but her mind took dark turns. If she was out of touch with her husband already, how would she know if anything was wrong? How would she know if he was alive, in danger, dead? She was getting ahead of herself. He was in no danger. The winds were gone, and now it was just water, placid water. And troops were on their way. No cause for worry.

Returning to her family's house in Baton Rouge, she found her

mother there. She had come to deliver ice. She greeted all the kids and looked at Kathy.

"Why don't you take off that thing and relax?" she said, pointing to Kathy's hijab. "He's not here. Be yourself."

Kathy suppressed a dozen things she wanted to say, and instead channeled her rage into packing. She would take the kids and go to a motel, a shelter. Anywhere. Maybe to Arizona. It just wasn't working in Baton Rouge. And it was all so much worse not knowing where Zeitoun was. Why did that man insist on staying? It was a cruel thing, really. He wanted to make sure that his family was safe, but Kathy, his wife, wasn't afforded the same certainty. When they next spoke, she was determined to get him to leave the city. It didn't matter anymore why he wanted to stay. Forget the house and property. Nothing could be worth it.

In New Orleans, Zeitoun was invigorated. He had never felt such urgency and purpose. In his first day in his flooded city, he had already assisted in the rescue of five elderly residents. There was a reason, he now knew, that he had remained in the city. He had felt compelled to stay by a power beyond his own reckoning. He was needed.

Zeitoun and Frank's next stop was Zeitoun's property, back on Claiborne at number 5010. He and Kathy had owned the home, a two-story residence, for five years. It was a rental unit, with four to six tenants at any given time.

When they arrived, they found Todd Gambino, one of Zeitoun's tenants, on the front porch, a bottle of beer in his hand. Todd was a stout man in his late thirties, and had lived there as long as the Zeitouns had owned the building. He worked as a mechanic at a SpeeDee Oil Change and Tune-Up franchise most of the week, and had a part-time job delivering lost luggage for the airport. He was a good tenant; they'd

never had a late check or any sort of problem from him.

He stood up, incredulous, as Zeitoun approached.

"What're you doing here?" he asked.

"Really? I came to check on the building," Zeitoun said, smiling, knowing how ludicrous it sounded. "I wanted to check on you."

Todd couldn't believe it.

Zeitoun and Frank got out of the canoe and tied it to the porch. They were both happy to stand on solid ground again.

Todd offered them beers. Zeitoun passed. Frank accepted and sat on the porch steps while Zeitoun went inside.

Todd lived in the first-floor unit of the building, and had brought all of his possessions up to the second floor. The front rooms and hallway of the house were full of furniture, chairs and desks stacked on tables and couches. Various electronics saved from the flood were now resting on the dining-room table. It looked like a haphazard estate sale.

The damage to the house was extensive but not irreparable. Zeitoun knew the basement would be a loss, and might not be habitable for some time. But the first and second floors had not been badly harmed, and this gave Zeitoun comfort. There was a lot of dirt, mud, grime — much of it from Todd moving things upstairs and rushing in and out of the house — but the damage could have been far worse.

Zeitoun learned from Todd that because the house's phone box was above the water line, the landline was still working. He immediately dialed Kathy's cell phone.

"Hello? I'm here," he said.

She almost screamed. She hadn't realized how worried she'd been. "*Alhamdulilah*," she said, Arabic for *Praise be to God*. "Now get out."

He told her he would not be leaving. He told her about the woman in the ballooning dress in the foyer, how he had lifted the ladder to save her. He told her about the fishermen, and Frank, and the two elderly couples. He was talking so fast she laughed.

"So when do you plan to leave?" she asked.

"I don't," he said.

He tried to explain. If he left, what would he do? He would be in a home full of women, with nothing to occupy himself. He would eat, watch TV, and be left to worry from afar. Here, in the city, he could stay and monitor developments. He could help where needed. They had a half-dozen properties to look after, he reminded her. He was safe, he had food, he could take care of himself and prevent further damage.

"Really? I want to see this," he said.

He wanted to see everything that had happened and would happen with his own eyes. He cared about this city and believed in his heart he could be of use.

"So you feel safe?" she asked.

"Of course," he said. "This is good."

Kathy knew that she couldn't dissuade him. But how would she explain to her children, as they watched images of the city drowning, that their father was there by choice, paddling around in a secondhand canoe? She tried to reason with him, noting that the TV reports were saying that things were only getting worse, that the water would soon become infected with all manner of pollutants — oil, garbage, animal remains — and that diseases would soon follow.

Zeitoun promised to be careful. He promised to call back at noon the next day, from the house on Claiborne.

"Call every day at noon," she said.

He said he would.

"You better," she said.

They hung up. Kathy turned on the television. The news led with reports of lawlessness and death. The media consensus was that New Orleans had descended into a "third-world" state. Sometimes this comparison was made with regard to the conditions, where hospitals were not open or working, where clean water and other basic services weren't available. In other instances, the words were spoken over images of African American residents wilting in the heat outside the Morial Convention Center or standing on rooftops waving for help. There were unverified reports of roving gangs of armed men, of guns being fired at helicopters trying to rescue patients from the roof of a hospital. Residents were being referred to as refugees.

Kathy was certain Zeitoun was unaware of the level of danger being reported. He may have felt safe where he was in Uptown, but what if there really was chaos, and that chaos was simply making its way to him? She was reluctant to believe the hyperbolic and racially charged news coverage, but still, things were devolving. Most of those left in the city were trying desperately to get out. She couldn't stand it. She called the house on Claiborne again. No answer.

He was already gone. Zeitoun and Frank were paddling back to Zeitoun's house on Dart Street. As they made their way home, passing a half-dozen fan boats along the way, it occurred to Zeitoun that he and Frank had heard the people they had helped, in particular the old woman floating inside her home, because they were in a canoe. Had they been in a fan boat, the noise overwhelming, they would have heard nothing. They would have passed by, and the woman likely would not have survived another night. It was the very nature of this small, silent craft that

allowed them to hear the quietest cries. The canoe was good, the silence was crucial.

Zeitoun dropped Frank at his house and made for home. His paddle kissed the clean water, his shoulders worked in perfect rhythm. Zeitoun had traveled five, six miles already that day, and he wasn't tired. Night was falling, and he knew he had to be home, safe on his roof. But he was sorry to see the day end.

He tied the canoe to the back porch and climbed up into the house. He retrieved a portable grill and brought it to the roof. He made a small fire and cooked chicken breasts and vegetables he'd thawed that day. The night fell as he ate, and soon the sky was darker than any he'd known in New Orleans. The sole light came from a helicopter circling downtown, looking tiny and powerless in the distance.

Using bottled water, Zeitoun cleaned up and prayed on the roof. He crawled into the tent, his body aching but his mind alive, playing back the events of the day. He and Frank really had saved that woman, hadn't they? They had. It was a fact. They had brought four others to safety, too. And there would be more to do tomorrow. How could he explain to Kathy, to his brother Ahmad, that he was so thankful he had stayed in the city? He was certain he had been called to stay, that God knew he would be of service if he remained. His choice to stay in the city had been God's will.

Too excited to sleep, he went back through the window and into the house. He wanted to find the photo of Mohammed again. He'd forgotten who was with him in the picture — was it Ahmad? — and he wanted to see the expression on Mohammed's face, that world-conquering smile.

He retrieved the box of pictures, and while looking for that one he found another.

He'd forgotten about this photo. There he was, Mohammed with the vice president of Lebanon. Zeitoun hadn't seen the image for a few years. Mohammed wasn't even twenty, and he'd won a race starting in Saida and ending in Beirut, a distance of twenty-six miles. The crowd was stunned. He had come out of nowhere, Mohammed Zeitoun, a sailor's son from the tiny island of Arwad, and stunned everyone with his strength and endurance. Zeitoun knew his father, Mahmoud, was somewhere in the crowd. He never missed a race. But it had not always been so.

Mahmoud wanted Mohammed, and all of his sons, working on dry land, so Mohammed spent his early teenage years as a craftsman, laying brick and apprenticing for an ironsmith. He was a powerfully built young man, and was finished with school at fourteen. At eighteen he looked much older, with a full mustache and a square jaw. He was both a workhorse and a charmer, admired equally by his elders and the young women in town.

With his father's grudging approval, Mohammed crewed on local fishing boats in the afternoons and evenings, and even at fourteen, after a full day of fishing miles from land, Mohammed insisted on swimming to shore. The other fishermen would have barely pulled in the last net when they would hear a splash and see Mohammed cutting through the sea, racing them to the beach.

Mohammed didn't tell his father about such endeavors, and he certainly didn't tell him when, a few years later, he decided that he was destined to be the world's greatest long-distance swimmer.

It was 1958. Egypt and Syria, reacting to a number of political factors, including growing American influence in the region, merged,

creating the United Arab Republic. The union was meant to create a more powerful bloc, one that might grow to include Jordan, Saudi Arabia, and others. There was wide public support for the alliance, pride bursting from the streets and windows of Syria and Egypt, the citizens of both countries seeing the union as a step along the way to a broader alignment between the Arab states. There were parades and celebrations from Alexandria to Lattakia.

One of the commemorative events was a race between Jableh and Lattakia, in which swimmers from all over the Arab world would swim thirty kilometers through the Mediterranean. It was the first race of its kind on the Syrian coast, and eighteen-year-old Mohammed followed every step, from the preparations to the race itself. He watched the swimmers train, studying their strokes and regimen, longing to be part of it himself. He managed to be appointed to the crew of the guide boat for one of the competitors, Mouneer Deeb, which would keep pace with him along the race's route.

Along the way, unable to contain himself, Mohammed jumped in and swam alongside Deeb and the other contestants. He not only kept up with the professionals, he impressed one of the judges. "That boy is great," the judge said. "He is going to be a champion." From that day on Mohammed thought of little else but the fulfillment of that prophecy.

Still only eighteen years old, he worked mornings as a mason and ironsmith, afternoons as a fisherman, and at night he began to train for the next year's race. He kept his training secret from his father, even when he undertook two long-distance tests, one between Lattakia and Jableh and another between Jableh and Baniyas. Soon enough, though, Mahmoud learned of his son's aspirations, and, fearing he would lose his son to the unforgiving sea that had almost taken his own life, he forbade him from swimming long distances. He wanted him out of fishing, away from the sea. He wanted his son alive.

But Mohammed could not stop. As difficult as it was to disobey his father, he continued to train. Telling no one in his family, Mohammed entered the next year's race. As he stepped out of the water in Lattakia, the cheers were deafening. He had won handily.

Before Mohammed could return home, an old friend of Mahmoud's, himself a champion swimmer, visited the Zeitoun house, congratulating Mahmoud on his son's victory. This is how Mahmoud learned that Mohammed Zeitoun was the best swimmer in all of Syria.

By the time Mohammed arrived home that night, Mahmoud had given up his resistance. If his son wanted this, and if his son was destined to swim — if God had made him a swimmer — then Mahmoud could not stand in the way. He bought Mohammed a bus ticket to Damascus to train and compete with the best swimmers in the region.

Zeitoun found another photo. Mohammed's first major victory came

in that same year, 1959, in a race in Lebanon. The field was crowded, filled with well-known names, but Mohammed not only finished first, he did so in record time: nine hours and fifty-five minutes. This photo, Zeitoun was almost sure, was taken during the celebration afterward. Thousands were there, applauding his brother.

How old was Zeitoun at the time? He did the calculations in his head. Just a year. He was maybe one year old. He remembered nothing of those early wins.

The next year, Mohammed entered the famed race between Capri and Naples, a contest that attracted the best swimmers in the world. The favorite was Alfredo Camarero, an Argentinean, who had placed first or second in the race five years running. Mohammed was an unknown when the race began at six in the morning, and after eight hours, when he was approaching shore, he had no idea that he was in the lead. It wasn't until he stepped out of the sea, hearing shrieks of surprise and the chanting of his name, that he realized he'd won. "Zeitoun the Arab has won!" they cheered. No one could believe it. A Syrian winning the world's greatest long-distance competition? Camarero told everyone that Mohammed was the strongest swimmer he had ever seen.

Mohammed dedicated the victory to President Nasir. In return, Nasir made the twenty-year-old Mohammed an honorary lieutenant in the navy. The prince of Kuwait attended the race and celebrated him at an honorary dinner in Naples. The next year Mohammed won the Capri-to-Naples race again, this time breaking the course record set by Camarero by fifteen minutes. Mohammed was now indisputably the best ocean swimmer in the world.

As a boy, Abdulrahman was enthralled, proud beyond measure. To grow up in that house, with a brother like that, to bask every day in the

glory he'd brought to the family — his siblings' pride in Mohammed fueled how they felt when they awoke each day, how they walked and talked and were perceived in Jableh and Arwad and everywhere across Syria. It changed, permanently, how they saw the world. Mohammed's accomplishments implied — proved, really — that the Zeitouns were extraordinary. It was incumbent, thereafter, on each and every child to live up to that legacy.

It had been forty-one years since Mohammed's death. Mohammed's incredible rise and premature passing had shaped the trajectory of Zeitoun's family in general and of Abdulrahman in particular, but he didn't like to dwell on it. In his less generous moments he believed his brother had been stolen from him, that the unfairness of taking such a beautiful man so young put many things into question. But he knew he was wrong to think this way, and it was unproductive in any case. All he could do now was honor his brother's memory. Be strong, be brave, be true. Endure. Be as good as Mohammed was.

Zeitoun tucked himself into the tent and fell into a fitful sleep. All over the neighborhood, the dogs were mad with hunger. Their barking was wild, unmoored, spiraling.

THURSDAY SEPTEMBER 1

By six a.m., Kathy had the Odyssey packed and the kids buckled in. Her sisters were still asleep as she quietly backed out of the driveway, leaving Baton Rouge. It was fifteen hundred miles to Phoenix.

"Are we really leaving Mekay?" Nademah asked.

Even Kathy couldn't believe it, but what else could they do? She had begged Patty to let her leave the dog there for a week; she'd given

dog food and money to one of Patty's teenage sons to care for poor Mekay. It was better than putting her in a kennel, and far better than trucking the dog all the way to Phoenix and back. Kathy didn't have the nerves for it. It was hard enough with four kids.

They were beginning what would be a three-day drive, minimum — more likely four or five. What was she doing? It was crazy to drive four days in a car full of kids. And making the decision without her husband! It had been so long since she'd been in such a situation. But she had no choice. She couldn't stay in Baton Rouge for however many weeks it would be before New Orleans was habitable again. She hadn't even begun to think about school, about clothes — they'd only packed for two days — or about what they would do for money while the business was at a standstill.

Heading west on I-10, she felt some measure of relief in knowing that at the very least, on the open road she would have some time to think.

Out on the highway, she dialed the Claiborne house. Though it was hours before their agreed-upon time, she called in case Zeitoun had gotten there first and was waiting to call her. The phone rang three times.

"Hello?" a man said. The voice was an American's, not her husband's. It was gruff, impatient.

"Is Abdulrahman Zeitoun there?" she asked.

"What? Who?"

She repeated her husband's name.

"No, no one here by that name."

"Is this 5010 Claiborne?" she asked.

"I don't know. I think so," the man said.

"Who is this?" she asked.

There was a pause, then the line went dead.

* * *

Kathy drove for a mile before she could even wrap her mind around what had just happened. Who was that voice? It was not one of the tenants; she knew them all. It was a stranger, someone who had found a way into the house and was now answering the phone. Again her mind took quick turns downward. What if the man on the phone had killed her husband and robbed the house and moved in?

She pulled into a McDonald's and parked, calming herself down. She turned on the radio and almost immediately came upon a report from New Orleans. She knew she shouldn't listen, but she couldn't help it. The reports of lawlessness were worse than before, and Governor Blanco, in a statement directed to would-be criminals, warned that war-hardened U.S. soldiers were on the way to New Orleans to restore order at any cost. "I have one message for these hoodlums," she said. "These troops know how to shoot and kill, and they are more than willing to do so if necessary, and I expect they will."

Kathy knew she should turn the dial before the kids heard any of it, but it was too late.

"Did they say the city was flooded, Mama?"

"Is our house under water?"

"Are they shooting people, Mama?"

Kathy turned the radio off. "Please, babies, don't ask me questions."

She steeled herself and got back on the highway, determined to drive straight through to Phoenix. She just had to get to Yuko and she would be okay. Yuko would settle her. Of course Zeitoun was okay, she told herself. The man on the phone could have been anyone. There would be nothing unusual about people sharing a phone when most of the city's landlines had ceased to function.

For a few minutes she was calm. But the kids started in with the questions again.

"What happened to our house, Mama?"

"Where's Daddy?"

This got Kathy's mind going again. What if that man *was* her husband's killer? What if she had just spoken to the man who had murdered him? She felt as if she had been watching, from above, the convergence of forces on her husband. Only she knew what was happening in the city, the madness, the suffering and desperation. He had no television, couldn't know the extent of the chaos. She had seen the images from helicopters, the press conferences, she had heard the statistics, the stories of gangs and rampant crime. Kathy bit her lip. "Babies, don't ask me right now. Don't ask me."

"When are we going home?"

"Please!" Kathy snapped. "Just leave it alone for a minute. Let me think!" She couldn't hold it in anymore. She could barely see the road. The lines were disappearing. She felt it coming on and pulled over. She was blind with tears, wiping her nose with the back of her hand, her head against the steering wheel.

"What's wrong, Mama?"

The highway flew beside her.

In a few minutes, she managed to gather herself enough to pull into a rest stop. She called Yuko.

"Don't drive another foot," Yuko said.

Within twenty minutes a plan was shaped. Kathy stayed put while Yuko's husband Ahmaad looked into flights. Kathy would only have to make it as far as Houston. Yuko would arrange for Kathy and the kids

to spend the night at a friend's house there. Ahmaad would fly to Houston immediately, and in the morning he would meet her there and drive the family all the way to Phoenix.

"Are you sure?" Kathy asked.

"I'm your sister. You're my sister. You're all I have," Yuko said. Her mother Kameko had passed away that year. The loss had been devastating to both Yuko and Kathy.

This got Kathy crying all over again.

That morning Zeitoun woke after nine, exhausted from the howling of the dogs. He was determined this day to find them.

After his prayers, he paddled out over his flooded yard. The dogs seemed very near. He crossed the street and went left on Dart. Only a few houses down, he found the source.

It was a house he knew well. He paddled closer, and the dogs went wild, their desperate sounds coming from within. Now he had to find a way inside. The first story was flooded, so he assumed the dogs — two of them, he guessed — were trapped on the second. There was a many-boughed tree near the house. He paddled to it and tied the canoe to the trunk.

He lifted himself into the tree, climbing until he could see through a second-story window. He saw no dogs, but he could hear them. They were in that house, and they knew he was close. The tree where he was standing was about ten feet from the window. He couldn't jump. It was too far.

At that moment, he spotted a plank, a foot wide and sixteen feet long, floating in the sideyard. He climbed down, paddled to the plank, brought it to the house, and leaned it against the tree. He climbed up again and lifted the plank to create a bridge between the tree and the

roof. He was about sixteen feet off the ground, about eight feet above the waterline.

The bridge he created was not so different from the scaffolding he used every day in his work, so after testing it quickly with the weight of one foot, he walked across and onto the roof.

From there he pried a window open and ducked into the house. The barking grew louder and more urgent. He walked through the bedroom he'd arrived in, hearing the dogs grow more hysterical. As he strode through the second-floor hallway he saw them: two dogs, a black Labrador and a smaller mixed breed, in a cage. They had no food, and their water dish was empty. They seemed confused enough to bite him, but he didn't hesitate. He opened the cage and let them out. The Labrador ran past him and out of the room. The smaller dog cowered in the cage. Zeitoun stepped back to give him room, but he stayed where he was.

For the Labrador, there was nowhere to go. He tried the stairs and saw the water reached to just a few inches below the second floor. He returned to Zeitoun, who had a plan.

"Wait here," he told them.

He walked back across the plank bridge, climbed down the tree and into his canoe, and paddled back to his house. He climbed up to the roof, slipped through his window, and went down the few steps not underwater. Knowing Kathy kept the freezer stocked with meat and vegetables, he leaned down and removed two steaks, quickly closing the door to keep the finite cold from escaping. He walked back up to the roof, grabbed two plastic water bottles, and dropped them and the steaks into the canoe below. He shimmied down and returned to the house of the dogs.

Again they sensed him approaching, and this time they were both waiting by the window, their heads peeking over the sill. When they smelled the meat, frozen though it was, they began barking wildly, their tails wagging. Zeitoun refilled their water dish and they dove for it. After drinking their fill they went to work on the steaks, gnawing on them until the meat thawed. Zeitoun watched for a few minutes, tired and content, until he heard more barking. There were other dogs, and he had a freezer full of food. He went back to his house to prepare.

He stacked more meat into his canoe and went in search of the other animals left behind. Almost immediately after leaving his house he heard a distinct barking, muffled, coming from almost the same location as the dogs he'd just found.

He paddled closer, wondering if there was actually a third dog in the home he'd just been in. He anchored the canoe to the tree again, took two steaks with him, and climbed up. From the middle bough he looked this time to the neighboring house, the one on the left, and saw two more dogs, jumping against the glass.

He pulled the plank away from the first house and arranged it so it extended to the other. The dogs, seeing him coming, went wild, leaping in place.

In a moment, he had opened the window and stepped in, the two dogs jumping at him. He dropped the two steaks and the dogs pounced, forgetting about him entirely. He needed to give them water, too, so he again paddled home and brought more water bottles and a bowl back to them.

Zeitoun left the window open enough to allow the dogs to get fresh air, then walked across the plank again and climbed down the tree to his canoe. He paddled off, thinking it was about time to call Kathy.

<p style="text-align:center">* * *</p>

As he paddled, he noticed that the water was growing more contaminated. It was darker now, opaque, streaked with oil and gasoline, polluted with debris, food, garbage, clothing, pieces of homes. But Zeitoun was in high spirits. He felt invigorated by what he'd been able to do for the dogs, that he was there for those animals, and four dogs that almost certainly would have starved would now live because he had stayed behind, and because he had bought that old canoe. He couldn't wait to tell Kathy.

By noon he'd returned to the house on Claiborne. Today Todd was gone and the house was empty. He went inside and called.

"Oh thank God!" Kathy said. "Thank God thank God thank God. Where have you been?" She and the kids were still driving to Houston. She pulled over.

"What're you worried about?" Zeitoun asked. "I said I'd call at noon. It's noon."

"Who was that man?" she asked.

"What man?" he asked.

She explained that when she'd called earlier that day, someone else had answered the phone. This was unsettling to Zeitoun. As they spoke, he looked around the house. There was no sign of theft or crime of any kind. There were no broken locks or windows. Maybe the man had been a friend of Todd's? He promised Kathy it was nothing at all to worry about, that he would get to the bottom of it.

Kathy, calmer now, was glad to hear that he had been able to help the dogs, that he was feeling useful. But she didn't want him in New Orleans anymore, no matter how many dogs he was feeding or how

many people he was finding and saving.

"I really want you to leave," she said. "The news coming out of the city, it's so bad. There's looting, killing. Something bad is going to happen to you."

Zeitoun could hear how worried she was. But he hadn't seen anything like the chaos she described. If it existed at all — and she knew how the media was — it would be downtown. Where he was, he said, it was so quiet, so calm, so otherworldly and strange, that he couldn't possibly be in danger. Maybe, he said, there was a reason he'd stayed, a reason he'd bought that canoe, a reason he was put in this particular situation at this particular time.

"I feel like I'm supposed to be here," he said.

Kathy was silent.

"It's God's will," he said.

She had no answer to this.

They moved on to practical matters. Her cell phone never worked well at Yuko's house in Phoenix, so she gave Zeitoun the landline there. He wrote it down on a piece of paper and left it by the Claiborne phone.

"Get the kids into school when you get to Phoenix," he said.

Kathy rolled her eyes.

"Of course," she said.

"I love you and them," he said, and they hung up.

He set out again, and immediately saw Charlie Ray, who lived just to the right of the Claiborne house. He was a blue-eyed carpenter in his fifties, a friendly and easygoing native Zeitoun had known for years. He was sitting on his porch like today was a day like any other.

"You stayed too," Zeitoun said.

"I guess I did."

"You need anything? Water?"

Charlie didn't, but said he might soon. Zeitoun promised to check in with him again, and paddled off, curious about how many people had remained in the city. If Frank stayed, and Todd and Charlie had weathered the storm, surely there were tens of thousands more. He was not alone in his defiance.

He continued on, knowing he should feel tired. But he was not at all tired. He had never felt stronger.

This day he ventured closer to downtown, passing families wading through the water, pushing laundry tubs full of their possessions. He paddled by a pair of women pushing an inflatable baby pool, their clothes and food inside. Each time, Zeitoun asked if he could help, and occasionally they would ask for a bottle or two of water. He would hand them whatever he had. He was finding so many things — bottled water, MREs, canned food — and whenever he saw anyone, he gave them whatever was in his canoe. He had plenty for himself at home, and didn't want any more weighing him down.

He paddled up to the I-10 ramp at Claiborne and Poydras, a concrete structure about ten feet above the waterline. Dozens of people were there, waiting for rescue. A helicopter had dropped off water and food, and they seemed to be well provisioned. They asked Zeitoun if he wanted any water, and he said that he had enough, but that he would bring it to those who needed it. They gave him a case. As he turned his canoe around he saw a half-dozen dogs with the group, most of them puppies. They seemed healthy and well-fed, and were keeping cool from the heat under the shade of the cars.

Zeitoun, assuming that whatever was ailing the city was likely worse downtown, chose not to get too close to the epicenter. He turned around and made his way back to Dart Street.

As Kathy was driving to Houston, Yuko was making arrangements for the family to spend the night with a longtime friend of theirs she called Miss Mary. Like Yuko and Kathy, Mary was an American, born into a Christian household, who had converted to Islam as an adult. Now her house had become a sanctuary for families fleeing the storm, and when Kathy's Odyssey pulled into the driveway there were already a dozen or more people there, all of them Muslims from New Orleans and other parts of Louisiana and Mississippi.

Mary, a bright-eyed woman in her forties, met Kathy and the kids in the driveway. She took their bags and hugged Kathy so tight that Kathy started crying yet again. Mary took them inside and showed the kids the pool in back, and within minutes the four of them were swimming and happy. Kathy collapsed on the couch and tried not to think of anything.

When he got back to the house on Dart, Zeitoun found his tent in the water below. It had been blown off the roof — probably, Zeitoun guessed, by a helicopter. He retrieved it and set it up again, dried the interior with towels, and then went inside the house to look for ballast. He brought out stacks of books, this time the heaviest ones he could find, and put them in the corners of the tent.

As he was inside stabilizing it, he heard another helicopter approach. The sound was deafening. He expected it to pass over his house on its way elsewhere, but when he poked his head out and looked up he saw that it was hovering over his house, over him. Two men inside were signaling to him.

He waved them off, trying to indicate that he was fine. But this only seemed to intrigue them more. The second man in the helicopter was beginning to lower a cage to him when Zeitoun thought to give the man a thumbs-up. He signaled to his tent and then to himself and gave the helicopter a series of frantic thumbs-ups and *a-okay* signals. Finally understanding Zeitoun's intent to stay, one of the men in the helicopter decided to drop a box of water down to him. Zeitoun tried to wave him off again, to no avail. The box came down, and Zeitoun leapt out of the way before it knocked the tent flat and sent plastic bottles bouncing everywhere. Satisfied, the helicopter tilted away and was gone.

Zeitoun returned to restabilizing his shelter, beginning to get ready for bed. But like the night before, he was restless, his mind racing with the events of the day. He sat on the roof, watching the movement of the helicopters circling and swooping over the rest of the city. He made plans for the following day: he would venture farther toward downtown, he would revisit the I-10 overpass, he would check on the state of their office and warehouse over on Dublin Street. On the first floor there they kept their extra supplies — tools, paints, brushes, drop cloths, everything — and on the second floor they had their offices, with their computers, files, maps, invoices, deeds to the properties. He winced, thinking of what had become of the building, a rickety thing to begin with.

All night the helicopters roamed overhead. Besides them it was quiet; he heard no dogs. After his prayers, he fell asleep under a vibrating sky.

FRIDAY SEPTEMBER 2

In the morning Zeitoun rose early, climbed down to his canoe, and

paddled across the street to feed the dogs. They whimpered as he approached, and he took it as relief and gratitude. He climbed the tree, stepped carefully across the plank to the house on the right, and crawled through the window. He dropped two large pieces of steak for the dogs and refilled their water dish. As they busied themselves, he climbed out of the window, stepped carefully over to the next-door roof, and made his way into the second house to feed the second pair of dogs. They barked and wagged their tails, and he dropped two pieces of lamb between them and refilled their water. He left through the window, climbed down to his canoe, and paddled off.

It was time to see what had become of his office building. It was about a half mile away, just off Carrollton, a nearby road lined with warehouses, chain stores, and gas stations. The water was filthy now, streaked with oil and spotted with detritus. Anyone left to wade through this would become sick, he was sure. But so far this day, he had seen no one in the water. The city was emptying. Every day there were fewer people wading, fewer faces in windows, fewer private watercraft like his.

It had been drizzling throughout the morning but now the rain began to pick up. The wind came on, and the day grew miserable. Zeitoun paddled into the wind, struggling to control the canoe, the wind rippling the brown-blue water.

He took Earhart over to Carrollton, and took Carrollton southwest on his way to Dublin. He expected that there might be people on Carrollton — like Napoleon and St. Charles, it seemed a logical thoroughfare for rescue or military boats — but when he got close, he saw no official personnel at all.

Instead he saw a group of men gathered at the Shell station just across the street from his office. The station was elevated from the main

road and was under only a few feet of water. The men, about eight or nine of them, were carrying full garbage bags from the station's office and loading them into a boat. It was the first looting he had seen since the storm, and these men were the first who fit the description of those Kathy had warned him about. This was an organized group of criminal opportunists who were not simply taking what they needed to survive. They were stealing money and goods from the gas station, and they were operating in numbers that seemed designed to intimidate anyone, like Zeitoun, who might see them or try to impede them.

Zeitoun was far enough away to observe without fear of them reaching him — at least not quickly. Still, he slowed his canoe to keep a safe distance, trying to figure out a way to get to his office without passing directly by them.

But one of the men had already noticed him. He was young, wearing long denim shorts and a white tank top. He squared his shoulders to Zeitoun and made a point of revealing the handle of a gun he had holstered in his belt.

Zeitoun quickly looked away. He did not want to invite confrontation. He turned his canoe around and made his way toward the house on Claiborne. He would not check on the office this day.

He arrived before noon and called Kathy. She was still in Houston at Miss Mary's house.

"Won't be able to check on the office today," he said.

"Why?" she asked.

He didn't want her to worry. He knew he had to lie.

"Rain," he said.

She told him that friends had been calling her, checking in to see

where she and Zeitoun were, if they were safe. When she told them that her husband was still in the city, there was always a three-stage response. First they were shocked, then they realized it was Zeitoun they were talking about — a man who did not inspire worry in any situation — and finally they asked that while he was paddling around, would he mind checking on their property?

Zeitoun was all too happy to be given a mission, and Kathy obliged. She had just gotten a call from the Burmidians, friends of theirs for thirteen years. Ali Burmidian was a professor of computer science at Tulane University, and ran the Masjid ar-Rahmah, a Muslim student association on campus. They had a building on Burthe Street that housed a resource center and dorm for visiting students from the Arab world.

Delilah Burmidian had just called Kathy, asking if Zeitoun could check on the building, to see what kind of damage it had sustained. Zeitoun said no problem, he would check on it. He knew the building well — he'd been to functions there a few times over the years — and he knew how to get there. He was curious, actually, to see what had become of the campus, given that it was on higher ground.

"Call again at noon," she said.

"Of course," Zeitoun said.

Before he left, Zeitoun called his brother Ahmad. After expressing great relief to hear from him, Ahmad got serious.

"You must leave," Ahmad said.

"No, no. I'm fine. Everything is fine," Zeitoun said.

Ahmad tried playing the big brother. "Go to your family," he said. "I really want you to leave. Your family needs you."

"They need me here more," Zeitoun said, trying not to sound too grandiose. "This is my family, too."

Ahmad had no way to counter such a statement.

"This call is expensive," Zeitoun said. "I'll call you tomorrow."

When he arrived at Tulane, the water was so low there that he easily stepped from the canoe onto dry land. He walked into the tiled courtyard of the Masjid ar-Rahmah and looked around. The grounds were crosshatched with downed branches, but otherwise the property was undamaged. He was about to look inside when he saw a man emerging from the building's side door.

"Nasser?" he said.

It was Nasser Dayoob. Also from Syria, Nasser had left the country in 1995, traveling first to Lebanon. From Beirut he stowed away on a tanker whose destination he did not know. It turned out it was heading to the United States, and when it made port Nasser jumped off and immediately sought asylum. He was eventually granted sanctuary, and by then he'd moved to New Orleans. He had stayed at the Masjid ar-Rahmah during his legal proceedings.

"Abdulrahman?"

They shook hands and exchanged stories of what they had been doing since the storm. Nasser's home, in the Broadmoor neighborhood adjacent to Uptown, had been flooded, and he'd come to the student association for shelter, knowing it was on higher ground.

"You want to stay here or come with me?" Zeitoun asked.

Nasser knew that he would be safe at the campus, with little possibility of flooding or crime, but still he went with Zeitoun. He too wanted to see what had become of the city and of his home.

He ran back into the building to get his duffel bag and then

stepped into the canoe. Zeitoun gave him the other paddle and they were off.

Nasser was thirty-five and tall, with freckles and a thick mess of red hair. He was quiet, with a slightly nervous demeanor; when Kathy met him she'd thought he was a fragile sort of man. He was a sometime housepainter, and had occasionally worked for Zeitoun. They were not close friends, but running into Nasser here, after the flood, gave Zeitoun some comfort. They shared a lot of history — Syria, emigration to America and New Orleans, work in the trades.

As they paddled, they talked about what they had seen so far, what they had been eating, how they had been sleeping. Both men had heard the dogs barking. Always the dogs barking at night. And Nasser, too, had fed dogs in the empty homes, on the streets, wherever he encountered them. It was one of the strangest aspects of this in-between time — after the storm but before anyone had returned to the city — the presence of these thousands of left-behind animals.

The wind was stronger now. Fighting through an angry horizontal rain, they paddled by the post office near Jefferson Parkway and Lafitte. The parking lot there had become a staging ground for evacuations. Residents who wanted to be airlifted out of the city could come to the post office and helicopters would take them, presumably, to safety.

As they paddled closer, Zeitoun asked Nasser if he wanted to leave. Not yet, Nasser said. He'd been hearing about the New Orleanians stranded under highway overpasses, and he didn't want to be among them. Until he heard more reliable reports of successful evacuations, he would stay in the city. Zeitoun told him he was welcome to stay at the Dart house or the house on Claiborne. He mentioned that there was a

working phone on Claiborne, and this was a godsend to Nasser. He needed to call a half-dozen relatives, to let them know he was alive.

They paddled back to Claiborne, passing a full case of bottled water bobbing in the middle of the waterway. They lifted it into the canoe and continued on.

When they arrived at the house, Nasser got out and began tying up the canoe. Zeitoun was stepping out when he heard a voice calling his name.

"Zeitoun!"

He figured it was Charlie Ray, calling from next door. But it was coming from the house behind Charlie's, on Robert Street.

"Over here!"

It was the Williamses, a couple in their seventies. Alvin was a pastor at New Bethlehem Baptist Church and wheelchair bound; Beulah was his wife of forty-five years. Zeitoun and Kathy had known them for almost as long as they'd lived in New Orleans. When the Zeitouns had lived nearby, Pastor Williams's sister used to come to Kathy for meals. Kathy could never remember how it started, but the sister was elderly, and liked Kathy's cooking, so around dinnertime, Kathy always had a plate ready for her. It went on for months, and it warmed Kathy to know someone would go to the trouble to eat what she'd made.

"Hello!" Zeitoun called out, and paddled over.

"You think you could help us get out of here?" Alvin asked.

The pastor and Beulah had waited out the storm but had now exhausted their supply of food and water. Zeitoun had never seen them look so weary.

"It's time to go," Alvin said.

<center>* * *</center>

Given the rain and the wind, it was impossible to try to evacuate them in the canoe. Zeitoun told them he would find help.

He paddled up Claiborne, the wind and rain fighting him, to the Memorial Medical Center, where he knew there were police and National Guard soldiers stationed. As he approached, he saw soldiers in the alleyway, on the roof, on the ramps and balconies. It looked like a heavily fortified military base. When he got close enough to see the faces of the soldiers, two of them raised their guns.

"Don't come any closer!" they ordered.

Zeitoun slowed his canoe. The wind picked up. It was impossible to stay in one place, and making himself heard was difficult.

"I'm just looking for help," Zeitoun yelled.

One of the soldiers lowered his gun. The other kept his trained on Zeitoun.

"We can't help you," he said. "Go to St. Charles."

Zeitoun assumed the soldier hadn't heard him correctly. The wind was turning his canoe around, veiling his words. "There's an old couple down the road that needs to be evacuated," he clarified, louder this time.

"Not our problem," the soldier said. "Go to St. Charles."

Now both guns were lowered.

"Why not call somebody?" Zeitoun asked. Did the soldier really mean that Zeitoun should paddle all the way to the intersection of Napoleon and St. Charles when the soldier could simply call another unit on his walkie-talkie? What were they doing in the city, if not helping evacuate people?

"We can't call nobody," the other soldier said.

"How come?" Zeitoun asked. "With all this technology, you can't call someone?"

Now the soldier, only a few years older than Zeitoun's son Zachary, seemed afraid. He had no answer, and seemed unsure of what to do next. Finally he turned and walked away. The remaining soldiers stared at Zeitoun, holding their M-16s.

Zeitoun turned his canoe around.

He paddled to the intersection of Napoleon and St. Charles, his shoulders aching. The wind was making the work twice as difficult. The water grew shallow as he approached the intersection. He saw tents there, and military vehicles, and a dozen or so police officers and soldiers. He stepped out of his canoe and walked up to a man, a soldier of some kind, standing on the grassy median — New Orleanians called it the *neutral ground*.

"I have a situation," Zeitoun said. "I have a handicapped man who needs help, medical attention. He needs help now."

"Okay, we'll take care of it," the man said.

"Do you want the address?" Zeitoun asked.

"Yeah, sure, give me that," the man said, opening a small notebook. Zeitoun gave him the exact address.

The man wrote it down and put his notebook back in his pocket.

"So you'll go?" Zeitoun asked.

"Yup," the man said.

"When?" Zeitoun asked.

"About an hour," the man said.

"It's okay. They're on their way," Zeitoun said. "They said one hour."

The pastor and his wife thanked Zeitoun and he returned to the

Claiborne house. He picked up Nasser, and they set out to see what they could do. It was just after one o'clock.

A thousand miles away, Yuko's husband Ahmaad was driving the Odyssey. Kathy was resting and the kids were in the back as they barreled through New Mexico. Ahmaad had been at the wheel for seven hours without a break. At this pace, they would make it to Phoenix by Saturday afternoon.

Ahmaad discouraged Kathy from listening to any news on the radio, but even on the rock and country stations snippets of information were leaking through: President Bush was visiting New Orleans that day, and had just lamented the loss of Trent Lott's summer home in coastal Mississippi. Heavily armed National Guardsmen had just entered the Convention Center, and though they had been led to believe their entry would be met with something like guerilla warfare, they had found no resistance whatsoever — only exhausted and hungry people who wanted to leave the city. Kathy took comfort in this, thinking that perhaps the city was coming under control. The military presence, one commentator was saying, "would soon be overwhelming."

Making their rounds, Zeitoun and Nasser found an abandoned military jeep and in it, a box of meals, ready-to-eat — MREs. Shortly after, they encountered a family of five on an overpass, and gave them some water and the box of MREs. It was a tidy coincidence. Zeitoun didn't like to carry anything of value at all, and welcomed any opportunity to unload anything he'd found.

It was about five o'clock, the sky darkening, when Zeitoun and Nasser made their way back to the Claiborne house.

Zeitoun was sure that the pastor and his wife would have been rescued by that point, but just to be certain, he and Nasser made a detour and paddled over to Robert Street.

Alvin and Beulah were still there, on the porch, their bags still ready, a light rain still falling on them. They had been waiting for four hours.

Zeitoun was furious. He felt helpless, betrayed. He'd made a promise to the pastor and his wife, and because he had been lied to, his promise had not been kept.

He apologized to the couple, explaining that he had first tried the hospital, where he was sent away at gunpoint, and then gone to St. Charles to tell the soldiers and the relief workers about their plight. The pastor expressed confidence that help was still on its way, but Zeitoun didn't want to take any chances.

"I'll figure something out," he said.

When he and Nasser returned to the Claiborne house, they saw a small motorboat tied to the front porch. Inside the house, they found Todd Gambino sitting inside with a new dog. With the boat — which Todd had seen floating under a ruined garage and figured he would put to use — he'd been making his own rounds around the city, plucking people from porches and rooftops and bringing them to the overpasses and other points of rescue. He'd even found this dog, which was now happily eating food at Todd's feet, on a roof and had taken him in.

Again Zeitoun felt the presence of some divine hand. The Williamses needed help immediately, help he had not been able to provide, and here was Todd, with precisely the vehicle they needed, at precisely the right moment.

Todd did not hesitate. Zeitoun agreed to care for the dog while he was gone, and Todd was off. He picked up Alvin and Beulah, cradling

them one by one into the motorboat. Then he sped off toward the staging ground at Napoleon and St. Charles.

The mission took all of twenty minutes. Soon Todd was back, drinking a beer and relaxing again on the porch, his hand stroking the rescued dog's matted fur.

"Some things you just have to do yourself," he said with a smile.

Zeitoun had known Todd to be a good tenant, but he didn't know this side of him. They talked for a time on the porch, and Todd told him stories of his own rescues — how he'd picked up dozens of people already, how he'd been shuttling them to hospitals and staging grounds, how easy it was with a motorboat. Todd had always been, to Zeitoun's mind, a bit of a wanderer, something of a playboy. He liked to have a good time, didn't want to be too tied down with rules and responsibilities. He smoked, he drank, he kept irregular hours. But here he was, his eyes alight, talking about carrying people to safety, how his arrival at any given house or overpass was met with cheers and thanks. A time like this could change a man, Zeitoun knew, and he was happy to see it happening here and now to Todd: a good man made better.

That night Nasser came back with Zeitoun to the house on Dart. They removed the last of the lamb from the freezer and barbecued on the roof, recounting what they had seen and what they had heard. But Nasser was exhausted, and faded quickly. He crawled into the tent and was soon fast asleep.

Again Zeitoun was restless. He was still angry about the pastor and his wife. Nothing upset him more than someone breaking a promise. Who had that man been, at Napoleon and St. Charles, who had said he would send help to the Williams couple? Why had he said he would

come if he did not plan to come? Zeitoun tried to be generous. Perhaps he had been pulled away to another emergency. Perhaps the man had gotten lost along the way. But it was no use. There was no excuse that could suffice. The man had abrogated a simple agreement. He had promised help and he had not kept that promise.

Unable to sleep, Zeitoun went back inside and sat on the floor of Nademah's room. Her smell, the smell of his girls, was faint now, replaced by rain and the beginnings of mildew. He missed them already. He could not think of more than a few times when he had been apart from them this long. It was always like this: the first day alone afforded a welcome sense of calm and quiet, but slowly the missing would begin. He would miss their voices, their bright dark eyes, the rumble of their feet up and down the stairs, their squeals and constant singing.

He opened one of the photo albums he'd saved and lay down on Nademah's bed, smelling her strawberry shampoo on the pillowcase. He found a picture from his first year at sea, aboard a ship captained by Ahmad. He marveled at his hair, so much of it then, and such vanity. He was about thirty pounds lighter then, a constant grin on his face, a man tasting the full feast of youth. His brother Ahmad had saved him, had opened to him worlds upon worlds.

Ahmad left home a year after their father's death, traveling to Turkey to study medicine. This was the presumption in the house, at least. Though Mahmoud had forbidden his sons from pursuing a life on the sea, Ahmad wanted nothing else. So he took a bus to Istanbul, telling his mother that his intention was to become a doctor. And for a while he did study medicine. But soon Ahmad left college and enrolled in a naval officer's training academy. When his mother learned Ahmad was

1978 New Orleans USA

1978 Greek Pascua , Altamar , M/V Glyfada Spirit

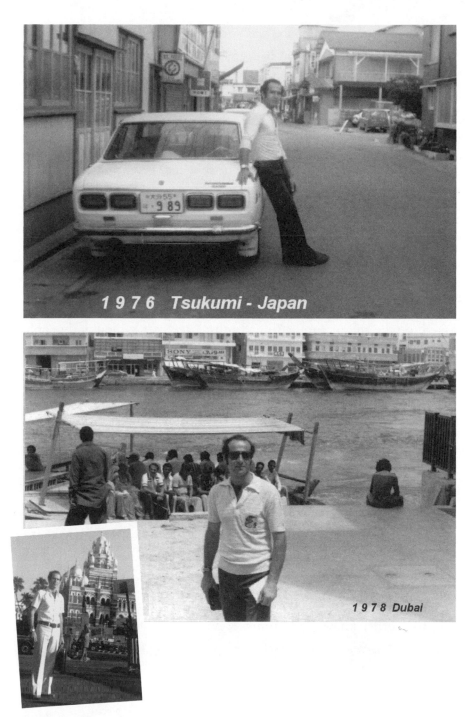

1 9 7 6 *Tsukumi - Japan*

1 9 7 8 *Dubai*

to become a ship captain, she was surprised, but did not stand in his way. Two years later, Ahmad had graduated and was crisscrossing the Mediterranean and the Black Sea.

Zeitoun found one of Ahmad's photos. He had more pictures of Ahmad than he did of himself — it was almost comical how many photos his brother took and kept and distributed to family members. He documented every port, every ship. In this one, he and his crew were grilling something, some kind of animal. Zeitoun stared at it. It looked like a greyhound. *Could it be?* No. Zeitoun hoped it was not a dog. The banner above the men said EASTER 1978. In another picture, Ahmad was standing in the middle of downtown New Orleans. When he saw this photo, and so many others of Ahmad standing in front of this city or that monument, Zeitoun always thought of the people Ahmad had asked to take the pictures. Ahmad must have met a thousand people during these trips, chiefly in the pursuit of someone to help him document that *Ahmad Zeitoun, of Jableh, Syria, was here.* Here in Tokyo. Here in America. Here in India.

While Ahmad was seeing every corner of the world in rapid succession, Zeitoun was back home in Jableh, and he wanted out. It was a hollow home, and Zeitoun couldn't stand it. During the days he worked at his brother Lutfi's construction-materials store, hearing the stories of Ahmad's continuing adventures, his trips to China, Australia, South Africa, Holland. Zeitoun knew his father would not have approved when he was alive, but he was gone now, and Mohammed was gone, too. Zeitoun did not want to be stuck in Jableh.

His mother knew his feelings. She had heard him pace back and forth on the second floor, had seen his eyes' longing look when he talked to Ahmad on the phone. So on her own accord, she called Ahmad one

day and asked him to take his younger brother with him. It was time, she said, for Abdulrahman to leave Jableh and get away, if only for a spell, from their home so full of melancholy.

Ahmad called his younger brother and told him he'd be shipping out in a few weeks' time. Zeitoun was speechless. He kissed the phone. He kissed his mother and sisters. And when the time came, he gathered a sackful of things and met Ahmad in Greece.

On his first voyage, he was a deckhand, the youngest man onboard. The other crew members hailed from everywhere — South Africa, Turkey, Nigeria — and welcomed him warmly. Zeitoun was convinced Ahmad was treating him a bit more roughly than the others, to compensate for any suspicions of nepotism, but he didn't mind. He washed and painted and hauled. He did the jobs no one wanted to do.

They sailed from Piraeus to Naxos and back, and Zeitoun was in love with it all. He let his hair grow, he spent his free time on deck, looking out, watching the water come at the ship and disappear behind it. Though the schedule was grueling, four hours on and four off, all day and night, he didn't mind. He didn't need to sleep, not yet.

He had not known until then how badly he had needed this kind of freedom. He felt twice as strong, three times as tall. And finally Zeitoun knew Ahmad's secret, why he had become a sailor, why he had risked so much to become a captain. As they passed on deck or on their way to their different quarters, Zeitoun and Ahmad shared knowing glances, sheepish smiles. Only now did Zeitoun know liberation, and it was everything. Ahmad could see that his younger brother would not be returning to Jableh any time soon.

Their lives were at sea, together and apart, as they passed from their

twenties to their early thirties. There were cargo ships, passenger ships, combinations of both. They brought Nebraskan wheat to Tokyo, Brazilian bananas to London, American scrap metal to India. They brought Romanian cement to Nigeria, and always in Nigeria there were stowaways; every time they left Lagos they could count on finding two or three men hiding, and always they made the same arrangement: earn your keep onboard, and when we reach the next port you're on your own.

Jobs on general cargo ships were prized most; they usually spent a week or two at port, giving the crew plenty of time to investigate the area. Zeitoun explored dozens of cities, always docking with a pocketful of money and no obligations to anyone. He would rent a car, devour the surrounding towns, explore the coast, visit famed mosques, meet women who would beg him to stay.

But he was a serious young man, perhaps too serious at times. It was no secret that seamen liked to play cards and enjoy a drink or two. Zeitoun didn't gamble and had never had a drop of alcohol, so when his own shifts were over, he went back to work, helping whoever needed it. And when there wasn't work to do, while his crewmates got stoned and took each other's money playing cards, he found a different diversion: he would go to the small pool onboard the ship and tie a rope around his waist. He would tie the other end to the wall, and then he would swim — three hours at a stretch, strengthening his arms and back, testing himself. He was always testing himself, seeing how much his body could do.

In the end, Zeitoun spent ten years as a sailor. Aboard a ship called the *Star Castor* he saw the Persian Gulf, Japan, Australia, and Baltimore. Aboard the *Capitan Elias*, he saw Holland and Norway. He saw herds of humpbacks, breaching grey whales, schools of dolphins leading the ships to port. He saw the aurora borealis, meteor showers over tumbling black

waves, night skies so clear the stars seemed within reach, hung from a ceiling by fishing wire. He served on the *Nitsa*, the *Andromeda*, he sailed all the way until 1988, when he landed in Houston and decided to explore inland. That brought him to Baton Rouge, and Baton Rouge brought him to Kathy, and Kathy brought him Zachary and Nademah and Safiya and Aisha.

Zeitoun prayed on the floor in his house, and then lay down on Nademah's bed, wondering where his wife and children were this night, if they had made it to Phoenix yet, thanking God that they were safe, that he was safe, that they would see each other soon.

SATURDAY SEPTEMBER 3

In the morning Zeitoun rose with the sun, prayed, and then checked the freezer. There wasn't much left, and what was left was thawing. It would be rotten by the following day. He figured it had to be eaten immediately, so he removed some hamburger for the dogs and figured he'd barbecue the rest that night. He'd invite Todd and Nasser and anyone else he could find. They'd cook all the meat that remained, and have some grim semblance of a party on his roof.

He paddled across the street to feed the dogs.

"How are you boys today?" he asked the first two.

They whimpered, and ate, and licked his legs. He was amused by how grateful, how surprised, they were every day.

"Have a little faith," he said.

He climbed across the rickety board to the second pair of dogs. They whined as he climbed through the window.

"What're you so worried about?" he asked them. "Every day I come, same time. Don't worry."

Yuko's husband Ahmaad had driven through the night, stopping only once, and they finally arrived in Arizona midday on Saturday. They were both too dazed, too wired to sleep, and that first day at Yuko and Ahmaad's house was full of welcome distraction. Yuko and Ahmaad's five children loved the Zeitoun kids, and they loved their Aunt Kathy, particularly the boys. She was one of them, effortlessly so, and they treated her like a peer. They played video games and watched TV, and Kathy tried not to think about what had become of their home, where Zeitoun might be at that moment.

Zeitoun still feared getting near his office on Dublin — the armed men were likely still nearby — so he and Nasser had no set itinerary this day. They decided to do a thorough check of Uptown, to see if any neighbors were left, if any help was needed.

Paddling south on Octavia Street, Zeitoun noted that with the strength of two, and without rain or wind, they were fast. They sped past homes, over cars, around debris.

Zeitoun had worked on a dozen or so homes on this street, and knew he would return when the waters fell away. With every passing day, the standing water went deeper into the homes, made it less likely anything within would be salvageable.

Nasser saw the helicopter first.

The helicopters were everywhere, but didn't usually hover so low for so long, and rarely in such a densely built neighborhood. Zeitoun could see this one through the trees and over the roofs long before he could

see the water below it. Zeitoun and Nasser paddled toward it to find out what was going on. As they got closer, they saw a dark smudge in the water, a log or piece of debris. They continued paddling, now feeling the wind from the rotors, the ripples radiating outward.

The object in the water looked like a tire, shiny and bulbous—

It was a body. They were sure now. It had turned, and now the head was visible. It was a man of average size, wearing a T-shirt and jeans, half-submerged, face-down.

Zeitoun looked up to the helicopter. Was it a rescue in progress? He looked closer. No. A man was pointing a camera at the body. He did so for a few more minutes and then the helicopter rose, tilted, and drifted off.

Zeitoun and Nasser maintained their distance. Zeitoun knew too many people in this neighborhood. If this was a neighbor or friend, he didn't want to see him this way.

Rattled, they paddled silently to the Claiborne house. Zeitoun had never imagined that the day would come that he might see such a thing, a body floating in filthy water, less than a mile from his home. He could not find a place for the sight in the categories of his mind. The image was from another time, a radically different world. It brought to mind photographs of war, bodies decaying on forgotten battlefields. *Who was that man?* Zeitoun thought. *Could we have saved him?* Zeitoun could only think that perhaps the body had traveled far, that the man had been swept from closer to the lake all the way to Uptown. Nothing else seemed to make sense. He did not want to contemplate the possibility that the man had needed help and had not gotten it.

When Zeitoun tied the canoe to the Claiborne porch, the phone was ringing. He picked it up and found his brother Ahmad.

"I wish you would leave," Ahmad said.

"I'm fine. Safer every day," Zeitoun said. He had no plans to tell Ahmad about the body.

"My kids are worried about you." Ahmad's son Lutfi and daughter Laila had been watching CNN since the storm. They saw the images of devastation and desperation, and could not believe that their uncle was living amid all that.

"Tell them not to worry," Zeitoun said. "And hello from me."

Zeitoun was grateful for his brother's constant concern. The Zeitoun siblings were all close-knit, but no one worried more, and spent more time collecting and updating addresses and phone numbers and photos, than Ahmad. Perhaps it was because he felt disconnected from them, living in Spain, but in any case he liked to know where his siblings were, what they were doing. And he focused on Abdulrahman in particular, so much so that one day, a few years before, Ahmad had called in the middle of the day in New Orleans and made a very strange proposal.

"What are you doing today?" he'd asked.

It was a Saturday, and Zeitoun was about to go to the lake with Kathy and the kids.

"Do you know the corner of Bourbon and St. Peter?"

Zeitoun said he did.

"I have an idea," Ahmad began, and then explained that he had found a website where he could tap into a live webcam at that corner. If Zeitoun went there, Ahmad could watch him, in real time, while sitting at his computer in Spain.

"You up for it?" Ahmad asked.

"Sure," Zeitoun said. "Why not?"

Zeitoun packed the kids up in the van, drove the few miles to the

French Quarter, and looked for the corner of St. Peter and Bourbon. Once there, he searched for the camera. He didn't find it, but figured he should at least stand there for a while. He and the kids stood on every corner, in fact, just in case. And when he got home, he called Ahmad, who was just about leaping through the phone.

"I saw you!" he said. "I saw you all! Next to the hot-dog stand!"

He had watched them for five minutes, grinning the whole time. He had made a screen capture and emailed it.

When he saw it, Zeitoun laughed, amazed. There he was, with all four kids. Nademah was just below the streetlight, Zachary was holding Safiya, and Zeitoun was holding Aisha. Ahmad, technophile and deeply protective brother, was, in very real ways, watching over Zeitoun at all times.

On the roof that night, Zeitoun and Todd and Nasser barbecued

the remaining meat, noting that it was the first time any of them had been at any sort of social event since the storm. The conversation was awkward, and the humor had a dark edge to it. They talked about FEMA, about the Superdome and the Convention Center. They had been hearing isolated reports from the radio and others who had stayed in the city, and they were all relieved they had eschewed shelter there; they had known it would turn out poorly. None among them could live caged like that.

They talked about what the city would look like when the water was gone. There would be trees and trash everywhere — the ground would look like that of a dredged lake. The roads would be impassable for cars and bikes, for almost any kind of vehicle.

"A horse could do it," Zeitoun said. "We'll get some horses. Easy."

Everyone laughed.

As the sky blackened, Zeitoun saw an orange light through the trees, less than a mile away. Soon all three men were watching the light grow, the flames twisting higher. Zeitoun was sure it had engulfed two or three buildings at least. Then he looked closer, realizing that the fire was very close to—

"My office," he said.

There was paint there, hundreds of gallons. Paint thinner, lumber. So many toxic and flammable things.

"We have to go," he said.

Zeitoun and Todd climbed down the side of the house and into Todd's motorboat. They sped toward the fire until they could see the flames blooming white and orange between buildings and over treetops. When they got close, they saw that the fire encompassed an entire block. There were five houses alight, the flames grasping for a sixth. They had

no tools to stanch a fire, and no plan at all for what they might do to put out a chemical inferno.

Zeitoun's office was unharmed, but it was no more than twenty feet from the fire. They tested the winds. It was a still night, with heavy humidity. There was no predicting where the fire would go, but it was certain that nothing could stop its course. There was a fire station four blocks away, but it was empty and flooded; there were no firefighters in sight. And with the phones down, with 911 inoperative, there was virtually no way to alert anyone. They could only watch.

Zeitoun and Todd sat in their boat, the heat of the fire pulsing at them. The smell was musky, acrid, and the flames swallowed the homes with remarkable speed. One was an old Victorian Zeitoun had always admired, and a few doors down was a house he had considered buying when it had been on the market a few years earlier. Both homes were devoured in minute. The pieces disappeared into the dark water, leaving nothing.

The wind was picking up, blowing away from Zeitoun's office. If there had been any gust in the other direction, his building would have succumbed, too. He thanked God for this small mercy.

As they watched, they glimpsed a few other watchers, faces orange and silent. Other than the crackle of the fire and the occasional collapsing wall or floor, the night was quiet. There were no sirens, no authorities of any kind. Just a block of homes burning and sinking into the obsidian sea that had swallowed the city.

Coming back to the house on Dart, Zeitoun and Todd were quiet. The stars were out. Todd steered the boat like he was captaining a great yacht. He dropped Zeitoun at his house, and they said good night. Back on the roof, Nasser was already asleep in the tent.

Zeitoun stood there, watching the fire ebb and flow. The flood, and now the fire: it was difficult not to think of passages in the Qur'an that recounted the flood of Noah, the evidence of God's wrath. And yet despite the devastation visited upon New Orleans, there was still a kind of order to the night. Zeitoun was safe on his roof, the city was silent and still, the stars were in their place.

He had been on a tanker once, maybe twenty years earlier, navigating through the Philippines. It was late, after midnight, and Zeitoun was keeping the captain company on the bridge.

To stay awake and alert, the captain, a Greek man of middle age, liked to take up provocative subjects. He knew that Zeitoun was a Muslim and a thoughtful man, so he sparked a debate about the existence of God. The captain began by expressing his utter conviction that there was no God, no deity in the sky watching over the human world.

Zeitoun had been on the bridge with the captain for an hour at that point, watching him pilot the ship through the many islands, avoiding high shelves and sandbars, other ships and countless unseen dangers. The Philippines, with over seven thousand islands but only five hundred lighthouses, was known for its frequency of maritime accidents.

"What would happen," Zeitoun asked the captain, "if you and I went below the deck, and just went to our bedrooms and went to sleep?"

The captain gave him a quizzical look and answered that the ship would most certainly hit something — would run aground or into a reef. In any event, disaster.

"So without a captain, the ship cannot navigate."

"Yes," the captain said, "What's your point?"

Zeitoun smiled. "Look above you, at the stars and moon. How do the stars keep their place in the sky, how does the moon rotate around the

earth, the earth around the sun? Who's navigating?"

The captain smiled at Zeitoun. He'd been led into a trap.

"Without someone guiding us," Zeitoun finished, "wouldn't the stars and moon fall to earth, wouldn't the oceans overrun the land? Any vessel, any carrier of humans, needs a captain, yes?"

The captain was taken with the beauty of the metaphor, and let his silence imply surrender.

On his roof, Zeitoun crawled into his tent, trying not to wake Nasser. He turned his back to the fire and slept fitfully, thinking of fires and floods and the power of God.

SUNDAY SEPTEMBER 4

In the morning Zeitoun rose early, climbed down to his canoe, and paddled across the street to feed the dogs. He climbed up the tree, crawled through the windows, and fed them all the last of the meat.

"Like barbecue?" he asked.

They did.

"See you tomorrow," he said, making a mental note to get some dog food from Todd.

He picked up Nasser, dropped him at the house on Claiborne, and went on alone. He wasn't sure where he would go today, so he chose a new route, this time going back to Dart, then east on Earhart, heading to Jefferson Davis Parkway.

This day was quieter than the few before it. There were no helicopters, no military boats. He was seeing far fewer people wading through the water, now green-grey and streaked everywhere with oil.

It smelled dirtier every day, a wretched mélange of fish and mud and chemicals.

As he approached the junction of Earhart, Jefferson Davis, and Washington, the land rose up a bit, and he could see dry grass, a wide intersection with a large green and brown patch in the middle. And on the grass there was an astonishing sight, especially given what he and his guests had been talking about the night before. There were three horses, chewing happily. They were free, with no riders or saddles. The scene was at once idyllic and hallucinatory. He paddled closer. One of the horses lifted its head, noticing Zeitoun. It was a beautiful animal, white and perfectly groomed. Seeing Zeitoun as no threat, the horse returned to its meal. The other two, one black and one grey, continued to eat. How they had gotten there was beyond Zeitoun's imagination, but they seemed ethereally content, luxuriating in their freedom.

Zeitoun watched them for a few minutes, then traveled on.

Zeitoun paddled down Jefferson Davis. He carried his canoe across the bridge over I-10 and continued on, reaching the residential stretch of the road. Near the corner of Banks Street, he heard a female voice.

"Hey there."

He looked up to see a woman on the second-floor balcony of a home. He slowed down and paddled toward her.

"Give me a ride?" she asked.

The woman wore a shimmering blue blouse. Zeitoun told her he would be happy to help, and he steered the canoe to her steps. As she descended from the balcony, Zeitoun noticed her short skirt and high heels, her heavily made-up face, her small glittering purse. And finally he realized what might have been obvious to many: she was a prostitute. He

didn't know what he thought about paddling around in his canoe with a prostitute aboard, but he didn't have time to turn her away now.

She was about to step into the canoe when Zeitoun stopped her.

"Can you take off the shoes?" he asked.

He was afraid the high heels might puncture the boat's thin aluminum. She complied. She was going to Canal, she said. Could he drop her off there? Zeitoun said he would.

She sat in front of him, her hands on either side of the canoe. Feeling like a gondolier, Zeitoun paddled steadily and said nothing. He wondered if there was, only a few days after the hurricane, already a market for her services. Could she have been working in the home where he picked her up?

"Where you going?" he asked, unable to quell his curiosity.

"To work," she said.

At the corner of Jefferson Davis and Canal, she pointed to the First United Methodist Church.

"Drop me here," she said.

He paddled to the pink brick building, where the water met the church's higher steps, and she lifted herself out.

"Thank you, honey," she said.

He nodded and paddled on.

Zeitoun came to the I-10/Claiborne overpass again, and even from a distance he could see that the people who he had seen awaiting rescue there a few days ago had been taken away. The cars remained, as did piles of garbage and human waste. As he floated closer, something caught his attention: a patch of fur. In a moment he was close enough to see that it was a dog, lying on its side. He remembered that when he was last here, there had been a half-dozen small dogs, most of them

puppies, taking shelter in the shade of the cars. As his canoe tapped against the overpass, he could see that there were ten or more animals, the same ones he'd seen before and a few others, in various positions on the road. He anchored his canoe to the overpass and climbed up onto the pavement. He gagged at the sight. They were dead. The dogs had been killed, each of them shot in the head. Some had been shot repeatedly — head, torso, legs.

He paddled quickly back to the house on Claiborne, shaken. He called Kathy. He wanted to hear her voice.

"I saw the most terrible thing," he said. He told her about the dogs. He couldn't understand it.

"I'm so sorry," she said.

"I don't know who would do this."

"I don't know either, honey."

"Why kill them all?"

They tried to make sense of it. Even if they were euthanizing the animals, it didn't add up. There were so many boats in the city. It would only take a moment to take them aboard and set them loose anywhere. But perhaps something had changed irrevocably. That this was considered a sane or even humane option signaled that all reason had left this place.

"How're the kids?" he asked.

"Fine," she said. "They miss you."

"Tomorrow you'll put the kids in school?" he asked.

"I'll try," she said.

He tried to understand, but he was frustrated. The kids needed to be in school. But he was in no mood to argue.

They talked about what he planned to do that afternoon. There was

both more and less to see each day. There were fewer people left in the city, even downtown, and yet the horses, the prostitute, the dogs — it was growing ever more apocalyptic and surreal. He thought maybe he would relax this day. Think about it all.

"You should," she said. Any time he stayed home she felt more sure of his safety. "Stay at home today."

He decided he would.

He tried to, at least. He lay there on Nademah's bed, trying to relax. But he couldn't stop thinking about the dogs. Who could shoot a dog? All those animals, needing, trusting. He tried, as always, to give the benefit of the doubt to whoever had done it. But if they could find their way to the dogs with guns and bullets, wouldn't it be just as easy to feed them?

He got out of bed and looked for his Qur'an. There was a passage he'd been thinking about, *al-Haqqah*, "The Reality." He took the book from Nademah's shelf and found the page. It was as he remembered it.

In the name of God,
The Merciful, The Compassionate,
The Reality!
What is The Reality?
What would cause you to recognize
what The Reality is?
Thamud and Ad denied
the Day of Disaster.
Then as for Thamud,
they were caused to perish
by a storm of thunder and lightning.

As for Ad,
they were caused to perish
by a fierce and roaring, raging wind.
He compelled against them
for seven uninterrupted nights and eight days
so you would have seen the people laid prostrate
as if they were the uprooted fallen-down palm trees.
Then see you any ones who endure among them?
Pharaoh and those who came before him,
and the cities overthrown,
were ones of iniquity;
they rebelled against the Messenger
of their Lord,
so He took them with the mounting taking.
When the waters became turbulent,
we carried you in the floating Ark,
that We might make it a Reminder for you,
and attentive ears would hold onto it.

Zeitoun crawled through the window and onto the roof. The sky was muddy, the wind cool. He sat down and watched the city in the distance.

He was struck by the possibility that those who had killed the dogs might not have been law-enforcement officers at all. Perhaps Kathy was right, and armed gangs were free in the city, shooting whatever they chose to.

He pondered his own possibilities for self-defense. What would he do if men came here, to him? He had seen no robberies in his neighborhood thus far. But what if they came here?

As the night darkened, Zeitoun wished he was not alone. He

thought of returning to the other house, to talk to Todd and Nasser about what he'd seen.

But instead, he sat on his roof, pushing away thoughts of the dogs on the overpass. Perhaps he was weak in this way. He had always been soft when it came to animals. As a child, he had kept many. He'd caught lizards and crabs. He'd even kept a stray donkey in the back alley for a few days, wanting it to be his, to take care of it. His father scolded him for that, and for the pigeon-grooming operation he'd run with his brother Ahmad. It was Ahmad's idea, really — another scheme into which he had enticed his little brother.

"Want to see something?" Ahmad had said one day. Ahmad was sixteen, and Abdulrahman would follow him anywhere.

After swearing Abdulrahman to secrecy, Ahmad brought him up to the roof and showed him a cage he had built from scrap wood and chicken wire. Inside was a nest of straw and newsprint, and inside the nest was a bird — something, Abdulrahman thought, between a pigeon and a dove. Ahmad planned to keep dozens like this one on the roof, to feed and care for them, to try to train them to deliver messages. Ahmad asked if Abdulrahman wanted to help. Abdulrahman did indeed, and they agreed to care for the birds together. Abdulrahman, being younger, would clean the cages when necessary, and Ahmad, being older and more experienced in these matters, would find new birds, feed those who lived there, and train them when the time came.

And so they spent hours there, watching the birds come and go, feeding them from their palms, exulting in the familiarity that allowed the birds to land on their arms and shoulders.

Soon there were thirty or more birds living on their roof. Ahmad and Abdulrahman built more homes for them, until they had assembled

a complex that looked not unlike the stone and adobe structures in their neighborhood, homes stacked upon each other, rising up from the ocean, interlocking like a crude mosaic, extending inland.

All was good until their father Mahmoud discovered their hobby. He considered the keeping of birds a terrible and unsanitary waste of time. Since Mohammed's death, Mahmoud had been impatient, irritable, and so the kids had tried to find diversions outside their grieving home. This hobby, Mahmoud insisted, was taking them away from their schoolwork, and if they forsook their education for pigeons, he would be stuck with not only the birds but two illiterate sons.

He demanded that they free the birds and dismantle the cages. The boys were despondent, and argued their case to their mother. She deferred to her husband, and he was unbending. Abdulrahman and Ahmad refused to do it themselves, so one day, as the boys were leaving for school, Mahmoud said he would do it himself while they were gone.

The boys returned that afternoon and ran straight to the roof to see what had been done. They found the birds still there, their homes untouched. Amazed, they ran down to the kitchen, where they found their mother beaming. Apparently when Mahmoud had gone up to the roof, the birds had flocked to him, alighting on his shoulders and arms, and he was so charmed that he couldn't send them away. He allowed the birds to stay.

Mahmoud died a few years later. The cause was heart disease, but the talk in Jableh was that it was simple heartache. He had never gotten over the death of his golden son, the glory of the family and all of Syria, Mohammed.

Zeitoun assumed Nasser was staying at the other house. If he wanted

to be here, he could. Todd had a boat. So Zeitoun settled into the tent and went to sleep alone.

MONDAY SEPTEMBER 5

In the morning Zeitoun rose early, said his prayers, and paddled across the street to feed the dogs. He'd gotten a bag of dog food from Todd.

"No more steak, guys," he said. "I'm out."

They didn't seem to mind. They devoured what he poured. They seemed to be doing well now, and were no longer in the same state of shock as a few days before.

"See? I come every day," he said. "I always come."

He climbed down from the roof and paddled away.

He went by the Claiborne house and found Todd and Nasser on the porch, eating breakfast. He went inside and called Kathy.

"The cops are killing themselves," she said.

Two different officers, overcome by the storm and its aftermath, had taken their own lives. Sergeant Paul Accardo, a prominent spokesman for the department, was found in nearby Luling, in his squad car; he'd shot himself. Officer Lawrence Celestine had committed suicide on Friday, in front of another police officer.

This hit Zeitoun hard. He'd always had good relations with the police in the city. He knew the face of Sergeant Accardo well; the man was frequently on television, and projected an air of reason and calm.

Kathy mentioned the roving gangs, the toxic chemicals, the diseases that were being unearthed and spread. She was trying, again, to convince her husband to leave.

"I'll call you later," he said.

Rob, Walt's husband, called Kathy to check on the Zeitouns, to see where they were staying and if they needed any help. When Kathy told him that Zeitoun was still in New Orleans, Rob was incredulous.

"What's he doing there?" he asked.

"Oh, he's got his little canoe," Kathy said. "He's paddling around the city." She tried to sound nonchalant.

"He's got to get out," Rob said.

"I know," Kathy said. "That's what I tell him every day."

As they talked, Rob mentioned that he and Walt had left their cat when they fled the storm. They had tried to find her before they left, but she was an outdoor cat, given to roaming, and hadn't been in or near the house. Now he was hoping that if Zeitoun found himself in their neighborhood, he could look for any sign of her. If Zeitoun happened to make it over there, there was a generator in the garage that he was welcome to if he needed it.

She called the house on Claiborne. Zeitoun was still there, about to leave. Kathy told him about Rob's hope that he could check on the house. It was a good three miles away, and would require a portage over the highway, but Zeitoun was happy to have a clear-cut task. Kathy mentioned the possibility of the generator, but Zeitoun dismissed it. He preferred not to travel with any possessions at all. Besides being doubtful he'd be able to get the generator into the canoe, he was wary of picking up anything of value. He knew the police were looking for looters.

He and Nasser made their way to Walt and Rob's house. The day was warm and white. They decided to check on Nasser's house along the

way, so they went up Fontainebleau to Napoleon. Nasser's house was at the corner of Napoleon and Galvez, and he wanted to see if anything could be salvaged.

When they got there, the water had reached the eaves of the roof. There was no way to get into the house, and nothing inside would be worth it. Nasser had prepared himself for this sight, and it was exactly as he'd expected.

"Let's go," he said.

They took Jefferson Davis Parkway to Walt and Rob's. The water at the house was far lower, only about eighteen inches. Zeitoun got out of the canoe and walked up to the front door. The house would be fine. But he saw no sign of the cat. He considered jumping the fence to get to the backyard, but it was this kind of suspicious activity that police and neighbors would be looking for.

They turned the canoe around and left. On the way home, they passed the post office at Jefferson Davis and Lafitte, the staging ground for helicopter rescues. They saw no helicopters, but there were rescue workers milling in the parking lot.

"You want to go?" Zeitoun asked Nasser.

"Not today," he said.

That night Zeitoun and Nasser prayed together on the roof of the house on Dart and barbecued hamburger meat on the grill. The night was humid and quiet. There was the occasional sound of breaking glass, the growl of a low-flying helicopter. But overall the city seemed to have reached a new equilibrium. Zeitoun fell asleep missing Kathy and the children, wondering if it was time to leave.

In the morning, after his prayers, Zeitoun made his way to the dogs across the street and fed them more of the dog food Todd had acquired for his rescued pet. When he paddled back to the house to pick up Nasser, he noticed Nasser was carrying his black duffel bag.

Zeitoun nodded at it. "You're ready to go?"

Nasser said he was. He was ready to be evacuated. Zeitoun would be sad to see him go, but he was happy to know that his friend would be safe, and that, even better, Zeitoun would no longer have to share his tent. Nasser got in the canoe and they were off.

They made their way to the post-office parking lot. They had passed it together a half-dozen times, and always Zeitoun had asked Nasser if he was prepared to leave, but he had not been ready, not until now.

"There's your ride," Zeitoun said, pointing to an orange helicopter in the distance, resting on the ground.

They paddled closer and realized there was something strange about the helicopter. It was resting on its side.

"Oh no," Nasser said.

Its rotor was broken, the grass blackened all around it.

"It crashed," Zeitoun said, awed.

"It crashed," Nasser repeated, in a whisper.

They coasted toward it. There was no one near it, no sign that anyone had been hurt. There was no smoke, no rescue crew. The crash must have been the day before. All there was now was a mound of orange steel. Nasser would not fly out this day.

They returned to the Claiborne house, dazed. Zeitoun called Kathy.

He couldn't decide if he should tell her about the helicopter. He knew it would upset her, so he chose not to.

"You put the kids in school yet?"

Kathy said she was trying, but it wasn't easy.

Zeitoun exhaled loudly.

"You're like the man who lost his camel and is looking for the rope," she said. It was one of his favorite expressions, and she relished using it against him. He would often say it when he felt Kathy was focusing on irrelevant details while ignoring the crux of a problem.

He wasn't amused.

"C'mon honey," she said.

School wasn't the first thing on Kathy's mind. She had been determined, the night before and all morning, to convince her husband to leave the city. Mayor Nagin had ordered a forced evacuation of everyone remaining.

"A forced evacuation," she repeated.

Officials were concerned about the spread of E. coli, the risk of typhoid fever, cholera, dysentery. Unsanitary conditions would threaten the health of anyone still in the area.

"I'm not drinking the water," he said.

"What about the toxic waste?" she asked. "You know the crap buried underground there." She reminded him that parts of the city had been built on landfills containing arsenic, lead, mercury, barium, and other carcinogens. "What if that stuff leaches through?"

Zeitoun didn't know what to say.

"I'll be careful," he said.

What he didn't say was that he was considering leaving. Everything was becoming more difficult, and there was less for him to do. Fewer people were left in the city, and fewer still needed help. There was only

the matter of his properties, looking after them, and of course the dogs. Who would feed the dogs, if not him? For now, he told her it would be fine, that he would be careful. That he loved her and would call her in a few hours.

He set out alone for a while and before long, at the corner of Canal and Scott, he encountered a small boat. It was a military craft, with three men aboard: a soldier, a man with a video camera, and one holding a microphone and a notebook. They waved Zeitoun down and one of the men identified himself as a reporter.

"What are you doing?" the reporter asked.

"Just checking on friends' houses. Trying to help," Zeitoun said.

"Who are you working with?" the reporter asked.

"Anybody," Zeitoun said. "I work with anybody."

As he paddled back to Claiborne, a hope flickered within Zeitoun that his siblings might see him on TV. Perhaps they would see what he was doing, that he had done something good by staying in his adopted city. The Zeitouns were proud, and there was plenty of sibling rivalry that had pushed them all to an array of achievements — all of them measured against the deeds of Mohammed. None of them had ever done something like that, none had achieved on his level. But Zeitoun felt again that perhaps this was his calling, that God had waited to put him here and now to test him in this way. And so he hoped, as silly as it seemed, that his siblings might see him like this, on the water, a sailor again, being useful, serving God.

When Zeitoun got back to 5010 Claiborne, he saw a blue-and-white motorboat tied to the porch.

When he entered the house, there was a man inside, a man he had never seen before.

"Who are you?" Zeitoun asked.

"Who are *you*?" the man asked.

"This is my house," Zeitoun said.

The man apologized. He introduced himself. His name was Ronnie, and he'd passed by the house one day, looking for a place that might have a working phone. He'd seen the phone box above the waterline and walked into the house. Since then, he'd been coming in periodically to make calls to his brother, a helicopter pilot. Ronnie was white, about thirty-five, six feet, two hundred pounds. He told Zeitoun that he worked for a tree company.

Zeitoun couldn't think of a good reason to ask Ronnie to leave. Zeitoun was happy to see anyone alive and well in the city, so he left Ronnie in the house and went upstairs to see if the water worked. He found Nasser on the second floor.

"You meet this man Ronnie?" Zeitoun asked.

Nasser had, and had found him to be agreeable enough. They both felt there was a certain strength in numbers, and again, if the man wanted to use the phone occasionally, who were they to prevent him from communicating with the outside world?

Impossibly, the water in the bathroom was still functioning. Zeitoun hadn't even thought to check it sooner. It was a miracle. He told Nasser he was going to take a shower.

"Be quick," Nasser said. "I'm next."

No shower had ever felt better. Zeitoun washed away all the sweat and grime, and what he assumed was a fair amount of oil and raw sewage. Afterward, he came downstairs.

"All yours," he told Nasser.

He picked up the phone and called his brother in Spain. He wanted to check in with him quickly before calling Kathy.

Again Ahmad tried to convince him to leave.

"Do you realize the images we're seeing on TV?" he asked.

Zeitoun assured him that he was far away from that kind of chaos. Not counting the armed man at the Shell station, Zeitoun had seen almost no danger in all the time he had been canoeing around the city.

"Hey," he said, excited, "I might be on TV. Someone just interviewed me. Look for it. Tell Kathy."

Ahmad sighed. "So you won't go."

"Not yet."

Ahmad knew better than to argue. But he did want to remind his brother that even if he felt safe now, danger could come at any time. There were roving gangs of armed men, he said. That's all the media could talk about — that it was the Wild West out there. Ahmad felt powerless, and he hated the feeling. He knew his little brother considered him overly cautious. "Won't you please consider leaving, for the sake of your beautiful family, before something happens?"

Zeitoun was holding the piece of paper with Kathy's Phoenix number on it. He needed to call her before she started worrying. He was already ten minutes late. He was about to get off the phone with Ahmad when he heard Nasser's voice from the porch. He was talking to someone outside.

"Zeitoun!" Nasser called.

"What?" Zeitoun said.

"Come here," Nasser said. "These guys want to know if we need water."

Zeitoun assumed it was more men like himself and Nasser — people with boats who were roaming around, trying to help.

When he put the phone down and looked toward the front porch, he saw a group of men, all of them armed, bursting into the house. Zeitoun hung up the phone and walked toward the door.

III

WEDNESDAY SEPTEMBER 7

Kathy woke up tense. She fed and dressed the kids, trying not to think about the fact that her husband hadn't called the afternoon before. He had promised to call. Yuko told her not to worry. It was silly to worry. It had barely been a day, and even the regular contact Zeitoun had maintained so far was remarkable. Kathy agreed, but she knew she would be anxious until he called again.

After Yuko took her own kids to school, she helped keep Kathy's children occupied while Kathy paced, phone in her hand.

At nine, Ahmad called from Spain.

"You hear from Abdulrahman today?" he asked.

"No. You?"

"Not since yesterday."

"So you talked to him?" she asked.

"I did."

"He called you and not me."

"He was about to call you. But he got off the phone quickly. There was someone at the door."

"Who was it?" Kathy asked. Her stomach dropped.

"I have no idea."

She called the Claiborne house and let it ring a dozen times before hanging up.

Now she was a wreck. *He must call today*, she thought. *I'll kill him if he doesn't call at noon.*

At ten o'clock Phoenix time it was noon in New Orleans. Kathy waited. The phone did not ring at ten, ten-thirty, eleven — one o'clock New Orleans time. By noon in Phoenix she was frantic.

She called the Claiborne house again. No answer.

Yuko tried to put it in context. It was miraculous that the phone line at the Claiborne house was working at all. Chances were that it finally gave way and died. He'll find a way to call, she said. He's in an underwater city, she said. Cut the man some slack.

Kathy was calmer now, but still she paced the living room.

Yuko took the kids to the mall. She didn't want to leave Kathy alone, but the pacing was worrying the kids. Yuko was sure Zeitoun would call while they were gone, so why not let the kids enjoy themselves? The mall had a food court, an arcade for Zach. They planned to be back at three.

Kathy called the Claiborne house again. No answer.

Walt called. "You hear anything from Zeitoun?"

Kathy told him she hadn't.

She called Adnan, Zeitoun's cousin.

"I'm still ashamed," she said. Last they had spoken, Kathy had had

to tell him that her sister would not allow Adnan and Abeer to stay with them. It had been painful.

"Don't worry. We're fine," he said.

He was still in Baton Rouge with Abeer and his parents. After spending two nights in their car, they had returned to the mosque, and had been sleeping on the floor there for the past week.

"How is Abdulrahman?" he asked.

"I haven't heard from him. Have you?"

Adnan had not.

Alone and seeking distraction, Kathy turned on the TV, avoiding the news, finding Oprah Winfrey. Or she thought it was Oprah's show. But soon she realized it was a news report replaying portions of the previous day's show, with New Orleans police chief Eddie Compass and Mayor Nagin as Oprah's guests.

Compass was lamenting the extent of the crime in the Superdome. "We had babies in there. Little babies getting raped," he said, weeping. From Mayor Nagin: "About three days we were basically rationing, fighting, people were — that's why the people, in my opinion, they got to this almost animalistic state, because they didn't have the resources. They were trapped. You get ready to see something that I'm not sure you're ready to see. We have people standing out there that have been in that frickin' Superdome for five days watching dead bodies, watching hooligans killing people, raping people. That's the tragedy. People are trying to give us babies that were dying."

Kathy turned the TV off again, this time for good. She called the house on Claiborne. The phone rang and rang. She paced. She walked outside, into the assaulting Phoenix heat, then went back inside. She called again. The rings began to sound hollow, desolate.

<center>* * *</center>

Four o'clock arrived and he hadn't called.

She called Ahmad in Spain. He hadn't heard from Zeitoun either. He had been calling the Claiborne house all day, to no avail.

In the late afternoon, the kids returned.

"Did Dad call?" Nademah asked.

"Not yet," Kathy said, "still waiting."

She held herself together for a few seconds but then imploded. She excused herself and ran to the guest room. She did not want her girls to see her this way.

Yuko came in and sat on the bed with Kathy. It's been just one day, she said. Just one day in the life of a man in a city with no services. He would call tomorrow. Kathy pulled herself together, and together they prayed. Yuko was right. It was one day. Of course he would call tomorrow.

THURSDAY SEPTEMBER 8

Kathy woke up with a better outlook. Maybe her husband didn't even realize he'd forgotten to call. He was likely saving any number of new people and animals and homes, and in the midst of it all he'd gotten overwhelmed. In any case, Kathy was determined to put on a brave face for the kids. She cooked their breakfast and pretended she was sane and content. She played GameCube with Zachary and killed the morning with diversions.

Periodically she pushed the redial button on Yuko's phone. The

<center>186</center>

phone at Claiborne rang in an infinite loop.

Noon came and went.

Kathy was losing her grip again.

"I need to go to New Orleans," she told Yuko.

"No you don't," Yuko said. She peppered Kathy with logistical questions. How would she get into the city? Did she plan to buy a boat and dodge the authorities and find her husband on her own? Yuko dismissed the notion.

"We don't want to have to worry about you, too."

Ahmad called Kathy. His tone had been neutral the day before, but now he sounded worried. This unnerved Kathy. If Ahmad, made of the same stuff her husband was — and both of them made of the stuff of their father Mahmoud, who could survive two days at sea tethered to a barrel — felt this to be a dire situation, then if anything, Kathy was underreacting.

Ahmad said he would try to contact the TV station that had interviewed Zeitoun. He would contact all the agencies that tracked missing persons in New Orleans. He would contact the Coast Guard. They agreed to call each other as soon they heard something.

Date: Thu, 8 Sep 2005 19:08:04 +0200
To: SATERNKatrinaReliefUpdates@csc.com
Subject: Ref. AMER-6G2TNL

Dear Sires,
Many thanks for your answering.
Kindly please do your best to give us any good news about him.
He's my brother, he leave many years ago in New Orleans:
4649 Dart St. New Orleans

New Orleans, LA

70125-2716

Actually I'm at Spain, but her wife and childrens they left a day before Katrina hit to ARIZONA, his wife: Mrs. Kathy Zeitoun actual contact: 408-[number omitted]

More information:

He remained at home without phone, but he've a small boat and he went daily to: Mr. TODD at:

5010 S. Claiborne Ave 70125-4941 New Orleans

Last calling was on Sept 6 at 14:30 local time, after that till now no calls, no news. The phone which he used is ringing but no answering. Here I including his pictures maybe can help.

Many thanks.

Sincerely,

Ahmad Zeton

In the afternoon, Zeitoun's family began calling from Syria. First it was Fahzia. A secondary-school teacher in Jableh, she spoke fluent English.

"Have you heard from Abdulrahman?"

Kathy told her she had not for two days.

There was a long silence on the line.

"You have not heard from Abdulrahman?"

Kathy explained that the phones were down, that it was likely that her husband was just trying to reach a working phone. This did not sit well with Fahzia.

"Again, please — you have not heard from Abdulrahman?"

Kathy loved the Zeitouns of Syria, but she did not need this extra burden. She excused herself and hung up.

Kathy did not attempt to sit at dinner. She paced the rooms, the phone an extension of her arm. She thought through the possibilities — who she knew and what they could do to help. She didn't know a soul still in the city, she realized. It was paralyzing. It seemed impossible that in 2005, in the United States, there was an entire city cut off from all communication, all contact.

Later, thinking the kids were asleep, she passed one of the bedrooms and heard Aisha talking to one of Yuko's kids.

"Our house is under ten feet of water," Aisha said.

Kathy held her breath at the door.

"And we can't find my dad."

In the bathroom, Kathy covered her face in a towel and bawled. Her body convulsed, but she tried not to make a sound.

FRIDAY SEPTEMBER 9

Kathy had no choice but to lie. She had never told a bald-faced lie to her children before, but now it seemed necessary. Otherwise they would all lose their composure. She planned to enroll them in school on Monday, and to have the strength to be thrown into such a situation they had to believe that their father was healthy and in contact. So at breakfast, when Aisha asked if she had heard from Dad, Kathy did not hesitate.

"Yup, heard from him last night," she said.

"On what phone?" Nademah asked. They hadn't heard a ring.

"Yuko's phone," Kathy said. "I got it on the first ring."

"So he's at the house?" Nademah asked.

Kathy nodded. And as smart and skeptical as her kids were, they believed her. Especially Nademah and Zachary. Whether or not they

sensed the lie, they *wanted* to believe it. Safiya and Aisha were harder to read, but for the time being her kids' fears had been assuaged and now Kathy only had to worry about her own.

Just after breakfast, the phone did ring. Kathy leapt to it.

It was Aisha, another sister of Zeitoun's. She was the director of an elementary school in Jableh, and also spoke English.

"Where is Abdulrahman?" she asked.

"He's in New Orleans," Kathy answered calmly.

Aisha explained that no one had heard from him in days. He had been in touch a few times after the storm, and then nothing. She was calling on behalf of all the siblings, and she was worried.

"He's fine," Kathy said.

"How do you know?" Aisha asked.

Kathy had no answer.

Kathy got online. Immediately she was swamped with horrific news from the city. Officials were reporting the death toll in and around New Orleans at 118. But Mayor Nagin estimated that the final number might climb as high as ten thousand. She checked her email. Her husband had never sent an email in his life, but she couldn't rule it out. She found an email from Zeitoun's brother Ahmad. He had cc'ed her on an email to another aid agency.

> From: CapZeton
> Date: Fri, 9 Sep 2005 22:12:05 +0200
> To: [name omitted]@arcno.org
> Subject: Looking for my brother /Abdulrahman Zeitoun

Dear sires,

Kindly, would you please if it's possible to know from you about the persons which they forced to leave houses from New Orleans last Tue. Sept 6th, where they are now?

I would like to have any news about my brother, which we lost the contact with him from Tue. Sept. 6th after 14:30 hrs, while he was at (5010 S. Claiborne Ave. 70125-4941 New Orleans) using a small boat. Moving to 4649 Dart St. where he stay.

My brother's details:

Name: Abdulrahman Zeitoun

Age: 47 years

Address: 4649 Dart St. - New Orleans, LA 70125-2716

From that time till now we haven't any news about him,

Kindly please do your best to help us.

Thanking you indeed,

Ahmad Zeton

Malaga-Spain

When it was noon in New Orleans Kathy called the Claiborne house. She let the phone ring, willing it to stop, to be interrupted by her husband's voice. She called all day, but the ringing had no end.

Walt and Rob called. Kathy told them she had not heard from Zeitoun, and asked if Walt knew anyone who could help. Walt knew everyone, it seemed, and always had a solution. He said he would call a friend, a U.S. marshal, who he knew was near the city. Maybe he could get inside and get to the house on Claiborne.

As Kathy put the kids to bed that night, she forced herself to present a face of confidence. They asked if their house was underwater, and

Kathy admitted that yes, there was some damage, but that lucky them, their father was a contractor, and that any damage could be quickly fixed.

"And guess what?" she told them. "Now you'll all get new bedroom sets!"

SATURDAY SEPTEMBER 10

Walt called. He had spoken to his friend, the U.S. marshal. The marshal had driven toward the house on Dart Street, but he couldn't get close. The water was still too high.

Walt said he would call a friend he knew who had a helicopter. He hadn't thought it through beyond that — where the helicopter would go or how they would scout for Zeitoun — but he said he would make more calls and call Kathy back soon.

Just as she had the day before, when it was noon in New Orleans she called the Claiborne house. Again the ringing had no end.

Zeitoun's family called.

"Kathy, where's Abdulrahman?" they said. It was Lucy, one of his nieces. All of Zeitoun's nieces and nephews were fluent in English, and were translating for the rest of the family.

"I don't know," Kathy said.

Another cousin got on the phone.

"You need to go find him!" she insisted.

Throughout the morning Zeitoun's sisters and brothers called from Lattakia, from Saudi Arabia. Had Kathy heard from him yet? Why wasn't she in New Orleans looking for him? Hadn't she been watching the TV?

She told them she hadn't, that she couldn't bear it.

They filled her in. There had been looting, rapes, murders. It was chaos, anarchy. They repeated Mayor Nagin's assertion that the city had devolved into an "animalistic state." And in this way she got the media's funhouse picture of the state of the city via her husband's relatives halfway around the world. God knows, she thought, what kind of spin the media was putting on things out there.

Twenty-five thousand body bags have been brought to the area, they noted. How can you live in that country? they asked. You need to move back here. Syria is so much safer, they said.

Kathy couldn't deal with the questions and the pressure. She was overcome, helpless, trembling. She got off the phone as politely as she could.

She went to the bathroom and for the first time in days looked at her face. There were blue rings around her eyes. She removed her hijab and took in a quick breath. Her hair. She had had no more than ten grey hairs before all of this. Now there was a stripe of white hair rising from her forehead, as wide as her hand.

Yuko forbade Kathy to answer the phone when anyone called from Syria. Yuko fielded all the calls, telling them that Kathy was doing everything she could, everything humanly possible.

Yuko and her husband Ahmaad took Kathy and the kids to Veterans Memorial Coliseum, where the Red Cross had set up a shelter and triage unit for New Orleanians. Various missing-persons agencies were collecting information and trying to connect those separated from their families. Kathy brought a photo of Zeitoun and every piece of information she could find.

At the gym, it was a grim scene. There were dozens of people from New Orleans there, looking like they had fled that very day. Injuries were being treated, families sleeping on cots, piles of clothing everywhere. Kathy's girls clung to her.

The Red Cross took down all of Zeitoun's information and scanned the photo Kathy had brought. They were efficient and kind, and told Kathy that thousands of people had been located, that they were scattered all over the country and every story was stranger than the last. They told Kathy not to worry, that each day brought more order to the world.

Kathy left with some renewed hope. Perhaps he had been injured. He could be in a hospital somewhere, heavily sedated. He could have been found somewhere, unconscious and without identification. Now it was just a matter of time before the doctors and nurses looked through the missing-persons database to find him.

But now the kids were confused. Was their father safe or not? The signals were mixed. Kathy had told them he was fine, he was safe, he was in his canoe. But then why report him to the Red Cross? Why the missing-persons files, why the mentions of police and Coast Guard? Kathy tried to shield them from all this but it was impossible. She wasn't strong enough. She felt weak, porous.

When they got home again Kathy called the Claiborne house. The phone rang and rang. Until now she had been telling herself that the phone might have been out of service, but this day she checked with the phone company. If the phone was not working at all, they told her, she would have gotten something like a busy signal, a particular sound to indicate that the lines were down. But the ringing persisted, and the ringing meant that the phone worked, but no one was there to answer it.

* * *

Aisha was taking it the hardest. She seemed to swing between worry and fatalistic resignation. She was irritable. She couldn't concentrate. She withdrew and wept alone.

That night, after the other kids had fallen asleep, Kathy sat behind Aisha on her bed. She took her daughter's thick black hair in her hands and kneaded it with one hand, brushing it with the other. It was something she had done with Nademah to calm her before bed, and Yuko's mom had done the same with Kathy after their baths. It was soothing, meditative for both mother and daughter. In this case Kathy was humming a tune she couldn't even remember the name of, and Aisha was sitting, tense but accepting. Kathy was confident that this would ease her worry, would end with Aisha dropping back into Kathy's lap, contented and sleepy.

"You hear from him?" Aisha asked.

"No, baby, not yet."

"Is he dead?"

"No, baby, he's not dead."

"Did he drown?"

"No."

"Did they find his body?"

"Honey, stop."

But after a half-dozen strokes of her brush, Kathy took in a quick breath. Aisha's hair was coming out in clumps. The brush was full of it.

Aisha's eyes welled. Kathy bawled.

There is nothing worse than this, Kathy thought. *There can be nothing worse than this.*

It had been six days since Kathy had spoken to Zeitoun. She could no longer explain his absence. It didn't make sense. The city was overrun with help. The National Guard was everywhere, and officials were insisting that the city was virtually empty.

She ran the possibilities through her mind again. If he was still there, canoeing around New Orleans, he would have called again from the Claiborne house. If the Claiborne phone no longer worked, by now he would have found another working phone. Or he would have encountered one of the soldiers and asked for help in contacting Kathy. There seemed to be no way that he was in the city and unable to call.

Which meant that he had left the city. He might have been running low on water or food. He might have accepted a ride out of the city from one of the helicopters or rescue boats. But if he had left, and had been brought to a shelter, he would have called immediately.

She knew that bodies had been found floating, unclaimed and uncovered in the water. *He could be dead*, she told herself. *Your husband could be gone.* There had been murders, she knew. She did not truly believe the accounts of untethered mayhem, but she knew that some murders would have occurred. *It could have been a robbery*, she thought. *Someone had come to steal from one of our properties, he had been there, he had fought back—*

He could not have drowned. He could not have fallen victim to any other sort of calamity. She knew her husband too well. She could not picture any accident taking him. He was too smart, too wary, and even if he had had some kind of incident, he was indestructible. He would

have survived, he would have gotten help.

When it was noon in New Orleans Kathy called the Claiborne house. She let it ring, needing to hear her husband's voice, but still the ringing had no end.

She had to think of life insurance. She had to think about how she would support her four children. Would she be able to run the business on her own? Of course not. But some semblance of it? She would have to sell the rental properties. Or maybe the rental properties would be something she could manage on her own. Too many questions. No, she would sell the painting and contracting business and hold on to the rentals. Or she could sell a few of the buildings, bring it down to a number she could manage on her own. Should she stay in New Orleans, or move the family to Baton Rouge? To Phoenix? It would have to be Phoenix.

And how long would anyone wait before assuming the worst? One week? Two weeks, three?

She got online and found another email from Ahmad. This one was sent to the TV station that had broadcast the brief interview with Zeitoun. From his office in Spain, Ahmad had found out which station it had been, and had found the name of one of the producers.

> From: CapZeton
> Date: Sun, 11 Sep 2005 02:01:34 +0200
> To: [name omitted]@wafb.com
> Subject: New Orleans Hurricane-impacted areas
>
> Dear Sires,

As I informed from some friends in Baton Rouge, that you have on Sept. 5th a meeting with my brother:

Name Abdulrahman Zeitoun, 47 years old, at New Orleans effected zone 4649 Dart St. LA 70125-2716 where he stay, our friend saw him on your TV WAFB CH9 on Sept. 6th.

From that time till this moment we lost the contact with him. Kindly would you please can you give me any information about the day and time when you met him? Or if you have any other information?

Thanking you indeed,

Ahmad Zeton

Malaga-Spain

Kathy found a website with current photos of New Orleans from the air. She searched until she found Uptown, and zoomed in until she saw what was left of her home and neighborhood. The water was filthier than she could have imagined. It looked like the entire city was bathing in oil and tar.

She called every number of every person she knew who might still be in New Orleans. Nothing.

Yuko and Ahmaad consoled her.

"He's old school," Ahmaad said. It was normal for a man like Zeitoun, rugged and independent, to be out of contact for a few days. "They don't make guys like that anymore."

Yuko kept Kathy away from the phones and the news. Still, Kathy caught snippets in the car. In the Odyssey, she heard President Bush's weekly radio address. The president compared the storm to 9/11 and the War on Terror. "America is confronting another disaster that has

caused destruction and loss of life," he said. "America will overcome this ordeal, and we will be stronger for it."

MONDAY SEPTEMBER 12

It was time for the girls to start school. They had been out for almost two weeks now, and no matter how awkward it might be to start classes in the middle of September, they needed some semblance of routine.

Kathy made the calls. The closest public school was Dr. Howard K.

Conley Elementary School. "Bring them right away," Kathy was told. Zach, as a high schooler, would have a more difficult entry.

The girls were nervous. They were not happy to be brought to a new school, where they knew no one and where they would be branded as refugees. Why couldn't they just wait until they returned to New Orleans? What would they study? The books and lesson plans would be different. What was the point? The point, Kathy said, was that their father wanted them in school, and that was enough.

Yuko and Ahmaad bought the girls a new set of school supplies, binders and notebooks and pens and pencils, and Pokémon and Hello Kitty backpacks to carry all of it. This gave the girls some measure of comfort, but when Kathy dropped them off, leaving them all in the office of the Conley principal, she was devastated. She couldn't look at Aisha. Everything was in that girl's wet black eyes, every worry Kathy shared — that these were the first days of their new life together, living in Phoenix, living without their father.

Driving away from the school, Kathy caught the news on the radio. The official death toll in New Orleans was now 279. It seemed to be leaping by a hundred a day, and the search for bodies had only just begun.

Did she have to prepare for a funeral? It had been seven days now. How long could she explain away his absence? President Bush had come to New Orleans two or three times at that point. If the president could make his way to Jackson Square for a press conference, her husband, if alive, could find a phone and call out.

TUESDAY SEPTEMBER 13

With the kids at school during the day, Kathy spiraled downward. She

had more time to herself and more time to worry, more time to plan a wretched new life.

She called the house on Claiborne every hour. She called Zeitoun's cell phone in case he had found some place to charge it.

The death toll jumped to 423.

She found Todd Gambino's girlfriend's number and called her. She was in Mississippi, and hadn't heard from Todd in a week. This meant something. Perhaps something had happened to both of them? This was good news. It had to be. The two women agreed to stay in touch.

From Spain, Ahmad called Kathy every day. He called the Coast Guard and the Navy. He wrote to the Syrian Embassy in Washington. Nothing from anyone. He looked into flights to New Orleans. What could it hurt to have him searching for his brother on the ground? He worried that his siblings expected him to go, given that he was the only one who might have any chance at all of entering the United States; getting a visa from Syria was hopeless. His wife ruled out the notion, but still, the idea burrowed into him.

WEDNESDAY SEPTEMBER 14

The death toll was at 648 and climbing.

Kathy checked in with the Red Cross every day. She soon had Zeitoun registered at half a dozen agencies dealing with missing persons. His photo was everywhere.

*　　*　　*

The girls went to school, came home, watched TV. They found momentary distraction with Yuko and Ahmaad's kids, but their eyes were hollow. They too were planning lives without their father. Did they want to move to Phoenix? Would there be a funeral? When would they know what had happened?

In the countless hours of darkening thoughts, Kathy imagined again where she would live. Could she live in Arizona? She would have to find a house near Yuko's. Ahmaad would have to be a father figure. Kathy had already leaned so heavily on Yuko and Ahmaad, she couldn't imagine permanently thrusting her entire family onto them.

She thought of Zeitoun's family in Syria. There was such a support network there, a vast and tight fabric of family. She and Zeitoun had brought the kids there in 2003 for two weeks to visit, and it had been unlike anything she'd expected. First there was the snow. Snow in Damascus! They'd taken a bus north to Jableh, and all along she'd been shocked at what she saw. She'd had, she later admitted, an antique idea of Syria. She'd pictured deserts, donkeys, and carts — not so many busy, cosmopolitan cities, not so many Mercedes and BMW dealerships lining the highway heading north, not so many women in tight clothes and uncovered hair. But there were vestiges of a less modern life, too — merchants selling sardines and cabbage by the roadside, crude homes of brick and mud. As they drove north to Jableh, the road soon met the coastline, and they traveled along a beautiful seaside stretch, hills cascading to the sea, mosques perched above the road, side by side with churches, dozens of them. She'd assumed Syria was entirely Muslim, but she was wrong about this, and about so many things. She loved

being surprised, coming to realize that in many ways Syria was a quintessentially Mediterranean country, connected to the sea and in love with food and new ideas and reflecting the influence of Greece, Italy, so many cultures. Kathy devoured it all — the fresh vegetables and fish, the yogurts, the lamb! The lamb was the best she'd had anywhere, and she ate it whenever she had the opportunity. In beautiful seaside Jableh she'd seen the homes that Zeitoun's grandfather had built, saw the monument to his brother Mohammed. They stayed with Kousay, Abdulrahman's wonderfully life-loving and gregarious brother, who still lived in their childhood home. It was a gorgeous old place on the water, with high ceilings and windows always open to the sea breezes. There was family everywhere within walking distance, so many cousins, so much history. While Zeitoun darted around town, reconnecting with old friends, Kathy had spent an afternoon cooking with Zeitoun's sister Fahzia, and she'd done something wrong with the propane and almost burned down the kitchen. It was terrifying at the time but made for much hilarity in the coming days. They were such good people, her husband's family, everyone so well educated, so open and hospitable, each of their houses full of constant laughter. Would it be impossible to think that Kathy could take the kids and live there, in Jableh? It was a radical idea, but one that would put her in a place of such comfort, embraced by family; the girls would be surrounded by so many relatives that perhaps they wouldn't be quite so devastated at the loss of their dad.

Zeitoun's family in Syria became increasingly despondent and resigned to the loss of Abdulrahman. There were so many bodies being found. Almost seven hundred in New Orleans. Their brother was surely one of them; to believe otherwise was folly. Now they just wanted the

peace of mind of knowing how he had died. They wanted his body. To cleanse it, to bury him.

SATURDAY SEPTEMBER 17

Yuko had forbidden her to watch TV or get on the internet, but Kathy couldn't resist. She searched for her husband's name. She searched for their address, their company. She searched for any sign that her husband had been found.

She found nothing about him, but found other, terrible things. All over the web she found news of the violence and evidence of its over-statement. One page would report hundreds of murders, crocodiles in the water, gangs of men rampaging. Another page would report that no babies had been raped. That there had been no murders in the Super-dome, no deaths in the Convention Center. There was no end to the fear and confusion, the racist assumptions and the rumor-mongering.

No one debated that the city was in chaos, but now there was debate over where that chaos had originated. Was it the residents or was it those sent to bring order? Kathy's mind spun as she read about the unprece-dented concentration of armed men and women in the city.

First she read about the mercenaries. Immediately after the storm, wealthy businesses and individuals had called in private-security firms from all over the world. At least five different organizations had sent soldiers-for-hire into the city, including Israeli mercenaries from a firm called Instinctive Shooting International. Kathy took in a quick breath. Israeli commandos in New Orleans? That was it, she realized. Her hus-band was an Arab, and there were Israeli paramilitaries on the ground in the city. She leapt to conclusions.

And the Blackwater soldiers. Blackwater USA, a private-security

firm that employed former soldiers from the U.S. and elsewhere, had sent hundreds of personnel to the region. They were there in an official capacity, hired by the Department of Homeland Security to help maintain order. They arrived in full battle dress. Some carried badges as deputies of the Louisiana State Police.

Kathy became obsessed with all the guns. Her brother had been in the National Guard, and she knew how they were armed. She started doing the math. If all the Blackwater mercenaries were carrying at least two guns each, that would mean hundreds of 9mm Heckler and Koch sidearms, hundreds of M-16 rifles and M-4 machine guns.

She felt as if she had stumbled upon the answer to her husband's disappearance. Nothing else made sense. This seemed the most logical thing. One of these mercenaries, responsible to no one, had shot Zeitoun. Now they were covering it up. This is why she had heard nothing. The whole thing would be covered up.

But there were also so many American troops. Surely they had things under control. As well as she could surmise, there were at least twenty thousand National Guard troops in New Orleans, with more arriving every day. But then she thought of the guns again. If each one of those soldiers had at least one M-16 assault rifle, there were about twenty thousand automatic rifles in the city. Too many. And if Governor Blanco was right, that these were vets coming straight from Afghanistan and Iraq, it could not bode well for her husband.

She searched more websites, went deeper. There were 5,750 Army soldiers in the New Orleans area. Almost a thousand state police officers, many of them there with SWAT teams, armed for urban combat. Four

hundred Customs and Border Protection agents and officers deputized for local law enforcement. This included more than one hundred men from Border Patrol Tactical Units — men usually armed with grenade launchers, shotguns, battering rams and assault rifles. There were four Maritime Security and Safety Teams, the new Coast Guard tactical units that Homeland Security had formed as part of the War on Terror. Each MSST carried M-16s, shotguns, and .45 caliber handguns. There were five hundred FBI special agents and a U.S. marshals special-ops team. And snipers. They were sending snipers into the city to shoot looters and gunmen. Kathy added it up. There were at least twenty-eight thousand guns in New Orleans. That would be the low number, counting rifles, handguns, shotguns.

She couldn't look anymore. She turned off the computer and paced. She lay in bed, staring at the wall. She got up, went to the bathroom, inspecting the new swath of white hair on her head.

Again she returned to the computer in search of her husband. She was furious with him, with his stubbornness. If he had just gotten in the Odyssey with them! Why could he not simply surrender to the same logic hundreds of thousands of people had recognized? He had to be apart from that. He had to do more. He had to do something else.

She found an email Ahmad had sent to one of the missing-persons agencies. The pictures he had attached were now the only ones she had of her husband — the only ones she had in Phoenix, anyway. They had been taken a year before, in Málaga. They'd gone, the whole family, and the picture was taken on the beach near Ahmad's house. When Kathy saw that beach, she could only think of the hike, that insane hike her husband had insisted they take. If ever there was a totemic memory that encompassed the man, it was that day.

They had been in Málaga for a few days when the older kids felt comfortable enough in Ahmad and Antonia's house to be left for the morning. Zeitoun wanted to take Kathy and Safiya for a walk on the beach, to be alone for a bit. Zachary and Nademah and Aisha, entertained with Lutfi and Laila and the pool in the backyard, barely noticed when they left.

Kathy and Zeitoun walked down to the beach, Zeitoun carrying Safiya. They walked for a mile or so down the shore, the water cool and calm. Kathy was as content as she had been in years. It was almost like a real holiday, and her husband actually seemed relaxed, like a regular person on an actual vacation. To have him this way, just walking on a beach for no real reason, just to feel the water between his toes — it was a side of him she rarely saw.

But it didn't last long. Almost as soon as she took notice of his sense of peace and leisure, his eyes focused on something in the distance.

"See that?" he asked.

She shook her head. She didn't want to see what he saw.

"That rock. See it?"

He had taken notice of a small rock formation in the distance, jutting into the sea a few miles down the shore. Kathy held her breath, afraid of whatever notion was brewing in his mind.

"Let's walk there," he said, his face bright, his eyes alive.

Kathy did not want to walk to a particular destination. She wanted to stroll. She wanted to stroll, then sit on the beach and play with their daughter, then go back to Ahmad's. She wanted a vacation — idleness, frivolity even.

"C'mon," he said. "Such a nice day. And it's not so far."

They walked toward the rock, and the water was pleasant, the sun gentle. But after another thirty minutes, they had not gotten noticeably closer. And they had come upon a low promontory that separated one part of the beach from the next. It seemed a perfect place to turn around. Kathy suggested this, but Zeitoun dismissed it out of hand.

"We're so close!" he said.

They were not so close, but she followed her husband as he climbed over the rock, holding Safiya with one hand, over the jagged ridge and down again to the next stretch of beach.

"See?" he said when they landed on the wet sand. "So close."

They walked on, Zeitoun transferring Safiya to his shoulders. They continued another mile, and again the beach was interrupted by a ridge. They climbed over this one, too. When they were again on level ground, the rock in the distance seemed no closer than when they'd set out. Zeitoun wasn't fazed.

They had been walking two hours when the beach was interrupted by another, much larger promontory, this one big enough that homes and shops had been built atop it. They had to climb up a set of steps, through the roads of this small town. Kathy insisted they stop for water, for ice cream. She drank her fill, but they did not pause for long. Soon he was off again, and she had no choice but to follow. They jogged down the steps on the other side to continue on the beach. Zeitoun never broke

pace. He was barely sweating.

"So close, Kathy!" he said, pointing to the rock in the distance, which looked no closer than before.

"We should turn around," she said. "What's the point?"

"No, no, Kathy!" he said. "We can't turn around till we touch it." And she knew that he would insist she do it, too. He always wanted his family along for his quests.

Zeitoun showed no signs of fatigue. He switched Safiya, now sleeping, from one arm to the other, and kept going.

They walked for four hours in all, up and over three hillside towns, across fifteen miles of beach, before they were finally close enough to the rock to touch it.

It was nothing much to see. Just a boulder jutting out into the sea. When they were finally upon it, Kathy laughed, and Zeitoun laughed too. She rolled her eyes, and he smiled at her mischievously. He knew it was absurd.

"C'mon, Kathy, let's touch the rock," he said.

They walked out to it and quickly climbed to its peak. They sat there for a few minutes, resting, watching the waves crash against the rocks below. And as ridiculous as it had seemed en route, Kathy felt good. She had married a bullheaded man, a sometimes ridiculously stubborn man. He could be exasperating in his sense of destiny. Whatever he set his mind to, even a crackpot idea of touching some random rock miles in the distance, she knew he would not rest until he had done it. It was maddening. It was strange, even. But then again, she thought, it gave their marriage a certain epic scope. It was silly to think that way, she knew, but they were on a journey that did sometimes seem grand. She had grown up in a small Baton Rouge house with nine siblings, and now she and her husband had four thriving kids, had been to Spain, to

Syria, could seemingly achieve any of the goals they conjured.

"C'mon, touch it," he said again.

They were sitting on it, but she hadn't yet officially touched it.

Now she did. He smiled and held her hand.

"It's nice, right?" he asked.

After that, it became a joke between them. Any time something seemed difficult and Kathy was ready to give up, Zeitoun would say, "Touch the rock, Kathy! Touch the rock!"

And they would laugh, and she would find the strength to continue, partly out of a strange sort of logic: wasn't it more absurd to give up? Wasn't it more absurd to fail, to turn back, than to continue?

MONDAY SEPTEMBER 19

Kathy woke up having reached a new kind of peace. She felt strong, and was ready to start planning. She had been paralyzed for almost two weeks now, waiting for word about her husband, but this was folly. She needed to go home, to the house on Dart. She was suddenly sure that she would find her husband there. His family in Syria was right. The most dangerous thing was these roving gangs of men. That made the most sense. As the city emptied out, the looting likely grew more brazen and engulfed neighborhoods like Uptown. The thieves had come to the house on Dart, and, not expecting to find anyone there, had killed her husband.

She needed to get back to New Orleans, hire a boat of some kind, and return to the house on Dart. She needed to see him, wherever he was. She needed to find him and bury him. She needed all of this to end.

All morning she felt a new serenity. It was time to get serious, to stop hoping, and to start working toward whatever came next.

Midday, Kathy heard that another hurricane, this one called Rita, was bearing down on New Orleans. Mayor Nagin, who had planned to reopen the city, now canceled those plans. The storm, being tracked over the Gulf with winds above 150 miles per hour, was expected to hit September 21. Even if she could make it near New Orleans, the winds would again push her back.

Nademah came in the living room.

"Should we pray?" she asked.

Kathy almost said no — all she did was pray — but she didn't want to disappoint her daughter.

"Sure. Let's."

And they prayed on the living room floor. Afterward, she kissed Nademah's forehead and held her close. *I will rely on you so much*, she thought. *Poor Demah*, she thought, *you have no idea*.

And then Kathy's cell phone rang. She picked it up. "Hello?"

"Is this Mrs. Zeitoun?" a voice asked. The man seemed nervous. He pronounced *Zeitoun* wrong. Kathy's stomach dropped. She managed to say yes.

"I saw your husband," the man said.

Kathy sat down. An image of his body floating in the filth—

"He's okay," the voice said. "He's in prison. I'm a missionary. I was at Hunt, the prison up in St. Gabriel. He's there. He gave me your number."

Kathy asked him a dozen questions in one breath.

"Sorry, that's all I know. I can't tell you anything else."

She asked him how she could get hold of Zeitoun, if he was being well cared for—

"Look, I can't talk to you anymore. I could get in trouble. He's okay, he's in there. That's it, I've got to go."

And he hung up.

IV

TUESDAY SEPTEMBER 6

Zeitoun was enjoying the cool water of his first shower in over a week. The water might shut off for good at any time, he knew, so he lingered for a few seconds longer than he should have.

But he was ready to go. The neighborhoods were emptying out, and it wouldn't be long before there was no one else to help and little left to see. He wondered when and how he might leave. Maybe in a few days. He could head up to Napoleon and St. Charles and ask the officers and aid workers there how he could get out. He would only need to get to the airport in New Orleans or Baton Rouge, and then fly to Phoenix. There wasn't much left to do here, he was running low on food, and he missed Kathy and the kids. It was time.

He walked downstairs.

"Shower's all yours," he told Nasser.

Zeitoun called his brother Ahmad in Spain.

"Do you realize the images we're seeing on TV?" Ahmad asked.

As they were talking, he heard Nasser's voice from the porch. He was talking to someone outside.

"Zeitoun!" Nasser called.

"What?" Zeitoun said.

"Come here," Nasser said. "These guys want to know if we need water."

Zeitoun hung up the phone and walked toward the door.

The men met Zeitoun in the foyer. They were wearing mismatched police and military uniforms. Fatigues. Bulletproof vests. Most were wearing sunglasses. All had M-16s and pistols. They quickly filled the hallway. There were at least ten guns visible.

"Who are you?" one of them asked.

"I'm the landlord. I own this house," Zeitoun said.

Now he saw that there were six of them — five white men and one African American woman. Under their vests it was hard to see their uniforms. Were they local cops? The woman, very tall, wore camouflage fatigues. She was probably National Guard. They were all looking around the house as if they were finally seeing the inside of a building they had long been watching from afar. They were tense, each of them with their fingers on their triggers. In the foyer, one officer was frisking Ronnie. Another officer had Nasser against the wall by the stairway.

"Give me your ID," one man said to Zeitoun.

Zeitoun complied. The man took the ID and gave it back to Zeitoun without looking at it.

"Get in the boat," he said.

"You didn't look at it," Zeitoun protested.

"Move!" another man barked.

 * * *

Zeitoun was pushed toward the front door. The other officers had
already gathered Ronnie and Nasser onto an enormous fan boat. It was
a military craft, far bigger than any other boat Zeitoun had seen since
the storm. There were at least two officers pointing automatic rifles at
them.

At that moment, another boat arrived. It was Todd, coming home
from his rescue rounds.

"What's happening here?" he asked.

"Who are you?" one of the officers demanded.

"I live here," Todd said. "I have proof. It's inside the house."

"Get in the boat," the officer said.

Zeitoun was not panicking. He knew there had been a mandatory
evacuation in effect, and he assumed this had something to do with that.
He knew it would all get straightened out wherever they were being
taken. All he needed was to call Kathy, who would call a lawyer.

But Yuko's number was in the house, by the phone, on the hall table.
If he didn't get it now, he would have no way to reach Kathy. He hadn't
memorized it.

"Excuse me," he said to one of the soldiers. "I left a piece of paper on
that table. It's my wife's phone number. She's in Arizona. It's the only
way—" He moved toward the house, smiling politely. It was everything,
that number. The piece of paper was fifteen feet away.

"No!" the soldier yelled. He grabbed the back of Zeitoun's shirt,
turned him around, and shoved him onto the boat.

The four captives rode standing, surrounded by the six military per-

sonnel. Zeitoun tried to figure out who they were, but there were few clues. Two or three of the men were dressed in black, with no visible patches or insignia.

No one spoke. Zeitoun knew not to exacerbate the situation, and assumed that when they were interviewed by a superior, everything would be explained. They would be scolded for staying in the city when there was a mandatory evacuation in effect, and they would be sent north on a bus or helicopter. Kathy would be relieved, he thought, when she heard he was finally on his way out.

They sped down Claiborne and then Napoleon, until the water grew shallow at the intersection of Napoleon and St. Charles.

The boat cut its engine and coasted toward the intersection. There were a dozen men in National Guard uniforms there, and they all took notice. A smattering of other men in bulletproof vests, sunglasses, and black caps all looked up. They were waiting for them.

The moment Zeitoun and the three other men were led off the boat, a dozen soldiers descended upon them. Two men in bulletproof vests leapt on Zeitoun, tackling him to the ground. His face was pushed into the wet grass. He spat out mud. There was a knee in his back, hands on his legs. It felt like there were at least three men keeping him down with all their force, though he had not moved or struggled. His arms were pulled behind his back and he was handcuffed with plastic ties. His legs were tied together. All the while the men were barking orders: "Hold still!" "Stay there, motherfucker." "Don't move, asshole." Out of the corner of his eye he could see the other three men, Nasser, Todd, and Ronnie, all on the ground, face down, with knees on their backs, hands on their necks. Photographers were taking pictures. Soldiers were watching, their fingers ready on the triggers of their guns.

* * *

Struggling to gain their balance with their legs tied, the four men were lifted up. They were shuffled into a large white van. They sat on two benches inside, opposite each other. No one spoke. A young soldier stepped into the driver's seat. His face seemed open; Zeitoun took a chance.

"What's happening here?" Zeitoun asked him.

"I don't know," the soldier said. "I'm from Indiana."

They waited for thirty minutes in the van. Zeitoun could see the activity outside — soldiers talking urgently to each other and on radios. This was a busy intersection that he passed every day. He could see Copeland's restaurant, where he'd often eaten with his family, right there on the corner. Now it was a military post, and he was a captive. He and Todd exchanged looks. Todd was a joker, and he'd had a run-in or two with the law, so even in the back of a military van he seemed amused. He shook his head and rolled his eyes.

Zeitoun thought of the dogs he had been feeding. He caught the attention of one of the soldiers passing by the open back of the van.

"I've been feeding dogs," Zeitoun said. "Can I give you the address, and you can take them out, bring them somewhere?"

"Sure," the soldier said. "We'll take care of them."

"You want the address?" Zeitoun asked.

"No, I know where they are," the soldier said, and walked away.

The van drove toward downtown.

"We're going to the Superdome?" Todd wondered aloud.

A few blocks from the stadium, they pulled into the crescent-shaped driveway of the New Orleans Union Passenger Terminal, where incoming and outgoing Amtrak trains and Greyhound buses docked. Zeitoun's earlier assumption — that they were being evacuated by force — seemed to be confirmed. He was relieved, and sat back on the bench. It was wrong that he hadn't been allowed to retrieve any possessions, and he felt that the treatment by the cops and soldiers had been rough. But the result was going to be simple and fair enough: they were being put on a bus or train and sent out of the city.

Zeitoun had picked up and dropped off friends and relatives at the station a handful of times over the years. Fronted by a lush lawn and palm trees, the Union Passenger Terminal had opened in 1954, an art deco–style building once aspiring to grandness but since overtaken by a certain grey municipal malaise. There was a whimsical candy-colored sculpture on the lawn that looked like a bunch of child's toys glued together without reason or order. A few blocks beyond, the Superdome loomed.

As they pulled to the side of the building, Zeitoun saw police cars and military vehicles. National Guardsmen patrolled the grounds. The station had become a kind of military base. A few personnel were casual, talking idly against a Humvee, smoking. Others were on guard, as if expecting a siege at any moment.

The van stopped at the station's side door, and the captives were taken out of the van and led inside. When Zeitoun and the others entered the main room of the station, immediately fifty pairs of eyes, those of soldiers and police officers and military personnel, were upon them. There were

no other civilians inside. It was as if the entire operation, this bus station-turned-military base, had been arranged for them.

Zeitoun's heart was thrumming. They saw no civilians, no hospital or humanitarian-aid workers, as had been common in areas like the Napoleon–St. Charles staging ground. This was different. This was entirely martial, and the mood was tense.

"Are you kidding me?" Todd said. "What the hell is going on?"

The four men were seated in folding chairs near the Greyhound ticket desk. With every passing minute, everyone in the bus station seemed to take more interest in Zeitoun, Nasser, Todd, and Ronnie.

All around there were men in uniform — New Orleans police, National Guard soldiers, prison guards with the words LOUISIANA DEPARTMENT OF CORRECTIONS on their uniforms. Zeitoun counted about eighty personnel and at least a dozen assault rifles within a thirty-foot radius. Two officers with dogs kept watch, leashes wrapped tight around their fists.

Todd was lifted from his chair and brought to the Amtrak ticket counter against the wall. As two officers flanked him, a third officer on the other side of the counter began to question him. The other three men remained seated. Zeitoun could not hear the interrogation.

The soldiers and guards nearby were on edge. When Nasser shifted in his seat, there were immediate rebukes.

"Sit still. Go back to your position."

Nasser at first resisted.

"Stop moving!" they said. "Hands where I can see them."

Zeitoun examined his surroundings. In essential ways, the station

was still the same. There was a Subway franchise, various ticket counters, an information kiosk. But there were no travelers. There were only men and women with guns, hundreds of boxes of water and other supplies stacked in the hallways, and Zeitoun and his fellow prisoners.

Todd was arguing with his interrogators. Zeitoun could hear occasional bursts as the questioning at the Amtrak desk continued. Todd was hotheaded on a normal day, so it didn't surprise Zeitoun that he was agitated during the processing.

"Are we going to get a phone call?" Todd asked.

"No," the officer said.

"You have to give us a phone call."

There was no answer.

Todd raised his voice, rolled his eyes. The soldiers around him stood closer, barking admonitions and threats back at him.

"Why are we here?" he asked a passing soldier.

"You guys are al Qaeda," the soldier said.

Todd laughed derisively, but Zeitoun was startled. He could not have heard right.

Zeitoun had long feared this day would come. Each of the few times he had been pulled over for a traffic violation, he knew the possibility existed that he would be harassed, misunderstood, suspected of shadowy dealings that might bloom in the imagination of any given police officer. After 9/11, he and Kathy knew that many imaginations had run amok, that the introduction of the idea of "sleeper cells" — groups of would-be terrorists living in the U.S. and waiting, for years or decades, to strike — meant that everyone at their mosque, or the entire mosque itself, might be waiting for instructions from their presumed

leaders in the hills of Afghanistan or Pakistan.

He and Kathy worried about the reach of the Department of Homeland Security, its willingness to contact anyone born in or with a connection to the Middle East. So many of their Muslim friends had been interviewed, forced to send in documents and hire lawyers. But until now Zeitoun had been fortunate. He had had no experience with profiling, hadn't been suspected of anything by anyone with real authority. There were the occasional looks askance, of course, sneers from people upon hearing his accent. Maybe, he thought, this was just one soldier, ignorant or cruel, wanting to stir things up. Zeitoun decided to ignore it.

Still, Zeitoun's senses were awakened. He scanned the room for more signals. He and the three others were still being watched by dozens of soldiers and cops. He felt like an exotic beast, a hunter's prize.

Moments later, another passing soldier looked at Zeitoun and muttered "Taliban."

And as much as he wanted to dismiss both comments, he couldn't. Now he was sure that there was a grave misunderstanding taking place, and that unraveling it, disproving it, was going to take days. Todd ranted, but Zeitoun knew it would do no good. The question of their innocence or guilt would not be answered in this room, not any time soon.

He sat back and waited.

Before them was an alcove housing a bank of vending machines and video games. Above the machines, wrapping around the interior of the entire station, was a vast mural that occupied, in four long segments, the upper half of the station's main walls.

In all, the mural was about 120 feet long, and it sought to depict the entire history of Louisiana in particular and the United States generally.

Zeitoun looked up at it, and though he had been in the terminal before, he had never really seen this mural. Now that he did, it was a startling thing, a dark catalog of subjugation and struggle. The colors were nightmarish, the lines jagged, the images disturbing. He saw Ku Klux Klan hoods, skeletons, harlequins in garish colors, painted faces. Just above him there was a lion being attacked by a giant eagle made of gold. There were images of blue-clad soldiers marching off to war next to mass graves. There were many depictions of the suppression or elimination of peoples — Native Americans, slaves, immigrants — and always, nearby, was the artist's idea of the instigators: wealthy aristocrats in powdered wigs, generals in gleaming uniforms, businessmen with bags of money. In one segment, oil derricks stood below a flooded landscape, water engulfing a city.

Nasser was processed next. He was brought to the Amtrak ticket counter, and now Zeitoun saw that they were fingerprinting and photographing each of them.

Soon after Nasser's interrogation began, his duffel bag created a stir. A female officer was removing stacks of American money from the bag.

"This isn't from here," she said.

Nasser argued with her, but this discovery only got the building more excited.

"That *ain't* from here," she said, now more certain.

The money was laid out on a nearby table and soon there was a crowd around it. Someone counted it. Ten thousand dollars.

This was the first Zeitoun knew of the contents of Nasser's bag. When Nasser had brought it into the canoe, Zeitoun had assumed it contained clothes, a few valuables. He never would have guessed it contained $10,000 in cash.

* * *

Soon there were more discoveries. Todd had been carrying $2,400 of his own. The officers stacked it on the table in its own pile next to Nasser's. In Todd's pockets they found MapQuest printouts.

"I deliver lost luggage," Todd tried to explain.

This didn't satisfy the officers.

In one of Todd's pockets they discovered a small memory chip, the kind used for digital cameras. Todd laughed, explaining that on it were only photos he'd taken of the flood damage. But the authorities were seeing something more.

Watching the evidence on the table mount, Zeitoun's shoulders slackened. Most municipal systems were not functioning. There were no lawyers in the station, no judges. They would not talk their way out of this. The police and soldiers in the room were too worked up, and the evidence was too intriguing. Zeitoun settled in for a long wait.

Todd grew more exasperated. He would calm down for a time, then explode again. Finally one of the soldiers raised his arm, as if to strike him down with the back of his hand. Todd went quiet.

Then it was Zeitoun's turn for processing. He was brought to the Amtrak counter and fingerprinted. He was pushed against a nearby wall on which height markers had been written by hand, from five to seven feet. Zeitoun had stood in this exact place before while waiting to buy train tickets for friends or employees. Now, while handcuffed and guarded by two soldiers with M-16s, his photograph was being taken.

At the ticket counter, he surrendered his wallet and was frisked for any other possessions. He was asked basic questions: name, address,

occupation, country of origin. He was not told of the charges against him.

Eventually he was brought back to the row of chairs and was seated again with Todd and Nasser, while Ronnie was processed.

Moments later, Zeitoun was grabbed roughly under the arm. "Stand up," a soldier said.

Zeitoun stood and was led by three soldiers into a small room — some kind of utility closet. Inside there were bare walls and a small folding table.

The door closed behind him. He was alone with two soldiers.

"Remove your clothes," one said.

"Here?" he asked.

The soldier nodded.

Until this point, Zeitoun had not been charged with a crime. He had not been read his rights. He did not know why he was being held. Now he was in a small white room being asked by two soldiers, each of them in full camouflage and holding automatic rifles, to remove his clothes.

"Now!" one of the soldiers barked.

Zeitoun took off his T-shirt and shorts and, after a pause, stepped out of his sandals.

"And the undershorts," the same soldier said.

Zeitoun paused. If he did this, he would live with it always. The shame would never leave him. But there was no alternative. He could refuse, but if he did, there would be a fight. More soldiers. Some sort of retribution.

"Do it!" the soldier ordered.

Zeitoun removed his underwear.

One of the soldiers circled him, lifting Zeitoun's arms as he passed. The soldier held a baton, and when he reached Zeitoun's back, he tapped Zeitoun's inner thigh.

"Spread your legs," the soldier said.

Zeitoun did so.

"Elbows on the table."

Zeitoun couldn't understand the meaning of the words.

The soldier repeated the directive, his voice more agitated. "Put your elbows on the table."

He had no options. Zeitoun knew that the soldiers would get what they wanted. They were likely looking for any contraband, but he also knew that anything was possible. Nothing on this day had conformed to any precedent.

Zeitoun bent over. He heard the sounds of the soldier pulling plastic gloves onto his hands. Zeitoun felt fingers quickly exploring his rectum. The pain was extreme but brief.

"Stand up," the soldier said, removing the glove with a snap. "Get dressed."

Zeitoun put on his shorts and shirt. He was led out of the room, where he saw Todd. He was arguing already, threatening lawsuits, the loss of all their jobs. Soon Todd was pushed into the room, the door was closed, and his protestations were muffled behind the steel door.

When Todd's search was complete, the two of them were led back through the bus station. Zeitoun was certain that he saw a handful of looks of recognition, soldiers and police officers who knew what had happened in the room.

Zeitoun and Todd were brought to the back of the station and toward the doors that led to the buses and trains. Zeitoun's thoughts were a jumble. Could it be that after all that, they *were* being evacuated? Perhaps they had been stripped to ensure that they hadn't stolen anything, and now, deemed clean, they were being sent away on a bus? It was bizarre, but not out of the realm of possibility.

But when the guards pushed open the doors, Zeitoun took a quick breath. The parking lot, where a dozen buses might normally be parked, had been transformed into a vast outdoor prison.

Chain-link fences, topped by razor wire, had been erected into a long, sixteen-foot-high cage extending about a hundred yards into the lot. Above the cage was a roof, a freestanding shelter like those at gas stations. The barbed wire extended to meet it.

Zeitoun and Todd were brought to the front of the cage, a few feet from the back of the bus station, and a different guard opened the door. They were pushed inside. The cage was closed, then locked with chain and a padlock. Down the way, there were two other prisoners, each alone in their own enclosure.

"Holy shit," Todd said.

Zeitoun was in disbelief. It had been a dizzying series of events — arrested at gunpoint in a home he owned, brought to an impromptu military base built inside a bus station, accused of terrorism, and locked in an outdoor cage. It surpassed the most surreal accounts he'd heard of third-world law enforcement.

Inside the cage, Todd ranted and swore. He couldn't believe it. But then again, he noted, it was not unprecedented. During Mardi Gras, when the local jails were full, the New Orleans police often housed drunks and thieves in temporary jails set up in tents.

This one, though, was far more elaborate, and had been built since the storm. Looking at it, Zeitoun realized that it was not one long cage, but a series of smaller, divided cages. He had seen similar structures before, on the properties of his clients who kept dogs. This cage, like those, was a single-fenced enclosure divided into smaller ones. He

counted sixteen. It looked like a giant kennel, and yet it looked even more familiar than that.

It looked precisely like the pictures he'd seen of Guantánamo Bay. Like that complex, it was a vast grid of chain-link fencing with few walls, so the prisoners were visible to the guards and each other. Like Guantánamo, it was outdoors, and there appeared to be nowhere to sit or sleep. There were simply cages and the pavement beneath them.

The space inside Zeitoun and Todd's cage was approximately fifteen by fifteen feet, and was empty but for a portable toilet without a door. The only other object in the cage was a steel bar in the shape of an upside-down U, cemented into the pavement like a bike rack. It normally served as a guide for the buses parking in the lot and for passengers forming lines. It was about thirty inches high, forty inches long.

Across from Zeitoun's cage was a two-story building, some kind of Amtrak office structure. It was now occupied by soldiers. Two soldiers stood on the roof, holding M-16s and staring down at Zeitoun and Todd.

Todd raged, wild-eyed and protesting. But the guards could hear little of what he said. Even Zeitoun, standing near him, could hear only muffled fragments. It was then that Zeitoun realized that there was a sound, a heavy mechanical drone, cloaking the air around them. It was so steady and unchanging that he had failed to notice it.

Zeitoun turned around and realized the source of the noise. The back of their cage nearly abutted the train tracks, and on the tracks directly behind them stood an Amtrak train engine. The engine was operating at full power on diesel fuel, and, Zeitoun realized in an instant, was generating all the electricity used for the station and the makeshift jail. He looked up at the monstrous grey machine, easily a hundred tons,

adorned with a small red, white, and blue logo, and knew that it would be with them, loud and unceasing, as long as they were held there.

One guard was assigned to them. He sat on a folding chair about ten feet in front of the cage. He stared at Zeitoun and Todd, his face curious and disdainful.

Zeitoun was determined to get a phone call. He reached for the chain-link fence in front of him, intending to get the attention of an officer of some kind he saw near the back door of the station. Todd did so, too, and was immediately set straight by the guard who had been assigned to watch them.

"Don't touch the fence!" the guard snapped.

"Don't touch the fence? Are you kidding?" Todd asked.

But the soldier was not joking. "You touch the fence again I'll fuck you up."

Todd asked where they were supposed to stand. He was told they could stand in the middle of the cage. They could sit on the steel rack. They could sit on the ground. But if they touched the fence again there would be consequences.

There were a dozen other guards roaming behind the terminal. One walked by, led by a German shepherd. He made sure to pause meaningfully at their cage, giving Zeitoun and Todd a look of warning before moving on.

Zeitoun could barely stand. There was a stabbing pain in his foot he had ignored until now. He took off his shoe to find his instep discolored. There was something wedged under his skin — some kind of metal splinter, he thought, though he couldn't remember where or

when he'd gotten it. The area was purple in the center, ringed by white. He needed to clear out the splinter or the foot would get worse, and quickly.

Zeitoun and Todd took turns sitting on the steel rack. It was only wide enough for one person, so they traded ten-minute shifts.

After an hour, the doors to the station burst open. Nasser and Ronnie appeared, escorted by three officers. Zeitoun and Todd's cage was opened, and Nasser and Ronnie were pushed inside. The cage was locked again. The four men were reunited.

Under the rumble of the engine, the men compared their experiences thus far. All four had been strip-searched. Only Todd had been told why they were being held — possession of stolen goods was the only charge mentioned — and none had been read their rights. None had been allowed to make a phone call.

Nasser had tried to explain the cash he had in his knapsack. The police and soldiers were in the city to prevent the widespread looting everyone had heard about. Nasser, being equally concerned about the looting, had decided to keep his money, his life savings, with him.

His interrogators did not accept this. Nasser had had no luck explaining that legions of immigrants kept their money in cash, that trust in banks was tenuous. He explained that one reason a person in his position kept his money in cash was for the possibility, however remote, that he would be stopped, questioned, detained — or deported. With cash he could hide it, keep it, direct its retrieval if he was sent away.

The four men didn't know what would happen to them, but they knew they would spend the night in the cage.

The Syrian names of Zeitoun and Dayoob, their Middle Eastern

accents, the ten thousand dollars cash, Todd's cash and MapQuest printouts — it all added up to enough evidence that the four of them knew that their predicament would not be straightened out anytime soon.

"We're screwed, friends," Todd said.

In the cage, the men had few options: they could stand in the center, they could sit on the cement, or they could lean against the steel rack. No one wanted to sit on the ground. The cement beneath them was filthy with dirt and grease. If they made a move toward the fence, the guards would yell obscenities and threaten retribution.

For the first hours in the cage, Zeitoun's overriding goal was to be granted a phone call. All the men had made the request repeatedly during processing, and had been told that there were no phones functioning.

This seemed to be fact. They saw no one talking on cell phones or landlines. There was a rumor that satellite phones were working and that there was one phone, connected to a fax line, in the upstairs office of the bus station.

Every time a guard passed, they begged for access to this or any phone. At best they got shrugs and glib answers.

"Phones don't work," a guard told them. "You guys are terrorists. You're Taliban."

The day's light was dimming. Processing had taken three hours, and the four men had been in the cage for three more. They were each given small cardboard boxes with the words BARBECUE PORK RIB printed on the side. Inside was a set of plastic cutlery, a packet of cheese spread, two crackers, a packet of orange-drink crystals, and a bag of pork ribs.

These were military-style meals, ready to eat.

Zeitoun told the guard that he and Nasser were Muslims and could not eat pork.

The guard shrugged. "Then don't eat it."

Zeitoun and Nasser ate the crackers and cheese and gave the rest to Todd and Ronnie.

With the darkness coming, the sound behind them seemed to grow louder. Already he was tired, but Zeitoun knew that the engine would ensure that none of them slept. He had worked on ships before, in engine rooms, but this was louder than that, louder than anything he had ever known. In the glare of the floodlights, it resembled a great furnace, moaning and ravenous.

"We can pray," Zeitoun said to Nasser.

He had caught Nasser's eye, and he knew what he was thinking. They needed to pray, were urged to do so five times a day, but Nasser was nervous. Would this arouse more suspicion? Would they be mocked or even punished for worshiping?

Zeitoun saw no reason not to do so, even while being held in an outdoor cage. "We must," he said. If anything, he thought, they needed to pray more often, and with great fervor.

"What about *wuduu*?" Nasser asked.

The Qur'an asked that Muslims wash themselves before their prayers, and there was no means of doing so here. But Zeitoun knew that the Qur'an allowed that if there was no water available, Muslims could use dust to cleanse themselves, even if only ceremoniously. And so they did so. They took gravel from the ground and rubbed it over their hands and arms, their heads and feet, and they knelt and per-

formed *salaat*. Zeitoun knew their prayers were arousing interest from the guards, but he and Nasser did not pause.

As the night went black, the lights came on. Floodlights from above and from the building opposite. The night grew darker and cooler, but the lights stayed on, brighter than day. The men were not given sheets, blankets, or pillows. Soon there was a new guard on duty, sitting on the chair opposite them, and they asked him where they were supposed to sleep. He told them that he didn't care where they slept, as long as it was on the pavement, where he could see them.

Zeitoun didn't care about sleep this night. He wanted to stay awake in case a supervisor of some sort, a lawyer, any civilian at all, happened by. The other men tried to rest their heads on the pavement, in the crooks of their arms. No one slept. Even when someone would find themselves in a place where they might be able to rest, the sound of the engine, its vibrations in the ground, took over. There could be no sleep in this place.

Somewhere in the small hours, Zeitoun tried to drape himself over the steel rack, stomach-down. He found a minute or so of rest this way, but it was a position he could not maintain. He tried to lean his back against it, arms crossed. It could not be done.

Other guards occasionally walked by with their German shepherds, but the night was otherwise uneventful. There was only the face of the guard, his M-16 by his side, the floodlights coming from every angle, illuminating the faces of Zeitoun's fellow prisoners, all drawn, ex-hausted, half-mad with fatigue and confusion.

When the sky began to pale into dawn, Zeitoun realized he had not slept at all. He had closed his eyes for a few minutes at a time, but had not found sleep. He'd refused to lie on the pavement, but even if he could have brought himself to do so, even if he could quell the panic about his situation, his family, his home, the uninterrupted drone of the engine would have kept him awake.

He watched as the night guard left and was replaced by a new man. The new guard's expression was the same as his predecessor's, seeming to take for granted the guilt of the men in the cage.

Zeitoun and Nasser performed their *wuduu* and their *salaat*, and when they were done, they stared at the guard, who was staring at them.

Zeitoun became more alert, even optimistic, as the sky brightened. He assumed that with each day since the hurricane, the city would find its way toward some kind of stability, and that the government would soon send help. With that help, the chaos that had brought him to this cage would be reined in and the misunderstanding manifested here would be mitigated.

Zeitoun convinced himself that the previous day had been an aberration, that today would bring a return to reason and procedure. He would be allowed a phone call, would learn about the charges against him, might even see a public defender or a judge. He would call Kathy and she would hire the best lawyer she could find, and this would be over in hours.

* * *

The other men in the cage, all of whom had finally found some rest during the night, woke one by one, and stood to stretch. Breakfast was brought. Again it was MREs, this time including ham slices. Zeitoun and Nasser ate what they could and gave the rest to Todd and Ronnie.

As the prison awoke, Zeitoun examined the chainlink structure closely. It was about 150 feet long. The razor wire was new, the portable toilets new. The fencing was new and of high quality. He knew that none of this had existed before the storm. New Orleans Union Passenger Terminal had never before been used as a prison. He did some rough calculations in his mind.

It would have taken maybe six flatbed trucks to get all the fencing to the station. He saw no forklifts or heavy machinery; the cages must have been assembled by hand. It was an impressive feat, to get such a construction project completed so soon after the storm. But when had they done it?

Zeitoun had been brought into the station on September 6, seven and a half days after the hurricane passed through the city. Even under the best of circumstances, building a prison like this would have taken four or five days. That meant that within a day of the storm's eye passing over the region, officials were making plans for the building of a makeshift outdoor prison. Fencing and razor wire would have had to be located or ordered. The toilets and floodlights and all other equipment would have had to be borrowed or requisitioned.

It was a vast amount of planning and execution. A regular contractor would have wanted weeks to complete the task, and would have used heavy machinery. Without machines, dozens of men would be

needed. To do it as quickly as they had, fifty men would be needed. Maybe more. And who were these men? Who did this work? Were there contractors and laborers working around the clock on a prison days after the hurricane? It was mind-boggling. It was all the more remarkable given that while the construction was taking place, on September 2, 3, and 4, thousands of residents were being plucked from rooftops, were being discovered alive and dead in attics.

At midday, Zeitoun heard something strange: the sound of buses at the bus station. He looked up to see a school bus arriving at the far end of the lot. From it descended thirty or more prisoners, one woman among them, in orange jumpsuits.

They were the incarcerated from the Jefferson Parish and Kenner jails — those who had been in jail before the storm. Within the hour, the long row of cages began to fill. And again, just like Guantánamo, all prisoners could be seen by anyone, from any angle. Now, with the orange uniforms completing the picture, the similarities were too strong to ignore.

Quickly after each group was locked into a cage, they were warned about touching the fence. Any touching of any fence would result in severe consequences. And so they came to know the strange rules of their incarceration. The pavement would be their bed, the open-door toilet would be their bathroom, and the steel rack would be the seat they could share. But for the first hour, while the new prisoners got acquainted with their new cells, there was much yelling from the guards about where and how to stand and sit, what not to touch.

A man and a woman were housed one cage away from Zeitoun, and

soon a rumor abounded that the man was a sniper, that it had been he who had been shooting at the helicopters that had tried to land on the roof of a hospital.

Lunch was different than previous meals. This time the guards brought ham sandwiches to the cages and then stuffed them through the holes in the wire.

Again Zeitoun and Nasser did not eat.

The presence of dogs was constant. There were at least two always visible, their handlers sure to parade them past the cages in close proximity. Occasionally one would explode into barking at some prisoner. Someone in Zeitoun's cage mentioned Abu Ghraib, wondering at what point they'd be asked to pose naked, in a vertical pyramid, and which guard would lean into the picture, grinning.

By two o'clock there were about fifty prisoners at the bus station, but Zeitoun's cage was still the only one with its own dedicated guard.

"You really think they consider us terrorists?" Nasser asked.

Todd rolled his eyes. "Why else would we be alone in this cell while everyone else is crammed together? We're the big fish here. We're the big catch."

Throughout the day, a half-dozen more prisoners came through the station and were brought to the cages. These men were dressed in their civilian clothes; they must have been picked up after the storm, as Zeitoun and his companions had been. The pattern was clear now: the prisoners who were being transferred from other prisons came by bus and weren't processed, while those arrested after the storm were

processed inside and brought through the back door.

By overhearing the guards and prisoners talking, Zeitoun realized the prison had been given at least two nicknames by the guards and soldiers. A few referred to it as Angola South, but far more were calling it Camp Greyhound.

In the afternoon, one of the guards approached a man in the cage next to Zeitoun's. He talked to an orange-clad prisoner for a few moments, gave him a cigarette, and then returned to the bus station.

Moments later, the guard reappeared, leading a small television crew. The guard led them straight to the man he'd given a cigarette to. The reporter — Zeitoun could see now the crew was from Spain — conducted an interview with the prisoner, and then, after a few minutes, he approached Zeitoun with the microphone and began to ask a question.

"No!" the guard yelled. "Not that one."

The crew was ushered back into the station.

"Holy shit," Todd said. "They bribed that dude."

As they were leaving, the cameraman swept his lens over the whole outdoor jail, Zeitoun included. There was a bright light attached to the camera, and being viewed that way, in the glare of a floodlight and shown to the world as a criminal in a cage, made Zeitoun furious. It was a lie.

But Zeitoun had a sudden hope, given that the crew was Spanish, that the footage might be broadcast to his brother in Málaga. Ahmad would see it — he saw everything — and he would tell Kathy, and Kathy would know where he was.

At the same time, Zeitoun couldn't bear the thought of his family in Syria knowing he was being kept like this. No matter what happened,

if and when he was released, he could not let them know that this had happened to him. He did not belong here. He was not this. He was in a cage, being viewed, gaped at, seen as visitors to the zoo see exotic animals — kangaroos and baboons. The shame was greater than any his family had ever known.

In the late afternoon a new prisoner was brought through the bus-station doors. He was white, about fifty, thin and of average height, with dark hair and tanned skin. Zeitoun thought little of him until his own cage was opened and the man was pushed inside. There were now five prisoners in their cage. No one knew why.

The man was dressed in jeans and a short-sleeved shirt, and seemed to have stayed clean during and after the storm. His hands, face, and clothing were all without dirt or stain. His attitude, too, bore no shadow of the suffering of the city at large.

He introduced himself to Zeitoun and the three others, shaking each of their hands like a conventioneer. He said his name was Jerry. He was gregarious, full of energy, and made jokes about his predicament. The four men had spent a sleepless night in an outdoor cage and did not have the energy to make much conversation, but this new prisoner more than filled the silence.

He laughed at his own jokes, and about the bizarre situation they found themselves in. Without prompting, Jerry told the story of how he had come to be arrested. He had stayed behind during the storm, just as he always did during hurricanes. He wanted to protect his house, and after Katrina passed, he realized he needed food, and couldn't walk to any stores nearby. His car was on high ground and was undamaged, but he was out of gas. So he found a length of tubing in his garage and was in the middle of siphoning gasoline from a neighbor's car — he planned

to tell his neighbor, who would have understood, he said — when he was discovered by a National Guard flatboat. He was arrested for theft. It was an honest misunderstanding, he said, one that would be straightened out soon enough.

Zeitoun pondered the many puzzling aspects to Jerry's presence. First, he seemed to be the only prisoner in the complex entertained by the state of affairs — being held at Camp Greyhound. Second, why had he been put in their cage? There were fifteen other cages, many of them empty. There didn't seem to be any logic to taking a man brought in for gasoline-siphoning and placing him with four men suspected of working together on crimes varying from looting to terrorism.

Jerry asked how the rest of them had come to be in Camp Greyhound. Todd told the story for the four of them. Jerry said something about how badly the four of them had gotten screwed. It was all common small talk, and Zeitoun was tuning out when Jerry changed his tone and line of questioning.

He began to direct his efforts toward Zeitoun and Nasser. He asked questions that didn't flow from the conversational strands he had begun. He made disparaging remarks about the United States. He joked about George W. Bush, about the administration's dismal response to the disaster so far. He questioned the competence of the U.S. military, the wisdom of U.S. foreign policy around the world and in the Middle East in particular.

Todd engaged with him, but Zeitoun and Nasser chose to remain quiet. Zeitoun was deeply suspicious, still trying to parse how this man had ended up in their cage, and what his intentions might be.

"Be nice to your mom!"
While Jerry talked, Zeitoun turned to see a prisoner a few cages away

from him. He was white, in his mid-twenties, thin, with long brown hair. He was sitting on the ground, his knees drawn up to his chest, and he was chanting the statement like a mantra, but loudly.

"Be nice to your mom! Treat her kind!"

The other three detainees in the young man's cage were visibly annoyed by him. He had apparently been repeating these strange directives for some time, and Zeitoun had only begun to hear them.

"Don't play with matches! Fire is dangerous!" he said, rocking back and forth.

The man was disabled in some way. Zeitoun watched him carefully. He was not right in the head. He seemed to have been stunted, mentally, at no more than five or six years of age. He recited basic rules and warnings that a very small child might be asked to memorize in kindergarten.

"Don't hurt your mom! Be nice to your mom!"

He went on like this. His cage mates hushed him and even nudged him with their feet, but he took no notice. He was in something like a trance state.

Because the train engine was so loud, his chanting wasn't much of a nuisance for anyone else. But his child's mind could not seem to understand where he was or why.

One of the guards, sitting a few yards away from the man's cage, kept insisting that he stay in the middle of the enclosure, where he could be easily seen. Any movement left or right was forbidden. But the man in the cage didn't understand this. He would simply get up and move over to another side. What motivated the man to decide it was time to move from here to there was unclear. But the unprovoked and unsanctioned movement enraged the guard.

"Get back there! Where I can see you!" he yelled.

The man didn't know he was being addressed. "Brush your teeth

before bed," he was saying. "Wash your arms and hands. Go pee-pee now so you don't wet the bed."

The guard stood. "Get back over there or I'm gonna come down on you, motherfucker!"

The man remained where he was, in an unsanctioned part of the cage. There he continued to rock, squatting, focused on the space between his feet.

"I'm going to count to three," the guard yelled.

The man, in an almost deliberate provocation, reached out and touched the fence.

That was it. The guard got up and a few seconds later returned with another guard. The second guard was carrying something that looked like a fire extinguisher.

They opened the cage. As they did, the man looked up, suddenly afraid. His eyes were wide with wonder and surprise as they lifted him to his feet and dragged him out of the cage.

A few feet away, they dropped him on the pavement, and with the help of two more guards, they tied his hands and feet with plastic handcuffs. He did not resist.

Then they stepped away, and the first guard, the one who had warned him, aimed the hose and sprayed him, head to toe, with a substance Zeitoun could not immediately discern.

"Pepper spray," Todd said.

The man disappeared in the haze and screamed like a scalded child. When the smoke cleared, he was cowering in a fetal position, wailing like an animal, trying to reach his eyes with his hands.

"Get the bucket!" the guard said.

Another guard came over and dumped a bucket of water on the screaming man. They didn't say another word. They left him screaming,

and soon moaning, soaked and gassed, on the pavement behind the Greyhound station. After a few minutes, they dragged him to his feet and returned him to the cage.

"You have to wash the pepper spray off," Todd explained. "Otherwise you get burned, blistered."

This night's MRE was beef stew. Zeitoun ate. The smell of pepper spray hung in the air.

The previous night had been calm compared to the day, but this night brought more fury, more violence. Other prisoners had been added to the cages throughout the evening, and now there were more than seventy at Camp Greyhound; they were angry. There was less space, more agitation. There were challenges issued by the prisoners to the guards, and soon more pepper-sprayings.

Always the procedure was the same: a prisoner would be removed from his cage and dragged to the ground nearby, in full view of the rest of the prisoners. His hands and feet would be tied, and then, sometimes with a guard's knee on his back, he would be sprayed directly in the face. If the prisoner protested, the knee would dig deeper into his back. The spraying would continue until his spirit was broken. Then he would be doused with the bucket and returned to his cage.

Zeitoun had watched elephants as a boy, when a Lebanese circus passed through Jableh. Their trainers used large steel hooks to pull the beasts one way or the other, to prod or punish them. The hooks looked like crowbars or ice picks, and the trainers would grab the elephants between the folds of their hide and then pull or twist. Zeitoun thought

of the trainers now, how these guards too had been trained to deal with a certain kind of animal. They were accustomed to hardened maximum-security prisoners, and their tools were too severe to work with these men, so many of them guilty of the smallest of crimes — curfew violations, trespassing, public drunkenness.

The night dragged on. There were bursts of screaming, wailing. Arguments broke out among prisoners. Guards would leap up, remove a man, put him in a new cage. But the fighting continued. The prisoners this night were wired, agitated.

Zeitoun and Nasser brushed whatever dust they could over their hands and arms and neck to cleanse themselves, and they prayed.

The guilt Zeitoun now felt was profound and growing. Kathy had been right. He should not have stayed in the city, and he certainly should not have stayed when she asked him, every day after the storm, to get out. *I'm so sorry, Kathy*, he thought. He could not imagine the suffering Kathy was enduring now. She had said every day that something bad could happen, something unexpected, and now she had been proven right. She did not know if he was alive or dead, and every indication would point to the latter.

Anything in this prison would be tolerable if he could only call her. He did not want to imagine what she was telling the kids, what kinds of questions they would be asking.

But why not allow the prisoners their phone call? Any way he approached the question, he couldn't see the logic in prohibiting calls. It was troublesome, maybe, to escort the prisoners into the station to make the calls, but wouldn't the calls end up relieving the prison of at least some of the jailed? Any municipal jail, he figured, expects many

of their prisoners to leave within a day or two, through bonds or dropped charges or any number of outcomes for the small-time offender.

The ban on phone calls was, then, purely punitive, just as the pepper-spraying of the child-man had been born of a combination of opportunity, cruelty, ambivalence, and sport. There was no utility in that, just as there was no utility in barring all prisoners from contacting the outside world.

Oh Kathy, he thought. *Kathy, I am so sorry. Zachary, Nademah, Aisha, Safiya, I am so very sorry tonight that I was not and am not with you.*

By two or three in the morning, most of the prisoners were asleep, and those who remained awake with Zeitoun were quiet. Again Zeitoun refused to sleep on the pavement, and caught only occasional rest by draping himself over the steel rack.

He knew the conditions had begun to take a very real toll on his psyche. He had been angry until now, but he had been thinking clearly. Now the connections were more tenuous. He had wild thoughts of escape. He pondered whether something very bad might happen to him here. And throughout the night he thought of the child-man, and heard his screams. Under any normal circumstances he would have leapt to the defense of a man victimized as that man had been. But that he had to watch, helpless, knowing how depraved it was — this was punishment for the other prisoners, too. It diminished the humanity of them all.

THURSDAY SEPTEMBER 8

Zeitoun woke to screams and curses. He had somehow managed to doze off in the early hours, while draped over the steel rack. He stood

and saw that down the line of cages, more prisoners were being sprayed.

Now the guards were shooting the pepper spray through the fencing. They didn't bother removing the prisoners from their cages. The tactic lessened the individual dosages, but spread the gas all over the complex. After Zeitoun and Nasser prayed, they and the rest of the prisoners spent the morning shielding their eyes and mouths with their shirts, coughing through the poison.

The splinter in Zeitoun's foot was now infected. It had darkened to a dull blue overnight, and he could no longer put any weight on it. He had seen his workers, most of whom were uninsured and afraid to register at a hospital, ignore their injuries. Broken fingers went unset, horrible cuts went untreated and led to all manner of sickness. Zeitoun had no idea what kind of object was lodged inside him, but knew he needed to take it out as soon as possible. All he needed was a moment of attention, a sterile needle, a knife even. Anything to carve into the foot and remove whatever was lodged inside.

The pain was intense, and Zeitoun's cage mates tried to help, to come up with a solution — anything sharp to use on it. But none of them had even a set of keys.

Minutes later, a man emerged from the station and came toward him. He was wearing green hospital scrubs and had a stethoscope around his neck. He was portly, with a kind face and a ducklike walk. The relief Zeitoun felt in the seconds he saw him approach was beyond measure.

"Doctor!" Zeitoun called.

The man did not break stride. "I'm not a doctor," he said, and continued on.

* * *

Breakfast again was MREs, an omelet filled with bacon, and again Zeitoun and Nasser gave their pork to Todd and Ronnie. But there was something new to the breakfast this day, Tabasco, and Zeitoun had an idea. He took the small bottle and slammed it on the cement, breaking it into shards and blades. He took the sharpest piece and cut into the swollen area of his foot, releasing far more fluid — clear, then white, then red — than he thought possible. Then he cut through to the dark object lodged inside, and after soaking his foot in blood, he pried it out. It was a metal sliver, the size of a toothpick.

He wrapped his foot in all the extra paper napkins in the cage, and the relief was immediate.

Throughout the day there were more pepper sprayings, both individual treatments and more indiscriminate ones. In the late afternoon one of the guards brought out a thick-barreled gun and shot it into one of the cages. Zeitoun thought a man had been killed until he saw that the gun was shooting not bullets but beanbags. The victim writhed on the ground, holding his stomach. From then on, the beanbag gun became a favorite weapon for submission. The guards alternated between the pepper spray and the beanbag gun, shooting the men and women in the cages.

Jerry continued to engage Zeitoun and Nasser in conversation. He was pointedly uninterested in Todd and Ronnie. He asked Zeitoun more about his heritage, about Syria, about his career, about his visits back home. He churned through the same line of questioning with Nasser, always disguising it with good cheer and innocent curiosity. Nasser, ret-

icent by nature, withdrew almost completely. Zeitoun tried to brush off the questions, feigning exhaustion. The presence of Jerry grew more unsettling by the day.

Who was he? Why, when there were almost one hundred prisoners elsewhere in the complex, was he in their cage? Todd would later insist that he had been a spy, a plant — meant to glean information from the Syrians in the cage. Of course he was undercover, Todd said. But if this were true, Zeitoun thought, he was a very dedicated public servant. He ate outside in the cage, and when night fell and the air cooled, he slept as Zeitoun's cage mates slept, without blankets or pillows, on the filthy ground.

That night, when it was his turn to lie over the guardrail in the cage, Zeitoun tried to do so comfortably but could not. There was a new pain in his side, coming from the area of his right kidney. The pain was sharp when he tried to drape himself over the steel rail, and when he stood in place it dulled but remained. It was yet another thing to think about, another reason he would not find rest this night.

FRIDAY SEPTEMBER 9

At midday, Zeitoun and the cage mates were told they would be moving out of Camp Greyhound. A series of school buses pulled into the far area of the lot.

Zeitoun was removed from his cage, handcuffed, and pushed toward one of the buses. He was lined up and then handcuffed to another prisoner, a man in his sixties. It was a simple school bus, decades old. Zeitoun and his companion were told to board. They shuffled up the steps, past the armed driver and a handful of armed guards, and sat

down. Todd, Nasser, and Ronnie, all paired with new men, were brought onto the bus. None of the fifty prisoners onboard were told where they were going. Zeitoun looked for Jerry, but he was no longer with them. He was gone.

They drove out of the city, heading north. Zeitoun and the man to whom he was handcuffed did not talk. Few prisoners spoke. Some seemed to know where the bus was heading. Others could not imagine what was next. Still others seemed content that finally they were out of the bus station, that it could not possibly get worse.

They left the city and Zeitoun saw the first expanse of dry land he'd witnessed since the storm. It reminded him of reaching port after a long trip at sea; the temptation was to leap from the ship and dance and run on the solid and limitless earth.

Forty miles on, Zeitoun saw a sign on the highway indicating that they were approaching the town of St. Gabriel. He took this as a positive sign, or a darkly comic one. In Islam, the archangel Gabriel, the same Gabriel who in the Bible spoke to the Virgin Mary and foretold the birth of Jesus, is believed to be the messenger who revealed the Qur'an to the Prophet Muhammad. In the Qur'an, Gabriel is described as having six hundred wings, and is assumed to have accompanied Muhammad when he ascended to the heavens.

The bus slowed at what at first looked like a country club. There was a vast green lawn enclosed by a white fence, the kind typically surrounding a horse ranch. The bus turned and passed through a gate of red brick. On the entranceway Zeitoun saw a sign confirming where they were: the ELAYN HUNT CORRECTIONAL CENTER. It was a maximum-

security prison. Most of the men on the bus seemed unsurprised. The silence was absolute.

They made their way down a long driveway lined with tidy trees. White birds scattered as they approached another gate, this one resembling a highway tollbooth. A guard waved the bus through, and soon they arrived within the prison grounds.

Hunt Correctional Center was a complex of one-story red-brick buildings laid out across an immaculate green campus. Everything was arranged in orderly grids. The fences, and the barbed wire atop them, gleamed in the sun. The grass was bright and newly cut. Sprinklers ticked and spun in the distance.

The prisoners were processed one by one, at tables placed outside. Zeitoun's entrance interview was brief and his hosts were polite. Two women asked him about his health, any medications he was using, his food restrictions. He was struck by how professional and respectful they were. It occurred to him that this level of professionalism might mean that standard procedure — a phone call for the accused — would be observed, and he would be free within a day or two. At the very least, Kathy would know he was alive. That was all that mattered.

They were brought into a changing room and told to strip naked. Zeitoun did so, in the company of a dozen other men, and with such numbers he did not fear strip searches or violence. He removed his shirt, shorts, and underwear, and they were taken away by prison workers.

He and the other prisoners were given orange short-sleeved jumpsuits. They were not given underwear. Zeitoun stepped into the jumpsuit, zipped it up, and put his shoes back on.

* * *

They were put back on a bus and driven through the prison complex — an array of geometrically arranged buildings with blue roofs. The bus stopped at what seemed to be the last prison block, in what was evidently the highest-security section of the prison.

Zeitoun and the others on the bus were led into one of the long cell-blocks. He was brought down a long concrete hallway and then directed into a cell. It was no more than six feet by eight feet, meant for one prisoner. Nasser was inside already. The door closed. The bars were baby blue.

The cell was constructed entirely from cement. The toilet was molded from cement and placed in the center of the cell. The bed, on the side of the room, was made of cement, with a rubber mattress atop it. On the back wall there was a small window covered in thick Plexiglas. A vague white square was visible, presumably the sky.

Zeitoun and Nasser barely spoke. There was nothing to say. They both knew their predicament had just taken a far more serious turn. The two Syrian Americans had been isolated. When they had been caged with Todd and Ronnie, it seemed possible that the charges against them — whenever they were actually leveled — might be limited to looting. But now the two Syrians had been separated from the Americans, and there was no predicting where this would go.

Zeitoun remained certain that one phone call would free him. He was a successful and well-known man. His name was known all over the city of New Orleans. He only needed to reach Kathy and she would knock down every wall to get to him.

All day Zeitoun made it his business to sit by the bars, waving a napkin, pleading with the guards to grant him a call. The guards seemed to relish concocting variations of their denials.

"Phone's broken," they would say.

"Not today."

"Lines are down."

"Maybe tomorrow."

"What'll you do for me?"

"Not my problem. You're not our prisoner."

This was the first but not the last time Zeitoun would hear this. He had not been processed in a traditional way, and was not assigned to Hunt for the long term. Therefore he was not technically a Hunt prisoner, and so was not bound by the institution's standard operating procedure. This was what Zeitoun was told many times by the guards:

"You're FEMA's problem."

FEMA was footing the bill for his incarceration, they said, and that of all the other prisoners from New Orleans. The Elayn Hunt Correctional Center was renting space to warehouse these men, but otherwise made no claims to their welfare or rights.

The night came but was barely distinguishable from the day. The lights were out by ten, but the prison was full of voices. Prisoners talked, laughed, screamed. There were various unidentifiable sounds coming from all corners. Smacking, grunting. The smoke seemed to increase as the night went on. The smells were rancid — cigarettes, marijuana, old food, sweat, decay.

The pain in Zeitoun's side had gotten worse. It was a throbbing ache, as if his kidney were inflamed. He never overworried about any such

problems, but what if Kathy had been right, that toxins in New Orleans had found their way into his body? Or perhaps it was the pepper spray at Greyhound — he had surely inhaled enough of the gas to cause some internal reaction.

But he dismissed the pain. He could think only of Kathy. It had now been four days since she had heard from him. He could not imagine her suffering. Where would his mind be if she went missing for four days? He hoped she had not told the children. He hoped she had not told anyone. He hoped she had found comfort in God. God had a plan, he was certain.

In the early hours, Zeitoun, weakened by lack of sleep and food and the grim nothingness of his surroundings, recalled the passage of the Qur'an called *al-Takwir*, or "The Darkening":

> *In the Name of God*
> *The Merciful, The Compassionate*
> *When the sun is darkening,*
> *when the stars plunge down,*
> *when the mountains have been set in motion,*
> *when the pregnant camels have been ignored,*
> *when the savage beasts*
> *have been assembled together,*
> *when the seas have been caused to overflow,*
> *when the souls have been mated,*
> *when the buried infant girl has been asked*
> *for what impiety she was slain,*
> *when the scrolls have been unfolded,*
> *when the heaven has been stripped off,*
> *when hellfire has been caused to burn fiercely,*

when the Garden has been brought close,
every soul shall know to what it is prone.
So no! I swear an oath by the stars that recede,
by the ones that run, the setting stars
by the night, when it swarms,
by the morning, when it sighs,
truly that is the saying of a generous Messenger,
possessed of strength,
secure with the Possessor of the Throne,
one who is obeyed and trustworthy.
Your companion is not one who is possessed.

SATURDAY SEPTEMBER 10

Again Zeitoun had not slept. The night before, the fluorescent lights above had been turned off at ten p.m., and had come on at three in the morning. In this prison, three o'clock was considered the beginning of the day.

After he and Nasser prayed, Zeitoun tried to exercise inside the cell. His foot was still raw, but he jogged in place. He did push-ups, jumping jacks. The pain in his side, though, only increased with the activity. He stopped.

Breakfast was sausage, which he could not eat, and scrambled eggs, which were nearly inedible. He took a few bites and drank the juice provided. He and Nasser sat on the bed, side by side, barely talking. The only thing on Zeitoun's mind was making a phone call. There was nothing else in the world.

He heard the guard coming down the hallway, picking up the

breakfast trays. As soon as the footsteps were close enough, Zeitoun leapt up to the front gate. The guard jumped back a step, startled by Zeitoun's sudden appearance.

"Please," he said, "one phone call?"

The guard ignored the question and instead looked around Zeitoun to Nasser, who was still sitting on the bed. The guard gave Zeitoun a quizzical eye and moved on to the next cell.

An hour later, Zeitoun heard the guard's footsteps again, and again Zeitoun rose up to meet him as he passed the gate. "Please, can I make a call?" he asked. "Just to my wife."

This time the guard issued a cursory shake of the head before peering around Zeitoun to see Nasser, who again was sitting on the bed. Now the look the guard gave Zeitoun was suggestive, even lewd. He raised his eyebrows and nodded over to Nasser. He was implying that Zeitoun and Nasser were romantically engaged, and that Zeitoun, fearing detection, had leapt from the bed when he heard the guard approaching.

By the time Zeitoun realized what the guard was implying, it was too late to argue. The guard was gone, down the hall. But this implication, that Zeitoun was bisexual, that he would betray his wife, so enraged him that he could barely contain himself.

At midday, Zeitoun was taken out of his cell. He was brought to a small office, where a prison guard stood next to a digital camera. He instructed Zeitoun to sit down on a plastic chair. As Zeitoun waited for the next command, the photographer squinted at him and cocked his head.

"You eyeballing me?" he yelled.

Zeitoun said nothing.

"Why the fuck you eyeballing me?" the photographer yelled.

He went on about how difficult he could make Zeitoun's stay at Hunt, that a man with an attitude like that would not last long. Zeitoun had no idea what he had done to provoke the man. He was still cursing as Zeitoun was led out of the room and returned to his cell.

In the late afternoon, Zeitoun again heard footsteps coming down the hallway. He went to the front of the cell and there he saw the same guard.

"What are you two doing in there?" the guard asked.

"What are you saying?" Zeitoun hissed. He had never been so angry.

"You can't do that kind of thing in your cell, buddy," the guard said. "I thought that was against your religion anyway."

That was it for Zeitoun. He let loose a barrage of expletives and threats to the guard. He didn't care what happened.

The guard seemed shocked. "You really talking to me that way? You know what I can do to you?"

Zeitoun was finished. He went to the back of the cell and folded his arms. If he were any closer, he would be too tempted to throw himself against the bars, grabbing for any part of the guard's flesh.

SUNDAY SEPTEMBER 11

In the morning the door was opened and four men were added to their cell. All four were African American, between thirty and forty-five. Zeitoun and Nasser nodded to them in greeting, and with a quick choreography about who would sit where, the new residents found places in the tiny cell. Three men sat width-wise on the bed, and three on the floor, against the wall. Cramped and soaked in sweat, they rotated every hour.

*　*　*

Zeitoun no longer harbored any expectations of being granted a phone call from any of the guards he had seen thus far. He pinned his hopes on seeing a new guard, a new employee of the prison, some visitor. He had no idea how the prison worked, how any prison worked. But he had seen movies where lawyers walked the cellblocks, where visitors passed through. He needed to find someone like that. Any one person from the world outside — someone who might grant one small mercy.

The men in the cell told each other how they had ended up at Hunt. All had been picked up in New Orleans after the storm. This entire wing of the prison, they said, held Katrina prisoners. "We're all FEMA," one said. Two of the men had been arrested for moving furniture, in situations not unlike Zeitoun's.

One man said he was a sanitation worker from Houston. His company had been contracted shortly after the storm to come in and begin the cleanup. One morning he was walking from the hotel to his truck when a National Guard truck pulled up. He was arrested on the spot, handcuffed, and brought to Camp Greyhound.

It was his first time behind bars, and of all the prisoners doing "Katrina time," as they'd termed it, he was the most perplexed by it all. He had, after all, come to New Orleans at the behest of his company. He usually picked up garbage in Houston, but after the hurricane, his supervisor said they had taken a contract in New Orleans. This prisoner, thinking it would be interesting to see what had become of the city and wanting to help in its cleanup, went willingly. He was in uniform, and had identification, the keys to his truck, everything. But nothing

worked. He was charged with looting and put in the cages behind the bus station.

Another of the cellmates said he was a fireman in New Orleans. He stayed after the storm, just as he had been asked to stay. He was in his yard when he was picked up by a passing Humvee. They charged him with looting, loaded him into the back, and brought him to Greyhound.

Zeitoun learned that most of those brought to Camp Greyhound had been arraigned in a more or less standard fashion. Most had been brought inside the bus station the morning after their arrest, and in an upstairs office, a makeshift court had been arranged. There had been a judge, and at least one lawyer. The arrestees were told their charges, and most of them were offered a deal: if they didn't contest the charges, they would be given a misdemeanor conviction and would be required to perform community-service hours, starting immediately. Some of those who took the bargain — thus accepting the permanent strike on their record — were promptly brought to the police station downtown, where they began repairing and repainting the damaged offices.

The stabbing pain in his side, which Zeitoun had first felt at Greyhound, had now amplified tenfold. It felt like a long screw was being twisted, slowly, into his kidney. It was difficult to sit, to stand, to lay down. Whenever he switched positions, he would find relief for five minutes before the pain returned. He was not one to worry about such things. He had had so many injuries over the years and rarely sought treatment. But this felt different. He thought of infections, the many diseases Kathy had mentioned when trying to get him to leave the city. He needed to find help.

*　*　*

There was a nurse who came through the cellblock once a day, pushing a cart full of medicine, handing pills to the prisoners.

Zeitoun stopped her as she wheeled by. He told her about the pain.

"Do you have a prescription?" she asked.

He told her no, that the pain was new.

"Then you need to see the doctor," she said.

He asked how he could see the doctor.

She told him to fill out a form describing his pain. The doctor would look at the form and then decide if Zeitoun needed attention. The nurse handed him the form and wheeled her cart down the hall.

Zeitoun filled out the form, and when she came back on her way out, he handed it to her.

After dinner Zeitoun's cellmates shared the stories they had heard from the other prisoners they'd encountered. The prisoners who had arrived at Hunt during the first days after the storm had lived through conditions beyond comprehension.

The thousands from Orleans Parish Prison, including those who were in jail for public intoxication, shoplifting, and other misdemeanors, had been left on the city's Broad Street overpass for three days. They'd been on television, a sea of men in orange sitting on a roadway filthy with feces and garbage, surrounded by guards with automatic rifles.

When buses finally arrived, the prisoners were taken to Hunt. Instead of being housed inside the prison, they were brought to the football stadium on the property. There they were held for days more, outside, without any kind of shelter. Thousands of prisoners, from

murderers and rapists to DUIs and petty thieves, were thrown together on the stadium grass.

There were no bathrooms. The prisoners urinated and defecated wherever they could. There were no pillows, sheets, sleeping bags, or dry clothing. The men were given one thin blanket each. The area on which Hunt had been built was marshland, and the ground grew wet during the night. The men slept on the mud, with no protection against the elements, bugs, or each other. There were multiple stabbings. Men fought over blankets.

Water was received through two small pipes extending from the grass. The men had to wait their turn and then drink from their hands. For sustenance, prison guards took sandwiches, fashioned them into balls, and threw them over the wall of the stadium and onto the field. Whoever caught one ate. Whoever could defend themselves ate. Many did not eat at all.

None of the men in Zeitoun's cell knew whether or not these prisoners were still on the football field, or what had become of them.

MONDAY SEPTEMBER 12

In the morning, the other four men were removed from the cell, and Zeitoun and Nasser were alone again. They had nothing to do but wait for any new face, anyone who might lead to recognition from the outside world that they existed here.

The boredom was profound. They had been given no books, no paper, no radio. The two men could only stare at the grey walls, the black floor, at the baby blue bars, or at each other. But they feared talking too much.

They assumed they were being monitored in some way. If a spy, Jerry, could be planted with them in an outdoor cage, it would be unsurprising if their conversations were being monitored here, in a maximum security prison.

Zeitoun sat against the bed and closed his eyes. He wanted only to pass these days.

He recounted their arrest, and the hours and days before it, countless times, trying to figure out what had brought such attention to them. Was it simply that four men were occupying one house? Such a thing, after a hurricane, when most of the city had been evacuated, was worthy of investigation, he conceded. But there had been no investigation. There had been no questions, no evidence seized, no charges leveled.

Kathy often worried about the National Guard and other soldiers returning to the United States after time in Iraq and Afghanistan. She warned him about passing groups of soldiers in airports, about walking near National Guard offices. "They're trained to kill people like you," she would say to Zeitoun, only half-joking. She had not wanted their family to become collateral damage in a war that had no discernible fronts, no real shape, and no rules.

Almost twenty years earlier, he had been working on a tanker called the *Andromeda*. They had just brought Kuwaiti oil to Japan, and were returning to Kuwait for more. This was 1987, and Iran and Iraq were in the midst of their long and crippling war. Most of their own refineries had been destroyed during the fighting, so both nations had come to rely on imported oil, and routinely tried to blockade or damage any ships bringing oil to their enemy via the Straight of Hormuz. Zeitoun and his shipmates knew that entering the Gulf of Oman, en route to

the Persian Gulf, meant risking the wrath of Iraqi or Iranian submarines and warships. The seamen were paid extra for the risk.

Zeitoun's bunk was over the fuel tanks, and he was asleep one early morning when he was jolted by an explosion below. He didn't know if it was one of the tanks, or if the ship had struck something. He quickly realized that if the tank had exploded, he would be dead, so they must have hit something, or had something hit them. He was rushing to the bridge to find out when another explosion shook the ship.

They had been struck twice by Iranian torpedoes. Together they created a hole big enough to drive a small motorboat through. But it was clear the Iranians didn't mean to sink the tanker. If they had wanted to, that would have been quite easy. They wanted only to send a warning, and to cripple the ship.

They managed to make it to Addan, and there they spent a month repairing the hull. While waiting to ship out again, Zeitoun decided that perhaps his father Mahmoud had been right. It was time to settle somewhere, time to build a family, to remain safe and constant, on land. A few months later, he got off the *Andromeda* in Houston and began searching for Kathy.

TUESDAY SEPTEMBER 13

Zeitoun and Nasser did not discuss the possibility that they would not be released from this prison for many months, or even years. But they were both thinking it — that no one knew where they were, which afforded the authorities, whoever it was who wanted them kept here, complete and unchecked power to keep them detained and hidden indefinitely.

Zeitoun could think of no indication so far that any measure could

be taken to advance his case. He had not been allowed to make a phone call, and there was no hint that he would ever be allowed to do so. He'd had no contact with anyone from outside. There was the nurse, but she was a full-time employee of the prison. Professing his innocence to her was futile, as professions of innocence were likely all she heard all day. In fact, he knew that his very presence in a maximum-security prison likely proved his guilt in the minds of all who worked at the facility. The guards were used to overseeing men who had been convicted at trial.

Further, the prison was so isolated that there was no oversight whatsoever, no civilians who came to check on conditions. He had not been let out of the cellblock once, and had been let out of the cell only to shower; the shower itself had bars. If they had refused him a phone call for seven days now, why would they change their policy in the future?

He had one hope, which was to impart his name and innocence to every prisoner he might meet, so that in the event that one of them was someday released they might not only remember his name, but also bother to call Kathy or tell someone where he was. But again, who among them would believe he was one of the true innocents in the prison? How many other names and promises had they known and made?

When he was originally arrested, Zeitoun had not been sure his country of origin had anything to do with his capture. After all, two of the four men in their group were white Americans born in New Orleans. But the arrest had taken on an entirely different cast by the time they were brought to Camp Greyhound. And though he was loath to make this leap, was it so improbable that he, like so many others, might be taken to an undisclosed location — to one of the secret prisons abroad? To Guantánamo Bay?

He was not the sort to fear such things. He was not given to conspiracy theories or believing that the U.S. government willfully committed human rights violations. But it seemed every month another story appeared about a native of Iran, Saudi Arabia, Libya, Syria, or any one of a number of other Muslim countries who was released after months or years from one of these detention centers. Usually the story was similar: a Muslim man came to be suspected by the U.S. government, and, under the president's current powers, U.S. agents were allowed to seize the man from anywhere in the world and bring him anywhere in the world, without ever having to charge him with a crime.

How different was Zeitoun's current situation? He was being held without contact, charges, bail, or trial. Would it not behoove the Department of Homeland Security to add a name to their roster of dangerous individuals? In the minds of some Americans, the very thought of two Syrians paddling through New Orleans together after a hurricane would seem suspicious enough. Even the most amateur propagandist could conjure sinister implications.

Zeitoun did not entertain such thoughts lightly. They went against everything he knew and believed about his adopted country. But then again, he knew the stories. Professors, doctors, and engineers had all been seized and disappeared for months and years in the interest of national security.

Why not a house painter?

WEDNESDAY SEPTEMBER 14

The pain in Zeitoun's side was overtaking him. While standing or sitting in certain positions, he could barely breathe. He had to get help.

When he heard the nurse's cart making its way down the cellblock, he jumped up to meet her at the bars.

"Did you give the doctor my form?" he asked her.

She said she did, and that she would hear back soon.

"You look sick," Nasser said.

"I know," Zeitoun said.

"You've lost too much weight."

"The pain. It's so bad now."

Zeitoun had a sudden and strange thought, that the pain in his side could be caused not by infection or injury, but by sorrow. Maybe there wasn't a medical reason for it. Maybe it was just the manifestation of his anger and sadness and helplessness. He did not want any of this to be true. He did not want it to be true that his home and his city were underwater. He did not want it to be true that his wife and children were fifteen hundred miles away and might by now presume him to be dead. He did not want it to be true that he was now and might always be a man in a cage, hidden away, no longer part of the world.

THURSDAY SEPTEMBER 15

Now Zeitoun knew the rhythmic ticking of the nurse's cart like his own heartbeat. He leapt to the bars again to meet her.

"What did the doctor say?" he asked.

"About what?" she said.

"About my condition," he said. "You gave him the form."

"Oh, you know, I don't think he got it. You better fill it out again," she said, and handed him another form.

He did not see her again that day or the next.

* * *

Zeitoun began to feel faint when he rose to his feet. He was not eating enough. It seemed that every meal had pork at its center. And even when he could eat what was offered, he was often too agitated or despondent to do so.

After lunch three guards arrived. The gate to the cell opened, and they entered. Zeitoun was handcuffed and his legs were shackled, and he was led out from the cell. He was walked to another building, and was put into another, empty cell. Now he was alone.

He and Nasser had not spoken much, but the contrast in being alone was stark.

Zeitoun tried to remember how much his life insurance policy was worth. He should have bought a larger one. He had not thought hard enough about it. The woman at Allstate had tried to convince him to insure his life for more than a million dollars, given that he had four children, and how much the business relied on him. But he could not envision his death. He was only forty-seven. Too early to contemplate life insurance. But he knew that by now Kathy would have checked the value of the policy. She would have begun to imagine a life without him.

When he pictured his wife having to make such plans, presuming him to be dead, his heart raged. He had wrathful thoughts about the police who had arrested him, the jailors who kept him here, the system that allowed this. He blamed Ronnie, the stranger who had come to the house on Claiborne, whom he didn't know and couldn't account for —

whose presence might very well have brought suspicion upon all of them. Maybe Ronnie *was* guilty, maybe he *had* done something wrong.He cursed Nasser's bag of cash. What a fool! He should never have been carrying around money like that.

Kathy. Zachary. The girls. The girls might grow up without a father. If Zeitoun was transferred to a secret prison, their lives would be reversed completely: they would go from the well-off children of a successful man to the disgraced children of a presumptive sleeper-cell mastermind.

And even if he got out tomorrow or next week, their father had now been in prison. The scarring was inevitable — to live in fear of their father's death, and then to find out he had been taken to prison at gunpoint, made a prisoner, made to live like a rat?

He clutched his side, pushing back at the pain, trying to contain it.

FRIDAY SEPTEMBER 16

The news came down to the prisoners that after lunch they would be allowed to go outside. It had been a week since Zeitoun had seen the sun.

During the hour they were allowed in the yard, Zeitoun tried to jog, but felt light-headed. He walked around the yard, overhearing one bewildered story after another.

He met a man who said he had been moving furniture in his house just after the storm hit. The police spotted him and broke in. When he protested his innocence, they beat him up and left. A few days later, he came to the Greyhound station to complain. They arrested him and sent him to Hunt.

No story was more absurd than the tale of Merlene Maten. One of

the prisoners had just seen her story on TV. She had been held next door, at Hunt's sister prison for women.

Maten was seventy-three years old, a diabetic, and a deaconess at the Resurrection Mission Baptist Church. Before the storm, she and her husband, who was eighty, had checked into a hotel downtown, knowing that there they would be among other residents and guests. They would have access to help if they needed it, and would be safer, given that the hotel was on high ground. They drove to the hotel in their car and paid for the room with their credit card.

They had been at the hotel for three days when Maten went downstairs to get some food from their car. Mayor Nagin had told everyone in the city to have three days' food on hand, and she had duly packed enough into the car to last. The car was parked in the lot next to the hotel, and Maten had left a cooler inside, full of the foods her husband liked. She retrieved a package of sausages and was walking back to the hotel when she heard yelling and footsteps. It was the police, and they accused her of looting a nearby store.

The nearby Check In Check Out deli had just been looted, and the police were looking for anyone who might have benefited. They found Maten. She was handcuffed and charged with stealing $63.50 worth of groceries. Her bail was set, by a judge calling by phone, at $50,000. The usual bail for such a misdemeanor would be $500.

She was brought to Camp Greyhound, where she slept on the concrete. Then she was brought to the Louisiana Correctional Institute for Women, Hunt's sister prison, for more than two weeks. She was finally freed with the help of the AARP, volunteer lawyers, a private attorney, and an article about her plight published by the Associated Press.

The lawyers finally convinced a judge that a septuagenarian staying at a hotel would not need to loot a store for sausages. They proved that

the store did not even sell the sausages she was carrying. Maten had never been in the store. Furthermore, to even enter the damaged store, strewn everywhere with debris and broken glass, would have required an agility that she did not possess.

In the late afternoon Zeitoun heard a group of guards enter the cellblock. He couldn't see them, but it sounded like at least four or five men. A cell down the hall rattled open. The guards yelled and cursed, and there was some kind of scuffle. Then quiet for a few minutes, and then the cell closed shut again. The process repeated itself half a dozen times.

Then it was his turn. First he saw their faces, five men on the other side of the blue bars. He had seen one of the guards before, but the other four were strangers. They were all wearing black riot gear, dressed like a SWAT team. They had shields, padding, batons, helmets. They waited at the ready for the door to open.

Zeitoun was determined not to struggle. He would not present any appearance of opposition. When the cell door slid open, he stood in the center of the floor, his hands in the air, his eyes level.

But still the men burst in as if he were in the process of committing a murder. Cursing at him, three men used their shields to push him to the wall. As they pressed his face against the cinderblock, they handcuffed his arms and shackled his legs.

They brought him into the hallway. Three guards held him while the other two ransacked the cell. They threw open the bedding, overturned the mattress, scoured the tiny room.

Two of the guards unlocked Zeitoun's handcuffs and shackles.

"Take off your clothes," one said.

He hesitated. He had not been given underwear when he arrived at Hunt, so if he took off his jumpsuit he would be naked.

"Now," the guard said.

Zeitoun unzipped the jumpsuit and pulled it off his shoulders. It dropped to his waist, and he pushed it to the floor. He was surrounded by three men fully dressed in black riot gear. He tried to cover himself.

"Bend over," the guard said.

Again he hesitated.

"Do it."

Zeitoun complied.

"Farther," the guard said. "Grab ankles."

Zeitoun could not tell who was inspecting him or how. He expected something to enter his rectum at any moment.

"Okay, get up," the guard said.

They had spared him this one indignity.

Zeitoun stood. The guard used his foot to slide Zeitoun's jumpsuit back into the cell, and then pushed Zeitoun in, too. While Zeitoun was putting on his clothes, they backed away from him, shields up, and out of the cell.

Zeitoun's door closed, and the guards assembled themselves at the next cell, ready for the next prisoner.

From the other prisoners Zeitoun learned that these searches were common. The guards were looking for drugs, weapons, any contraband. He should expect such a procedure every week.

SATURDAY SEPTEMBER 17

Zeitoun lay in bed much of the day, wrecked by fatigue. He had not slept. He had run the strip-search through his mind most of the night, trying to erase all memory of it, but every time he closed his eyes he

saw the men in their riot gear, at the other side of the cell door, waiting to flood in and take him.

For weeks, it seemed, he had been stealing hours of sleep during the day, a few at night. He could not remember the last time he had strung more than three hours of rest together.

Why had he done this to his family? There was something broken in the country, this was certain, but he had begun all this. He had refused to leave the city. He had stayed to guard his property, to watch over his business. But then something else had overtaken him, some sense of destiny. Some sense that God had put him there to do His work, to glorify Him with good deeds.

It seemed ridiculous now. How could he have been guilty of such hubris? He had put himself in harm's way, and by doing so had put his family in danger. How could he not have known that staying in New Orleans, a city under something like martial law, would endanger him? He knew better. He had been careful for so many years. He had kept his head low. He had been a model citizen. But in the wake of the storm, he'd come to believe he was meant to help the stranded. He believed that that damned canoe had given him the right to serve as shepherd and savior. He had lost perspective.

He had expected too much. He had hoped too much.

The country he had left thirty years ago had been a realistic place. There were political realities there, then and now, that precluded blind faith, that discouraged one from thinking that everything, always, would work out fairly and equitably. But he had come to believe such things in the United States. Things had worked out. Difficulties had been overcome. He had worked hard and achieved success. The machinery of

government functioned. Even if in New Orleans this machinery was sometimes slow, or poorly engineered, generally it functioned.

But now nothing worked. Or rather, every piece of machinery — the police, the military, the prisons — that was meant to protect people like him was devouring anyone who got close. He had long believed that the police acted in the best interests of the citizens they served. That the military was accountable, reasonable, and was kept in check by concentric circles of regulations, laws, common sense, common decency.

But now those hopes could be put to rest.

This country was not unique. This country was fallible. Mistakes were being made. He was a mistake. In the grand scheme of the country's blind, grasping fight against threats seen and unseen, there would be mistakes made. Innocents would be suspected. Innocents would be imprisoned.

He thought of bycatch. It was a fishing term. They'd used it when he was a boy, fishing for sardines by the light of the moon they'd made. When they pulled in the net, there were thousands of sardines, of course, but there were other creatures too, life they had not intended to catch and for which they had no use.

Often they would not know until too late. They would bring their catch back to shore, a mound of silver, the sardines dying slowly. Zeitoun, exhausted, would rest against the bow, watching the fish slowly cease their struggles. And once on shore, when the crew unloaded the nets, they would sometimes find something else. One time there was a dolphin. He always remembered this dolphin, a magnificent ivory-white animal shining on the dock like porcelain. The fishermen nudged it with their feet, but it was dead. It had gotten caught in the net and,

unable to reach the surface to breathe, it had died underwater. If they had noticed it in time, they could have freed it, but now all they could do was throw it back into the Mediterranean. It would be a meal for the bottom-feeders.

The pain in Zeitoun's side was growing, rippling outward. He could not stay here another week. He would not survive the heartbreak, the wrongness of it.

There was no way to come out of this prison improved. Not the way he was being treated. He had seen parts of Hunt that seemed well-run, clean, efficient. When he first arrived and was being processed, he saw prisoners milling about freely in a grassy courtyard. But he had been confined twenty-three hours a day to his cell, with no distractions, no companionship or beauty. The environment would drive any sane man mad. The grey walls, the blue bars, the strip searches, the showers behind bars watched by guards and cameras. The lack of any mental stimuli. Unable to work, to read or build or improve himself, he would waste away here.

He had risked too much in the hopes that he might do something to match the deeds of his brother Mohammed. No, it had never been a conscious part of his motivation — he had done what he could in the drowned city because he was there, it needed to be done, and he could do it. But somewhere in his gut, was there not some hope that he, too, could bring pride to the family, as Mohammed had so many years ago? Was there not some wish that he might honor his brother, his family, his God, by doing all he could, by circling the city looking for opportunities to do good? And was this imprisonment God's way of curbing his pride, tempering his vainglorious dreams?

As the prisoners awoke, with their rantings and threats, Zeitoun prayed. He prayed for the health of his family. He prayed that they felt at peace. And he prayed for a messenger. All he needed was a messenger, someone to tell his wife that he was alive. Someone to connect him with the part of the world that still worked.

SUNDAY SEPTEMBER 18

Zeitoun had been napping through the morning, dazed and sluggish from the heat. His sweat had soaked through his orange jumpsuit. He heard notice that they would be allowed to walk outside again after lunch, and he wasn't sure he could stand to make it.

He was disappointed in himself. Part of him had given up, and the part that still believed stood apart from the broken half of his soul, incredulous.

The wheels of the nurse's cart echoed down the hallway. He had no reason to think she would help him, but he stood up and made ready to plead with her again. But when he looked down the hall, it was not the nurse, but a man he had never seen before.

He was pushing a cart of black books, and had stopped a few cells away from Zeitoun's. He was talking to whichever prisoners were there, and Zeitoun watched him, unable to hear the conversation. The man was black, in his sixties, and watching him interact with the prisoners down the row, it was clear he was a man of God. The books in his cart were Bibles.

When he finished and passed by Zeitoun's cell, Zeitoun stopped him. "Please, hello," he said.

"Hello," the missionary said. He had almond-shaped eyes, a wide smile. "Would you like to hear about Jesus Christ?"

Zeitoun declined. "Please sir," he said. "Please, I shouldn't be here. I committed no crime. But no one knows I'm here. I haven't gotten a phone call. My wife thinks I'm dead. Can you call her?"

The missionary closed his eyes. It was obvious he often heard things like this.

"Please," Zeitoun said. "I know it's hard to believe a man in a cage, but please. Can I just give you her number?"

Zeitoun could only remember Kathy's cell phone number, and hoped it would work. The missionary looked up and down the cellblock and gave a nod. "Be quick."

"Thank you," Zeitoun said. "Her name is Kathy. My wife. We have four children."

Zeitoun had no pen or paper.

"This is against the rules," the missionary said, finding a pen in his cart. He had no paper. Now they were both nervous. The missionary had been too long at his cell. He opened a Bible and tore a page from the back. Zeitoun gave him the number. The missionary stuffed the page into his pocket and moved his cart quickly down the block.

Hope rose in Zeitoun's heart. He couldn't sit down for hours. He paced, hopped in place, elated. He pictured the missionary leaving the prison, getting to his car, retrieving the number, calling Kathy from the road. Or maybe he would wait till he got home. How long could it take? He counted the minutes until Kathy would know. She would know! He estimated the hours until Kathy would arrive here to free him. If she knew he was alive, he could wait. The process might take days, he knew. But he could wait if it meant seeing her. It would be no

problem. He pictured it all. He would be free in a day.

Zeitoun struggled to sleep that night. There was a man in the world who knew he was alive. He had found his messenger.

MONDAY SEPTEMBER 19

After breakfast two guards came to Zeitoun's cell. They told Zeitoun that his presence was requested.

"Where? With who?" Zeitoun asked. *Already it's begun*, he thought.

The guards told him nothing. They opened his cell, handcuffed him, and shackled his legs together. He was led out of the cell and down the hall. A few minutes later they arrived at another cell, where Zeitoun was deposited. He waited there for five minutes until the door opened again.

"Van's here," the guard said. The guard handed him to another guard, who walked him down another hallway and to a final gate. The gate opened, and Zeitoun was led to a white van waiting outside. He squinted in the full light of day. He was inserted into the van, the guard riding with him. They drove through the complex until they arrived at the main offices at the front of the prison.

Zeitoun was led out of the van and handed over to another guard, who led him into the building. Inside, they walked through an immaculate hallway until they arrived at a spare cinderblock office.

Outside the office were Nasser, Todd, and Ronnie, sitting on folding chairs in the hallway. Zeitoun was surprised to see them all assembled, and they gave each other looks of mutual bewilderment. Zeitoun was led past them and into a small room.

In the room there were two men wearing suits. They sat down and gestured to Zeitoun that he could take a seat. They were from the

Department of Homeland Security, they said. They smiled warmly at Zeitoun and told him that they needed to ask him some simple questions. They asked him what he did for a living. He told them that he was a painter and contractor. They asked him why he hadn't left the city when everyone had evacuated. He told them that he never left New Orleans during storms, and that he had a number of properties he wanted to watch over. They asked about Todd, Nasser, and Ronnie — how he knew them. He explained his relationship to each. They asked him why he didn't have any money on him.

"What am I going to do with money in a canoe during a flood?" Zeitoun said.

"But Nasser had money," one of the men said.

Zeitoun shrugged. He could not account for why Nasser had money with him.

The interview lasted less than thirty minutes. Zeitoun was struck by how friendly the men were, how easy the questions were. They did not ask about terrorism. They did not accuse him of plotting against the United States. At the end, they apologized for what Zeitoun had been through, and asked if there was anything they could do for him.

"Please call Kathy," he said.

They said they would.

MONDAY SEPTEMBER 19

Kathy was in a state. She'd just gotten the call from the missionary a few hours before. And now the phone was ringing again. Yuko, who had been fielding calls for days, no longer knew what to do. Kathy picked it up.

A man introduced himself as belonging to the Department of Homeland Security. He confirmed that Zeitoun was at the Elayn Hunt Correctional Center.

"He's fine, ma'am. We have no more interest in him."

"You have no more interest in him? Is that good or bad?"

"That's good."

"Well, what was he in there for?"

"Well, they have 'looting' on his arrest sheet. But those charges will be dropped."

The call was brief and businesslike. When she hung up, Kathy

praised and thanked God for his mercy. She shrieked and jumped around the house with Yuko.

"I knew he was alive," Yuko said. "I knew it."

"God is good," they said. "God is good."

They called Yuko's husband and made plans to get the kids out of school early. They had to celebrate. And plan. There were so many things to do.

First of all, Kathy had to go. She knew she had to go. She had to leave that day for the prison. She didn't know where it was yet, but she had to go. Where was it? She looked it up online. St. Gabriel, less than an hour from Baton Rouge.

She called Hunt and was bounced around the various automated extensions until she reached a person. She could barely speak. She wanted to fly through the phone and be there with him.

"I'm trying to reach my husband. He's in there."

"The prisoner's name?" the woman asked.

Kathy had to take a breath. She could not stomach the idea of her husband being called a prisoner. By naming him she was expanding this lie, the one being told by everyone involved in his incarceration thus far.

"Abdulrahman Zeitoun," she said, and spelled it.

Kathy heard the typing of computer keys.

"He's not here," the woman said.

Kathy spelled the name again.

Again the sound of typing.

"We have no one by that name," the woman reiterated.

Kathy tried to remain calm. She told the woman that she had just received a call from someone from Homeland Security, and that that man had told her that Abdulrahman Zeitoun was at that very prison.

"We have no record of him," the woman said. She went on to say

that Hunt had no records for anyone who came via the hurricane. None of the prisoners from New Orleans were in their computer system. "All of those records are on paper, and we don't have that paper. We have no actual records of any of those people. They're FEMA's."

Kathy almost collapsed. She was spinning, helpless. She didn't have a number for the Homeland Security man who had called; she cursed herself for not asking for a way to contact him. And now she was being told that her husband was not in the institution where the Homeland Security people and the missionary had seen him. Was this some kind of game? Had he been there at all? He might have been moved already. He had been a prisoner at Hunt but then some other agency wanted him. He had been spirited away to a secret prison somewhere—

She had to go. She would go to Hunt Correctional Center and insist she see him. She had a right to see him. If he wasn't there she would demand they tell her where he'd been taken. It was the only way.

She told Yuko and Ahmaad she was going.

"Where?" they asked.

"Hunt. The prison," she said.

They asked her if she was sure he was there. She was not. They asked if she was sure she would be allowed to visit. She was not. They asked where she would stay. Kathy didn't know. Already she was crying again. She didn't know what to do next.

They convinced her to stay in Phoenix for the time being, until she could be sure of Zeitoun's whereabouts and how she could actually help him. She needed to be smart, they said. They didn't want to worry about her, too.

Kathy called Raleigh Ohlmeyer, an attorney they had worked with

before. Raleigh had helped a few of the Zeitouns' workers who had legal issues to straighten out. Raleigh's father was a well-known and powerful lawyer in New Orleans, and Raleigh, though in the family business, had chosen to break away, at least in his appearance. He wore his brown hair long, usually pulled back in a ponytail. He worked downtown and took on a wide variety of cases, from traffic tickets to criminal defense. Kathy was sure he would know how to straighten out this Hunt business.

There was no answer. She left a message.

Kathy called Ahmad in Spain and woke him up. She didn't care.

"He's alive!" she said.

He yelled a string of Thank Gods and Praise Gods.

"Where is he?" he asked. "With you?"

"No, he's in prison," Kathy said. "But it's okay. I know where he is. We'll get him out."

Ahmad was silent. Kathy could hear him breathing.

"How? How will you get him out?" he asked.

Kathy did not have a plan just yet, but she had a lawyer, had put in a call to him, and—

"You need to go there," Ahmad said. "You have to see him and get him out. You must."

Kathy was unsettled by Ahmad's tone. He seemed almost as worried by Zeitoun's incarceration as he had been by his disappearance.

Fahzia, Zeitoun's sister in Jableh, called soon after.

Kathy told her the good news. "We know where he is. He's in prison. He's okay."

Another long silence.

"Have you seen him?" she asked.

Kathy said she had not, but that she was sure she would soon.

"You need to see him," Fahzia said. "You need to find him."

In the afternoon, Raleigh Ohlmeyer called Kathy back. He had fled the city just before the storm and had been staying in Baton Rouge. His house in New Orleans was under six feet of water.

Kathy told him what had happened to Zeitoun.

"What?" Raleigh said. "I just saw him on TV." He had seen the local news broadcast of Zeitoun in his canoe.

Kathy told him about the calls from the missionary and the Homeland Security officials, how they had seen him at Hunt.

Raleigh was reassuring. He already knew all about Hunt. After the storm he had set up a makeshift office in Baton Rouge and was already working with prisoners brought to the prison.

The system's broken, he said. There was no means to post bail. It would take some time before it could be rectified. Raleigh promised that he would get Zeitoun released, but given the state of the courts — there were none to speak of — he could not predict or guarantee a timeline.

TUESDAY SEPTEMBER 20

In the morning Ahmad called Kathy, tense.

"Did you tell Fahzia that Abdulrahman was in prison?"

His tone was severe.

"Yes, she asked and—"

"No, no," he said, and then softened. "Let's not do that. Don't worry them. We cannot tell them he's in prison. We cannot do that."

"Okay, but I just thought—"

"We'll call them and tell them he's fine, he's home, it was a mistake. Okay? We need to tell them this. You don't understand the worry they'll have if they think he's in jail."

"Okay. Should I—"

"I'll call them and tell them he's fine. If they call you, tell them the same. He's at home, he's safe, all is fine. You made a mistake. Okay? This is what we tell them. Okay?"

"Okay," she said.

Ahmad wanted to know which prison he was in. Kathy told him it was in St. Gabriel, and that because the legal system was in limbo, it would be some time before they could even hope to get Abdulrahman out. But she had spoken to a lawyer, and he was on the case. It was only a matter of time.

But Ahmad was thinking beyond simple cases of attorneys and bail. He did not want his brother in prison at all. A Syrian in an American prison in 2005 — this was not to be trifled with. Abdulrahman had to be seen. He had to be freed immediately.

The next time Kathy checked her email she saw a message from Ahmad; she had been cc'ed. He was trying to find Zeitoun, but he had gotten the city wrong. He had done an internet search for San Gabriel in the United States, had found a match, and had written this:

From: CapZeton
To: ACOSTA, ALEX
Subject: Urgent from Spain

The San Gabriel Police Department
San Gabriel, CA

Dear Sires,

My name is: Ahmad Zeton, from Spain

Reason: I'm looking for my brother (New Orleans Katrina evacuated). On Sept. 7th I missed the contact with my brother which we talked daily by phone after the Hurricane Katrina batch, I asked every place in order to have any news about him, lastly I learned that the Police Force him on Sept. 6th to evacuated his house in New Orleans and tacked him for San Gabriel, and he is actually still arrested at San Gabriel.

Kindly would you please if there is a possibility to learn if he is all right, and if it's possible to talk to him, or to call me by a collected call to my phone [number omitted].

The detail of my brother is:

Name: Abdulrahman Zeitoun.

Date of berth: 24/10/1957

Address: 4649 Dart St., New Orleans, LA

Well be very kind from you just to let me know if he's all right,

Thanking you indeed,

Ahmad Zeton

Malaga-Spain

Kathy began to see the situation through Ahmad's eyes. What if the prosecutors, hoping to justify Zeitoun's incarceration, tried to make a case against him — a connection, any distant connection, to some terrorist activity? Any connection, no matter how specious, might be used to justify his incarceration and extend it.

Kathy did not want to think this way.

THURSDAY SEPTEMBER 22

She called Raleigh Ohlmeyer again. He had just called Hunt, and they had confirmed that Zeitoun was there.

Kathy called Ahmad and told him the news.

"Yes, but has anyone seen him?" he asked.

"No," she said.

"Then we can't be sure," he said.

"Ahmad, I'm sure that—"

"You have to go," he said. "Kathy, please."

He apologized; he knew that he was pushing too hard, that he was calling Kathy too often, but his mind was filled with images of his brother on his knees, in an orange jumpsuit, in an outdoor cage. Every additional hour Zeitoun was in custody increased the chances of something taking a turn for the worse.

"I'll fly to New Orleans," he said.

"And do what?" Kathy asked.

"I'll find him," he said.

"Don't. Don't," she said. "They'll put you in jail, too."

FRIDAY SEPTEMBER 23

By now Raleigh was familiar with some of the judges and administrators working to process the post-storm prisoners being kept at Hunt. Hoping to get Zeitoun's case dismissed, Raleigh told Kathy it was time to come to Baton Rouge. She should fly out and be ready to come to the prison at a moment's notice; there was a chance she could visit him on Monday. Kathy booked a flight and called Adnan, Zeitoun's cousin.

"Abdulrahman?" he asked, hesitant.

"He's okay," she said.

He exhaled. She told him the story of her husband's incarceration, and that she was coming to get him.

"You'll stay with us," Adnan said. After sleeping on the floor of a Baton Rouge mosque for that first week, he and his wife had rented an apartment for the month, and were living there.

Adnan would pick her up and drive her to the prison.

SUNDAY SEPTEMBER 25

There was something wrong with the airplane. They were flying so low, descending too quickly. Kathy was certain the plane would crash. She no longer trusted anything about New Orleans, even the sky above the city. She gripped the armrest. She looked around to see if anyone else was alarmed. The pilot's voice came on the intercom. He announced that they were flying low over the city so the passengers could survey the damage. Kathy couldn't look.

When they landed, the airport was desolate. There were airport security officers, New Orleans police, National Guardsmen, but few civilians. The passengers of Kathy's plane seemed to be the only people in the building. All the stores were closed. The lights were dim. There was detritus all over the floors — garbage, papers, bandages and other medical supplies.

Adnan picked her up and they drove to the apartment he and Abeer had rented in Baton Rouge. Kathy, exhausted and overwhelmed, fell asleep with her shoes on.

Zeitoun knew nothing about the work Kathy and Raleigh were doing. He still had not been allowed a phone call. All he knew was that he had been assured by both the missionary and the Homeland Security men that they would call his wife. But since then, he had no assurance that contact had been made.

After lunch, Zeitoun was taken from his cell and again handcuffed and brought to the same building near the front gate of the prison. Inside he was brought to a small cinderblock room, where a table and a handful of chairs had been arranged. Sitting on one side of the table was a man in his late fifties, wearing a suit. On the other side were two men in coats and ties. Three other prisoners were seated in chairs at the back of the room. It was some kind of courtroom.

A young man introduced himself to Zeitoun as the public defender. He would be representing Zeitoun that day. Zeitoun began to explain his case, the mistakes that had brought him to prison, and asked for an immediate phone call to his wife. The public defender closed his eyes to indicate that Zeitoun should stop talking.

"You're not here to be judged," he said. "This is just a hearing to set bail."

"But don't you want—"

"Please," the young man said, "just don't say anything. Let me speak for you. Just sit and be quiet if you can. Don't say a word."

The charges against Zeitoun were read: possession of stolen property valued at $500. The prosecutor suggested setting bail at $150,000.

The defender countered that Zeitoun had no prior record, and that the bail should be far lower. He suggested $35,000.

The judge set the bail at $75,000. That was the end of Zeitoun's hearing. The defender extended his hand to Zeitoun, and Zeitoun shook it. He was led out of the room as the defender opened the file for the next prisoner. On his way out, Zeitoun again asked for a phone call. The defender shrugged.

"But why set bail when I can't tell anyone I'm in prison?" Zeitoun asked.

From the judge, the prosecutor, and the defender, there was no answer. Zeitoun was brought back to his cell.

TUESDAY SEPTEMBER 27

Raleigh called Kathy.

"Okay," he said, "they finally have a system arranged, and we've got a court date. They want to clear the docket as much as we want him out of there. So gather as many people as you can to come to court and testify on his behalf. Character witnesses."

This seemed sensible enough to Kathy. It was a clear-cut task, and she dug in. But while making a list of friends to call, she realized she had forgotten to ask Raleigh where the courthouse was. She called him back and got his voicemail.

She called the New Orleans District Attorney's office. A recording gave her a number in Baton Rouge. She called it, expecting to get a recording, but to her surprise a woman answered the phone on the second ring. Kathy asked for the address of the courthouse.

"We don't have one right now," the woman said.

"What?" Kathy said. "I just need the address of the courthouse where the hearings are, the hearings for prisoners at Hunt? I just need the court address."

"We don't have one of those," the woman said.

"A court?"

"Right."

"Where are people going to pay tickets?"

"No one's paying tickets right now," the woman said.

Kathy asked to speak to a supervisor.

She was transferred, and this time a man picked up the phone. Kathy explained that she had just gotten word that her husband had been arrested, and now there was a court date. She only wanted to know where court hearings were being held.

"Oh, we can't tell you that," the man said.

"What? You can't tell me?"

"No, that's privileged information," he said.

"Privileged for who? I'm his wife!"

"I'm sorry, that's private information."

"It's not private! It's public!" Kathy screamed. "That's the point! It's a public court!" She asked to speak to another, more knowledgeable person. The man sighed and put her on hold.

Finally a third person, a woman, picked up the phone.

"What is it you want?" she asked.

Kathy composed herself, hoping that perhaps the other two officials hadn't heard her clearly. She said, "I want to know the location of the court. The court where sentencing and bail hearings are being held."

The woman's voice was even and firm: "That is private information."

Kathy fell apart. She wailed and screamed. Somehow this, knowing that her husband was so close but that these layers of bureaucracy and incompetence were keeping her from him — it was too much. She cried out of frustration and rage. She felt like she was watching a baby drown,

unable to do anything to save it.

When she'd gathered herself, she called CNN.

She reached a producer and told her the story: her husband's incarceration, the call from Homeland Security, the stonewalling, the courts that didn't even exist. The producer said she would investigate, and took Kathy's number.

Raleigh called back. He apologized. Now he knew where the hearing would be held — at Hunt itself. He told Kathy to call anyone she could and tell them to be at Hunt the next day, at nine a.m.

"I'm going to try to see Zeitoun today," he said.

Kathy prayed that he would.

Kathy began calling friends, neighbors, and clients. In two hours she managed to secure at least seven people who said they would come, including the principal of her daughters' school.

Zeitoun was again called out of his cell for a meeting. He was handcuffed, his legs were chained, and again he was led to the white van. He was driven to the front of the prison complex and was brought to another small cinderblock room, where he saw Raleigh, the first representative of the outside world he'd seen since his arrest.

He smiled, and they shook hands warmly.

"I want to get out," Zeitoun said.

"You have to pay to get out," Raleigh said. He sighed deeply. "We've got a situation with this bail."

Zeitoun could either find and pay $75,000, and if he eventually won his case he would be refunded the full amount. Or he could pay thirteen percent of the bail to the courts and three percent to the bondsman —

about $10,000 total. And regardless of the outcome of his case, he would lose that amount.

"Isn't $75,000 a lot for petty theft?" Zeitoun asked.

Raleigh agreed it was. It was about a hundred times what it should be. Zeitoun could find the $10,000, but it seemed silly to him to throw away that much money. It would be, in effect, paying the government for incarcerating him for a month.

"Can't you reduce it?" Zeitoun asked.

"I'll have to fight for it," Raleigh said.

"Well, then fight for it," Zeitoun said.

"What if it doesn't work?" Raleigh asked.

"Then check if we can use my property as bail," Zeitoun said.

"You don't want to pay the bond?"

"No," Zeitoun said.

If he paid for his release, what would he do, after all? He couldn't work. There was nothing to do in New Orleans, not yet. And by now he knew that Kathy and his kids knew he was alive. He trusted that he would be released. So he would be paying $10,000 to be free for a few extra days — and he would spend that time pacing around Yuko and Ahmaad's living room. He would see his daughters, yes, but they knew he was safe now, and that money would be better spent elsewhere — in their college trusts, for example. He had already been kept two and a half weeks; he could wait a few more days.

"I'll check about using your property as collateral," Raleigh said.

"Call Kathy," Zeitoun said.

WEDNESDAY SEPTEMBER 28

Kathy drove into Hunt, holding her breath. It was a surreal sight — the

tidy white fencing, the bright green lawn. It looked like a golf course. White birds scattered as she made her way down the long driveway and up to the gate.

In the parking lot, she stood outside and waited. It was eight-thirty in the morning, and she needed all the friends they had. They began to arrive a few minutes later. Rob and Walt had driven from Lafayette. Jennifer Callender, who worked with Walt and whose house Zeitoun had renovated, arrived with her husband and father. Tom and Celeste Bitchatch, neighbors on Claiborne, had driven from Houston. Nabil Abukhader, the principal at the girls' school, had driven from the French Quarter.

They all embraced. No one had been sleeping. They all looked terrible, and were shocked that such a thing had brought them together. But they were heartened, somewhat, to know that they would be able to speak about the character of Abdulrahman Zeitoun. They were confident that when the judge heard from them all and realized that the police had imprisoned a well-known businessman, the judge might very well release him that day. Perhaps they could all celebrate together.

Kathy couldn't stop thanking them. She was a wreck of tears and gratitude and anticipation.

When Raleigh arrived, he was impressed. He gathered everyone together and gave them a brief rundown of how the proceedings would go. He wasn't sure exactly where the hearing would take place, or even what time. But he was confident that between Zeitoun's reputation, lack of any prior infractions, and this showing of character witnesses — a wide swath of upstanding New Orleanians — the judge would release Abdulrahman Zeitoun with profuse apologies.

They waited through the morning. No word. Finally Raleigh went

to see what was happening. He came back out, his face a cloud.

"They won't see any of you," he said.

The hearing had been canceled. There was no explanation why.

Now the only chance was to post bail. Kathy would have to go back into the city and find papers proving ownership of their office building. They would use the building as collateral against the bond.

Adnan insisted he drive Kathy into the city.

They took I-10 and exited at Carrollton. Immediately they were struck by the smell. It was so many things — acrid, rotten, and even, from the branches and trees lying in the sun, sweet. But most of all the smell was overpowering. It was loud. Kathy wrapped her scarf around her face to blunt its power.

The city looked like it had been abandoned for decades. The cars, their colors washed grey from the toxic water, were strewn about like playthings. They took Carrollton to Earhart, and at one point had to cross over to the opposite lane to avoid downed trees. The debris was everywhere and bizarre — tires, refrigerators, tricycles, couches, a straw hat.

The streets were deserted. They saw no one — no human or vehicle — until a police cruiser pulled up behind them a few blocks from the office. Kathy told Adnan to let her do the talking. It was a long-held strategy she developed with Zeitoun. It was always easier and quicker when she did the talking; a Middle Eastern accent would only provoke more questions.

Two officers approached their car, both with their hands on their sidearms. The officer at the driver's side window asked Adnan what he was doing in the city. Kathy leaned over to explain and extended her driver's license through the window.

"I live in the house down the street," she said. "Just coming back to assess the damage, pick up anything that survived."

He listened to Kathy but turned back to Adnan. "What are you doing here?"

Kathy preempted him. "We're contractors," she said. She gave the officer her business card.

The officer took it back to the squad car. He and his partner spent ten minutes there before returning to Adnan's window.

"Okay," the officer said, and let them go.

They decided to drive straight to the office, for fear that the next time they were stopped they would not be so fortunate.

When they reached the building on Dublin, Kathy could see the remains of the homes that had burned to the ground. It seemed miraculous that the fire had stopped only a few yards away. The office appeared damaged from the outside, but not in a way that would hint at what they would find within. Kathy went to the door. Her key didn't work. The lock was rusted inside and out.

Across the street, Adnan spotted something. He jogged over to a neighbor's house and came back carrying an ancient, ruined ladder.

"I'm going up," he said. "You stay here."

He set the ladder against the building and began to climb. The steps were crooked and some of them broken, but he went up carefully, and when he arrived at the second-floor window, he climbed through and quickly disappeared inside.

Kathy heard some thumps and scraping, and then it was quiet. Soon there was a voice from the other side of the door.

"Move away," he said. "I'm kicking the door down."

He kicked it four times and the door gave way, falling flat.

"Be careful when you're going up the stairs," he said.

Inside, the building was ruined. It looked like it hadn't been inhabited in decades. The ceiling was half-destroyed, dotted with jagged holes. Exposed wiring and papers everywhere. A grey sludge covered the floor. The smell was strong. Mildew and rain and sewage.

Kathy and Adnan carefully climbed the stairs to the office. It was unrecognizable. The carpet squished with every step. She could smell the presence of animals, and there were scurrying sounds as they walked through the office. She opened a closet door and a dozen roaches fell onto her hands. She screamed. Adnan calmed her.

"Let's just get the papers and go," he said.

But nothing was where she remembered it. The file cabinets had shifted. The desk organizers were all over the floor. She searched through the cabinets and desk drawers, sweeping bugs off the few files left undamaged. Some of the files were so wet and soaked in mud that they were useless. She made a pile of the files that were unreadable, hoping that among the few that she could recognize was proof that they owned this building. It seemed so absurd, that she was searching through her own building, widely known as the headquarters of their well-known business, for a simple, filthy piece of paper that a makeshift court would accept in exchange for her husband. And what if she didn't find it? Her husband might fall deeper into the abyss of this broken judicial system for lack of this piece of paper?

"Please help," she asked Adnan, choking on the words.

They searched for an hour. They opened every drawer and every file, until she thought they were simply examining the same, few, undamaged files they'd already read repeatedly. But finally, in a drawer she was sure contained nothing of value, she found it, the act of sale for 3015 Dublin. She was on her knees, her abaya filthy, and she held it in her

hands, and cried. She sat back and shook.

"This better work," she said.

With the papers in hand, they returned to Raleigh's office in Baton Rouge. Raleigh prepared the paperwork and faxed it over to the bondsman. The bondsman confirmed that he had received it and that the bond had been paid. Raleigh called Hunt to confirm that all the paperwork had gone through for the surety bond. He was told that they had the paperwork, but that the office had closed early. It was three p.m.

Zeitoun would have to spend another night at Hunt.

THURSDAY SEPTEMBER 29

In the morning, Kathy and Adnan drove to the prison, arriving before eight. They went into the office and were told Zeitoun would be released that day. They waited in the same room where Zeitoun's friends had gathered two days earlier.

They waited until eleven. No word. Twelve. Nothing. It wasn't until one o'clock that they were given notice that he would be released any moment. Kathy was told to wait for him outside. A bus would be dropping him off at the gate.

Zeitoun was in his cell praying.

In the name of God, the Most Beneficent, the Most Merciful:
Praise be to God, the Lord of the Heavens and the Earth.
The Most Beneficent, the Most Merciful.
Master of the Day of Judgment.

"Zeitoun!"

A guard was calling to him.

The guard can wait, Zeitoun thought. He had no idea that Kathy was at the prison and his release was imminent.

He continued his prayers.

You alone we worship, and You alone we ask for help.
Guide us to the straight way;
The way of those whom you have blessed,
not of those who have deserved anger,
nor of those who are astray.

"Zeitoun!" Now the guard was at his cell, yelling through the bars. "Get ready!"

Zeitoun continued his prayers until he was finished. The guard waited silently. When Zeitoun stood, the guard nodded to him.

"Get your stuff. You're getting out today."

"What?" Zeitoun said.

"Hurry up."

Zeitoun fell against the wall. His legs had given way.

Kathy waited outside the prison with Adnan.

A white bus arrived at the gate. A figure moved from within, from left to right, and then stepped down onto the pavement. It was Abdulrahman, her husband. He had lost twenty pounds. He looked like a different man, a smaller man, with longer hair, almost all of it white. Tears soaked her face. *He's so small*, she thought. A flash of anger overtook her. *Goddamn those people. All of you people, everyone responsible for this.*

Zeitoun saw her. He smiled and she went to him. Tears all over her

face, she could barely see. She ran to him. She wanted to protect him. She wanted to take him in the crescent of her arms and heal him.

"Get back!"

A heavy hand was on her shoulder. A guard had stopped her.

"Stay here!" he yelled.

Kathy had crossed a barrier. It wasn't visible to her, but the guards had delineated an area within which the prisoners' relatives were not allowed.

She waited, standing a few yards away from her husband. They stared at each other, smiling grimly. He looked like a sad old man. He was wearing denim pants, a denim shirt, orange flip-flops. Prison clothes. They hung off him, two sizes too big.

A few minutes later he was free. He walked to her and she ran to him. They held each other for a long moment. She could feel his shoulder blades, his ribs. His neck seemed so thin and fragile, his arms skeletal. She pulled back, and his eyes were the same — green, long-lashed, touched with honey — but they were tired, defeated. She had never seen this in him. He had been broken.

Zeitoun hugged Adnan, and then quickly pulled away.

"We should go," Zeitoun said.

The three of them quickly got in the car. They didn't want whoever was responsible for this to change their minds. It wouldn't have surprised them. Nothing at all would have surprised them.

They left the prison as fast as they could. They felt better after they passed through the main gate, and felt better still as they drove down

the long white-fenced driveway and reached the road. Zeitoun turned around periodically, to be sure no one was following them. Adnan checked his rearview mirror as they sped down the rural route, trying to put as much distance as possible between themselves and the prison. They passed through a long corridor of tall trees, and with each mile they felt more sure that Zeitoun was absolutely free.

Kathy sat in the back seat, reaching forward, stroking her husband's head. But she wanted to be closer. She wanted him in her arms, she wanted to hold him and restore him.

They were only ten minutes away from the prison when Ahmad called Kathy's cell phone.

"We've got him!" she said.

"What? You do?"

She handed the phone to Zeitoun.

"Hello brother!" he said.

"Is it you?" Ahmad asked.

"It's me," Zeitoun said.

"Praise God. Praise God. How are you?"

Ahmad's voice was trembling.

"Okay," Zeitoun said, "I'm okay. Were you worried?" He tried to laugh.

Now Ahmad was crying. "Oh praise God. Praise God."

V

FALL 2008

Kathy has lost her memory. It's shredded, unreliable. The wiring in her mind has been snapped in vital places, she fears, and now the strangest things have been happening.

She was at the bank in November, just to deposit checks from clients and withdraw cash for the week. She comes to this bank, Capital One, so often that everyone there knows her. This morning, like any other, the employees greeted her when she entered.

"Hi, Mrs. Zeitoun!" they sang, and she waved and smiled.

She walked to one of the tellers and removed her checkbook and picked up a pen. She needed to write two checks, one for cash and the other to move money into the company's payroll account.

She wrote the first check and gave it to the teller, and when she returned her attention to her checkbook, she paused. She didn't know what to do next. She couldn't remember what her hand was supposed to

be doing. She didn't know how to write, or what to write, or where. She stared and stared at the checkbook; it became more foreign by the moment. She couldn't identify the purpose of the checkbook on the counter or of the pen in her hand.

She looked around, hoping to see someone with these tools in their hands, to see how they were using them. She saw people, but they provided no clues. She was lost.

The teller said something but Kathy couldn't understand the words. She looked at the young woman, but the sounds coming from her mouth were garbled, backward.

Kathy couldn't speak. She knew, inwardly, that she was beginning to worry the teller. *Focus*, she told herself. *Focus, focus, focus, Kathy!*

The teller spoke again, but the sounds were more distant now, coming, it seemed, from underwater, or far away.

Kathy's eyes locked on to the sliding wooden partition that separated this teller from the others. She lost herself in the blond wood grain, slipping into the elliptical lines of age on the wood's surface. Then she realized what she was doing, staring at the grain on the wood, and urged herself to snap out of it.

Focus! she thought. *C'mon.*

Her hands felt numb. Her vision was blurry.

Come back! Come back!

And slowly she returned. The teller was talking. Kathy made out a few words. Kathy felt herself re-enter her body, and suddenly everything clicked into place again.

"Are you okay, Mrs. Zeitoun?" the teller asked again.

Kathy smiled and waved her hand dismissively.

"Just spacing out for a second," she said. "Busy day."

The teller smiled, relieved.

"I'm fine," Kathy said, and wrote the second check.

She's been forgetting numbers, names, dates. She has trouble concentrating. She tells friends that she's going crazy, and laughs it off. She's not going crazy, she is sure and they are sure — she's still the same Kathy almost all the time and certainly to most of the people she knows — but episodes like the one at the bank are accumulating. She's not as sharp as she once was, and there are things she can't count on doing as she did before. One day she'll be unable to place the name of one of the workers she's known for ten years. Another day she'll find herself with the phone in her hand, the other end of the line ringing, and will have no idea who she is calling or why.

It is the fall of 2008 and the Zeitouns are in the process of moving into a new house. It's the same house, really — the one on Dart — but it's been gutted, expanded, tripled. Zeitoun designed an addition that will give all the children their own rooms, and will allow Kathy to work at home. There are balconies, gabled roofs, a large kitchen, four bathrooms, two sitting rooms. It is the closest thing to a dream house they will ever have.

The office on Dublin was a total loss. They went there a few days after Zeitoun's release from prison and found only mud and insects. The roof had given way, and everything inside was covered in the same grey mud. Kathy and Zeitoun took the few things they could salvage and eventually sold the building. They planned to move their office to their home. Now their house has an entrance on Dart, the residential address, and another one on Earhart Boulevard.

The Zeitouns have lived in seven apartments and houses since the storm. Their Dublin Street office was leveled and is now a parking lot. The house on Dart is still unfinished.

They are tired.

When they returned from Hunt, they stayed for two days on Adnan's floor in Baton Rouge, then moved into the studio apartment of their rental unit on Tita Street, on New Orleans' West Bank. There was no furniture, but it had been undamaged in the storm. Those first few nights, Kathy and Zeitoun lay on the floor, with borrowed blankets, talking very little. He did not want to talk about prison. He did not want to talk about Camp Greyhound. He was ashamed. Ashamed that his hubris, if that was what it was, had caused all this. Ashamed that he had been handcuffed, stripped, caged, treated like an animal. He wanted it all erased from their lives.

On that night and for many nights after, they lay on the floor and held each other, bitter and thankful and frustrated, and they said nothing.

Kathy fed him as much as she could each day. The day after his release, Kathy and Adnan took Zeitoun to Our Lady of the Lake Regional Medical Center, where the doctors found no major injuries. They could find no reason for the stabbing pain in his side. But he had lost twenty-two pounds. It would be a year before he was back to his previous weight. He'd lost hair, and what was left had gone grey. His cheeks were hollow, his eyes had lost their spark. Slowly, he regained himself. He grew stronger. The pain in his side dissipated, and this convinced Zeitoun it had been caused not by anything visible on an X-ray, but by heartbreak, by sorrow.

After Zeitoun's release, their friend Walt loaned them a car from his Lexus dealership, and Kathy and Zeitoun drove it back into the city and to the house on Dart.

The smell was overpowering, a mixture of mold, sewage, and dead animals. Kathy pulled part of her hijab to her mouth to mute the stench. Zeitoun tried to flush one of the toilets and sewage poured out. More water had made its way into the rooms on the second floor. A shelf of books was ruined, as well as most of the electronics.

Without Zeitoun there to plug holes as they arose, the house had been devastated. He looked at the gaps in the roof and sighed.

Kathy leaned against the wall in the hallway. She was overwhelmed. Everything they owned was filthy. To think she had cleaned this house a thousand times!

"You okay?" he asked her.

She nodded. "I want to leave. I've seen enough."

They took the computer and some of the kids' clothes and put them in the car. Zeitoun started the engine but then ran back inside, retrieved the box of photos, brought it down, and put it in the trunk. He backed out of the driveway, turned down Dart, and remembered something else.

"Wait!" he said. "Oh no..." He jumped out of the car, leaving the door open. *The dogs.* How long had it been? He ran across the street and down the block, his stomach spinning. *The dogs, the dogs.*

He knocked on the front doors of the two houses where he had fed them. No answer. He looked in the first-floor windows. No one. The owners had not come back.

Zeitoun went back to the tree. His plank was still there, and he leaned it against the trunk. He climbed up to his usual perch and then pulled the plank up. He stretched the plank across to the house on the right and walked to the roof. Usually the dogs were barking for him by now, but today he heard nothing.

Please, he thought. *Please God.*

He lifted the window and slipped inside. The stench hit him

immediately. He knew the dogs were dead before he saw them. He found them together in one of the bedrooms.

He left the roof, stepped back to the tree, and arranged the plank to reach the second house. The dogs were just under the windowsill, a tangle of limbs, heads to the heavens, as if they had been waiting, for weeks, for him.

After two weeks, Kathy and Zeitoun were still in the studio apartment, and the kids were ready to return to New Orleans. Zeitoun was nervous. "Do I look like me?" he asked Kathy. He was afraid he would scare them, having lost so much weight and hair. Kathy didn't know what to say. He did not look like him, not yet, but the kids needed to see their father. So Kathy and Zeitoun flew to Phoenix, and amid much crying and hugging, the Zeitouns were reunited. They drove back to New Orleans and returned to the apartment on Tita. For a month they slept together on the floor.

One day Kathy opened a letter from the Federal Emergency Management Agency. They were offering the Zeitouns a free trailer, a two-bedroom portable unit that would be delivered to them at their request.

Kathy filled out the appropriate forms and sent them back. She didn't expect much from the process, so she was startled when, in December 2005, an eighteen-wheeler pulled up in front of their apartment with a gleaming white trailer in tow.

Zeitoun was on his rounds, so he didn't see them install it. When he returned, he was puzzled. They hadn't connected the trailer to water or electricity. And it had been installed on a rickety tower of cement blocks, easily four feet off the ground. There were no steps to reach the door. It was so high that there was no way to get inside without a stepladder.

And even if one reached the door, you couldn't enter the trailer, because the delivery team had failed to leave a set of keys.

Kathy called FEMA and let them know about these issues. They said they were doing the best they could, and would get to it as soon as possible. Weeks passed. No key was delivered. The Zeitouns watched every day for signs of any FEMA personnel. The trailer stayed where it was, unused, unconnected, and locked.

After a month, a FEMA pickup truck arrived and dropped off a set of steps, about four feet high. They left no equipment that might attach the steps to the trailer. There was a foot-wide gap between the steps and the door. To get inside, one would have to jump. But the door still couldn't be opened. They had yet to provide the key.

After another six weeks or so, a FEMA inspector appeared and gave Kathy the key to the trailer. But when he saw the trailer, he noted that because it was leaning, it was unsafe to use. He left, telling Kathy that someone would come to fix it.

Zeitoun and Kathy began to buy houses in their neighborhood. Their next-door neighbor had fled the storm and hadn't returned. She put the house on the market and the Zeitouns made an offer. It was half the value of the house before the hurricane, but she accepted. This was the most satisfying of all the transactions they made. Before the storm, they'd also bought the house on the other side of their own. Soon they were living in this house, while renovating their original house on Dart, and renting out the other house next door.

Meanwhile, the FEMA trailer was still parked in front of the house on Tita. It had been there eight months, and had never been connected to water or electricity. A practical way to enter the trailer had never

been devised, and now the Zeitouns didn't need it. It was an eyesore. Zeitoun had repaired all the damage to the Tita house, and they were trying to sell it. But the trailer was blocking the view of the house, and no one would buy a house where an immovable leaning trailer was parked out front.

But FEMA wouldn't pick it up. Kathy called every week, telling FEMA officials that the trailer had never been used and now was decreasing the value of their property. She was told each time that it would be removed soon enough, and that, besides, thousands of people would love to have such a trailer; why was she trying to get rid of it?

In June 2006, a FEMA representative came to collect the keys. He said they would return to take away the trailer. Months went by. There was no sign of anyone from FEMA. Kathy called again, and FEMA had no record of anyone picking up the keys.

Finally, in April of 2007, Kathy wrote a letter to the *Times-Picayune* detailing the saga of the trailer. At that point, the trailer had sat, unused and unusable, for over fourteen months. On the morning the letter ran, a FEMA official called Kathy.

"What's your address?" he asked.

They took it away that day.

Kathy's problems with memory gave way to other difficulties, equally difficult to explain. She began to have stomach problems. She would eat any small thing, a piece of pasta, and her stomach would swell to double its original size. Soon she was choking on anything she tried to eat. Food would not go down some days, and when it did, she would have to gag and fight it down.

She grew clumsier. She knocked over glasses and plates. She broke a lamp. She dropped her phone constantly. Some days, when she walked,

she would feel tipsy, swaying side to side, needing to rest against walls as if struck by vertigo. Some days her hands or feet would grow numb while she was doing normal everyday things like driving or working with the kids on their homework.

"Honey, what's happening to me?" she asked her husband.

She went in for tests. One doctor suggested she might have multiple sclerosis; so many of her symptoms seemed to indicate some kind of degenerative illness. She was given an endoscopy, an MRI, and a barium swallow to test her gastrointestinal tract. Doctors administered tests of her cognitive skills, and she did poorly on those that measure memory and recognition. Overall the tests pointed to post-traumatic stress syndrome, though she has yet to decide on the strategy to manage it.

Kathy and Zeitoun had no intention of suing anyone over his arrest. They wanted it in the past. But friends and relatives fanned their outrage, and convinced them that those responsible needed to be held accountable. So they hired a lawyer, Louis Koerner, to pursue a civil suit against the city, the state, the prisons, the police department, and a half-dozen other agencies and individuals. They named everyone they could think of — the mayor, Eddie Jordan, and everyone in between. They were told by everyone who knew anything about the New Orleans courts to get in line. There were hundreds, perhaps thousands, of cases against the city, the federal government, FEMA, police officers, the Army Corps of Engineers. Three years after the storm, few of the lawsuits had gone anywhere.

A few months after Zeitoun's release, Louis Koerner found his arrest report. Kathy was shocked that it even existed, that any records had been made or kept. Finding the names of those who arrested her husband

was satisfying at first, but then it only fueled her rage. She wanted justice. She wanted to see these men, confront them, punish them. The arresting officer was named Donald Lima, and this name, Donald Lima, seared itself into her mind. The other officer named on the report was Ralph Gonzales. Lima was identified as a police officer from New Orleans. Gonzales was a cop from Albuquerque, New Mexico.

Out-of-state police could not make arrests, Kathy discovered, so on any arrest, a local officer had to be present along with any Guardsmen or contractors. Kathy and Zeitoun decided to name Donald Lima, the officer on the arrest report, in the lawsuit. The Zeitouns' lawyer contacted the New Orleans Police Department and found that Lima was no longer employed there. He had resigned in 2005, a few months after the storm. The department had no forwarding address.

Gonzales was easy to find. On the arrest report, he was identified as being an officer from Albuquerque, and he was still with that department in the fall of 2008. When he was reached by phone, he told his side of the story.

Gonzales had been a police officer for twenty-one years when, in August of 2005, his captain suggested that they send a team to New Orleans. The New Orleans Police Department had put out a nationwide request for law enforcement help, so Gonzales agreed to go, along with about thirty other officers from Albuquerque.

The New Mexico team arrived a few days after the storm, were sworn in as deputies, and began to assist with search and rescue operations. Before arriving in New Orleans, Gonzales and his fellow officers had heard a lot about the conditions in the city, and they were tense. They had heard about shootings, rapes, gangs of heavily armed and fearless

men. They saw no such crime, but they saw plenty of death. They were one of the first units to investigate one of the hospitals. Gonzales didn't remember which one, but they found dozens of bodies. The smell was indescribable.

Conditions worsened every day. He and his fellow cops wouldn't go out at night. They could hear windows breaking and shots fired after dark. The entire city smelled of death and decay. "Everyone was on guard," he said of his fellow cops. "We thought we were in a third-world country."

On September 6, Gonzales was at the Napoleon–St. Charles staging ground. Cops and soldiers and medical personnel gathered there every day to share information and receive assignments. Gonzales got word that there would be a search of a house down the road, occupied by at least four suspects presumed to have been looting and dealing drugs. It could be very dangerous, he was told, and they needed as many cops and soldiers as possible. It was the first law-and-order assignment he'd been part of since he had arrived.

He jumped on the boat wearing a bulletproof vest and carrying a pistol and an M-16. He was one of six cops, National Guard soldiers, and soldiers-for-hire on the boat. When they arrived, Gonzales was one of the first to enter. He saw a pile of computer components and stereo equipment on the dining room table, and he saw the four men. There was something in their attitude, he thought, which signaled that "they were up to no good."

They arrested the four men, brought them to the staging ground, handed them to the authorities there. They were finished with the assignment in fifteen minutes. That was the extent, Gonzales asserted, of their duties. He never went to Camp Greyhound and was only vaguely aware that a jail had been installed there. Neither he nor any part of the

arresting party secured the house or collected any evidence. In fact, none of them returned even once to the house on Claiborne.

The arrest of Zeitoun and the other three men on Claiborne Avenue was one of two arrests Gonzales made while he was in New Orleans. Every other task he performed was related to search and rescue. Ten minutes after bringing the four men to the staging ground, he was on another boat, looking for people in need.

Gonzales was asked how he felt about the fact that Abdulrahman Zeitoun, a middle-aged businessman and father of four, had done a month in maximum-security prison.

Gonzales seemed regretful. "If he was innocent, then I feel very bad," he said. "Here's the bottom line: I wouldn't want something like that to happen to me personally."

Gonzales talked about how the system is supposed to work: police officers investigate, make arrests, and then hand the process over to the judicial system. Under normal circumstances, if the men were innocent, he maintained, they would have been given a phone call and the opportunity to post bail.

"They should have gotten a phone call," he said.

Lima was more difficult to track down, but he had not gone far. He had left the New Orleans Police Department in 2005 and was living in Shreveport, Louisiana.

He knew that Zeitoun and the others had spent time in jail. He knew about Zeitoun's case because he'd been served papers when the lawsuit was undertaken. He didn't know how long the other men had spent in prison. He was quick to note that their imprisonment wasn't his doing. He only made the arrest.

At the time of Katrina, he was living in a five-thousand-square-foot

house on Napoleon. During and after the storm, he stayed in the city with members of his family, guarding his house. He had two generators and enough food and water for three weeks. He also had over forty pistols and automatic rifles. During the day he traveled the city with other police officers and National Guard troops, making rescues. Each day he met with other law-enforcement personnel, and they would map out a plan of action. They divided up tasks and territory.

The National Guardsmen in the city had plenty of gasoline but were low on other supplies. In exchange for gasoline, Lima and other New Orleans police officers broke into convenience stores and took cigarettes and chewing tobacco. A majority of the National Guardsmen, Lima said, chewed tobacco and smoked Marlboros, so this arrangement kept both sides well supplied. Lima considered the looting a necessary part of the mission. The gasoline, he said, helped them make the rescues they did. He also needed it to power his home generators. When he couldn't find Guardsmen who had gas, Lima siphoned fuel from cars and trucks. His throat was sore from all the gas-siphoning he did after the storm, he said.

"The whole place was anarchy," he said.

While making his rounds on a motorboat one day, Lima observed four men leaving a Walgreens carrying stolen goods. They left the Walgreens and put the goods into a blue-and-white motorboat. Lima had two rescuees with him, so he couldn't pursue the thieves at the time, but he made a mental note. He continued to make rounds, seeing dead bodies and being confronted by angry residents, many of them armed.

"My state of mind was rattled," he said.

Two days later he passed a house on Claiborne and saw the same blue-and-white boat tethered to the porch. He raced to the Napoleon–St. Charles staging ground and gathered a crew of police and military personnel. They were "heavily armed" with sidearms and M-16s. He

didn't know the other four men or the one woman who joined in the mission. Together they took a flatboat to the house. Lima was the lead cop on the arrest.

When they entered, they saw what they thought were stolen goods on the dining room table. They found four men inside, and something about them and the scene seemed amiss. Lima was sure that these were the same four men he had seen leaving the Walgreens, so they arrested them and brought them to the staging ground.

"It was a fairly routine arrest," he said. "All four of the guys were very quiet."

They handed the men over to National Guardsmen, and the Guardsmen put them in the white van. Lima filled out paperwork about the arrest and gave it to the Guardsmen, and they drove the arrestees to Camp Greyhound. Later, Lima went to Greyhound, where he saw the men's property laid out on a table. He saw Todd's maps, Nasser's cash, and the memory chips. "They'd been up to something," he said.

Lima was not sure what goods he had seen the four men stealing. And he did not see any goods customarily sold by Walgreens in the house on Claiborne. He did not secure the house on Claiborne as a crime scene. No stolen goods were recovered. But he was certain the men in the house were guilty of something, though the extraordinary circumstances of post-storm New Orleans did not allow for the same degree of thoroughness as he would have liked.

Nor was the post-arrest procedure standard or fair, he said. In a normal situation, Lima said, they would have been arraigned properly, given a phone call and an attorney, and would have been out on bail within days. When he was a cop, he was frustrated by the revolving-door nature of the justice system. He would arrest someone in the morning and they would be out on the street in the afternoon. It was

maddening for a police officer, but he admitted that this element of checks and balances would have been useful in this case.

"They should have gotten a phone call," he said.

Lima quit the NOPD in November 2005, and moved with his wife and daughter to Shreveport. He was a police officer in Shreveport for a time, but was treated, he said, "like a second-class citizen." The officers there assume that all cops from New Orleans are corrupt, he said. So he quit, and now he's looking for a new career. Before joining the force, he was a stockbroker, and he was considering going back to that.

The Zeitouns were conflicted about what they heard about Lima and Gonzales. On the one hand, knowing that these two police officers had not purposely hunted and arrested a man because he was Middle Eastern gave them some comfort. But knowing that Zeitoun's ordeal was caused instead by systemic ignorance and malfunction — and perhaps long-festering paranoia on the part of the National Guard and whatever other agencies were involved — was unsettling. It said, quite clearly, that this wasn't a case of a bad apple or two in the barrel. The barrel itself was rotten.

Soon after, a friend emailed Kathy a document that seemed to shed light on the state of mind of the soldiers and law-enforcement agencies working in New Orleans at the time.

The Federal Emergency Management Agency had been its own free-standing agency for decades, but after 9/11 had been folded into the Department of Homeland Security. FEMA had historically been granted broad powers in the wake of a federal emergency; they could take command of all police, fire, and rescue operations. This was the case after Katrina, where it was necessary for FEMA to assume the responsibility for all

prisoners being evacuated from New Orleans. And thus the prisoners, including Zeitoun, were overseen by the Department of Homeland Security.

While Katrina bore down on the Gulf Coast, a four-page document was apparently faxed and emailed to law-enforcement agencies in the region, and to National Guard units headed to the Gulf area. The document, issued in 2003 by the Department of Homeland Security, was written by a "red cell" group encompassing representatives of the Department of Homeland Security, the CIA, the Marines, corporate security firms, and Sandia National Laboratories.

The authoring committee had been asked to "speculate on possible terrorist exploitation of a high category hurricane." And though the authors admitted that it was unlikely that terrorists would act during or after a hurricane, they nevertheless enumerated the many ways they might do so. "Several types of exploitation or attacks may potentially be conducted throughout the hurricane cycle — hostage situations or attacks on shelters, cyber attacks, or impersonation of emergency response officials and equipment to gain access." These terrorists "might even hope that National Guard and other units are less able and well-equipped to respond... because of deployments overseas."

Then they broke their findings into three categories: Pre-Event, During Event, and Post-Event. Before the storm, the committee wrote, the terrorists would be most likely to use the occasion "to observe precautionary measures to gauge emergency response resources and continuity of operation plans at critical infrastructures." They also warned that terrorists might target evacuation routes, creating "mass panic" and "loss of public confidence in the government." Terrorist activity during the storm, the committee felt, was "less likely due to the severe weather, unpredictability of the storm path and the difficulty of mobilizing resources." After the storm, the options for terrorists were few but

potent. They might "build on public panic to further destabilize the system by disseminating rumors" and therefore "increase media coverage" and "stress the public health system."

The committee had several recommendations to reduce the threat posed by such terrorists. They included: "Institute increased security procedures (e.g. identification checks) at evacuation centers and shelters"; "Advise the first responder community, telecommunications personnel, and power restoration personnel to increase identification procedures to prevent imposters from gaining unauthorized access to targets"; and "Increase patrols and vigilance of staff at key transportation and evacuation points (for instance, bridges and tunnels), including watching for unattended vehicles at these locations."

The "red cell" committee thought it unlikely that an established terrorist group would work in the United States during a hurricane. Instead, they felt that "a splinter terrorist cell, or a lone actor... would be more likely to exploit a hurricane on site. This includes persons pursuing a political agenda, religious extremists, or other disgruntled individuals."

Kathy isn't sure whether hearing things like this is helpful or not. She has moved on from Katrina in many ways, and yet the residual effects arrive at unexpected times. There are plenty of normal days. She drives the kids to school and picks them up, and in between she manages the affairs of the painting and contracting company. When the kids get home she makes them a snack and they watch TV and do their homework.

But the other day Kathy had to ask for Nademah's help. She was trying to get onto the Internet but couldn't make it work. She looked behind the computer and the wires were a chaos she couldn't decipher. "D, can you help me get connected?"

Nademah came to help. It was Kathy who had set up all the computers in the house, Nademah reminded her, and Kathy who had taught Nademah how to use them. Kathy knew this, but at that moment she couldn't remember which wires went where, which buttons did what, how everything was connected.

Camp Greyhound has been the subject of investigative reports and a source of fascination for the city at large. Even employees of Greyhound and Amtrak are amazed at what became of the station after the storm. Clerks at the Amtrak desk will happily show visitors the place where prisoners were fingerprinted, where their heights were determined. The height chart is still there. Under a poster next to the counter, the handwritten marks are still there. You just have to move the poster to see them, just as they were in the days of Camp Greyhound.

As Zeitoun had suspected, the jail was built largely by hand. When he was incarcerated there, he couldn't imagine what workers were available and ready to work long hours a day after the hurricane, but the answer makes a certain amount of sense. The work was completed by prisoners from Dixon Correctional Institute in Jackson, Louisiana, and from the Louisiana State Penitentiary in Angola.

Angola, the country's largest prison, was built on an eighteen-thousand-acre former plantation once used for the breeding of slaves. Meant to hold those convicted of the most serious crimes, it has long been considered the most dangerous, most hopeless prison in the United States. Among the five thousand men held there, the average sentence is 89.9 years. Historically the inmates were required to do backbreaking labor, including picking cotton, for about four cents an hour. In a mass protest decades ago, thirty-one prisoners cut their Achilles tendons, lest they be sent again to work.

At the time of the hurricane, Marlin Gusman, sheriff of Orleans parish, knew that there was a chance that the Orleans Parish Prison, where most offenders were kept while awaiting trial, would flood. So he called Burl Cain, warden of Angola. An arrangement was made to build an impromptu prison on high ground in New Orleans. Warden Cain rounded up fences and portable toilets, all of which he had available at the Angola campus, and sent the materials on trucks to New Orleans. They arrived two days after the hurricane struck the city.

Cain also sent dozens of prisoners, many of them convicted of murder and rape, and tasked them with building cages for new prisoners and those forced out of Orleans Parish Prison. The Angola prisoners completed the network of outdoor jails in two days, sleeping at night next door to the Greyhound station. Cain also sent guards. When the cages were finished, the Angola prisoners were sent back north, and the guards remained. These were the men who guarded Zeitoun's cage.

When the prison was completed, Cain said it was "a real start to rebuilding" New Orleans. In the weeks that followed, more than 1,200 men and women were incarcerated at Camp Greyhound.

This complex and exceedingly efficient government operation was completed while residents of New Orleans were trapped in attics and begging for rescue from rooftops and highway overpasses. The portable toilets were available and working at Camp Greyhound while there were no working bathrooms at the Convention Center and Superdome a few blocks away. Hundreds of cases of water and MREs were readily available for the guards and prisoners, while those stranded nearby were fighting for food and water.

There have been times when someone speaks to Kathy in English and she can't understand what the person is saying. It happened the

other day with Ambata, a woman the Zeitouns recently hired to help with office work. The kids had just come home from school, the TV was on, a stereo was playing — there was noise throughout the house. Kathy and Ambata were sending out invoices when Ambata said something Kathy couldn't understand. She saw Ambata's mouth moving, but the words conveyed no meaning.

"Can you repeat that?" she asked.

Ambata repeated herself.

The words made no sense.

"I'm sorry," Kathy said. "I have no idea what you're saying." She grew scared. She jumped up and, frantic, she turned off the TV, the stereo, and the computer. She wanted to eliminate any variables. She sat down again with Ambata and asked her to repeat what she said.

Ambata did, but Kathy still could not parse the words.

One day, in 2006, Zeitoun was visiting his cousin Adnan at his Subway franchise downtown. Zeitoun occasionally stopped there for lunch, and was eating there that day when he saw an exceptionally tall African American woman enter. She was in tan-and-green fatigues, evidently a National Guard soldier. She looked very familiar.

Zeitoun realized why he recognized her. She was, he was almost certain, one of the people who had arrested him. She had the same eyes, the same short hair. He stared for a few long moments and tried to muster the nerve to say something. He couldn't devise the right thing to say, and soon she was gone.

Afterward he asked Adnan about her.

"Have you seen her before?"

"I'm not sure. I don't think so."

"If she comes in again, you have to ask her questions. Ask her if she

was in New Orleans after the storm."

Zeitoun spent the day reliving his arrest and the weeks afterward. It wasn't every day that the arrest came to him, but late at night it was sometimes difficult to send away his anger.

He knew he couldn't live in the city if he felt he would continue to encounter people like this soldier. It was painful enough to pass by the Greyhound station. It was almost unavoidable, though, given how central it was — within sight of the Home Depot. He had adjusted his habits in a dozen small ways. He was exceedingly careful not to commit any minor traffic infraction. He feared that because of the lawsuit he would be a target of local police, that they would manufacture charges against him, try to justify his arrest. But these were fleeting thoughts. He fought them off every day.

One confrontation was unavoidable.

Four days after his release, Zeitoun had had time to sleep, and to eat a bit. He felt stronger. He didn't want to return to Camp Greyhound. But Kathy had insisted, and he knew she was right. They had to get his wallet back. It held his driver's license, and without it the only identification he had was the prison ID he had been given at Hunt. He and Kathy needed to fly to Phoenix to gather their children and drive home, and the only way he could do so was with his driver's license. They thought about it a dozen ways but couldn't find a better way. They had to return to the Greyhound station and retrieve the wallet.

They pulled into the crescent-shaped drive. All around were police cars, military Humvees, jeeps, and other military vehicles.

"How do you feel?" Kathy asked.

"Not good," Zeitoun said.

They parked and stayed in the car for a minute.

"Ready?" Kathy asked. She was primed for a fight.

Zeitoun opened his door. They walked toward the station. Outside the entrance, there were two soldiers.

"Please don't say anything," Zeitoun said to Kathy.

"I won't," she said, though she could barely contain her rage.

"Please don't," he repeated. He had warned her repeatedly that they could both be put in jail, or he could be returned to prison. Anything could happen. Anything *had* happened.

As they approached the bus station, Zeitoun was trembling.

"Please be calm," he said. "Don't make it worse."

"Okay, okay," Kathy said.

They walked past a dozen military personnel and into the building. It looked much like Zeitoun remembered. For the first time in his life, he tried to shrink. Trying to hide his face — the very people who caged him might still be there — he followed Kathy through the doors.

They were stopped by a pair of soldiers. They patted Zeitoun down and searched Kathy's purse. They directed them both through a metal detector. Zeitoun's eyes darted around the building, looking for anyone he recognized.

They were directed to a set of chairs, the same chairs Zeitoun had been questioned in, and were told to wait for a chance to meet with the assistant district attorney. Zeitoun wanted badly to get out as soon as possible. The situation was far too familiar. He had no faith that he would leave again.

As they waited, a man holding a tape recorder approached them. He told them that he was a reporter from the Netherlands, and that his friend had been held overnight at the station in one of the cages, and had just been released.

He began asking Zeitoun and Kathy why they were there. Kathy didn't hesitate, and began to tell him that her husband had been wrongfully arrested, sent to a maximum-security prison, held there for twenty-three days, and that now they were trying to retrieve his possessions.

"Get away from them!"

Kathy looked up. A female officer in her fifties, wearing full camouflage, was glaring at them, and barking at the Dutch reporter. "Get out of here," she said to him. "Interview's over." Then she turned to a pair of National Guardsmen. "If that man is seen in here again, arrest him and put him in a cage." The soldiers approached the reporter.

Kathy stood up and strode toward the woman.

"Now you take away my freedom of speech? Really? You took away my husband, you wouldn't let me speak to or see my husband, and now you take away my ability to speak freely? I don't think so! You know anything about freedom of speech?"

The officer turned away from Kathy and ordered that the reporter be removed. Two soldiers guided him to the front door and led him outside.

The assistant district attorney, a heavyset white man, approached them and asked how he could help. Kathy reiterated that she needed her husband's wallet. The man led them to the gift shop, which had been converted into an office. It was a glass box in the middle of the station, full of Mardi Gras T-shirts and paperweights. Kathy and Zeitoun explained their situation.

The assistant DA said he was sorry, but the wallet was still being used as evidence. Kathy blew up. "Evidence? How could his ID be used as evidence? You know his name. Why would you need his ID? He didn't commit a crime with his wallet."

The man sighed. "I'm sympathetic, but you can't have it without permission of the district attorney," he said.

"You mean Eddie Jordan?" Kathy asked. "Where is he?"

"He's not here," he said.

"When will he be here?" Kathy asked.

The assistant DA didn't know.

Kathy and Zeitoun walked into the station lobby, not knowing what their next step was. But then, through the station's front window, she saw Eddie Jordan. He was standing out front, surrounded by a phalanx of reporters.

Kathy marched out the door to confront Jordan. He was dressed in a three-piece suit.

"Why can't we have his wallet?" she asked.

"Excuse me?" Jordan said.

Kathy told him a brief version of Zeitoun's situation, and reiterated her demand that the wallet be returned.

Jordan said that there was nothing he could do about it, and turned around, resuming his conversation.

Now Kathy saw that the Dutch reporter was nearby. She wanted him and the other reporters to hear what was happening. She spoke as loudly as she could.

"You arrested my husband in his own house, and now you won't give him his wallet back? What's going on here? What is wrong with this city?"

Jordan shrugged and turned away.

"We're going back inside," Kathy said to Zeitoun.

Zeitoun didn't see the point, but the fire in her eyes did not encourage debate. They went back in and walked directly up to the

assistant DA. Kathy wouldn't allow that damned prison ID to define her husband, to be the only government-issued identification he owned.

"You have to do something," she said. She was near tears now, a mess of frustration and rage.

The assistant DA closed his eyes. "Let me see what I can find," he said. He left the office. In ten minutes, he came back with the wallet and handed it to Zeitoun.

Zeitoun's driver's license and permanent-resident card were there, but all his cash, business cards, and credit cards were gone.

"Where are the other things?" Zeitoun asked.

The man didn't know. "That's all there was."

Kathy didn't care. All she wanted, for now, was proof that her country recognized her husband as a citizen.

"Thank you, sir," she said. "Thank you." She wanted to hug him. He was the first person representing any part of the city or state government who had shown any humanity at all. Even this one easily executed task, retrieving the wallet of a man they'd held in a cage a few yards away, seemed, in the context, an act of great courage and empathy.

They left, satisfied that they had gotten the most crucial thing, the driver's license. Given the nature of the city's judicial system, it was miraculous that the wallet had been kept at all. Kathy had already canceled the credit cards. The rest they could replace.

That was the last time Kathy felt that focused, that angry. Now she is more diffuse. She gets angry, but not as often, and she can't focus her rage as she once could. Where she was once ready and willing to fight any battle, she prefers now to retreat, reinforce her defenses, double the locks on the doors. She finds herself fearful, always, that something will happen to her family. She doesn't like her kids playing in the neighborhood.

She wants them where she can see them, even Nademah, who is thirteen now, and almost as tall as Kathy herself. She watches them sleep. She never did that before. She checks on them frequently during the night. She wakes up and has trouble getting back to sleep.

Nademah, always responsible, always whip-smart, is now sharing in the care of her sisters. Zachary is eighteen, lives with friends in New Orleans, and works at one of Adnan's Subway restaurants. Safiya and Aisha are the same as always: blithe, full of joy, given to bursts of song. All of the kids make life very easy for little Ahmad, born on November 10, 2006 at East Jefferson Hospital.

Ahmad is, by all accounts, a preternaturally content baby. He never wants for attention, with his sisters taking turns holding him, taking dangerous things out of his mouth, reading to him, dressing him in their old clothes.

Zeitoun was so thankful for a boy. And the name was never an issue. Ahmad was the first and only name.

Zeitoun's brother Ahmad, still living in Spain, now works as a ship inspector. He's waiting for his brother to bring the new baby to Málaga. It's time he saw his nephew, his namesake.

Kathy is working less these days. There's the baby to care for, and her mind is not sharp enough, not lately, to handle all the paperwork on her own. They have some help now, from Ambata and others, which gives Kathy some room to breathe, to be a mother, to try to make sense of the last three years.

There are appointments with doctors. Doctors to try to figure out why her hands go numb without warning. Doctors to investigate her digestive problems, memory problems.

Doctors have asked Kathy what she thinks the most traumatic part of the Katrina experience was. She surprised herself and the doctors when she realized that it was after she knew Zeitoun was alive, and had been told he was at Hunt Correctional Center, but wasn't allowed to see him or even know where a court hearing might be held. It was that moment, being told by the woman on the phone that the hearing's location was "private information," that did the most damage.

"I felt cracked open," she says.

That this woman, a stranger, could know her despair and desperation, and simply deny her. That there could be trials without witnesses, that her government could make people disappear.

"It broke me."

She finds herself wondering, early in the morning and late at night and sometimes just while sitting with little Ahmad sleeping on her lap: *Did all that really happen? Did it happen in the United States? To us?* It could have been avoided, she thinks. So many little things could have been done. So many people let it happen. So many looked away. And it only takes one person, one small act of stepping from the dark to the light.

She wants to find out who that missionary was, the man who met her husband in prison and took her phone number — the messenger. The man who risked something in the name of mercy.

But did he risk so much? Not really. Usually you needn't risk so much to right a wrong. It's not so complicated. It's the opposite of complicated. To dial a number given to you by a man in a cage, to tell the voice on the other end, "I saw him." Is that complicated? Is that an act of great heroism in the United States of America?

It should not be so.

*　*　*

Kathy worries that her husband is working too hard now. He works every day, even Sundays. He's home for meals, and bedtimes, but he works whenever he can. And how he does it while fasting on Mondays and Fridays — he's become more religious — is beyond her. He seems to eat even less than before, and works harder than ever.

Friends who know what happened to Zeitoun after the storm ask why he hasn't left, why he hasn't gone to another city, another country — even back to Syria — anyplace removed from the memories embedded into New Orleans. He does have dark feelings when he passes by the Greyhound station, when he drives past the house on Claiborne where he and two friends and a stranger were carried off. When he drives by the home of Alvin and Beulah Williams, the pastor and his wife, he says a quick prayer for them. Beulah Williams died in 2007. Reverend Alvin Williams died in 2008.

When he passes by the home of Charlie Ray, his neighbor on Claiborne, he waves if Charlie is on his porch, which he often is. One day after the storm, Charlie was visited by the National Guard. They told him that he should leave the city, and that they would help him. They waited for him to pack, and then carried his bags to their boat. They ferried him to an evacuation point, whereupon a helicopter flew him to the airport and he was given a free plane ticket to New York.

His rescue took place the same day Zeitoun was arrested. A few months after the storm, Charlie returned to New Orleans and still lives on Claiborne.

Todd Gambino now lives in Mississippi. He spent over five months

at Hunt Correctional Center. He was released on February 14, 2006. All charges against him were dropped. More than $2,400 had been confiscated from him when he was processed at Camp Greyhound, and when he was released, he attempted repeatedly to recover it. He was unsuccessful. He was not compensated in any way for the five months he spent at the maximum-security prison.

After his release, he went to work on an oil rig in the Gulf of Mexico but was laid off in the fall of 2008.

Nasser Dayoob spent six months at Hunt. All charges against him were eventually dropped; when he was released, he tried to recover the $10,000 he'd had with him when he was arrested. No authorities had any record of it, and he never recovered the money, his life savings. In 2008 he moved back to Syria.

Ronnie spent eight months at Hunt. Since his release in the spring of 2006, the Zeitouns have not heard from him.

Frank Noland and his wife have moved. Just about everyone in the Zeitouns' neighborhood has moved. Gone, too, is the woman Zeitoun found in her foyer — the woman whose cries he heard because he paddled quietly. The new occupant of her house doesn't know where she went, but he has heard the story of Zeitoun's rescue.

Zeitoun thinks of the simple greatness of the canoe, of the advantages of moving quietly, of listening carefully. When he was released from prison, he and Kathy looked for the canoe where he'd last seen it, at the Claiborne house, but it was gone. The house had been robbed, too. Everything was stolen, because the soldiers and police who arrested Zeitoun had left the house unlocked and unguarded. Thieves walked in unimpeded and made off with all the tenants' belongings, everything

Todd had gathered there in the front rooms to keep dry.

All those things were replaced, but he misses the canoe. He keeps his eye out for it, hoping he'll see it at a yard sale or in someone's sideyard. He'd pay for it again. Maybe he should get a new one, he thinks. Maybe his girls will like it more now. Maybe little Ahmad, like his uncle and father and grandfather and countless Zeitouns before them, will feel the lure of the sea.

Some nights Zeitoun struggles to sleep. Some nights he thinks of the faces, the people who arrested him, who jailed him, who shuttled him between cages like an animal, who transported him like luggage. He thinks of the people who could not see him as a neighbor, as a countryman, as a human.

Eventually he finds his way to sleep, and in the morning he awakens to the sounds of his children — four young ones in the house now, so many voices in this now-bigger house, the smell of fresh paint filling the home with possibility. The kids fear water, yes, and when a pipe burst last year there were screams and nightmares, but slowly they're growing stronger. For them he has to be strong, and he needs to look forward. He needs to feed them, to hold them close, and he needs to show them that God had a reason for their trials. He tells them that perhaps God, by allowing him to be jailed, saved him from something worse.

"Everything happens for a reason," he tells them. "You do your duty, you do what's right, and the rest is in God's hands."

He has watched the progress of the rebuilding of the city. The first few years were frustrating, as legislators and planners bickered over money and protocols. New Orleans, his home, needs no speeches, no

squabbling, and no politics. It needs new flooring, and new roofing, new windows and doors and stairs.

For many of his clients, it took time for the insurance money to come through, for the FEMA money to appear, for any number of complications to work themselves out. But now things are moving. The city is rising again. Since Hurricane Katrina, Zeitoun A. Painting Contractor LLC has restored 114 houses to their former states, or improved versions thereof.

Zeitoun bought a new van and drives through the city, through Uptown, the Garden District, the French Quarter, Lakeview, the West Bank, Broadmoor, Metairie, Gentilly, the Lower Ninth, Mirabeau Gardens — and every time he sees a home under construction, no matter who's doing it, he smiles. *Build*, he thinks. *Build, build, build.*

And so he makes his rounds, checking in on his crews. They're working on some very good and important projects. Even with a slowing economy, there is much to do.

There's McDonough #28, a three-story junior high school on Esplanade. It's been closed since the storm, but it can come back. Zeitoun is fixing the woodwork with caulk and putty, repainting the interiors with medium grey and sage-green and bone-white. That shouldn't take too long. It'll be good to see that school open again.

It would be easy, he knows, with that building and so many others, to simply tear them down and begin again. As a builder, it certainly is easier starting with a piece of flat, cleared land. But so much is lost that way, far too much is lost. And so for three years of rebuilding he has always asked, first, "What can be saved?"

There's the Leidenheimer Bakery on Simon Bolivar Avenue. The building is a wonderful brick structure, over a hundred years old, and

the bakery is still run by the descendants of George Leidenheimer, an immigrant from Germany. Zeitoun was proud to get the job, as he always is with buildings of significance; he hates to see them torn down. The masonry weathered the storm just fine, but the windows and wood need refinishing or replacing. So he and his crew are doing that, and remodeling the inner office, installing some cabinets, painting the vents.

And there's the St. Clement of Rome Parish Church on West Esplanade and Richland. The interior woodwork needs priming and refinishing. The exterior sustained some damage, so they'll pressure-wash it, sand and caulk it, and repaint every wall and window. He intends to oversee that project very carefully. He always does when hired to restore any house of worship. He is sure that God is watching the work he and Kathy and his men are doing, so it must be done with great care and even, he tells his crews, with soul.

More than anything else, Zeitoun is simply happy to be free and in his city. It's the place of his dreams, the place where he was married, where his children were born, where he was given the trust of his neighbors. So every day he gets in his white van, still with its rainbow logo, and makes his way through the city, watching it rise again.

It was a test, Zeitoun thinks. Who among us could deny that we were tested? But now look at us, he says. Every person is stronger now. Every person who was forgotten by God or country is now louder, more defiant, and more determined. They existed before, and they exist again, in the city of New Orleans and the United States of America. And Abdulrahman Zeitoun existed before, and exists again, in the city of New Orleans and the United States of America. He can only have faith that will never again be forgotten, denied, called by a name other than his own. He must trust, and he must have faith. And so he builds,

because what is building, and rebuilding and rebuilding again, but an act of faith? There is no faith like the faith of a builder of homes in coastal Louisiana. And there is no better way to prove to God and neighbor that you were there, that you are there, that you are human, than to build. Who could ever again deny he belonged here? If he needs to restore every home in this city, he will, to prove he is part of this place.

As he drives through the city during the day and dreams of it at night, his mind vaults into glorious reveries — he envisions this city and this country not just as it was, but better, far better. It can be. Yes, a dark time passed over this land, but now there is something like light. Progress is being made. It's so slow sometimes, so terribly so sometimes, but progress is being made. We have removed the rot, we are strengthening the foundations. There is much work to do, and we all know what needs to be done. We can only do the work, he tells Kathy, and his children, and his crew, his friends, anyone he sees. So let us get up early and stay late, and, brick by brick and block by block, let us get that work done. If he can picture it, it can be. This has been the pattern of his life: ludicrous dreams followed by hours and days and years of work and then a reality surpassing his wildest hopes and expectations.

And so why should this be any different?

THE ZEITOUN FOUNDATION

All author proceeds from this book go to the Zeitoun Foundation, founded in 2009 by the Zeitoun family, the author, and McSweeney's. Its purpose is to aid in the rebuilding of New Orleans and to promote respect for human rights in the United States and around the world. The Zeitoun Foundation will serve as a grantor of funds generated from this book; the first group of recipients include the following nonprofit organizations.

REBUILDING TOGETHER
Rebuilding Together's Gulf Coast operations have focused on preserving and rehabilitating one thousand houses of low-income homeowners, which were damaged in the wake of Hurricane Katrina and Rita.
www.rebuildingtogether.org

THE GREEN PROJECT
The Green Project obtains and resells building materials salvaged in the New Orleans area. The purpose is to encourage recycling, thereby reducing waste; to enable residents of New Orleans to purchase low-cost materials; and to preserve the architectural history of the area.
www.thegreenproject.org

THE LOUISIANA CAPITAL ASSISTANCE CENTER

After Hurricane Katrina, the LCAC was a leading force in locating the thousands of inmates who had been displaced, highlighting the plight of the prisoners who had been evacuated into terrible conditions, and securing the release of hundreds of inmates who were wrongfully imprisoned. The LCAC now aims to provide legal representation for defendants in Louisiana who are facing capital punishment, and seeks to address racism in the criminal justice system.

www.thejusticecenter.org/lcac

INNOCENCE PROJECT OF NEW ORLEANS

This New Orleans–based organization provides legal aid for people who have been wrongfully convicted, and helps them in their transition from incarceration to liberty. They focus on the states where incarceration rates (and rates of wrongful conviction) are highest — Louisiana and Mississippi.

www.ip-no.org

MEENA MAGAZINE

Meena ("port" in Arabic) is a bilingual literary journal based in the port cities of New Orleans and Alexandria, Egypt. The journal publishes poetry, fiction, essays, travel writing, mixed-genre media, and art. *Meena* hopes to exist as a port between the Western and Arab worlds by exchanging ideas about culture, language, conflict, and peace through writing and dialogue.

www.meenamag.com

THE PORCH SEVENTH WARD CULTURAL ORGANIZATION

An organization committed to the Seventh Ward in New Orleans, The Porch is a place to come together and share culture and community. The Porch seeks to promote and sustain the cultures of the neighborhood, the city, and the region, and to foster exchange between cultural groups.

www.ny2no.net/theporch

CATHOLIC CHARITIES, ARCHDIOCESE NEW ORLEANS

Catholic Charities works with the entire community of New Orleans to respect the dignity of every human person. They are currently operating eleven community centers in the Greater New Orleans area to help with hurricane recovery. These centers provide case-management services, direct assistance, and other services as needed.

www.ccano.org

ISLAMIC RELIEF USA

Islamic Relief strives to alleviate suffering, hunger, illiteracy, and diseases worldwide, without regard to color, race, or creed. In the event of man-made or natural disasters, it aims to provide rapid relief. Working with the United Nations World Food Program (UNWFP) and the Department for International Development, Islamic Relief establishes development projects in needy areas to help tackle poverty at a local level.

www.irw.org

THE MUSLIM AMERICAN SOCIETY

The Muslim American Society (MAS) is a charitable, religious, social, cultural, and educational not-for-profit organization. Its mission is to build an integrated empowerment process for the American Muslim community through civic education, local leadership training, community outreach, and coalition building. MAS also strives to forge positive relationships with other institutions outside of its community, in order to facilitate the protection of civil rights and liberties for American Muslims and all Americans.

www.masnet.org

THE NEW ORLEANS INSTITUTE

The New Orleans Institute is dedicated to engaged citizenry and is determined to cultivate local solutions. This is a networking alliance with a shared interest and commitment to fostering the resilience of New Orleans through innovation.

www.theneworleansinstitute.org

ACKNOWLEDGMENTS

THE ZEITOUN FAMILY WOULD LIKE TO ACKNOWLEDGE:

Ahmad Zeton; Mrs. Trufant; Yuko and Ahmaad Alakoum for putting up with us in our darkest hours; Mary Amarouni; Crystal and Keene Kelly; Celeste and Tom Bitchatch; the Callender family; Tom and Luke; Nabil Abukhader; Mohammed Salaam; Rob Florence; and all of those who helped us.

THE AUTHOR WOULD LIKE TO ACKNOWLEDGE THE WORK
OF THE FOLLOWING JOURNALISTS AND RESEARCHERS:

Gwen Filosa, Rob Nelson, Bruce Nolan, Emmet Mayer III, Mark Schleifstein, John McCusker, *New Orleans Times-Picayune*; Dr. Daniel L. Haulman, the Air Force Historical Research Agency; Tech. Sgt. Mark Diamond, the Air Force Medical Services Monthly Newswire; Jenny Carchman, Michelle Ferrari, Stephen Ives, Lindsey Megrue, Amanda Pollak, Mark Samels, *The American Experience*; Donna Miles, Rudi Williams, the American Forces Press Service; Marina Sideris, Amnesty Working Group; Betty Reid, *Arizona Republic*; Joseph R. Chenelly, *Army Times*; Craig Alia, *Army Magazine*; Lolita C. Baldor, Wendy Benjaminson, Rick Bowmer, Allen G. Breed, Melinda Deslatte, Linda Kleindienst, Marilynn Marchione, Brett Martel, Janet McConnaughey, Kevin McGill, Adam Nossiter, John Solomon, the Associated Press; Kelly Bradley, Lt. Col. Tim Donovan, Larry Sommers, *At Ease Magazine*; Mickey Noah, *Baptist Press*; Olenka Frenkiel, BBC; Amy Goodman, *Democracy Now!*; Brandon L.

Garrett, Tania Tetlow, *Duke Law Journal*; Charlie Savage, *Boston Globe*; Patrik Jonsson, the *Christian Science Monitor*; Jamie Wilson, the *Guardian*; Jason Carroll, Anderson Cooper, Jacqui Jeras, Chris Lawrence, Ed Lavandera, Rob Marciano, Ed Zarrella, Jeanne Meserve, Betty Nguyen, CNN; Tamara Audi, *Detroit Free Press*; Neil deMause, Steve Rendall, *Extra!*; Todd Stubing, *Fort Myers News-Press*; Dave Reynolds, *Inclusion Daily Express*; Adnan Bounni, Iran Chamber Society; Guy Siebold, *Journal of Political and Military Sociology*; Stacy Parker Aab, The Katrina Experience Oral History Project; Alan Zarembo, *Los Angeles Times*; Capt. David Nevers, *Marines Magazine*; Jeremy Scahill, the *Nation*; Staff Sgt. Jon Soucy, National Guard Bureau; Daniel P. Brown, Richard D. Knabb, Jamie R. Rhome, National Hurricane Center; John Burnett, Jeff Brady, National Public Radio; Ken Munson, *Nautical Notes*; Diane E. Dees, *Mother Jones*; Curtis A. Utz, Naval Historical Center; Ruth Berggren, *New England Journal of Medicine*; Lou Dolinar, *New York Post*; David Carr, Melissa Clark, N.R. Kleinfield, Merrill Perlman, Shadi Rahimi, Joseph B. Treaster, Richard W. Stevenson, Alex Berenson, Sewell Chan, Paul von Zielbauer, *New York Times*; Sarita Sarvate, Pacific News Service; Kevin Callan, paddling.net; Yvonne Haddad, Fariborz Haghshenass, *PolicyWatch*; Peter Henderson, Michael Christie, Jane Sutton, Reuters; Richard Burgess, *Sea Power Magazine*; Jordan Flaherty, *Southern Studies: An Interdisciplinary Journal of the South*; Morris Merrill, *Southern Quarterly*; Fred Kaplan, *Slate*; Angie Welling, *Salt Lake City Deseret News*; Ken Kaye, Robert Nolin, *South Florida Sun-Sentinel*; Jeff Schogol, *Stars and Stripes*; Harry Mount, the *Telegraph*; Amber McIlwain, *Times of London*; Matthew Van Dusen, *Times of Northwest Indiana*; Joel Stein, *Time Magazine*; Anna Mulrine, Dan Gilgoff, *US News and World Report*; Douglas Brinkley, *Vanity Fair*; Renae Merle, Guy Gugliotta, Peter Whoriskey, Eugene Robinson, the *Washington Post*; Michael Pope, Christiana Halsey, *Customs and Border Protection Today*; the Center for Human Rights and Global Justice; Charles Janda, Chucksphotospot.com; Jordan Flaherty, *ColorLines*; Eugen Tarnow, PhD, Cogprints.org; Amy Belasco, Steve Bowman, Lawrence Kapp, Department of Defense; Maj. Mark Brady, Capt. Lisa Kopczynski, Sgt. Les Newport, First U.S. Army in the News; Gary Mason, the *Globe and Mail*; Hugh Hewitt, *The Hugh Hewitt Show*; The Indy Channel; Indiana University, Bloomington; The Innocence Project; staff, *Killeen Daily Herald*; Jason Brown, *Lafayette Daily Advertiser*; Jamie Doward, *London Observer*; Rosa Brooks, *Los Angeles Times*; Chris Kelly, *MichelleMalkin.com*; Michael Robbins, *Military History*; staff, *Naples Daily News*; staff, *NGAUS Notes*; Lt. Col. Deedra Thombleson, National

Guard; Erick Studenicka, National Guard Bureau; Navy Office of Information; Carl Quintanilla, Tony Zumbado, NBC News; New Orleans Copwatch; Jayne Huckerby, New York University Center for Human Rights and Global Justice; Gregory Smith MD, Woodhall Stopford MD, *North Carolina Medical Journal*; peopleshurricane.org; Keith Woods, Poynter Institute; Eric Barr, Taylor Rankin, John Baird, *ThinkQuest*; David Crossland, *Times of London*; United States Coast Guard; Marina Sideris, University of California Berkeley Law School; Jerry Seper, the *Washington Times*; Wrongful-Convictions.blogspot.com; Kelly Leosis, Katherine Yurica, *yuricareport.com*; Neworleans.indymedia.org.

THE FOLLOWING BOOKS AND REPORTS WERE CRUCIAL
TO THE WRITING OF *ZEITOUN*:

The Great Deluge: Hurricane Katrina, New Orleans, and the Mississippi Gulf Coast by Douglas Brinkley (William Morrow, 2006); *Severe and Hazardous Weather* by Bob Rauber, John Walsh, Donna Charlevoix (Kendall Hunt Publishing, 2005); *On Risk and Disaster: Lessons from Hurricane Katrina,* edited by Ronald J. Daniels, Donald F. Kettl and Howard Kunreuther (University of Pennsylvania Press, 2006); *Hurricane Katrina: America's Unnatural Disaster*, by Jeremy I. Levitt and Matthew C. Whitaker (University of Nebraska Press, 2009); *Come Hell or High Water* by Michael Eric Dyson (Basic Civitas, 2006); *Disaster: Hurricane Katrina and the Failure of Homeland Security* by Robert Block and Christopher Cooper (Henry Holt Books, 2006); *Down in New Orleans: Reflections from a Drowned City* by Billy Sothern and Nikki Page (University of California Press, 2007); *The Essential Koran*, translated and presented by Thomas Cleary (HarperCollins, 1993); *A Modern History of Syria* by A.L. Tibawi (St. Martin's Press, 1969); *Fifty Years of Modern Syria and Lebanon*, by George Haddad (Dar-al-Hayat, 1950); *Modern Syria, from Ottoman Rule to Pivotal Role in the Middle East*, edited by Moshe Ma'oz, Joseph Ginat, and Onn Winckler, (Sussex Academic Press, 1999); *Supporting the Future Total Force*, by John G. Drew, Kristin F. Lynch, James Masters, Sally Sleeper, and William Williams (RAND, 2007); *By the Numbers: Findings of the Detainee Abuse and Accountability Project* by Human Rights Watch (Human Rights Watch, 2006); *Irreversible Consequences: Racial Profiling and Lethal Force in the War on Terror,* by the Center for Human Rights and Global Justice (NYU School of Law, 2006); *Public Safety, Public Spending: Forecasting America's Prison Population 2007–2011*, by the JFA Institute, the Public Safety Performance Project, and the Pew Charitable Trusts (Pew Charitable Trusts, 2007); *Abandoned and Abused: Orleans*

Parish Prisoners in the Wake of Hurricane Katrina, by the National Prison Project of the American Civil Liberties Union, the American Civil Liberties Union of Louisiana, the American Civil Liberties Union Racial Justice Program, Human Rights Watch, the Juvenile Justice Project of Louisiana, the NAACP Legal Defense and Educational Fund, Inc., and Safe Street/Strong Communities (American Civil Liberties Union and the National Prison Project, 2006); *Enabling Torture: International Law Applicable to State Participation in the Unlawful Activities of Other States*, by the Center for Human Rights and Global Justice (NYU School of Law, 2006); *Beyond Guantanamo: Transfers to Torture One Year After Rasul v. Bush*, by the Center for Human Rights and Global Justice (NYU School of Law, 2005); *Louisiana National Guard Timeline of Significant Events, Hurricane Katrina*, by the Louisiana National Guard (Louisiana National Guard, 2005); *Torture by Proxy: International Law applicable to "Extraordinary Renditions"* by the Association of the Bar of the City of New York and the Center for Human Rights and Global Justice (ABCNY and the NYU School of Law, 2004); *Use of Force: ATF Policy, Training and Review Process Are Comparable to DEA's and FBI's*, by USGAO (United States General Accounting Office, 1996).

THE FOLLOWING AGENCIES AND ORGANIZATIONS
PROVIDED ESSENTIAL INFORMATION:

44th Medical Brigade Public Affairs; Air National Guard 920 Rescue Wing; American Civil Liberties Union; Blackwater USA; Bureau of Alcohol Tobacco and Firearms; Camp Pendleton Public Affairs; Center for Disease Control; DynCorp International; Defense Logistics Agency Defense Supply Center; Federal Emergency Management Agency; First Army Public Affairs; Fort Hood Public Affairs; Fort Hood Media Relations; Fort Carson Public Affairs; Fourth Infantry Division Public Affairs; Immigration and Customs Enforcement Public Affairs; Louisiana National Guard Public Affairs; Louisiana State Police; NASA; National Guard Association of the United States; National Oceanic and Atmospheric Administration; National Weather Service; National Hurricane Center; Office of the Attorney General; SOPAKCO; State of Michigan Department of Military and Veterans Affairs; State of Wisconsin Department of Military Affairs; Texas National Guard Community Relations; U.S. Army Public Affairs; U.S. Capitol Police; U.S. Department of Homeland Security, Department of Public Affairs; U.S. Marine Corps Public Affairs; U.S. Marshals.

NOTES ABOUT THE QUR'AN QUOTED HEREIN

Many translations of the Qur'an into English exist and many were consulted. The translation quoted in this book is by Laleh Bakhtiar, published in 2007 by Kazi Publications under the title *The Sublime Quran*. As is evidenced in the quotations included in this book, the Qur'an contains very powerful and surpassingly beautiful language, and this English edition reflects that beauty exceedingly well.

AUTHOR NOTES ON PROCESS AND METHODOLOGY

The process behind this book started in 2005, when, shortly after Hurricane Katrina struck New Orleans, a team of volunteers from Voice of Witness, our series of books that use oral history to illuminate human rights crises, fanned out all over the Southeast to collect testimonies. From Houston to Florida, they interviewed residents and former residents of New Orleans about their lives before, during, and after the storm. The result was *Voices from the Storm*, edited by Chris Ying and Lola Vollen and published by McSweeney's/Voice of Witness in 2005. The book featured vivid narratives from dozens of New Orleanians, including Abdulrahman and Kathy Zeitoun. His story stuck with me, and the next time I was in New Orleans, to speak to students at the New Orleans Center for the Creative Arts (a great high school arts program), I visited the Zeitouns. From our first talk, it was clear that there was more to their story than we were able to include in *Voices from the Storm*. And so began an almost-three-year process of interviews and research that went into *Zeitoun*. During that time, I was able to get to know Abdulrahman and Kathy, as well as their beautiful family here and in Syria.

Additional notes:

- All events are seen through the eyes of either Abdulrahman or Kathy Zeitoun, so the view of events reflects their recollections. Todd Gambino was also a participant in the writing and fact-checking of this book. All conversations are reconstructed from the memories of the participants.
- Interviews with Officers Donald Lima and Ralph Gonzales were conducted by the author in 2008.
- I visited the Elayn Hunt Correctional Center in 2008. It seemed to be a very well-run prison, a progressive and rational place with a keen eye toward rehabilitation and re-entry, and toward giving prisoners the opportunity to advance their educations, whether academic or vocational. And yet Adbul

rahman's experience there was not acceptable. I don't intend to denounce the operation of that prison; perhaps the institution was simply overwhelmed after Katrina and fell short of its higher standards.

AUTHOR THANKS

Chris Ying and Lola Vollen laid the groundwork for this book and deserve vast thanks for encouraging me to pursue this story further. Billy Sothern, the New Orleans lawyer and author who conducted the initial interviews with Abdulrahman and Kathy Zeitoun for *Voices from the Storm*, deserves profound thanks. He was a constant guide and mentor during the writing of *Zeitoun*, and his own book, *Down in New Orleans*, was both inspiration and roadmap. As deputy director of the Capital Appeals Project, he continues to fight every day in the defense of those left vulnerable to the judicial system's frailties and oversights. Annie Preziosi of the Louisiana Capital Assistance Center provided expert research at crucial junctures. Her colleague at LCAC, Julie Kilborn, was very helpful in providing context for the arrests and processing of prisoners after Katrina. Thanks also go to Pam Metzger at the Tulane University Law School and to Nikki Page, whose hospitality and warmth was appreciated always. Anne Gisleson, extraordinary New Orleans writer and teacher and activist, provided invaluable guidance and encouragement and was an expert reader of the manuscript. The courageous Todd Gambino provided fact-checking and context and important details. Elissa Bassist provided key and voluminous research early on. Yousef Munayyer and Mohammed Khalil provided gentle guidance in Arabic and Islamic matters. Naor Ben-Yehoyada provided expert counsel on the history and practice of *lampara* fishing. Farah Aldabbagh translated a rare book about Mohammed Zeitoun from Arabic to English in a timely and expert manner. Peter Orner and Stephen Elliott provided surgical notes and deeply appreciated encouragement. Proofing and copyediting was provided by Lindsay Quella, Juliet Litman, Tess Thackara, Emily Stackhouse, and Henry Jones. Thanks to all at McSweeney's — Jordan Bass, Heidi Meredith, Angela Petrella, Eli Horowitz, Mimi Lok, and especially to Andrew Leland, whose early read of the manuscript was crucial. Extraordinary and tenacious fact-checking was also performed by the indefatigable Chris Benz. Michelle Quint, associate editor at McSweeney's, was the day-to-day research director for this book. Her dedication, reliability, intelligence, and efficiency will never be forgotten, as this book would have been impossible without her. And of course life generally would not be possible without my wife Vendela, our children, and my brothers Bill and Toph.

Finally, profound thanks go to the Zeitouns of America, Spain, and Syria. Captain Ahmad Zeton — there are many ways to spell the name — and his family in Málaga, Spain (Laila, Lutfi, and Antonia) were generous hosts and brought forth crucial memories. Ahmad was not only a champion of this project from the beginning, but also a meticulous record-keeper, and his photos, emails, and calls from before and after the storm were invaluable. Warm thanks and greetings go to the Zeitoun family in Syria, and to Qusay and young Mahmoud in Jableh in particular. The hospitality of all the Zeitouns knew no limits, and the beauty and laughter and warmth permeating every part of their extraordinary clan was inspiring and enriched this book and this author beyond measure. Most of all, thanks go to Abdulrahman and Kathy, and to their remarkable children, for their stunning personal generosity and for their unwavering commitment to the writing of this book. The process of bringing their story to print required a great deal of them, but they fought through unpleasant memories in the hopes that something constructive might come from their days of personal struggle. Their courage knows no bounds, and their faith in family and in this country renews the faith of us all.

The VOICE OF WITNESS SERIES

Voice of Witness is a nonprofit book series, published by McSweeney's, that empowers those most closely affected by contemporary social injustice. Using oral history as a foundation, the series depicts human rights crises in the United States and around the world. There are currently four books in the series, including:

SURVIVING JUSTICE
America's Wrongfully Convicted and Exonerated
Edited by Lola Vollen and Dave Eggers Foreword by Scott Turow

These oral histories prove that the problem of wrongful conviction is far-reaching and very real. Through a series of all-too-common circumstances — eyewitness misidentification, inept defense lawyers, coercive interrogation — the lives of these men and women of all different backgrounds were irreversibly disrupted.

ISBN: 978-1-934781-25-8 469 pages Paperback

UNDERGROUND AMERICA
Narratives of Undocumented Lives
Edited by Peter Orner Foreword by Luis Alberto Urrea

By living and working in the U.S. without legal status, millions of immigrants risk deportation and imprisonment. They are living underground, with little protection from exploitation at the hands of human smugglers, employers, or law enforcement. *Underground America* presents the remarkable oral histories of men and women struggling to carve a life for themselves in the U.S.

ISBN: 978-1-934781-15-9 379 pages Paperback

OUT OF EXILE
The Abducted and Displaced People of Sudan
Edited by Craig Walzer
Additional interviews and an introduction by Dave Eggers and Valentino Achak Deng

Millions of people have fled from conflicts and persecution in all parts of Sudan, and many thousands more have been enslaved as human spoils of war. In this book, refugees and abductees recount their escapes from the wars in Darfur and South Sudan, from political and religious persecution, and from abduction by militias. They tell of life before the war, and of the hope that they might someday find peace again.

ISBN: 978-1-934781-13-5 465 pages Paperback

For more on Voice of Witness, please visit voiceofwitness.org

348

VOICES FROM THE STORM
The People of New Orleans on Hurricane Katrina and Its Aftermath

The second book in the McSweeney's Voice of Witness series, *Voices from the Storm* is a chronological account of the worst natural disaster in modern American history. Thirteen New Orleanians describe the days leading up to Hurricane Katrina, the storm itself, and the harrowing confusion of the days and months afterward. Their stories weave and intersect, ultimately creating an eye-opening portrait of courage in the face of terror, and of hope amidst nearly complete devastation. In addition to the story of Abdulrahman Zeitoun, the book features the accounts of men and women such as:

FATHER VIEN THE NGUYEN, who stayed through the storm to look after parishioners unable to flee New Orleans East. Yet once the storm had passed and supplies began to dwindle, rescue was nowhere to be found.

RHONDA SYLVESTER, who placed her grandchildren in buckets and trudged through miles of flooded streets in search of help. She and many others then spent days under a highway, waiting to be evacuated.

PATRICIA THOMPSON, whose family was threatened with guns on multiple occasions — once while trying to cross a bridge to safety, and again while seeking help outside one of the city's designated refuges.

DANIEL FINNIGAN, who tried to defend his neighborhood from looting, but acquiesced when he realized that the looters were in dire need of the most basic necessities.

Available at bookstores or through www.mcsweeneys.net

ABOUT THE AUTHOR

Dave Eggers is the author of five previous books, including *What Is the What*, a finalist for the 2006 National Book Critics Circle Award. That book, about Valentino Achak Deng, a survivor of the civil war in southern Sudan, gave birth to the Valentino Achak Deng Foundation, run by Mr. Deng and dedicated to building secondary schools in southern Sudan. Eggers is the founder and editor of McSweeney's, an independent publishing house based in San Francisco that produces a quarterly journal, a monthly magazine (*The Believer*), and *Wholphin*, a quarterly DVD of short films and documentaries. In 2002, with Nínive Calegari he co-founded 826 Valencia, a nonprofit writing and tutoring center for youth in the Mission District of San Francisco. Local communities have since opened sister 826 centers in Chicago, Los Angeles, Brooklyn, Ann Arbor, Seattle, and Boston. In 2004, Eggers taught at the University of California–Berkeley Graduate School of Journalism, and there, with Dr. Lola Vollen, he co-founded Voice of Witness, a series of books using oral history to illuminate human rights crises around the world. A native of Chicago, Eggers graduated from the University of Illinois with a degree in journalism. He now lives in the San Francisco Bay Area with his wife and two children.

www.mcsweeneys.net
www.voiceofwitness.org
www.826national.org
www.valentinoachakdeng.org
www.zeitounfoundation.org